THE
HISTORICAL ATLAS
OF
WORLD
RAILROADS

A FIREFLY BOOK

Published by Firefly Books Ltd. 2009

First printing

Publisher Cataloging-in-Publication Data (U.S.)
Westwood, John.
 The historical atlas of world railroads : 400 maps and photographs chart the networks that span the world / John Westwood.
[400] p. : photos. (chiefly col.), maps ; cm.
Includes bibliographical references and index.
Summary: The rise, fall and revival of railroads over the past 200 years, from the earliest experiments with wooden rails and horse-drawn wagons, through the rail-building boom of the steam age, to the onset of 21st century high-speed lines, diesel-electric locomotives and electric tilting trains.
ISBN-13: 978-1-55407-523-2
ISBN-10: 1-55407-523-8
1. Railroads – History -- Maps. I. Title.
385.09 dc22 HE1021.W478 2009

Library and Archives Canada Cataloguing in Publication

A CIP record is available for this title
from Library and Archives Canada.

Published in the United States by
Firefly Books (U.S.) Inc.
P.O. Box 1338, Ellicott Station
Buffalo, New York 14205

Published in Canada by
Firefly Books Ltd.
66 Leek Crescent
Richmond Hill, Ontario L4B 1H1

Printed in Singapore

Acknowledgments
Editorial & Design: Platanós Publications
Managing Editor: Richard Wiles
Editor: Ian Penberthy
Designer: Ian Christmas

Produced by Cartographica Press
6 Blundell St, London N7 9BH

THE HISTORICAL ATLAS
OF
WORLD
RAILROADS

JOHN WESTWOOD

FIREFLY BOOKS

CONTENTS

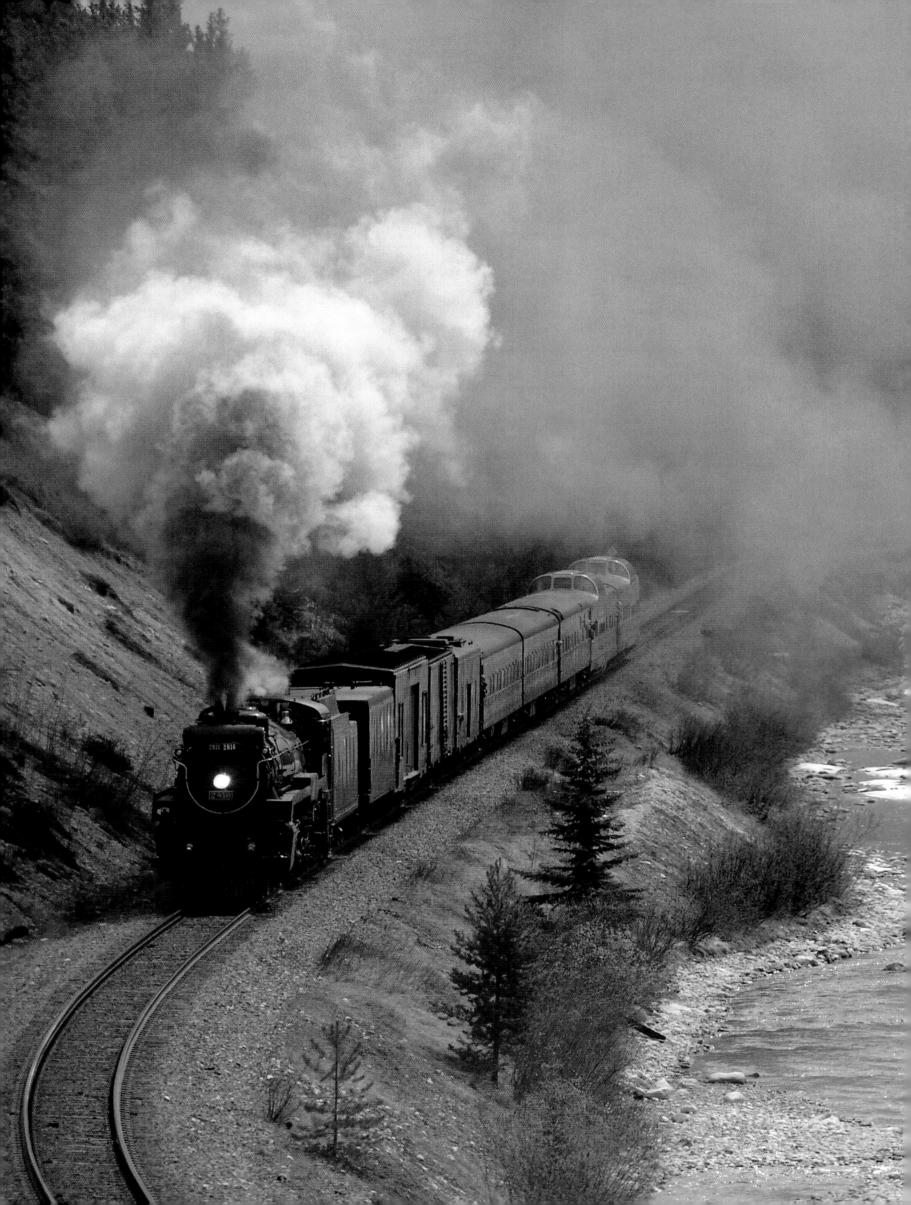

MAP LIST

INTRODUCTION

THE PREDOMINATING INFLUENCE OF GEOGRAPHY LED TO
THE GROWTH OF RAILROADS, SO IT IS FASCINATING AND
WORTHWHILE TO STUDY THE SITUATION ON A WORLDWIDE
BASIS, WITH THE AID OF MAPS.

In the early days of railroads, engineers followed winding routes through river valleys and along coastlines when laying the tracks, as this map of the New York Central Railroad's Water Level Route shows. These geographical features provided easier grades.

Not so many years ago, there was a widely held opinion in most parts of the world that railroads were relics of the past. For medium-distance travel, the passenger train had been outstripped both in speed and general convenience by the private automobile; in commuter travel, city workers were beginning to prefer road congestion and the difficulties of parking to the gross discomfort, overcrowding and occasional breakdowns in local train services; while for long-distance travel, the airplane enjoyed an immense superiority in speed. Above all, popular opinion had it that rail travel was being outmoded. In the transport of small individual freight consignments, struggling amid antiquated facilities and outmoded legal regulations, railroads could not match the rapidly developing road service provided by fast trucks. Only the handling of heavy freight and bulk minerals remained with the railroads, and that mainly because no one else wanted the business. Nowadays, there is a

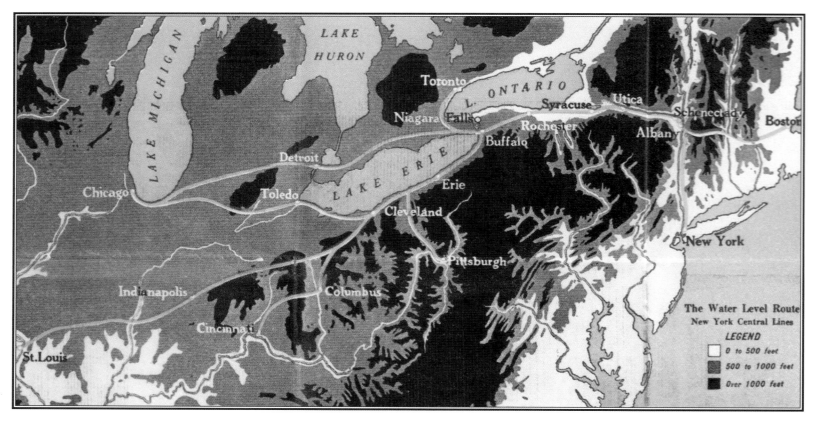

The Water Level Route
New York Central Lines
LEGEND

☐ 0 to 500 feet
▨ 500 to 1000 feet
■ Over 1000 feet

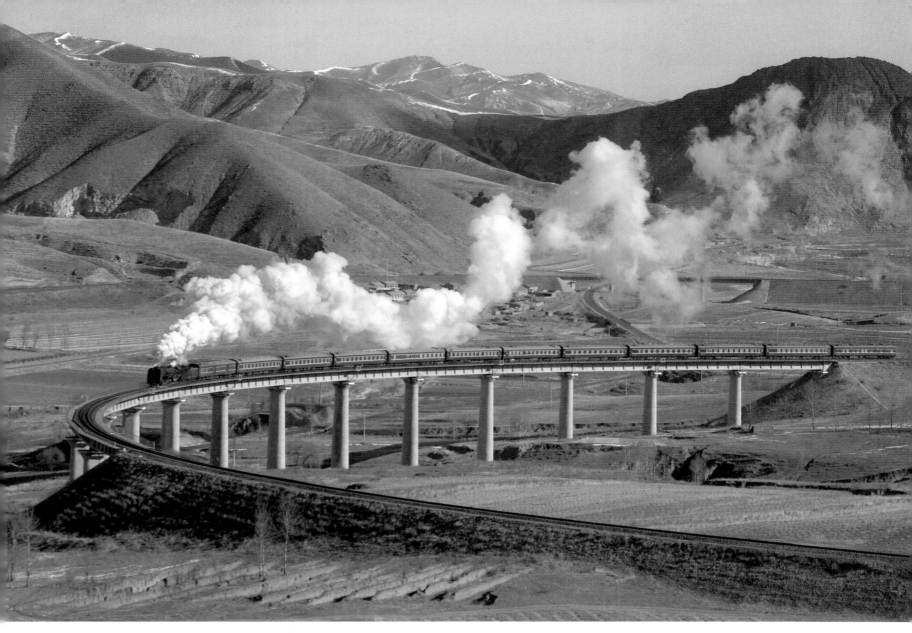

realization that, apart from heavy-haul, railroads are competitive in intercity passenger service and in fast freights over longer distances, as well as being indispensable for cities with heavy commuter requirements. Their relatively low energy consumption is also a recommendation.

Because the predominating influence of geography led to the growth of railroads in the first place, so, in this critical phase, when so many outside influences are beginning to highlight the importance of railroads in modern society, it is fascinating and immensely worthwhile to study the situation anew, on a worldwide basis, with the aid of maps. Two of the first public railroads in the world, the Stockton & Darlington and the Baltimore & Ohio, were built to convey minerals from inland areas to the sea for shipment. When the merchants of large industrial centers wanted quicker connection with their interests elsewhere, routes were chosen where geography made the going easiest and cheapest from the constructional point of view, and gave prospects of fast transit while minimizing running costs.

The purpose of this book is to show how geography as much as sociology and industry has dictated railroad evolution. That said, it must not be imagined that geography was always on the side of the railroad entrepreneurs and engineers. After the first modest beginnings, often accompanied by phenomenal financial success, business interests demanded the execution of bolder projects and more direct connections. Contentment with roundabout routes, following the contours of river valleys or coastlines (to find easy grades), and with low initial costs began to evaporate, and engineers were faced with calls to cross mountain ranges, span rivers, and traverse wide tracts of level, though unstable, marshland. This last mentioned geographical hazard had been encountered on one of the first railroads, the Liverpool & Manchester, which crossed the notorious Chat Moss peat bog. The methods

For a railroad to climb over high mountain passes, it is often necessary for the track to double back on itself in a series of long, gentle curves, gradually rising in elevation. Here, the steam hauled *Shangri-La Express*, a tourist train, crosses the fabled curved viaduct at Simingyi, on the Jing Peng section of the Ji-Tong Railroad in Inner Mongolia, on its way to the summit at Shangdian.

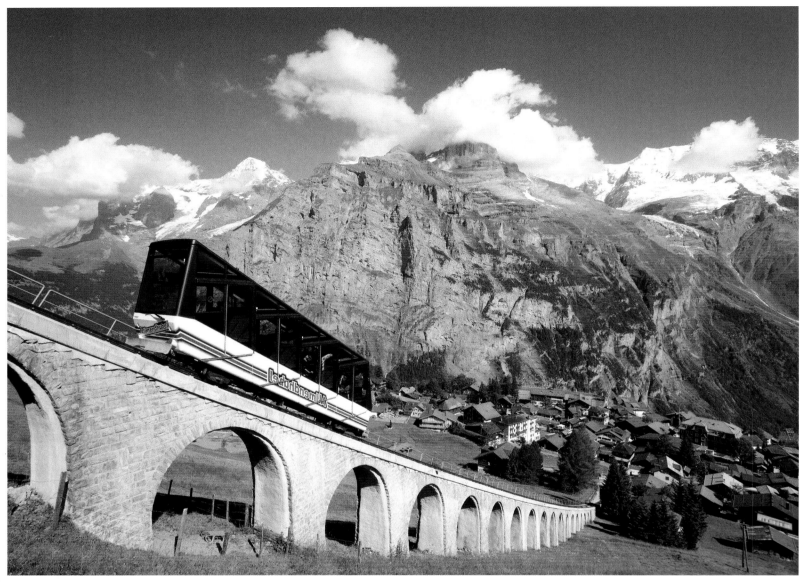

Building railroads through mountainous regions presented many problems for engineers, since trains could only climb gentle grades. This viaduct in the Lauterbrunnen Valley, Switzerland, was one solution.

by which George Stephenson finally conquered this obstacle became the pattern for dealing with similar difficulties in many parts of the world.

Many of the engineering problems were entirely new. The established professional men had built harbors, lighthouses, roads, and canals, but the introduction of the steam locomotive brought new demands. There was a limit to the steepness of the grades it could climb, for while a military road for foot soldiers, pack horses, or even elephants could be taken up a steep mountainside, such a route was impossible for locomotives. Surveys to obtain a practicable grade often had to be made in extremely difficult physical conditions: in the hill country at the foot of mountain ranges or in dense forests, where there were few opportunities for obtaining long sights ahead or for taking levels. Nor could established concepts like the suspension bridge be used for crossing broad valleys or tidal waterways. New ideas for long-span bridges had to be formed.

It is interesting to trace how the principles of construction and early operation, which developed in Great Britain, the USA, and Europe, were gradually extended and adapted to geographical and other conditions around the world. In Britain, conditions and prospects for expansion called for massively built, and relatively straight and level railroads, and there was plenty of capital ready for investment

in such enterprises. In the USA, by contrast, railroads were needed to open up the virgin country. Little money was available, however, so tracks had to be built as cheaply as possible with indigenous materials. U.S. heavy industry was in its infancy and could hardly afford large-scale imports. One outcome was the evolution of that masterwork of light civil engineering, the wooden trestle bridge, so skilfully erected across many a deep valley or mountain torrent. Similarly, because of the infrequency of train services and the need to avoid high capital expenditure, engineers developed the system of regulating traffic by telegraphic "train order," in contrast to the more comprehensive system of signaling and interlocking that was essential on the much busier routes of western Europe.

As the railroad networks spread, so the natural geographical resources of the world became part of the overall picture. The conveyance of coal was the first task of railroads in Great Britain and France, and although horses did much of the hauling in the very early days, coal was the locomotive fuel. In the USA, although major deposits of coal had been discovered in certain areas, the vastness of the country made its transport to other parts uneconomic, so the great majority of early American locomotives burned the indigenous fuel of the forests—wood. Thus environmental considerations were in evidence from the earliest days. Those in Great Britain who opposed railroads on principle, secured the insertion of clauses in Acts of Parliament prohibiting the emission of smoke by steam locomotives. To comply with such limitations, locomotives were fueled with coke in place of coal.

Out of this deeply interesting historical foundation, there emerges the majestic edifice of steady technical development, the evolution of codes of practice to ensure the safe running of trains at speeds that even our own grandfathers would not have thought possible. The replacement of steam traction by diesel and electric power became inevitable in the modern age. In recording this, and in recalling some of the grandest moments of the steam era, tribute is paid to one of the most wonderful and most "human" of machines ever devised and used by man.

This book highlights some of the major engineering achievements and great trains of the past. But there are modern developments, too: the purpose built, high-speed lines in Europe and the Far East, the conveyor-belt functions of heavy-duty mineral lines like the Hammersley Railroad in Australia and the Powder River Basin developments in the USA, and the fast low-cost "doublestack" container trains introduced in the USA. Today, railroads around the world are once again a very important feature on the map.

Often the only way to drive a railroad through hilly or mountainous country was to follow river valleys and the shores of lakes, where the ground was relatively level. Here, a restored Canadian Pacific Hudson locomotive hauls a tourist train beside a placid lake in the Rockies.

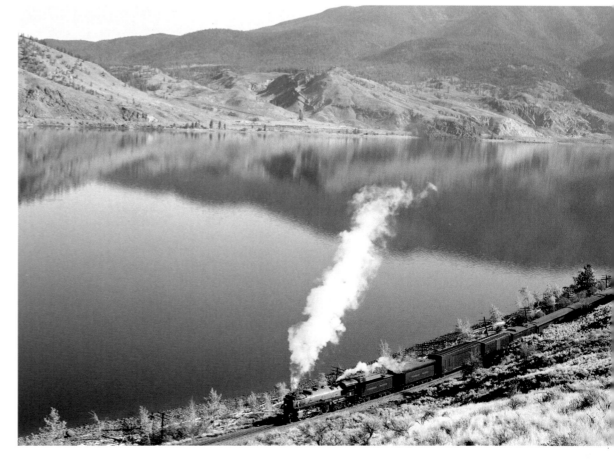

The Worldwide Spread of Railroads

THREE FACTORS HELPED TO SPREAD RAILROADS AROUND THE WORLD: BRITISH ENTERPRISE AND ENGINEERING SKILLS, AMERICAN ENTHUSIASM FOR THE NEW IDEA; AND DEVELOPMENT AND EXPLOITATION OF COLONIAL POSSESSIONS.

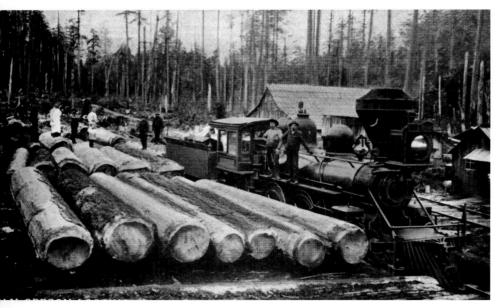

Railroads made it possible to move bulky and heavy materials over long distances with ease. In the USA, for example, trains were vital for logging operations (above), while the movement of coal (opposite page) and other minerals from mines and quarries around the world also greatly benefited.

Although there had been railroads of a kind in many countries to assist in the transport of horsedrawn wagons loaded with merchandise, even before the astonishing developments of the nineteenth century, the invention of the steam locomotive and its successful use on the first public railroad in the world, the Stockton & Darlington, in Great Britain, provided the catalyst in the development of world transport. British engineers were to the fore in every facet of early railroad pioneering, such as in the evolution of track; in tunneling and railroad bridge building; and in locomotive experimentation and operation.

A study of railroad developments around the world in the momentous decade following the opening of the second great English pioneer work—the Liverpool & Manchester Railroad, in 1830—shows that, in most of them, British engineers were consultants, contractors or manufacturers of locomotives. In Europe alone, railroads were established in Austria, Belgium, France, Germany, the Netherlands, and Russia before 1840; in the same decade, railroads were expanding rapidly in Canada and the USA, and

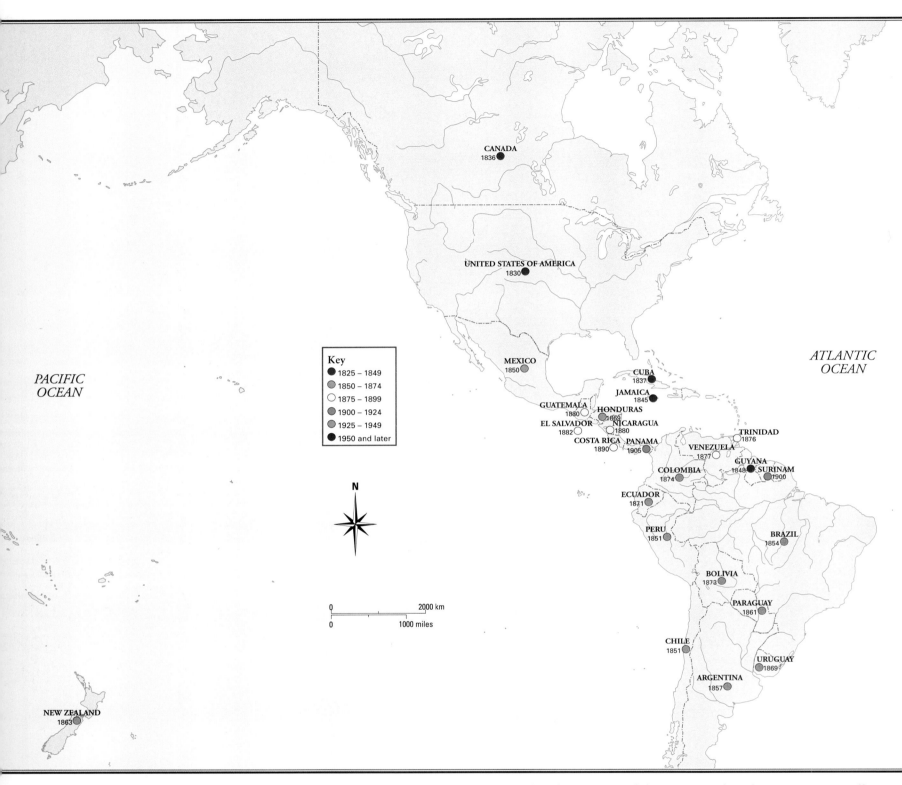

Key
● 1825 – 1849
● 1850 – 1874
○ 1875 – 1899
● 1900 – 1924
● 1925 – 1949
● 1950 and later

PACIFIC
OCEAN

ATLANTIC
OCEAN

CANADA
1836

UNITED STATES OF AMERICA
1830

MEXICO
1850

CUBA
1837

JAMAICA
1845

GUATEMALA HONDURAS
1880 1889
EL SALVADOR NICARAGUA
1882 1880
COSTA RICA PANAMA
1890 1905

TRINIDAD
1876

VENEZUELA
1877

GUYANA
1848 SURINAM
 1900

COLOMBIA
1874

ECUADOR
1871

PERU
1851

BRAZIL
1854

BOLIVIA
1873

PARAGUAY
1861

CHILE
1851

URUGUAY
1869

ARGENTINA
1857

N

0 2000 km
0 1000 miles

NEW ZEALAND
1863

From their early beginnings in Great Britain, railroads spread around the world, being taken up enthusiastically in that country's colonial possessions and in the United States.

there had been a start in Cuba. Naturally, railroad expansion did not proceed at the same rate in all countries, nor did the advances in technology, speed, and quality of service. The earliest and almost phenomenal increases in extent occurred in the nineteenth century in the industrialized countries, of which Great Britain was foremost as an exporter of machinery, minerals, and manufactured goods of all kinds to the whole world. The USA was only just emerging as a great industrial nation, while in Europe, France, Germany, and Italy had all been disrupted by political and military upheavals. In all of them, however, railroads played a great part in the subsequent consolidation. In the USA, free

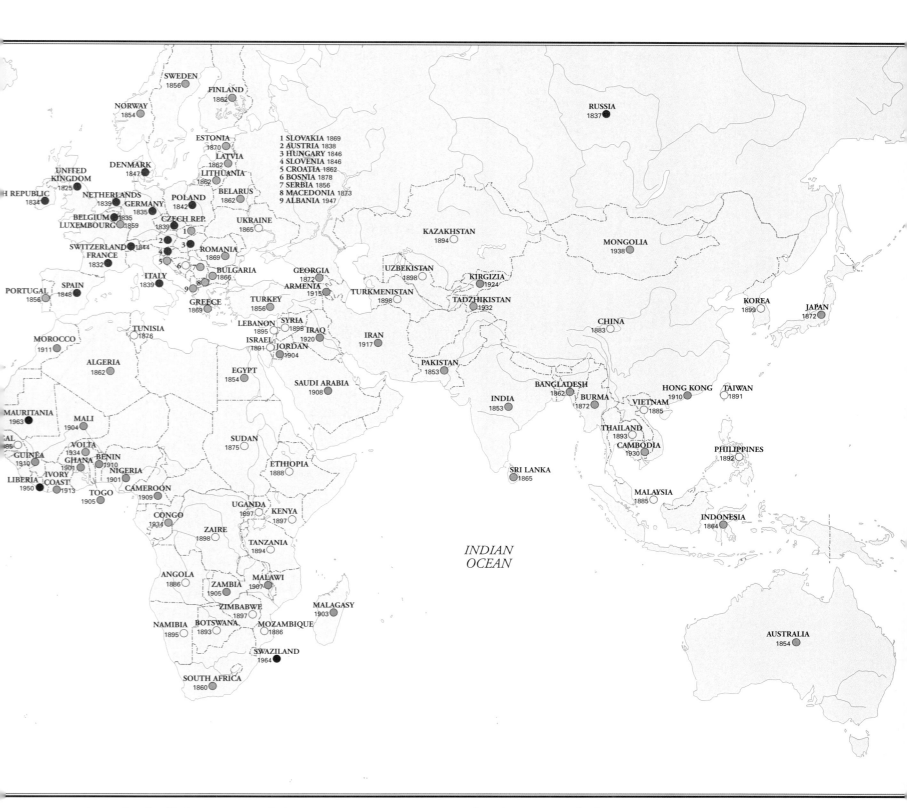

SWEDEN 1856
FINLAND 1862
NORWAY 1854
RUSSIA 1837

ESTONIA 1870
LATVIA 1862
LITHUANIA 1862
DENMARK 1847

1 SLOVAKIA 1869
2 AUSTRIA 1838
3 HUNGARY 1846
4 SLOVENIA 1846
5 CROATIA 1862
6 BOSNIA 1878
7 SERBIA 1856
8 MACEDONIA 1873
9 ALBANIA 1947

UNITED KINGDOM 1825
H REPUBLIC 1834
NETHERLANDS 1839
BELGIUM 1835
LUXEMBOURG 1859
GERMANY 1835
POLAND 1842
BELARUS 1862
CZECH REP. 1839
UKRAINE 1865

KAZAKHSTAN 1894
MONGOLIA 1938

SWITZERLAND 1844
FRANCE 1832
ROMANIA 1869
2 3
5
6 7
ITALY 1839
8
9
BULGARIA 1866
GEORGIA 1872
ARMENIA 1913
UZBEKISTAN 1898
KIRGIZIA 1924
TURKMENISTAN 1898
TADZHIKISTAN 1932

PORTUGAL 1856
SPAIN 1848
GREECE 1869
TURKEY 1856
KOREA 1899
JAPAN 1872

TUNISIA 1876
LEBANON 1895
SYRIA 1895
IRAQ 1920
IRAN 1917
CHINA 1883

MOROCCO 1911
ISRAEL 1891
JORDAN 1904

ALGERIA 1862
EGYPT 1854
SAUDI ARABIA 1908
PAKISTAN 1853

MAURITANIA 1963
MALI 1904
BANGLADESH 1862
HONG KONG 1910
TAIWAN 1891

AL
GUINEA 1910
VOLTA 1934
GHANA 1901
BENIN 1910
SUDAN 1875
INDIA 1853
BURMA 1872
VIETNAM 1885

LIBERIA 1950
IVORY COAST 1913
NIGERIA 1901
TOGO 1905
CAMEROON 1909
ETHIOPIA 1888
SRI LANKA 1865
THAILAND 1893
CAMBODIA 1930
PHILIPPINES 1892

UGANDA 1897
KENYA 1897
MALAYSIA 1885

CONGO 1934
ZAIRE 1898
TANZANIA 1894
INDONESIA 1864

ANGOLA 1886
ZAMBIA 1905
MALAWI 1907
INDIAN OCEAN

ZIMBABWE 1897
MALAGASY 1903

NAMIBIA 1895
BOTSWANA 1893
MOZAMBIQUE 1886

SWAZILAND 1964
AUSTRALIA 1854

SOUTH AFRICA 1860

enterprise and unbridled competition led to an enormous increase in railroad activity in the last years of the nineteenth century. At the same time, colonizing activities by the great nations of Europe led to the building of railroads in many remote areas, quite apart from major, carefully planned projects like the Indian railroad network, or the great imperial ambitions of Cecil Rhodes in southern Africa. Before 1900, railroads had been constructed, mostly on a modest scale, in Tunisia, in what is now Vietnam, Angola, Mozambique, and Indonesia, while in the South American states, the railroads had flourished long before 1900.

Success bred success. The provision of improved transport benefited remote communities, making their agricultural produce or mineral wealth available to wider and hitherto unattainable markets. This, in turn, led to a demand for improved railroad facilities, larger locomotives, and better means of traffic regulation. There was more work for the manufacturers in Great Britain and other countries. Overseas railroads needed coal to fire their locomotives. British owned railroads in South America purchased their coal from South Wales; at least one French railroad had its own fleet of ships to collect the choice grades of Welsh steam coal from Cardiff. New railroads were

A freight train belonging to Ferrovias Guatemala, hauled by Spanish-built diesel locomotives, waits at Sanarate.

Steam locomotives continue to do sterling service on some mineral lines, such as this one at an open-pit mine in Mongolia.

built in South Wales to convey coal from the valleys to new ports, for shipment overseas. In some cases, it was a booming reciprocal trade. Coal for locomotives was exported from English east-coast ports to the Baltic states in exchange for lumber; Baltic pine was judged the finest material for railroad ties.

The expansion in world trade, which fostered the building of more railroads, was aided to no small extent by the ability of railroads to convey mail quicker than ever before. Where ocean travel was concerned, as in the case of Anglo-American mail, it was sometimes quicker to put eastbound mail ashore at Queenstown (Cobh) in the south of Ireland, take it by train to Kingstown (Dun Laoghaire) on Dublin Bay, ship it across to Holyhead, and thence by train to London rather than wait for the steamer to make its way into the Mersey and dock at Liverpool.

Even though the upheavals and reorientation of world trade after World War I profoundly affected railroad operations in many countries, expansion continued elsewhere; it was only after 1960 that the opposite trend began to become apparent. Nevertheless, to balance contraction in Great Britain and other industrialized areas, there are major new projects in China, Canada, Australia, and elsewhere.

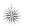

A variety of small steam locomotives were built for agricultural purposes; many found their way to sugar cane plantations, where they proved invaluable for transporting the harvested cane. Even today, some of these locomotives remain in use, such as this 0-4-0 Well 'Cheetle' in India.

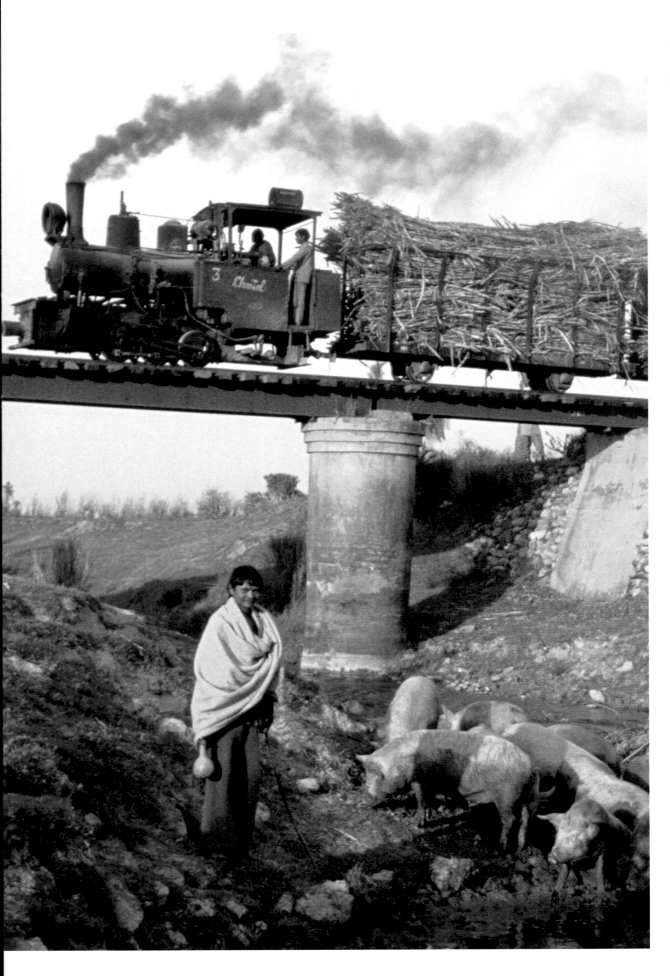

THE BEGINNING OF RAILROADS, 1700-1824

THE EARLIEST RAILROADS EMPLOYED HORSEDRAWN CARS ON WOODEN TRACKS, BUT THE ARRIVAL OF THE STEAM LOCOMOTIVE AND IRON RAILS POINTED THE WAY AHEAD.

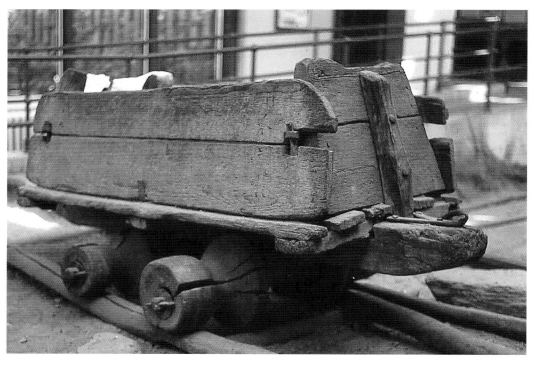

This sixteenth-century mining car illustrates the early beginnings of railroad practice. Note the wooden rails and flanged wheels.

The origin of railroads for the exclusive use of vehicles with flanged wheels can be traced back to mining practice in medieval Germany; but the development of railroads as a public means of transport took place entirely in Great Britain. In using the word "public," however, and applying it to the transport of goods and minerals, activity has been recorded in both the sixteenth and seventeenth centuries. The influence of this development is evident from reference to a system in the Ruhr coalfields of Germany as an *englischer Kohlenweg*. The rails were of wood and laid exactly straight, and one reads that toward the end of the seventeenth century, bulky carts were made with four so-called "rowlets" fitting the rails. The term "rowlets" is thought to imply some form of flanged wheel, because it was claimed that their use made movement so easy that one horse could draw four or five of the bulky carts laden with coal. No less celebrated a writer than Daniel Defoe told of coal being loaded "into a great machine called a Waggon" and run on an artificial road called a "waggon-way."

Early in the eighteenth century, mining interests in north-eastern England led to the great coalition known as the "Grand Allies," consisting of three hitherto independent groups of colliery owners. These were the Liddell family, of Ravensworth; the Montagu family and Thomas Ord, of Newcastle; and George Bowes. In 1726, they agreed to combine their interests, and the arrangements concluded also involved linking some of their collieries by wagon-ways to rationalize movement. The result was a remarkable development, including the construction of what was termed a "main line" inland from the River Tyne. This was 8 miles (13km) long. Traffic was so heavy that the line was laid with a double track so that loaded and empty "trains" would not interfere with one another. The country through which the lines of the Grand Allies ran is hilly, and some engineering works of considerable magnitude were undertaken to provide an even gradient. An embankment was built at Tanfield, being 100ft (30m) high with a transverse width of 300ft (91m) at the base; but perhaps the most historic construction was the Causey Arch—the first bridge ever built for the exclusive purpose of carrying a railroad. Constructed in 1727, it was a single-arch stone bridge with a length of 103ft (31m) and a width of 22ft (7m). It carried two tracks of 4ft (1,219mm) gauge side by side.

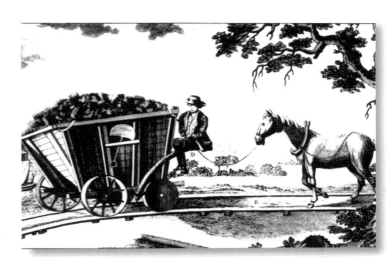

A scene from a colliery tramway in England in 1773. On inclined sections of track, the wagon would be allowed to roll under the influence of gravity, while the horse ran behind. The front wheels were larger than the rear to keep the load horizontal on the incline.

Because these railroads ran from inland to the banks of a navigable river, it was possible to arrange the routes on a slightly falling grade, making the task of a horse easier when pulling loaded cars. At that time, it was considered necessary to keep the load horizontal when descending a grade. To achieve this, the leading wheels of each car were made of larger diameter than the trailing ones. Furthermore, on some cars, the leading wheels were spoked while the trailing ones were of solid wood. Flanges that were 1in (25mm) or 1.5in (40mm) deep were fixed to the inner faces of the wheels to provide an appropriate guiding effect. The cars used in Durham and Northumberland had a primitive form of lever brake acting upon the rear pair of wheels. On the rail tracks running down to the rivers Tyne and Wear, there was usually one horse to a car; trains of cars were not run.

Causey Arch—the first bridge ever built for the exclusive purpose of carrying a railroad, was constructed in 1727.

There were places where the direction of the line had to be changed fairly abruptly and, because of the additional effort that would have been necessary to pull loaded cars around a sharp curve, turntables were adopted. Each consisted of a circular table that swiveled about a central vertical axis. These were the prototypes of turntables that came to be used at countless British passenger stations for transferring the small four-wheeled cars of the mid-nineteenth century from one track to another. On the early colliery wagon-ways, there were places where the loaded vehicles would run by gravity. There, the man in charge of the horse would transfer from front to rear, hitch a ride on the car, and control the speed with the hand brake while the horse ran behind. At a later date, in localities where horses pulled a train of three or

Richard Trevithick, a builder of pumping engines for mines, created the first steam locomotive to run on rails, at Pen-y-Darren, Wales, in 1804.

Before his railroad engine, Trevithick experimented with road locomotives. This was the first passenger carrying example, which appeared at Camborne, Cornwall, in 1801.

The *Salamanca* employed John Blenkinsop's rack-and-pinion propulsion system. The toothed rack was fitted along the edge of the track and was engaged by a large cog-wheel on the side of the locomotive.

more wagons, a special "dandy car" was provided to transport the horse while the train ran downhill by gravity.

An important development in the 1750s was the substitution of iron rails for wooden ones. Although there were other early uses of, and experiments with, iron rails, one of the most important was that made on the wagon-ways of the Coalbrookdale Ironworks in Shropshire. These tracks had been laid originally with fine-quality oak rails, but then, in an attempt to improve their wear resistance, and use the products of the company's own furnaces, the surfaces of the rails were covered with cast iron. In the years between 1768 and 1771, some 800 tons of strap rails were produced at Coalbrookdale. A contemporary development in the Sheffield area made use of iron-plate rails with flanges on both sides. This enabled cars with unflanged wheels to be used. It seems that the intention was to use one type of car for hauling both along rail tracks and ordinary roads or dirt tracks; arrangements were made at certain places where the transfer from one to the other could be made. These "plateways," as they were called, became very popular in South Wales.

The true turning point in the early development of railroad track occurred in 1789 with the invention of William Jessop's edge-rail, which was cast in 3ft (914mm) lengths. This was a beautifully conceived design based on scientific principles. At each end, the base was flat where it rested on the track support, while in between, the web portion below the running surface became gradually deeper to provide strength exactly in proportion to the distribution of stress caused by a load rolling along the upper surface. Instead of wooden cross-ties, the ends were supported on massive stone blocks sunk into the ground. Although so carefully and so correctly proportioned on theoretical grounds, Jessop's rail was inconvenient in that it could be manufactured only in short lengths; in Scotland, around the end of the eighteenth century, the first steps were taken toward the production of wrought-iron rails that could be rolled in much longer lengths. Many manufacturing difficulties had yet to be overcome, however, and the rails that supported the earliest steam locomotives in northeastern England were mostly manufactured in local foundries from cast iron and in short lengths.

While the edge-rail first patented by Jessop was ideal for hauling short trains of coal wagons by horse, Richard

Trevithick's adventures with his first locomotive on the Pen-y-Darren plateway suggested to other pioneers that contact between a smooth wheel and a smooth rail would not give sufficient grip for a locomotive to haul a heavy load. On the Middleton colliery railroad, near Leeds, a form of rail with projecting teeth at the side was installed to carry locomotives with toothed wheels. The weight of the locomotive was taken on the head of the rail as in Jessop's arrangement, but the engagement of tooth with tooth prevented any slippage due to lack of adhesion with the rail surface. This ingenious design by John Blenkinsop in 1812 was expensive to make, however, and was suitable only for slow moving trains. At that time, of course, there was no thought of speed on railroads. Moreover, the toothed-wheel device was soon shown to be unnecessary for hauling heavy loads. It deserves credit, though, as a fine example of contemporary inventiveness.

In 1813, at Wylam Colliery, Northumberland, William Hedley produced the first locomotive to run satisfactorily on a smooth rail, the *Puffing Billy*. At that time, George Stephenson was engine builder at the neighboring colliery of Killingworth, and in 1814, he built his first locomotive. But Stephenson was far more than a clever engine mechanic, and he had the vision of a nationwide railroad system. One thing that caused endless trouble to these early pioneers was the track. Jessop's edge-rail was excellent in theory, but in practice there were many difficulties. The simple butt joints between sections of rail, whether resting on stone blocks or transverse wooden ties, became uneven; the stone blocks sank into the ground, some deeper than others. As a result, Stephenson and his friend William Losh developed a method of joining the rails by means of a scarfed, or overlapping, joint. This was patented in 1816 and solved the problem, at least as far as slow running colliery railroads were concerned. Then, in 1820, at the Bedlington Ironworks, Northumberland, John Birkinshaw produced the first really successful wrought-iron rail, which was rolled through a mill to the required shape. This rail not only was much stronger and less liable to fracture than a cast-iron rail, but also it could be made much longer—up to 18ft (5.5m). Although Stephenson himself had patented another type of rail, he specified Birkinshaw's for the Stockton & Darlington Railroad in 1825.

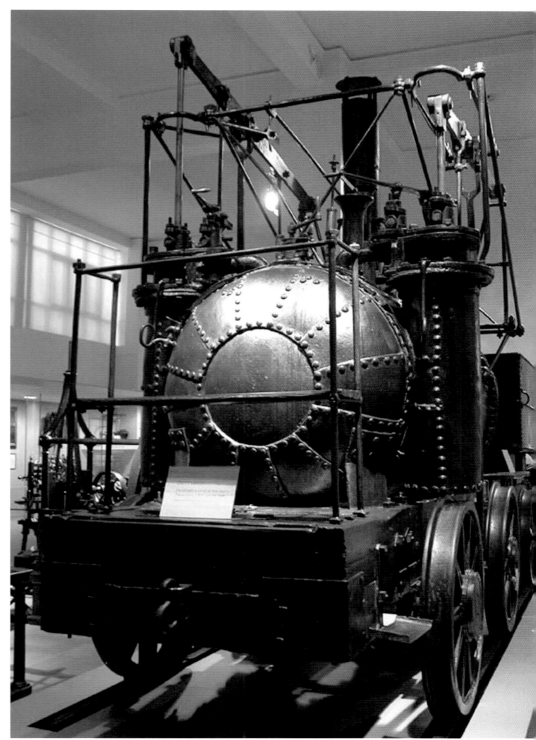

William Hedley's locomotive *Puffing Billy*—now preserved at the Science Museum, London— was the first locomotive to run satisfactorily on smooth rails during 1813.

The Iron Horse, Steam Power Arrives, 1825-30

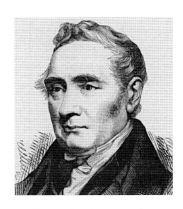

George Stephenson, who not only engineered the Stockton & Darlington Railroad, but also pushed for haulage by steam locomotive instead of horses.

IN EUROPE AND THE USA, FAR-SIGHTED ENTREPRENEURS AND ENGINEERS REALIZED THAT SPEED WOULD BOOST THE RAILROAD CAUSE. ONLY THE STEAM LOCOMOTIVE COULD MEET THAT NEED.

The Stockton & Darlington, the first public railroad in the world, was conceived as a coal carrier to provide transport from the rich coalfields in the Bishop Auckland district of County Durham to tidewater at Stockton. From there, the coal was exported to other countries, or carried to other British ports by coastal shipping. The businessmen of the northeast backed the railroad strongly, but local landowners and farmers were implacable. One member of the aristocracy even secured an alteration to the proposed route because it ran through his fox covers. The surveyors were harried by farmhands armed with pitchforks and accompanied by fierce dogs. But through the

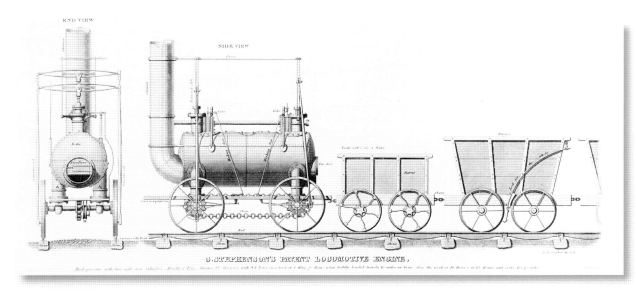

An early drawing showing rear and side views of Stephenson's *Locomotion*, together with its tender and rolling stock.

sagacity of Edward Pease, the great merchant of Stockton, the professional influence of Nicholas Wood, a distinguished mining engineer, and the dogged common sense of George Stephenson's pioneer engineering, the railroad was built and opened to the public in September 1825. With the exception of one isolated steam locomotive, the original motive power was by horses, which pulled all the passenger services.

To all the promoters, however, the use of horses was only a temporary expedient. George Stephenson was convinced that the future lay in steam power, and the one locomotive on the line, the *Locomotion*, was undoubtedly the best that had been built anywhere in the world up to that time. There were features other than motive power, however, that made the Stockton & Darlington Railroad a milestone for future development. The company was prepared to provide wagons for the transport of coal or other traffic, and it was also prepared to carry freight in the shipper's own wagons, if they were suitable to run on the railroad tracks. Thus began a practice that developed to a significant extent

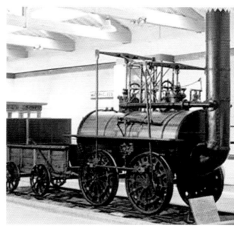

Locomotion Number 1 preserved at the Darlington Railroad Center and Museum.

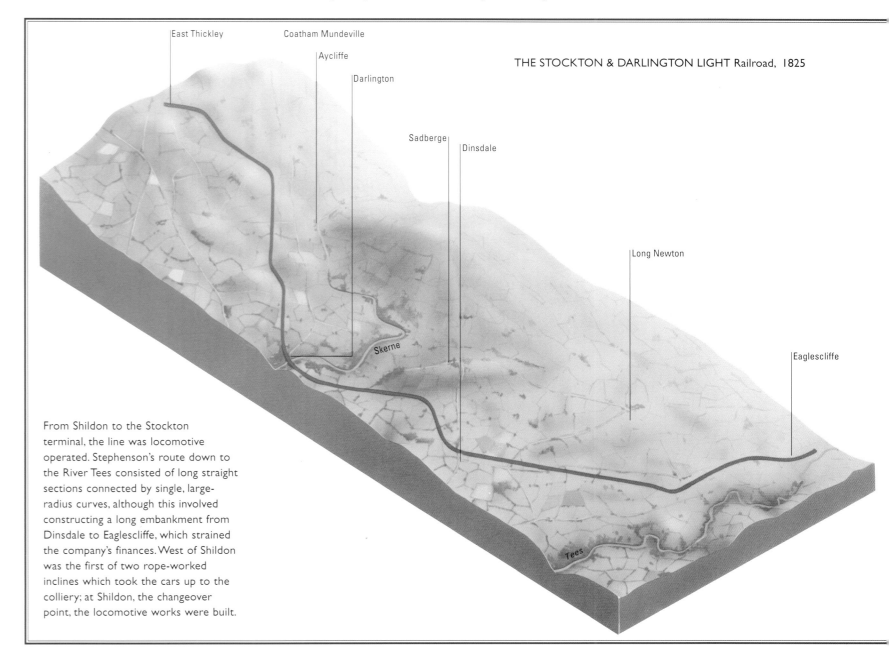

THE STOCKTON & DARLINGTON LIGHT Railroad, 1825

East Thickley

Coatham Mundeville

Aycliffe

Darlington

Sadberge

Dinsdale

Long Newton

Skerne

Eaglescliffe

Tees

From Shildon to the Stockton terminal, the line was locomotive operated. Stephenson's route down to the River Tees consisted of long straight sections connected by single, large-radius curves, although this involved constructing a long embankment from Dinsdale to Eaglescliffe, which strained the company's finances. West of Shildon was the first of two rope-worked inclines which took the cars up to the colliery; at Shildon, the changeover point, the locomotive works were built.

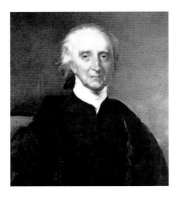

Charles Carroll, a signatory of the American Declaration of Independence in 1776, was an enthusiastic supporter of railroads. He was a director of the Baltimore & Ohio, the first road to be built in America, and laid its foundation stone in February 1828, when more than 90 years old.

The famous race between a horse and the *Tom Thumb* steam locomotive on the USA's Baltimore & Ohio Railroad.

on the railroads of Great Britain, and which was ended only when the railroads were nationalized in 1948. So far as motive power was concerned, primitive as the *Locomotion* was, if it had not been "made to go," it is likely that the whole development of railroads would have been seriously retarded.

In the USA in the 1820s, there was a need for good communication between the developing lands west of the Allegheny Mountains and the seaports of New York, Philadelphia, Washington, and Baltimore. The first three cities opted for canals, and indeed the successful Erie Canal between Buffalo and New York was intended to draw trade away from the others. Baltimore alone determined upon a railroad, and no minor project at that. It was to be a double track, right through from the city to the Ohio River at Wheeling, and in 1827 an application was made to the Legislature of Maryland for an Act incorporating the Baltimore & Ohio Railroad Company. It is interesting that the term "railroad" rather than "railroad" was adopted; today, in the USA, of the many companies, a few are still styled "railroads" rather than "railroads."

Unlike the earliest railroads in Great Britain and other parts of Europe, the incorporation of the Baltimore & Ohio was acclaimed by virtually universal rejoicing in Baltimore and in the country through which it would run. It was regarded as a great popular venture, albeit a plunge into the unknown. In 1827, no one knew whether the primitive locomotives, tracks, and rolling stock then used on the earliest English railroads would withstand the onslaught of the severe American winters and the even more furious spring floods that followed the thawing of the snows. Nevertheless, the merchants of Baltimore pressed on. It was perhaps indicative of their iron resolve that one of the

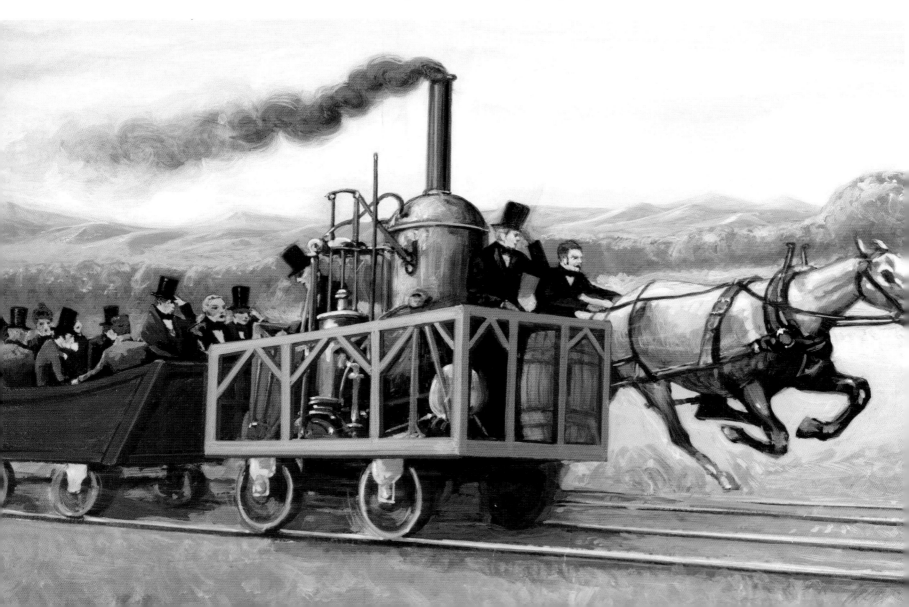

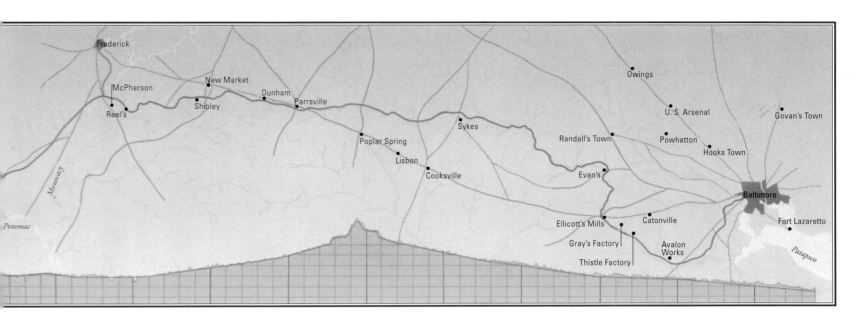

first directors of the B & O was Charles Carroll, who in 1827 was the sole surviving signatory of the Declaration of Independence. He was over 90 years old, but in February 1828 was fit enough to turn the first spadeful of earth, with a silver spade, and to lay the symbolic foundation stone of the railroad. After the ceremony, he said, "I consider this among the most important acts of my life, second only to my signing the Declaration of Independence, if even it be second to that."

The railroad followed the course of rivers where it could, to make the grades as easy as possible. It was not until May 1830 that the road was opened for passenger traffic over the first 26 miles (42km) from Baltimore to Ellicott's Mills. The motive power was provided by horses. The sharp curves necessitated by the rugged country in the valley of the Patapsco River suggested that steam locomotives would be impracticable. However, Peter Cooper, an industrialist and inventor from New York, had made a large investment in Baltimore land, and it was important to him that the railroad succeeded, which meant speed with the use of steam power. He built a locomotive, the *Tom Thumb*, and in the summer of 1830 took the directors of the railroad for a ride along the line as far as Carrollton, the home of Charles Carroll. They covered the 13 miles (21km) in 57 minutes.

The more conservative among the railroad's supporters remained sceptical of the value of locomotives, so on August 28, 1830, a race was run between the *Tom Thumb* and a horse. It was a close run thing—neck and neck for most of the way—until the locomotive's drive-belt slipped from the drum. With the blower inoperative, steam pressure dropped, and the horse forged ahead to win. Even so, the moral victory was with Peter Cooper.

In France, the first railroad, the St. Étienne and Andrézieux, built in 1828, was also primarily a coal carrier, and at first was worked entirely by horses. Two, in tandem, were used to haul trains of six or seven cars loaded with coal. However, the provision made for passenger service was more elaborate than on the Stockton & Darlington. There were quite commodious coaches after the fashion of a stage-coach, covered over and with three separate compartments. In addition, there was an even more elaborate doubledecker. The lower deck had open sides to all three compartments, but with curtains that could be drawn to give protection against the weather. The upper deck was completely open to the elements.

The first line in America, the Baltimore & Ohio Railroad, was built on a grand scale—it was 380 miles (608km (380km) long and double tracked throughout, and it had to pass through the Allegheny mountains. The first 26 miles (42km) were opened in May 1830.

PIONEERING IDEAS, 1831-50

THE SUCCESSFUL EXPERIMENTS WITH STEAM LOCOMOTIVES ON THE PIONEERING RAILROADS IN ENGLAND SOON LED TO AN UPSURGE IN INTEREST AROUND THE WORLD.

Liverpool

River Mersey

N

Lime Street · Edge Hill · Broad Green · Roby · Huyton · Wiston

0 5 km

0 5

In 1835, Stevenson supplied the first steam locomotive for the Bavarian Ludwigsbahn, the first railroad built in the German states. This replica, completed in 1935 to celebrate the centenary of German Railroads, was destroyed by fire in 2005.

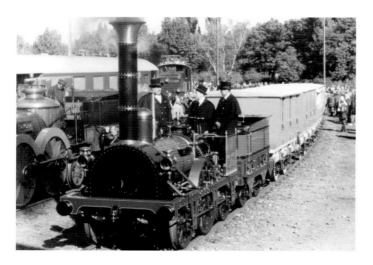

The opening and instant success of the Liverpool & Manchester Railroad in Great Britain, together with the immense prestige gained by George Stephenson with locomotives, and by his son Robert in civil engineering, prompted the building of railroads in many parts of the world. Although the Liverpool & Manchester was a relatively small project, even compared to some of the railroads engineered in the following decade, the experience gained had been profound, particularly in surmounting the unexpected and severe difficulties of crossing Chat Moss, a desolate boggy area that had lain untouched and untraversed for centuries. There the problem had been to create a stable foundation to carry the railroad; tipping stones and gravel to form an embankment proved useless, since the filling just slipped away.

The solution was found by building layers of brushwood and hurdles

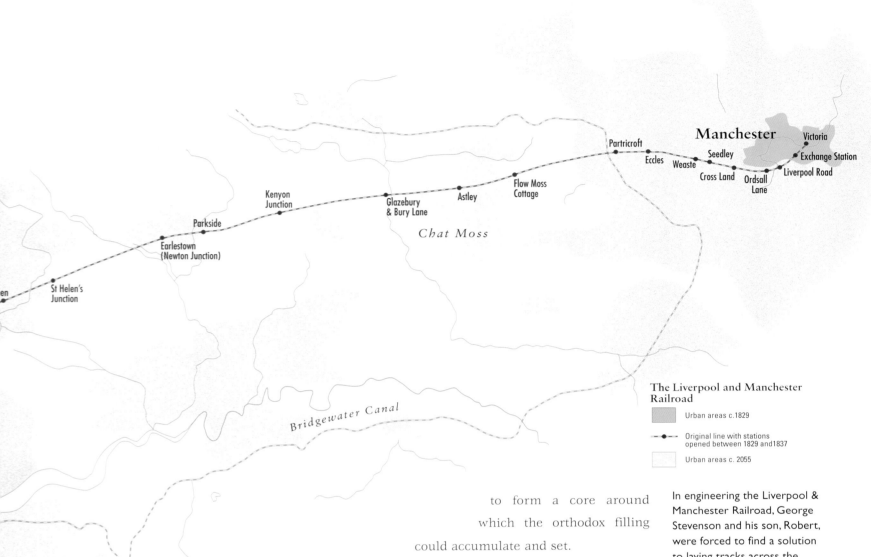

The Liverpool and Manchester Railroad

Urban areas c.1829

Original line with stations opened between 1829 and 1837

Urban areas c. 2055

In engineering the Liverpool & Manchester Railroad, George Stevenson and his son, Robert, were forced to find a solution to laying tracks across the boggy wasteland of Chat Moss. Their success in this feat of civil engineering brought them international renown.

to form a core around which the orthodox filling could accumulate and set.

When it came to building the first line between Amsterdam and Rotterdam in the Netherlands, F.W. Conrad, the engineer, was faced with a similar problem to that on Chat Moss, except that it extended for the greater part of the entire route. Practically all of the country to be traversed by the new railroad lay below sea level, being protected from inundation by the wonderful system of dikes or embankments; elsewhere, the ground was soft and spongy. Conrad employed the same technique as George Stephenson, except that in most places he had to use many more layers of hurdles and brushwood before he could obtain a reasonably firm foundation. He had the first section of his line, from Amsterdam to Haarlem, open in 1839.

In 1834, Ludwig I of Bavaria gave his assent to the construction of the first railroad to be built in any of the German states. It was named after the king himself, the Ludwigsbahn, and ran from Nürnberg to Fürth. This name set a fashion that has been followed ever since in countries where the language is German, or is a dialect of German: *bahn*, "road," without any qualification. Apparently, the opening date, by royal desire, had been fixed long before the line was finished or even the equipment ordered. A German manufacturer, asked to supply the first locomotive, could not meet the delivery date, so the

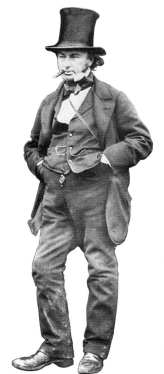

Isambard Kingdom Brunel (1806–59) was the most revolutionary of the early rail engineers, but he caused problems with his insistence on using broad-gauge tracks.

order was placed with the Stephensons. It was the first steam locomotive to run in Germany.

In France, as in England, railroads had begun with purely mineral lines in the St. Étienne district. The first public common carrier was opened in 1837 between Paris and St. Germain, a distance of 13 miles (21km). From the outset, it was intended to be steam powered, but the locomotives were not entirely reliable. Like the Ludwigsbahn in Bavaria, the line enjoyed royal patronage and was formally opened by Queen Marie-Amélie. The event was regarded more as a fashionable social occasion than the beginning of a new epoch in industrial development, and the venturesome action of the 55-year-old queen was looked upon with much disfavor. The conservative attitude of the day was that the line was no more than a plaything.

In the same year that the Paris–St. Germain railroad was opened, the first railroad in Russia was built, again strongly influenced by British pioneering work and under royal patronage. The Tsar of Russia had been to England and had visited some of the colliery lines in the north. Impressed with what he had seen, he readily granted a concession to a company formed to build a railroad over the 15 miles (24km) from St. Petersburg to Pavlovsk, where a new entertainment center had been created. The first locomotives were obtained from England, one from Robert Stephenson and one from Timothy Hackworth. In the depths of winter, they had to be landed at the nearest open port on the Baltic, then taken by sleigh across the ice. The Tsar was present at the first steaming of the Hackworth locomotive in November 1836, the engine being baptized according to the rites of the Russian Orthodox Church.

This first Russian railroad was built to a rail gauge of 6ft (1,828mm), instead of 4ft 8½in (1,435mm), which was already being looked upon as something of a standard. In building the Great Western

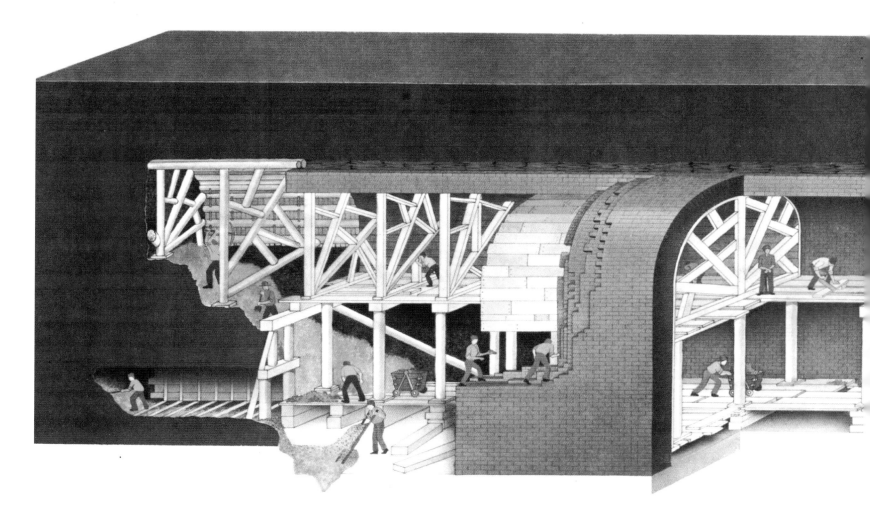

Railroad in England, however, I.K. Brunel pushed the question of gauge to a major confrontation by adopting 7ft (2,123mm). He felt that once the advantages of such a wide gauge had been demonstrated—its possibilities for speed, mass transport of freight, and roominess of passenger accommodation—all existing railroads in Great Britain would be converted. But it did not work out that way. The Stephensons and their associates stood firmly against any change, and the difficulties became so intense at places like Gloucester, where transfer from one gauge to the other had to be made, that a Royal Commission was set up to investigate the matter. In due course, its recommendations went against Brunel's broad gauge. That said, Brunel accomplished some magnificent engineering works for his broad-gauge lines, notably the great tunnel under Box Hill in Wiltshire.

Despite the difficulties that had arisen in England from a diversity of rail gauges, in the early days in North America, many lines were built with different gauges. In the USA, the situation was not finally resolved until after the Civil War, when some lines in the southern states were converted to the European and North American standard of 4ft 8½in (1,435mm). Some of the most interesting and picturesque projects in the early period of American railroads did not come about through disagreements about gauge, but because of the need to cross the mountain ranges that lay between the eastern seaboard and the Ohio River. The Alleghenies and the Appalachians do not have the rugged, desolate and forbidding character of the Rockies. Indeed, to see them from the air, densely covered with thousands of acres of forest, it is difficult to appreciate that they formed a natural barrier that posed many problems for the pioneering railroad engineers.

The Baltimore & Ohio, the first ever American railroad, made its way beside the Potomac River to Cumberland, Maryland, through a beautiful, but often difficult, terrain and then over the watershed to reach the Ohio River valley. At first, the main range of the Allegheny mountains had been considered impossible for a railroad, but on the advice of William Strickland, an extraordinary chain of

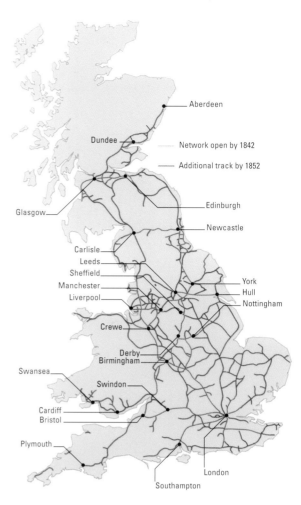

During the 1840s, England was infected by "railroad mania," which established most of the major routes.

The first railroad tunnels were built using very basic tools and equipment. The methods of construction had been developed by the canal builders and by Brunel's father, who excavated the first tunnel under the River Thames.

communication was developed between Philadelphia and Pittsburgh, being brought into service in 1832. In some ways, it was a primitive forerunner of the modern American "piggyback" principle. The whole journey was made in canal boats, which were constructed in halves. These were hauled on flatbed rail cars over the first 82 miles (132km) from Philadelphia to Columbia, on the Susquehanna River. There the two halves of each boat were joined and proceeded by canal to Hollidaysburg, in the very heart of the mountains. At that point, they were transferred to rail cars again for transport over the crest of the mountains and down the far side to Johnstown. After that, they reverted to the canal for the rest of the journey to Pittsburgh.

It was a slow and cumbersome means of transit, and the all-rail route of the Baltimore & Ohio, serving Pittsburgh directly, albeit by a roundabout route, was much quicker. Thus in 1846, the Pennsylvania Railroad Company was formed, its line following much of the route of the older composite transport system between Pittsburgh and Philadelphia. The crossing of the Alleghenies involved spectacular feats of engineering, however, especially in descending the eastern slopes by the great Horseshoe Curve below the Gallitzin summit; it was not until 1852 that this great artery of modern railroad traffic was first brought into use. American developments farther west came later.

Meanwhile, the rail network in Great Britain was spreading. By 1850, one could travel from London to Edinburgh by train, although the present direct line from Peterborough to Doncaster had not been completed, and trains to the north traveled via Sleaford and Lincoln. There was a rival route to Scotland,

A sixty-car freight train of the Pennsylvania Railroad negotiates the renowned Horseshoe Curve on its way through the Alleghenies in 1907.

up the west coast. A merger in 1847 produced the London & North Western Railroad, which, with its allies, the Lancaster & Carlisle and the Caledonian, boasted a continuous line from London to Glasgow, with an offshoot to Edinburgh. The central combination that produced the Midland Railroad in 1844 had not yet secured an outlet to the south, and reached London by the Great Northern's line into King's Cross.

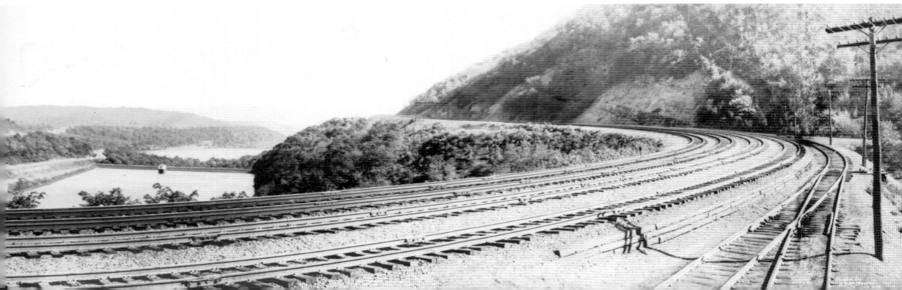

By 1850, railroads were pushing out in all directions in the eastern half of the USA. More than 9,000 miles (14,400km) of track had been laid.

Pushing tracks through the Alleghenies involved many great feats of engineering, among them the long sweep of the famous Horseshoe Curve on the eastern slopes at Altoona, Pennsylvania.

MINNESOTA TERR.

WISCONSIN

MICHIGAN

MAINE
Bangor

N.H.
Portland

VERMONT
Rutland
Concord

Milwaukee

IOWA

Detroit

Chicago

Toledo
Sandusky

Cleveland

Buffalo

NEW YORK
Albany

Boston
Worcester
MASS.
CONN.
Providence
R.I.
Hartford
New Haven
New York

PENNSYLVANIA

Trenton

ILLINOIS

INDIANA

OHIO
Columbus

Cumberland

Harrisburg

Philadelphia
Wilmington
Baltimore NEW JERSEY

DELAWARE

Springfield
Indianapolis

Cincinnati

MISSOURI

Madison
Louisville
Frankfort
Lexington

KENTUCKY

Washington D.C.

MARYLAND

VIRGINIA
Richmond
Petersburg
Portsmouth

NORTH CAROLINA
Raleigh
Goldsboro

TENNESSEE

Memphis

Chattanooga

Wilmington

Tuscumbia
Decatur

Athens
Columbia
SOUTH CAROLINA

ARKANSAS

Atlanta

Charleston

MISSISSIPPI

ALABAMA

Savannah

Vicksburg
Jackson

Montgomery

GEORGIA

LOUISIANA

New Orleans

FLORIDA

N

0 200 km
0 200 miles

Railroads, 1850:
9,021 miles

Overcoming Natural Obstacles, 1851-80

AS RAILROADS WERE PUSHED OUT INTO VIRGIN TERRITORY, ENGINEERS FACED ALL MANNER OF NATURAL OBSTACLES THAT HAD TO BE OVERCOME IF THE TRACKS WERE TO BE LAID.

Wide, navigable rivers were major obstacles for the early railroads. Here, a steamer passes under the Illinois Central Railroad bridge over the Ohio River at Cairo, Illinois, c. 1909.

While the Ohio River had been the goal of railroads being pushed westward from the Atlantic, the Mississippi proved the great obstacle to those building lines westward from Chicago. The mid-1850s were exciting days in the race to the West. The first line to reach the Mississippi was the Chicago & Rock Island, in 1854, followed in 1855 by the Illinois Central, and the Chicago & Alton; in the following year, the Chicago, Burlington & Quincy reached the left bank. All this railroad activity was looked upon with the greatest distrust by the steamboat men who operated a profitable traffic on the great river. That distrust turned to violent action when the railroad companies began to build bridges across the river. The Chicago & Rock Island was the first to do this, from Rock Island itself to Davenport, Iowa, the bridge being opened in April 1856.

The steamboat men tried to serve court injunctions claiming that the bridges were a danger to navigation; when these failed, they began employing more subtle and dangerous methods. In May 1856, a paddle steamer "accidentally" went out of control and crashed into one of the piers of the Rock Island bridge, bringing down the span. The steamboat, the *Effie Afton*, caught fire and sank, and the owners claimed, and were granted,

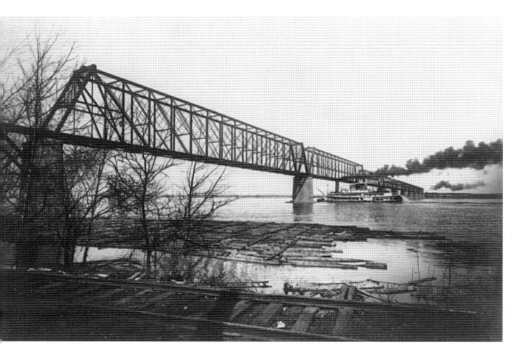

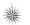

The Union Pacific and Central Pacific were the first railroad companies in the USA to forge an east–west link. The two lines met at Promontory, Utah, on May 10, 1869, where to celebrate the event, the last spike to be driven in was made of gold.

compensation. However, the steamboat men were fighting a hopeless battle.

At the same time, the first railroads were being built out in the West. At first, there were just a few local lines, but in 1861, the Central Pacific Railroad of California had been incorporated, with the aim of forging a link with the eastern states. Then came the Civil War, and little could be done. In 1862, however, Congress launched the great scheme for building the Union Pacific Railroad westward from the Mississippi. This great line, a vital artery of heavy east–west freight traffic, stands today as one of the very few railroads anywhere in the world that has always been privately owned, yet it was

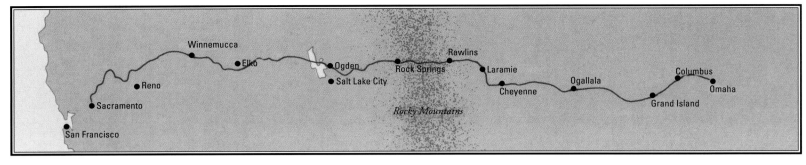

The construction of the Central Pacific and Union Pacific railroads provided the first east–west link from coast to coast in the USA.

A Tanana Valley Railroad train crosses a trestle bridge at the head of Fox Gulch in Alaska, c. 1916. The ready availability of lumber, made the trestle a popular and inexpensive bridge in North America.

inaugurated by direct government action. During the war, President Lincoln became anxious about the isolated and undefended states on the Pacific coast. Consequently, urgent encouragement was given to the construction of the Union Pacific Railroad. It was not until 1865, however, that the first rail was laid, in the Missouri valley. With this incentive, the Central Pacific began work in earnest to push the line eastward. It became a great race, because the fares and freight rates on this transcontinental route would be apportioned according to the mileage owned by each company.

The construction of the line became one of the great epics in the world of railroad building. Out on the prairies in wild undeveloped country, where the white man had scarcely penetrated, the survey parties and work trains were attacked by bands of Indians. The Union Pacific endured plenty of this kind of trouble, while the Central Pacific, forging its way through tough country in the Sierra Nevada

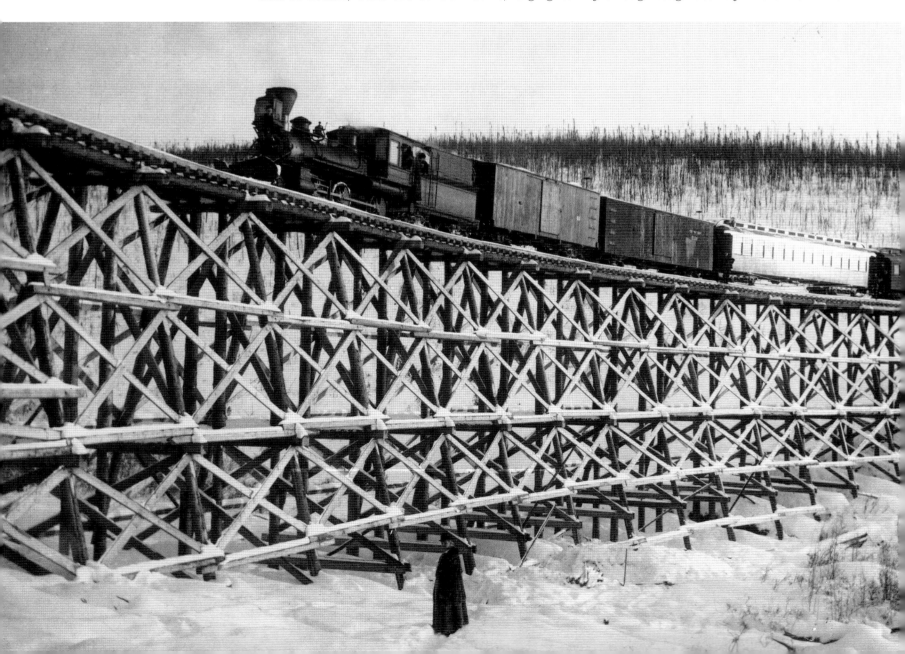

The Tay Bridge after the disaster, viewed from the south. A large section plunged into the water, taking a train with it. There were no survivors.

range, suffered the great handicap of having to obtain supplies by sea. There was no Panama Canal at that time, so everything had to be shipped to San Francisco around Cape Horn, at the tip of South America—a voyage from Baltimore or Philadelphia of about 15,000 miles (24,000km). The race to link up with the advancing construction gangs of the Union Pacific went on for four years, and eventually, on May 10, 1869, at Promontory, Utah, the last spike was driven in. The present main line takes what is known as the "Lucin Cutoff," which bypasses Promontory, but the site where the two original lines met is a popular tourist spot. To commemorate the event, two locomotives in period paint schemes face each other.

The jagged east coast of Scotland presented difficulties in building a direct line between Edinburgh and Aberdeen.

Along the deeply indented east coast of Scotland, the firths of Forth and Tay presented serious obstacles to the path of any direct rail line from Edinburgh to Aberdeen. The first step in overcoming these was the construction of a viaduct across the Firth of Tay, opposite Dundee. Thomas Bouch was the engineer, a man whose work was inclined to be venturesome, unlike the solid reliability of projects handled by the Stephensons and Joseph Locke. Unfortunately, on the Firth of Tay, Bouch underestimated the effect of the gale-force winds frequently experienced in that exposed area. Moreover, certain features of the detailed design were of questionable integrity—such as putting cast-iron sections under tension—and no inspections were carried out as the work progressed.

British engineering has an enviable

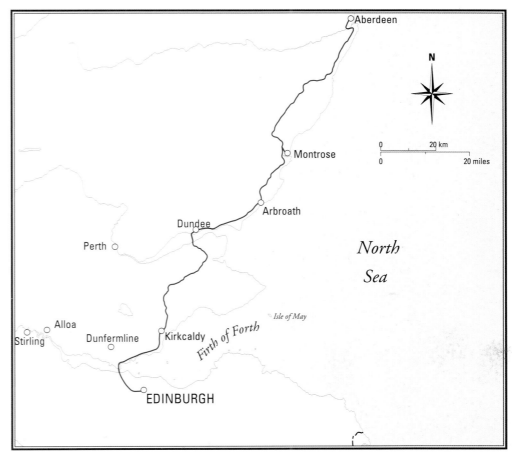

W. C. van Horne, the dynamic general manager of the Canadian Pacific Railroad.

A bridge on the Canadian Pacific—engineers had to cope with many natural obstacles.

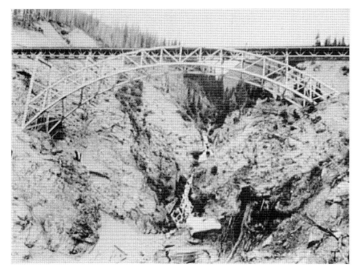

reputation for soundness of workmanship and a high sense of discipline. In this one tragic instance, however, the basic design had been a little incautious, while its execution was atrocious. The main columns had been cast badly, having an uneven thickness of metal; lugs, to which the tension members would be attached, fell off during casting and were reattached by the process of "burning on." In the circumstances, it was nothing short of a marvel that the bridge lasted as long as it did. It was opened to traffic in May 1878, carrying a single railroad track. The end came on the evening of December 28, 1879, when a great gale was sweeping in from the North Sea. A passenger train from Burntisland to Dundee entered the bridge, but as it reached the high girders carrying the line over the navigable part of the firth, the structure collapsed, taking the train and all its passengers down into the deep water. There were no survivors. At the time, Bouch had been commissioned to design a bridge across the Forth, but his reputation was shattered by the disaster.

The construction of the Canadian Pacific Railroad proved to be one of the greatest individual tasks ever undertaken by a single railroad company. It was built to honor a pledge made to the western provinces of British Columbia and Vancouver Island that in return for their joining the federation to form the Dominion of Canada, a transcontinental railroad would be provided. While the project had been initiated by the government, the company was privately owned, although often the financial situation became so desperate that several appeals had to be made for government aid. J.J. Hill, one of the original syndicate, had major interests in the USA and wanted the line to link up with them, so he urged that it be routed to the south of Lake Superior and so through United States territory. However, the general manager, W.C. van Horne, whom Hill had introduced, was implacably opposed to this. He was supported by the two Scottish tycoons who made up the remainder of the syndicate, George Stephen and Donald A. Smith. Hill resigned and immediately set to work to promote a rival transcontinental line in the USA, from St. Paul to Seattle, which became the Great Northern Railroad.

The all-Canadian route around the northern shores of Lake Superior involved some exceedingly difficult engineering. Although van Horne frequently took command "in the field" and pressed the construction work forward at an unprecedented rate across the open prairies west of Winnipeg, the continuation of the line through the Rockies presented further tremendous difficulties. The first

The Canadian Pacific route represented the first direct link across Canada.

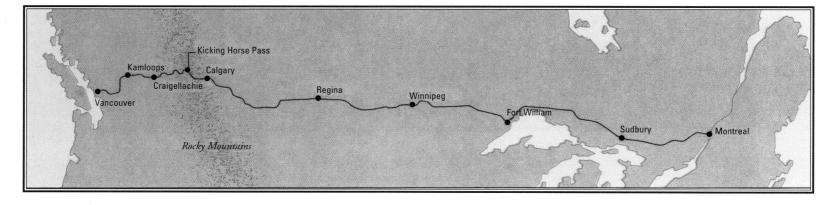

surveys had been made by the great veteran engineer Sandford Fleming; to avoid unduly steep grades and high constructional costs, he had proposed going through the mountains by way of the Yellowhead Pass, a fairly long detour to the north. Van Horne felt that such a route would leave a considerable stretch of Canadian territory near the United States border open to rival railroad infiltrations, however, and he instructed his engineers to find a way through that was as close as possible to a line drawn due west from Calgary. So they forged across The Great Divide near Lake Louise, then called Emerald Lake, and down the Kicking Horse Pass. Engineering difficulties did not end when the track reached Field, because finding a way through the tremendous barrier of the Selkirk Mountains proved even more difficult. Operationally, the ascent from Beavermouth to the Rogers Pass—named after the dynamic American engineer who found it—is the worst on the whole line; today, it requires the use of up to 13 diesel locomotives to haul the heaviest ore trains up the incline.

When competitive lines to the Canadian Pacific were surveyed and plans made for further routes to the west coast, the Yellowhead Pass route was adopted; the Canadian National Railroads operates a transcontinental service that way. The two lines came abreast of each other at Kamloops, then ran on opposite sides of the Fraser River for the rest of the way to Vancouver. At first, when they were running through canyon country, the scene was most dramatic, with rival trains passing along ledges cut in the rock walls, but they passed out of sight of each other as Vancouver was neared.

The CPR was built through Rogers Pass in 1884. Stoney Creek Bridge—here crossed by a freight train in 1988—is more than 600ft (182m) long, and 325ft (99m) above the creek.

FINDING SOLUTIONS, 1881-1913

AS THE WORLD'S RAILROADS GREW, ENGINEERS WERE FACED WITH
EVER CHALLENGING DIFFICULTIES TO OVERCOME, NOT ONLY
IN EXTENDING THE LINES, BUT ALSO IN ENSURING THEIR SAFE,
EFFICIENT OPERATION.

On June 12, 1889, there was a terrible accident near Armagh, on the Great Northern Railroad of Ireland. It was an accident that highlighted two fundamental weaknesses in operation on the railroads of the United Kingdom at that time. Both weaknesses were appreciated, and many of the railroad companies had already begun to take the necessary safeguards against them, but disaster struck on a line that was not so equipped. The first point concerned signaling. Early practice had been to work trains on a time-interval basis, allowing a train to go forward a specified number of minutes after the preceding one had passed. This system was subject to misjudgment and misunderstanding, and the principle of "absolute-block" working was being substituted. In this, a train was not allowed to proceed until positive advice by telegraphic bell signal had been received from the next block post that the preceding train had passed.

The second point concerned brakes. While brakes were operated on all vehicles by a valve on the locomotive, an early arrangement left the rear part of the train unbraked if it became detached from the part coupled to the locomotive. From Armagh, a very heavy excursion train was dispatched for Warrenpoint. It had to climb a steep grade, but the small engine was not powerful enough and stalled. The crew decided to divide the train, take the first half up to the top of the grade, then return for the rest. But the hand brake on the caboose could not hold the detached portion on the grade, and the cars began to run back downhill. Meanwhile, a second train, having started 20 minutes after the excursion, was climbing the grade. The runaway cars gathered speed and at 40mph (64km/h) smashed

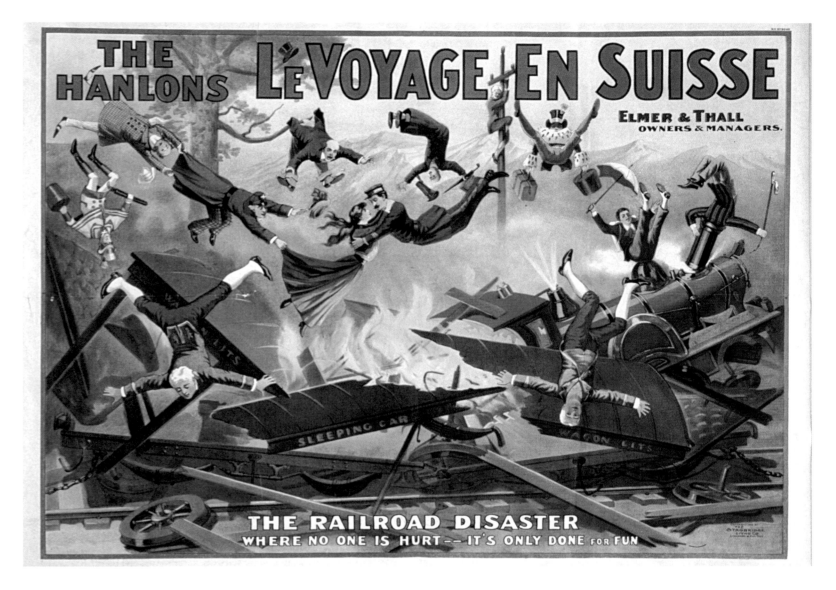

into the second train. Seventy-eight passengers were killed and 250 injured. Shocked by this terrible occurrence, Parliament rushed through a Regulation of Railroads Bill, making the absolute-block system compulsory on all passenger lines in the UK, as well as the installation of automatic continuous braking systems that would apply the brakes to both sections if a train became divided.

The findings of the Royal Commission on railroad gauges in Great Britain, unfavorable to Brunel's 7ft (2,144mm) gauge, were watered down somewhat by the subsequent parliamentary legislation, which, while discouraging its use, did not preclude any further extensions. After the death of Brunel in 1859, however, and the retirement as locomotive superintendent of Daniel Gooch, Great Western's enchantment with the broad gauge began to diminish rapidly. Mixed gauge was laid on many important routes so that both broad- and narrow-gauge trains could run, and other lines were converted. By the beginning of 1892, the only part of the line remaining wholly broad gauge was that between Exeter and Truro—100 miles (160km) on the main line and about 71 miles (114km) on various branch lines, such as those between Newton Abbot and Kingswear, and Truro and Falmouth. The remarkable decision was taken to convert the whole of this extensive area in a single weekend. All broad-gauge locomotives and rolling stock had to be evacuated from the area and worked to Exeter or beyond, where there

As railroads spread and traffic increased, accidents were inevitable, some involving considerable loss of life. This poster advertises a theatrical portrayal of a rail disaster, but only "done for fun."

The outline of an 1870s standard-gauge locomotive (red) superimposed on that of a broad-gauge locomotive and passenger car, showing the advantages Brunel claimed for his Great Western Railroad—greater space and stability, allowing higher speeds.

was mixed-gauge track. Then a workforce of 4,200 men was transported to Devon and Cornwall. The men were divided into gangs of 20, and each gang had 1 mile (1.6km) of plain line to convert. The business of moving the men with all their heavy tools and equipment was complicated because all the trains from the farther ends of the line were of standard gauge, and they had to change to broad-gauge trains at Exeter. The task needed tremendously detailed organization, because once the men had been conveyed to their places of work, the broad-gauge rolling stock had to be evacuated from the western areas—otherwise they would have been trapped and immovable. No time could be wasted in moving men from place to place during the operation, so accommodation was arranged close to the job. Sleeping facilities were provided in freight sheds and station buildings; where nothing suitable existed, tents were pitched beside the line. The whole operation went very smoothly; fortunately, the weather was fine. The last through broad-gauge train left Paddington for Penzance on Friday May 20, and on Monday May 23, the full service was restored with standard-gauge trains.

The technique of spiral tunneling, which needed consummate skill and precision in the preliminary and final surveys, was employed to remarkable effect in easing the grades on the Canadian Pacific main line in the Rocky Mountains—climbing the Kicking Horse Pass in British Columbia—and was used spectacularly in Switzerland on the Bern-Lötschberg-Simplon line at Blausee-Mitholz, in climbing from Frutigen to Kandersteg on the great line, which opened in July 1913.

Despite the speed and efficiency of spiral tunneling, the endeavor was often extremely hazardous. For example, in building the Lötschberg Tunnel, which began in 1906, over 3,000 workers were involved. In 1908, 30 men were killed when a workers' hostel was destroyed by an avalanche; only four months later, 25 men were drowned when water burst into a section of the tunnel, blocking over 0.6 mile (1km) of its length and causing its route to be diverted. The result was an increase in length of over 2,625ft (800m). Where the disaster had taken place, a wall 33ft (10m) thick was built to seal it off. Rock temperatures of up to 34°C (93°F) were encountered during the tunneling work.

Replacing the broad-gauge track with standard gauge at Devonport station on the Great Western Railroad, 1892.

The technique of spiral tunneling had been pioneered by Louis Favre while engineering the Gotthard line. This had been conceived as a major international main line on the route from Germany through Switzerland and into Italy. The St. Gotthard Pass had been a highway for centuries, albeit impassable in the winter snows, but the task of building a major railroad over the same route set a number of unprecedented problems. Driving a great tunnel under the pass itself, from Göschenen to Airolo, was not the major difficulty; it was the exceptional steepness of the approach valley to north and south. On both sides of the deep valley through which the railroad had to be pushed were high mountains, and Favre took the line into these by means of a series of spiral loops to gain height.

The actual grade of the railroad is about 2.5 percent, which was achieved by having no fewer than three spiral tunnels on the ascent from Erstfeld to Göschenen.

In the lengthy ranges of the Andes, which extend high and continuously from north to south on the South American continent, with their crests little more than 100 miles (160km) from the Pacific Ocean, are to be found the highest railroad summits in the world. The highest of all, the

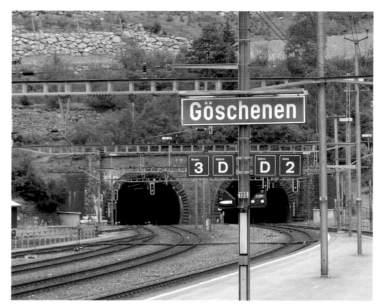

The northern entrance to the 9-mile (15km) St. Gotthard rail tunnel at Göschenen in Switzerland. From this point, the tunnel rises to a height of 3,800ft (1,151m) before descending to the southern portal at Airolo, in Italy, passing through the Gotthard massif.

Antofagasta (Chili) and Bolivia, was one of the first. It was a British enterprise and reached the remarkable altitude of 15,835ft (4,826m) on its Collahuasi branch. The company was formed in 1888 to take over certain concessions granted by the Chilean and Bolivian governments. The line was built on the 2ft 6in (762mm) gauge and had a length of 769 miles (1,230km) during its period of greatest prosperity in the early 1900s. Initially, it carried nitrates from Bolivia to the sea at Antofagasta, but in later years the traffic has been in tin and copper. By 1928, the line was converted to meter gauge, and powerful articulated locomotives of the Beyer-Garratt type were purchased to pull mineral trains on the heavy gradients. At the time of the gauge conversion, a third rail was laid on many sections. The final conversion, which involved some 200 miles (320km) of line, mostly in waterless, desolate country, took no more than six days.

Farther north, the Central Railroad of Peru has been claimed as the most spectacular in the world, reaching 15,845ft (4,829m) on the European standard gauge throughout. The ascent of the main range of the Andes began at Chosica, where the railroad was 33 miles (53km) inland from Callao and had already attained a height of 2,820ft (860m). Then came a tremendous climb to the summit of the line in the Galera tunnel. This point was only about 40 miles (64km) from Chosica, but with a difference in altitude of 12,870ft (3,923m), the average inclination would have been 1 in 16.5 but for the ingenious and spectacular engineering solution. The actual gradient of the line was about 1 in 25, height being gained not by building spiral tunnels, but by laying the track in a series of zigzags that rose up the side of the valley.

The trans-Andine railroad, which formed part of a continuous line of communication between Buenos Aires and Valparaiso, initially had separate Chilean and Argentinian sections, but between 1923 and 1939, it was operated first by a joint administration, and then by the British owned Buenos Aires and Pacific Railroad. It was meter gauge and included some rack sections to facilitate the climb to its summit level of 10,453ft (3,186m) near Las Cuevas. If the weather was fine, there was a sight from here of the highest mountain in all the Americas, the 22,834ft (6,959m) Aconcagua. In its later years, the trans-Andine passenger train took about 12 hours to cover the 240 miles (386km) from Valparaiso to Mendoza, the railhead of the Argentine line.

Railroads During and After the Great War, 1914-22

RAILROADS WERE VITAL ASSETS TO BOTH SIDES DURING WORLD WAR I, ALLOWING THE RAPID TRANSPORTATION OF VAST QUANTITIES OF MEN, MATERIALS, AND EQUIPMENT TO THE VARIOUS BATTLE FRONTS.

Until 1914, railroads had played small, yet significant, roles in warfare—in the confused campaigns in the Mississippi basin during the American Civil War, and in the operation of patrols with armored trains during the later stages of the Boer War. With the outbreak of World War I, however, much of the normal pattern of international travel on the continent of Europe was disrupted. Of necessity, the important chain of communication between England and Germany was severed, never again to be restored in its original form. Tracks were destroyed to hinder troop movements, bridges were blown up, particularly in Belgium during the first weeks of the campaign in the

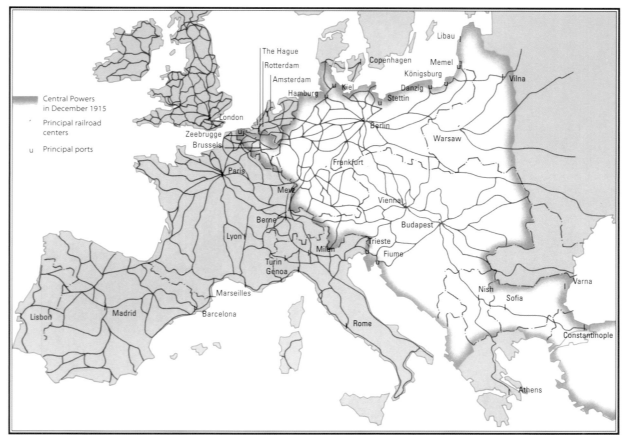

By December 1915, a great swathe of Europe—shown outlined in blue—was under the control of the Central Powers. Railroads played a major role in the war efforts of both sides.

west, and locomotives and rolling stock were hurriedly withdrawn to prevent them from falling into enemy hands. Then, after many of the industrial areas of northeastern France had been overrun by German forces and all the manufacturing facilities in Belgium had been lost, the French and British governments were faced with the problem of providing spare parts for the rolling stock that had been withdrawn. The heavy industries in both countries were rapidly switched to the production of armaments, and the railroads found great difficulty in obtaining raw materials to manufacture the necessary parts in their own workshops. To meet this need, a British purchasing mission was sent to the USA, where it arranged for large quantities of steel plate, bars, ingots, and other materials to be shipped to Britain.

The British Army set up a Railroad Operating Division, which proved invaluable in transporting reinforcements and munitions to the forward zones in the battle areas. Track was lifted from sections of the home railroads made temporarily redundant by the suspension of tourist and other peacetime activities. Many British locomotives were sent to Europe for use by the Railroad Operating Division. The neutrality of Switzerland made it a place where the repatriation of prisoners-of-war could be arranged, and Constance, on the German-Swiss frontier, was a center through which much of this unusual traffic passed. In the campaigns in the Middle East, much of the guerrilla activity against the Turkish forces, so dashingly organized and led by T.E. Lawrence, centered upon disruption of the Hedjaz Railroad and the destruction of troop trains. Among the Arabs, Lawrence became known as "Destroyer of Engines."

Despite the numerous and costly offensives during the four years of war, the Allied battle line from the North Sea to the Swiss frontier remained stable enough for the pattern of railroad operation to assume a fairly constant form. Two major routes of the Northern Railroad of France were completely

Opposite page: The Railroad Operating Division (ROD) 2-8-0 was the standard British steam locomotive during World War I. The preserved LNER Class 04 (previously GCR Class K) No. 63601 is shown here at Doncaster Works open day in July 2003.

Russian infantry laying a light railroad during World War I. Many armies used such portable railroads to transport supplies to the front lines.

severed, namely the line to Arras and Lille, and that leading into Belgium. The eastern main line toward Nancy and Strasbourg furnished reinforcements and munitions exclusively to the French line of battle. The northern main line to Boulogne and Calais became almost entirely a British Army supply route.

In Great Britain, the establishment of the main base of the Grand Fleet at Scapa Flow in the Orkneys imposed a severe task on the railroads. The huge battleships of the day were coal fired, and because best-quality steam coal was needed, this had to be hauled from South Wales, via Crewe, Carlisle, Perth, and Inverness to the most northerly railhead at Thurso. It was a tremendous operation, requiring the redeployment of many locomotives. A considerable number of new locomotives for the French railroad system were manufactured in Scotland. By the end of the war, the British Railroads Operating Division had built up a total manpower of over 18,000, covering a rail network of over 800 miles (1,300km).

The early conquests of the German and Austrian armies during World War I, which put Serbia, Romania, and most of Belgium into the hands of the so-called Central Powers, provided a remarkably

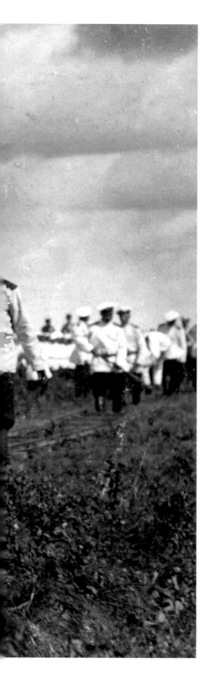

complete railroad network that was generally immune from assault by the Allied forces. At the time, the ability to mount effective aerial attacks was very limited. The overrunning of Belgium in the early stages of the war provided an additional outlet to the North Sea at Zeebrugge, while similar action against Serbia opened a direct line to Bulgaria and Turkey. The network itself was entirely of prewar construction, but, when linked under a largely unified wartime command, it was ideally suited to the movement of troops and supplies, both from the central areas to the battle fronts and from one front to another. In the early stages of the war, Russian forces were in evidence on the Eastern Front, but their collapse in the autumn of 1916 reduced the Central Powers' need for railroad transport in Poland and eastern Hungary, although the war in the Balkans was increasing.

The major powers equipped their armies with light, portable railroads to supply the front lines. These could be lifted and moved in accordance with advances and retreats, although with the static nature of trench warfare, many remained in place for a year or more. U.S. builders supplied many locomotives for the front lines in France and Russia; internal-combustion locomotives were also used because they did not attract gunfire by sending plumes of steam into the sky.

The peace conference of 1919, and the treaties that ratified its recommendations, not only redrew much of the map of Europe, but also led to a regrouping of many of the established railroad facilities. The total dismembering of the former Austro-Hungarian Empire had the most profound effects, with the great reduction of Austria itself, and the formation of the new autonomous states of Czechoslovakia and Yugoslavia. To the north, Poland gained independence. The existing railroads did not meet the needs of the newly formed countries, and

A mammoth French Mle 93-06 rail gun weighing 178 tons. Horizontal traverse was not possible, except by moving the gun around a curve in the track. It could fire a 767lb (348kg) shell over a distance of more than 17 miles (27km).

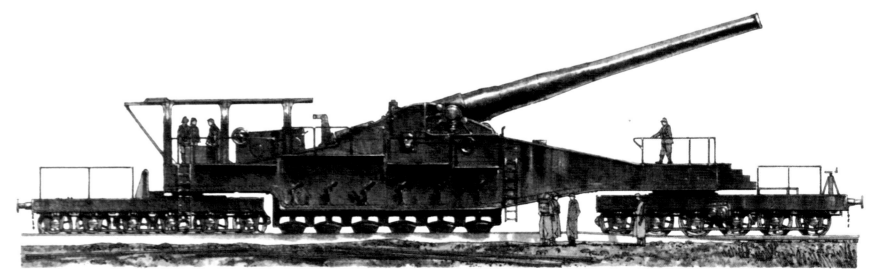

many new lines were required to create effective national networks. In Germany, the railroads were nationalized. From 1923, following the restoration of the Alsace-Lorraine lines, only France retained its original railroad administration.

In Great Britain, the coalition government returned to power with a huge majority after the so-called "khaki election" of 1918 and imposed legislation upon the former private railroads, forming them into four large groups.

The reason for the British grouping arose directly from circumstances that had pertained during the war. From the outbreak of hostilities in 1914, the entire network of Great Britain and Ireland had been put under government control and administered by the Railroad Executive Committee, formed of a consortium of general managers from the leading railroads. The interests of individual rail companies had been subjugated to the national interest, but the interests of the owners—the shareholders—had been safeguarded by a guarantee, for the duration of the war, that dividends equal to those of the year 1913 would continue to be paid.

During the war, however, strong representations were made by labor interests for uniform wage

A British railroad works in France, where American locomotives were assembled for use by the Allies.

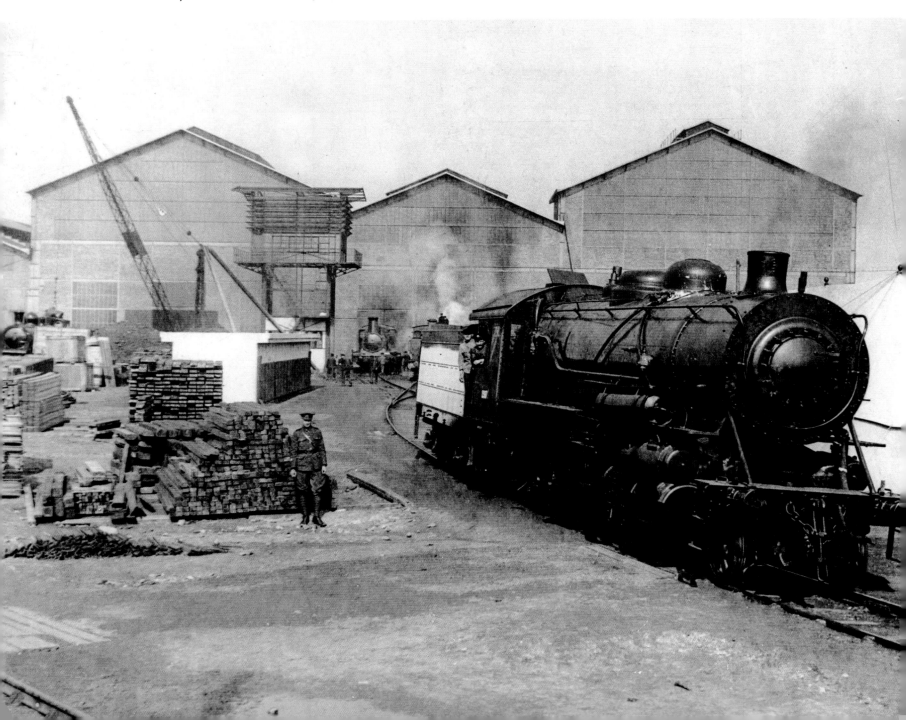

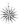

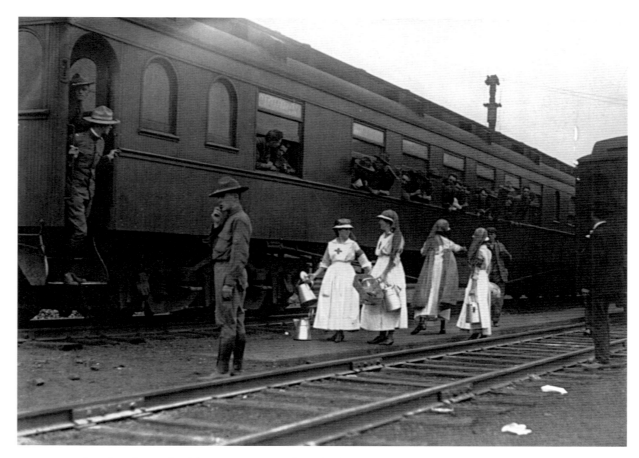

The railroads were vital for ferrying men and equipment to the battle fronts. Here, Red Cross workers prepare to board a troop train in Washington DC in 1918.

The Hedjaz Railroad was a vital artery for the Turkish Army in the Middle East. It was disrupted completely by Arab forces led by T.E. Lawrence.

rates; previously, these had been negotiated with the individual companies and there had been great disparity, for example, between English and Scottish rates. New national scales were negotiated and paid in the later stages of the war, but it was realized that these could not be sustained by some companies when the railroads were handed back. The solution seemed to be to group the "rich" with the "poor," at the same time aiming to continue some aspects of the uniform working conditions that had been found advantageous during the war.

The post-war situation in Britain, therefore, with government imposed mergers under private ownership, and with no subsidies, was notably different from that in all the other former belligerent countries, where reorganization immediately brought national ownership. After a brief postwar boom, the railroads of Britain entered a period of acute financial difficulty. The years immediately following the consolidation, in 1923, witnessed much confusion and frustration, while companies that had previously been rivals tried to settle down together.

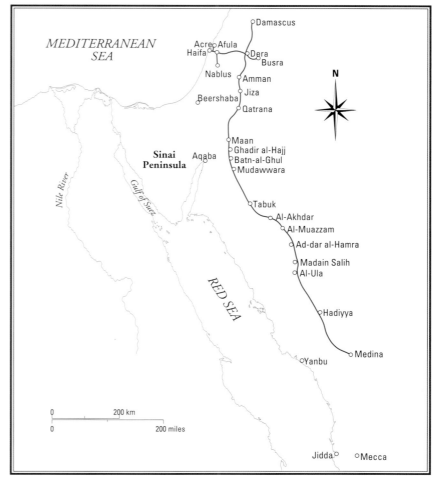

The Quest For Speed, 1923-45

FACED WITH COMPETITION FROM ROAD TRANSPORT AND PUBLIC
DISENCHANTMENT, THE RAILROADS OF THE WORLD STROVE
FOR FASTER SERVICES TO WIN BACK BUSINESS, AND PLAYED AN
IMPORTANT ROLE IN ANOTHER WORLD WAR.

In many ways, the grouping of the former British main-line railroads into four large companies, still privately owned and entirely self-supporting, which took effect from January 1, 1923, was typical of the worldwide attitude toward railroads during the period of reconstruction after World War I. The aims were greater comfort for the passenger, greater safety, and improved punctuality, although at first, there was little thought of doing more than restoring prewar standards of speed. Although this had been done in Great Britain by 1924, on the continent of Europe, after the ravages of war, most countries still lagged behind. However, what railroad managements around the world did not seem to foresee, still less plan to combat, were the extent and seriousness of the growing competition from highway transport, for both passengers and freight.

Around the great cities, with their increasing populations, attention was given to rail commuter traffic. Studies were made of traffic flows in relation to the capacity of the lines; around London in particular, junction layouts were changed to minimize delays from conflicting movements. Although electrification was envisaged, in many areas some ingenious replanning of commuter services was accomplished while retaining steam—notably in and out of London's Liverpool Street station, terminus of the former Great Eastern Railroad. On those services, passenger accommodation was provided in three classes. In other regions of Britain, second-class compartments had largely disappeared.

A most important trend around the world, was the beginning of a move away from coal as a steam-locomotive fuel; elsewhere, locomotive engineers were forced to use coal of a quality that was well

below the choicest steam grades. This came about during World War I, when hostile naval action cut off British coal exports. The South American railroads, then mostly British owned, were hit hard and had to improvise. When supplies were about to be restored after the war, there came the disastrous coal strike of 1926, which cut them again. After that, the changeover to oil firing became permanent. In the USA, railroads serving the Midwest and western states that were near the large indigenous oilfields made a similar switch. Some of the heavily graded U.S. mineral lines had been electrified, but opinions differed considerably as to the best power system.

With the exception of the newly developing countries, not a great deal of new railroad lines were built. The amalgamation of the major rail companies in Great Britain eliminated some routes and short connections to facilitate inter-running between what had been separate company lines. Some of the most significant works in developing the world's railroad network, however, were carried out in Australia. Connection between the states of New South Wales and Queensland had been made in 1888, by a roundabout route that involved a change of gauge at the border station of Wallangarra. In 1930, though, the North Coast Line of the New South Wales Railroads was completed. This was standard gauge throughout and ran through 70 miles (113km) of Queensland territory to a terminus in South Brisbane. Even in 1925, the journey between Sydney and Brisbane had taken 25 hours; after completion of the new line, the time was cut to 15 hours 30 minutes.

While electricity was being hailed as the motive power of the future, and committees in Great Britain and elsewhere were trying to establish the standard systems to be adopted, important developments were being made in steam-locomotive design, particularly in France, Great Britain, and the USA. Although speeds were creeping up, the aim of most locomotive designers was to increase thermal efficiency so that heavier loads could be hauled without a proportionate increase in fuel consumption. This was important on railroads that were dependent on coal as a locomotive fuel. There was also a move, strong in the USA, to increase the speed of long-distance freight trains. This was aided by the development of huge articulated locomotives from the Mallet compound type that had improved suspension and were capable of sustained fast running.

When the worldwide depression of the 1930s began to have a serious effect on railroads in the advanced countries of the world, their ability to compete effectively with road transport was compromised. This was particularly evident in Great Britain, because of legislation framed in economic, political, and international conditions totally different from those of the 1930s. The railroads of Britain were common carriers, and they found

Six of these high-speed locomotives were built in Belgium in 1939 for service from Brussels to Ostend and to Liège. The war meant that the proposed high-speed services were never introduced, so their 87mph (140km/h) running speed was never put to use.

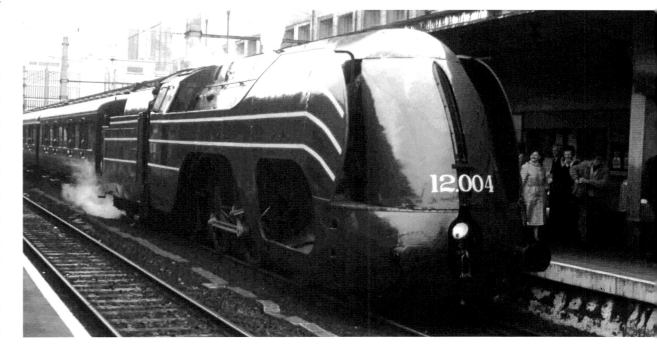

A view of the future. An unusual looking streamlined diesel locomotive pulls the *Burlington Zephyr* service into Dubuque, Illinois, c. 1940.

that all the choicest and most remunerative traffic was being taken by road transport, leaving them with the business that no one else wanted. Appeals for revised legislation were ignored; public sympathy was with the trucking companies. In rural passenger transport, the bus, making its way into the hearts of village communities, took the bulk of the business from the country branch lines, which were considered to be old-fashioned and whose services were often inconvenient.

The publicity departments of the railroads worked hard. The speeds of a few prestige trains in Great Britain, France, Germany, and the USA were pushed up; for a time, the honor of the fastest start-to-stop run anywhere in the world was held by the Canadian Pacific, which was waging an intense, but highly unprofitable, competition with the Canadian National Railroads for the intercity traffic between Montreal and Toronto. In Great Britain, there was mild competition, at no more than moderate speeds, for the maximum length of nonstop run on the Anglo-Scottish services: while the London Midland & Scottish had a year-round, daily run of 299.25 miles (478.8km) between Carlisle and London (Euston), during the summer season, the London & North Eastern ran the *Flying Scotsman* nonstop in both directions over the 392.75 miles (628.4km) between London (King's Cross) and Edinburgh. The Great Western scheduled the lightly loaded *Cheltenham Flyer* over the favorable 77.25 miles (123.6km) from Swindon to Paddington in 65 minutes. While this start-to-stop average of 71.4mph (114.4km/h) was not representative of the service provided as a whole over that route, it gave a splendid publicity boost, especially when, as a special feat, the journey time was cut to 56¾ minutes, an average speed of 81.7mph (130.72km/h).

By the early 1930s, however, despite the prevailing depression, the supremacy of steam as a rail motive power was being challenged, not by electricity, but by the diesel engine. One of the earliest successful examples of the diesel locomotive had been introduced on the Buenos Aires Great Southern Railroad. The use of diesel power on the railroads would soon spread around the world.

An American development that became of strategic importance in World War II was the mechanization of freight yards. Methods for the efficient sorting and resorting of freight trains had been developed early in Great Britain, notably on the London & North Western Railroad at Edge Hill, Liverpool; arrangements for centralized control and power operation of the switches had been adopted subsequently. The Americans had eliminated the need for hand operated brakes, however, by developing so-called "retarders," or rail brakes. Some large yards were equipped with retarders in the early 1920s; in Germany, the great yards at Hamm were similarly furnished (the Hamm yards became a familiar and frequent target for Allied bombers during World War II). British yards at March, in Cambridgeshire, and Hull were also provided with retarders, enabling these important centers of traffic to be operated with a greatly reduced workforce.

Although the weekly distances involved and the resultant revenues were quite small, the introduction of high-speed streamlined trains in the 1930s helped to keep railroads in the public eye. The German Railroads' *Flying Hamburger*, a two-car diesel railcar train that ran in and out of Berlin, was one of the first, although it was criticized for the cramped nature of its passenger

accommodation. In the USA, a series of *Zephyr* services were run with streamlined trains between Chicago and cities in the Midwest; competition was provided by the *Rocket* trains of the Chicago, Rock Island & Pacific Railroad. In Great Britain, the response to this movement was entirely with steam, principally on the London & North Eastern Railroad, which introduced the *Silver Jubilee* in 1935, and the Coronation in 1937. These trains were capable of start-to-stop average speeds of slightly more than 70mph (113km/h), which brought immense publicity and prestige. During one special test, the highest speed ever attained by a steam locomotive was recorded, namely 126mph (203km/h). This was achieved by the famous *Mallard* locomotive of the LNER, on July 3, 1938, running between Grantham and Peterborough.

In the last years before World War II, there was a great worldwide improvement in passenger train services. This was not purely the result of running a few spectacular streamlined trains, but applied across the board. It was particularly true on the great American railroads running east from Chicago, like the Pennsylvania and the New York Central, whose fast runs—with start-to-stop speeds of 65–70mph (105–113km/h)—were made with heavy, overnight sleeper expresses. In France, the standards were equally high, again with heavy trains, while in Great Britain the number of trains maintaining average speeds of 60mph (96km/h) was exceptionally high in relation to the size of the country.

Despite their financial difficulties, which in Great Britain meant low or non-existent dividends for shareholders, railroads were in excellent physical condition and everywhere proved an invaluable tool of basic strategy at the outbreak of World War II. In Great Britain and France, passenger facilities were reduced immediately and schedules greatly decelerated; as the aerial war developed, there was sustained and relentless bombing of railroad targets in Germany. Naturally, classification yards came in for much attention, but in Germany, as elsewhere, the organization for repair was highly efficient, and the offensive, although cumulatively serious, did not have such a crippling effect on railroad movements as the strategic bombing of the French railroads prior to the Allied invasion of 1944, during which many viaducts were destroyed, hindering the transport of supplies to the battle areas. In the USA, wartime traffic imposed an immense burden on the lines leading to the West Coast; to aid the passage of a far greater number of trains than that for which they were equipped, the technology of modern signaling, in the form of Centralized Traffic Control (CTC), was applied to advantage. Although large-scale production of diesel-electric locomotives had begun, steam carried the main burden of wartime traffic in the USA, passenger train speeds being little reduced from those achieved in peacetime.

The *Flying Hamburger* was a two-car diesel-electric train built in Germany during the early 1930s. It could carry 102 passengers at speeds of up to 100mph (160km/h). The shape of the streamlined train was developed in a wind-tunnel, while the center of gravity was kept low by placing the electric motors in the trucks.

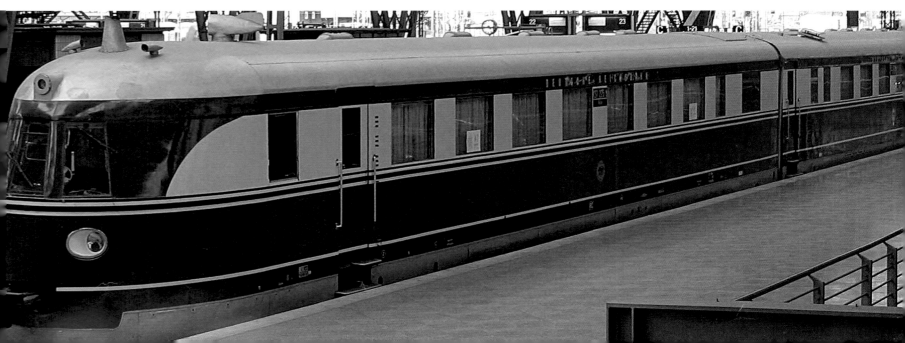

New Age of the Railroads

AFTER WORLD WAR II, MANY RAILROADS WERE IN TURMOIL,
LOSING OUT TO AIR AND ROAD TRANSPORT. IN MANY CASES,
GOVERNMENT INTERVENTION THROUGH NATIONALIZATION OR
SUBSIDY WAS THE ONLY SOLUTION.

The decade immediately after World War II saw great changes on the railroads of the world. In many cases, these took the unwelcome forms of withdrawals of facilities and reductions of worked track due to a rapidly worsening economic situation. In many countries, however, there were notable advances in technology. Apart from the USA, which had not been invaded or subjected to aerial attack, the railroads of Great Britain were practically alone among those of the most heavily involved belligerent nations in having their tracks and workshops intact at the end of the war. Damage had been repaired, although, by necessity, the standards of maintenance of track and rolling stock had been very much reduced. The fact that the railroads of Britain were still operating meant that they received nothing in the way of financial aid toward recovery, such as that made available to those on the continent of Europe and elsewhere through the U.S. Lend Lease Act and Marshall Plan, which enabled the rapid restoration of services.

In Great Britain, because of circumstances that were not at first widely understood, the prestige of railroads had sunk exceedingly low, and nationalization was hailed by many as the panacea for their ills. Then, after the necessary legislation had been passed by Parliament and the situation had deteriorated rather than improved, the blame for the worsening financial position was shifted on to the steam locomotive. At the beginning of the 1950s, however, no funds were available to permit a change to electric or diesel power on a large scale; apart from commuter routes, therefore, the railroads of Britain remained steam powered.

Ironically, railroads in the USA soon began to experience an unexpected and unprecedented downturn in business. All over the country, commercial air services were being introduced, while there was a major increase in the operation of large trucks on the highways. Businessmen began

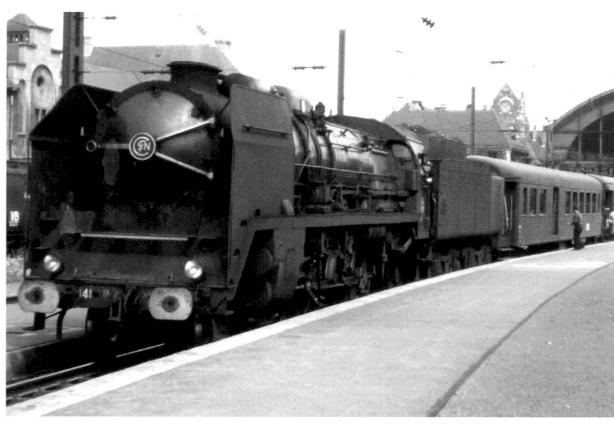

A French passenger train at Metz, hauled by a 141P locomotive, a Chapelon four-cylinder compound type designed in the 1940s and reputed to be a world-beater in terms of its power/weight ratio.

to transfer their patronage from the long-distance luxury express trains to air services, which were immeasurably quicker than the fastest trains.

In Britain, it was very different. The ever growing deficit on railroad operation was a charge on the national exchequer. In 1955, in an attempt to reverse the process, Parliament voted funds for a large-scale modernization plan, one of the principal features of which was the elimination of steam power. Large sums were spent on new rolling stock, improved signaling, and the construction of huge classification yards. The existing electrified lines were extended, and work began on electrifying the main line from London to Birmingham, Liverpool, and Manchester. Contracts were placed for hundreds of diesel locomotives, as a first step toward the replacement of some 18,000 steam locomotives. Still the adverse financial trend was not halted. In 1961, a distinguished industrialist, Dr. Richard Beeching, was appointed as chairman of the British Transport Commission, later reconstituted as the British Railroads Board. He subjected the entire network to a thorough and ruthless analysis to determine which routes and which facilities were profitable, with a view to closing the unremunerative lines and developing others. The plan, although highly controversial, was carried through, beginning in 1963.

The situation in Japan was a complete contrast, the great prewar plan of a new, high-speed national network being finally consummated, in its first phase, by the opening of the new Tokaido line in 1964. In the

Dr. Richard Beeching, later Lord Beeching, brandishes his controversial report, *The Reshaping of British Railroads*, which called for massive cuts in Britain's railroad network.

Opposite page: One of Japan's original 0 series Shinkansen "bullet" trains, which were introduced in 1964 on the first of the Japanese high-speed lines, the Tokaido Shinkansen. The trains ran at speeds of up to 130mph (210km/h) initially, but later this was increased to 135mph (220km/h).

USA, the railroad situation deteriorated alarmingly. The privately owned railroads were hamstrung by outdated legislation, which the government persistently refused to revise. Most railroads cut their passenger services to the legally mandated minimum, and would have abandoned them altogether had they been allowed to do so. To relieve the railroads of the responsibility of operating passenger services, the National Railroad Passenger Corporation (Amtrak) was set up by Act of Congress in 1970, and a network of long-distance passenger routes chosen for development. These included all except two of the remaining passenger routes in the USA. In the meantime, by the application of modern technology, great and successful efforts were made to win back some of the freight traffic lost to long-distance trucking enterprises.

In Great Britain, in 1976, a massive program of accelerated service was introduced between London (Paddington) and Swansea, and between Paddington, Bristol, and Weston-super-Mare, with a new large fleet of diesel powered High Speed Train (HST) sets, each having 4,400 engine horsepower and being scheduled to run at 200km/h (125mph) over long stretches of both routes. The important features of these new services were their uniformity of high speed throughout the day and the frequent intervals at which they ran.

British Rail's High Speed Trains (HSTs) ran at 125mph (200km/h) over long stretches. Here, a London-bound service crosses the River Ouse on the Midland main line, c. 1992.

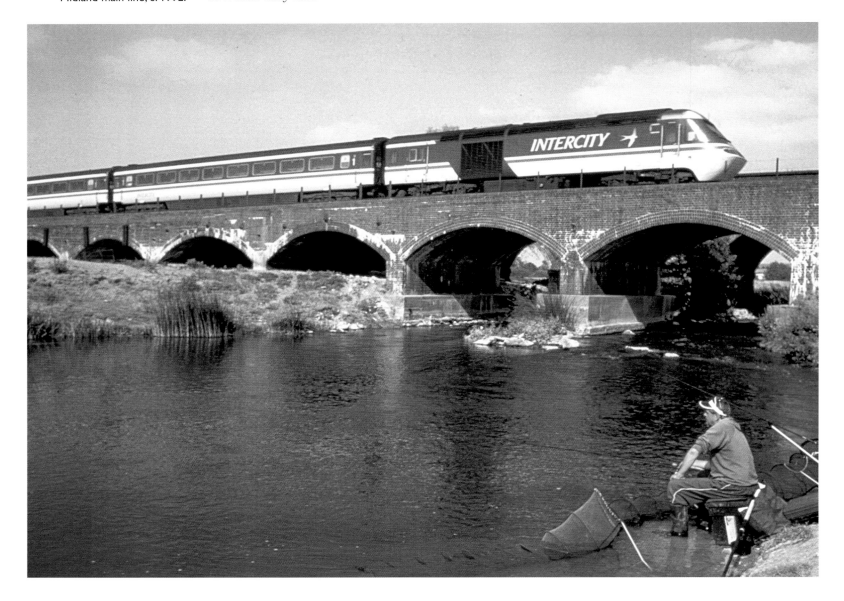

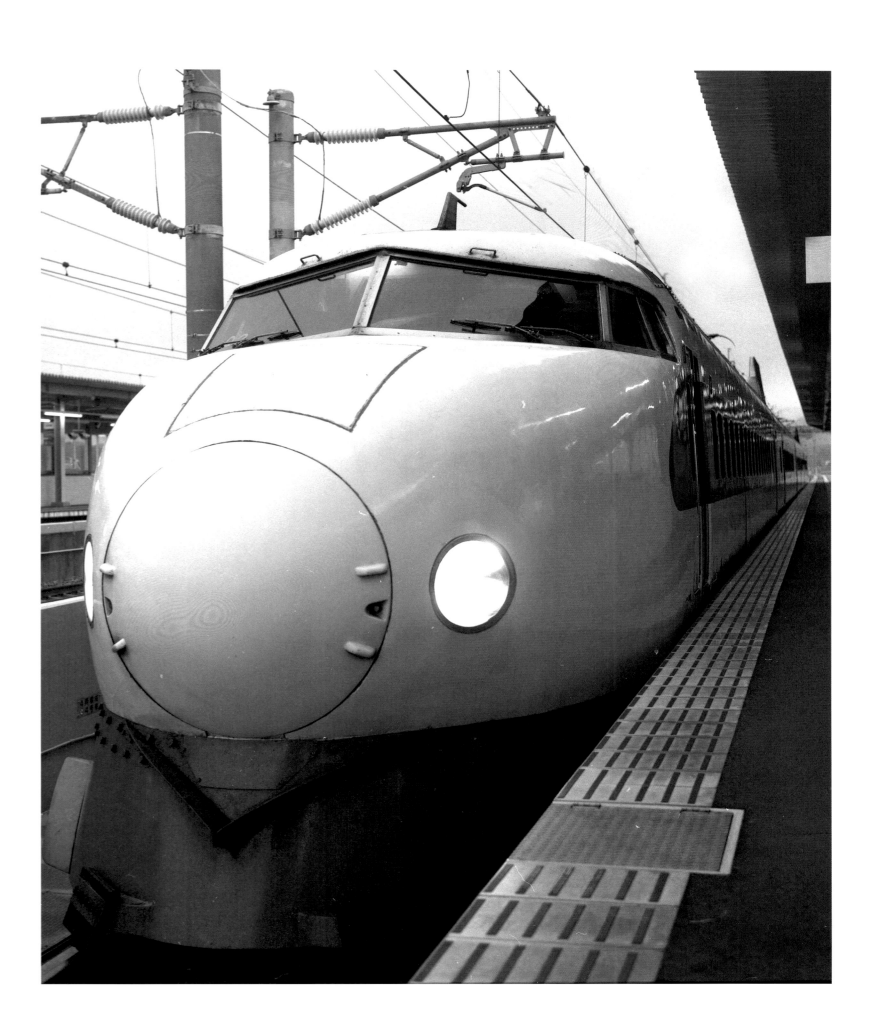

Railroad Restructuring, Late Twentieth Century

AS THE TWENTIETH CENTURY NEARED ITS END, GOVERNMENTS AROUND THE WORLD SOUGHT TO DIVEST THEMSELVES OF THE FINANCIAL BURDEN OF STATE RAILROAD SYSTEMS, BUT WITH VARYING DEGREES OF SUCCESS.

In the last decades of the twentieth century, most of the world's railroads underwent radical restructuring, involving privatization, the boosting of competition, and the separation of the infrastructure (track, stations, signaling) from railroad operation (running trains and marketing). In some cases, restructuring was introduced slowly and carefully; in others, the changes occurred all at once and required refinement later. In both instances, this meant that the restructuring process continued into the early part of the twenty-first century.

This restructuring had several reasons. Governments sought to reduce the financial burden of their state railroads, believing, with varying degrees of conviction, that private enterprise would reduce costs and increase income; even if this did not occur, the burden would fall on shareholders rather than taxpayers. With the emergence of the market economy and the concurrent loss of faith in socialism, there came an ideological boost for private ownership, a key element of which was competition. There was also a wish to put railroads on the same accounting basis as other forms of transport, by separating the operating function from the infrastructure; that way, it would be possible to find out how much the use of infrastructure really cost, and thereby ensure that the train operators paid a fair price for using it. Better costing would make it easier to eliminate that widespread weakness of the railroads, their cross-subsidization of loss-making passenger services from freight profits, a practice that made their freight services less price competitive.

Sweden was a pioneer in this trend, the State Railroad (SJ) becoming a train operator in 1988, while

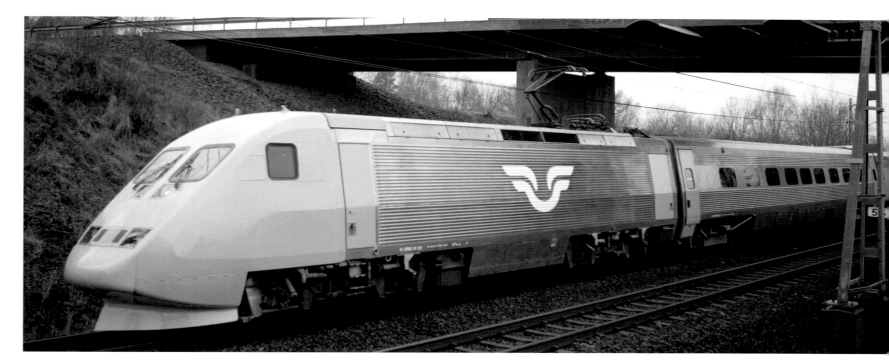

a new state company owned and charged for the infrastructure. Later, other companies were allowed to compete for franchises to operate trains over Swedish tracks, although SJ retained its monopoly of unsubsidized long-distance trains. This concept of the state retaining ownership and control of the infrastructure while permitting private train operators to share them was adopted by other countries, each of which varied the details to suit economic and political circumstances. In France, for example, French National Railroads (SNCF) lost ownership of the infrastructure, which was entrusted to a new state company, RFF, which was charged with opening the lines to competitive services, although it was required to give SNCF preference when setting train timetables (a provision that went a long way toward protecting SNCF's dominance). In Russia, the state railroad began to divest itself of its different functions, forming "daughter" companies for freight, passenger, commuters, refrigerator services, and so on. Eventually, those companies were opened to private investors in an attempt to gain an influx of much needed capital.

In the European Union, separation of infrastructure from train operation, and the introduction of competition, became obligatory. In due course, freight train operators began moving their trains all over the EU. Competition was part of the ideology of the time and, like other ideological ventures, did not always produce the expected results. It could be argued that allowing rival companies to operate trains over the same tracks might have boosted competition, but the idea that this actually *introduced* competition was bogus, for the railroads had been competing against highway, waterway, and air transport for decades.

In many countries, notably Britain, the burden on the taxpayer actually increased after privatization. By the 1990s, the state owned British Rail had become a more business-like organization. It still required government subsidy, but its traffic was developing and it had several creditable ventures under way. The High Speed Train, for example, was a great success, and the electrification of both the West Coast and East Coast lines to the north had transformed train services. BR was handicapped by government control, and especially by the need to persuade a reluctant Treasury to provide capital investment.

In 2000, the Swedish State Railroads, Statens Jämvägar (SJ) was split into six government owned limited companies, and SJ became exclusively a train operator. The company provides a high-speed service using X2000 tilting trains such as this.

Even the purchase of new rolling stock was subject to government approval, and in the few years preceding privatization, BR was not allowed to buy new passenger trains. This was partly responsible for the ruin of much of Britain's rolling-stock industry.

The Railroads Act of 1993 broke British Rail into a large number of small pieces, each reacting with the others on a contractual basis. Passenger train operating companies were to establish themselves by bidding for franchises covering specific areas or routes; these franchises would be valid only for a few years and, on termination, would be open to bidding again. Train operating companies would pay a separate infrastructure company, Railtrack, for the use of tracks, and it was the intention to encourage competing companies to use the same tracks. In the beginning, it was expected that companies would require government subsidy, but in the longer run, private enterprise was expected to result in profit making companies, which would pay the government a proportion of their profits. Although the government's Office of Passenger Rail Franchising, which allocated the franchises, worked on a confidential basis, it became clear that to win a franchise, it was necessary to meet the basic train-service requirements at the lowest possible subsidy.

Freight companies were also established, but these were all-network operators, not restricted to specific territories, and did not face the same franchising procedures. EWS (English, Welsh & Scottish Railroad) emerged as the leading freight company, but faced increasing competition.

The result of all this was to make the railroads more colorful. Bright new passenger train liveries appeared, which changed when one company outbid another for a renewed franchise. The trains were not owned by the operating companies—who in fact owned little—but by three rolling-stock companies, which leased their trains to the operators. These rolling-stock companies, which in due course came to be owned by large financial institutions, became highly profitable, as did Railtrack. Thanks to more attractive trains, and an improving economic climate, privatization was followed by a substantial rise in passenger traffic, to the extent that many lines became congested. Even so, government subsidy of the railroads did not gradually disappear, as had been expected, but multiplied by several times.

The working atmosphere also changed. Fragmentation of the system meant the end of teamwork. There was lack of coordination between the infrastructure owner and the operating companies. Formerly, all railroad workers cooperated to remedy or prevent late running; under the new regime, if a train was late, it was necessary to establish whether the fault rested with the operating company or the infrastructure company, and how much compensation should be paid by one to the other. Not surprisingly, lawyers and accountants began to be more important than engineers.

This came to a head in 2001 with an accident at Hatfield, soon followed by another at Potters Bar. In both cases, passengers died because of badly maintained track. It became evident that Railtrack's quest for profit, plus the ambience in which it worked, had cost lives. It was a private company, and the government ensured that it went out of business. It was replaced by Network Rail, which ostensibly was private, but in effect was very much a channel for government influence. Over the following years, Network Rail made great efforts to put right the many neglects of Railtrack, so it was unfortunate indeed that the fatal derailment of a fast train at Grayrigg in 2007 was attributed to faulty track maintenance.

Greater government influence, exerted through the Department for Transport, meant that privatization had not ended the British railroads' dependence on Treasury approval. Elsewhere in the

world, restructuring was a continuing process of trial and error. In New Zealand, it went into partial reverse when poor results obliged the government to buy back the infrastructure. In Australia, where some of the state railroads were broken up, legal wrangles and takeovers left new freight operating companies in a state of flux. In Estonia, the privatized system did so well that the government insisted on buying it back.

The big exception to the general trend was the USA. There, apart from the national passenger carrier, Amtrak, and some commuter operators, the railroads were already privately owned. However, there was a major restructuring as the process of railroad mergers and amalgamations continued, resulting in the emergence of half a dozen really big railroad companies. The Union Pacific swallowed up the Chicago & North Western, with which it had long had mutually friendly relations, and also the Southern Pacific, its competitor. Meanwhile, the Burlington Northern joined with the Santa Fe to form the Burlington Northern Santa Fe (BNSF), another massive western company. In the East, the Norfolk Southern was essentially an amalgamation of the Norfolk & Western and Southern railroads; its competitor was the CSX Railroad, which resulted from the amalgamation of the Seaboard Coast Line, serving the south and Florida, with the Chesapeake & Ohio, which earlier had absorbed America's pioneer line, the Baltimore & Ohio. CSX and NS split the lines of Conrail between themselves when that company was dissolved. Other big operators were the Kansas City Southern and the Canadian National. The latter acquired the Illinois Central, with its main line from Chicago to the Gulf of Mexico, and the Wisconsin Central.

The Canadian National, which previously had been a state company, was sold to private shareholders in 1995. Most of its new owners were American, and it became a big player outside Canada; in fact, it became the unenthusiastic owner of Britain's major freight railroad, EWS, when it acquired Wisconsin Central, which earlier had purchased EWS. In the early twenty-first century, CN and BNSF planned to amalgamate, but this was blocked by the U.S. government. CN's competitor, Canadian Pacific, did not expand in this way, but its acquisition of the Delaware & Hudson Railroad gave it an entry to the U.S. Northeast, while a previous purchase had provided access to Chicago and the Midwest.

A Sounder train about to leave Seattle for Tacoma. These commuter trains are operated by the local Central Puget Sound Transit Authority, using General Motors diesel locomotives and Bombardier bi-level cars.

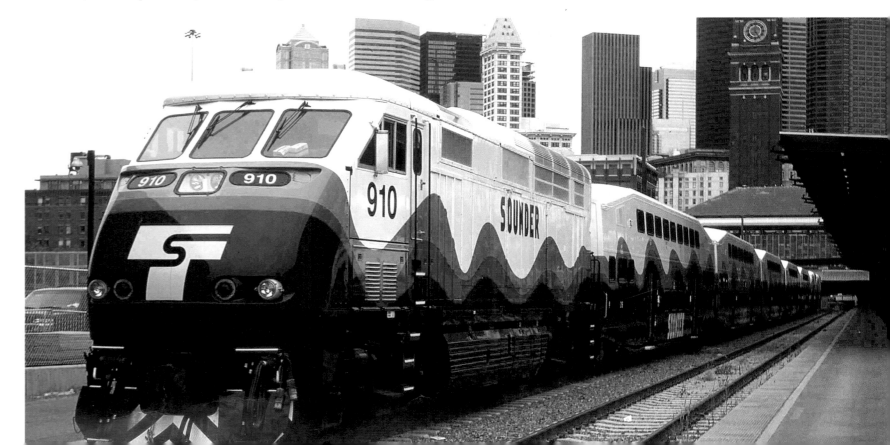

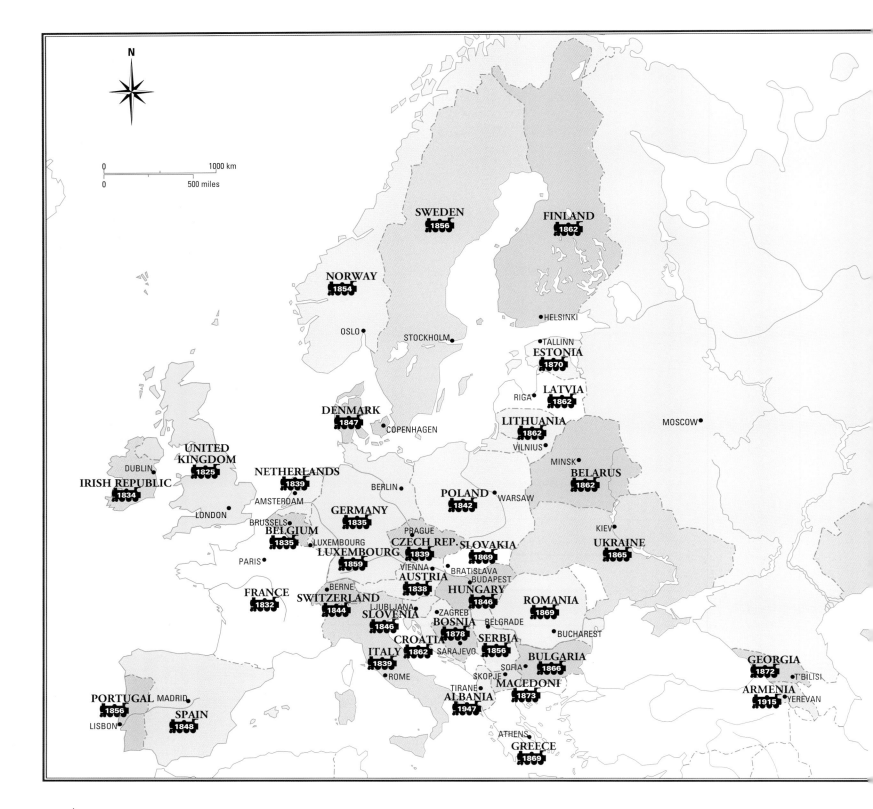

European Railroads

As might be expected from the birthplace of railroads, Europe has extensive rail networks throughout the states that form the continent.

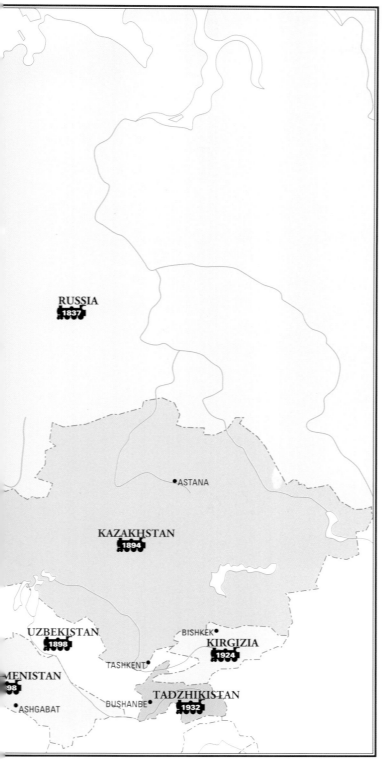

RUSSIA
1837

•ASTANA

KAZAKHSTAN
1894

UZBEKISTAN
1898

BISHKEK•
KIRGIZIA
1924

TASHKENT•

MENISTAN
98

BUSHANBE•
TADZHIKISTAN
1932

ASHGABAT

Railroads were a European invention and, with the exception of Albania, a comprehensive system was developed in every European country. The extent of the commitment to railroads has been shown twice during the twentieth century, by the rapid and thorough repair of the damage inflicted in the course of the two world wars. From an early date, most governments took control of the railroads, and attempts were made to unify gauges and create a truly continental network that transcended national boundaries.

Today, gauge changing facilities are necessary only at the borders of Finland, the former Soviet states, and Spain. This unification made possible the introduction of international trains at the end of the nineteenth century, the *Orient Express* being the most famous. Although the luxury of such trains is now little more than a memory, this decline has been countered by dramatic increases in train speeds.

Nowadays, the important European international trains are those using high-speed tracks to provide daytime connections between major centers. That said, international freight is of increasing importance as well, its prospects being enhanced by new tunnels under the Alps, English Channel, and Scandinavian waters. The European Union has striven to introduce measures to reduce the hindrance of national borders to the free flow of traffic, but a number of state railroads have resisted such measures, which seemed to threaten long-established practices—and irrationalities.

At the beginning of the twenty-first century, the long-standing controversy regarding state versus private railroads seemed to be resolving itself in favor of privatization. International freight companies, running their own trains over the tracks of the different countries, were increasingly noticeable and, on the whole, were generating new traffic. Even the Channel Tunnel link between Great Britain and France, which had failed to live up to its traffic generating expectations, was making a contribution to this trend.

Left: The first steam railroad was built in England in 1825, and gradually, over the following 100 years, the new form of transport spread throughout Europe and Scandinavia. Today, most European states have extensive rail systems, which are interconnected, creating a valuable international network.

Railroads of Britain and Ireland, from 1852

FROM THE EARLIEST PIONEERING EFFORTS BY THE LIKES OF GEORGE STEPHENSON, THE RAILROADS OF THE UNITED KINGDOM GREW INTO THE DENSEST NATIONAL NETWORK IN THE WORLD.

UNITED KINGDOM

The intricate railroad network of Great Britain developed from a series of privately originated, and quite unconnected, local projects. Although there were men of vision, like George Stephenson, who looked forward to a time when the whole country would be provided with railroads, there was no overall planning and no attempt at coordination by the governments of the day. Parliament exercised control only to the extent that the fixed equipment and rolling stock had to satisfy the inspectors appointed by the Board of Trade. From the success of pioneer enterprises like the Stockton & Darlington, the Liverpool & Manchester, and the Newcastle & Carlisle, the earliest trunk lines were projected, including the London & Birmingham, the North Midland (Derby to Leeds), and the Great Western (London to Bristol). From these, the nationwide system developed. Success led to an immense proliferation of new schemes, some quite spurious and with no solid financial backing. There were many proposals for amalgamation, but while Parliament looked favorably upon "lengthways" mergers, such as that of the London & Birmingham with northern companies that brought the line from London to Lancaster and Carlisle under a single management, any merging of competitive routes was vetoed, because it was felt that the existence of rival carriers would be in the interest of the traveling public.

By the 1880s, there were three independent routes to Scotland, each providing a lavish train service to Edinburgh from London, and two of the three serving Glasgow. There were three competitive routes from London to Manchester, and five different ways of traveling from England

and Wales to Ireland. There was competition between London and Plymouth, London and Portsmouth, and London and the Kentish resorts and packet stations. As the network grew, however, it could be criticized for the way in which attention became focused upon London. While cross-country routes existed, for the most part, the train services were slow and unattractive. The exception was between Liverpool and Manchester, where two rivals to the original line of 1830 were built—a swarm of fast express trains ran throughout the day on all three routes. With no competition except from canals, railroad freight traffic became heavy, but it was handled in relatively small, four-wheeled cars at slow speed. Small consignments could be sent from one end of the country to the other, and all remote country stations had freight tracks where goods of all descriptions could be brought for dispatch, or collected.

The early years of the twentieth century in Great Britain saw the heights of railroad preeminence as carriers of all kinds, but already there were signs of dissatisfaction, particularly with the freight service. Nevertheless, despite the steeply rising price of coal—almost the only form of locomotive fuel—and increasing costs of other services, the private railroads were prosperous throughout Britain. At the outbreak of World War I in 1914, there were 16 systems, with tracks extending from the Channel ports to

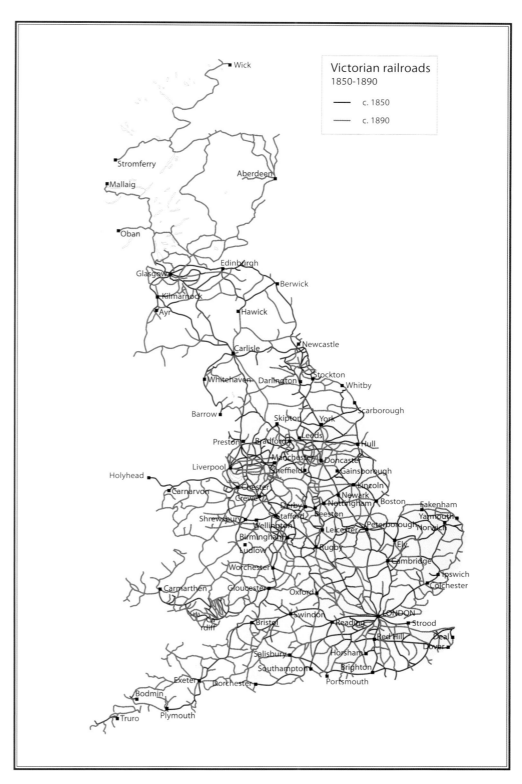

Wick and Thurso, and from East Anglia to Penzance, together with a number of active and prosperous companies with local services, such as the great coal carriers in the valleys of South Wales, the Furness, and the Hull & Barnsley. During the war, all the British railroads were brought under government control, and in 1921 legislation was imposed upon them by Parliament, forming the whole network into four group companies. Although these were still privately owned, the amalgamations and composition of each group were laid down by Act of Parliament. The era of the "Big Four"—Great Western; Southern; London, Midland & Scottish; and London & North Eastern—began on January 1, 1923.

The second half of the nineteenth century saw a massive expansion of railroads throughout Britain.

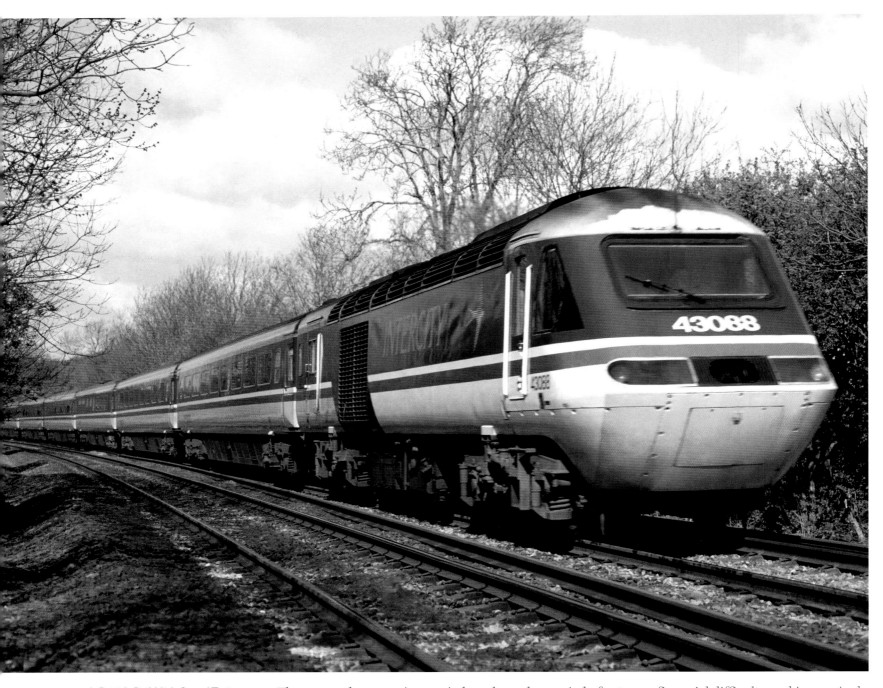

A British Rail High Speed Train on an intercity service, curves away from Newton Harcourt, on a beautiful spring day in 1993.

The grouped companies carried on through a period of extreme financial difficulty and increasingly severe competition from road transport. Legislation governing the fixing of rates and fares remained unchanged from the days of unchallenged railroad monopoly in transport and handicapped the railroads in their fight for traffic. Fortunately, the managements ensured that maintenance of track and rolling stock was kept at the highest level, and the railroads, once again under government control, were able to render a great national service during World War II. Less than three years after the end of hostilities, from January 1, 1948, the British railroads were nationalized. In the following decades, a considerable reduction was made in total track mileage, by eliminating one-time competitive routes and closing unprofitable branch lines.

The last British Rail steam train ran in 1968, diesel traction having been widely adopted, although the electrification of the existing West Coast main line from London to Glasgow was soon matched

by that of the East Coast line from London to Edinburgh. The first of the very successful, diesel High Speed Trains (HST) entered service in 1976.

In 1993, the Railroads Act enabled the privatization of BR. The infrastructure was allotted to a new company, Railtrack, and the passenger rolling stock to three leasing companies. Passenger operations were taken over by new companies, whose franchises were renewed by competitive bidding at varying intervals. Railroad works and other specialized activities were hived off to new firms. Freight services were taken over by a number of operators, which were not constrained by limited-term franchises as were the passenger companies.

Privatization fully satisfied the market-economy ideology of the day, and was followed by large increases in passenger traffic. Elsewhere in the world, however, the British privatization scheme was regarded as a useful lesson in what to avoid. It did not reduce the railroads' burden on the taxpayer, nor, in effect, did it reduce government constraints on new investment. After the Hatfield accident of 2001, which indicated that track maintenance expenditure had been restricted in favor of profits, Railtrack went out of business and was succeeded by Network Rail, which began to improve maintenance and better coordinate its work with that of the operating companies. It also became a channel through which government influence could be brought to bear, and the Department for Transport began to play an important role in evolving new strategies.

In 2006, the Great North Eastern Railroad, operating the East Coast route, and one of the best-run and best-liked of the companies, relinquished its franchise, a victim of the refranchising process and the government's rigidity. Its demise signaled that an ideology based on the survival of the fittest does not necessarily ensure the survival of the best.

In the new century, the renewal of rolling stock has continued, while the adoption by the Virgin operating company of tilting trains for its West Coast services resulted in notable service improvements. The completion of the high-speed Channel Tunnel Rail Link from Folkestone to London St. Pancras was another milestone.

As the railroad network spread in Britain, it became centered on the capital, London, the individual railroads having their own terminuses, but trains could not cross the city from one terminus to another.

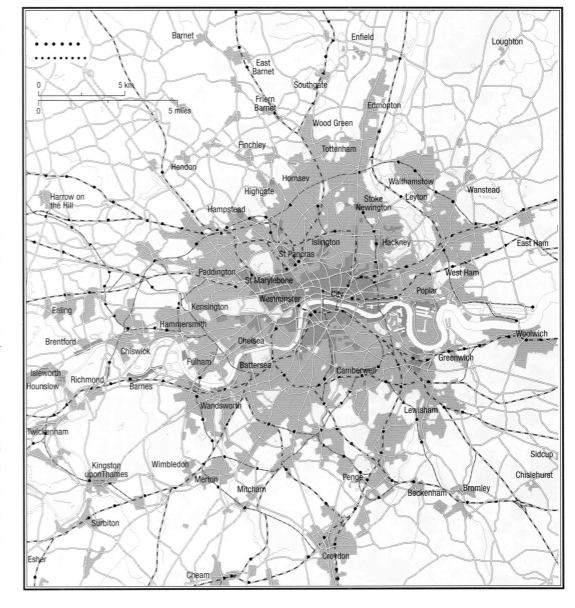

IRELAND

An Irish CIE Class 071 diesel-electric locomotive hauls the Dublin Connolly–Rosslaire service over the river bridge at Enniscorthy on May 18, 2004.

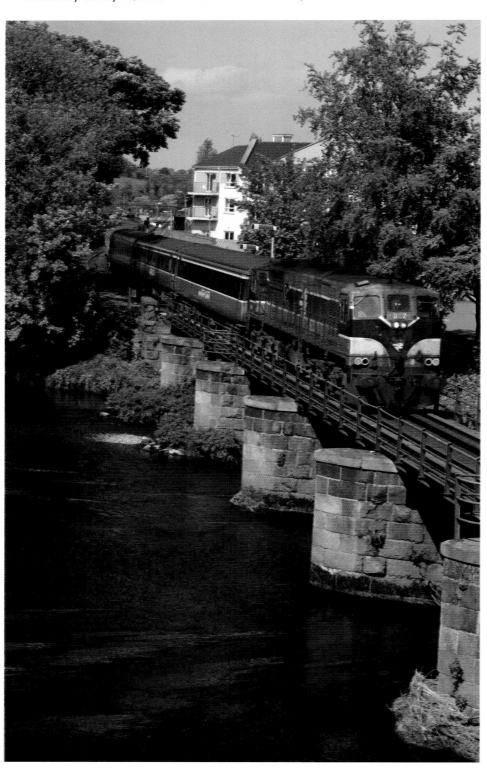

The railroads in this now politically divided land originated in the same way as those of Great Britain and were subject to the surveillance of the Board of Trade at Westminster. In a rural and unprosperous country, however, there was not the same opportunity for intense railroad development. Trunk routes were constructed from Dublin to Cork, to Galway, to Wicklow and Wexford, and to Belfast; the last, the Great Northern, had the distinction of becoming an international main line, operating in both Eire and Northern Ireland after partition in 1922. The cross-country connections were also important, serving Waterford and Limerick, while in the North, the Belfast & Northern Counties Railroad (to Londonderry) was a busy and prosperous concern, which was later taken over by the English Midland Railroad.

Because of the need to provide transportation in rural areas where a full-scale main-line railroad would not pay, through a series of Light Railroad Acts, Parliament authorized the construction of many narrow-gauge lines. Later, these lines became of great interest to those looking for the unusual in railroad practice, from the picturesque steam locomotives to the happy, leisurely ways of doing business. In 1925, the railroads of Eire were merged. The Great Northern, because of its international character, remained untouched, but all other lines were amalgamated into a new Great Southern system, which is still under private ownership. In 1945, it was nationalized as Cora Iompair Eireann. In 1958, it took over the portion of the former Great Northern Railroad that was situated in Eire.

Line closures and under-investment followed; by the 1980s, CIE was in a critical situation, and accidents were causing anxiety. However, rising prosperity and EU funds helped to restore the situation. In 1984, the DART electrified commuter service through Dublin was opened. In 1987, CIE was restructured, becoming a holding company for the railroads (Iarnrod Eireann) and two bus enterprises. Current plans envisage new

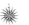

The main railroad networks of Britain and Ireland today. After a spell in the doldrums, the British railroads are vibrant once again, with increased passenger numbers and substantial private investment.

commuter services, upgrading of lines, and reopening of some closed lines. By 2007, new locomotives and trains were in course of delivery.

NORTHERN IRELAND

After World War II, the railroads in Northern Ireland were reorganized, but did not become part of British Railroads. The mileage diminished, and what remained was operated by Northern Ireland Railroads. At the end of the twentieth century, there were signs of a renaissance, a new line having been built in Belfast in 1997 to enable all passenger services to be concentrated on one station, Belfast Central.

LONDON TO GLASGOW, THE WEST COAST MAIN LINE

INCORPORATING PARTS OF BRITAIN'S MOST HISTORIC PIONEER LINES, THE WEST COAST MAIN LINE WAS A VITAL ARTERY, PROVIDING A HIGH-SPEED LINK BETWEEN THE CAPITAL, LONDON AND SCOTLAND.

Known as the west coast main line, the 401.5-mile (642.4km) route from London (Euston) to Glasgow is one of the most historic in Great Britain. It includes major lengths of two great pioneer railroads, the London & Birmingham, built by Robert Stephenson, and the Grand Junction, constructed by Joseph Locke. North of Lancaster, it incorporates two of the earliest fast running main lines built through mountain country, the Lancaster & Carlisle, which passes through the eastern flanks of the English Lakeland mountains, and the Caledonian, which continues the line to Glasgow. Both of these great routes were engineered by Joseph Locke. An important cutoff link in England was the Trent Valley line, from Rugby to Stafford, over which through trains to the north bypassed the complex area around Birmingham. Always a very busy main line, until January 1923, it was worked by two great railroads in partnership, the London & North Western in England, and the Caledonian north of Carlisle. From 1923, they were amalgamated into the London Midland & Scottish Railroad, although they were separated again at the time of the nationalization of British railroads in 1948, becoming the London Midland and the Scottish regions of the new organization. After railroad privatization, the primary operator became Virgin Trains.

The heritage was diverse. When the London & Birmingham Railroad was built, the capacity of steam locomotives was very limited. Robert Stephenson was well aware of this, so when planning the line, he decided that the steepest grade should be 0.3 percent. Although the route in the south of England did not involve crossing any mountain ranges, there were chalk escarpments on the north side of the

Joseph Locke was responsible for engineering significant parts of the west coast main line route—the Grand Junction, Lancaster & Carlisle, and Caledonian railroads.

Chiltern Hills, a northeastern extension of the Cotswold limestone at Blisworth and the Kilsby Ridge. To avoid steep grades, it was necessary to excavate, by hand, some tremendous cuttings, while the tunnel under the Kilsby Ridge was one of the most troublesome works on the line. The result, however, was a magnificent route over which heavy loads could be pulled by relatively small locomotives. Indeed, the rapid increase in the volume of traffic became an embarrassment, and before the nineteenth century was out, two additional 60-mile (96km) running tracks had to be laid. Today, most of this Trent Valley line is quadruple tracked, as is the line north of Stafford as far as Weaver Junction, some 175 miles (280km) north of London.

The London & North Western, and the Caledonian Railroads were regarded as the premier lines of England and Scotland respectively. They had the largest annual revenues, and their preeminence was indicated indirectly by their coats of arms. The LNWR adopted Britannia herself, while the Caledonian took the Royal Arms of Scotland. The west coast main line was also the principal artery of mail traffic between London and the north, as well as to Ireland via Holyhead, and it was known as the Royal Mail Route. Trains carrying traveling post offices from many parts of Great Britain fed into the postal trains of the west coast main line at Tamworth, Crewe, Preston and Carlisle. Both companies prided themselves on their punctuality of running. The nineteenth-century chairman of the LNWR, Sir Richard Moon, always said that the publication of a schedule was the promise of an English gentleman and should be honored as such. The prosperity of the LNWR was continually enhanced, and the company looked to the future by allocating large proportions of its profits for improvements to the line, such as new signaling, classification yards and improved junction layouts.

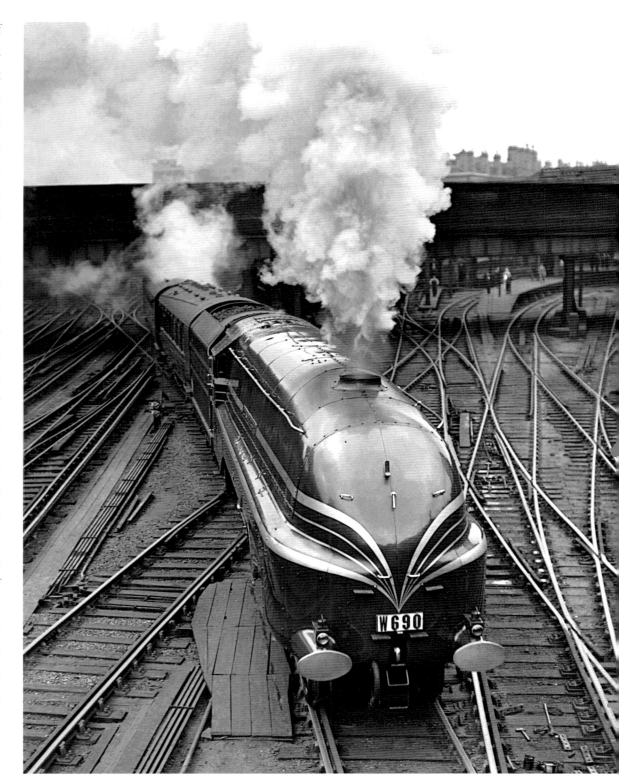

One of 35 Princess-Coronation class locomotives, the *Duchess of Gloucester* was built in 1937 for the high-speed London Midland & Scottish Railroad's Coronation Scot service over the west coast main line to Scotland.

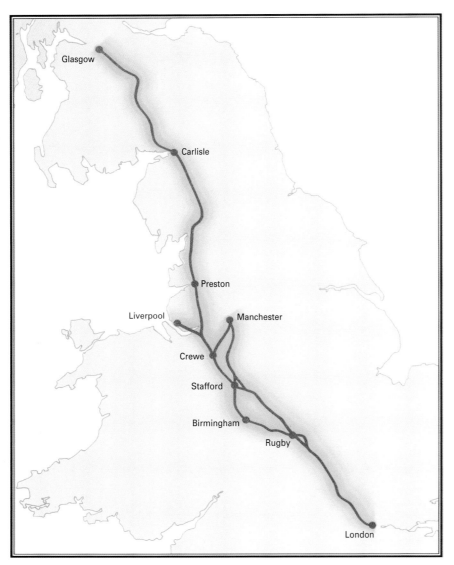

The west coast main line from London to Glasgow provides a vital high-speed rail link.

It has never been a purely Anglo-Scottish route. In fact, the very intensity of present-day traffic and the justification for the great modernization works carried out on it in recent years are rooted in the number of important centers that are served from its main line. Over the most southerly 82 miles (131km), between London and Rugby, there are separate services to Birmingham and Wolverhampton, to Liverpool, to Manchester, to North Wales, and over the *Irish Mail* route to Holyhead, to Blackpool and the Fylde coast, and to west Cumbria —all these in addition to the Anglo-Scottish services, which are quite separate.

When the great modernization plan for British railroads was launched in 1955, it was not surprising that this line was chosen for conversion to electric power, together with the northward continuation to Liverpool and Manchester, and the main-line network through Birmingham and Wolverhampton. As the modernization plan developed, it provided for a considerably more elaborate service than previously, and a great increase in scheduled speed. Whereas in steam and diesel days, the hallmark of a fast express was a start-to-stop average speed of 60–65mph (96–105km/h), the new services were planned to raise that speed to 80mph (130km/h).

Obviously, with many more trains and higher speeds, the track and all the equipment had to be upgraded. The line was virtually rebuilt, with new continuously welded rails, the latest type of reinforced-concrete cross-ties and extra-deep granite ballast. The system of electrification chosen was 25,000 volts, alternating current (ac), at the frequency of 50 cycles per second, with overhead-line current pick-up. The standard of speed on the open line for express passenger trains was set at 100mph (160km/h). Color-light, multiple-aspect signaling was installed throughout.

Section by section, the electrification was completed: Manchester to Crewe first, then southward to Nuneaton. A phenomenal change was experienced by passengers in the impressive acceleration from a stop and the smoothness of travel at high speed. The management of the London Midland Region, however, was anxious that the improved service on the electrified line should be reflected in the important connecting services that had to remain diesel operated for some time. As a result, an intricate pattern of cross-country connections was devised, centered upon Birmingham, whereby trains from the southwest of England and South Wales connected by cross-platform interchange with trains to the northwest and Scotland. No longer were long waits for connections to be tolerated, or missed connections through late running. New Street station, in Birmingham, was to be the focal point of the entire service.

The continuation of the electrified system northward to Carlisle and Glasgow was a much discussed, and somewhat delayed, project. Although the through train services from London to the Scottish cities were joined north of Preston by those from Liverpool and Manchester, there was not the same density of passenger traffic as on the line south of Crewe, and at first there was some difficulty in justifying the capital outlay. But with electric operation, there was the possibility of spectacular acceleration of service on the mountain grades of the north country. Between Carnforth, on Morecambe Bay, and Shap Summit, for example, the line rises 885ft (270m) in 31.5 miles (50km), and with heavy trains in preelectrification days, one could not expect to cover that distance in much less than 35 minutes. But the powerful electric locomotives were able to climb a 1.3 percent grade at 90mph (145km/h) pulling a 12-coach train, and it was possible to schedule a time of 22 minutes up that long climb, an average speed of 85mph (137km/h). The 90 miles (145km) between Preston and Carlisle were regularly run in under 65 minutes.

The acceleration was the same in Scotland, where the formidable Beattock Bank had to be climbed —10 miles (16km) at an inclination of 1.3 percent. As a result of electrification, passenger train speeds north of Preston were 100mph (160km/h) wherever the track permitted, except on the steepest grades. No less important, however, was the manner in which the very heavy night freight trains were operated. The basic speed for these was 75mph (120km/h), and with the maximum tonnage

A Class 87 diesel-electric locomotive hauls a northbound Virgin Trains passenger service up Shap on the west coast main line in Cumbria.

freightliners, carrying 60 containers on 20 flat car, a pair of electric locomotives was used to maintain the high speed required uphill, which was little below 75mph (120km/h), on a one percent grade.

With electric locomotives of 5,000hp and trains of 12 modern air-conditioned cars, the time over the 401.5 miles (642km) between London and Glasgow was five hours, an average of 80mph (130km/h). This included one stop.

Following railroad privatization, there was a lengthy and expensive upgrading of this route, followed by Virgin Trains' introduction of Pendolino tilting trains. Although it had been hoped to make the route suitable for 140mph (225km/h) running, this was not achieved, 125mph (200km/h) being the limit. Nevertheless, this allowed substantial acceleration. Trains began to run from Birmingham International to London at an average of 90mph (145km/h).

Poste Haste!

FOR MORE THAN A CENTURY, THE IRISH MAIL PROVIDED A RAPID MEANS OF TRANSPORTING MAIL AND PASSENGERS FROM LONDON TO HOLYHEAD, WHERE THEY CONTINUED TO DUBLIN BY STEAMER.

Communication between London and Dublin was a vital feature of transportation within the British Isles long before the arrival of the railroads. When the British railroad network began to develop in the 1840s, there was controversy as to where the main packet station for the Irish traffic should be located. Robert Stephenson was the engineer for the projected Chester & Holyhead Railroad, while his friend and rival, Isambard Kingdom Brunel, proposed a broad-gauge line running from Worcester through central Wales to Porth Dinllaen, on the Lleyd peninsula. Stephenson's route was preferred, and the line was constructed and ready for the inauguration of the *Irish Mail* train service on August 1, 1848.

The *Irish Mail* was the first named train in the world. In 1848, passengers could not travel all the way from London to Holyhead by train, however, because Stephenson's greatest work on the Chester & Holyhead—the Britannia tubular bridge over the Menai Strait—was not yet finished. Passengers, luggage and mail had to leave the train at Bangor, cross the strait by stagecoach, using Telford's beautiful suspension bridge, and then join another train at Llanfair for the journey across Anglesey. The Britannia Bridge was completed in 1850,

The 8:30 a.m. *Irish Mail* from London Euston leaves the Britannia tubular bridge, hauled by a Precursor 4-4-0 locomotive, c. 1850.

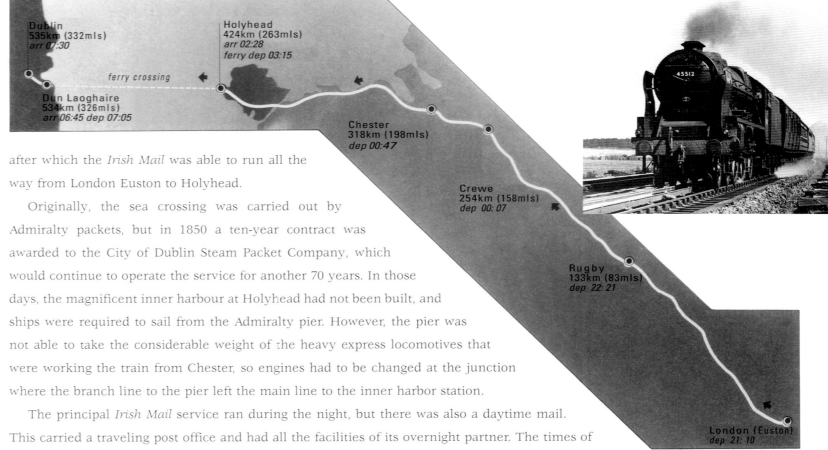

Dublin
535km (332mls)
arr 07:30

Holyhead
424km (263mls)
arr 02:28
ferry dep 03:15

ferry crossing

Dun Laoghaire
534km (326mls)
arr 06:45 dep 07:05

Chester
318km (198mls)
dep 00:47

Crewe
254km (158mls)
dep 00:07

Rugby
133km (83mls)
dep 22:21

London (Euston)
dep 21:10

after which the *Irish Mail* was able to run all the way from London Euston to Holyhead.

Originally, the sea crossing was carried out by Admiralty packets, but in 1850 a ten-year contract was awarded to the City of Dublin Steam Packet Company, which would continue to operate the service for another 70 years. In those days, the magnificent inner harbour at Holyhead had not been built, and ships were required to sail from the Admiralty pier. However, the pier was not able to take the considerable weight of the heavy express locomotives that were working the train from Chester, so engines had to be changed at the junction where the branch line to the pier left the main line to the inner harbor station.

The principal *Irish Mail* service ran during the night, but there was also a daytime mail. This carried a traveling post office and had all the facilities of its overnight partner. The times of both trains were arranged to suit the Post Office; the mail contracts even stipulated the speeds that had to be run, both on land and sea. The contract of 1860 required an overall speed of 42mph (68km/h) between Euston and Holyhead, the total time between London and Dublin being 11½ hours. This was a quite a remarkable achievement for the period, because it included essential intermediate stops. In fact, it was to permit non-stop running over the 84 miles (135km) between Chester and Holyhead that the first water troughs in the world were built near Aber, east of Bangor. As the train passed over a trough, the fireman would lower a scoop, through which water was forced into the tender 'on the fly.'

As traffic between England and Ireland increased, the London & North Western Railroad, which had its own steamers, put on two additional express trains between London and Dublin, the day express leaving Euston at 1.20pm, and the night at 9.50pm. These connected with steamers sailing from the inner harbour at Holyhead, and were much more convenient for passengers. After World War I, when political troubles led to a significant reduction in traffic to Ireland, the ordinary day and night expresses were not revived, and the day and night mail trains provided the only service. At the same time, the London & North Western Railroad secured the mail contract for the sea passage, and thereafter the packets sailed from Holyhead's inner harbour. When the London & North Western became part of the London Midland & Scottish Railroad, in 1923, the coach and engine livery became 'crimson lake,' and in 1927 coach name boards were added. When the train celebrated its centennial, in 1948, it was being worked by British Railroads.

The growth of air transport led to a decline and finally the end of the *Irish Mail*, although the rail/steamer service to Ireland still operates.

The *Irish Mail*'s route followed the west coast main line from London to Crewe, then branched off for the run through Chester to Holyhead.

Top: A former London Midland & Scottish Patriot class locomotive, No. 45512 *Bunsen*, operated by British Railroads, hauls the *Irish Mail* at Aber on the North Wales coast, c.1950. Built in 1932, this particular locomotive was withdrawn from service in 1965.

THE POWER OF STEAM, 1800-34

THE ARRIVAL OF THE STEAM LOCOMOTIVE REVOLUTIONIZED
TRANSPORT, OFFERING UNPRECEDENTED SPEED AND HAULING
ABILITY, AND SPARKING WORLDWIDE INTEREST IN RAILROADS.

I t is no exaggeration to assert that the invention of the steam locomotive changed the face of the
world. By paving the way toward unprecedented speed in transport, it put the finishing touch
upon the developments of the Industrial Revolution. It was the indirect, and highly competitive,
association of two men, both ingenious mechanics, that blazed the trail.

In 1765, James Watt, mathematical instrument maker at Glasgow University, had to repair an
instructional model of a Newcomen Cornish beam engine, and in doing so, he hit upon the idea of
using a separate condenser as a means of effecting a great economy in the use of steam. His innovation
created such interest that eventually he went into partnership with Matthew Boulton, an industrialist
in the West Midlands. The firm of Boulton & Watt prospered by building stationary steam engines,
but it was when they began to receive orders for pumping engines for the Cornish tin mines that the
practice developed by Watt had its first and only influence on the future of rail transport. One of the
men who saw the Watt engines in Cornwall was Richard Trevithick. He at once began building engines
using much higher pressure than Watt, and instead of condensing the steam after use, he allowed it to
escape to the atmosphere.

From stationary engines, Trevithick turned to rail traction, but not before he had experimented
with a locomotive on the roads in Cornwall, to the alarm of the populace. He became associated with
industrial activities in South Wales; then came the famous wager that led to the building of the first
steam railroad locomotive. The bet, between two prominent ironmasters, challenged Trevithick's 'tram
wagon', as it was called, to haul a load of 10 tons over the 9.75 miles (15.6km) from Pen-y-Darren to
Abercynon Basin on the Glamorganshire Canal. That Trevithick won the bet for his sponsor is a matter

Flywheel

Pinion wheel

Road wheel

Gear wheel

Crank/connecting
rod mechanism

The world's first ever railroad locomotive was built by Cornish engineer Richard Trevithick, being run on the Pen-y-Darren tramway, South Wales, in February 1804.

of history. His locomotive had only one cylinder, and to carry the drive over dead center, there was an enormous flywheel. The piston drove through a crank/connecting-rod mechanism to rotate a small pinion wheel that turned a large gear wheel. This engaged with gears on the same axles as the road wheels of the locomotive. It was a triumph, but had shortcomings.

Although Trevithick took little part in the further development of his locomotive, those who followed profited by its failures. It broke down frequently, and its great weight broke many rails. Matthew Murray, of Leeds, for example, suggested having two cylinders operating cranks at right angles to each other. This eliminated the 'dead center' position and dispensed with the huge flywheel. The arrangement was incorporated in Blenkinsop's locomotives on the Middleton Colliery railroad near Leeds, in 1812. It had been thought that the contact between a smooth rail and a smooth wheel tyre would not provide sufficient grip to enable a locomotive to haul a heavy load, and in 1811, Blenkinsop had taken out a patent for a toothed rail laid to one side of the running rail, in which a gear mounted on the axle of the locomotive worked as a pinion in a rack. Locomotives of this type, hauling trains of coal wagons, achieved a certain degree of reliability.

One of the Blenkinsop engines was purchased by the Wylam Colliery, Northumberland, where it was discovered that the toothed-rail arrangement was unnecessary. By this time, George Stephenson was beginning to enter the picture. He built his first locomotive for the Killingworth Colliery in 1814. It had many shortcomings, but the second Killingworth locomotive was a vast improvement. Stephenson held the patent for this in partnership with Isaac Dodds. The noise of the exhaust, which had caused many complaints about the first locomotive, was practically silenced by directing the exhaust steam into the stack, where it performed a second function: sharpening the draft of the fire, which increased the rate of steam production. The original complex gear drive was superseded by connecting the crosshead directly to the driving wheels through the connecting-rod. In this locomotive, built in 1815, Stephenson and Dodds had incorporated nearly all of the fundamental aspects of the classic steam locomotive:

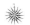

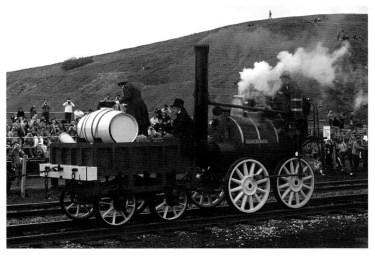

This replica of Timothy Hackworth's *Sans Pareil* locomotive was completed in 1980 and used in a restaging of the Rainhill Trials in May of that year, 150 years after the original event took place.

Three locomotives were entered in the Rainhill Trials of 1829: Stephenson's locomotive *Rocket* (top), the eventual winner; Braithwaite and Ericsson's *Novelty*, which broke down frequently (center); and Hackworth's *Sans Pareil*, which was crippled when a cylinder failed (bottom).

two cylinders, simple direct drive and exhaust directed from the cylinders into the stack to increase draft on the fire. The way was clear to introduce steam power on the projected Stockton & Darlington Railroad.

The celebrated *Locomotion*, engine No. 1 of the first public railroad in the world, incorporated all the best features of the Killingworth Colliery locomotives, but the working conditions were much more severe. The *Locomotion* was incapable of steaming continuously for any length of time, and stops had to be made to raise steam. At the time, Stephenson was engaged with the surveys for the Liverpool & Manchester Railroad, and had left his assistant, Timothy Hackworth, in charge of the Stockton & Darlington. Thus the task of making the pioneer locomotives reliable fell to him. In 1827, he built the *Royal George* locomotive at Shildon Works. It was much larger than any of the engines built by Stephenson, and had six coupled wheels. Moreover, Hackworth had increased the steaming capacity by designing the flue from the firebox to the stack in the form of a 'U', instead of a single large pipe; this gave a greater area of flue tube in contact with the water. Hackworth also invented the blast pipe, a narrowing cone with a nozzle, through which the exhaust steam passed at high velocity to create an intense draft on the fire.

The *Royal George* steamed very freely, but it looked odd. Because of the return flue, the firedoor was at the smokestack end of the boiler, and the fireman rode on a separate tender in front of the engine, while the engineer was at the rear, where a second tender carried water.

On the Liverpool & Manchester Railroad, which was nearing completion, the directors decided to stage a competition, the Rainhill Trials, to determine the best type of locomotive to work the line. Although Hackworth had done so much to save the Stockton & Darlington Railroad from failure, George Stephenson and his son, Robert, felt that the *Royal George* type of locomotive was clumsy and slow. Thus in preparing a locomotive for the competition, they introduced some further novel features. To promote rapid evaporation, they sought to increase the hot surfaces in contact with the water by modifying the flue from the firebox to the stack. Instead of passing through one large tube, the hot combustion gases were discharged through a nest of much smaller ones. The engine was the ever-famous *Rocket*, which steamed very freely.

Hackworth also entered the competition, building a four-wheeled engine at his own expense. Named the *Sans Pareil*, it had his return-flue type of boiler, but only one tender, propelled in front. The engineer stood on a small platform at the rear. This engine was sound in conception, but faulty parts put an end to its participation. The third competitor, the *Novelty* of Braithwaite and Ericsson, made some spectacular runs, but broke down frequently, and eventually the Stephensons' *Rocket* was the only one of the three to stay the course. Not only did it win the competition, but also it became a world prototype, incorporating all the basic features of design that were perpetuated for more than a hundred

years in locomotives built in increasing size around the world.

When it came to day-to-day working on the Liverpool & Manchester Railroad, however, the *Rocket* type did not prove entirely satisfactory. To overcome problems caused by jerky and rough riding, Robert Stephenson introduced the *Planet* locomotive in 1830. This had the cylinders between the frames, situated beneath the smokebox. All the machinery became largely concealed, which produced a much smoother riding engine. Locomotives of this type became very popular in Britain. Like the *Rocket*, the *Planet* had only a single pair of driving wheels, although they were situated at the rear instead of at the front. A single pair of driving wheels was favored for passenger trains, because it afforded greater freedom in running, but the four-wheel coupled type, such as the *Locomotion* and the *Sans Pareil*, was more suitable for freight trains, since it provided greater adhesion for hauling a heavy load.

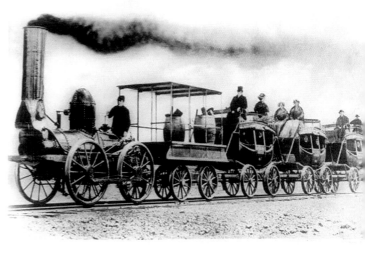

Built along British lines, the *De Witt Clinton* was the first locomotive to haul a passenger train in New York State, in August 1831. It reached a speed of 24km/h (15mph).

In the USA, the first ever railroad, the Baltimore & Ohio, had relied upon horse power since its inception in 1827. In 1830, however, a New York industrialist and inventor, Peter Cooper, had made a large investment in Baltimore & Ohio land. Determined to see the railroad succeed, he set to work to produce a steam locomotive. Working in the Mount Clare workshops at Baltimore, with scrap iron, borrowed wheels and gun barrels for boiler tubes, he built America's first home-made railroad steam locomotive, the *Tom Thumb*. It had a vertical boiler with the chimney extending directly from the boiler end. Although having many defects arising from the primitive methods used in its construction, it paved the way to success and was followed by locomotives of the same general type, built by the firm of Davis & Gartner. The *Atlantic*, from the same partners in 1832, was the first of the so-called 'grasshopper' type, again with vertical boiler, and the cylinders acting through large rocking shafts on the top of the boiler.

Built in 1830 by Robert Stephenson, the *Planet* had inside cylinders beneath the smokebox, the drive being via a cranked axle to a single pair of driving wheels at the rear.

The first locomotive ever to run in America, as distinct from the indigenous *Tom Thumb*, was imported from England by the Delaware & Hudson Canal Company in 1829. It was a typical four-wheeler of pre-*Rocket* days and named the *Stourbridge Lion*. While Cooper's *Tom Thumb* was going through its teething troubles on the Baltimore & Ohio, a much larger engine of the vertical-boiler type was put to work by the South Carolina Canal & Rail Road Company. This was named the *Best Friend of Charleston*, and it went down in history as the first locomotive to operate a regularly scheduled passenger service in the USA. Another notable American locomotive of early days, more in the contemporary British style, was the *De Witt Clinton* of 1831, which began operating between Albany and Schenectady. It was an 0-4-0 with a horizontal boiler and a chimney at the leading end, after the style of the *Locomotion*.

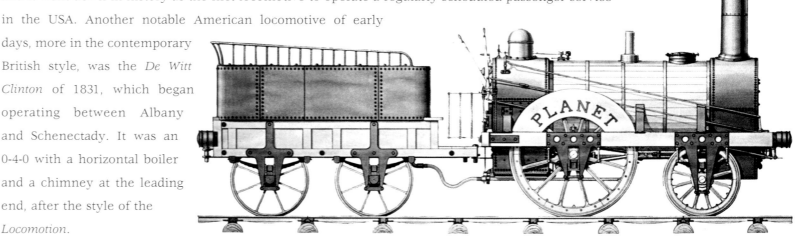

RAILROADS OF FRANCE, FROM 1832

DESPITE SUFFERING SEVERE DESTRUCTION DURING WORLD WAR II, FRENCH RAILROADS RECOVERED RAPIDLY. TODAY, WITH ITS TGV LINES, THE COUNTRY OPERATES SOME OF THE FASTEST PASSENGER TRAINS IN EUROPE.

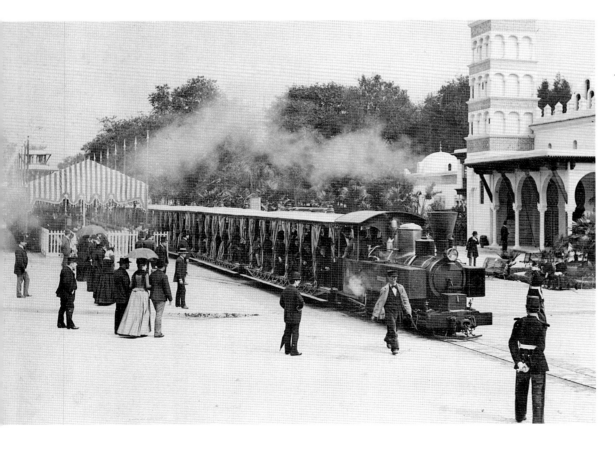

As in Great Britain, the first railroads in France were local mineral lines that relied on horses for power. At a very early stage in the development of public railroads, however, the government, in seeing what was happening with unbridled competition elsewhere, divided the whole country into a number of clearly defined geographical regions, giving the pioneer railroad companies concessions to build only within those limits. In this way, it was hoped that wasteful competition and unnecessary proliferation of routes would be avoided. Originally, there were seven companies, which held concessions that ran to the 1930s; during the intervening period, the dividends paid to their

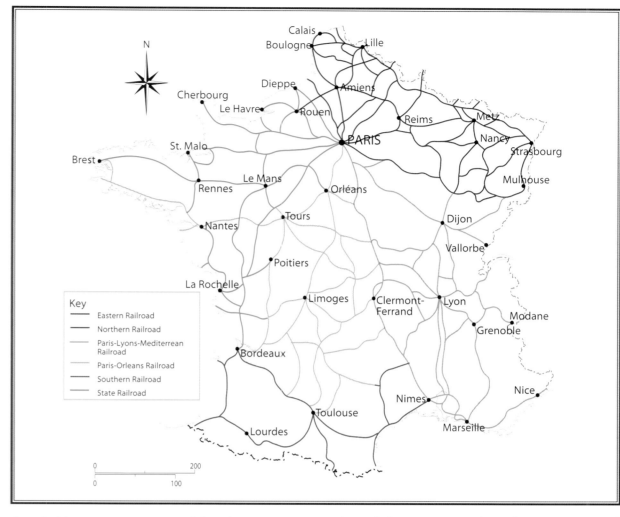

The railroads of France in the early 1930s, showing the lines of the various regional operating companies prior to the formation of the French national railroads (SNCF).

shareholders were guaranteed by the government. Five of them continued in this manner until nationalization in 1938, but the Western Railroad was seriously affected by the establishment of the French State Railroads in 1878, which introduced competition into Western territory, contravening the original conception. The Paris-Orléans Railroad was also affected, although not to such a serious extent. The other five original railroads remained in almost exclusive possession of their allotted territories. These companies were the Northern; the Eastern; the Paris, Lyon & Mediterranean (PLM); the Southern (Midi); and the Alsace-Lorraine.

The monopolies held by these companies tended to generate policies that lacked enterprise, and train services in the nineteenth century were relatively poor. The exception was the Paris-Orléans, which did become affected by competition. At both Bordeaux and Toulouse, it handed over traffic for the south to the Midi, which also received similar traffic from the PLM. The Midi was encouraged to favor the Orléans traffic for the better service from the north provided by that company. Before the general mergers of 1937–38, the Paris-Orléans and the Midi had already been amalgamated in 1934. Competition between the state owned system, the État, and the Western Railroad led to the absorption of the latter in 1908. Of the original companies, the Alsace-Lorraine was profoundly affected by the Franco-Prussian War of 1870–71—most of the territory in which it operated was annexed by Germany. For a period of 48 years until 1919, it was controlled and operated by Prussia, and its equipment changed in line with standard German practice.

Opposite page: This small, narrow-gauge tank locomotive was used to ferry visitors around the site of the Paris Exposition in 1889. Note the spark-arrester chimney.

In January 1938, the French railroads were nationalized and became a single entity, the Société Nationale des Chemins de fer Français (SNCF). Long before this, however, all the railroad companies had thrown off their nineteenth-century complacency, and were providing some of the fastest and most efficient train services in Europe. Because France had been invaded in 1870 and again in 1914, however, there was reluctance to electrify any of the lines leading to the eastern frontier; this development had appeared first on the Paris-Orléans and the Midi railroads during the 1920s.

In World War II, the French railroads experienced relatively minor destruction when the country was overrun by German forces in 1940, but suffered far worse just prior to the invasion by the Allies in 1944. The systematic bombing by Allied air forces to hinder the movement of German troops led to the almost complete disruption of the entire railroad network and the destruction of much of the rolling stock.

After the war, recovery was remarkable. The lines to the eastern frontier were electrified and

An SNCF Paris suburban 'push-pull' service from Gare de l'Est arrives at Bondy (Seine-St Denis), in April 2003.

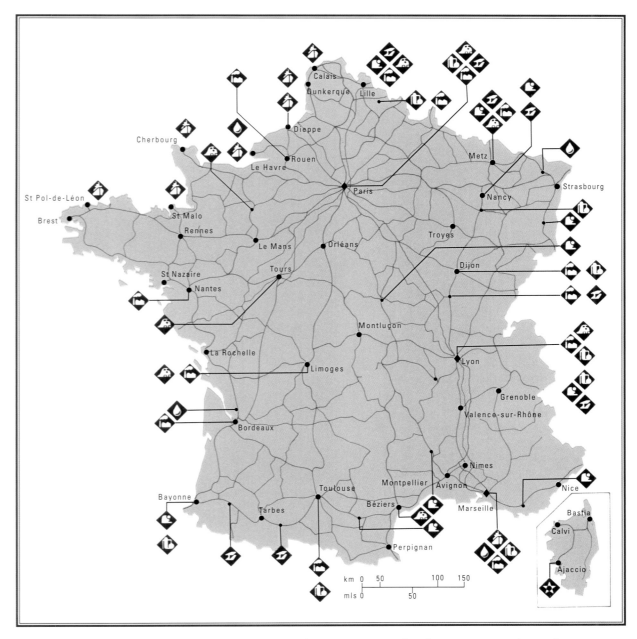

France has an extensive rail network, as this map of the main lines shows. Today the infrastructure is under the control of state owned RFF, with new companies taking on the role of train operators in a competitive environment.

fast services inaugurated, but the highest speeds were run on the former Paris-Orléans lines—up to 125mph (200km/h)—with heavy luxury express trains. However, the passenger train picture has been transformed by the building of TGV lines with their high average speeds and frequent service. Paris–Lyons was the first, introducing 185mph (300km/h) speeds, being followed by routes to the south-west, to Lille, Brussels and London, and later toward Strasbourg and the east.

France being a country where quality of life can take precedence over cost cutting measures, line closures have been gradual and working practices sometimes wasteful. EU directives aimed at liberalization have been followed reluctantly, although the requirement to separate operating from infrastructure has been embraced, and there has been a slow acceptance of access to the tracks by new freight companies. That said, there has been a severe decline of freight traffic in France. However, the financing and sponsorship of passenger services by local authorities has resulted not only in the development of short-distance services, but also in the appearance of smart regionally sponsored trains on longer routes.

The Orient Express, A Glorious Past

INTRODUCED IN 1883 TO PROVIDE A LUXURIOUS MEANS OF TRAVEL ACROSS EUROPE TO THE EAST, THE ORIENT EXPRESS SOON BECAME WOVEN INTO FICTIONAL TALES OF MURDER, MYSTERY AND ROMANCE.

Massive steam engines such as this hauled the *Orient Express* through Hungary, pictured here in 1987.

F ew trains have been surrounded by a greater aura of mystery and romance than the *Orient Express*. Unlike many other great trains of the world, the *Orient Express* has varied and diversified greatly since it was first run in 1883. In those days, its purpose was to provide a through service between Paris and Constantinople (Istanbul), but at the time it was not possible to travel the entire distance by train. The through coaches from Paris could go only as far as Giurgevo, a town on the Danube in Romania, where that river formed the frontier with Bulgaria. Passengers crossed the Danube by ferry, continuing by train across Bulgaria to the Black Sea port of Varna, thence by steamer to Constantinople.

The line through Turkey was completed in the winter of 1889, however, and the *Orient Express,* running once a week only beyond Vienna, took the main line of the Hungarian State Railroad

The sheer opulence of the *Orient Express* Pullman cars, with inlaid wood panelling and luxurious furnishings, and en suite bathroom, meant that passengers traveled in style.

southward from Budapest, travelling via Zaribrod and on to the Baron Hirsch Railroad in Turkey. The distance by this route from Paris to Constantinople was 1,857 miles (2,970km). Travelers left Paris by the Eastern Railroad of France on Wednesday night at 7.30pm and arrived in Constantinople at 5.35pm on the Saturday evening, an overall average speed of 43km/h (27mph). No fewer than ten railroad companies and six countries were involved.

At first, there were many peculiarities in its operation. It was organized by the International Sleeping Car Company, and substantial supplements over the ordinary first-class fare were charged. These varied over different parts of the route, which led to some criticism of the company. Actually, it received no more than a fraction of the supplement; the railroad companies cashed in on the luxury traffic and charged what they liked.

After the introduction of the through service to Constantinople via Belgrade, a connecting train was run twice weekly from Vienna to Bucharest. It was this service that until recent times carried the famous name 'Orient Express'. It left Paris nightly at 11.35pm and arrived in Bucharest at 11.45am on the third morning. The journey time was 36 hours 10 minutes, giving an overall average speed of 42.5mph (68km/h) over 1,530 miles (2,448km). While there were through coaches between Paris and Bucharest, the sleeping-car service was not continuous.

When the Simplon Tunnel was opened in 1906, a rival to the original *Orient Express* was introduced, using the Paris, Lyon and Mediterranean route in France, and traveling through Switzerland, Italy and Austria into Serbia. It was named the *Simplon-Orient Express*, and more recently the *Direct Orient*. This

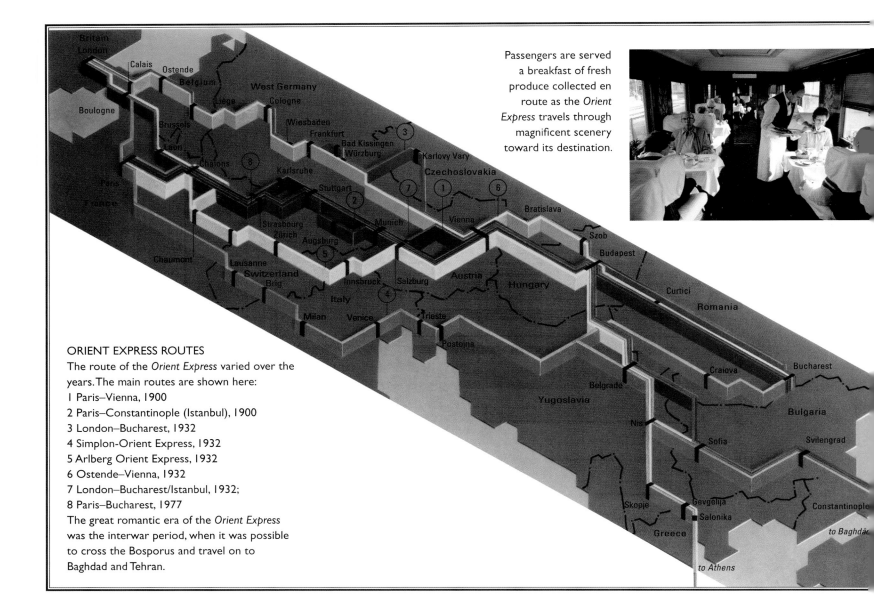

Passengers are served a breakfast of fresh produce collected en route as the *Orient Express* travels through magnificent scenery toward its destination.

ORIENT EXPRESS ROUTES
The route of the *Orient Express* varied over the years. The main routes are shown here:
1 Paris–Vienna, 1900
2 Paris–Constantinople (Istanbul), 1900
3 London–Bucharest, 1932
4 Simplon-Orient Express, 1932
5 Arlberg Orient Express, 1932
6 Ostende–Vienna, 1932
7 London–Bucharest/Istanbul, 1932;
8 Paris–Bucharest, 1977
The great romantic era of the *Orient Express* was the interwar period, when it was possible to cross the Bosporus and travel on to Baghdad and Tehran.

through service, between Paris and Istanbul, was withdrawn in May 1977. Before its withdrawal, the *Direct Orient Express* left the Gare de Lyon in Paris at 11.53pm and arrived in Istanbul at 8.25am on the fourth morning, a total of 56½ hours for the 1,890 miles (3,024km), or 33.5mph (53.6km/h) overall.

There was a time, after World War II, when the service was interrupted during the civil war that broke out in Greece. Then it was necessary to detrain at Svilengrad, on the Bulgarian frontier, take a motor truck through the Grecian province of Thrace, and join another train at Uzunköprü. Even when the service was restored in 1949, and it was possible once more to travel in a through coach from Paris to Istanbul, the journey through Thrace was hazardous. One traveler described how five empty freight wagons were propelled ahead of the locomotive to explode any mines on the tracks. Immediately behind the locomotive came four Turkish RPO cars, followed by the dining car and two through coaches. These were followed by some very old coaches carrying soldiers; finally, there was a wagon bearing an armored car armed with a field gun. Traveling in this way through Thrace, the maximum speed attained was no more than 32km (20mph).

In the final years, after normal operation had been restored, the romance and unique character of

the service began—for a traveler from the west—just after midnight, when the train passed from Italy into Yugoslavia at Sezana, not far beyond Trieste. In the days when steam still reigned supreme, there was no mistaking the change, because instead of the muted Italian electric locomotive could be heard the pounding beat of a massive steam locomotive climbing the grades, and then a clanking of rods as it ran downhill. East of Belgrade, the line into Bulgaria and its capital city of Sofia provided a major operating problem. It was a single track, and although the passenger trains were not as numerous as they were on the line west of Belgrade, it was used not only by traffic into Bulgaria, and thence to Istanbul, but also as far as Niš by trains running south into Greece and ultimately to Athens. Later, the connections originally provided from Paris by the *Direct Orient Express* were continued from Belgrade by the *Athens Express*.

East of Belgrade, the *Direct Orient Express* made slow progress. There were frequent stops to pass westbound trains, many of which would be extremely long. At one time, the *Direct Orient Express* carried its Athens and Istanbul sections—the present *Athens* and *Marmara Expresses*—combined as far as Niš, but the loads became too great. As the train rolled placidly through the eastern part of Yugoslavia, the pastoral scene was fascinating, but the traveler thinking of sustenance would be disappointed, because the dining-car service, once such a special feature of the International Sleeping Car Company's train, became largely non-existent. The *Direct Orient Express* used to have a dining car on the Yugoslav part of the journey; later, however, the would-be diner had to wait until the length of Bulgaria had been traversed, entirely in darkness, and until 2.00am the following morning, when the Turkish dining car was put on at Kapikule. The train did not exactly hurry across Bulgaria. It took 2 hours 18 minutes to cover the 45 miles (72km) from Dimitrovgrad to Sofia, and another 4¾ hours for the 195 miles (312km) to Svilengrad.

The *Orient Express* proper, to Bucharest, and the *Direct Orient*, to Istanbul, were at their heights of prestige and popularity in the years between the two world wars. Stories of mystery and intrigue were written around the journeys of the King's Messengers from the British Foreign Office, who traveled alone in reserved compartments with their diplomatic bags. One of these distinguished civil servants wrote, 'Romantic writers tell us of beautiful spies and glamorous young secret agents who haunt the international trains for the purpose of extracting information from couriers, but the Greyhound knows his business far too well to mix dalliance with duty. A King's Messenger I knew—a noted Lothario—was scandalized at the suggestion that he might have commerce with the sirens of the Orient Express —"Besides," he added naively, "I have never seen them."'

The *Direct Orient Express* reached the Turkish frontier in the early hours of the morning. It was at Edirne, however, that the traditional atmosphere of the Orient first struck the traveler. On the station, in English, French, German and Italian, was a large board carrying the words 'Welcome to Turkey', and if it was sufficiently light, the first minarets could be glimpsed from the train. Locomotives and coaches carried the crescent and star in large embossed characters on their sides. Then began the final run toward Istanbul, which took only 6½ hours, the train arriving at about 8.30am the next day. The terminus was at Sirkeci, on the banks of the Bosporus, beside the junction with the Golden Horn. From this station, ferries crossed the waterway to the Haydarpasa station, where one took the train for Ankara and the rest of Turkey.

THE AQUITAINE, FRENCH HEAVYWEIGHT FLYER

WITH ELECTRIFICATION OF FRANCE'S RAILROAD NETWORK AFTER WORLD WAR II CAME A DRIVE FOR FASTER SERVICES. PIONEERS OF THIS WORK WERE THE HIGH-SPEED EXPRESSES ON THE PARIS–BORDEAUX ROUTE.

S ince the middle of the nineteenth century, the main line between Paris and Bordeaux has been one of the most enterprising of French express routes. The Basque coast was already a favored holiday area and, at the same time, the route formed an important link on the international line from Paris to Madrid and Lisbon, even though there was, as now, a change of rail gauge at the Spanish frontier. At that time, the Paris-Orléans was the operating company as far south as Bordeaux, beyond which the Midi Railroad took over. The name *Aquitaine*, for one of the fastest trains on this line and, indeed, one of the fastest in all Europe at the time, was new, but the magnificently appointed 125mph (200km/h) electric train was one of the manifestations of a great heritage of express passenger train operation. Although the route is now completely electric, prior to electrification, the Paris-Orléans Railroad operated one of the greatest steam locomotives the world has ever seen.

In 1888, the Orléans company operated a deluxe train from Paris to Bordeaux that was the fastest long-distance express in Europe. Leaving Paris at 6.58pm, it arrived in Bordeaux at 3.30am the following day; the *Aquitaine* left at 5.53pm and, after a non-stop run, arrived at 9.43pm. The respective average speeds were 42.5 and 94.3mph (68 and 150.9km/h), a startling example of the advancement of railroad service on this route over 90 years. The steam train stopped at Les Aubrais (Orléans), St-Pierre-des-Corps (Tours), Poitiers, Angoulême and Coutras. It stopped for four minutes at each place

The electrically hauled *Aquitaine* flashes past the camera, maintaining a great tradition of express passenger train operation on the line between Paris and Bordeaux.

except Coutras. At Bordeaux, it was taken over by the Midi for the rest of the journey to Biarritz. On the Orléans, it was hauled by the picturesque 2-4-2 locomotives designed by Monsieur Forquenot.

Early in the twentieth century, the Orléans company purchased some very fine compound Atlantic engines designed by Alfred de Glehn; these locomotives provided the power for acceleration of the service with heavier trains. In 1907, the company was the first in Europe to introduce locomotives of the Pacific type. At the same time, most of the coaches on the trains from Paris to the towns and cities of the Aquitaine region were four-wheelers, although relatively large, with long wheelbases. The compartments inside were comfortable with tasteful decor, but rather feeble oil lighting. Between stops, the Atlantics and Pacifics used to wheel their long trains at speeds up to 70mph (113km/h). At the time, 74.5mph (120km/h) was the maximum speed permitted by law anywhere in France, and it was a limit that was strictly observed.

The Orléans Railroad was affected less than most of the French railroads during World War I, and

in the mid-1920s, the company embarked upon a programme of electrification that was intended to include the entire length of its two main lines, to Bordeaux and to its junction with the Midi Railroad at Montauban, near Toulouse. The system chosen was the French standard of 1,500 volts direct current (dc) from an overhead line; in December 1926, the first section was brought into operation between Paris and Vierzon. The latter station was at the beginning of the hilly section of the Toulouse line. This diverged from the Bordeaux line at the junction of Les Aubrais (Orléans), which meant that trains for Bordeaux and the south changed from electric to steam operation at Les Aubrais.

Those responsible for steam locomotives on the Orléans realized that with the powerful new electric locomotives at work, and the acceleration of service they made possible, unfavorable comparisons could be made between the standards of trains running north and south of Les Aubrais. At that time, the most modern steam passenger locomotives in service were nearly 20 years old. Furthermore, the large Pacific engines had not come up to expectation and, when worked at maximum capacity, were not a great deal better than the much smaller Atlantics. As a result, a thorough research programme was begun to pinpoint their deficiencies. The work was entrusted to a young engineer named André Chapelon, and by 1929, one of the old Pacifics had been extensively rebuilt, to his recommendations, at the company's Tours works. Tests on the line indicated that the capacity of the engine had been increased by no less than 50 percent.

More engines of the type were rebuilt, and soon it could be said that little if any difference could be discerned in the quality of the trains running north and south of Les Aubrais. Nevertheless, steam was fighting a rearguard action on the Orléans, because the policy of the company was to extend electrification southward. When amalgamation with the Midi Railroad occurred in 1934, steam operation was caught in a 'pincer movement,' because the main line of the Midi was electrified south of Bordeaux. What had been achieved by the men of the Orléans at Tours reverberated around the railroad world and formed the basis for improvements in steam locomotive design in such countries as the USA, the Soviet Union and Great Britain, as well as elsewhere in France.

After World War II, the remainder of the former Orléans main lines were electrified, now under national ownership, and a great drive began toward higher speeds. New electric locomotives were introduced and some thrilling high-speed trials conducted south of Bordeaux, where the record maximum speed of 206mph (329.6km/h) was attained on two successive trips. Following these runs, a magnificent 8,000hp electric locomotive was built, which made practicable the very fast schedule worked by the *Aquitaine* and other express trains on the Paris–Bordeaux route. Over a considerable proportion of the line, continuous running at 125mph (200km/h) was permitted, and a remarkable high-speed service provided. Until the autumn of 1976, it was considered very good going

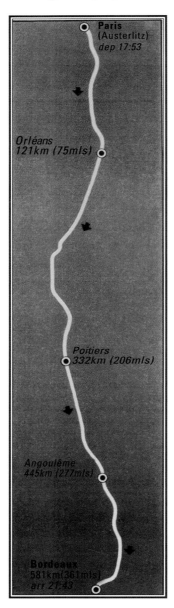

Paris
(Austerlitz)
dep 17:53

Orléans
121km (75mls)

Poitiers
332km (206mls)

Angoulême
445km (277mls)

Bordeaux
581km (361mls)
arr 21:43

The *Aquitaine* was scheduled to run from Paris to Bordeaux non-stop, at an average speed of 94.3mph (150.8km/h). The heavyweight train covered the distance in a very fast time of 3 hours 50 minutes.

to cover the 580km (360 miles) from Paris to Bordeaux in exactly 4 hours, that is an average speed of 90mph (145km/h), but in September of that year, further improvements were made.

Although there were many fast trains on this route, the two outstanding 'flyers' were the *Étendard* and the *Aquitaine*. Southbound, the *Étendard* left Paris at 7.51am, reaching Bordeaux in 4 hours 5 minutes with three intermediate stops—St-Pierre-des-Corps, Poitiers and Angoulême. The successive start-to-stop average speeds were 93.8, 101.6, 87.5 and 77.2mph (150, 162.5, 140 and 123.5km/h).

The original electrified length of the Paris-Orléans Railroad. The train is hauled by one of the locomotives designed for this route in the 1920s.

The *Aquitaine*, leaving at 5.53pm, ran non-stop in 3 hours 50 minutes, averaging 94.3mph (150.8km/h). In the opposite direction, the *Aquitaine*, leaving Bordeaux at 8.00am, reached Paris in 3 hours 59 minutes, stopping at Angoulême and Poitiers, while the *Étendard* ran non-stop in 3 hours 50 minutes, arriving in Paris at 9.40pm. These trains were no lightweights. The French had always specialized in hauling gargantuan loads, and a train like the *Sud Express*, which left Paris just after the *Étendard* had departed in the morning, may have had a total load of up to 16 or 17 cars.

The *Aquitaine* and the *Étendard*, which were scheduled to run at 125mph (200km/h), were actually limited, although the limit was not a low one. They took up to ten huge *Grand Confort* cars, which, when loaded with passengers and luggage, weighed about 550 tons. It was not that the great CC 6500 class electric locomotives could not take any more at the very high speeds scheduled; it was that, in so doing, they would draw too much electric current from the overhead line. In this respect, the Orléans line was paying the penalty of being a pioneer in electric traction in France. When the line was electrified in the mid-1920s, and the wires extended farther south in the 1930s, it was not envisaged that power would be required to drive a 550-ton train at 125mph (200km/h). The sub-stations supplying the overhead power line were spaced at distances thought to be more than adequate for the heaviest demands imaginable. That they were able to meet later needs is a tribute to the foresight of those who planned the electrification. But there was a limit.

On the very first day of the new timetable, the *Aquitaine* had to make an emergency stop on the first stage from Bordeaux in response to signals, and reached Angoulême 6½ minutes late. No time was regained on the next section, over which the 70 miles (113km) to Poitiers had to be run in 45 minutes start to stop, an average of 93.5mph (149km/h). On the final run from Poitiers to Paris, however, a distance of 206 miles (330km) with an allowed time of 2 hours 15 minutes, not only was all the lost time regained, but the effect of four slight checks absorbed. In fact, the train arrived in Paris 2 minutes early. Allowing for the effect of those checks, the net time from Poitiers was only 2 hours 4 minutes, an average of 100mph (160km/h), and 11½ minutes better than the new accelerated schedule.

Paris–Lyon, Pioneer TGV

Opened in the early eighties to meet the needs of high passenger traffic, the Paris–Lyon line introduced the new breed of French high-speed express train—the Très Grande Vitesse.

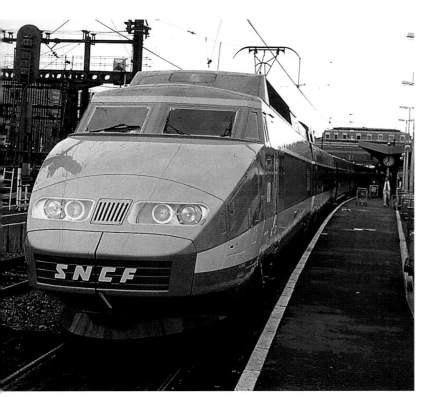

One of the TGV trains designed by Alstom for the first TGV route (Paris–Lyons). It is shown here ready to leave the Gare de Lyon in Paris.

The French National Railroads pressed the aim of high-speed services with a great deal of success on lines to the south-west, over the routes of the former Paris-Orléans-Midi Railroad, covering the 360 miles (580km) between Paris and Bordeaux non-stop in 3 hours 50 minutes, an average speed of 94mph (151km/h). The *rapides* ran at 125mph (200km/h) on favorable stretches of this line, but this route was not in the most urgent need of development. It was the south-eastern route from Paris to Dijon and Lyon that was becoming saturated, and by its nature it could not accommodate speeds above 100mph (160km/h). The decision was taken to build an entirely new line on which speeds of 185mph (300km/h) could be run.

Like the British HST sets and the Japanese Shinkansen trains, the new French Très Grande Vitesse (TGV) sets were to be self-contained consists, and it was the intention that all day services leaving Paris from the Gare de Lyon would eventually be of this type. Although traveling to a variety of destinations beyond the new line, the TGV trains would run at the higher speed while on it, and at the maximum permitted on the existing routes.

This arrangement would permit some striking accelerations that would make it difficult for the airlines to compete. For example, the fastest train time between Paris and Lyon, 507km (317 miles), was 3 hours 44 minutes, an average of 137km/h (85mph). By the TGV route, the time would be 2 hours. Continuing beyond Lyon along the route to

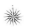

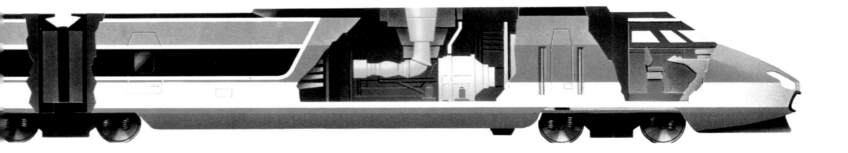

the south, the existing and future times to Avignon were 5 hours 37 minutes and 3 hours 49 minutes respectively; to Marseille, 6 hours 33 minutes and 4 hours 43 minutes respectively. Over a distance of 535 miles (856km) from Paris, this represented an average speed of 113mph (180km/h), even though 218 miles (349km) were over an ordinary line.

The new line ran through hilly country to the west of Dijon, but in order that TGV trains could reach Dijon and continue from there to the Swiss frontier at Vallorbe, and on to Lausanne, connection with the existing main line was made at Saint-Florentin. There was connection with the existing line at Mâcon for passage on to the line to Geneva and Turin via the Mont Cenis Tunnel. Again, the accelerations forecast were impressive, reducing the time from Paris to Lausanne from 4 hours 37 minutes to 3 hours 29 minutes, and to Geneva from 5 hours 30 minutes to 3 hours 19 minutes. The latter saving of more than 2 hours on a journey of international importance would be of advantage to a large number of rail users.

The new line did not actually enter Paris, but began at a junction with the existing line at Courbs la Ville. South of that station, progress was so swift that passengers saw little of the intervening countryside, and its place among the great railroad routes of the world was based solely on statistical performance, rather than on any attendant appreciation of the passing scene. This, of course, is very much the case with air travel, and it is with the airlines that the TGV trains compete. Like the Shinkansen lines in Japan, the new French line carried only passenger trains, but their removal from the existing line left that well-equipped railroad free to carry other traffic.

One important feature of the TGV sets was that their electrical equipment had to accommodate different systems of electric power supply. The existing PLM line into Paris, and south of Lyon, was operated on 1,500 volts dc, but the new line had the present French standard system of 25,000 volts ac, at 50 cycles. Furthermore, on the TGV sets that worked to Lausanne, provision was made to operate on the Swiss system of 16,000 volts ac at $16^{2/3}$ cycles. The equipment was designed to facilitate the switch from one to another at the change-over points without stopping.

The line was an immediate success and soon was extended to Marseilles; traffic was such that before long double-deck trains were considered necessary. It set the pattern for TGVs not only in France, but also elsewhere.

Above: the prototype TGV was fitted with a gas-turbine engine to propel it to required speeds for testing. Production versions were electrically powered.
Left: The Paris–Lyon line was built to cater for high passenger demand. It links urban areas containing 40 percent of the population, and provides a high-speed connection for international travelers. The line was designed to allow speeds of 186mph (300km/h).

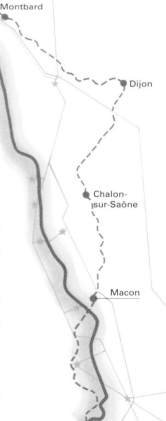

Improving Performance, 1835-74

Having established the steam locomotive as a viable means of traction on the world's early railroads, the engineers began refining its design for greater speed, comfort and safety.

To improve the stability and safety of his locomotive at speed, Thomas Russell Crampton placed the large-diameter driving wheels at the very rear. This allowed the boiler to be low slung, keeping the center of gravity low. (Kent Arts and Libraries)

By 1835, the steam locomotive had passed beyond the stage of questionable gimmick. The Liverpool & Manchester Railroad, worked entirely by steam, was proving a very profitable investment, and men like Robert Stephenson, having settled the fundamentals of operation, were concentrating on the finer points of performance. Speeds were increasing rapidly, more rapidly than development of the track, and the safe riding of locomotives became a point of considerable importance. The jerky action and rough riding of locomotives of the *Rocket* type, with outside cylinders, led to the production of Stephenson's famous *Patentee*, with inside cylinders. This was the prototype of many British locomotives that were exported to pioneer railroad enterprises in Belgium, France, Germany and Russia. It became popular on the early British railroads, and was exported to Canada and the USA. In North America, however, it was not successful.

There was a great difference between the lavishly engineered, solid tracks of England and the pioneer lines in America, where, with little supporting capital, tracks followed meandering courses in river valleys and up steep hillsides, all at an absolute minimum of construction cost.

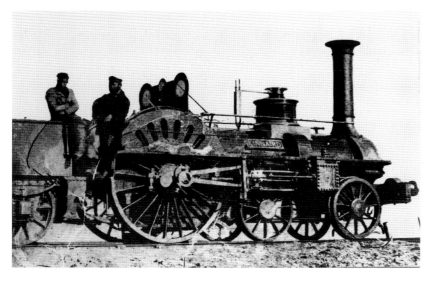

Locomotives of conventional European type, with short rigid wheelbases, took unkindly to these sinuous, lightly laid tracks, and derailments were frequent. As a result, a new concept of locomotive chassis design was developed, on the simple principle of the three-legged stool or three-point suspension, which will stand on any rough ground. Thus came the American or 4-4-0 locomotive, in which the three points of suspension were the mid-points between the driving wheels on each side, with compensating levers to the axle boxes, and the pivot point of the leading four-wheeled truck. This was so successful that the American became the standard type of locomotive for any kind of duty throughout North America, remaining in popularity for over 50 years.

The atmospheric railroad system was developed by Jacob and Joseph Samuda. A large pipe laid in the middle of the track had a slot in the top, which was closed by a leather flap. The flap was hinged on one side so that it could lift to allow passage of the arm connecting the piston to the power unit. Air was sucked from the tube in front of the piston, and the resulting higher pressure behind the piston pushed it along, together with the train.

Meanwhile a distinguished English engineer, Thomas Russell Crampton, who at one time had worked on the Great Western Railroad at Swindon, Wiltshire, was applying his own inventive mind to the problem of providing a smooth and safe riding, high-speed locomotive. He conceived the idea of placing the large-diameter driving wheels at the rear so that the centerline of the boiler could be made low, providing a steadier ride. A few of these picturesque 'stern-wheelers' were put into service in England and Scotland, but the type found great favor in France, and so many of these engines were built that 'prendre le Crampton' became a common phrase for 'going by train.'

Even in the 1840s, however, some inventors were considering alternatives to steam as the motive power, to avoid the use of coal and coke, the emission of smoke and sparks, and the puffing noise. One such experiment was the ill-fated atmospheric system of traction developed by Jacob and Joseph Samuda. This was based on a large pipe laid in the middle of the track, while the power unit was equipped with a piston that fitted into the pipe. Air in front of the piston was exhausted, thus creating a vacuum and drawing the unit along. The connection between the unit and the piston passed through a slot in the pipe, which was sealed by a leather flap that was pushed aside by the movement of the piston and resealed afterward. Unfortunately, because the flap was made of leather, it soon deteriorated, destroying the seal. This prevented a vacuum from being created, and the system became useless.

It was natural that the early primitive steam locomotives working on the colliery lines in north-eastern England should burn coal. When plans were laid for more and more public railroads, running through the green fields of the Midlands, however, those who opposed their construction managed to have restrictive clauses inserted into the Acts of Parliament that authorized them, prohibiting the use of locomotives that did not consume their own smoke. At that early stage of development, that meant burning coke instead of coal, which was more expensive. Even so, this measure could be regarded as no more than a temporary solution, and many experiments were undertaken with coal-fired locomotives to reduce the emission of smoke to an acceptable level.

In North America, no such restrictions applied, but in areas distant from the coalfields, wood burning locomotives were employed. These had a tendency to throw out sparks. Many of the early American railroads ran through densely forested country, and sparks, whether from wood or coal, could cause serious fires. Occasionally, they would even set fire to the great wooden trestle viaducts. While a major conflagration could lead to the complete loss of a viaduct, a smouldering insidious fire could weaken the structure, leading to a collapse when a train crossed. Various spark arresting devices of unusual appearance were fitted to the tall chimneys of early American locomotives, giving them such names as 'diamond stacks' and 'balloon stacks' according to their shape. The first spark arresters

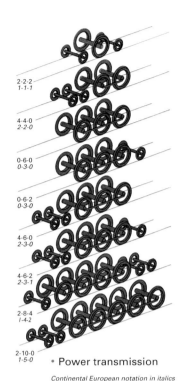

2-2-2
1-1-1

4-4-0
2-2-0

0-6-0
0-3-0

0-6-2
0-3-0

4-6-0
2-3-0

4-6-2
2-3-1

2-8-4
1-4-2

2-10-0
1-5-0

• Power transmission

Continental European notation in italics

Steam locomotive wheel notation, although baffling to the uninitiated, is a remarkably simple system. A distinction is made between driving and trailing wheels.

were developed in the early 1830s and pioneered by such engineers as Matthew Baird. More than 60 types were tried on American wood burning locomotives, and they had become standard throughout the continent by the 1860s.

In Great Britain, while experiments were being made to eliminate the use of coke, there were interesting developments in the boiler itself. Robert Stephenson introduced what was known as the 'long boiler' type, in conjunction with a relatively small firebox. The object was twofold: by having a long barrel, and making the products of combustion travel a considerable distance before being discharged, the fuel would be burned more completely; the long boiler would act as a large reservoir for steam, while the small grate would need less coal to keep the fire bars covered while the locomotive was standing. It seemed an ideal type of boiler for freight trains, which spent a good deal of their time standing or switching, using relatively little steam.

The coal burning problem was solved in a simple manner, namely a firebrick arch, built across the firebox from one side to the other. The flames and gases from the forward part of the grate were drawn back and around the rear edge of the arch by the draft from the smokebox; with the exception of when the locomotive was being fired, this gave a clear exhaust from the chimney. This arrangement was first used on the Midland Railroad in England in 1859; thereafter, the firebrick arch became universal.

For a time, locomotives of the 2-2-2 type, with outside frames, and sometimes double frames, were popular for passenger work in Great Britain, and both varieties were exported to Europe. An important English variation was the 'Jenny Lind' type, which had outside framing for the leading and trailing wheels, and inside frames for the single pair of driving wheels. On the London & North Western Railroad, Southern Division, J.E. McConnell used inside frames only for a notable series of 2-2-2 express locomotives, nicknamed 'bloomers.' Before the end of the period, however, locomotives of the 2-4-0 type were coming into general use for passenger work, with notable examples in France, Belgium, Holland and Germany, in addition to those of Great Britain.

In France, where the Crampton 'stern-wheeler' type had been employed for so long, the change to four coupled wheels was accompanied on the Paris, Lyon & Mediterranean Railroad by use of the 'long boiler,' but as the locomotives in question tended to pitch when running at speed, the 2-4-0 wheel arrangement was changed to 2-4-4, a type that later became known as the Columbia in the USA.

While the 4-4-0 or American type, with outside cylinders, leading truck and three-point suspension, remained the standard design for general service throughout the USA, larger locomotives were being introduced for heavier freight duties. These included the Mogul (2-6-0) and the Consolidation (2-8-0). Speeds were not high, and competition in speed for such important traffic as that between New York and Chicago had scarcely begun to play a major role.

The opening of London's Metropolitan Railroad in 1863, the first purely underground line in the world, required locomotives that consumed their own exhaust steam. No exhaust, no matter how clear, could be permitted in the tunnels; to meet this requirement, a successful range of tank engines of the 4-4-0 type was introduced. In these, the exhaust steam was diverted from the blast pipe into a large pipe on each side, which entered the tops of the side tanks, where the exhaust was discharged upon the surface of the water. At one time, no fewer than 120 of these locomotives were in service in the London area.

An interesting phase in the development of the steam locomotive occurred on lines of sub-standard gauge, principally in the USA, but the focus of world attention was on the 1ft 11½in (600mm) gauge Ffestiniog Railroad, in North Wales. Eminent engineers of the day stated that it would be impossible to design steam locomotives to operate satisfactorily on track with so narrow a gauge. After building some small locomotives of the 0-4-0 type, which were limited in their capacity, C.E. Spooner, engineer of the Ffestiniog Railroad, decided to try one of Robert Fairlie's patent double engines, which in effect were two tank engines arranged back to back on a single frame. Each engine unit, with its cylinders and running gear, was carried on a swivelling truck, there being ball-and-socket connections for the steam pipes below the smokebox at each end. These locomotives had two inside fireboxes, with doors side by side; the fireman rode on one side of the central platform, the engineer on the other. The first of these engines, *Little Wonder*, was put into service in 1869 and was an outstanding success. Subsequently, several similar locomotives were added, and the type can still be seen on the Ffestiniog Railroad today. Locomotives of the same general design, but much larger and for wider gauges, were built in England for service in Mexico, Russia, South America and Sweden.

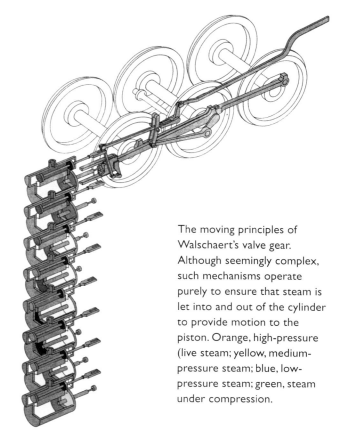

The moving principles of Walschaert's valve gear. Although seemingly complex, such mechanisms operate purely to ensure that steam is let into and out of the cylinder to provide motion to the piston. Orange, high-pressure (live steam; yellow, medium-pressure steam; blue, low-pressure steam; green, steam under compression.

By 1874, the speed of passenger trains was becoming an important consideration in Great Britain. The British Post Office, for example, had specified an average speed of 42mph (68km/h) between London and Holyhead for the *Irish Mail*; maintaining such an average, given the lengthy stops needed for postal traffic at such stations as Rugby, Stafford, Crewe and Chester, involved running at over 60mph (96km/h) on the open sections of line. By the 1870s, indeed, speeds of up to 70mph (113km/h) or so were being reached on favorable stretches, not only on the *Irish Mail* route, but also on the

The long-boiler concept was used by locomotive builders for many decades. This is a late example built in Germany for a Spanish railroad; it ended its days in Barcelona local service.

Great Northern line from London (King's Cross) and on the steep, though well-aligned, descents of the west coast main line north of Lancaster. At that time, both in scheduled speed and in maximum speeds attained, the leading railroads of Great Britain stood alone in the excellence of their performance, although this supremacy would not endure for many more years.

While every credit must be given to the locomotives and their designers, this standard of running could not have been sustained without a track that had been solidly built to the highest standards and thereafter maintained scrupulously.

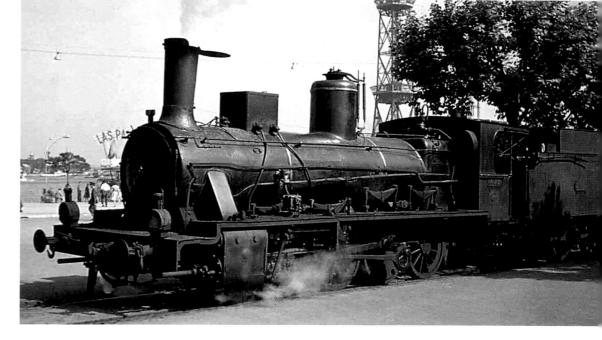

Railroads in Belgium and Luxembourg, from 1835

A PIONEER OF STATE OWNERSHIP OF RAILROADS, BELGIUM IS
AN IMPORTANT HUB FOR INTERNATIONAL TRAIN SERVICES IN
EUROPE. LUXEMBOURG, TOO, IS A MAJOR JUNCTION FOR SUCH
TRANS-EUROPEAN ROUTES.

BELGIUM

Belgium was the first country in the world to have a railroad system that, from the outset, was almost entirely state owned. The principal of state ownership had been introduced by an Act of Parliament passed in 1834, and the railroad system was planned as a co-ordinated network. It grew to be one of the busiest and most intense to be found anywhere, reckoned on the basis of route distance per square kilometer of territory served. Belgium has a high proportion of intensely industrialized areas, comparable to the English Black Country, and a frequent service of fast passenger trains coupled with ample freight facilities became necessary at an early stage of the network's development.

While the demands of Belgium itself have always been heavy, the country's geographical situation makes it an important connecting link in many international train services. Historically, Belgium has been called the 'cockpit' of Europe; from the railroad point of view, it does form a general crossroads. While the original network was planned so that all the main lines radiated from Brussels, not all of today's international trains pass through the capital. The crack trains from Paris to the Rhineland take a route to the south, passing through Charleroi, Namur and Liège to enter Germany at Aachen, and there is a busy electrified main line that diverges eastward from the principal north–south line at Mechelen, which passes through Louvain and Landen, then runs on to Liège. It was not until comparatively

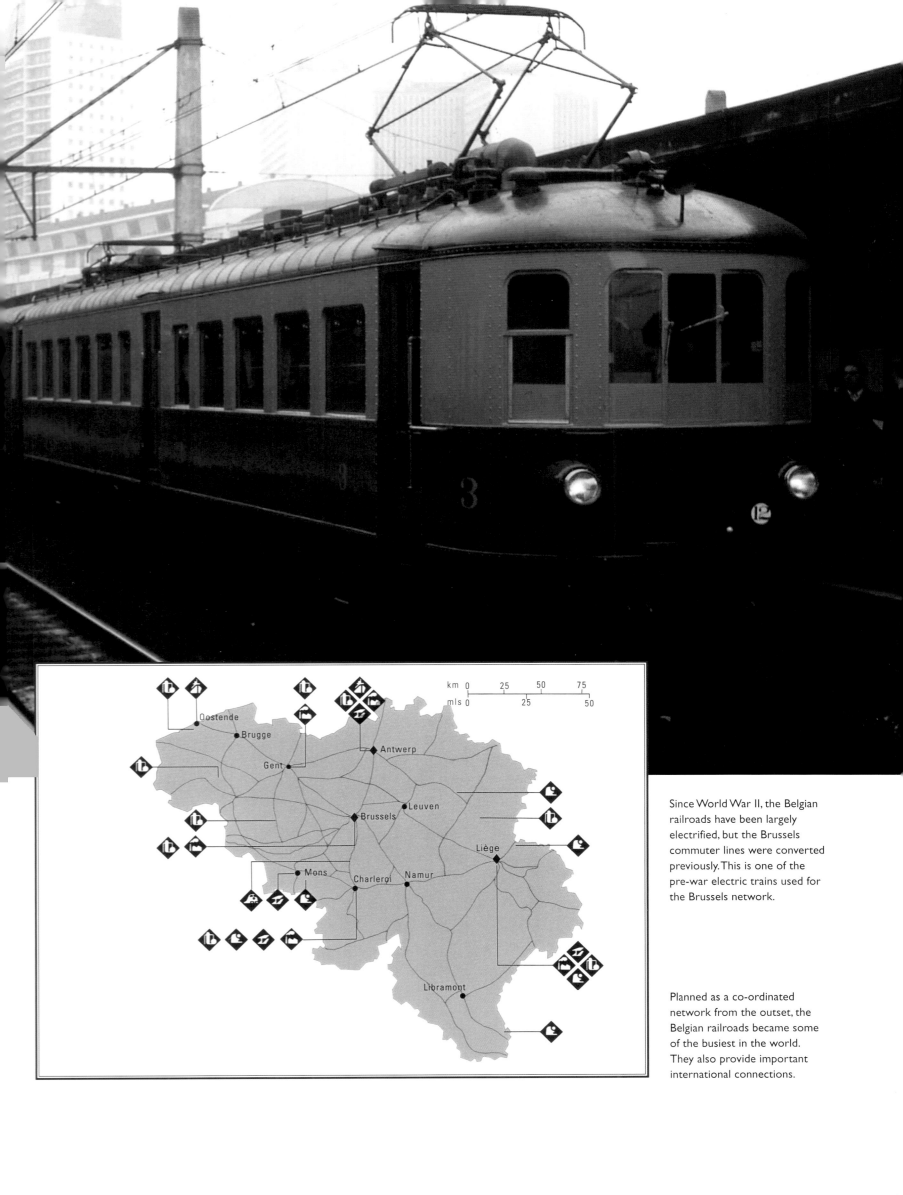

Since World War II, the Belgian railroads have been largely electrified, but the Brussels commuter lines were converted previously. This is one of the pre-war electric trains used for the Brussels network.

Planned as a co-ordinated network from the outset, the Belgian railroads became some of the busiest in the world. They also provide important international connections.

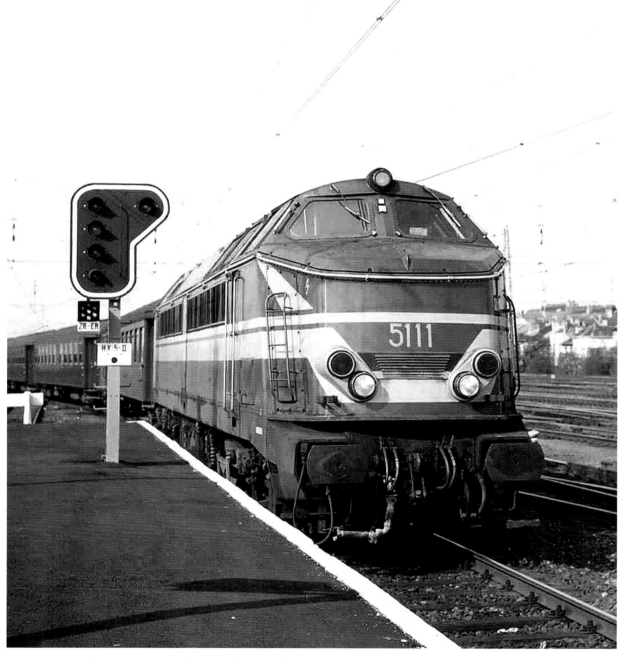

Belgium began a major switch to diesel power in the 1950s. This is one of a large class of diesel-electric locomotives introduced in 1961. It was built by the local Cockerill Company.

recent times that international through trains, like those from the Dutch cities to Paris, or from Ostend to Germany, or on the Luxembourg line, could pass through Brussels without reversal of direction at some point. Today, there is an underground main line through the heart of the city, connecting the Nord and Midi stations, and prestige trains pass beneath the city center.

Because of its geographical position and the intensity of internal traffic, which developed well before the end of the nineteenth century, the technical equipment of the Belgian railroads rapidly became some of the most sophisticated outside Great Britain. Comprehensive signaling was installed at large centers, such as Antwerp, Gent and Liège, in addition to those around Brussels, and these units incorporate full interlocking. Steam power has been eliminated entirely, and more than a third of the total network is electrified.

The national operator, Société Nationale des Chemins de Fer Belge (SNCB), went through a difficult period in the 1990s, and new financial arrangements were made, with increased state investment and budget support for some loss making passenger services. With the completion of the TGV line from Paris to Brussels, SNCB became a partner in the Thalys high-speed service and the Eurostar to London. A TGV line to Köln was under construction in 2007.

LUXEMBOURG

One of the most important international routes is that running south-east from Brussels in Belgium, which then makes its way through extremely mountainous country to enter Luxembourg at Arlon. Until 1946, there were several privately owned railroads in the Grand Duchy, but in April of that year, all the railroads were taken over by a new company—Société Nationale des Chemins de Fer Luxembourgeois (CFL).

The stock was split between the Luxembourg government (51 percent), and the Belgian and French governments (24.5 percent each). The system consists of a north–south line and an east–west system, which intersects the former at the city of Luxembourg. Much of the latter is electrified, but most of the international north–south route is worked by diesel locomotives. The total route length in the Grand Duchy is only about 364km (165 miles), half of which is electrified.

The city of Luxembourg is an important railroad center, being at the junction of five international routes. The south-west is part of the Luxembourg-Lorraine iron mining region and is well served by the Grand Duchy's railroads, which are concentrated in the south.

The state of Luxembourg increased its holding in CFL to 94 percent in 1998. At about the same time, CFL took the unusual step of discontinuing the collection of statistics for its domestic passenger-journeys and passenger-kilometers, on the grounds that most passengers bought multi-ride, all-line tickets that were hard to convert into actual journeys and distances.

The small railroad network in Luxembourg is centered on the city of Luxembourg, which forms the junction of five international routes.

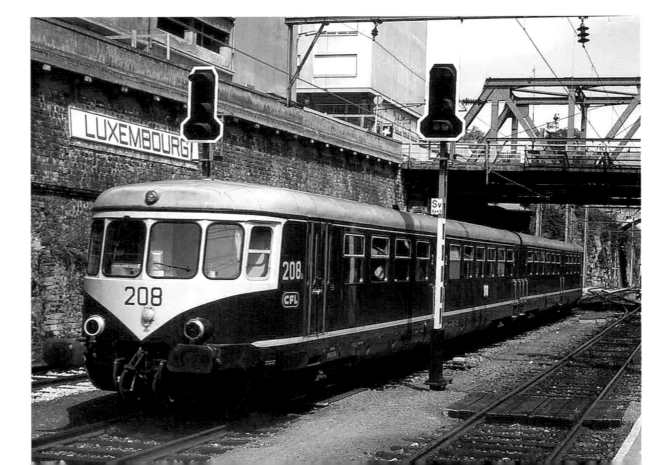

One of a class of diesel railcars built in Germany in the 1950s for Luxembourg's remaining light-traffic lines. ✳

Meeting the Customer's Needs, 1800-75

The Earliest Railroads Carried Minerals in What Were Little More Than Horsedrawn Wagons. With the Advent of Passenger and Varied Freight Traffic, It Was Clear That Something Much Better Was Needed.

The interior of an early Pullman car.

The earliest form of vehicle for conveyance on rails was the colliery tram, also know as a 'cauldron car,' designed for carrying coal. It was a four-wheeler and of a size that could be pulled by a horse on one of the rough cart tracks of the day. When such wagons were fitted with flanged wheels and run on the early form of edge-rails, it was found that a single horse could pull three or four of them, and the type was in general use when the first locomotives were tried out in north-eastern England. In early trials, men climbed aboard the wagons for the ride, and when the Stockton & Darlington Railroad was opened in 1825, many men and women rode in the traditional cauldron cars.

The earliest passenger coaches varied according to the class of traveler. First-class coaches were built to resemble the familiar stagecoach, while nothing more than an open coach was provided for third-class passengers. Between these two extremes was second class, an open coach with seats and a canopy to give some protection from the weather. Given that passengers traveled on the outside seats of the old stagecoaches, it was not surprising that thoughts turned to double-deck railroad cars, and some quaint examples were built in France and the USA. In Great Britain, however, the reduced headroom necessitated by passing under bridges and through tunnels precluded the use of double-deckers in the early days. Indeed, double-deck coaches have never raised any great degree of popular interest in Great Britain.

Although conditions of rail travel in the pioneer days were not very different from those on a stagecoach, at any rate for the outside passengers, the smoke, steam and red-hot cinders from the locomotive chimneys introduced new hardships, particularly as many more people than ever before were travelling. A general outcry against rail travel conditions in Great Britain led to the passing of Gladstone's famous Regulations of Railroads Act of 1844. This made it a legal requirement that on every line there should be at least one train every day with properly covered, third-class accommodation, at a fare of one penny per mile and serving every station on the line. The so-called 'Parliamentary trains,' despite the covered cars, did not offer the height of luxury.

Luggage was usually stacked on the roofs of the first-class cars, and sometimes was set on fire by sparks from the engine. On freight trains, cattle were carried in open cage-like vehicles, the drovers traveling with the animals. While movement of coal had been the basic traffic of the earliest railroads in the north-east of England, when railroads were opened in the rural counties farther south, it was considered undignified to carry coal. When such business was offered to one railroad manager, he is said to have exclaimed with much indignation, 'What, coal by railroad? They'll be asking us to carry dung next!'

At an early stage of development, larger cars were introduced on the American railroads for much the same reason as the traditional 4-4-0 locomotive was adopted. The short-wheelbase freight cars and passenger cars did not ride well on the sharply-curved and lightly laid tracks, and vehicles carried on two four-wheeled trucks, for both passengers and freight, were much preferred. Thus originated the American passenger car. This had entrances only at the ends; the inside was completely open, without any of the divisions that made a British or European coach a series of compartments. Usually, it had a high clerestory roof. Whereas an English passenger train might consist of 12 or 15 four-wheeled cars, an American train would have no more than three or four of these large cars. For third-class passengers,

A typical British four-wheeled passenger car. This example belonged to the Somerset and Dorset Joint Railroad, c. 1870.

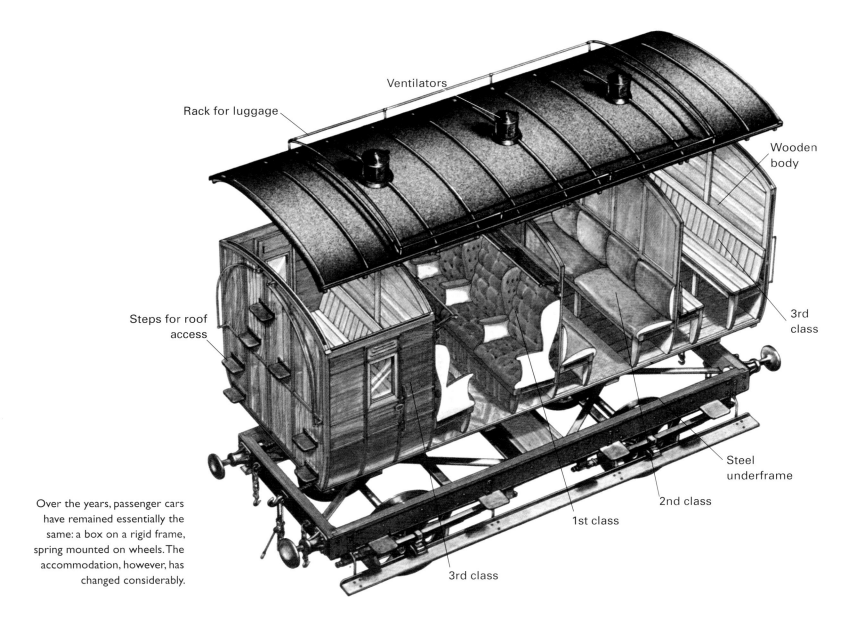

Ventilators

Rack for luggage

Wooden body

Steps for roof access

3rd class

Over the years, passenger cars have remained essentially the same: a box on a rigid frame, spring mounted on wheels. The accommodation, however, has changed considerably.

Steel underframe

2nd class

1st class

3rd class

there would be little difference in comfort—or lack of it: bare boards were the rule for all. Third-class accommodation took the form of a primitive, unlit, open saloon coach with wooden benches across the center, ventilation provided by a few doors and windows.

The British four-wheeler of the mid-nineteenth century was a basic feature of operation, and so far as size was concerned, the same applied to passengers, parcels, mail or even horses. They were light and could be pushed easily by human effort. At the larger stations, locomotives were not used for switching. Instead, on each of the tracks, there was a small turntable, large enough to take one four-wheeler. If it was necessary to transfer a car or wagon from one line to a parallel track, it was pushed on to a turntable, which was rotated 90 degrees, allowing the vehicle to be pushed across the connecting rails to the turntable for the neighboring track. This was turned until it was in line. These turntables were features of most early British railroad stations, and their existence goes some way to explaining the reluctance of many railroad managements to introduce larger cars.

A characteristic feature of many British railroads during this period was the family 'saloon' or parlor car. This was usually a four-wheeler that could be chartered on payment of so many first-class fares. Then it would be transported between any locations specified by the passengers. To achieve

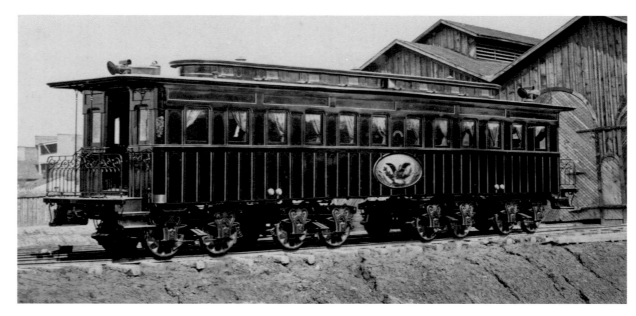

President Lincoln's personal rail coach. After his death, it was used as his funeral car.

this, it would be attached to scheduled train services, although there could be a lengthy wait when being transferred from one train to another at a junction. The accommodation comprised a drawing room with an adjoining compartment for family servants. Sometimes, in the case of a wealthy patron, there would be horse cars as well; these included accommodation for the grooms. During the shooting season in Scotland, trains from England often included ten or more of these family saloons, many with horse cars attached. The epitome of comfort and convenience was to be seen in the royal saloons built especially for Queen Victoria and her traveling court.

At this early stage in railroad development, the arrangements for braking were primitive. The British passenger train of the 1860s and 1870s had brake vans at the front and rear, the brakes being applied manually by the trainmen. When the engineer wanted the brakes applied, he would signal with the locomotive's whistle. This is quite remarkable given that, at the time, passenger trains were regularly running at 60mph (96km/h) or more. In America, trains had a front and rear brakeman, and on freight trains, which were usually made up of a series of closed cars, the brakeman could often be seen running along the tops of the cars while the train was at speed, applying or releasing the brakes as required. On British freight trains, when a steep descending grade was being approached, it was necessary to stop for the hand brakes to be applied on a specified number of vehicles before the descent was begun. British freight trains were manned by a single trainman, in addition to the locomotive crew, and there was no facility for a traveling brakeman. Because most freight was carried in closed cars on American freight trains, they had a more uniform appearance than their British or Continental counterparts in the latter part of the nineteenth century.

Because of long distances and slow trains, sleeping accommodation was the norm on Russian trains, seats being limited to short-distance services. This is a nineteenth-century four-wheel sleeping car; it was customary to paint First Class vehicles blue.

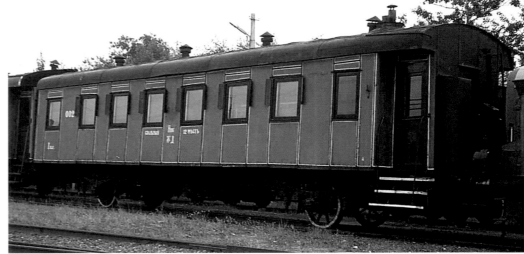

RAILROADS IN GERMANY, FROM 1835

SEVERELY DAMAGED DURING WORLD WAR II, GERMANY'S RAILROADS WERE DIVIDED BY THE SUBSEQUENT PARTITION OF THE COUNTRY. TODAY, THEY ARE REUNITED AND MAKING GREAT STRIDES IN PASSENGER AND FREIGHT SERVICES.

The railroads of Germany, like those of Great Britain, began as a large number of independent, unconnected private enterprises. They developed at a time when Germany itself did not even exist as a single co-ordinated state. The first was built in Bavaria in 1835, between Nürnberg and Fürth. Gradually, however, the various lines were taken over by the states in which they ran, many of them coming under the control of Prussia. Their origins could be discerned from the names of the 'Administrations' they carried, such as 'Magdeburg,' 'Right Rhine,' 'Breslau' and 'Hannover.' After the war with France in 1870–71, Bismarck tried to amalgamate all the railroads of Germany under one imperial control. He failed because the southern states, like Saxony, Bavaria and Baden-Württemberg, stood out strongly against such a merger. The annexation of most of the French provinces of Alsace and Lorraine after the war brought the French railroad of that name. It was thoroughly Germanized, being renamed Imperial Elsass-Lothringen, and controlled directly by Prussia. Moreover, the French practice of running on the left-hand track was changed to the German right-hand running. At the new frontier crossing point, between Nancy and Strasborg, special junctions were laid to facilitate the transfer. When the provinces were restored to France after World War I, the junction layout was not altered. The railroads of Germany tended to be focused upon the imperial capital, Berlin, as those of Great Britain radiated from London. The great complexity and proliferation of routes in the Ruhr and the Rhineland corresponded in some respect to the situation that applied in Britain at that time, especially in Lancashire, Yorkshire and the North Midlands.

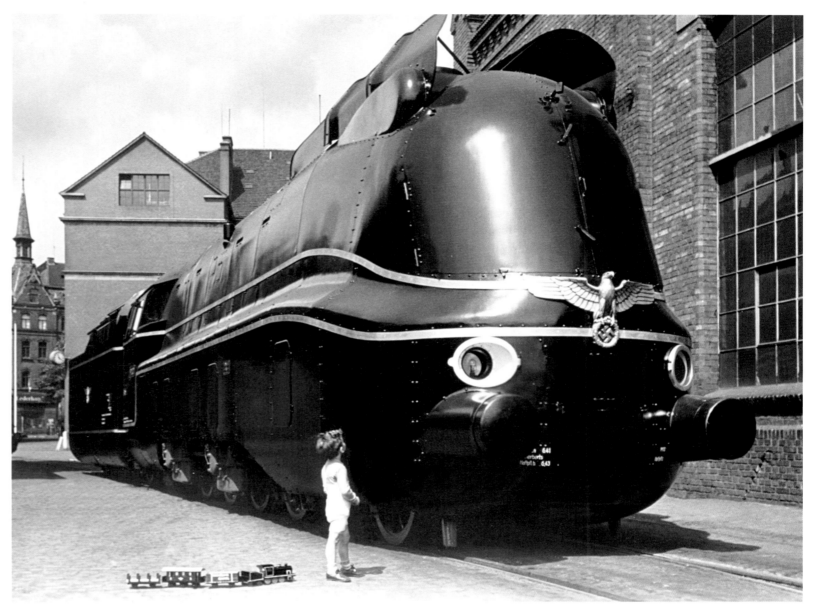

A small boy admires a massive Henschel steam locomotive in 1940. This streamlined express hauler had a top speed of 175km/h (109mph).

In 1920, the state railroads were taken into a single administration, the Deutsche Reichsbahn. Under this organization, great improvements were made in technology and in the services offered, both nationally and internationally. Until that time, German railroads had not been renowned either for convenience of the scheduling or for the speed of passenger trains; under the Reichsbahn, they gradually moved to the very front rank of speed, particularly with the diesel railcar trains developed in the 1930s. Much of the system suffered severe damage during World War II, but before any appreciable steps could be taken toward reconstruction, partition of the former Reich into the two separate and ideologically contrasting states of West and East Germany, in 1945, immediately changed the significance of the railroads.

The Deutsche Bundesbahn, operating in West Germany, was faced with providing a service in a state that was virtually cut off from the former imperial capital, and the traffic pattern became largely north–south, with main routes toward Berlin confined to those from Hamburg, Hannover, Bebra and Nürnberg. A great deal of thought was necessary to adapt the railroad organization to this new pattern. In addition to the main line up the valley of the Rhine, a popular tourist route, the line running roughly parallel

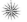

Germany made better use of branch-line railcars than did other countries. This photograph dates from the 1980s, but such vehicles lasted well into the twenty-first century.

to the frontier with East Germany, from Nürnberg northward through Würzburg, Bebra and Göttingen to Hannover and Hamburg, became of great importance. In addition, there was much closer liaison with the railroads in the countries of the West, there being interchange points with the Dutch, Belgian and French railroads, and an increasing number of international express train services. In imperial days, Germany had kept railroad connections with France and Belgium to a minimum,

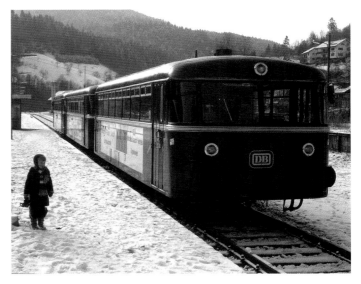

aiming to secure a preponderance of traffic from England to eastern and southern European business and holiday centers. Frankfurt became the headquarters of the Deutsche Bundesbahn.

In East Germany, the state railroads (Deutsche Reichsbahn) retained much of the radial layout of earlier days, with Berlin as the focal point. However, it had only about half the route length of the system in West Germany. Its services were co-ordinated more with those of Poland and Czechoslovakia than with the West. The radiating main lines from Berlin were those going east to Warsaw and beyond to the frontier with the USSR, south-east to Prague, west to Hannover, and south to the West German frontier and on to Munich. Additionally, there were two routes running north from Berlin, which diverged at Neustrelitz. These led to the train ferry ports of Warnemünde and Sassnitz, there being through train services to Copenhagen and Stockholm.

Mountainous southern Germany is ideal terrain for tilting trains. This example is shown at Stuttgart station, c. 2000, providing a service to Zürich.

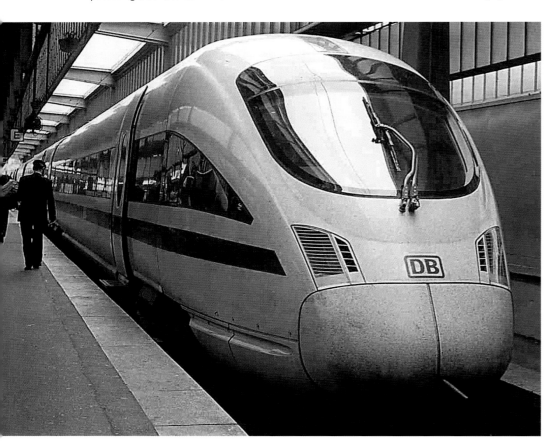

While the modernization of motive power progressed rapidly in West Germany, fewer than 1,000 miles (1,600km) of the East German system were electrified, and many steam locomotives remained in use into the 1970s. To some extent, the international set-up in Berlin simplified the railroad terminal arrangements, which at one time included many stations that had belonged to the formerly independent companies. Only a single route, known as the Stadtbahn, passed from West to East Berlin. Entering the international zone from the west, trains arrived first at Charlottenburg and then Zoo; after passing into East Berlin, they came to Friedrichstrasse and then Ost. These were followed by a complicated set of junctions, which directed Reichsbahn trains to the Baltic ferry ports, Warsaw, Leipzig and Dresden.

After forty years, the East German railroads

Mining and quarrying
Iron and steel production
Manufacturing center
Oil refining
Chemical processing
Grain processing
Port
Rail yard/construction

km 0 50 100
mls 0 50

For 40 years after World War II, the railroads of Germany were operated as two separate systems, in West and East Germany. Following reunification of the country, they were re-integrated under the Deutsche Bundesbahn name into a unified network.

were reintegrated into DB after 1986, and in 1994 the east German, west German and Berlin railroad properties were merged into Federal Railroad Assets. The combined railroad became Deutsche Bundesbahn AG, and by 2007 this was reaching the final stage of restructuring: DB Netz owns and administers the infrastructure; DB Regio, the passenger services; and DB Cargo, the freight side; with other subsidiaries for stations and tourism. DB Cargo has been the leading force in Railion, a company operating international freight trains in Europe.

Passenger services have been enlivened by the introduction of high-speed trains of the ICE family, and a moderate mileage of high-speed line has been built. Cities and regions sponsor and support many passenger services, and there is a large number of small independent companies.

TRANS-EUROPE EXPRESS TRAINS

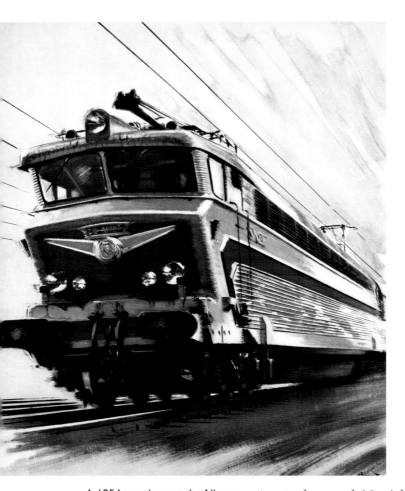

A 1954 travel poster by Albert Brenet, promoting the Trans-Europe Express services. It shows a French high-speed electric locomotive.

LINKING THE MAJOR CITIES OF EUROPE, THE TRANS-EUROPE EXPRESS NETWORK WAS CONCEIVED TO PROVIDE A VIABLE ALTERNATIVE TO AIR TRANSPORT FOR BUSINESSMEN AND OTHER FREQUENT TRAVELERS.

In 1957, the original six countries of the European Economic Community and Switzerland agreed to develop a network of fast inter-city trains that would provide comfortable accommodation for businessmen and other regular travelers. The idea was to combat the loss of railroad business to the airlines, and to provide out-and-home journeys on the same day, allowing time for business to be transacted at the farther destination. Later, it was extended considerably to include trains of the same standard running into Austria, Denmark and Spain. On some routes—between Paris and Brussels, Amsterdam and Munich, Paris and Hamburg—there was more than one train in each direction, although in the case of longer journeys, such as Hanover–Vienna by the Prinz Eugen or Paris–Venice by Le Cisalpin, it was not possible to apply the original out-and-home concept. All the new trains were named Trans-Europe Expresses (TEE), and some trains that were already well established on their own

account were designated TEE by the standard of their accommodation, speed and service. Such trains were the French *Mistral* (Paris–Nice), the *Rheingold* (Netherlands–Germany–Switzerland) and the *Étoile due Nord* (Amsterdam–Paris). All TEE trains offered first-class accommodation only, and the fare was subject to a special supplement, according to the distance traveled. On some trains, at the time of booking, it was necessary to specify the type of meal required, because this determined the section of the train where the passenger's reserved seat would be allocated.

The first TEE trains were operated jointly by the French and Belgian railroads, and consisted of six or twelve coaches, depending on traffic requirements, hauled by electric locomotives. The passenger accommodation was in compartments and open lounges, and meals were served at the passengers' own seats. The *Étoile du Nord* was made up of Pullman-type stock. The load was usually increased considerably at Brussels, where extra coaches were added for the non-stop run to the French capital.

The second type of TEE train was that of the German Federal Railroads and was known as the Rheingold type. Accommodation varied according to the route, with three to nine cars offering compartments and open saloons; meals were served in a separate 42-seat dining car. Some trains in this category were locomotive hauled, such as the *Rheingold* itself, while others, like the *Parsifal*, running between Paris and Hamburg via Cologne, were unit trains with power units at each end.

The third category of TEE train included, among others, the French 125mph (200km/h) flyers *Aquitaine*, *Étendard* and *Le Capitole*. They comprised seven to nine cars, with separate 42-seat dining cars. The *Cisalpin*, running through to Venice, included some Swiss rolling stock in its formation. The trains in the third group were electrically hauled, with the exception of the *Larbalete*, from Paris to Zurich, which took the eastern-region line through France, via Troyes, and was pulled by a diesel locomotive as far as Basel.

The fourth group of TEE trains included only the 'heavyweights' of the PLM system in France, the *Mistral* and the *Rhodanien*. Both were specified as providing 470 seats in fourteen cars; meals were served in the open saloon-type cars, or in a separate restaurant. Furthermore, the Paris–Nice section of the *Mistral* had a bookstall, bar and hairdressing salon. The *Mistral*, with a 9-hour run between Paris and Nice, was an afternoon train in each direction, but the *Rhodanien*, leaving Marseille at 7.10am, provided nearly 4 hours in Paris (1.44 to 5.37pm), with the return train arriving in Marseille just after midnight. The great weight of these trains provided some of the most interesting and severe locomotive duties to be

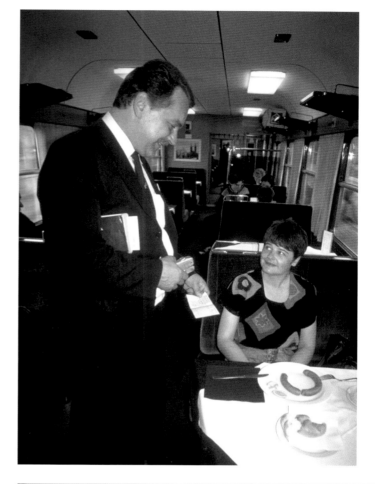

Top: A passenger's ticket is checked in the dining car of a TEE train.
Above: Driver's compartment of an Austrian TEE.

found anywhere in the world at that time. The *Rhodanien* ran the 507km (317 miles) between Paris and Lyon non-stop, in each direction, in 3 hours 43 minutes southbound and 3 hours 46 minutes northbound, at respective average speeds of 85.3 and 84.2mph (136.5 and 134.7km/h). The *Mistral* called additionally at Dijon and covered the 195 miles (312 km) from Paris (Lyon) in 2 hours 19 minutes southbound, and 2 hours 20 minutes northbound. The former entailed an average speed of 84mph (134km/h). Taking into account the slow running in the suburbs of Paris, both the *Mistral* and the *Rhodanien* had to run at 100mph (160km/h) for most of the way, and on the long southward climb into the Côte d'Or mountains to the summit at Blaisy-Bas tunnel, south of Dijon, usually the speed was not much below 95mph (152 km/h).

The fifth group of TEE trains included those operated by the Swiss Federal Railroads, which were five-car unit train sets, electrically worked, with seating for 168 passengers in open lounges and a separate dining car. One of these was the *Gottardo*, between Basel and Genoa, running non-stop over the highly picturesque Gotthard line between Zürich and Lugano. This train arrived in Genoa with just enough turn-around time for the same train set to make the return journey. However, a businessman could leave Zürich at 8.47am, reach Milan at 1.35pm and have more than four hours in the city before returning at 6.00pm to reach Zürich at 8.57pm.

The other Trans Europenan Express trains in the fifth group ran between Brussels and Zürich via Luxembourg, Strasbourg and Basel. During the winter months, the *Iris* left

The TEE system comprised 39 different express trains, working over 31 routes. Those routes with more than one service were: Brussels–Paris (4); Brussels–Strasbourg–Zürich (2); and Milan–Rome (2).

1 Étoile du Nord
2 Ile de France
3 Rubens
4 Oiseau Bleu
5 Brabant
6 Memling
7 Aquitaine
8 L'Étendard
9 Le Capitole
10 Le Mistral
11 Le Rhodanien
12 Le Cisalpin
13 L'Abalète
14 Stanislas
15 Kléber
16 Parsifal
17 Catalan-Talgo
18 Ligure
19 Saphir
20 Edelweiss
21 Iris
22 Lemano
23 Van Beethoven
24 Rheingold
25 Erasmus
26 Adriatico
27 Molière
28 Rembrandt
29 Helvetia
30 Roland
31 Prinz Eugen
32 Gottardo
33 Mediolanum
34 Blauer Enzian
35 Settebello
36 Ambrosiano
37 Vesuvio
38 Merkur
39 Cycnus

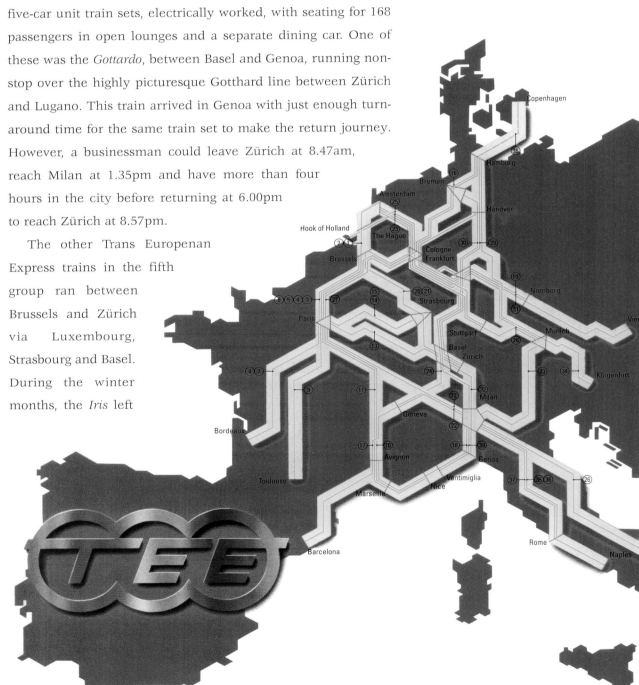

Brussels at 7.01am and reached Zürich at 1.59pm. The return time was 3.42pm, arriving at 10.39pm. The complementary service was that of the *Edelweiss*, which left Zürich at 6.59am and departed from Brussels on the return run at 4.11pm.

The sixth group was operated by the Italian State Railroads; it included some very interesting trains, like the *Settebello*. These were electrically operated with accommodation varying between four and eight cars, according to the service. There were two other trains on the Milan–Rome line in addition to the *Settebello*, the *Ambrosiano* and the *Vesuvio*, which ran through to Naples. Then there was the *Lemano*, which worked between Milan and Geneva, being named for its long run beside Lac Leman (Lake Geneva) and the Ligurian Sea. This train operated between Milan and Avignon, via Genoa, the Ligurian Riviera, the Côte d'Azur and Marseille. It was a long journey of more than seven hours, but it was interesting because it provided a connection at Avignon with another TEE, the *Catalan-Talgo*, which ran between Geneva and Barcelona. The *Catalan-Talgo* was unique among the TEE trains because it comprised special Talgo-type cars, each seating only 17 passengers in an open lounge. There were nine of these cars, meals being served in a separate 48-seat dining car. On this service, the car wheel sets were adjusted at Cerbère between the French gauge and the Spanish. The full journey was a long one, taking 9½ hr. The train traveled via Lyon, Avignon and Narbonne, and, after crossing the frontier between Cerbère and Port Bou, via Gerona in Spain.

One other Trans European Express requires particular mention, namely the *Merkur*, between Copenhagen and Stuttgart. This was the only train that involved transport by ferry. The train left Copenhagen at 9.45am, but did not reach Hamburg until 2.27pm. After that, it called at well-known German industrial centers, including Bremen, Dortmund, Essen, Düsseldorf, Cologne, Koblenz, Mainz and Mannheim, finally reaching Stuttgart at 10.58pm. The cars on this service were of German Federal Railroads type.

The *Catalan-Talgo* train approaches its final destination, Geneva, behind a French National Railroads electric locomotive. With this train, the locomotive and wheel gauge were changed at the Franco-Spanish border.

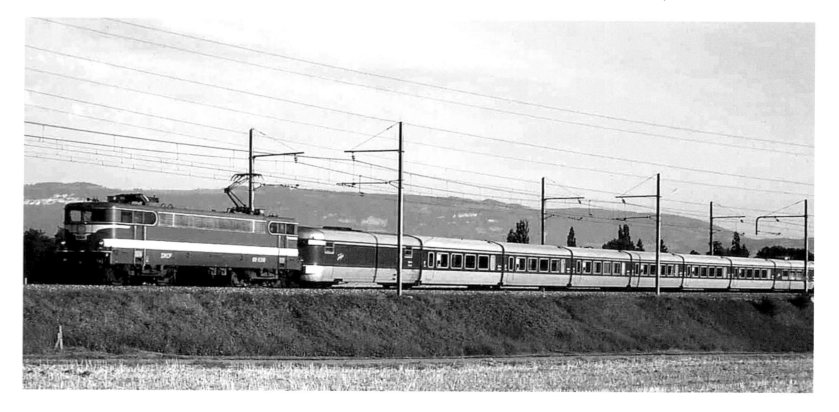

Efficiency Drive, 1875-1905

Increasing locomotive power involved more than simply building bigger engines; refining their designs so that they could make efficient use of fuel was essential.

The two sets of cylinders employed by the Mallet steam locomotive concept are clearly visible on this French narrow-gauge version of the type.

By 1875, the steam locomotive had become the predominant asset in the worldwide development of land transport. However, its overall efficiency, in terms of work done in hauling a train in relation to the latent energy in the coal or other fuel consumed, was very low, something less than eight percent. Consequently, engineers in Great Britain, France, Germany, Austria and the USA turned their attention to improving this low return for the fuel consumed. Studies were made of the stages in which steam was produced and employed; by common agreement, the use of two-stage, or compound, expansion of the steam appeared to offer the best prospects for improvement.

The theory was first put into practice by Anatole Mallet, who built a small tank engine for the Bayonne and Biarritz Railroad in 1875. Instead of being admitted simultaneously to two cylinders, steam was directed only to a single high-pressure cylinder; after expanding in that, it passed into a single low-pressure cylinder to complete its expansion before being exhausted to the atmosphere. In this way, Mallet was able to obtain a greater pressure range over the whole expansion of the steam than if it had been passed through

only one cylinder. Because the steam was at a much lower pressure on entering the low-pressure cylinder, it had to be of much larger diameter to ensure that each cylinder applied roughly equal thrust to the piston. Otherwise, the motion imparted to the locomotive would have been irregular, causing rough and dangerous riding.

Mallet's ideas were quickly taken up by other engineers, first by A. von Borries of the Prussian State Railroads, who built two locomotives of his own design in 1880. One of the problems that confronted designers of compound locomotives was starting. In a conventional two-cylinder locomotive using single expansion and cranks at 90 degrees to each other, if the crank and connecting-rod of one cylinder were at dead center, the second crank would turn the wheel and start the motion. In a two-cylinder compound engine, however, if the high-pressure cylinder was at dead center, the engine would not start. Von Borries designed a special starting valve that allowed a small amount of steam to pass directly into the low-pressure cylinder on starting, allowing the engine to get under way in all circumstances. Many locomotives of this type were built for service in Germany, while an adaptation of it was used on the North Eastern Railroad in England.

Tsarist Russia was a big user of the von Borries system, as illustrated by this standard freight locomotive. The photograph shows the big low-pressure cylinder; the left-hand cylinder was smaller.

One of the best known, but unfortunately least successful, of the compound systems employed in England was that of Francis William Webb, chief mechanical engineer of the London & North Eastern Railroad. For some reason, Webb employed three cylinders: two very small, high-pressure units outside, exhausting into one huge, low-pressure cylinder between the frames. It was a curious arrangement, and, despite its size, the low-pressure cylinder restricted the flow of steam. Another factor that handicapped these three-cylinder locomotives was that the two pairs of driving wheels were not coupled. This did not help when starting, since one pair might slip independently of the other and cause a lack of synchronization in the flow of steam. The Webb three-cylinder high-speed compounds, of which there were a hundred, did a great deal of hard work, but it might have been done much more easily had the two pairs of driving wheels been coupled.

A very important trend that affected all aspects of locomotive design, maintenance and operation on the line was the general switch to steel instead of wrought iron as the basic material of construction; this also applied to rails. With harder rails and harder tires on the wheels, locomotives and rolling stock could run more freely. In Great Britain, this was demonstrated by the fact that locomotives of good reputation, which had rarely exceeded 70mph (113km/h) in the 1870s, were reaching speeds of well over 80mph (130km/h) in the 1890s. The climax in speed achievement took place in Britain in the Race to the North in 1895, when competition between the east and west coast routes from London to Scotland led ultimately to an all-out race. This took place between express trains, which left Euston (west coast) and King's Cross (east coast) at 8.00pm for Aberdeen. The west coast record of 8 hours 32 minutes for a run of 870km (540 miles), with three intermediate stops to change locomotives, remained unsurpassed on any of the world's railroads for many years to follow. It is significant that all the fastest start-to-stop runs on both coasts were made by single-expansion engines of the 2-4-0 and 4-4-0 type.

Although larger locomotives were being introduced as prototypes to the end of the nineteenth

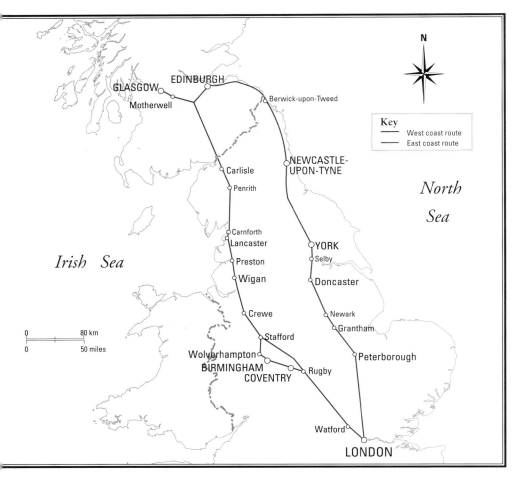

century, the 4-4-0 remained a world favorite for passenger work. In America, outside cylinders were universal and, although larger, the traditional locomotive was the same as the pioneers designed originally to run on the country's lightly laid tracks. The celebrated No. 999 of the *Empire State Express*, for which a maximum speed of 112mph (179km/h) was claimed, was of this type. In France, Germany and Austria, the various types of compound locomotive had outside cylinders, but in Great Britain, Holland and Belgium, inside cylinders were preferred.

Compound locomotive development took different routes in Austria and France. In the former, Karl Gölsdorf had to provide for climbing steep grades on main lines through the Alps, and at first he used a two-cylinder system. With outside cylinders of different sizes, these locomotives looked strange when viewed from the front, but the 2-8-0 type designed for the Arlberg Tunnel route in the Tyrol acquired a very high reputation, and some were still in service 70 years after their introduction, albeit on other parts of the network.

In France, the major development was the result of work by one of the pioneers of steam locomotive compounding, Alfred de Glehn. He employed four cylinders, two high-pressure outside and two low-pressure inside. The system was used on 4-4-0 locomotives of the Northern Railroad. These engines were complicated to operate, and their success was due to the French custom of allocating each locomotive to one engineer only, who had exclusive charge of it in service, and worked as a fitter on the engine when it was overhauled.

Three de Glehn Atlantic compounds were purchased by the Great Western Railroad for comparative

In Britain, in the late nineteenth century, there was fierce competition between the Great Northern Railroad (GNR) and London North Western Railroad (LNWR), which operated rival services from London to Scotland over the east and west coast main lines respectively. This led to an all-out race between London and Aberdeen in 1895, which was won by an LNWR 2-4-0 locomotive in a time of 8 hours 32 minutes.

Right: One of a large class of ten-wheelers supplied in the late nineteenth century by the British firm of Beyer Peacock to the New South Wales Government Railroads.

trials in England. This led to a development, not of compound locomotives, but of four-cylinder single-expansion engines. These 4-6-0 locomotives, which led to the famous Castle and King classes in 1923–27, included a number of de Glehn design features. At the time, however, Great Western boiler design was derived

largely from American practice, with tapered barrel and high raised Belpaire (or flat-topped) firebox.

Up to that point, locomotives had used steam just as it was boiled, known as saturated steam. In Germany, Dr. Wilhelm Schmidt was applying the principle of super-heating to locomotives of the Prussian State Railroads. After formation, the steam was heated further before use. This increased its volume considerably and thereby its power generating capacity in the cylinders. To obtain more steam, additional heat and more coal had to be used,

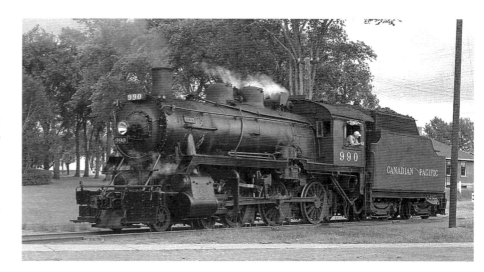

The Canadian Pacific was one of the few North American railroads to design and build its own locomotives. By the end of the nineteenth century, it had built ten-wheelers in large numbers, before moving on to larger types.

but the advantages far outweighed the cost. Eventually, super-heaters became universal on nearly all new locomotives from about 1912 onward.

With the twentieth century came an era of huge locomotives. In Great Britain, the 4-4-2 and 4-6-0 types superseded the 4-4-0 for passenger work, while in the USA the transition from the outside-cylinder 4-4-0 was rapid. Intervening stages of the 4-4-2 and 4-6-0, known in the USA as the Atlantic and the Ten-Wheeler respectively, gave way to the Pacific or 4-6-2.

In the USA, compounds were built on the Vauclain and tandem systems, favored because they allowed the cylinders to be mounted outside the frames. Both employed four cylinders. In the Vauclain, the high- and low-pressure cylinders were mounted in two pairs, one on each side of the engine. The high-pressure cylinder was above the low-pressure cylinder, their pistons were connected to a common crosshead. In the tandem system, one high- and one low-pressure cylinder were mounted on a horizontal axis, the pistons being attached to a continuous piston rod. Many locomotives of both types were built in America.

Left: Inside the smokebox of a British locomotive. The super-heater tubes can be seen bending out and up from the large boiler tubes

Railroads in Russia and the Former Soviet States, from 1837

ONCE AN INTEGRATED SYSTEM THAT SPANNED A VAST EMPIRE, THE RAILROADS OF THE FORMER SOVIET UNION HAVE SINCE BEEN SPLIT UP TO SERVE THEIR INDIVIDUAL STATES, WITH VARYING RESULTS.

RUSSIA

Russian Railroads was by far the largest of the systems that emerged after the dissolution of Soviet Railroads in 1992, following the break-up of the Soviet Union. The railroads of Soviet Russia had made up the largest single railroad system in the world. They had extended from the Polish frontier to Vladivostok, a distance of some 6,300 miles (10,000km), and from the White Sea in the north to Turkestan in the south.

The first public railroad was opened in Russia in 1836, using British locomotives supplied by both Stephenson

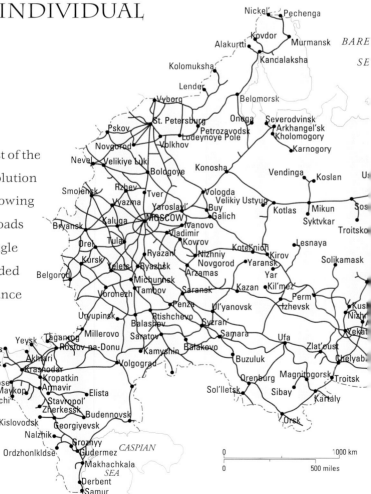

and Hackworth. From a modest beginning, great expansion followed the completion of the main line between Moscow and St. Petersburg (renamed Leningrad during the Soviet era) in 1851. By 1913, the railroad network consisted of no fewer than twenty-five state lines and thirteen private lines.

The almost legendary Trans-Siberian line was still under construction in the early twentieth century, although communication between Moscow and Vladivostok had been established by shipping passengers and freight by ferry across Lake Baikal. The line was completed by blasting out a route from the solid rock along the shores of the lake. The sparsity of good railroads in the European provinces of Russia was responsible in part for the collapse of Russian forces in World War I. After the revolution of 1917, the railroads were nationalized and great efforts made toward reconstruction. It was realized that efficient communication was an essential requirement of the new state, and by the 1930s, the railroad system had been so modernized that it had gone from being a serious liability to being one of the greatest assets of the national economy.

Although a great deal of damage was done to the lines in the war zones during 1941–44, reconstruction and development continued, and on the eve of the USSR's collapse, the route length was more than 80,000 miles (128,000km), of which more than 20,000 miles (32,000km) were electrified, including the Trans-Siberian line as far east as China. In non-electrified areas, there had been a general move to replace steam

Russian railroads survived the collapse of the Soviet Union and the loss of large portions of the original Soviet network to the various break-away states. Since 2000, they have undergone restructuring and there is fresh investment in infrastructure and rolling stock.

KARA SEA

N

SEA OF OKHOTSK

SEA OF JAPAN

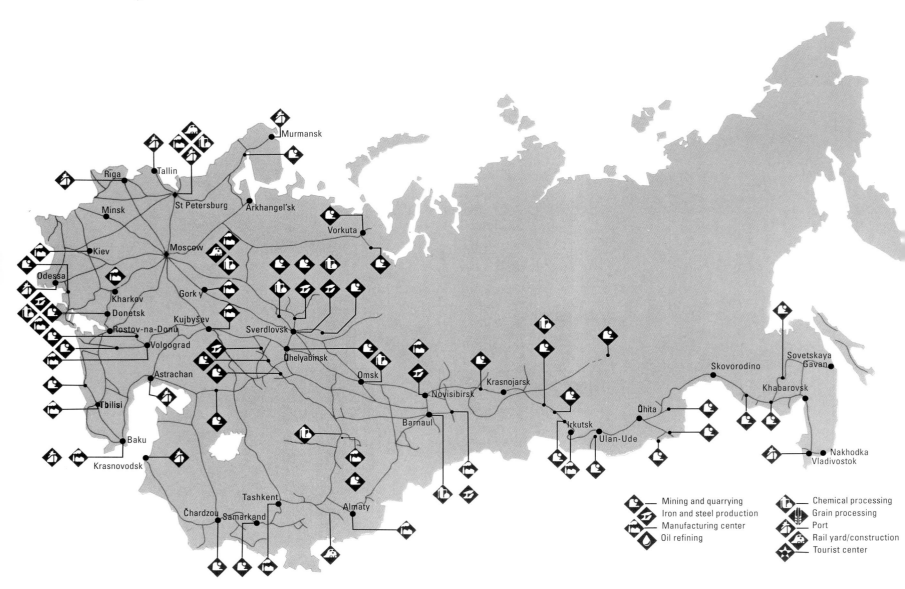

In the days of the Soviet Union, the Soviet Russian railroad system was the largest in the world, stretching from the Polish border in the west to Vladivostok in the east, and from the White Sea in the north to Turkestan in the south.

locomotives with diesels, and a new high-speed train was running between Moscow and Leningrad.

In the first difficult post-Soviet decade, the railroads remained an island of stability among surrounding chaos. Restructuring began after 2000, and Russian Railroads has been hiving off its various departments and activities to 'daughter' companies that eventually will be wholly or partially privatized, leaving Russian Railroads as owner and administrator of the infrastructure and the means through which the state can exercise supervision. Efforts have been made to attract east–west container traffic over the Trans-Siberian, while years of under-investment are being tackled by the construction of new designs of rolling stock; in addition, some fast trains have been introduced. Private companies have made an appearance, owning and operating their own freight wagons, as well as a few premium-fare passenger trains.

UKRAINE

Ukrainian Railroads was the second largest of the former Soviet railroads. It still used Soviet-era equipment and lived through hard times in the 1990s, failing in its effort to close loss making lines, while its management faced accusations of corruption. Many of its debtors were reluctant to settle their accounts, and in one year, on the eve of a conscription call-up period, it refused to issue military concession tickets until the Defence Ministry had paid off its previous debts. The system still carries much heavy traffic for the mining and industrial areas of the south.

BYELORUSSIA

The Byelorussian railroad system has remained in need of investment, but benefits from its main line, which is part of the Berlin–Moscow route and carries an increasing volume of east–west freight, including traffic from the Far East. Privatization is frowned upon by the government and, in 1998, a railroad law considerably modified the previous Soviet-style organization, with the aim of making it more difficult to achieve a privatization by stealth.

ESTONIA, LATVIA AND LITHUANIA

The three Baltic states of Estonia, Latvia and Lithuania were formerly regions of the Soviet Union, but now are members of the EU. All have railroad systems that are still dependent on Soviet-era equipment, but all, to varying degrees, have embraced the concept of restructuring. In Estonia, privatization was a troubled process, the initial choice of foreign investor being flawed, and a subsequent private owner doing so well that the government insisted on buying back the assets. All three derive much traffic from Russia, especially to and from the Baltic ports, so a change from the Russian to European standard gauge would be complex as well as costly.

KAZAKHSTAN, KIRGHIZIA, TURKMENISTAN AND UZBEKISTAN

The networks in Kazakhstan, Kirghizia, Turkmenistan and Uzbekistan made up the former Central Asia railroads of Soviet Railroads. Kazakhstan's system is largest, with 8,100 miles (13,000km) at the

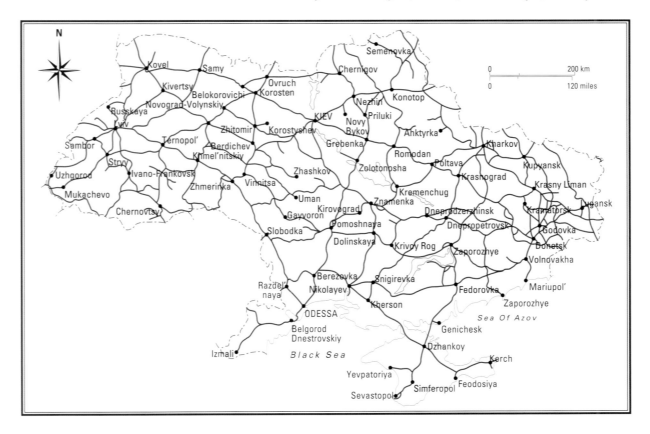

The Ukrainian railroad network is the second largest of the former Soviet systems. It includes many loss making lines, but carries heavy industrial traffic in the south.

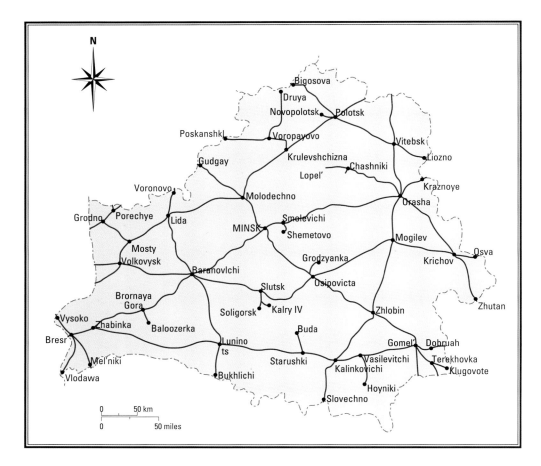

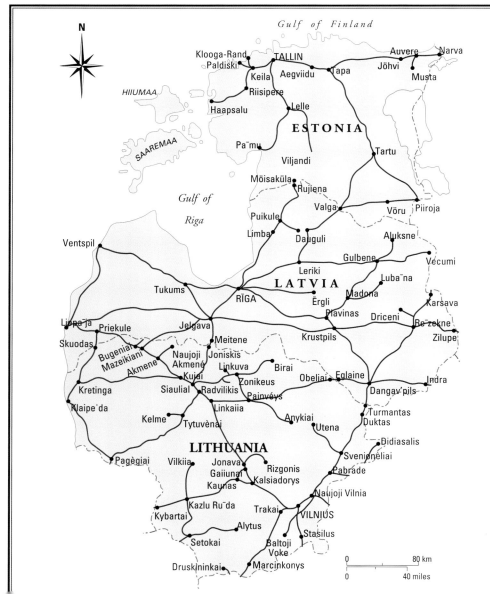

turn of the twenty-first century, of which a considerable mileage was electrified. New construction was under way, and there was the beginning of a rolling-stock industry.

Kirghiz Railroads, by contrast, is small and consists of what was virtually a branch line of the Soviet system, connecting the capital Biskek with the rest of the system. However, Kirghizia expects to benefit from the proposed Eurasian Railroad, which would make it a link between China and points west.

Turkmenistan State Railroad is also expanding. A line providing a link with Iran was finished in 1996, and some quite long lines are following. However, its main line remains that from the capital, Ashkhabad, to the Caspian at Turkmenbashy.

Uzbekistan Railroad, like all the ex-Soviet lines, has suffered from under-investment, and much of its rolling stock has spent years awaiting repair. There has been a gentle move toward restructuring, separation of infrastructure being the first recommended change.

ARMENIA, AZERBAIJAN AND GEORGIA

The railroads of Armenia, Azerbaijan and Georgia once belonged to Soviet Railroads, but have not prospered since independence due to the disturbed state of the region, with open warfare between Armenia and Azerbaijan, tense relations between Georgia and Russia, and the effects of the nearby Chechen wars. As everywhere in the former USSR, common standards enable through running of trains between these railroads; between them and Russia, however, such international traffic has dwindled.

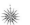

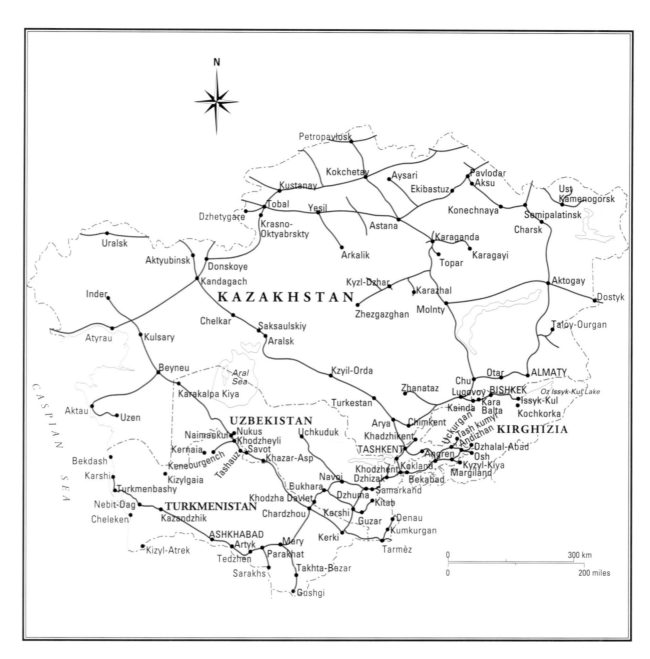

Opposite page, top: The main line of the Byelorussian network forms part of the Berlin–Moscow route, and the system provides a vital link for east–west traffic from the Far East.

Opposite page, bottom: The railroad systems of Estonia, Latvia and Lithuania carry a substantial amount of Russian traffic to the Baltic ports. They make extensive use of ex-Soviet equipment.

Top left: Formerly the Central Asia railroads of Soviet Railroads, the systems in Kazakhstan, Kirghizia, Turkmenistan and Uzbekistan are all undergoing restructuring and expansion, following years of under-investment.

Bottom left: In Armenia, Azerbaijan and Georgia, the railroads have not advanced since those countries gained their independence, mainly because of local political upheaval.

Backbone of an Empire, the Trans-Siberian

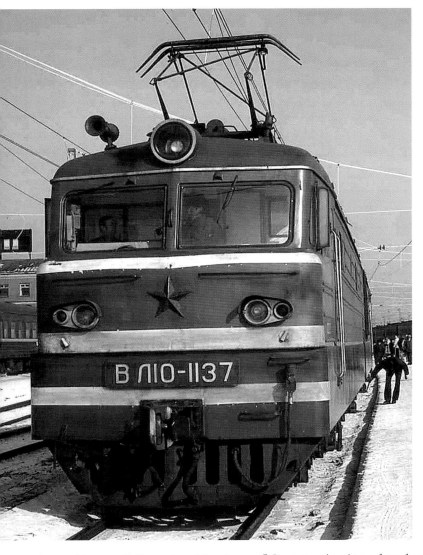

Moscow–Beijing train at Irkutsk. Electric freight locomotives like this were used for passenger services in the 1980s.

BUILT TO LINK MOSCOW WITH THE FAR FLUNG EASTERN SHORES OF THE VAST RUSSIAN EMPIRE, THE TRANS-SIBERIAN RAILROAD HAS PROVED A VITAL ARTERY IN TIMES OF PEACE AND WAR.

It was said that the Trans-Siberian Railroad was the backbone of the USSR. It is the longest continuous railroad in the world, for the distance from Moscow to Vladivostok is nearly 6,000 miles (10,000km). The Russians began their eastward progress in the sixteenth century, and the first Russian troops to reach the Pacific were a regiment of Cossacks in 1639.

The absorption of Siberia into the Russian Empire continued over the following 200 years, and in 1858, during the worldwide railroad mania, the first proposals were made for a trans-Siberian railroad to the Pacific. The Russian government turned a deaf ear, however, for the Crimean War had drained the treasury, and it was not until 1875 that the Ministry of Communications dared to put forward an official plan; even then, it was not approved. But the seed had been sown, and a succession of official and semiofficial plans were floated during the following years. In the late 1880s, a survey and estimates were made, and in 1891, the government gave its

official approval. Later that year, Crown Prince Nicholas broke the first ground at Vladivostok during his Far Eastern tour.

By that time, the Russian railroads had passed beyond the Siberian border to Chelyabinsk, and construction began at both ends. However, the Russian finance minister was still daunted by the estimated cost of the line, since a succession of bad harvests had caused financial stringency, and it was not until Sergius Witte, a professional railroad man, became finance minister that large-scale progress began, partly with loans from French and other sources. A Trans-Siberian Committee was formed, with Prince Nicholas in the chair and a membership that included almost every important figure in government circles; the whole vast undertaking was put on a business footing.

The route of the projected line passed through Omsk, Novosibirsk, and Krasnoyarsk to Irkutsk, near Lake Baikal. Up to that point, the project was fairly straightforward, as the line would be comparatively level, passing through fertile land bounded on the north by tundra and on the south by arid country. From Irkutsk, however, engineering difficulties began, for the country was mountainous from Lake Baikal eastward. After consideration, the committee decided that it would save time and money to cross the lake by train-ferry rather than to go around it by rail. From the eastern shore of Lake Baikal, the line would pass through Ulan-Ude and Chita.

A restored P36 class 4-8-4 express passenger locomotive, the only privately owned engine in Russia, hauling the *Trans-Siberian Express*, a tourist train, on the renowned railroad. The P36 was the last and most famous class of Soviet steam locomotives, and most were allocated to prestigious trains.

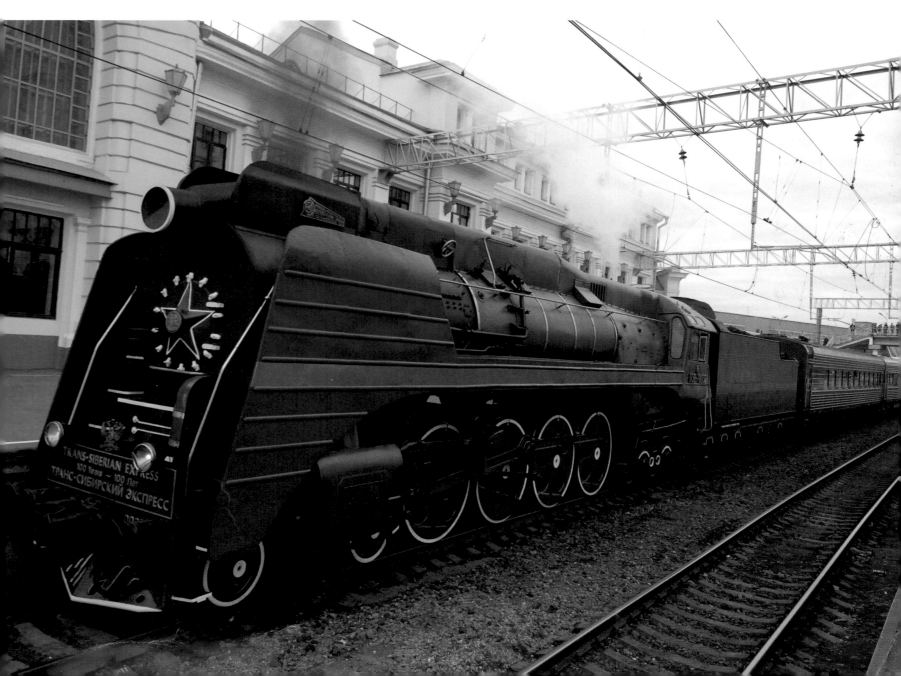

The engineers had submitted a pessimistic report about the section of the railroad that passed around the Chinese province of Manchuria. The country north of the Amur river (the frontier) was very rough, and much earthwork would be needed, which would consume large amounts of time and money. The committee decided that it would be much better if some arrangement could be made with the Imperial Chinese government that would allow the railroad to be built through the comparatively flat land of Manchuria, since this would give a shorter and cheaper route.

The coronation of Tsar Nicholas II in 1895 gave the Russians an opportunity of meeting high Chinese officials, and invitations were sent. They were pleased when the Imperial Chinese government selected Marquis Li Hung-chang as their envoy, for not only was he the most capable man of his time, but also he was a believer in railroads. Furthermore, he was known to be apprehensive about a war with Japan and inclined to seek other friends. An agreement resulted, leading to the creation of the Chinese Eastern Railroad, a joint Sino-Russian line stretching across Manchuria, which allowed the completion of the Trans-Siberian Railroad. The agreement also permitted the Russians, jointly with the Chinese, to construct a branch of the Trans-Siberian line southward about 500 miles (800km) to Talien (Luda) and Port Arthur at the southernmost tip of Manchuria. Unlike Vladivostok, both were ice-free ports, which made them preferable during the winter.

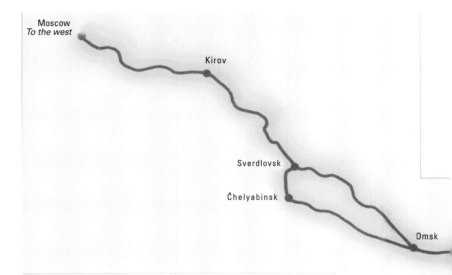

The Russians lost no time in pushing ahead with construction. However, they experienced difficulties with the Hung Hudze, wild and aggressive tribes that looted construction camps and stole wire from the railroad. The railroad police, almost wholly Russian in personnel, were reinforced to keep order, and the Russians became dominant in northern Manchuria. The lack of hard roads was another difficulty faced by the engineers, who finally decided to build a supply rail line of low quality along the selected route, with the permanent line alongside it. This saved time and money.

In 1903, the Chinese Eastern Railroad was complete, not only the west–east line, but also the branch to Port Arthur. As the connecting lines on both frontiers had already been built, through running from St. Petersburg (Leningrad during the Soviet era) to Vladivostok was possible, except for the line around Baikal, which was completed in 1904.

The quality of the line was poor, however, due to the original orders of the committee. The tracks had been laid with light rails that allowed an axle load of only 13 tons, while the ties were untreated and ballast was very thin due to a shortage of

The Trans-Siberian Railroad has been a vital artery for Russia during both the Soviet and post-Soviet eras, and in times of war and peace.

stone on several sections of the route. The Chinese Eastern Railroad also gave much trouble. Nevertheless, traffic began to flow, hindered only by numerous derailments. A major program of improvements, the cost of which would be met partly out of revenue, was instituted and lasted for many years, although the Russo-Japanese War disrupted the work. The railroad was in no fit state to cope with large-scale military traffic, and its limitations were an important, if not the prime, cause of the Russian defeat. The peace treaty conceded to the Japanese two-thirds of the Port Arthur line, together with the ports of Talien and Port Arthur.

Taiga, a junction in Western Siberia, photographed in the annual thaw in 1988. Apart from the electrification installations, the building has remained unaltered.

By then, the committee had already decided that it was necessary to circumvent Manchuria and the Chinese Eastern Railroad, and construction began. The work was difficult and not completed until 1916, when the railroad was at once used to its full capacity to carry war material from Japan and the United States to bolster Russia's military effort during World War I. By that time, however, the quality of the entire Trans-Siberian Railroad had been greatly improved, and it was able to withstand the additional traffic satisfactorily.

The line was vital during the civil war that followed the Russian Revolution, but after a pause, the program of improvements continued; in fact, it has never ceased. The Russians sold their share of the Chinese Eastern Railroad to the Japanese in 1935, but have pushed on with railroad construction in their own territories. The line from Moscow to Vladivostok has been double tracked and electrified. The quality of the passenger accommodation provided by the *Rossiya* train is almost on a par with the Wagons-Lit Company trains of the 1900s, which were regarded as equal to anything in the world at that time.

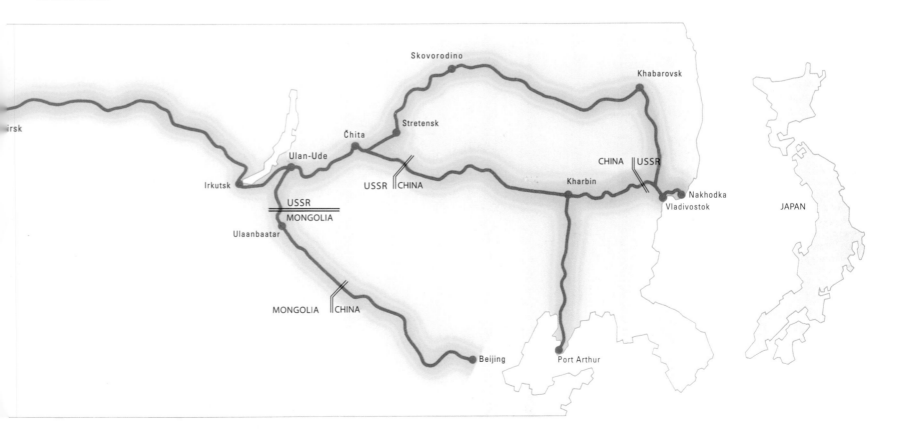

LOCOMOTIVE DEVELOPMENT, 1906-26

THE EARLY TWENTIETH CENTURY SAW MAJOR ADVANCES IN LOCOMOTIVE DESIGN AND DIMENSIONS, IMPROVING THEIR TRACTIVE EFFORT AND ALLOWING HEAVIER TRAINS TO BE HAULED AT GREATLY INCREASED SPEEDS.

By the end of the nineteenth century, it seemed that railroad administrations around the world aimed to have the smallest locomotives that would work the traffic, but within a matter of ten years, the pendulum had swung strongly in the opposite direction. Heavier and much more luxurious rolling stock was being built; dining and sleeping cars were being added to many of the principal trains; and while the urge to accelerate services had lessened, there was no deceleration. In all countries, much larger locomotives were being built, and for the first time—in Great Britain at any rate—size and weight began to approach the maximums that the lines could bear.

Civil engineers placed limits upon the maximum axle loads that they were prepared to accept, but in Great Britain, the crisis was postponed by the introduction of super-heating. Small locomotives equipped with this feature could pull heavier loads than their predecessors of equivalent size and weight. Certain locomotives of an unusual size by previous standards and of the 4-6-0 type were built by the Caledonian, and by the London & South Western Railroads, but for sheer size, Churchward's Pacific, *The Great Bear*, on the Great Western Railroad, surpassed all. This was only the second locomotive of its type to be built in Europe, the first being on the Paris-Orléans Railroad in 1907. Completed at Swindon in 1908, *The Great Bear* was virtually an experiment in boiler design to meet future requirements, although in fact these did not materialize.

The problem of maximum axle loading in locomotives was becoming much more acute on the continent of Europe. Most of the massively built and well-maintained British main lines were capable

of accepting axle loads of up to 18 or 19 tons, but this was not the case in Holland for example. In the early 1900s, traffic across that country, particularly conveying the Anglo-German mails, was becoming increasingly heavy, and the elegant British built 4-4-0s of the Netherlands State Railroad could not cope with the trains on their own. Larger locomotives were needed, which normally would have meant heavier axle loads, but the civil engineers would not permit that because of the nature of the foundations on many parts of the lines.

The matter of engine balancing became critical. In any locomotive, the revolving cranks, reciprocating rods, and pistons set up a degree of imbalance, and if no steps are taken to counteract this, unsteady and unsafe riding can result. Consequently, a degree of balance was provided by adding compensating weights to the wheels. These, while producing a smooth riding engine, imparted a "hammer-blow" effect on the track, which increased as the speed rose. On some British 4-4-0 locomotives, at 70–75mph (113–120km/h), this was equal to 50 percent of the static axle load, giving a total load on the track of 28–29 tons. If, however, four cylinders were used instead of two, and all four drove the same axle, the movements of the pistons, cranks, and rods exactly counterbalanced each other and there was no hammer blow at all. On the Netherlands State Railroads, the civil engineers were prepared to accept

A compound Mallet locomotive, built in 1911 by the American Locomotive Company for Mexican National Railroads.

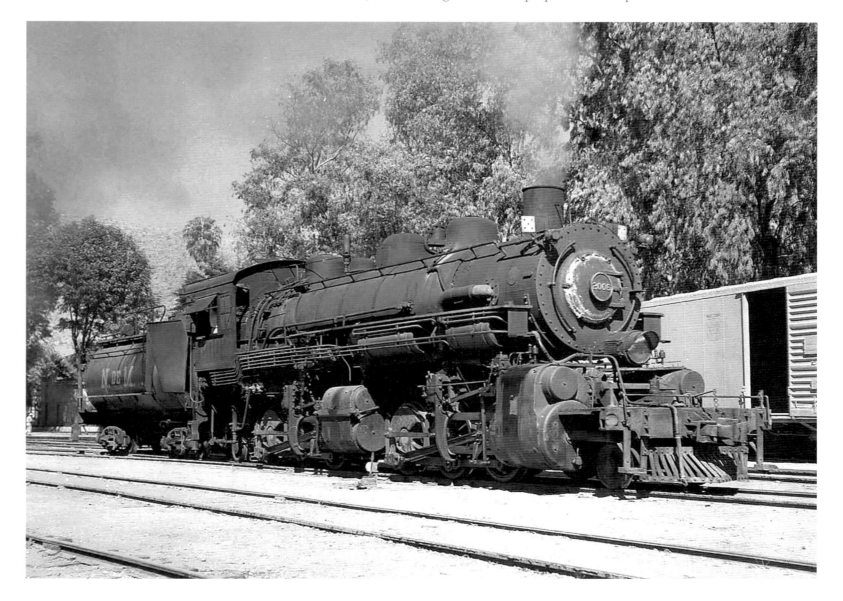

One of the original General
Electric locomotives built in
1906 for the New York Central
Railroad's electrified line into
Grand Central Terminal.

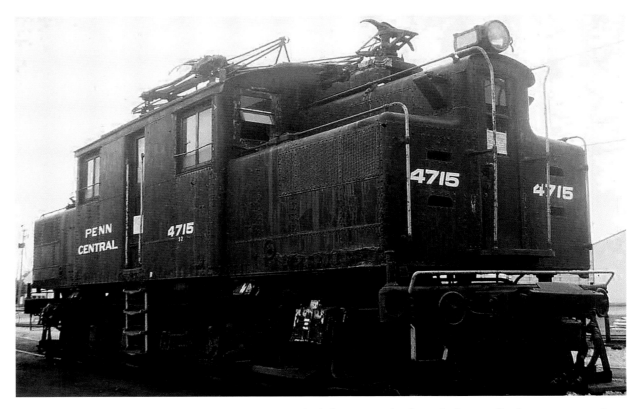

heavier axle loads on larger locomotives, provided they were built with four cylinders. As a result, a fine range of powerful 4-6-0 locomotives was built.

In the USA, the equipping of all freight trains with continuous automatic air brakes enabled very long and heavy trains to be safely controlled when descending steep grades, and the size and power of the locomotives needed to haul such trains on level track and adverse grades had to be increased accordingly. For this, the Mallet articulated compound type proved suitable, and it was enlarged to unprecedented length and tractive power. Some of the largest built in the period 1906–15 were 2-6-6-2s for the Chesapeake & Ohio, weighing 270 tons, and 2-8-8-2s for the Southern Pacific, weighing 265 tons. With such massive boilers and fireboxes, the rate of coal consumption was far greater than could be sustained by a single fireman, so mechanical stokers were introduced. These devices fed coal from the huge tenders directly on to the firegrate, distributing the fuel evenly over its wide area. The stokers were designed so that the rate of feed could be regulated by the fireman according to the needs of the journey.

These giant locomotives were four-cylinder compounds, and the low-pressure cylinders carried on the forward articulated engine unit were often as large as 40in (101cm) in diameter. Fortunately, the working of American freight trains did not require any fast running, since these compound Mallets became rather unstable at any speed above about 30mph (48km/h). Subsequently, this instability was shown to be due to uneven weight distribution between the front and rear engine units, which was corrected in later articulated locomotives, allowing them to be run safely up to 70mph (113km/h) when hauling the express freight trains of the 1930s.

One of the most important advances during this period was in the technique of locomotive testing. From an early date in the history of railroads, dynamometer cars had been used to measure the pull exerted by a locomotive. In effect, they were sophisticated versions of the simple spring balance.

However, when such measurements were taken while a locomotive was working a service train, they were subjected to all the incidentals of daily railroad operation—checks because of adverse signals and so on. In the USA, to avoid these problems, plants were set up at Purdue University and at the St. Louis Exhibition of 1904, on which locomotives could be tested under controlled conditions. The wheels were supported on rollers, the driving wheels being made to rotate the test-plant rollers against an applied load. This could be varied according to requirements, and the task of hauling a train of any load and at any speed could be simulated. The behavior of the locomotive, steam production, coal consumption, and all other workings could be observed in the carefully regulated atmosphere of a laboratory, instead of in the rough-and-tumble conditions of daily service on an ordinary railroad route. At the conclusion of the St. Louis Exhibition, the test plant, on which the working of a number of dissimilar American locomotives had been demonstrated, was removed and set up on a permanent basis at the principal locomotive works of the Pennsylvania Railroad at Altoona.

In Great Britain, modern dynamometer cars were built by the Great Western, North Eastern, London & North Western, and Lancashire & Yorkshire railroads, but only the Great Western followed the American example and built a stationary testing plant. In the beginning, this plant was not used to a great extent, reliance being placed upon tests with the dynamometer car on service trains. On the London & North Western Railroad, in November 1913, during tests with one of the four-cylinder 4-6-0 locomotives of the Claughton class, the highest output of power registered by a British locomotive was attained, namely 1,669hp at a speed of 70mph (113km/h). This was not surpassed until considerably larger locomotives entered service after World War I.

By 1912, the era of the "mixed-traffic" locomotive had begun. With the acceleration of freight services, it was felt that there was a need for units that could haul both fast freight trains and medium-speed passenger services. Valve gears were being improved, and locomotives with coupled wheels of no more than 5ft 6in (1,676mm) diameter were able to make speeds of up to 70mph (113km/h) economical. This

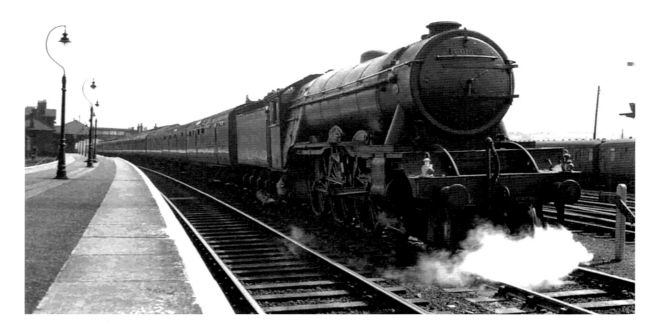

One of the original Gresley three-cylinder Pacifics at Grantham, Great Britain, on the East Coast route in the 1950s. These locomotives were named to commemorate famous racehorses: this is *Flying Fox*.

trend, and the locomotives that were entering service in Great Britain as a result of it, was particularly advantageous when motive power had to be supplied for serving the battle fronts during World War I. Dual-purpose locomotives were ideal for both troop and munitions trains. However, the taking of railroads under government control, both in Great Britain and France, due to the war, led those with overall responsibility to look toward a far greater degree of standardization of locomotive design than had been thought desirable previously. Committees were set up and new standard designs drafted.

In France, events moved somewhat faster than in Great Britain, because one sector of the French railroad network was actually owned by the state; the government placed large orders for the standard Pacific engine design of that railroad, together with a 4-6-0 dual-purpose type. Some orders were placed in Britain, because essential manufacturing facilities in France were in enemy hands. Arrangements were made for these new locomotives to be allocated also to the privately owned railroads of France, in the hope that subsequently they would be adopted as standard. In Britain at the end of the war, the Minister of Munitions, Winston Churchill, was anxious to place large orders for new locomotives, to help avoid the large-scale unemployment that it was feared would result from the sudden end to the demand for munitions. This project never materialized, however, partly because the independent British

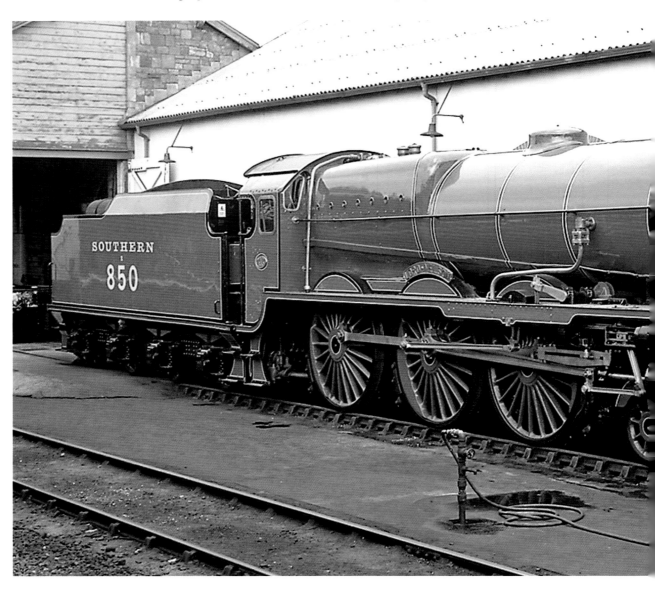

The Southern Railroad Class LN or "Lord Nelson" Class was a four cylinder 4-6-0 locomotive intended for express passenger work in the southwest of England. Sixteen were constructed and represented the ultimate in SR's 4-6-0 design. This preserved locomotive, built c.1926, is pictured at Minehead station in 2006.

railroads of the day could not agree among themselves on locomotive designs and specifications.

Just as the increasing size and weight of locomotives had brought Continental engineers together in the early 1900s, so also in Great Britain, after the war, locomotive and civil engineers were associated with scientific and university research programs instigated by the Bridge Stress Committee. The responsibility of this committee was to examine the effects that different types of locomotive had upon a variety of bridges. The outcome emphasized the beneficial effects of locomotives with three or four cylinders, and underlined the damaging effect of certain designs with only two inside cylinders. This confirmed the correctness of the policy adopted by all four of the large groups set up by the Railroads Act of 1921, the provisions of which took effect from January 1, 1923.

Notable multi-cylindered, high-speed passenger locomotives of the 1920s were the Gresley three-cylinder Pacifics of the LNER, the four-cylinder 4-6-0 Lord Nelson class of the Southern and the three-cylinder 4-6-0 Royal Scot of the LMSR. The Great Western's policy of building four-cylinder 4-6-0s for the heaviest passenger traffic continued with enlargements from the Churchward Star class of 1907 to the King of 1927, with the high nominal tractive effort of 40,300lb (18,280kg). The continued use of loose-coupled, unbraked cars on the majority of British freight trains meant that loads could not be

greatly increased, and no significant growth in the size or power of freight locomotives took place in Great Britain throughout this period.

In France, the allocation of government ordered locomotives to some of the private railroads did not have the desired effect. The Northern, and the Paris, Lyon & Mediterranean had always followed a strongly individual practice, and the new locomotives of the State Railroad type were regarded as no more than temporary assistance, being transferred elsewhere after a short time. The Northern introduced a splendid new design of Pacific, which did magnificent work on the very long English boat trains, while the PLM brought out a huge 4-8-2 for working over the steeply-graded central section of the main line from Paris to Marseille, between Laroche and Dijon, where the line passes through the Côte-d'Or mountains. In the meantime, the American Mallets were becoming larger than ever; in 1923, the Denver & Rio Grande Western took delivery of some compound freight engines of 2-8-8-2 type that had grates of 96.5sq.ft (9sq.m) and a tractive effort of 106,600lb (48,353kg). The diameter of their low-pressure cylinders was no less than 3ft 3in (1m), while the total weight of the engine and tender was a staggering 332 tons.

RAILROADS IN SWITZERLAND AND AUSTRIA, FROM 1838

THE MOUNTAINOUS LANDSCAPE OF SWITZERLAND AND AUSTRIA PROVED PARTICULARLY CHALLENGING TO EARLY RAILROAD BUILDERS, BUT CLEVER ENGINEERING PROVIDED INGENIOUS SOLUTIONS TO MANY PROBLEMS.

The railroads of Switzerland, most of which are nationalized, can be divided into two distinct geographical groups. There is the close, intensely used network in the broad valleys linking Zürich, Basel, Luzern, Lausanne, and Bern with a series of fast intercity electric trains; then there are the great mountain routes. The latter are famed for some of the most spectacular railroad engineering in the world, with many examples of spiral-track lines, viaducts of breathtaking height,

One of Swiss Federal Railroads many electric commuter trains awaits its passengers at Basel.

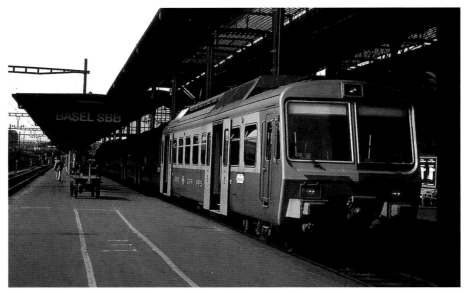

and some of the longest tunnels ever driven beneath mountain ranges. Within the mountain routes, there are distinct subdivisions. For example, the Gotthard, the Lötschberg, and the Simplon are teeming arteries of heavy north–south international traffic, while others are built on the meter gauge to provide access to some of the more remote resorts.

It was soon after the establishment of the Swiss Confederation in 1848 that the government invited Robert Stephenson to submit proposals for a national railroad system. At that time, only one railroad had been constructed, connecting Zürich with Basel. Stephenson proposed a main line from Zürich

through fairly level country to Lausanne and Geneva; this became the extremely busy line that forms the backbone of Switzerland's modern railroad operation.

When railroad connections with the neighboring states were proposed, it was clear that the Alpine ranges would have to be crossed. The Gotthard route was the first, heading south from the twin central "springboards" of Zürich and Luzern, beneath the historic mountain pass into the Italian speaking canton of the Ticino, and from there through Como to Milan. To obtain an acceptable grade for steam locomotives—2.7 percent—the technique of spiral tunneling through the mountain sides was developed. The great Gotthard Tunnel was opened in 1882. The approach to the Simplon Tunnel, opened in 1906, does not involve such dramatic engineering, because the former Jura-Simplon Railroad followed the valley of the Rhône from the head of Lake Geneva, near Montreux.

Today, the Gotthard and the Jura-Simplon lines are parts of the Swiss Federal Railroads. At Brig, at the eastern entrance to the Simplon Tunnel, however, the line into Italy is joined by the greatest of the Swiss private railroads, the Bern-Lötschberg-Simplon. This mammoth enterprise has tunneled under the mighty ranges of the Bernese Oberland and provided some truly spectacular sights for the traveler on the ascent to the Lötschberg Tunnel from Spiez on Lake Thun, and perhaps even more awe inspiring views on the descent into the vally of the Rhône.

Finally, there is the magnificently engineered meter-gauge Rhaetian Railroad, leading from Chur to the famous Alpine resorts of Pontresina and St. Moritz in the Upper Engadine. The Albula Line, as it is otherwise known, is also spectacular in the sharpness of its curves, and for the speed and smoothness with which they are negotiated, often on the edges of towering precipices.

Thanks to abundant hydroelectricity, Switzerland was a pioneer in electrification, and virtually all Swiss railroads employ this power source. There were financial difficulties in the 1990s, however, which led to a new strategic plan, named Bahn-2000. This included increased and well-integrated passenger services, with half-hourly trains on the main routes. Some new line construction was also undertaken.

Occupying a key position between Italy and the rest of Europe, Switzerland carries a heavy transit traffic, but is opposed to the use of heavy road vehicles and the driving of trucks at night. Various measures have been taken to deter road transport, while incentives for rail use have been provided. The latter include the "rolling highway," trains that carry trucks through Switzerland and provide rest breaks for their drivers. To increase line capacity, two new Gotthard and Lötschberg base tunnels were under construction in early 2008.

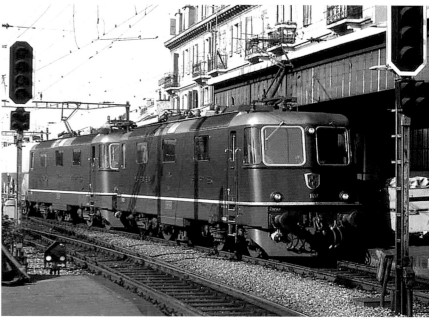

A pair of Swiss built electric locomotives haul a freight train through Geneva in the 1980s. Here, as elsewhere in Switzerland, most freight trains conveyed international traffic.

The mountainous terrain of Switzerland influenced the railroad network. Builders were obliged to follow broad valleys, but techniques developed that allowed the mountains themselves to be penetrated.

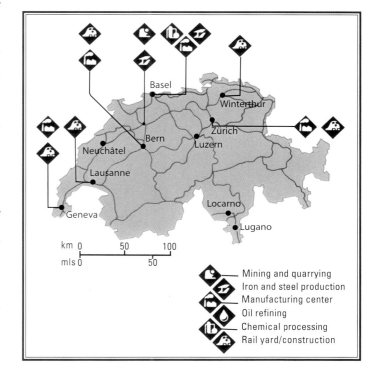

Mining and quarrying
Iron and steel production
Manufacturing center
Oil refining
Chemical processing
Rail yard/construction

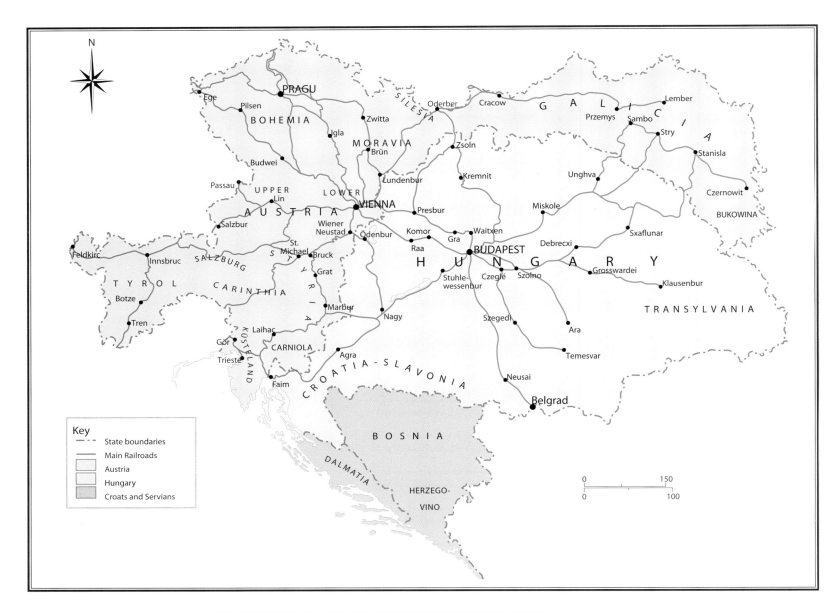

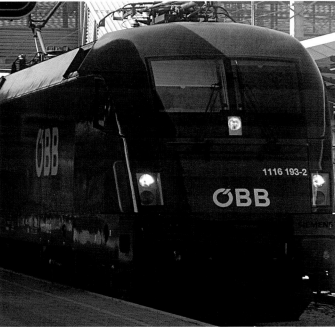

In the days of the Austro-Hungarian Empire, the railroad network was centered on the city of Vienna.

A Siemens class 1016 electric locomotive of Austrian Federal Railroads at Wiener Neustadt's main station, 2005.

AUSTRIA

The city of Vienna, once a great imperial capital, was the focal point of a remarkable system of railroads; at one time, there were seven trunk routes radiating from the city, belonging to five different companies. Competing for the traffic to Prague and southeast Germany were the Austrian North Western and the Imperial Royal Austrian State—both of which were state owned—and the Austro-Hungarian State, which, despite its name, was privately owned. To the west, the

Imperial Royal had the field to itself, but to the northeast of Vienna, the Kaiser Ferdinand's Northern (state owned) provided the main link to Warsaw. The Southern, which was privately owned, ran to the shores of the Adriatic at Trieste, then in Austrian territory.

After the general breakup of the Austro-Hungarian Empire at the end of World War I, the republic of Austria was left with the one-time Imperial Royal line to Salzburg and the west, and the interesting Southern line, which led over the famous Semmering Pass to the province of Styria. The construction of this line, by the celebrated Karl

Built by the Krauss company of Linz in 1912, this electric locomotive was one of several of the same type that were still in service with Austrian Federal Railroads in 2004. During its life, it received a new body and electropneumatic controls.

Ghega, was one of the epics of early railroad building. In the 1840s, without the benefit of modern aids such as aerial surveys, all the surveying had to be done at ground level, and on the northern approach to the pass, the land is just a wild confusion of crags, ravines, and steep slopes. There is no ordered geographical pattern, and to make things worse for the pioneers, the slopes were all thickly wooded. That Ghega managed to contrive a line on a steadily ascending grade of 2.5 percent is a marvel; when he had done it, no one believed that any locomotive would ever be able to climb that grade. But they did, and for a hundred years, steam worked all the traffic.

Today, for financial reasons, the infrastructure has been separated from operations, providing access for independent companies. There has been some new construction, including tunneling, to improve routes, the key Semmering Pass route being one of the first to benefit. A revision to the timetable has made regular-interval train services the norm.

Although not as extensive as in the days of the Austro-Hungarian Empire, the Austrian rail network has many international connections.

Railroads Through the Alps, from 1871

THE STEEP-SIDED, LOFTY MOUNTAINS CHALLENGED THE SKILLS OF RAILROAD ENGINEERS SEEKING TO CONSTRUCT WORKABLE GRADES ON THE ALPINE LINES.

The *Glacier Express* near Preda, Switzerland, in 2007. The trip from Zermatt to St Moritz is a 7½-hour railroad journey across 291 bridges, through 91 tunnels, and across the Oberalp Pass at 6,700ft (2,033m) in altitude.

The first proposals for a great railroad under the Alps were made in 1848, for a connection between the Italian province of Piedmont and the French province of Savoy. The timing was not propitious, however, with war looming between Austria and Italy. It was not until 13 years later that the project of a tunnel from Modane to Bardonecchia, under the Mont Cenis pass, was revived. Building the Mont Cenis Tunnel was a task without precedent. To secure bearings for the direction of the bores, which were to begin at Modane on the French side, and at Bardonecchia on the Italian, it was necessary to employ the surveying technique known as indirect triangulation. A geometrical link had to be obtained between the lines of entry at the two portals; this was done by taking a succession of bearings up the valley of the Maurienne, high above Modane, over the Mont Cenis pass, and then along the southern side of the pass to Bardonecchia. The survey was conducted with incredible accuracy, despite the fact that the geometrical link between the two ends was some 40 miles (64km) long and ran through mountainous country.

When the work was started in 1857, such were the original nature of the undertaking and the

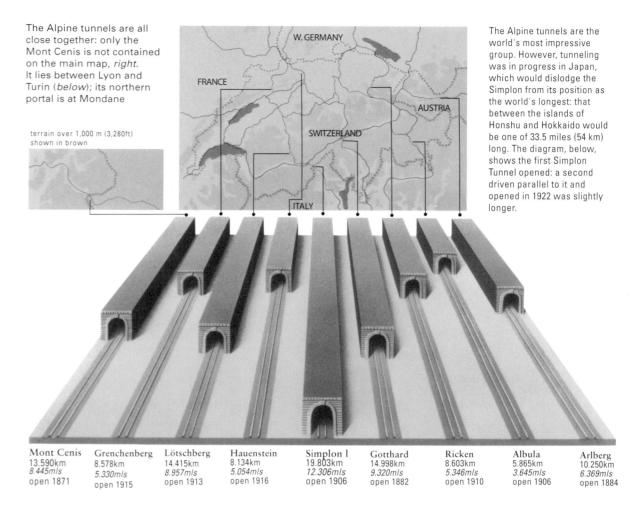

The Alpine tunnels are all close together: only the Mont Cenis is not contained on the main map, *right*. It lies between Lyon and Turin (*below*); its northern portal is at Mondane

terrain over 1,000 m (3,280ft) shown in brown

The Alpine tunnels are the world's most impressive group. However, tunneling was in progress in Japan, which would dislodge the Simplon from its position as the world's longest: that between the islands of Honshu and Hokkaido would be one of 33.5 miles (54 km) long. The diagram, below, shows the first Simplon Tunnel opened: a second driven parallel to it and opened in 1922 was slightly longer.

Mont Cenis	Grenchenberg	Lötschberg	Hauenstein	Simplon I	Gotthard	Ricken	Albula	Arlberg
13.590km	8.578km	14.415km	8.134km	19.803km	14.998km	8.603km	5.865km	10.250km
8.445mls	*5.330mls*	*8.957mls*	*5.054mls*	*12.306mls*	*9.320mls*	*5.346mls*	*3.645mls*	*6.369mls*
open 1871	open 1915	open 1913	open 1916	open 1906	open 1882	open 1910	open 1906	open 1884

unknown conditions in the mountains that it was expected the tunnel would not be completed in less than twenty-five years. Actually, the engineers were fortunate not to meet any undue hazards, the final breakthrough occurring on Christmas Day, 1870.

The completion of the Mont Cenis Tunnel, in 1871, provided a through route from Paris to Turin, and thence to Genoa. The route was constructed as a first-class main line, with double track throughout, the main tunnel being 8.5 miles (13.6km) long. The experience gained by the Italian engineers in building the tunnel was invaluable later when even longer tunneling projects were undertaken.

The second great Alpine tunnel was the Gotthard, which required the technique of spiral tunneling to be employed. It opened an important new international main line from Germany through Switzerland into Italy, leading direct to Milan.

By using the Eastern Railroad of France, to Belfort and Basel, it was possible to travel from Paris to Milan via the Gotthard Tunnel. It was a roundabout route, however, and after the war of 1870–71, one could well imagine that French travelers would have preferred to avoid passing through German territory. As a result, the great project of the Simplon Tunnel was launched. This tunnel, projected in the 1890s, was to be a continuation of the Jura-Simplon Railroad, which ran along the north shore of Lake Geneva, from Lausanne and then up the Rhône valley to Brig. It would provide a remarkable short route from the Paris, Lyon & Mediterranean line to northern Italy.

Work began simultaneously at both ends, near Brig in the Rhône valley, and at Iselle. Unlike the Gotthard, the Simplon Tunnel marked the crossing of the international frontier. The grade rose on

a moderate inclination from each end to a summit point near the middle of the tunnel, and almost exactly below the frontier, which is at the head of the Simplon Pass. Originally, it was intended that the line would be worked with steam locomotives, and because of the single track, the bore of the main tunnel was made very large, being 19ft 6in (5.9m) high with a maximum width of 16ft 5in (4.9m). Every precaution was taken to prevent any trouble from a concentration of exhaust fumes in the small space.

At first, all went well with the work, so well that there were high hopes of the tunnel being completed in far less than the estimated time. Then problems began to occur. In the workings from the Swiss side, the temperature rose to almost unbearable levels; at a point about 5 miles (8km) in, it rose to 53°C (127°F). It was found that the only way to keep conditions fit for men to work in was to bring in ice-cold water and spray it onto the rocks. Once the natural hazards were mastered, the contractors introduced round-the-clock working in three shifts to speed up the operation, and in February, 1905, over a year later than anticipated, the Swiss and Italian teams broke through. However, more than a year was to pass before the tunnel was completed and train services began. The actual date of opening to traffic was May 30, 1906.

So advantageous was the shortened route from France to Italy that soon the single-line section became a bottleneck. To facilitate construction of the tunnel, a parallel pilot tunnel had been bored so that material could be removed and air pumped to the workface. Plans were prepared for enlarging the pilot tunnel to full size, and it was opened as the second Simplon Tunnel in December, 1921.

The fourth of the great main-line Alpine tunnels was the Lötschberg. In view of the forthcoming opening of the first bore of the Simplon, the need was expressed for a main north–south line from central Switzerland to link up with the Jura-Simplon line and provide yet another direct connection into Italy. Thus the Bern-Lötschberg-Simplon Railroad was projected, and to reach Brig from Bern and the beautiful shores of the lake of Thun, the line would have to be carried through the heart of the Bernese Oberland. The great tunnel at the summit, just over 9 miles (14km) long, was to be bored beneath the lofty peaks of the Balmhorn and the Altels, but unlike the Mont Cenis, Gotthard, and Simplon tunnels, the routes to the tunnel entrances did not lie on

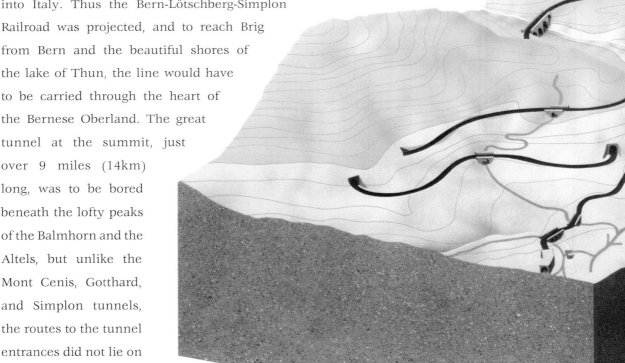

meters
2,300

2,100

1,900

1,700

1,500

any existing highways. The Lonza gorge, leading to the south portal at Goppenstein, was as desolate a ravine as could be imagined, and subject to avalanches. Due to a series of disasters, involving much loss of life, the route from the Kandersteg end had to be diverted. In July 1913, however, the Lötschberg line was finally completed and opened to traffic.

The meter-gauge Rhaetian Railroad includes some extraordinary examples of spiral tracks and tunneling as it climbs the Albula valley, making its way on a continuous ascent of 3.4 percent to its summit point in the Albula

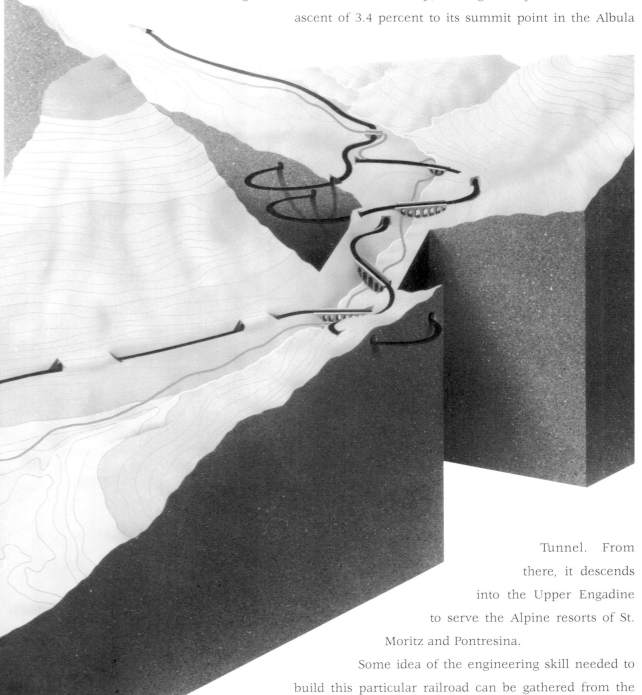

The Albula line of the Rhaetian Railroad climbs 1,365ft (416m). The grade was kept to a manageable 3.4 percent by a series of spiral tunnels. This illustration shows how the line loops back on itself as it climbs toward the summit tunnel from the south.

Tunnel. From there, it descends into the Upper Engadine to serve the Alpine resorts of St. Moritz and Pontresina.

Some idea of the engineering skill needed to build this particular railroad can be gathered from the gain in vertical height of 416m (1,365ft) over a direct distance of 6km (4 miles). If climbed directly, this distance would produce a grade of 6.6 percent, but because of the spirals and reversals of direction, the actual grade is 3.4 percent. Speed is maintained at around 48–56km/h (30–35mph).

CLIMBING THE MOUNTAINS

ALTHOUGH SPIRAL TRACKS CAN PROVIDE WORKABLE GRADES IN THE MOUNTAINS, SOMETIMES MECHANICAL ASSISTANCE IS NEEDED TO HELP LOCOMOTIVES COPE WITH STEEP ASCENTS.

The Mount Washington Cog Railroad, built in 1869, was the world's first mountain climbing railroad, and it remains in operation today. The locomotives, equipped with a cogwheel that engages a rack incorporated in the track, have angled boilers to compensate for the inclination of the track.

The breathtaking panorama to be enjoyed from the summit of a high mountain normally is not attainable without a great deal of physical effort of a skilled and specialized kind, but daring and highly ingenious railroad engineering has enabled some of the most famous peaks in Europe to be ascended by train. The very first mountain railroad in the world, however, was constructed in the USA in 1869, when Silvester Marsh, using a ladder-type of rack between the rails that engaged with a vertical pinion under the locomotive, built a cogwheel railroad to the summit of Mount Washington, the highest point in the White Mountains of New Hampshire, 6,293ft (1,918m) above sea level. This pioneer line is still worked by steam.

In 1871, the first mountain railroad in Europe was opened, to the summit of the Rigi overlooking Lake Lucerne. The engineer was Niklaus Riggenbach, and although he employed the same general principle as the rack pioneered by Marsh, he used a greatly improved form of rung in the ladder, which gave a better locking effect on the locomotive pinion wheel. Nevertheless, the maximum inclination permitted was 20 percent. In the meantime, another inventor, Edouard Locher, had designed a remarkable form of rack rail. It was provided with two parallel sets of horizontal teeth and each axle of the electric cars had double horizontal pinion wheels. These engaged and gripped the central rack on both sides, which made grades of up to 50 percent possible.

In 1889, the sensational rack railroad up Mount Pilatus was built, again overlooking Lake Lucerne. It climbs from a station on the lakeside to a height of 5,344ft (1,629m) in no more than 2.5 miles (4km), making an average grade of 36 percent throughout. It was steam operated at first. The seating in the present electric powered cars is in step formation, so that the passengers are sitting roughly level on each step as the ascent is made. At times, the outlook is breathtaking, but nowhere more so than when the stark, precipitous face of the Eselwand is rounded and the track is carried on a ledge blasted out of a solid, almost vertical, rock wall with a dizzy drop below on one side. Near the summit, the line passes through a tunnel hewn out of the rock, to emerge on a plateau between mountain tops, where the hospitality of two hotels awaits at an altitude of 6,778ft (2,066m) above sea level.

In sheer altitude, however, the Pilatus Railroad is far surpassed by that of the Jungfrau, in the Bernese Oberland, which climbs to a ridge between the great mountains Jungfrau and Mönch at 11,333ft (3,454m) above sea level. At that great height, a deficiency of oxygen in the air may cause faintness when a passenger steps out of the train. As a piece of mountain tunnel engineering, the Jungfrau Railroad is magnificent, but because so much of it is in tunnel, the ride is not as interesting or as thrilling as that up the Pilatus. The approach, through Interlaken, is one of great natural beauty, with superb mountain scenery, but the Jungfrau railroad proper begins at Kleine Scheidegg, and it is then 5.75 miles (9.2km) to the summit station of Jungfraujoch. That run takes 65 minutes, and for no less than 50 minutes, the train is continuously in tunnel.

For mountain grandeur, apart from sheer sensation, the Gornegrat Railroad, from Zermatt, easily takes first place, because the ascent is made in full view of that most majestic and striking of Alpine peaks, the Matterhorn. From an engineering viewpoint, the Gornegrat Railroad is notable as being the first in Switzerland to be operated by electricity from the outset. It was opened in 1898, fourteen years before the completion of the Jungfrau line. The ruling grade is 20 percent, and the passenger is lifted 4,872ft (1,485m) in 5.75 miles (9.2km). The ascent from Zermatt is made in 43 minutes, inclusive of stops.

Much of the Jungfrau Railroad, in the Bernese Oberland, is in tunnel. It climbs to a height of 11,333ft (3,454m) above sea level, where a lack of oxygen can cause problems for passengers.

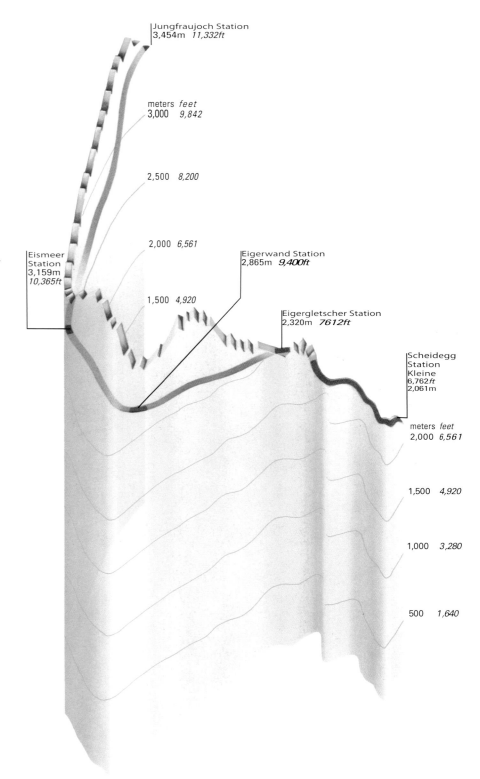

Specialized Rail Traffic, 1876-1924

Pullman cars, developed in the United States, were noted for their high level of service and passenger comfort.

AS THE RAILROADS GREW AND PROSPERED, THEY BEGAN TO OFFER MORE COMFORT AND FACILITIES FOR THEIR PASSENGERS, AND TO DEVELOP A VARIETY OF SPECIALIZED VEHICLES TO COPE WITH EFFICIENT FREIGHT HANDLING.

I n the last years of the nineteenth century, there was a marked transformation in the size and comfort of passenger rolling stock in Great Britain, continental Europe, and in colonial territories. The influence came from the introduction to certain English railroads of the American Pullman car. It was a movement that found little favor at first. British railroad managements were rather horrified at the size and length of these vehicles, and feared that their inclusion in trains of conventional cars would cause havoc if a derailment or collision occurred. However, the move to provide better accommodation for the lower social classes, pioneered on the Midland Railroad, gradually gathered impetus.

Although the Pullman car as such was adopted on only a few railroads, longer cars, carried on two four-wheeled trucks, began to enter more general use in the 1880s and 1890s in Britain. At the same

time, the four-wheelers, designed to suit the old station turntables, had given way to six-wheelers on most main lines; these were built to quite remarkable lengths, particularly some of the postal cars in service on the East Coast route from London (King's Cross) to the North. At the time of the exciting race to Aberdeen in August 1895, the 8.00pm express from King's Cross was composed entirely of six-wheeled cars, including sleeping cars.

On the continent of Europe, a great variety of passenger cars was in use, ranging from the very luxurious sleeping cars of the Wagons-Lits company to cramped, ill-lit, compartment vehicles that were not inaptly nicknamed "dog-boxes." All the older rolling stock was built entirely of wood, whereas the more modern cars were steel framed.

In the USA, with railroads still providing the premier means of land transport, the large double-truck cars offered increased luxury for those who could pay substantial supplements over the ordinary fares. In addition to dining and sleeping cars on the night trains, lavishly appointed club cars, lounges, and facilities for businessmen were added. For railroad officials traveling on company business and entertaining guests, so-called "business cars" were introduced. These were very large cars with four or more sleeping compartments, a business lounge, private dining room with a first-class chef in constant attendance, and usually an end observation platform. In Great Britain, the corridor car entered general use on the principal express trains; as in continental Europe, but unlike North America, the corridor was along one side of the car, providing access to individual compartments. In America, the cars remained open, with access to seats from a central aisle.

The developing traffic in all parts of the world led to the construction of many special vehicles for freight. Although the advantages of bulk transport were recognized, with coal, for example, huge cars carrying 30 tons or more, no matter how excellent on the run, were not entirely convenient because of the difficulty of getting them to the mines for loading. They were used mostly by the railroads

During a visit to the USA in 1867–68, the 23-year-old Belgian Georges Nagelmacker was so impressed by the Pullman night trains that, on his return home, he decided to establish a network of similar European night trains, which offered luxurious sleeping cars, and dining cars such as this. In 1874, Nagelmacker founded the Compagnie Internationale des Wagons-Lits.

A British ventilated freight car for perishable fruit. Built in the 1890s, it has continuous brakes, permitting inclusion in fast trains. Prompt return of empty rolling stock (in this case to Evesham, center of the Worcestershire fruit growing industry) was obligatory.

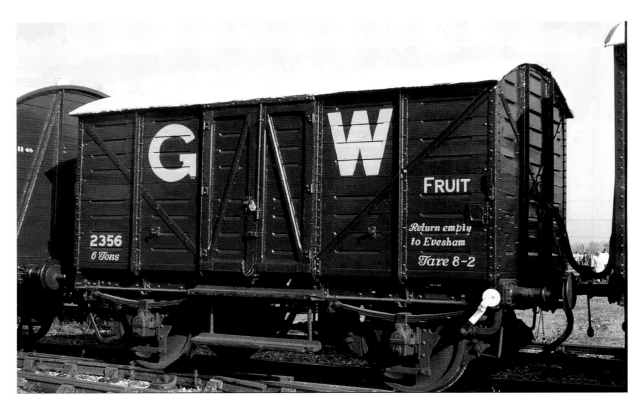

themselves for carrying locomotive coal.

One problem associated with vehicles for specific types of freight was that they carried loads in one direction only, and had to be returned empty. In Britain, a great number of collieries and individual coal suppliers had their own private cars, and the requirement of the railroads to haul these put further restrictions upon movement and economical use. Apart from coal, there were a great number of miscellaneous private cars in circulation.

An early British tank car. This privately-owned vehicle was built in the 1890s and used for the conveyance of liquid tar.

Some of the most interesting and specialized of freight cars were those designed for perishable goods. These included refrigerated cars carrying meat across continents or from ships bringing imports from overseas. Some British companies made a speciality of running express fish trains from northern ports direct to the larger cities. The cars used, although four-wheeled, were designed for running at up to 60mph (96km/h) and were fitted with continuous automatic brakes, as on passenger trains. Other vehicles were fitted for carrying fruit, fresh vegetables, and spring flowers in bulk. Because of the relatively short journeys involved in transporting these perishable goods from one part of Britain to another, it was not thought necessary to employ refrigerated cars.

Postal business required the provision of special cars. Traveling post offices were attached to many express passenger trains, while both Britain and the USA introduced exclusive mail trains. In Britain, mail was collected and set down at a great number of points, without the train stopping, by means of a mechanical pickup apparatus. Thus mail was delivered to many relatively small communities on or near the mail train routes. The special postal cars incorporated mailboxes where

members of the public could post letters, for which convenience a small extra charge was made. Although these cars had aisle connections, they were not for the purpose of connecting to the corridor of the train's passenger section. The aisles were set to one side so that the entrances at each end of a mail car would be clear of the sorting tables that ran from one end to the other.

Mail exchange apparatus used on Britain's Great Western Railroad. The net is extended, ready to catch a mailbag suspended beside the track.

Another specialized item of freight on British railroads was milk. Large six-wheeled cars with slatted sides were loaded in large numbers with the once-familiar milk cans. From the rural districts of the west of England, and from West Wales, special trains were run to London and other major cities at almost passenger train speed. Later, however, milk was conveyed in glass-lined tank cars. A familiar sight on British railroads was the so-called tarpaulin-bar car. This was an open four-wheeler with a central horizontal bar. It could be used for any consignment that needed covering in transit, a tarpaulin being passed over the central bar and fastened at the two sides. Flat cars were also used to carry small private conveyances and containers, brought to the railroad freight yards on road vehicles. This practice, which began in the early years of the twentieth century, was the forerunner of modern containerized, or intermodal, traffic.

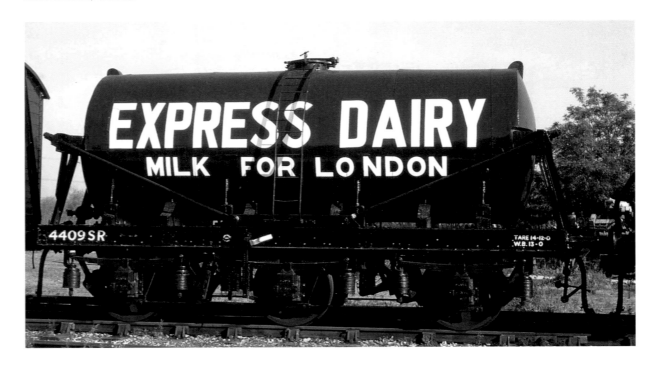

A milk tank car built for use on Britain's Southern Railroad in the 1930s. Both the Southern and the Great Western Railroads operated night trains to carry milk from Devon and Somerset for London morning deliveries.

RAILROADS IN THE NETHERLANDS, FROM 1839

HOLLAND'S LOW LYING, UNSTABLE GROUND MADE BUILDING RAILROADS DIFFICULT, BUT EXCELLENT DUTCH ENGINEERING SKILLS OVERCAME THE PROBLEMS TO PRODUCE A HIGHLY EFFICIENT SYSTEM.

Due to high traffic density, the Netherlands Railroads makes great use of doubledeck trains such as this.

I n the Netherlands, railroads were built, and are maintained today, in physical conditions unparalleled anywhere in the world. With the exception of the eastern frontiers, the countryside is flat and intersected by an elaborate system of canals, but the ground is soft and spongy, and far from ideal for sustaining the weight and pounding effect of heavy, fast railroad traffic. The existence of a frequent and efficient service is a tribute to the excellent maintenance of the track and of the foundation beneath it.

Until January 1938, there were several independent railroads in Holland, one owned by the state and the rest private, but in that year, a complete merger took place, the subsequent organization being given the title of Netherlands Railroads.

Although a significant amount of the traffic carried by the original companies was international, the

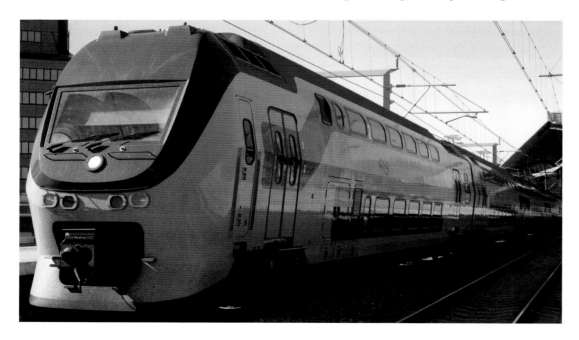

growth of industry and commerce in Holland has led to the development of a different pattern of activity today. In the nineteenth century, the close connection between the royal houses of Great Britain and Imperial Germany made the mail service between England and Germany very important, while the prevailing fashion for wealthy English families to patronize the spas of southern Germany sustained another prestige service through Holland. Almost without exception, the steam locomotives on most of the Dutch railroads were constructed in Great Britain.

In many ways, the growth of railroads in Holland during the nineteenth century was similar to that in Britain. Companies were formed and lines built in direct competition with one another, and there was no attempt by the state to coerce or squeeze the private companies out of the picture. One could travel from Rotterdam to Amsterdam, for example, either by the Holland Railroad, via Delft and The Hague, or by the Dutch Rhenish Railroad via Utrecht.

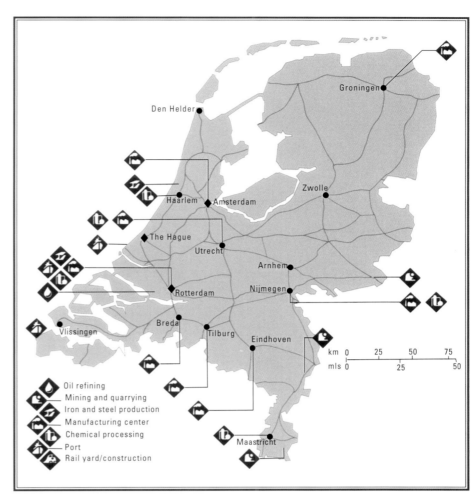

Building the Netherlands railroad network required clever engineering due to low-lying ground. Today the system provides a fast and efficient means of transport for both passengers and freight.

There were rivals for the cross-channel business from England, each having its own packet station. The State Railroad ran to Flushing, whence there were sailings at first to Queenborough in the Isle of Sheppey and later to Folkestone. At the same time, the Dutch Rhenish Railroad worked in conjunction with the steamers from the Hook of Holland to Harwich. Both companies were involved in the Anglo-German traffic, yet small as Holland is, the State Railroad did not carry this traffic right across the country to the German frontier. At Boxtel, there was a switch to another private railroad, the North Brabant German, which, although entirely Dutch owned, ran for a considerable distance into Germany to reach Wesel.

The Dutch Rhenish went as far as the Rhine, to Arnhem. Another interesting private line was the Netherlands Central, which ran from Utrecht north-eastward through Amersfoort to Zwolle. At times, the central station at Utrecht had the colorful glamor of some great English junctions. There would be the bright green locomotives of the State Railroad, the rich reds of the Rhenish, the dark greens of the Holland Railroad, and the bright yellows of the Netherlands Central. It is notable that the first major amalgamation of railroads in Holland did not concern the state system, but occurred between two of the private concerns, the Holland Railroad and the Dutch Rhenish. Travelers with experience of railroads in many parts of the world were quick to notice one significant difference between the largely private railroads of Holland and the nationally owned railroads of Belgium: in the nineteenth century, the Dutch were much more efficient.

Today, the passenger train service in Holland is provided by fast, closely integrated, electric,

multiple-unit trains, so timed that if a through train is not provided between the towns or cities that a passenger wishes to visit, there are connections at intermediate points where the change of trains involves a wait of no more than a few minutes. Obviously, in the operation of such a pattern of service, a high standard of punctuality is essential; this is ensured by a comprehensive system of train dispatching, coupled with the automatic operation of the major junctions. The equipment is programmed to operate in accordance with the planned schedule, and it is only in the event of irregularities or late running that the men in the control centers have to intervene.

Not all the Dutch railroad network is electrified. Routes with low traffic density are worked by diesel, multiple-unit set trains. Several international express trains originate in Holland, such as the

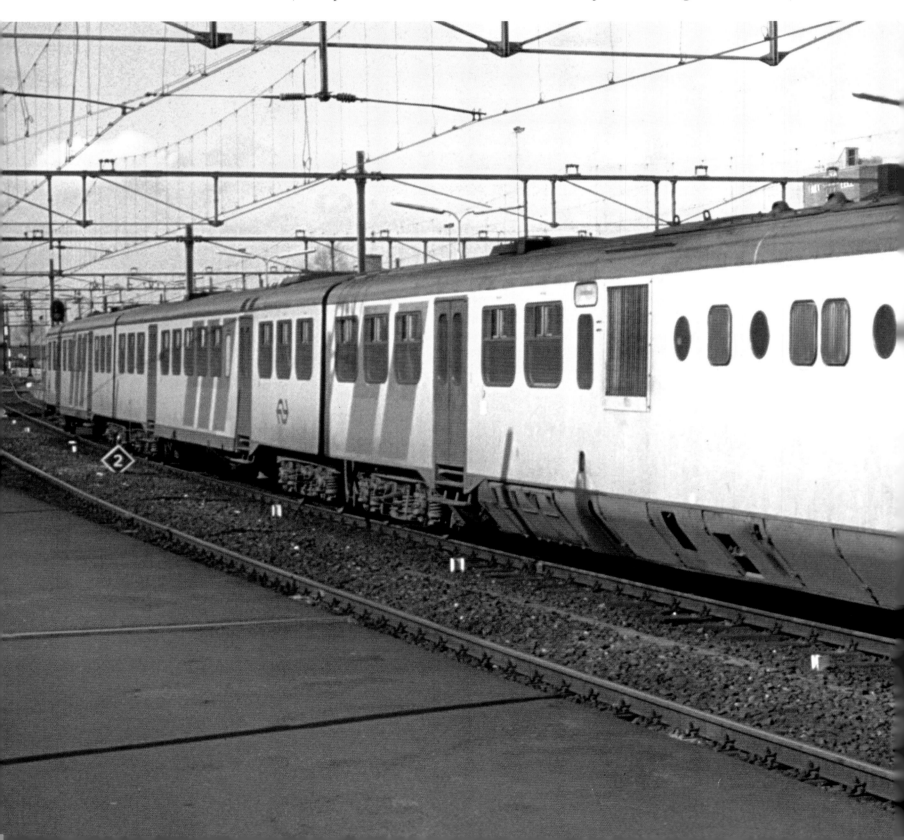

Rheingold, with sections from both Amsterdam and the Hook of Holland running south through the Rhineland to Switzerland; others operate into north and northwest Germany.

Netherlands Railroads is now operated as an independent business. Other operators have appeared, one of which, Lovers' Rail, introduced brightly painted passenger trains on selected routes, but had difficulty in finding a niche. The timetables were restructured in 1970, but in 2007, after traffic had more than doubled, there was another radical revision. Train frequencies were increased, typically to four an hour on busy routes. The diversion of some passengers to the new Amsterdam–Antwerp high-speed line, and of the heavy freight flow southward from the ports to the new Betuwe freight line, was expected to free capacity for extra domestic passenger trains.

A Plan U multiple-unit, diesel-electric, commuter train of Netherlands Railroads. The Dutch railroad system provides and rapid and efficient commuter service.

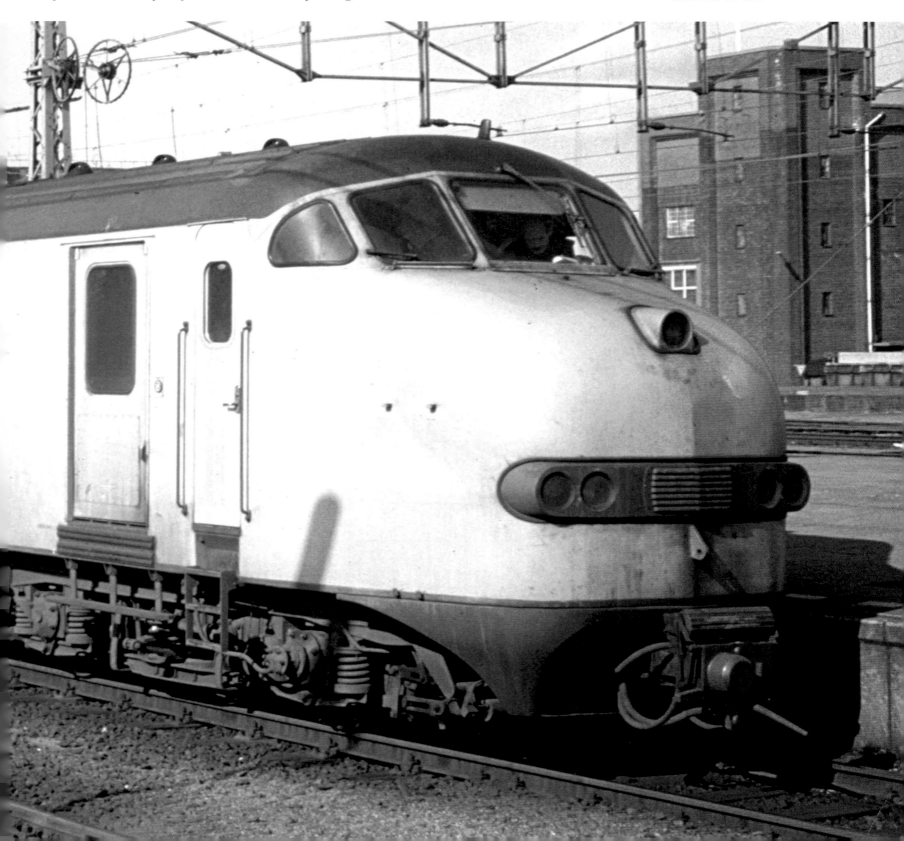

THE ZENITH OF STEAM, 1927-34

THE LATE 1920s AND EARLY 1930s SAW MAJOR INCREASES IN STEAM LOCOMOTIVE PERFORMANCE AS DESIGNERS SOUGHT TO MEET CONSTANT DEMANDS FOR GREATER POWER AND SPEED.

The years from 1927 until the outbreak of World War II were among the most momentous and productive in the history of the steam locomotive. By the mid-1920s, it had reached the limit of physical size in Great Britain, France, and North America. However, increased tonnage requirements, competition from newer forms of motive power, and the economic conditions presented designers with the urgent need to improve the machine's performance in the broadest sense.

The situation in 1927 was graphically portrayed at the time of the centennial celebrations of the Baltimore & Ohio Railroad, when a great pageant of locomotives was staged. At that time, the Pacific type (4-6-2) was being superseded by the 4-6-4, or Hudson, for the heaviest express passenger traffic, because a four-wheeled truck at the rear was advantageous in supporting the ever-larger fireboxes that were necessary. Even so, the 4-6-4 was not considered large enough on some North American railroads, and the 4-8-4 was introduced. In the year of the Baltimore & Ohio celebration, the Northern Pacific took delivery from ALCO of some huge 4-8-4s, while across the border, the Canadian National was also using the type in its celebrated Confederation class. At one time, it was thought that eight coupled wheels would restrict the maximum speed of a locomotive, but 4-8-4s were run regularly at 80mph (130km/h) and even higher speeds.

An important feature of American practice was the almost universal abandonment of multi-cylinder layouts. One of the last designs to have anything but the simplest two-cylinder arrangement was a series of large freight locomotives built by ALCO for the Union Pacific in 1926. These were of the 4-12-2 wheel arrangement, with three cylinders and conjugated valve gear of the type introduced by Sir Nigel Gresley on the Great Northern Railroad of England, and standardized on all his principal designs for the London & North Eastern Railroad. By 1930, two cylinders only were employed in North America,

The restored former LNER A3 Pacific locomotive *Flying Scotsman* hauling the *Cumbrian Mountain Express* in September 1982. Built in 1923, this locomotive was the first steam engine to be officially recorded at 100mph (160km/h). It was one of several similar engines that hauled the express service after which it was named.

and on freight locomotives having tractive efforts approaching 100,000lb (45,359kg), the cylinders were necessarily large. On a class of 2-10-2 locomotives built by Baldwin for the Reading Railroad in 1931, the cylinders were 30½in (77cm) diameter by 32in (78cm) stroke.

Another notable American development of the period was to design the main frames and their cross-stretchers as a single, one-piece, steel casting, instead of the usual method of assembling them from flat sections. The cylinders were also included as part of this all-embracing "bed." One of the first instances of this development was in a class of 4-8-4 passenger locomotives for the Southern Pacific built in 1930. These large units had a booster engine on the four-wheeled trailing truck beneath the

firebox, which served to increase the tractive effort from 60,000 to 72,000lb (27,200 to 32,660kg).

Although American practice had swung so notably toward the simplest of all machinery layouts, with two cylinders and all the running gear outside, the four "grouped" railroads of Great Britain were employing three- or four-cylinder, single-expansion types for their principal express services. Meanwhile, the French railroads retained an unshakable preference for the four-cylinder compound design, mostly continuing to use the de Glehn arrangement of cylinders. Locomotives of this type had complex machinery and required skill to be driven efficiently. French railroad traditions were more than equal to the need, however, and some outstanding work was performed around 1930.

French expertise in all matters connected with four-cylinder compound locomotives was epitomized on the Paris-Orléans Railroad, after the electrification of the sections leading out of Paris. Steam locomotive men feared that, with acceleration of service and increased tonnage capacity of the electric locomotives, unfavorable comparisons would be made with the standards of running south of Orléans. A scientific study was made of one of the Pacific engines, and certain weaknesses in the 20-year-old design were identified. The young engineer charged with this investigation, André Chapelon, recommended a redesign of the cylinders, improvement in the internal steam passages, and enlargement of the superheater. One engine was modified in accordance with his findings, and when tested, it was found that the locomotive's capacity was increased by 50 percent, while at the same time it was able to run more freely. The features embodied in what became known in France as the "PO Transformations" became a yardstick for locomotive improvement throughout Europe.

In England, Sir Nigel Gresley embodied Chapelon principles in a new large 2-8-2 design for use in heavy passenger service on the East Coast main line between Edinburgh and Aberdeen, where increased train loads had made double-heading a regular necessity while older types of locomotive had to be used. One of the most important developments in Britain in the early 1930s, however, was the mandate given to the new chief mechanical engineer on the London Midland & Scottish Railroad to "scrap and build": to replace the varied stock of locomotives, inherited from the constituent companies of the 1923 merger, with standard new designs of as few different classes as possible. Associated with this program was the aim to obtain greater monthly mileage from each locomotive. To this end, in total contrast to the continuing French practice of allocating one driver to each locomotive, the LMSR intended that individual locomotives would be operated by several crews in the course of a journey. There was an instance of six crews manning a locomotive on successive stages of a 290-mile (467km) journey. To meet such requirements, a locomotive with simple handling and outstanding reliability was needed, and W.A. Stanier, the chief mechanical engineer of the LMSR, provided such a locomotive in the mixed-traffic 4-6-0, classed 5P5F, but known colloquially as the "Black Five."

By the early 1930s, major developments in locomotive design had taken place in Great Britain, France, and the USA. Elsewhere, the process of evolution reflected the practice of one or another of the leaders, adapted to suit local conditions. A distinctive development in two directions became evident on the sub-standard-gauge railroads of the world, particularly in southern Africa. Hitherto, it had been thought that the 3ft 6in (1,067mm) gauge would impose limitations upon size and the intrinsic merits of designs, but South African Railroads introduced new locomotives of the 4-8-2 type, which, in terms of height, size, width, and performance, surpassed many of the medium-speed units operating in Europe

on the 4ft 8½in (1,435mm) gauge. The most remarkable development in Africa was in respect of the Beyer-Garratt articulated locomotive. In a series of comparative tests on the Natal main line of the South African Railroads, in 1921, this had been shown to have a considerable advantage over the Mallet articulated type on a sub-standard-gauge line with extreme curves and a limitation on maximum axle loads. The Garratt, with two separate, but identical, engine units and one huge boiler carried on a cradle slung between the two, proved an ideal locomotive for a sharply-curved, sub-standard-gauge line. The boiler could be built to ideal proportions for

Named to commemorate its designer, Sir Nigel Gresley, this former BR A4 Pacific locomotive was one of several streamlined examples built for the Silver Jubilee service, now preserved and seen here departing Goathland for Pickering in 2002.

free steaming—short barrel and large diameter—which was impossible on the Mallet. The latter was successful on the relatively straight, standard-gauge lines of the USA.

In India, an area of intensive utilization of steam locomotives, much was done by the Indian Railroad Conference Association (IRCA) to standardize design for the several previously independent railroads that were gradually being taken under national ownership and control. The IRCA produced three classes of Pacific—XA, XB, and XC—for various conditions of passenger service on the 5ft 6in (1,676mm) broad-gauge lines, and two classes of 2-8-2 freight engine. At the same time, the remaining independent railroads pursued an individual line. Notable among them was the Bengal Nagpur, which favored the de Glehn four-cylinder compound system in some large Pacific engines. Powerful articulated locomotives of the Beyer-Garratt type were introduced for coal-train use in Bengal.

In express passenger service, the introduction of high-speed diesel powered trains in both Germany and the USA spurred steam engine designers to apply external streamlining to locomotives allocated to prestige high-speed trains. This was done to remarkable effect on the London & North Eastern Railroad in 1935, when a high-speed service was to be introduced to mark the Silver Jubilee of King George V. Aware of Chapelon's achievements in France and with experience from his large 2-8-2 engines on the Edinburgh–Aberdeen route, Sir Nigel Gresley modified the design of his Pacific engines, one of which had already attained a maximum speed of 108mph (173km/h). With an eye to gaining some good publicity and saving a little coal by reducing air resistance, he added external streamlining to the new Pacifics. It was not true streamlining, but rather a form of aerodynamic screening copied from the external shape of some high-speed Bugatti railcars being operated in France. This, coupled with a silver finish to match the name of the new train, was well received by the public, and when the *Silver Jubilee* train attained a speed of 112.5mph (180km/h) on a preliminary demonstration run, its success as a commercial proposition was assured. It took 4 hours to cover the 268 miles (429km) between London (King's Cross) and Newcastle, but it was a one-off, traveling from Newcastle to London in the morning and returning at 5.30pm.

THE GREAT LOCOMOTIVE WORKS

THE SUBSTANTIAL DEMAND FOR LOCOMOTIVES DURING THE STEAM AGE LED TO THE RISE OF A SIGNIFICANT SECTOR OF HEAVY INDUSTRY IN MOST INDUSTRIALIZED NATIONS.

The first locomotives were built by mechanics who, sometimes, would join together to form companies to manufacture the machines. In England, the Tyneside works of Robert Stephenson were among the first to flourish, but there were scores of others, some of which prospered while others failed or were taken over by their competitors. As railroads became the main force of economic life, industrializing countries soon possessed their own locomotive works, which became part of heavy industry. Britain, being the pioneer, soon had a flourishing export market, but faced competition from Germany and the USA among others.

Britain was unusual in that almost all of its railroad companies preferred to build their own locomotives. Even the tiny North Staffordshire Railroad had its own works at Stoke. In fact, once a railroad possessed an erecting shop for the capital repair of locomotives (and most did), it could easily progress to building new locomotives. In time, the locomotive works of Swindon (Great Western Railroad), Crewe (London & North Western Railroad), Derby (Midland Railroad), and Doncaster (Great Northern Railroad) became best known by virtue of their large output and long histories.

These works had their own design offices, which meant that each British railroad had its own locomotive designs, claimed to be perfectly adapted to that particular railroad's needs. In some cases, this was true: Great Western designs, for example, had fireboxes suitable for the high-calorific Welsh steam coal that its locomotives burned. In other cases, the individuality of design resulted from an accumulation of traditions, some merely of style; a connoisseur could recognize the provenance of a locomotive merely by looking at the shape of its smokestack.

The locomotive works made almost all the components for their engines, having their own

foundries and machine shops, the results of their labor being sent to the erecting shop where lines of new locomotives were assembled with the help of overhead cranes. Boiler shops worked at noise levels that would seem shocking today; they were a key part of the enterprise, repairing as well as building boilers. The latter, like other components, soon became standardized on each railroad and could be interchanged; it was not unknown for a new locomotive to receive a reconditioned boiler.

Sometimes, the independent British builders received orders from the home railroads, but they relied on the export trade, especially from railroads of the British Empire. In these colonial territories, it was not impossible for non-British works to sell locomotives, but they rarely did. In such markets, the competition was between rival British companies, although there was a tendency for certain territories to favor certain builders. The Beyer-Peacock company, for example, was entrenched in New South Wales, although a big railroad system, like that of British India, relied on a variety of builders, which, by the twentieth century, were producing standard designs approved by the Indian government.

By the end of the steam age, four big companies had emerged. These were the long running Robert Stephenson & Hawthorn; Beyer-Peacock, founded by a German immigrant and a Great Western draftsman in Manchester, and holder of a license to build the Garratt patented locomotive; the Vulcan Foundry; and North British in Glasgow. The last was an amalgamation of three old and renowned Scottish builders, Sharp Stewart, Neilson, and Dubs.

In North America, there was a similar early profusion of small builders, but soon there emerged the "Big Three" of Baldwin (Philadelphia); American Locomotive (Schenectady), usually known as

A locomotive being built at the Datong works in China, c.1990. The Chinese continued to build and use steam locomotives long after they had been withdrawn from service elsewhere.

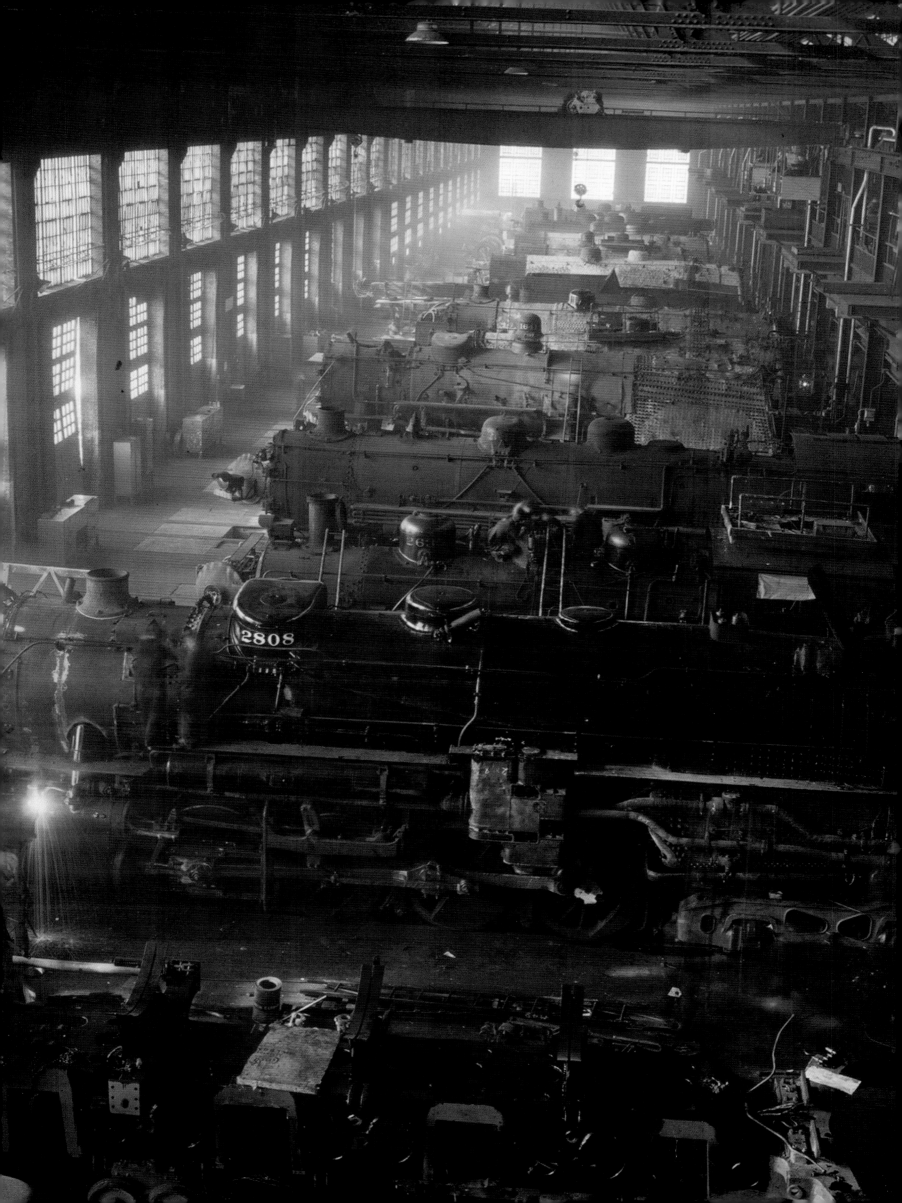

ALCO and later acquiring the Montreal Locomotive Works as a subsidiary; and Lima (Lima, Ohio). Of these, Lima was the smallest, but it distinguished itself in the building of the Shay flexible-wheelbase locomotive for logging and other light railroads, and at the other end of the scale in its 1920s introduction of "superpower" locomotives with large fireboxes. In North America, few railroads built their own locomotives, the only major exceptions being the Pennsylvania Railroad at Altoona, and the Canadian Pacific at its Angus Works in Montreal. Elsewhere in Canada, the Canadian Locomotive Company at London, Ontario, provided competition for the Montreal Locomotive Works.

In France, main-line locomotive construction was soon concentrated in two companies, Schneider and Société Alsacienne. In addition, there were a few niche companies. The big German locomotive industry included such famous names as Krupp, Maffei, and Henschel. The industry was notable for the formation of cartels to deal with the difficulties that followed World War I; the companies shared orders, and one company, Hohenzollern, even left the industry to improve prospects for the others.

Russia and Japan had big locomotive industries to supply their own railroads, while in the short period between World War II and the end of steam construction, China and India built new works. The Indian Chittaranjan Works specialized in the mass construction of the post-war, standard, broad-gauge freight locomotive. The Datong Works in China was building big steam locomotives long after construction of these engines had ceased elsewhere. Australia remained a big importer of locomotives to the end of the steam era, although Queensland Railroads built some locomotives at its Ipswich Works, and the New South Wales Railroads designed and built the capable C38-class locomotives in its Sydney repair shops during World War II.

With the advent of modern forms of traction, the picture changed radically. In Britain, the railroads' own works were progressively closed down, Crewe being the last survivor; it assembled some of British Rail's new generation of electric locomotives. Meanwhile, the Brush company, originally a tram maker, became a diesel locomotive builder and also constructed electric locomotives for Channel Tunnel shuttle trains. Most of the original steam locomotive builders, having attempted and failed to make a long-term success of diesel locomotive construction, were merged into other companies. Many were absorbed by General Electric (GE), which itself was merged with the French Alstom company and ceased locomotive construction; this process meant that English Electric, hitherto a very successful builder of electric units, disappeared from the scene.

In North America, Baldwin and Lima ceased locomotive construction. Westinghouse, a pre-war builder of electric locomotives, failed to find a place. ALCO, which, with GE, pioneered the development of the diesel locomotive, ran a profitable business for decades, but dropped out soon after GE (which had supplied traction equipment) decided to go into full-scale diesel locomotive construction. GE became the biggest builder of American diesel locomotives, while General Motors sold its locomotive division to a company that continued to operate the GM business in London, Canada, under the EMD name, remaining a big producer of locomotives for American and worldwide markets.

In Europe, a long-drawn-out succession of mergers and amalgamations saw the locomotive and self-propelled train market dominated by three big enterprises, Alstom, Siemens, and Bombardier, the last being a Canadian company. They competed strongly in Europe and elsewhere, occasionally finding it hard to make a profit because of this competition.

Opposite page: Unlike the UK, few railroads in the United States built their own locomotives; most bought them from independent builders. In the early days the Chicago & North Western built their own locomotives, however after 1900, they sourced the majority of their trains from the American Locomotive Company. Here, one of its engines is undergoing a rebuild at the company's 40th Street facility, Chicago, Illinois.

Railroads in the Czech Republic, Slovakia, and Hungary, from 1839

ONCE PART OF THE AUSTRO-HUNGARIAN EMPIRE, THESE CENTRAL EUROPEAN STATES ENDURED POLITICAL UPHEAVAL THROUGHOUT MUCH OF THE TWENTIETH CENTURY, WHICH CAUSED IMMENSE PROBLEMS FOR THE RUNNING OF THEIR RAILROADS.

CZECH REPUBLIC AND SLOVAKIA

Czechoslovakia was one of several eastern European countries that continued to use steam locomotives long after they had disappeared from western European railroads.

When the state of Czechoslovakia was set up under the provisions of the Treaty of Versailles after World War I, the rationalizing of the railroad system was a matter of some urgency and difficulty. The provinces of Bohemia, Moravia, and Silesia had formerly belonged to Austria, having railroads focused upon Vienna and Prague, while the province of Slovakia had been part of Hungary, with its railroads directed toward Budapest.

From 1924, therefore, efforts were made to provide better west–east communication within the new country. No fewer than 100 miles (160km) of new main line were constructed in the late 1920s, while about 150 miles (240km) of single-tracked secondary line were converted to double track and brought up to full main-line standards.

During World War II, the Czechoslovak railroad system was severely damaged, and after the war, it was necessary to undertake repairs to many tunnels and bridges, while more than 1,200 miles (1,920km) of line had to be totally renewed. Many new lines were built subsequently, and conversion to electric power proceeded steadily, including that of the principal west–east line. Of a total of approximately 8,000 miles (12,800km) of route, a total of about 1,500 miles (2,400km) was also electrified.

In 1999, the division of the railroad system between the new Czech Republic and the Slovak Republic was finalized. Later, Czech Railroads became a shareholding company and, in line with EU requirements, its infrastructure and operations were separated.

A cross-city line beneath the Czech capital city of Prague was under construction by the year 2004—by linking together several existing trunk routes, this was planned greatly to improve the effectiveness of the system when it was finished. Subsequently, the new Slovakian Republic Railroads became a joint-stock company owned by the government.

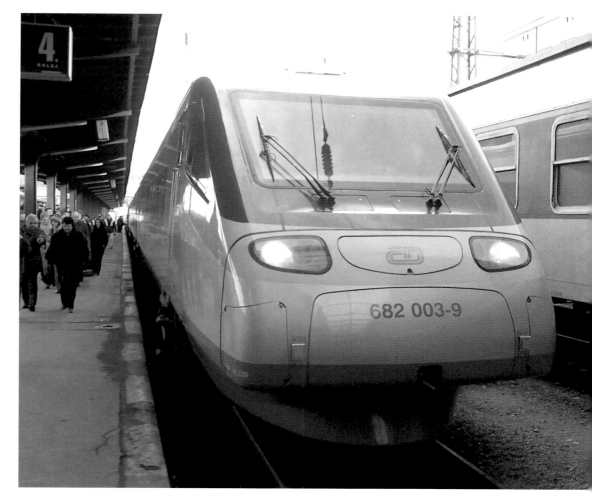

A Czech Railroads Pendolino tilting train, operating an express service, arrives at Masaryk station, Prague, 2005.

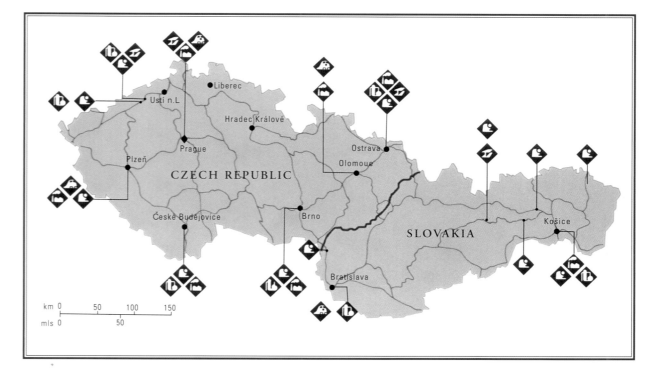

In 1999, the railroad network that had served the original state of Czechoslovakia was divided between the newly formed Czech Republic and Slovakia. In line with EU requirements, the infrastructure and operations of these railroads were separated.

HUNGARY

In imperial days, three separate railroads operated in Hungary, roughly a third of the system being state owned. The privately owned lines were the Austro-Hungarian State (despite its name) and the Austrian Southern. Budapest was very much the center of all railroad activities. The Hungarian State and the Austro-Hungarian State competed directly for the traffic between Budapest and Vienna, one on each side of the River Danube. Today, however, although both routes still exist, the northerly one—the former Austro-Hungarian—is no longer competitive; it forms the most easterly section of the main line between Budapest and Prague.

From Budapest, the Hungarian State had three routes striking out to the north and east, but one of the most important was that running south to Belgrade. Until World War I, the River Danube marked the frontier between Hungary and Serbia, as it was then known. The third railroad entering Budapest was the Austrian Southern, from the southwest. This made a junction with the line over the Semmering Pass from Vienna, and provided a through route from Budapest to Trieste.

Because of the change in state boundaries after World War I, the extent of the Hungarian State Railroads (formed by merging the three separate railroads) was reduced from the original route length of 5,700 miles (9,120km) to 4,900 miles (7,840km). Since the end of World War II, considerable

Siemens Desiro multiple-unit, diesel, suburban trains belonging to Hungarian State Railroads. A dozen of these trains were purchased from the German manufacturer.

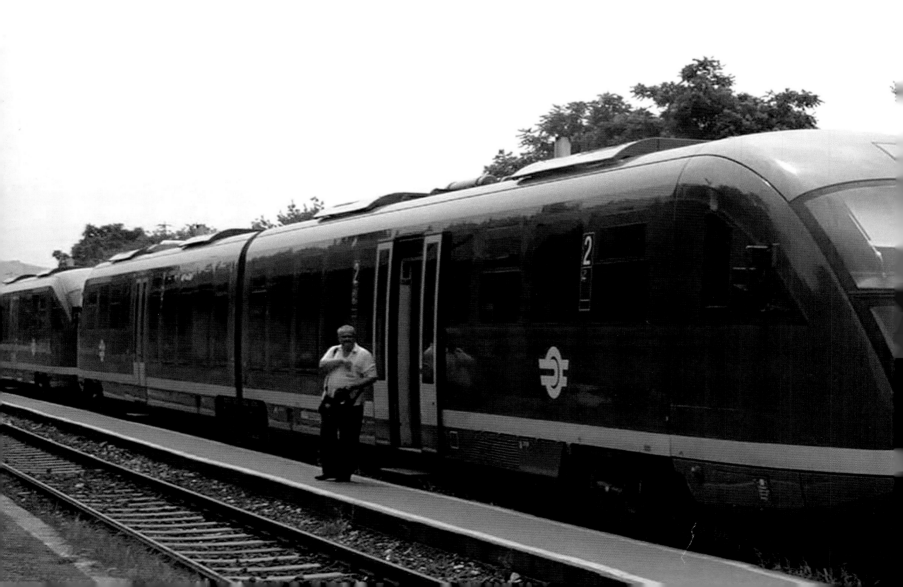

progress had been made in electrification; the circular railroad in Budapest, 12 miles (19km) long, is also electrified.

Although the railroads of Hungary run on the European standard gauge, the loading gauge is considerably taller. Hungarian steam locomotives were often built to the maximum possible heights and, like those also used in Austria, seemed immense when compared with western European engines. As everywhere else, however, steam power was superseded. The now withdrawn *Orient Express* originally turned south from Budapest to serve Belgrade and eventually Constantinople (Istanbul).

Post-communist economic difficulties resulted in financial problems for Hungarian State Railroads, but the situation improved after 2000. Infrastructure and operations have been separated and, in line with its tradition of international links, the operator became a member of the European InterCity system as early as 1988.

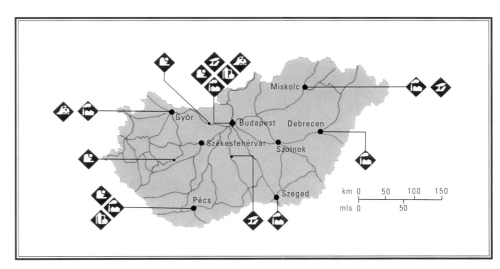

The railroad network of Hungary has a large number of international connections, a legacy from the days of the Austro-Hungarian Empire.

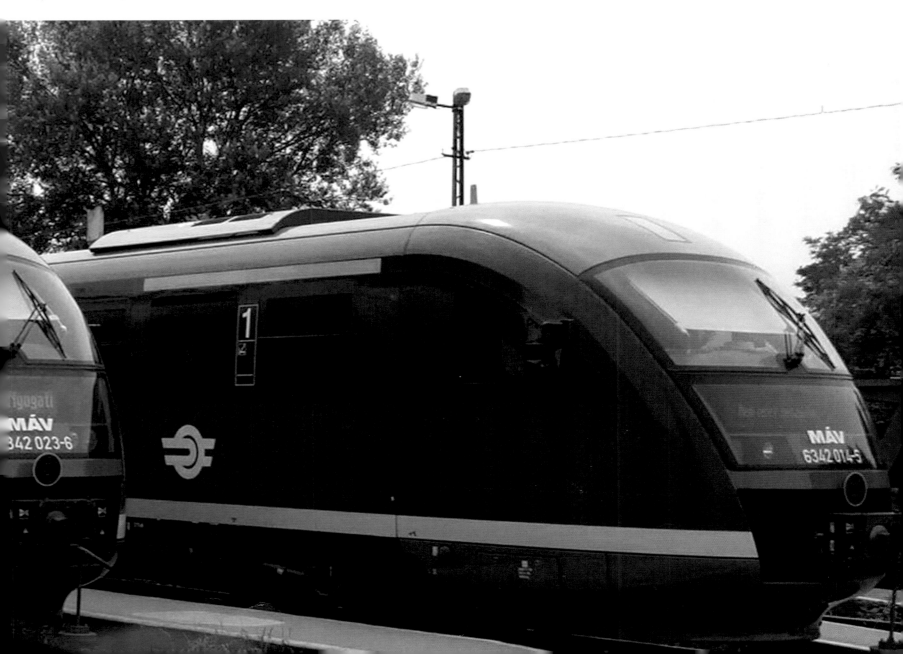

FIT FOR PURPOSE, ROLLING STOCK, FROM 1925

THROUGHOUT THE TWENTIETH CENTURY, FREIGHT ROLLING STOCK BECAME INCREASINGLY SPECIALIZED, WHILE PASSENGER SERVICES MOVED TOWARD AIRLINE-STYLE ACCOMMODATION.

From the mid-1920s, freight rolling stock became increasingly specialized to provide more efficient service and reduce damage in transit. In North America, the universal employment of center couplers involved buffing and absorbing shocks when trains were starting or being braked. The standard box car was gradually developed to enormous size, up to 85ft (27m) long and 18ft (5.5m) high, and the improvement in braking techniques enabled long trains of such cars to be controlled safely.

In the USA, refrigerator cars, nicknamed "reefers," are used for the transport of great quantities of citrus fruit from California eastward; at specific points on the long journey, the examination of brakes and running gear, and the servicing of locomotives are supplemented by checking the car's icing equipment. The trains are put on to what are termed "icehouse" tracks. Oil is another commodity that requires special vehicles, while the transport of coal, in enormous hopper cars, from which the entire load can be dumped onto a conveyor belt in a few seconds, forms the lifeblood of railroads such as the Norfolk & Western, and the Chesapeake & Ohio.

In Britain, the transport of coal used to be a very profitable, but exceedingly slow, business. It was carried in long trains of four-wheeled, unbraked cars, rarely traveling

A North American "piggyback" train of the late twentieth century. The space (and weight) penalty imposed by the need to haul the road wheel sets is evident; containers are more efficient in that respect.

at more than 25mph (40km/h), and involving much tedious switching and reswitching. In addition, it was necessary to return the empty cars to specific mines or other owners. Today, the "merry-go-round" principle is used for conveying coal to regular standing orders, from collieries to electricity generating stations. The trains are made up of large hopper cars equipped with continuous air brakes, the diesel-electric locomotives remaining coupled during the loading and unloading processes. The trains run at speeds of 50mph (80km/h) or more.

On the continent of Europe, freight vehicles have been developed as long-wheelbase four-wheelers, which have excellent riding qualities and can be run at speeds up to 50mph (80km/h). Through the activities of the International Union of Railroads (UIC), a great deal of standardization of size, couplings, and brake equipment has been achieved, permitting the interchange of rolling stock between the railroads of Europe. A number have been built to run on the more restricted British loading gauge, thus facilitating the working of through loads to and from the Continent via the Channel Tunnel.

Road congestion in all the advanced countries of the world has led to arrangements for the delivery

The GATX 96500 railroad tank car was, in 2006, reputed to be the largest ever built at 63,000 gallons (238,000 liters) capacity.

Many railroads around the world have adopted airline-style passenger accommodation on long-distance trains. This Japanese train has seats that are exactly the same as those in an airliner, with drop-down, seat-back tray tables. The cart snack service has taken the place of the dining car.

of new automobiles by train. In the USA, advantage has been taken of the height available for loading to build three-deck automobile carriers; one of these "tri-levels," as they are known, will carry fifteen automobiles. In Britain and on the Continent, only two decks can be accommodated.

Intermodal freight, in the form of container transport, developed fast from the 1950s. At first, the carriage of road-going articulated trailers ("piggyback" in the USA; "kangaroo" in continental Europe) on special flat cars was favored, but container-on-flat-car largely superseded that technique. In the USA, the "double-stack" container train appeared, with flat cars carrying one container resting on another; this reduced costs and helped the struggle against highway operators for this traffic. Special railroad cars that could be fitted with rubber-tired wheels were developed in the USA, allowing movement over highways for collection and delivery, but they had only a limited success.

One of the most important developments in main-line passenger service was the addition of air conditioning. This banished to memory the discomfort of long-distance intercity or transcontinental travel, caused by drafts from open windows, and the dust and smoke from heavily fired steam locomotives; only when the air conditioning plant in a modern car failed temporarily did that discomfort return, in the form of stifling heat because the windows could not be opened.

The general tendency in most parts of the world was to make passenger accommodation on long-distance trains more like that of an airliner. This was partly because of shorter journey times, and the growing practice of offering snacks rather than the elaborate meals of a full dining car service. On an increasing number of modern trains, arrangements were made to serve packaged meals to every passenger at his seat, again in airline style. The passenger stock designed for the super-high-speed service in France, from Paris to Lyon and beyond, had seating with no greater space between seats than in a modern airliner. Prior to this trend, vehicles of great luxury were introduced on some routes in Europe, notably the 'Grand Confort' cars on some French trains, such as the all-first-class *Mistral*, *Capitole*, and *Aquitaine*.

In the USA, advantage was taken of the height available to build cars with seating on an upper deck, with baggage space, lavatories, and so on below. The same principle was used in the "dome" observation cars run on many American long-distance trains. In Japan, where there was more passenger travel per capita than anywhere else in the world, the practice of seat reservation by computer was carried to an all-embracing extent on the super-high-speed Shinkansen "bullet" trains. Booking a ticket also conferred a reserved seat on a particular train. So many of these trains were run that if the first was full at the time of booking, one could be fairly sure of getting on to the next, 15 minutes later. Knowing the number of the car by the seat reservation, the passenger could wait on the platform in exactly the right position to enter the train when the doors opened.

The problem of commuters became acute in all large cities. In the USA and Canada, many double-

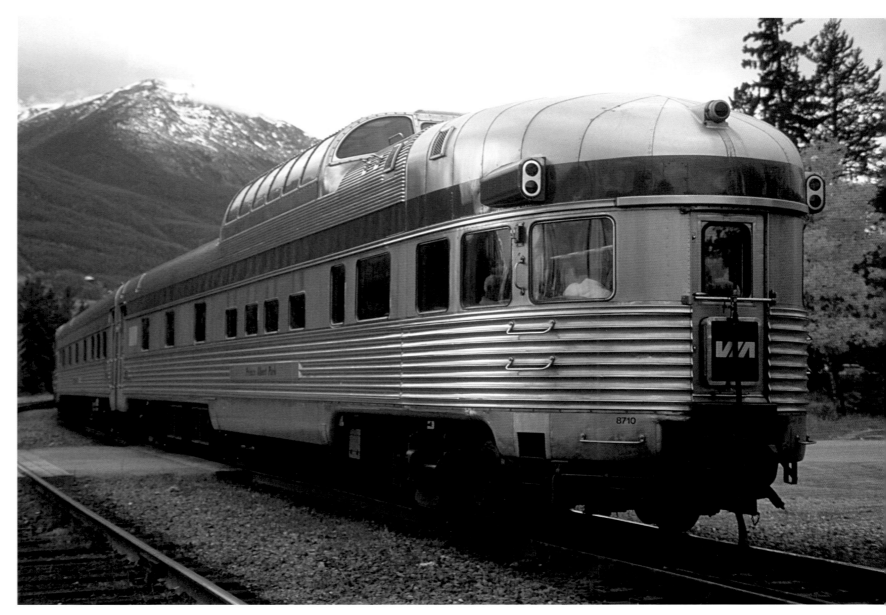

deck cars of immense size were built for service around Montreal, Chicago, and other major cities. The intensity of service required in North America, however, was not comparable with that of London. There, the need for station stops of no more than 30 seconds completely precluded the use of the type of huge double-deck car seen around Chicago, which had only one door on each side, through which all passengers entrained or alighted. At the time, non-corridor compartment cars, with individual doors to every compartment, seemed to be the only solution to a traffic situation such as that existing on the Southern Region of British Rail.

On the so-called "rapid transit" lines operating around cities in many parts of the world, multiple-unit electric trains, with wide opening sliding doors, were designed to take a high proportion of standing passengers. It has been found that even with only two wide openings on each side of a car, the interior, designed to facilitate easy movement of passengers, and the limited length of individual cars, made it possible to stop briefly at stations even during rush hours, and to close the doors despite crowding inside. It was only in certain Indian cities that commuters clustered so thickly around doors that they could not be closed!

In North America, the dome car became popular on long-distance trains. Its upper seating level with all-round glazing allowed passengers a panoramic view of the passing countryside. This example belongs to the Canadian Pacific's prestigious *Canadian Express*.

RAILROADS IN ITALY, FROM 1839

LIKE MANY COUNTRIES, ITALY'S RAILROADS GREW IN PIECEMEAL FASHION UNTIL TAKEN UNDER STATE CONTROL. IT WAS NOT UNTIL THE FASCIST ERA OF THE 1930s, HOWEVER, THAT MAJOR IMPROVEMENTS WERE MADE.

Italy's railroads were improved by the Fascists, led by Benito Mussolini (shown in his armored train with Adolf Hitler when visiting Berlin in 1937).

Although the first railroad in Italy was built in 1839, and various other projects followed, there was no coordination, because at that time, Italy had not been unified as a single country. Lombardy was occupied by Austria, while the Dukedom of Tuscany and the Papal States were independent. After the union of 1861, plans were drawn up for a national network. From the various independent and unconnected lines, five companies were set up: the Upper Italian, operating in Lombardy and Piedmont; the Roman, taking over lines in Tuscany and the Papal States; the Southern, working east of the Apennine mountains; the Royal Sardinian, in Calabria; and the Victor Emmanuel Railroad in Sicily. In 1885, a further merger took place, creating three private companies. Finally, between 1905 and 1907, all were taken under state control.

Italy was one of the first countries to introduce main-line electric power, on the line between Genoa and the French frontier at Ventigmiglia, and on the steeply graded Giovi Incline. The system adopted was not suitable for heavy modern traffic, however, and the lines were reequipped.

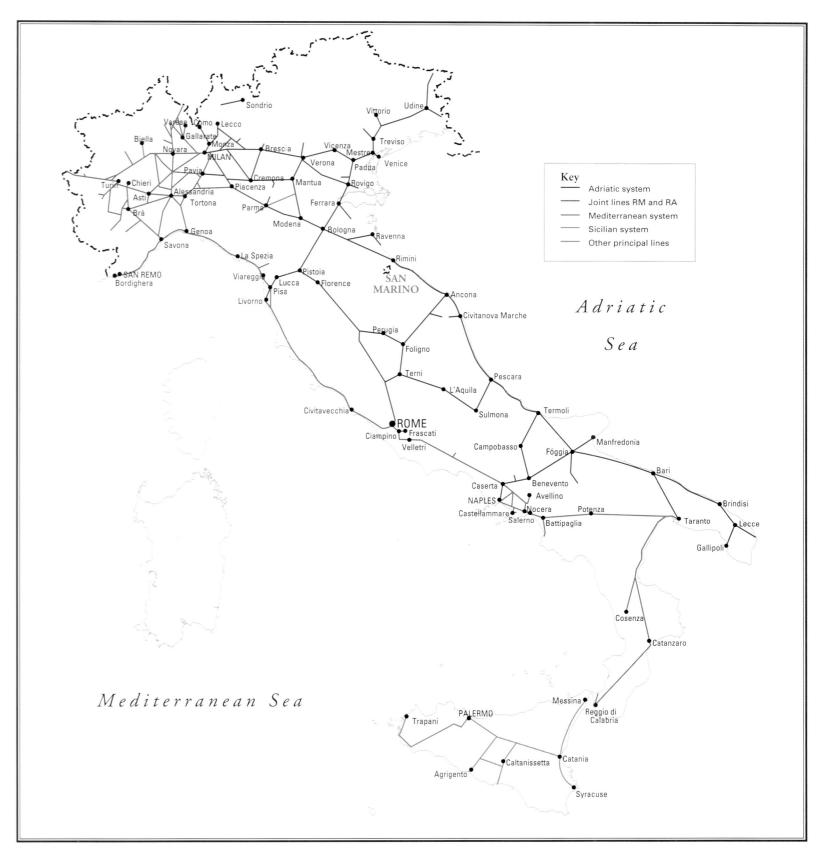

Key
— Adriatic system
— Joint lines RM and RA
— Mediterranean system
— Sicilian system
— Other principal lines

Adriatic Sea

Mediterranean Sea

During the Fascist era, notable improvements were made to the national network. The piecemeal nature of the original construction of the lines, at a time when reliance had to be placed on foreign capital, had resulted in many important routes being sharply curved and built to minimize initial costs. While the main lines eastward—from Milan to Venice, and from Milan through Bologna to Rimini and

In the late-nineteenth century, the railroads of Italy were under the control of a number of different companies.

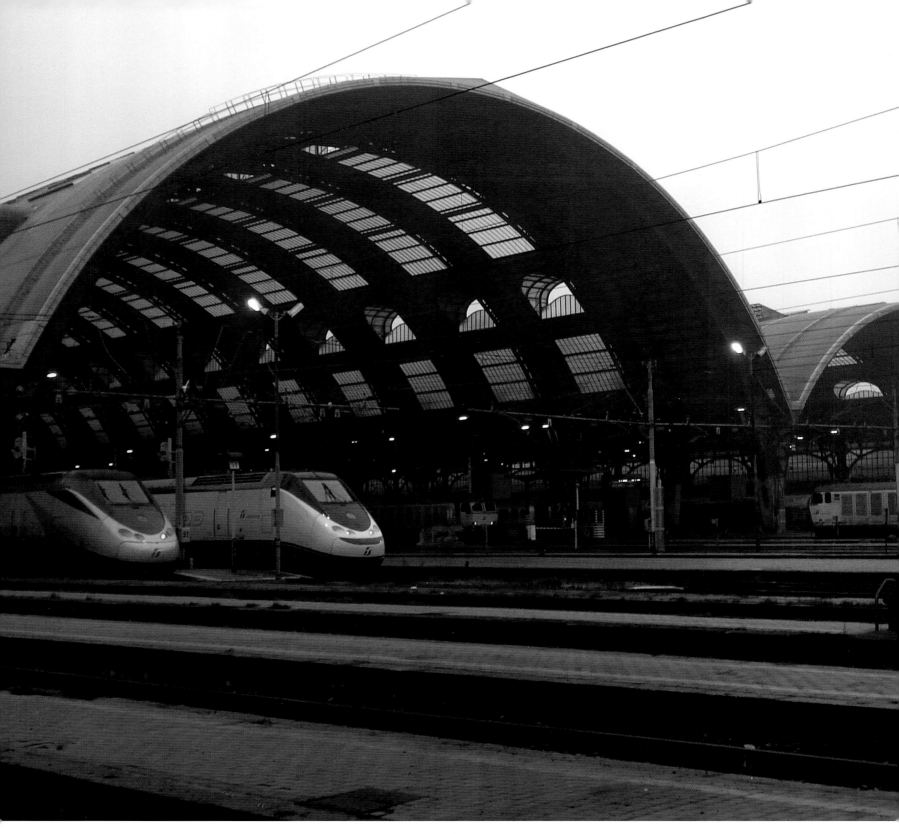

On a foggy morning in 2007 at Milan's central station, an ETR 500 very-high-speed train (left) waits alongside a Trenitalia Eurostar train. Built by Fiat Ferroviaria and operated by Trenitalia, the ETR 500 is capable of 186mph (300km/h). In the main, it is employed on the main trunk line between Milan and Naples. Some ETR 500s are multiple-voltage units, allowing their use on the railroads of neighboring countries for international express services.

Ancona—were straight and capable of use by fast trains, the important route from Bologna to Florence and Rome was extremely sinuous and heavily graded. Under the Fascists, a new direct line was built from Bologna to Florence, a great 12-mile (19km) tunnel through the Apennine range being opened in 1934. Another great project was the building of a high-speed direct line between Rome and Naples, running near the coast for much of the way and avoiding the old inland route, which was unsuitable for fast operations.

These improvements left the line between Florence and Rome as the only remaining section of the route between Milan and Naples in the old style. In mountainous country, it was extremely difficult to operate. Eventually, the decision was taken to build a new direct line regardless of the natural obstacles. This involved some tremendous engineering feats, great viaducts, and long tunnels; in fact, nearly a third of the entire distance—160 miles (257km)—from Florence to Rome is in tunnel. The

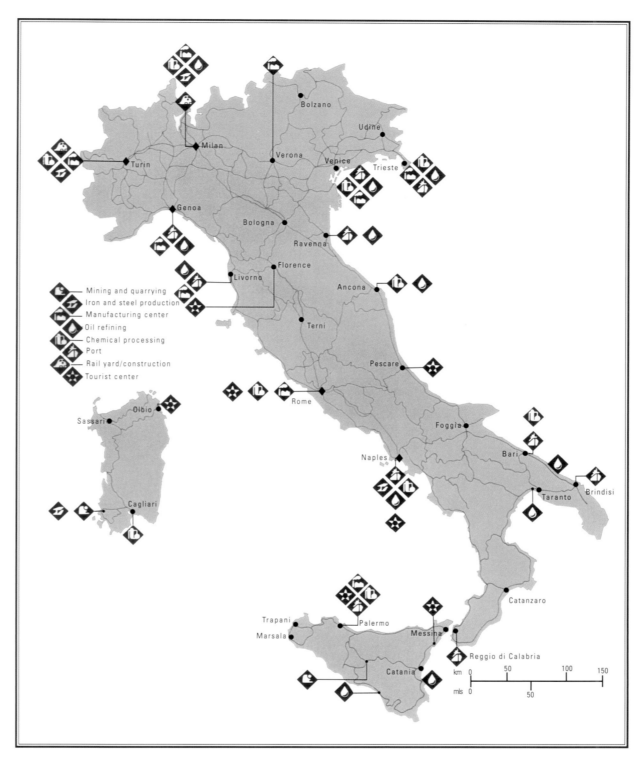

Mining and quarrying
Iron and steel production
Manufacturing center
Oil refining
Chemical processing
Port
Rail yard/construction
Tourist center

The railroad network of Italy owes much to improvements made during the Fascist era, under Benito Mussolini. Today, the system benefits from a number of high-speed lines.

end-to-end average speed of the fastest trains was planned to be no less than 110mph (177km/h), with a maximum of about 155mph (250km/h). This line took much of the traffic burden from the old route. Subsequently, it became part of the Naples–Milan high-speed line.

In 1992, the Italian state railroad—Ferrovie dello Stato-Italia (FS)—became a joint-stock company, all the shares being held by the state. There has been liberalization on the EU pattern, infrastructure having been separated from operations so that competing companies have access to the tracks. The FS passenger operation is in the hands of its Trenitalia business unit, and FSCargo became responsible for freight. A high-speed line linking Naples, Rome, and Milan was almost complete in 2007.

SPEED AND LUXURY, THE SETTEBELLO

WITH ITS LUXURIOUS ACCOMMODATION, FRONT AND REAR OBSERVATION LOUNGES, AND STREAMLINED STYLING, THE ITALIAN SETTEBELLO SET NEW STANDARDS FOR HIGH-SPEED EXPRESS TRAINS DURING THE 1950s.

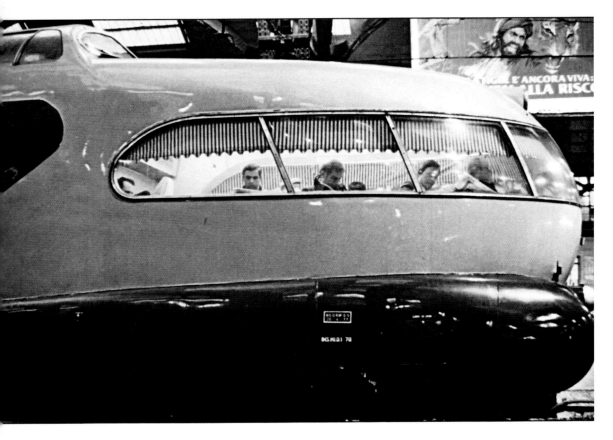

A free translation of the Italian name for this fast luxury train is "lucky seven." Indeed, passengers on it were lucky compared to their forebears, who had to travel on the so-called "*Rapidos*" of Italy in pre-Fascist days. Although a substantial supplement was charged over the regular first-class fare for the privilege of traveling on any train designated as a Trans-Europe Express (TEE), by and large, it was worthwhile. Before the Fascists took over the government of Italy in the 1930s, even the main-line express trains and famous international services, such as the *Rome Express*, were haphazard in their operation. However, among a great many other rhetorical utterances,

Mussolini said that Italian trains must run on time—period! And railroad operation was certainly improved to an almost unbelievable extent.

The *Settebello* provided a high-speed luxury service between Milan and Rome, but it should be explained that the established and famous *Rome Express* did not use the route of the *Settebello* at any point. Leaving Paris just before midnight, it entered Italy through the Mont Cenis Tunnel, stopped at Turin, then took Brunel's historic line down to the Mediterranean at Genoa. From there, it followed the coastal route to Rome, through Pisa, where someone on the platform would undoubtedly try to sell the unwary traveler a model of the leaning tower.

The *Settebello*, which left Milan at 7.50am, did follow the same route as that famous international express train, the *Italia*, which hauled sleeping cars through from Calais, Hamburg, and Brussels to Rome. This train did not go into the huge central station at Milan, which is a terminus. Arriving from

Opposite page: A unique feature of the *Settebello* was its front and rear observation lounges, which provided passengers with an uninterrupted view of the line ahead or behind.

Below: The driver of the train occupied an upper compartment immediately behind the observation lounge.

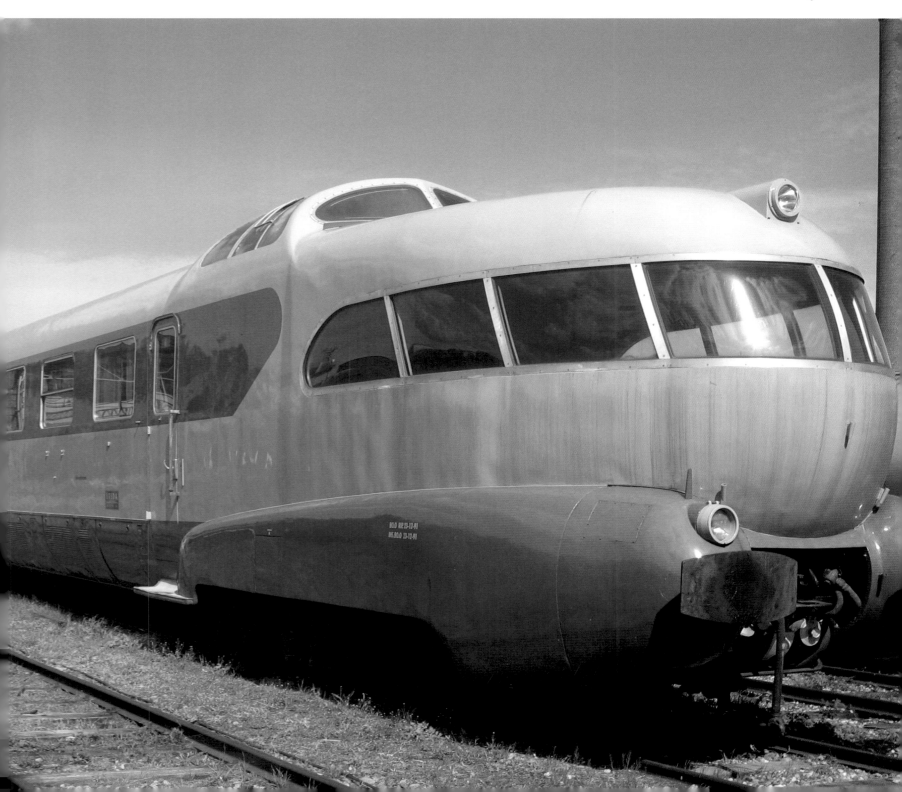

The *Settebello* covered the 351 miles (630km) between Milan and Rome in 5 hours 35 minutes, and the timetable made it possible to spend a full afternoon in either city and be back before midnight.

the north, from the Gothard line, it took the bypass line and stopped at Milan's Lambrate station. It did join the main line to the southeast, however, close on the heels of the *Settebello*, only seven minutes later; it was a much heavier train, though, and the time interval gradually increased until it was nearly three-quarters of an hour behind when it reached Rome. Even so, the *Italia* was no laggard.

Introduced in 1953, the *Settebello* was something of a pacesetter, not only in speed. Italian Railroads was one of the first to realize that if traffic was not to be lost to the airlines or the private automobile, it had to provide something more than comfortable compartment cars and trains that ran at 75–80mph (120–130km/h) between stops. Something very much faster was needed to entice the busy executive, and the wealthier tourist. Great progress had been made after World War II in electrifying the principal main lines in Italy, and improving the quality and maintenance standards on the track; the next step was the concept of a push-pull train with power units at both ends. This avoided the use of separate locomotives and the need to change locomotives at terminals, such as Florence, where through trains changed their direction of running. Thus the *Settebello* was designed as a self-contained, seven-car, unit train.

The new train set a standard of speed and luxurious accommodation previously unknown in Italy, rivaling anything else on European rails and, indeed, throughout the world at the time. The high supplement charged for this service was virtually double the regular first-class fare, but the passenger was offered a service comparable to that of a five-star hotel. Each car consisted of five spacious compartments containing comfortable armchairs and couches. There were tables and lockers for hand luggage. The toilet facilities included showers and special ladies' rooms. All the cars were completely soundproofed, and there was an extremely efficient air conditioning system. The three center cars of the train contained a restaurant, bar, and kitchen; a baggage compartment where passengers' luggage was stored at the beginning of the journey; and an office where a traveler could make a telephone call to any location in Italy. The interior decor was elegant and tasteful.

It was a style of high-speed express passenger train that later was followed on railroads in several parts of the world, including diesel powered TEE trains running between French and German cities, the spectacular *Shinkansen* "bullet" trains in Japan, and the HST units providing such an intense service of high-speed running on British Rail. In one fascinating respect, the Italian ETR-300 trains operating the *Settebello* service differed from all their successors. In the rounded, streamlined ends of the seven-car set, there were observation lounges, which were additional to the ordinary registered seating accommodation. These allowed passengers to ride at the very front and rear of the train, and enjoy a completely uninterrupted view of the line ahead or behind. The driver's controls were located

in a "flight deck" above the lounge.

When the *Settebello* got going, it left everything else well behind. In the early days, the train left Milan at 5.50pm and reached Rome at 11.40pm, covering a large part of the journey in darkness, even in the height of the summer. Initially, there was only one train set, which shuttled back and forth, the northbound service leaving Rome at 10.50am. Later, a *Settebello* ran in each direction in the mornings, the northbound leaving Rome at 8.05am. The overall time in each direction

The *Settebello*, with its unmistakable appearance and luxurious accommodation, set new trends in high-speed rail transport.

was 5 hours 35 minutes, including stops at Bologna (3 minutes) and Florence (5 minutes), and the average running speed over the 390 miles (630km) between Milan and Rome was 71.2mph (113km/h). This was a similar average to that of the *Flying Scotsman* over the 393 miles (632.5km) between London and Edinburgh. With the rescheduling of the *Settebello*, and use of another fast TEE train, the *Vesuvio*, it was possible to leave Rome or Milan in the morning, have a full afternoon in either city, catch the return train and be back before midnight. The *Vesuvio* was not quite as fast as the *Settebello*, however, taking 5 hours 50 minutes in each direction.

On its schedule, the *Settebello* normally ran at its fastest over the 135 miles (218km) between Milan and Bologna, the time being 1 hour 44 minutes southbound and 1 hour 42 minutes northbound. The latter represented a start-to-stop average speed of 80mph (130km/h). The 60-mile (95km) section between Bologna and Florence was the slowest, being allowed 1 hour 2 minutes. This was due not so much to the severe grades over the ascent to the great Apennine Tunnel as to the speed restriction necessary on the many curves leading to the tunnel. It was a thrilling stretch when viewed from the forward observation lounge, the track curving first to one side and then to the other, with magnificent views over the countryside as the train gathered height, followed by the passage through the tunnel itself at 11.5 miles (18.4km) long. Anyone riding at the head of the train through the tunnel would have been surprised to see what looked like a station midway between the ends. In fact, this was a manned tower that controlled a long siding at each entrance to the tunnel. These acted as refuges for slow running freight trains. The tower-man down there, at Precedenze, as the tower was called, must have had one of the strangest jobs on any railroad in the world, hundreds of feet below the crest of the mountain, and about 5 miles (8km) from daylight at the nearest end.

The southern end of the *Settebello*'s journey provided some further splendid sightseeing vistas. The line from Florence to Rome followed a winding course through beautiful mountainous country, but there was also another opportunity for fast running here, and the 203 miles (326km) were covered in just 2 hours 41 minutes. This time was nothing, however, compared to what was intended when the new Direttissima was complete.

RAILROADS IN POLAND, FROM 1842

POLAND'S TURBULENT HISTORY—RAVAGED BY WAR AND SUFFERING POLITICAL UPHEAVAL—HAS BEEN MIRRORED IN THE DEVELOPMENT OF ITS RAILROADS. NOW RESTRUCTURING IS TAKING PLACE.

The EP05 electric locomotive served on Polish State Railroads from the early 1960s into the early twenty-first century.

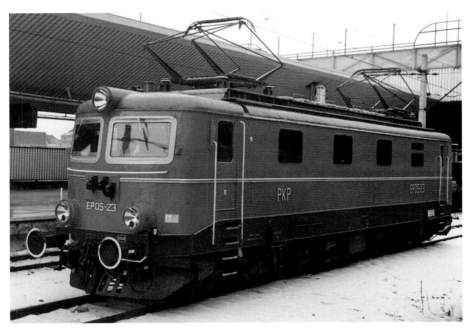

Polish State Railroads has one of the most complicated histories imaginable. When railroads were first constructed in eastern Europe, Poland did not exist as an independent country. The territory was divided between Germany, Austria, and Russia, remaining so until 1919. The first railroads—which were started in 1835, but did not actually enter service until several years later—were sponsored by those countries to suit their own needs. As a result, those in what could be termed the German and Austrian sectors were built on the European standard gauge, while those in the Russian sector had the 5ft (1,524mm) gauge. The Russians and Austrians built a line to connect Warsaw with Vienna; the former also constructed a line north from Warsaw to join up with the Grand Russian Railroad. This provided a through route to St. Petersburg (Leningrad during the Soviet era). By 1862, Warsaw was connected by rail to St. Petersburg, Vienna, and the Prussian railroad system, and therefore to systems throughout western Europe.

During World War I, the Russian part of Poland

was overrun by German and Austrian forces, and after the war, the lines in these territories were converted to the standard gauge. The establishment of the new independent state of Poland—including the highly strategic "Polish Corridor" to the Baltic at Danzig, which cut off East Prussia from the rest of Germany—brought railroad, as well as political, problems. This was particularly true in the operation of through trains from the west to Königsberg (Chojna). In the meantime, the Polish railroads were extensively modernized, only to suffer appalling destruction during World War II.

One of the most important improvements had been to equip all the freight rolling stock with continuous automatic air brakes, and to install much color-light signaling. Both advances were contained in contracts placed in Great Britain, but, unhappily, were to have little lasting effect. A total of 46 percent of all tunnels and bridges, 600 steam locomotives, and 60,000 items of rolling stock were destroyed. After the war, progress was made toward electrification, and by reason of Poland's geographical position, the railroads played a major role in the movement of westbound traffic from other countries of eastern Europe and, equally, eastbound traffic from western Europe.

The entry of Poland into the EU has been accompanied by railroad restructuring; many lines have been closed, including much of the extensive narrow-gauge mileage, while some passenger services have been withdrawn. Polish State Railroads has been divided into business companies, and privatization in some form is envisaged.

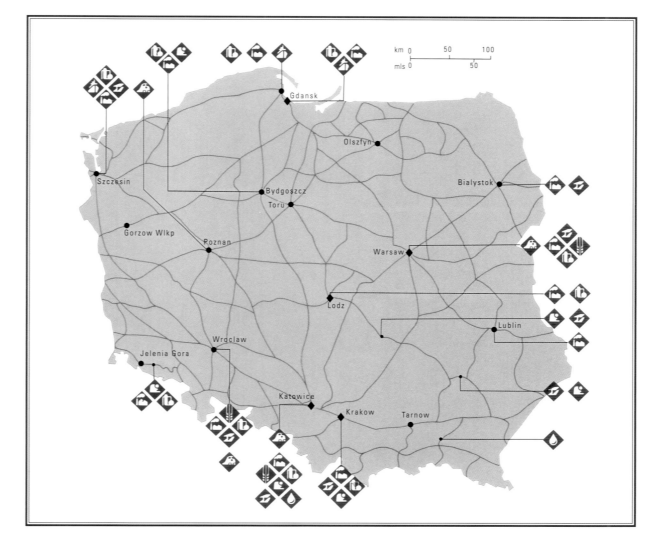

The railroads of Poland endured tumultuous times during the twentieth century. Political upheaval and war caused many problems and did much damage. Today, they are undergoing restructuring, but in the process, many lines have been closed.

Dawn of a New Age, 1935-44

For a Century, Steam Had Been the Driving Force Behind the World's Railroads; in the 1930s, However, a Rival Arrived in the Form of Diesel Power.

During the late 1930s, technical opinion in the advanced countries of the world was much divided over the relative merits of steam and diesel power. In the USA in particular, while railroads operating prestige transcontinental services—such as the Burlington, the Rock Island, and the Union Pacific—were moving toward diesel power, some of the greatest American railroads of the day—such as the New York Central, the Norfolk & Western, and perhaps the greatest of them all, the Pennsylvania—remained solidly with steam. The policy was to run long trains at speeds of 75–80mph (120–130km/h) on level track, rather than attempt to emulate the spectacular, very high speeds of the diesel hauled streamliners. An exception was the Milwaukee Road, which was in competition between Chicago, Milwaukee, and St. Paul with the streamlined diesel trains of the Burlington. The Milwaukee Road's reply was to introduce the super-high-speed, steam hauled *Hiawatha* expresses, for which special streamlined locomotives were designed.

For working the high-speed Silver Jubilee express of the London & North Eastern Railroad, introduced in September 1935, Sir Nigel Gresley built a new range of Pacific locomotives—class A4—with important modifications from his previous standard A3 series. Apart from the striking external streamlining and silver-gray color scheme, which attracted much attention from the public, the A4's internal steam passages and valve ports were fully streamlined. This afforded the maximum free flow of steam, while the use of a higher boiler pressure—250lb/sq.in (17.58kg/sq.cm) against 219lb/sq.in (15.47kg/sq.cm)—smaller cylinders and larger valves contributed to a very free running engine. Whereas an A3 class locomotive had to be pressed beyond its natural limit to attain speeds of more than 100mph (160km/h), the A4 could run up to 110mph (177km/h) and more with ease.

The form of streamlining on the LNER A4 Pacifics was very effective in deflecting the exhaust steam clear of the cab. At the time, the increased girth of locomotive boilers was causing difficulties on some types, the steam beating down and obscuring the view ahead from the cab. On the huge articulated freight locomotives of the Southern Pacific Railroad, which worked over a route that included long tunnels on single-line sections, the locomotive was turned "back to front," the cab being placed at the leading end to provide a clear view. The locomotives in question were oil burners, the fuel supply being piped from a large tender attached to the smokebox end of the engine. A notable range of locomotives of this general type were operated on the heavily graded coastal route north and south of Oakland, California, as well as on other similar routes in the United States.

In the USA, the fastest regular running in the steam era was made by *Hiawatha* trains on the Milwaukee Road, which attained speeds of more than 100mph (160km/h) between Chicago, Milwaukee, and St. Paul. When these trains were first introduced in 1935, and the train consist was relatively light, special streamlined locomotives of the Atlantic type were used, built by the American

The A4 Pacific locomotive *Mallard* at King's Cross Station, 1958. The streamlining on this type of locomotive was very effective at deflecting exhaust steam clear of the cab.

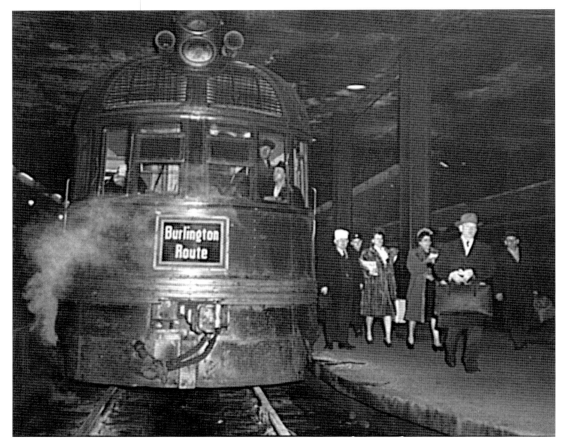

A streamlined, diesel hauled *Zephyr* train of the Chicago, Burlington & Quincy Railroad arrives at Union Station, Chicago, Illinois, some time during 1943. The high speed of these trains heralded a new era in rail transport.

Locomotive Company. The service grew so much in popularity, however, that much larger locomotives became necessary to haul the heaviest trains, a class of 4-6-4s of similar appearance, styling, and coloring being introduced in 1938. They had a tractive effort of 50,300lb (22,815kg) compared to the 40,000lb (18,144kg) of the Duchess class on the British London, Midland & Scottish Railroad.

The zenith of British express passenger locomotive development was reached in 1937 with the introduction by Sir William Stanier of the LMS Princess-Coronation class of Pacific. Initially, this was streamlined for the *Coronation Scot* train, but later it was developed into a standard type for heavy express working on the Anglo-Scottish west coast route. In its non-streamlined final form, it was known as the Duchess class. This very powerful and free running locomotive holds the British record for the maximum recorded performance in continuous "all-out" steaming, at a rate of 40,000lb/hr (18,144kg/hr) from the boiler. It also was timed at speeds up to 114mph (185.5km/h), although the record for British locomotives, and the maximum attained anywhere in the world with steam, was by the LNER A4 Pacific *Mallard* in 1938. When pressed to the limit, it reached a speed of 126mph (203km/h) on a special test run. Locomotives of this type were capable of pulling a train of up to twenty passenger cars.

One of the most significant developments in the history of railroad traction came in the late 1930s from the Electro-Motive Corporation of General Motors. Under the direction of Richard Dilworth, the highly successful 567 diesel engine, designed and perfected by Charles F. Kettering and his son, Eugene, was built into a main-line diesel-electric locomotive. Using all standard components, these engines could be managed by a single crew without the expense of multiple manning, which was necessary when heavy trains were double- or triple-headed by steam locomotives. While some American railroads, such as the Burlington and the Rock Island, introduced special streamlined diesel unit trains, Dilworth decided that the most profitable use for diesel traction was as a direct replacement of steam; his handsomely styled and brightly painted, first-generation locomotives began to do that most successfully.

Following the spectacular, albeit transient, success of the diesel powered *Zephyr* trains in the Midwest of the USA, the development of the General Motors locomotives initiated a movement that soon would sweep through the railroads of North America like a prairie fire. The basic 1,800hp unit could be linked

Zephyr trip

Denver to Chicago
1,015 miles
13 hours, 5 minutes

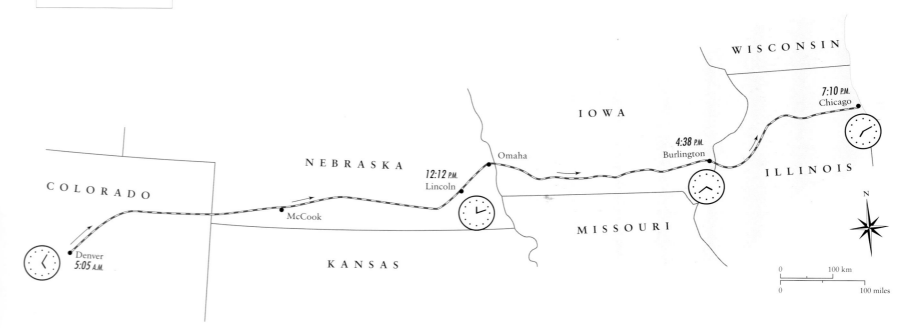

into multiples of as many as four, providing a locomotive of 7,200hp with the completely standard 567 engine. The first passenger locomotive for long-haul duty was introduced in 1937, while the freight variant followed in 1939. The outstanding advantage of the diesel freight locomotive, in heavy-grade service, lay in its high power output at low speed, roughly double that of a steam locomotive of equal nominal tractive effort.

In France, an impressive development of the 4-6-4 type was interrupted by the outbreak of hostilities in 1939. After the general amalgamation to form the French National Railroads in 1938, a central office for studies and design had been set up, and Monsieur de Caso produced a plan for a super-high-speed 4-6-4 that would haul trains of 200 tons at a speed of 105mph (169km/h) on level track. Eventually, eight were built, remarkably under the German occupation. Three of them were three-cylinder, single-expansion machines, while the other five were four-cylinder compounds in the characteristic French style. They were never employed for high-speed work, but they gave excellent service in heavy-load use until the lines they operated were electrified.

In 1938, the German State Railroads introduced a powerful 2-10-0 for general freight service, known as the class 50. A large number were put into service. With the onset of war, however, and the need to economize in the use of all metals, an "austerity" version was produced. This was known as the class 52, or Kriegslok, and every part that could be dispensed with had been discarded. Sections that could be made lighter or in a more economical manner were redesigned. None but the basest of materials was permitted. As a result, whereas the class 50 with its tender weighed 146 tons, the Kriegslok weighed only

The Chicago, Burlington & Quincy Railroad's diesel hauled *Zephyr* made a stunning debut in 1934, running from Denver, Colorado, to Chicago, Illinois—1,015 miles (1,634km)—in 13 hours 5 minutes.

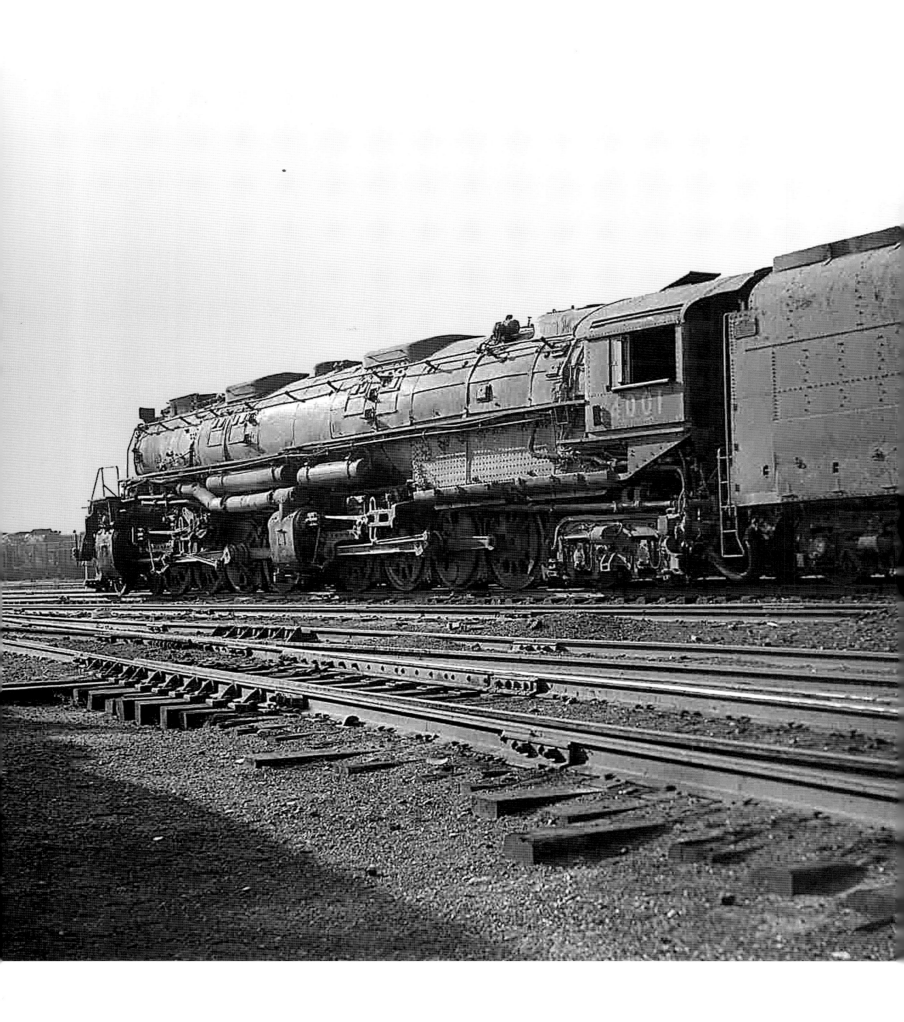

120 tons. During the war, no fewer than 10,000 of these "austerity" locomotives were constructed in Germany and countries under German occupation.

It was during this period that the articulated locomotive began to reach its ultimate size and tractive power. In the USA, this took the form of an extension to the Mallet principle of having two engines carried beneath one huge boiler. The rearward engine was mounted on the main frame, while the forward one was articulated and gave a degree of flexibility to the locomotive. While the trend was away from the original Mallet concept of a compound locomotive, in a few notable instances—particularly locomotives designed for relatively slow and heavy freight work—the compound principle was retained.

The ultimate in steam locomotive construction for heavy fast freight service came in 1941, when ALCO produced the celebrated 4000 class, 4-8-8-4 type, for the Union Pacific Railroad. These were the largest and heaviest steam locomotives ever built. The engine alone weighed 350 tons, while the huge tender was another 197 tons. This vast assemblage of 547 tons may be compared to the 162 tons of an LMS Duchess 4-6-2. The Union Pacific 4000 class locomotives were nicknamed the "Big Boys," but their tractive effort of 135,400lb (61,400kg) was not the highest achieved in the USA. Essentially, they were fast running locomotives, used mainly between Ogden, Utah, and Cheyenne, Wyoming. Detailed to heavy priority freights, they performed invaluable service during World War II.

At this time, the British firm of Beyer-Peacock was continuing to develop the Beyer-Garratt type of articulated locomotive for use in difficult terrain and on sub-standard-gauge lines in the countries of the British Empire. One of the most successful designs ever produced by the company, the 4-6-4 + 4-6-4 of the 15th class for the Rhodesia Railroads, was introduced in 1939. This was a dual-use unit, employed on heavy freights and mail trains. Although the coupled wheels were no more than 4ft 9in (144.78cm) in diameter, these locomotives ran very smoothly at high speed on the 3ft 6in (1,067mm) gauge, and their excellent tracking qualities enabled them to take the curves without any appreciable reduction from the maximum allowed speed of 55mph (88km/h). Each engine had a total weight of 179 tons and delivered a tractive effort of 47,496lb (21,544kg).

Another remarkable Beyer-Garratt design was the EC3 class on the Kenya and Uganda Railroad, where the maximum axle load was limited to 11.75 tons on the meter gauge, compared to 23 tons on the main lines of Great Britain. The EC3 had a 4-8-4 + 4-8-4 wheel arrangement and, despite the limitations imposed by the gauge and track, these engines had a tractive effort of no less than 46,100lb (20,910kg). Essentially, these locomotives were used as heavy freight haulers.

One of the Union Pacific Railroad's "Big Boy" Mallet locomotives, which were reputedly the world's biggest steam locomotive design. This example was built in 1941.

Railroads in the Former Yugoslav States and Albania, from 1846

FOR YEARS, POLITICAL TROUBLES HAVE TAKEN THEIR TOLL ON THE RAILROADS OF THIS REGION OF THE ADRIATIC. WHILE SOME ARE MAKING PROGRESS, OTHERS CONTINUE TO STRUGGLE.

SERBIA, SLOVENIA, CROATIA, BOSNIA-HERZEGOVINA, AND MACEDONIA

The state of Yugoslavia, created after World War I, inherited a mixed collection of railroads. There had been groups of lines in Croatia and Slovenia, the lines of the former Serbian State Railroads, and meter-gauge lines (and some even narrower) in Bosnia, Herzegovina and Dalmatia. The first aim of the Yugoslav government was to establish the line from the northwest to the southeast, from Ljubljana through Belgrade to Caribrod (later Dimitrovgrad), as an international main line. Belgrade became a focal point of main routes from Austria and Italy in the west, Hungary in the north, and Greece and Turkey in the east. While it was no longer possible to travel through in one coach from Paris to Istanbul, the *Simplon Express* from Paris to Belgrade made a connection there with the *Marmara Express* and also the *Athens Express*.

Yugoslavia was divided into six socialist republics, and in 1954 the railroads introduced workers' self-government, the Community of Yugoslav Railroads (JZ) losing the title 'State.' There were five Railroad Transport Enterprises, or regional headquarters, in Belgrade, Zagreb, Ljubljana, Sarajevo and Skopje. The co-ordinating authority was in Belgrade.

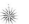

Originally developed as one integrated network to serve the former state of Yugoslavia, the railroads of the region have since been divided to create new national systems for Serbia, Slovenia, Croatia, Bosnia-Herzegovina and Macedonia.

With the progressive dissolution of Yugoslavia, JZ was replaced by new national railroads, JZ itself becoming, in effect, the Serbian state railroad. Of the new national railroads, Slovenian Railroads and the Croatian State Railroad became subject to EU recommendations and directives. Bosnia-Herzegovina, hampered by its division into two ethnic regions, strove to create a unified railroad. Macedonian Railroads, consisting essentially of a north–south line passing through its territory, did rather better and began to study the construction of new lines.

ALBANIA

Albania's first railroad was opened as late as 1947, but the system has experienced a hard life due to ongoing political circumstances. In 1986, however, a new line into Montenegro became the country's first international connection. The World Bank launched a rescue effort in the 1990s, but progress has been extremely slow.

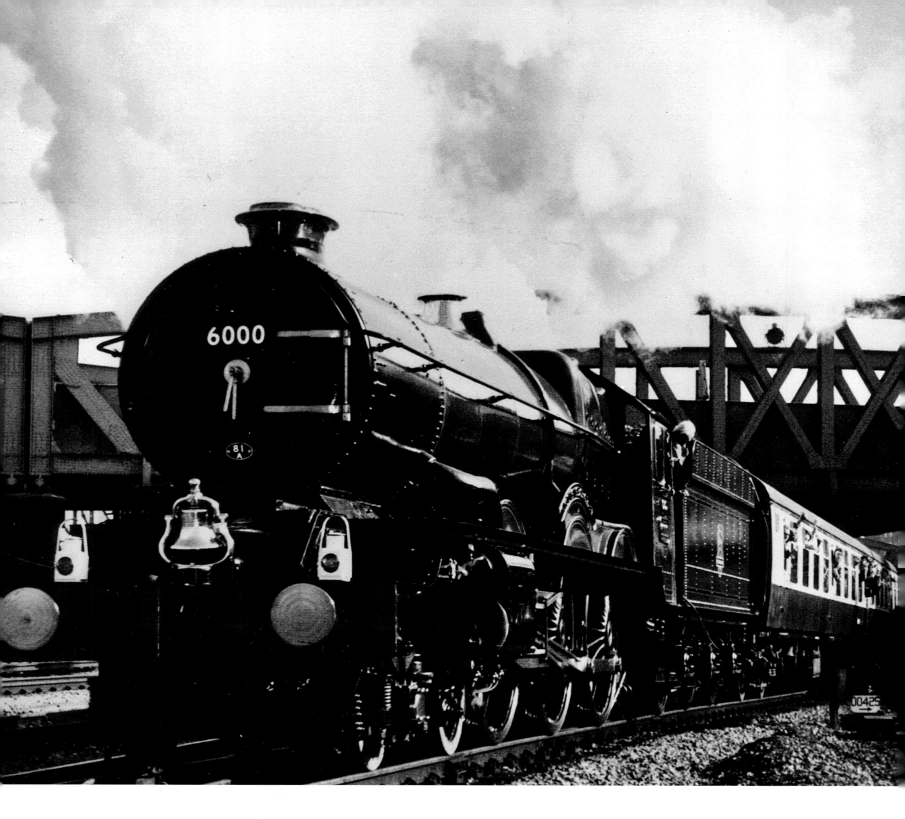

THE ECLIPSE OF STEAM

ALTHOUGH MORE EXPENSIVE AND MORE COMPLEX THAN STEAM
LOCOMOTIVES, DIESELS OFFERED MANY ADVANTAGES THAT MADE
THEM AN ATTRACTIVE PROPOSITION FOR THE RAILROADS OF THE
WORLD IN THE POST-WAR ERA.

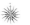

The steam locomotive was the simplest, least expensive and most reliable form of motive power devised for railroads, but its cheapness related primarily to first cost. After World War II, when the immediate rehabilitation of British Railroads was a priority and economic considerations were uppermost, R.A. Riddles, a member of the Railroad Executive responsible for mechanical and electrical engineering, said that investment would be made first in the form of traction that gave the most tractive effort per pound sterling. At that time, a diesel locomotive cost two-and-a-half times more than a steam locomotive of equal tractive power.

Steam locomotives had many disadvantages in the era dawning. Fuel was a problem. Although railroads in many parts of the world used alternatives, coal was still the most generally used, and its cost was increasing. The introduction of cutting machinery in mines meant that coal was being produced in a form not ideal for locomotive firing; troubles were experienced with inadequate steam production. There was also the question of labor; even the smallest steam locomotive needed the attention of two men, and changing attitudes toward working conditions after the war made work on a steam locomotive unattractive. Much had been done in the 1930s to reduce the work content of daily servicing—by the introduction of self-cleaning smokeboxes and hopper ashpans, and by streamlining procedures—but a locomotive would rarely be in service for more than 10 hours out of 24, and the average was much less than that.

By contrast, the diesel locomotive had several advantages, once the initial cost had been covered. It needed little by way of daily servicing, and its first cost was balanced by its higher availability —double that of steam. This meant that fewer locomotives would be needed to work the traffic. Economy in space could also be made—roundhouses took on the form of roadside filling stations, so short was the time that units were out of traffic. The most difficult problem was covering the time of transition from one form of motive power to the other, because if not properly maintained, a diesel could become a greater liability than a steam locomotive. Servicing facilities had to be kept separate; diesels could not be housed or serviced amid the inevitable dirt of a steam shed.

The power-to-weight ratio of non-steam locomotives is often quoted to their advantage. In North America particularly, the performance characteristics of a diesel-electric indicated an advantage over steam on severe grades. At speeds below 20mph (32km/h), the power to pull was double that of a steam locomotive of nominally equal tractive power, whereas at 50mph (80km/h) and over, the advantage, if any, would have been with steam. On the Euston–Glasgow route, electric locomotives of 80 tons total weight developed 5,000hp, whereas the largest and most modern steam Pacifics, with an all-up weight of 160 tons, produced around 2,000hp.

In post-war Britain, steam traction was steadily replaced by diesel and electric. The highpoint of British diesel development was the HST (High Speed Train), which regularly ran at 200km/h (125mph). An HST is shown here alongside a preserved steam locomotive.

RAILROADS IN SCANDINAVIA, FROM 1847

DIFFICULT LANDSCAPES AND A HARSH CLIMATE HAVE MADE THE CONSTRUCTION AND OPERATION OF RAILROADS IN SCANDINAVIA PARTICULARLY CHALLENGING.

SWEDEN

The Swedish railroad system began in 1849, when an 5-mile (8km) narrow-gauge line was opened between Fryksta and Klarälven, using horsedrawn trains; the main-line network and state owned system, however, date from 1856. Before the restructuring of 1988, the Swedish State Railroads (Statens Jarnvagar) operated more than 90 percent of the total traffic and had a route length of approximately 7,000 miles (11,200km). More than half of this was electrified.

Several Swedish railroads are still privately owned, notably the Grängesberg-Oxelösund, which has a main line that is 185 miles (296km) long. This is an east–west route that threads its way from the coast at Oxelösund through the picturesque lake country to the

To a certain extent, the landscape of Sweden has dictated the extent of the rail network, which, for the most part, runs on level terrain. In the north, however, it penetrates mountainous country on its way to the Norwegian border.

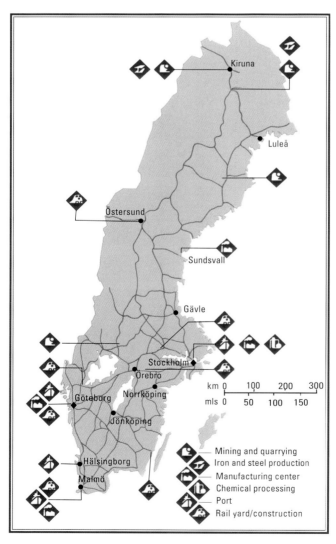

Mining and quarrying
Iron and steel production
Manufacturing center
Chemical processing
Port
Rail yard/construction

west of Stockholm. It is entirely electrified, although its experiments with a non-condensing steam-turbine locomotive in 1932 led to the construction of similar, but much larger, locomotives in Great Britain and the USA.

From Stockholm, headquarters of the state system, main lines run westward to Charlottenberg, on the Norwegian frontier, and southward to Gothenburg and Malmö; fast express trains are operated over the two latter routes. Northward from Stockholm, the main line runs through Uppsala, to the junction of Ånge, where there is a large mechanized classification yard for dealing with eastbound traffic from Trondheim in Norway. The main line continues to Boden, where it intersects the important north-west/south-east ore carrying line of the Riksgransen Railroad, which traverses the Arctic Circle, from Narvik, via the Norwegian State Railroads, to the port of Luleå on the Gulf of Bothnia.

More than a third of the lines are carried over generally level track, while another 20 percent are on grades that are no steeper than 0.5 percent. Only the approaches to the Norwegian frontier are through mountainous regions. The track gauge is the standard European, the rails being carried on impregnated wood ties. This gauge permitted the operation of several important international train services by ferry; now, there is a continuous rail link between Sweden and Denmark.

In 1988, infrastructure and operations were separated, the state retaining ownership of the former, while operations were opened to competing companies. Much short-line business, in particular, has been taken by smaller companies, but SJ has remained dominant and, indeed, has revolutionized long-distance services with its X2000 tilting trains.

Unlike the Swedish rail network, most of the Norwegian system runs through rugged mountainous country, and operations are hampered by extreme weather conditions.

NORWAY

The Norwegian railroads, the first section of which was opened in 1854, are particularly fascinating because, for the most part, they are operated in exceedingly rugged country and subjected to great extremes of climate. In striking contrast to Sweden, less than 6 percent of the total length of about 2,800 miles (4,480km) is on grades of less than 1 percent. More than three-quarters of the total is on truly mountain grades of 1.5–2.5 percent.

Until World War II, the very severe Dombas line, forming the main route from Oslo to Trondheim, was worked by some of the most powerful steam locomotives in Europe. The principal main lines are electrified, but the line from Trondheim northward across the Arctic Circle to Boden, opened as recently as 1962, is diesel powered. In the far north, the line from Narvik to the Swedish frontier is completely isolated from the rest of the Norwegian State Railroads system, but it forms part of the important iron-ore route into northern Sweden. The fastest trains in Norway

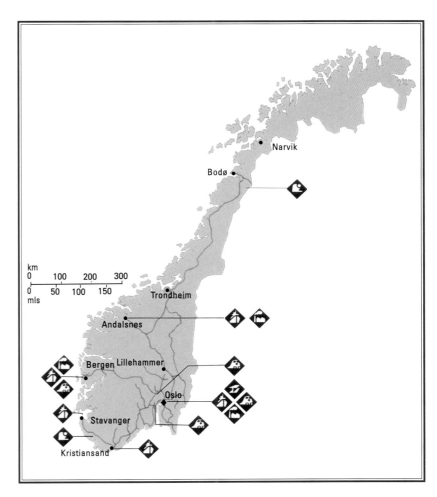

are those that follow the southern coastline from Oslo, south to Kristiansand and then north-west to Stavanger. This line runs on easier grades than the mountain routes from Oslo to Bergen and Oslo to Trondheim; the Stavanger Express covered the 370 miles (592km) from Oslo in eight hours, including ten stops. Since then, there has been considerable speeding up of services, the import of Swedish X2000 tilting trains having helped this process. In 1993, a freight service from Oslo to Narvik via Sweden was introduced, with a daily 900-ton train taking only 27 hours for the 1,210-mile (1,950km) trip.

In 1996, Norwegian State Railroads became a limited-liability company, its infrastructure being transferred to a separate national authority.

DENMARK

The geographical structure of Denmark, where some of the most important and populous areas are on islands, presented special problems when it came to building an efficient railroad network. The first section was from Copenhagen to Roskilde, opened in 1847. It required the construction of large bridges to link the islands. In some cases, however, the distances were too great for bridges, leading to the introduction of train and car ferry services. No fewer than four of the train ferries involved international co-operation: Rødby–Fehmarn, with the Federal Railroad of West Germany; Gedser–Warnemünde, with the State Railroad of East Germany; and Copenhagen-Malmö and Helsingør–Helsingborg, with the Swedish railroads. It was only in the Copenhagen suburban area that electric power was employed in Denmark, although the new rail link to Sweden is also electrified. The principal main-line services are worked either by diesel-electric locomotives or diesel railcars.

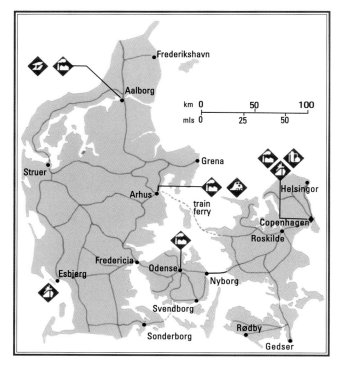

In 1997, Danish State Railroads handed over its infrastructure to a new company, and in other ways, EU recommendations and directives have been followed, independent operating companies having open access to the tracks. The opening of the Oresund rail link, connecting Copenhagen with Malmö in Sweden, has seen the introduction of a frequent train service between the two countries.

FINLAND

Because of the long eastern frontier, from its inception in 1862, the Finnish state railroad system has been orientated toward Russia rather than toward the rest of Europe. The rail gauge is 5ft (1,524mm), although at Tornio, in the far north of the country, there are interchange facilities with the

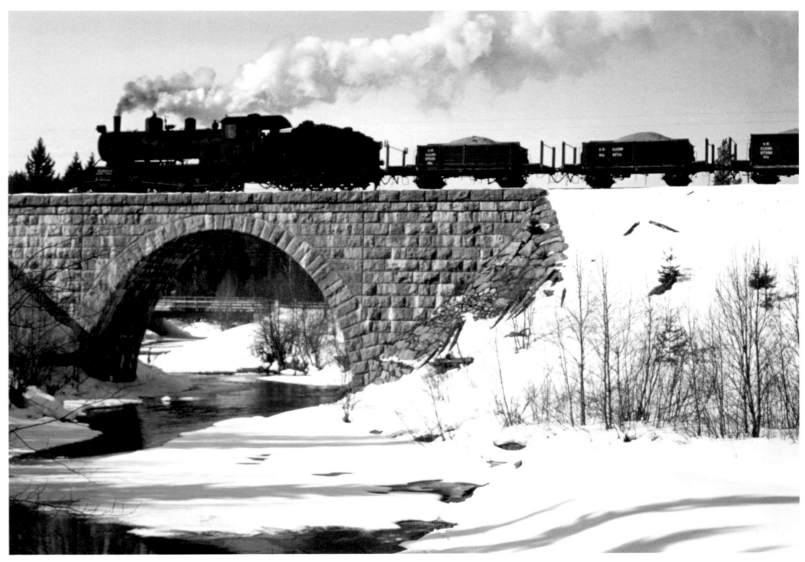

standard-gauge Swedish system. Each day, there are through express trains running from Helsinki with sleeping cars, one for St. Petersburg and one for Moscow, with the departure times being arranged to provide arrivals in the Russian cities at around 9.00am. However, this was expected to change during 2008 with the introduction of tilting trains.

Although Finland is subjected to extremes of climate, the railroads are operated efficiently even in the depths of the sub-Arctic winters. The Finnish railroads still operate a number of electric locomotives that were imported from the Soviet Union. There are ferry services across the Baltic, between Helsinki and Lübeck, and between Naantali and Stockholm.

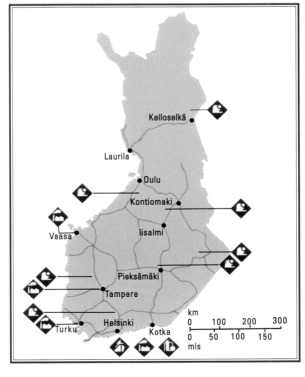

A Finnish State Railroads TV1 class 2-8-0 steam train heads towards Kontiomaki with freight from Hyrynsalmi, Finland.

THE DIESEL LOCOMOTIVE

VARIOUS TYPES OF DIESEL LOCOMOTIVE HAVE BEEN EMPLOYED ON THE WORLD'S RAILROADS, THE MAJOR DIFFERENCE BEING IN THE WAY THAT POWER IS DELIVERED TO THE DRIVING WHEELS.

An early EMD locomotive of the Atchison, Topeka & Santa Fe Railroad. This type formed the mainstay of the company's early diesel operations.

The diesel heavy-oil engine had a large theoretical advantage over steam because of its much higher thermal efficiency. Moreover it uses a lower grade of fuel than is necessary for motor vehicles. The diesel is a quick running engine compared to the reciprocating steam locomotive, which had direct drive to its wheels. A steam express passenger locomotive with driving wheels of 6ft 6in (2m) diameter made about 300rpm when running at 70mph (113km/h), whereas the normal engine speed of a diesel is about 750rpm or more. That speed needs to be reduced at the driving wheels, which is carried out by inserting some form of gearbox or transmission between the engine and wheels, in the same manner as a road vehicle. This allows the engine itself to be kept running at an almost constant speed.

There are two principal types of diesel engine in general railroad use. The great majority are relatively slow running marine types, exemplified by the Sulzer, General Motors and General Electric designs, which have an engine speed of about 800rpm. The other type is the Napier quick running 'Deltic' engine, which has had an outstandingly successful record in a small specialist application on the railroads of Great Britain.

Of the transmission systems, the simplest is mechanical, although the power to be transmitted precludes the use of a purely manual gearbox, as on an automobile. One of the most successful early applications in Britain was on the former Great Western Railroad, which collaborated with bus builder AEC to introduce diesel powered railcars in the 1930s. These had a similar type of engine and transmission to buses of the period. The transmission was the well-tried Wilson gearbox, which is the best-known application of epicyclic change-speed gearing to

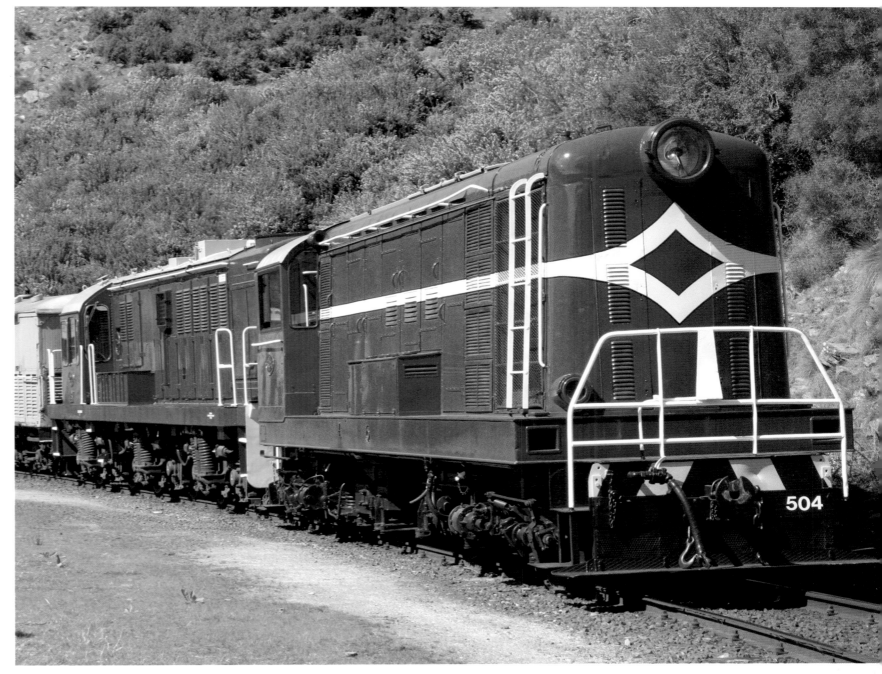

locomotives and railcars. It utilized the so-called 'sun and planet' type of mechanism and could be built with either four or five speeds. Gear changing was effected by compressed air. These railcars were introduced at a time when private cars were the exception rather than the rule among employees of British railroads, and the traditional locomotive men, used to steam, were puzzled at first over the matter of changing gear. There is a story told of an engineer who felt ashamed to go home and tell his wife that he had 'been trying to drive a blue pencil motor bus.' However, all the engineers became expert enough in a very short time.

Mechanical transmissions, however, could be used only for relatively small power units, and electric transmissions became the most common in the very rapid switch from steam to diesel power in the USA, immediately after World War II. In a diesel-electric locomotive, there is no physical connection between the engine and the driving wheels. More correctly, it should be described an

A preserved example of a DE class diesel-electric locomotive of New Zealand Railroads (NZR). Built by English Electric in Bo-Bo configuration, between 1951 and 1952, this type of locomotive was purchased originally for yard work. However, it was also used to haul suburban passenger trains. In all, 15 such locomotives were operated by NZR, being retired in the late 1980s.

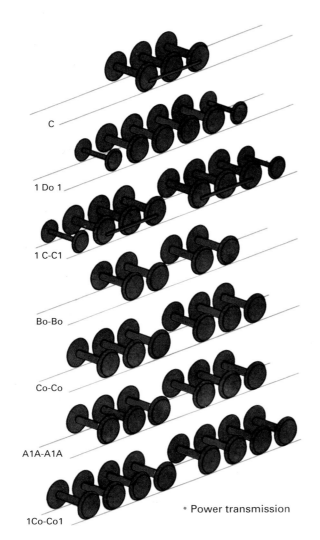

C

1 Do 1

1 C-C1

Bo-Bo

Co-Co

A1A-A1A

1Co-Co1

• Power transmission

Wheel notation employed for UK diesel stock appears even more baffling than that applied to steam locomotives. Numbers are given to carrying axles, and letters to driving axles: A=1, B=2, C=3 and so on. Axles that are driven individually have the suffix 'o'.

electric locomotive that carries its own power generating station. Like a steam locomotive, it is completely self-contained, needing only supplies of fuel and water to be added at regular intervals.

In most designs of diesel-electric locomotive, the generator and the diesel engine that drives it are mounted on a common foundation, while the electric traction motors are quite separate and carried directly on the driving axles. On the British Rail Peak class C+C, for example, there were six traction motors, three on each truck. These locomotives had the Sulzer double-bank type of diesel engine, whereas the English Electric type is of the V-form, as is the celebrated 567 engine built by General Motors in the USA. Early British diesel-electric locomotives had the added complication of having to carry steam generators, since they were introduced at a time when all main-line passenger rolling stock in Britain was steam heated. The auxiliary electrical generator, coupled to the main generator and part of the engine unit, had to have additional capacity to feed the steam generator when it was required. While the output of the main generator could be varied according to the immediate demands for power from the traction motors, the output of the auxiliary generator, providing power for lighting and so on, had to remain constant.

The transmission of power between the main generator and the traction motors is controlled by the engineer, using the throttle handle, which is linked to the power controller. This operates the traction motor contactors, regulates the diesel engine speed and varies the excitation current of the main generator according to requirements. All these controls are interconnected and electrically interlocked one with another.

In West Germany, the hydraulic system of transmission was favored; for a time, this was also standard on the Western Region of British Rail. Moreover, German manufacturers are still building locomotives of this type. The transmission is different from that of a diesel-electric locomotive in

The basic layout of a diesel-electric locomotive. The diesel engine powers a generator that produces electricity to drive the traction motors.

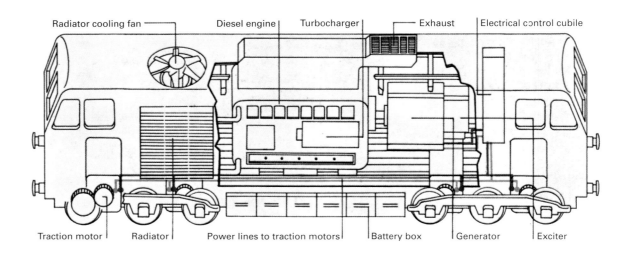

Radiator cooling fan | Diesel engine | Turbocharger | Exhaust | Electrical control cubicle

Traction motor | Radiator | Power lines to traction motors | Battery box | Generator | Exciter

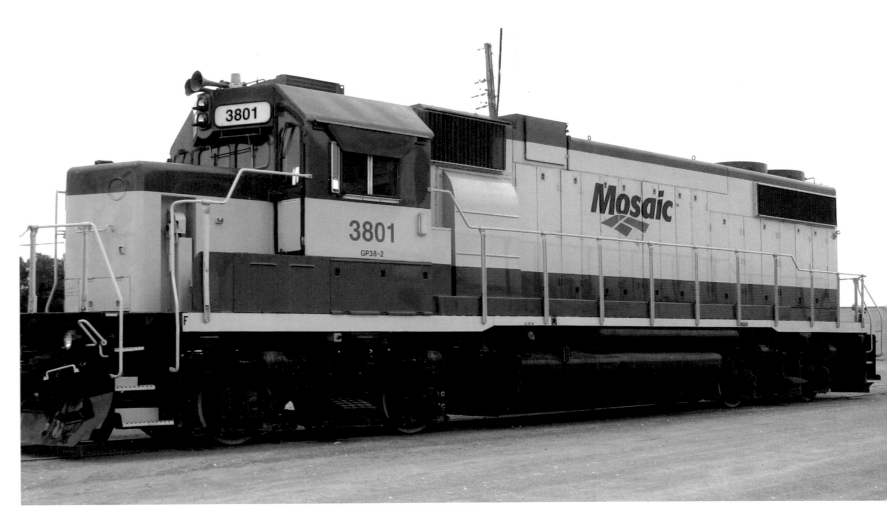

that there is a direct mechanical connection between the engine and the driving wheels. The diesel engine's crankshaft is connected to the fluid transmission unit through a device called a Cardan shaft, which consists of a telescopic shaft with a universal joint at each end. There is a separate diesel engine for each truck of the locomotive, and the transmission unit is mounted so that its drive wheel is on the center-line of the truck, in the case of a locomotive with two four-wheeled trucks. From this drive wheel, Cardan shafts extend fore and aft to the final drive units on the axles of the driving wheels. The hydraulic form of transmission has the advantage that less weight is actually carried on the truck, but the use of diesel-hydraulic locomotives on British railroads came to an end when those on the Western Region were phased out.

When diesel-electric locomotives first entered service, it was thought that they would have less effect on the tracks than steam locomotives; that the smooth action, in contrast to the fluctuation of load due to the rotation of heavy parts, would be beneficial. In fact, there was no advantage, because of the heavy weight of traction motors carried low down on the actual truck axles. These caused a pounding action that had not previously been experienced. In the extremely successful 'all-adhesion' electric locomotives introduced in Switzerland at the end of World War II, the traction motors were not mounted on the trucks. These types of locomotive were used in other railroad systems, the Swiss always being leaders in this field.

In recent years, alternators have been used increasingly instead of generators, the ac current being converted to dc for all traction motors.

Built by General Motors' Electro-Motive Division, the EMD GP38-2 was a dual-purpose locomotive, known as a road-switcher, being suitable for both yard and main-line work. It was a four-axle design with a 2,000hp 16-cylinder engine.

RAILROADS IN SPAIN AND PORTUGAL, FROM 1848

BOTH SPAIN AND PORTUGAL DEVELOPED BROAD-GAUGE RAILROAD SYSTEMS, MUCH OF WHICH REMAIN. NEW HIGH-SPEED LINES HAVE BEEN BUILT ON THE STANDARD GAUGE, HOWEVER, FACILITATING INTERNATIONAL CONNECTIONS.

SPAIN

Railroad operation in Spain began in 1848 under rather curious circumstances. A 18-mile (29km) length of line was built between Barcelona and Mataro, but a Royal decree of 1845 had insisted on extensive state intervention. Among other things, this demanded the adoption of a wider gauge than the European standard of 4ft 8½in (1,435mm). It is thought that this was influenced by the work of Brunel in England; and while Spain had nearly the same gauge as Portugal— 5ft 6in (1,674mm) against 5ft 5½in (1,665mm)—there developed a major confrontation at the French frontier that still remains in force today.

From that beginning, Spanish railroad construction, dependent upon foreign capital and the need for

A RENFE series 352 diesel locomotive heading a Talgo III express train, c.1988.

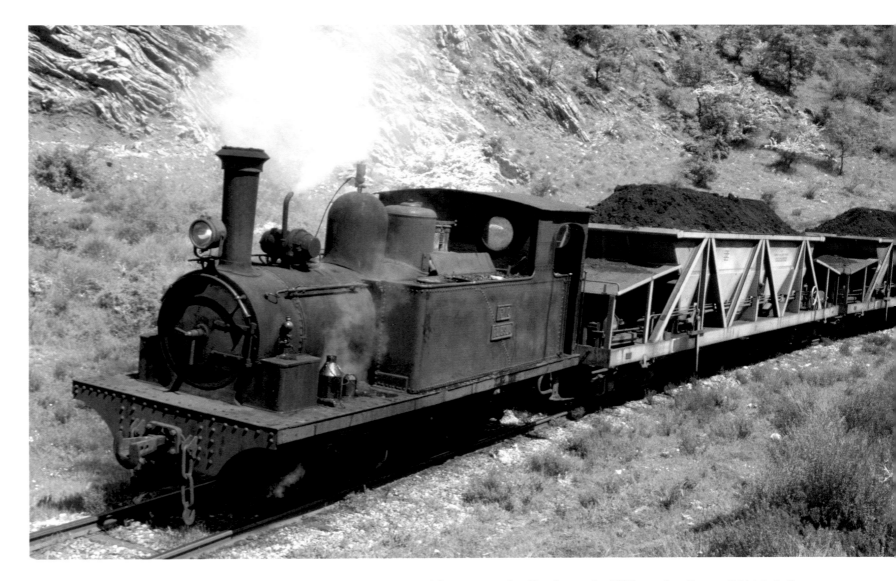

A well-worn, British built Sharp Stewart 0-6-0 tank locomotive hauls coal at the Sabero Colliery, Northern Spain.

foreign advisers, progressed slowly. Major companies incorporated later were the Northern, in 1858, to build a line from Madrid to Irun; the Madrid, Zaragoza and Alicante in 1857; and the Andalusian Railroad. In due course, all suffered from a lack of staple traffics, the difficulties of operating in mountainous country, and the imposition of low rates for both freight and passenger business. Unable to renew their assets, they went into decline. In 1924, a convention in Madrid, signed by the state and the companies, provided state capital for railroad restoration and authorized the establishment of more realistic rates. The latter condition was not fulfilled, however, and despite the infusion of state capital, the railroads were in poor shape when the Civil War broke out in 1936.

Destruction was widespread and severe during the war. More than a thousand locomotives—over half the total stock—were destroyed, and many bridges, tunnels and sections of track damaged. After the war, the government took control of the railroads, purchasing the entire stock of the private operating companies in 1943. An autonomous corporation, nominally independent of the government, was set up to operate the railroads, being named Red Nacional de los Ferrocarriles Españoles (RENFE). Under this unified management, great progress was made in rebuilding and re-equipping the Spanish railroads. Many sections were electrified; others were switched from steam to diesel power. One of the most important developments was the construction of a new direct line from Madrid to Burgos

via Aranda, avoiding the long westward detour through Avila, Medina del Campo and Valladolid, and saving a total of 75 miles (130km) on the journey between Madrid and the French frontier.

Conforming to EU practice, separation of the infrastructure from the operating company was achieved in the 1990s, and access provided for competing operators, although RENFE remained dominant. Enormous funds have been poured into the Spanish rail system, and a series of high-speed lines has been built and planned. These are standard gauge; the intention is to maintain the traditional broad-gauge lines for conventional trains, but to permit through running with gauge changing installations at break-of-gauge points. Some trains, like the Talgo lightweights in international service, already have quick-action gauge changing wheel sets. That said, conversion of some broad-gauge lines to standard has not been excluded.

PORTUGAL

The first railroad in Portugal was opened in 1856, between Lisbon and Carregado, and the national network, amounting eventually to 2,200 miles (3,520km) of route, was built up under private enterprise. The principal main line connected Lisbon with Oporto, and had a branch running northward into Spain and continuing to La Coruna. Important west–east international routes link Lisbon with Madrid, Barcelona and Sevilla, while a more northerly line, which reaches the Spanish frontier at Vilar

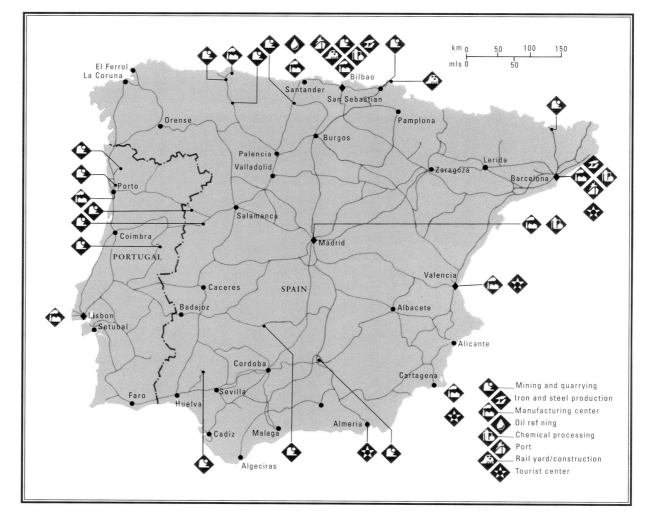

After the Spanish Civil War in the 1930s, the government, under General Franco, took control of the Spanish railroads, and much work was done to rebuild and re-equip the network. The system was built to broad gauge, but in recent times, high-speed lines have been laid to standard gauge to permit easy passage of international expresses. The Portuguese railroads are also broad gauge, but standard-gauge high-speed lines are planned.

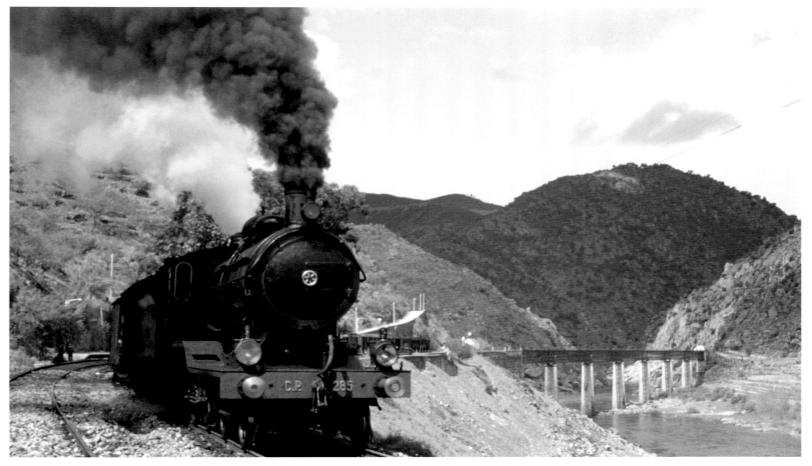

A German built Henschel 4-6-0 steam locomotive on the broad-gauge Douro Valley line in Portugal. Many of the steam engines operated in Portugal were supplied by Henschel.

Formoso, is used by trains providing the international service between Lisbon and Paris. These routes are laid to the Portuguese broad gauge of 5ft 5½in (1,665mm).

Until 1926, roughly half of the lines were privately owned, while the remainder were under state control. Then the government leased its own lines to the private operating company. In 1947, however, the whole concern was taken directly under the control of the Ministry of Communications, although day-to-day operation remained with the company. Finally, in 1951, the government granted the company a 50-year concession to work the lines previously leased.

A feature of Portuguese railroads of great interest to enthusiasts and photographers is the system of narrow-gauge feeder lines in the north. A series of branches extends into the frontier regions from the Oporto–Barca d'Alva broad-gauge main line. On the broad-gauge lines, steam operation came to an end in March, 1977. In the Lisbon suburban area, and on the main line northward toward Oporto, electrification progressed, using the same system—25,000 volts ac at 50 cycles—as standardized in Great Britain and France. On other routes, extensive use is being made of diesel-electric locomotives on long-distance and international trains, and railcars for local branch-line work.

Severe financial difficulties hastened the restructuring of the operating company, and in the late 1990s it was reorganized into five business units. At the same time, the EU policy of separating infrastructure from operations and granting open access to independent operators was adopted. Inspired by the Spanish example, Portugal has also planned two high-speed railroads, from Lisbon to Oporto and from Lisbon to a connection with Spain. Pendolino trains are in use. There has been talk of converting all lines to standard gauge to match the high-speed lines.

The Modern Approach, from 1945

AS RAILROADS SOUGHT TO MODERNIZE POST-WAR, STEAM POWER
RAPIDLY GAVE WAY TO THE MORE EFFICIENT DIESEL-ELECTRIC
AND PURE ELECTRIC FORMS OF TRACTION.

A major event that influenced the design of steam locomotives in Britain was the nationalization of the railroads in 1948, and the decision of the newly formed Railroad Executive Committee to rely on steam power for some years to come. In the same year, after a series of trials between locomotives from the four original private operating companies had shown no design that was markedly superior to any other, the committee decided to produce a series of new standard locomotives that would embody the best features of the regional types. The first of these was the class 7P7F dual-purpose Pacific, the first example of which was constructed at Crewe in 1951 and named *Britannia*.

The Pacific, followed by 4-6-0s in various power classes and new standard tank engines for short-distance traffic, achieved a considerable degree of success in the short time before the launch of the British Railroads Modernization Plan in 1955. A major aspect of this was the elimination of steam power throughout Britain. Therefore, the new standard locomotives, of which 999 were built, were not fully developed before it was decided that all future work would be concentrated on non-steam forms of power. Most successful of all the new standard designs was the 9F 2-10-0, intended primarily as a freight engine, but so versatile that it was employed in high-speed passenger service, attaining speeds up to 90mph (145km/h).

In the USA, the elimination of steam power was more rapid even than in Britain. The diesel-electric locomotive had traction characteristics definitely superior to those of steam, in engines of nominally equal tractive effort when working hard up a severe grade at speeds of 20mph (32km/h) or less, and its introduction came in areas where bad grades existed. On some of the eastern lines, where

grades were less exacting, extensive trials were conducted between diesel-electric locomotives and the latest steam designs. Elsewhere, however, steam was finally swept away.

Two factors tended to hasten the end of steam power in the USA. One was the uncertainty of fuel supplies in the eastern United States, where there were severe and recurring labor troubles in the coal industry; the other was the greatly reduced turn-around time necessary with diesel-electric locomotives compared to steam. The swift replacement of steam locomotives by diesels in the USA had repercussions around the world, prompting commercial rather than technical interest to press for similar 'revolutions' elsewhere, nowhere more strongly than in Britain. Eventually, this culminated in the elimination of all steam power on that system by 1968.

A Royal train carrying Queen Elizabeth arrives at Fielding in New Zealand on January 6, 1954, to be greeted by crowds of well-wishers. The train is hauled by a pair of English Electric DE diesel-electric locomotives, newly purchased by New Zealand Railroads.

In France, and to a lesser extent other European countries, the drive toward modernization was as strong, but to electric rather than diesel power. The mountainous regions of the Alps lent themselves to the generation of hydro-electric power, while the large-scale importation of fuel oil was undesirable. Consequently, much of the funding made available for reconstruction after World War II was directed toward electrification.

In addition to some obsolete systems, three forms of electric-traction current supplies were in use in 1950: 1,500 volts dc in France and the Netherlands; 3,000 volts dc in Belgium and Italy; and 15,000 volts ac at $16^2/_3$ cycles in Germany, Austria and Switzerland. These systems were continued in the first reconstruction work after the war, notably on the Paris–Lyon–Marseille line of the French National Railroads. One of the most notable developments, derived from the practice of the Bern-Lötschberg-Simplon Railroad in Switzerland, was the adoption in France and elsewhere of electric locomotives that had all their axles powered. Earlier notions that non-powered guiding wheels were needed at front and rear on locomotives used in high-speed service were dispelled, first by Swiss experience and then by the remarkable performances of the new French locomotives, two of which attained a maximum speed of 206mph (330km/h) in tests.

In the USA, while a few routes had been electrified for upward of 30 years, all post-war development was directed toward diesels. However, although the so-called 'carbody' type had been first in sweeping steam aside, as the diesel conquest continued, the 'hood' type predominated. This was a less elegant, but more serviceable design, external walkways giving access to the engines and affording much easier maintenance. Locomotives of this type virtually took over freight working in the USA, pulling trains of unprecedented length.

A British Rail diesel-hydraulic, multiple-unit SuperSprinter train crosses a bridge in the fens of East Anglia, England, c.1990. This class of train, still in use on British railroads, is very adaptable and can be seen on light-traffic rural lines as well as heavy commuter lines.

In Britain, the introduction of diesel power was not so clear cut. The policy of British Railroads had been to trial a variety of makes and transmissions: on the Western Region, for example, all the first-generation diesels had hydraulic rather than electric transmission.

However, steam power continued to be employed in India and southern Africa. Economic conditions in India, following independence, meant that fuel imports had to be kept to a minimum, but with ample supplies of coal available, development of the steam locomotive continued. New standard designs for both the broad- and meter-gauge lines, derived from experience with locomotives used in Imperial days, continued to be built in large numbers until it was possible to extend electrification and import sufficient oil to make diesel power an acceptable alternative. Today, the indigenous manufacture of both electric and diesel-electric locomotives is proceeding satisfactorily.

In southern Africa, development of the Beyer-Garratt articulated locomotive continued, the engines reaching colossal proportions. On the Kenya & Uganda Railroad, for example, improved track construction permitted the use of locomotives with a 21-ton axle load. Advantage was taken of this to introduce the powerful 59 class, having the 4-8-2 + 2-8-4 wheel arrangement, a total weight of 252 tons and the high tractive effort of 83,350lb (37,807kg). They were the most powerful locomotives ever built for meter-gauge track, and hauled freight trains of more than 1,000 tons on 2 percent grades.

Electric power in France, and Britain, and subsequently many other countries, took a new turn after experiments in France showed that by using 25,000 volts ac at the commercial frequency of 50 cycles per second, considerable savings could be made in the cost of installation. In the electrification schemes embodied in the British Railroads Modernization Plan, this form of power supply was standardized, except on the Southern Region, where large areas were already equipped with the 'third rail' system of pick-up instead of an overhead line. The locomotives used on the London Midland Region, operating the most intense main-line express passenger service in the world, were carried on two four-wheeled trucks and developed 5,000hp. They were capable of hauling a twelve-coach train of 420 tons up a 1 percent grade at 90mph (145km/h).

The newest forms of rail traction moved away from the locomotive hauled train for high-speed passenger service. In 1964, the new Tokaido line of the Japanese National Railroads was opened, its so-called 'bullet' trains running at speeds of 130mph (210km/h) on a specially designed track. The

same general principle was used in the British high-speed train (HST) sets, except that they had a 2,200hp diesel power unit at each end, while the Japanese trains were electric. The Western Region HST sets, running at a maximum speed of 125mph (200km/h), provided the fastest and most intense diesel operated service in the world, between London and Bristol, and London and South Wales. In France, construction went ahead with an entirely new high-speed line between Paris and Lyon, on which electric trains of the unit type, like the Japanese 'bullets' and the British HSTs, would run at speeds of up to 185mph (300km/h). In addition, the latest French electric locomotives were of 8,000hp and could run at 125mph (200km/h).

Electronic technology continued to advance. In North America, General Electric and General Motors offered their diesel locomotives with either dc or ac drive. The latter could convert more of their power into usable tractive effort and were preferred for heavy haulage, whereas dc drive was chosen for lighter and faster trains, and notably for container trains. The 1990s were boom years for locomotive orders in the USA; in 1999, the Union Pacific ordered from GM a thousand locomotives of a single design, the largest such order ever placed. At the same time, American designers engaged in a horsepower race, 6,000hp becoming the norm in place of the previous 4,000hp; in theory, this enabled railroads to replace their locomotive stock on a two-for-three basis.

Partly because of new regulations to control the emission of pollutants, both GE and GM introduced new or modified engines. The Canadian company RailPower marketed 'green' locomotives. The 'Green Goat,' intended mainly for freight-yard work, had three small diesel engines that could trickle-charge a battery. For most of the time, this locomotive did not need to run all three engines, burning less fuel.

General Motors (later EMD of London, Ontario, after being sold off by its parent company) produced most of Britain's freight locomotives. These were the class 66, designed for a British quarrying company. Locomotives of this type were ordered by continental European freight operators also. Elsewhere in Europe, builders continued to produce electric locomotives with improved electronics, and a range of diesels, which were of high quality, but not bought in large numbers. In Britain, locomotive construction seemed to have come to an end with the delivery of electric locomotives for the Channel Tunnel.

India, China and Japan, among others, all had locomotive works producing their own designs. In the early years of the twenty-first century, China was importing considerable numbers of high-technology locomotives while exporting its own, somewhat less-sophisticated products.

Steam traction had virtually disappeared by the early twenty-first century. It had ceased to be used by the main-line railroads of India and China, although still employed on industrial lines. A few countries, bereft of resources to maintain their diesels, brought back some steam (as late as 2007, Garratt locomotives were operating in Zimbabwe). Elsewhere, steam traction could be seen in operation as a tourist attraction, usually on preserved railroads.

The unusual looking 'Green Goat' from Canadian RailPower Technologies Corporation increased diesel locomotive efficiency considerably. The hybrid switcher has its electric traction motors powered by a large bank of custom-designed lead acid batteries. A low maintenance microturbine engine keeps the batteries automatically charged at all times, offering a 15-45 percent reduction in fuel costs during yard switching work while being much quieter than the standard units in operation.

Railroads in Romania, Bulgaria, and Greece, from 1866

AS MEMBERS OF THE EUROPEAN UNION, ROMANIA, BULGARIA AND GREECE HAVE OPENED UP THEIR RAILROADS TO PRIVATE ENTERPRISE. ALL ARE BRINGING THEIR SYSTEMS UP TO DATE.

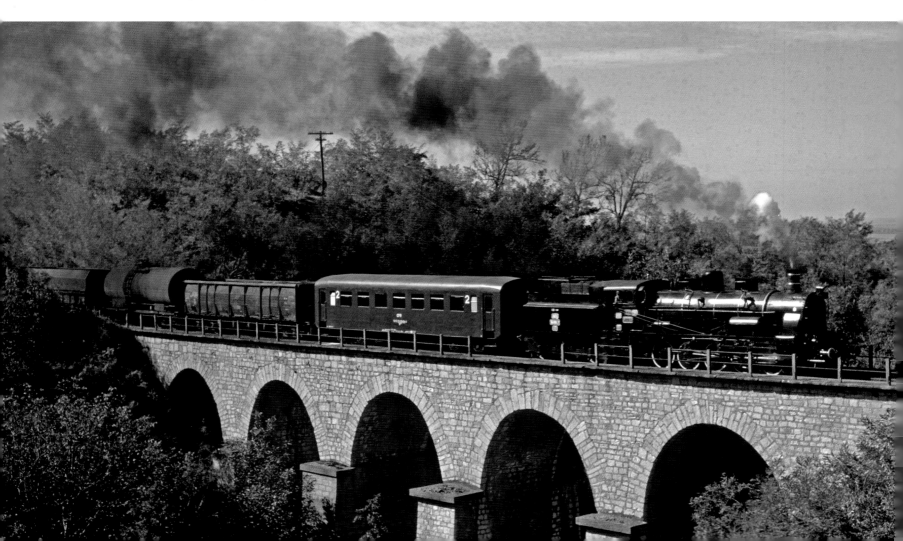

ROMANIA

Opposite page: Steam traction continued to play a major role in Romania long after it had been abandoned by western European railroads.

The first railroad in Romania, built in 1869, was the result of a concession granted to two Englishmen, John Barkley and John Staniforth; it connected Bucharest with the Danubian port of Giurgiu, 45 miles (72km) distant. The construction and operation of railroads by private enterprise did not last long, and in 1888, all Romanian railroads were taken over by the state. The rail gauge is the European standard, but there is a short length of mixed gauge, with three rails, to provide access for the Russian standard gauge of 5ft (1,524mm). The total route length on standard gauge is 6,300 miles (10,100km). The principal route into Romania from the west enters the country from Budapest at Apiscopia Bihor and links up with a more southerly route at Teius. Bucharest, the former eastern terminus of the *Orient Express*, is a major railroad center, lines running north to cross the Russian border at Ungeny, and east to the Black Sea port of Constantza.

In the late 1990s, EU-style practices were introduced, the railroads becoming a joint stock company, with operations and infrastructure separate accounting units. Conditions were better than in some former Soviet-bloc countries, and equipment was imported, including German rolling stock. Premium-service passenger trains were introduced, and electrification continued to make steady progress, especially on mountainous main-line sections.

For many years under communist control, the railroads of Romania and Bulgaria are undergoing restructuring in accordance with EU directives. Both have important international connections.

BULGARIA

For a relatively small country, Bulgaria began railroad construction on a large scale, with a 139-mile (225km) line from the Danubian port of Ruschuk to Varna on the Black Sea in 1866. A greater milestone was the completion of the international line across the country from Dragoman on the present Serbian frontier, through Sofia to Svilengrad. This provided the route of the *Orient Express* to Constantinople. King Boris of Bulgaria was a railroad enthusiast and frequently drove steam locomotives.

Today, more than half the total route of 2,700 miles (4,300km) is electrified; the rest is operated by diesel traction.

Deterioration of assets and accession to the EU prompted the government to develop a new railroad plan, and in 2007, the national rail infrastructure company, NRIC, prepared to grant access to non-Bulgarian operators. Division of the railroad into business units was envisaged, a passenger company being the first.

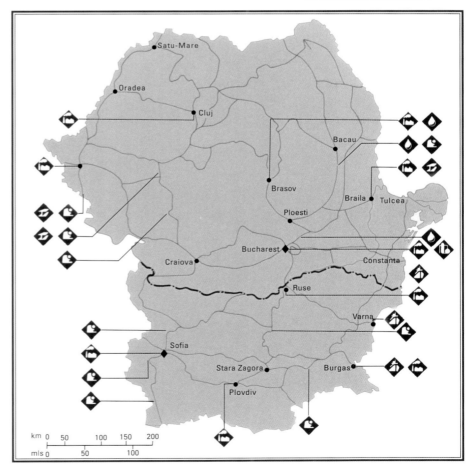

GREECE

Opposite page: A Hellenic Railroads DE2000 diesel locomotive built by Adtranz-Bombardier.

Map: Greece was slow to adopt the railroad, and the network is not extensive. However, in recent times, the system has been modernized and progress made with electrification.

Below: Desiro trains are also operated in Greece. This example is leased by Proastiakos for the Athens Airport–Korinthos line.

In view of its ancient civilization, it is remarkable that Greece should have been one of the slowest of European countries to adopt modern means of communication in the form of railroads. Even more remarkable is the fact that the country was not connected to the rest of Europe by rail until 1916. Indeed, one of the first railroads in Greece was directed away from Europe. This was the result of a concession granted to a company called the Piraeus, Athens and Peloponnesus to construct a line across the isthmus of Corinth and into the Peloponnesus. It was built on the meter gauge and, by the beginning of the twentieth century, had a total route length of about 500 miles (800km). It passed through Athens to reach the port of Piraeus.

The standard-gauge main line from Piraeus and Athens to Papapouli in the north was opened in sections between 1904 and 1909. At that time, its limit was the Turco-Greek frontier, but the Treaty

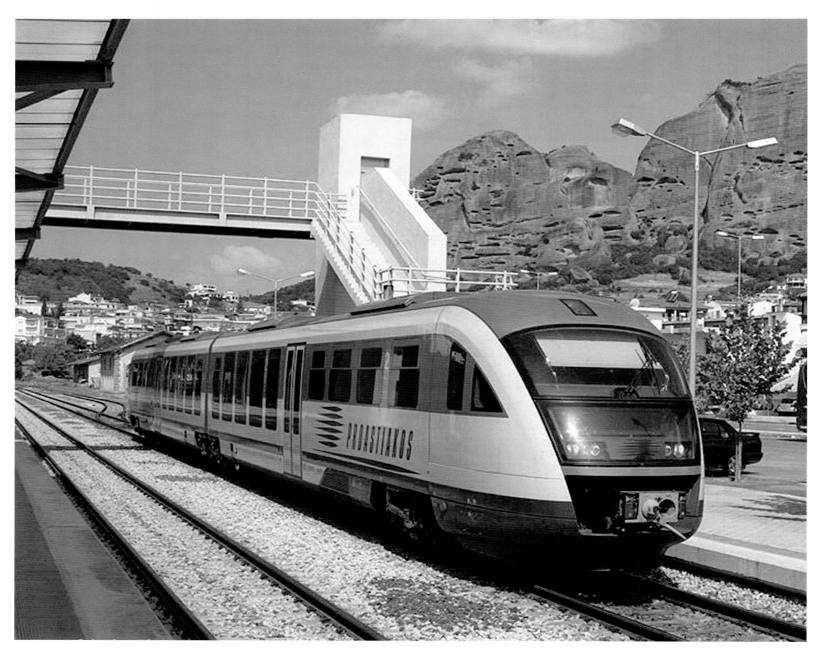

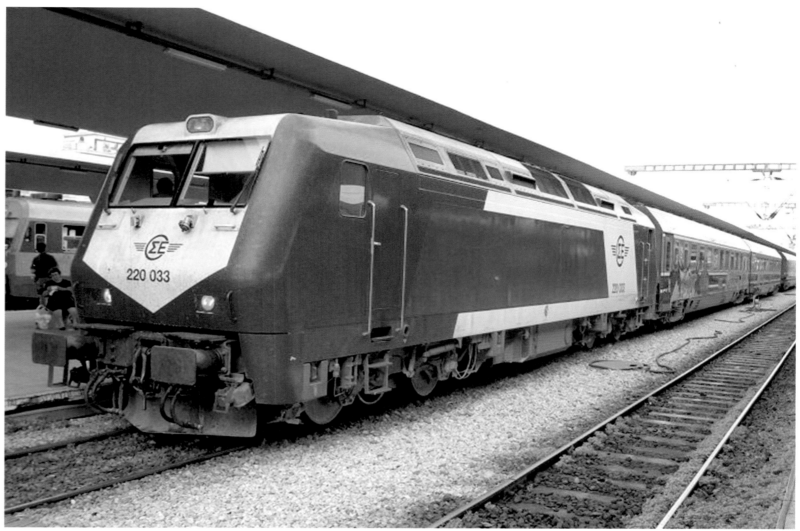

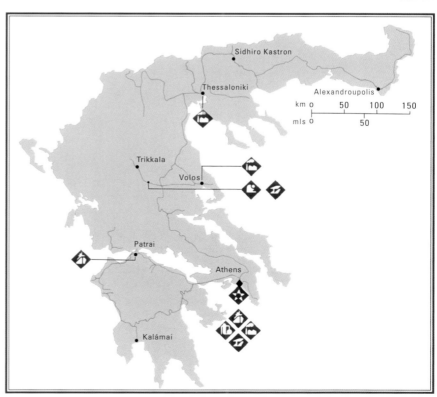

of Bucharest, following the Balkan war of 1913, saw the frontiers redrawn; the borders of Greece were pushed northward to those of Serbia and Bulgaria. This put the Thessaly Railroad in Greek territory, and in 1916, the link was made between Papapouli and Platy. As a result, through railcar services were established between Athens and other European cities.

In 1962, all the railroad companies in Greece were amalgamated under the title of Hellenic Railroads, and in 1971, they became a state owned company with the title Hellenic Railroads Organization Ltd.

In 1998, a large scale railroad modernization plan was inaugurated, and since then there has been considerable upgrading and re-equipment throughout the networks. This work has included the electrification of some sections of line and the importation of electric multiple-unit trains.

Electric Power

MANY RAILROADS RELY ON ELECTRIC TRACTION LINES AND MANY
MORE HAVE ELECTRIFICATION PROGRAMMES. THESE SYSTEMS
HAVE EVEN LED TO THE ADVENT OF DRIVERLESS TRAINS.

There is a diversity of electric traction systems on the railroads of the world, largely because of the different eras in which the various countries made major investment and consequent standardization. The four systems in widespread use in Europe are: 1,500 volts dc in the Netherlands and on early French lines; 3,000 volts dc in Belgium, Poland, Italy, and the Czech and Slovak republics, also in Brazil, Chile and South Africa; 15,000 volts ac at $16^2/_3$ cycles in West Germany, Norway, Sweden, Austria and Switzerland; 25,000 volts ac at 50 cycles in Britain, except for the third-rail dc system of the former Southern Region. The last is standard for new works in France and is being adopted in all countries installing main-line electric traction, notably Hungary and India.

The 25,000 volts ac system has the advantage of being cheaper to install, requiring lighter overhead conductor wires and less robust supporting structures. It was first adopted on a large scale in France, in preference to the previous standard 1,500 volt dc system, after extensive trials and close comparison of costs with a line largely used by heavy freight between Valenciennes and Thionville. In addition to the reduced initial cost of trackside equipment, an attraction of the system was that the development of static devices for converting alternating current to direct current made it possible to operate the overhead line at the industrial frequency of 50 cycles per second, at high voltage, yet retain the advantage of the dc traction motor for driving the axles of locomotives and multiple-unit trains.

In Europe, the existence of four different systems of overhead-line electrification is no longer an obstacle to the operation of many international services, which otherwise would require locomotives or power units to be changed at frontiers. The French introduced electric locomotives equipped with four retractable pantographs, which could be raised to suit the supply voltage and type of overhead-wire design. They could pass from one electric system to another without stopping. Power was shut off on the approach to a frontier crossing point, and the train allowed to coast until under the wires of the new network. Then the appropriate pantograph was raised. Many railroads now use such multi-current

locomotives; bi-current designs are common, but quadri-current are rare. High-speed trains using the Channel Tunnel were equipped with both pantographs and collector shoes for use over the third-rail system of southern England. The French also pioneered the use of pre-set controls. On locomotives working the Paris–Strasbourg route, they introduced a feature that enabled the locomotive-man to preset and automatically maintain the speed he required over changing grades. In more recent times, the introduction of computer control has made it possible to pre-set a train's journey. Driverless trains have appeared on short civic lines, those at Lille in France being among the earliest, with London's Docklands Light Railroad coming later.

Built for the German Federal Railroads, the Series E410 electric locomotive was of Bo-Bo configuration and had a 4,300hp 1-hour rating, with a starting output of 6,800hp.

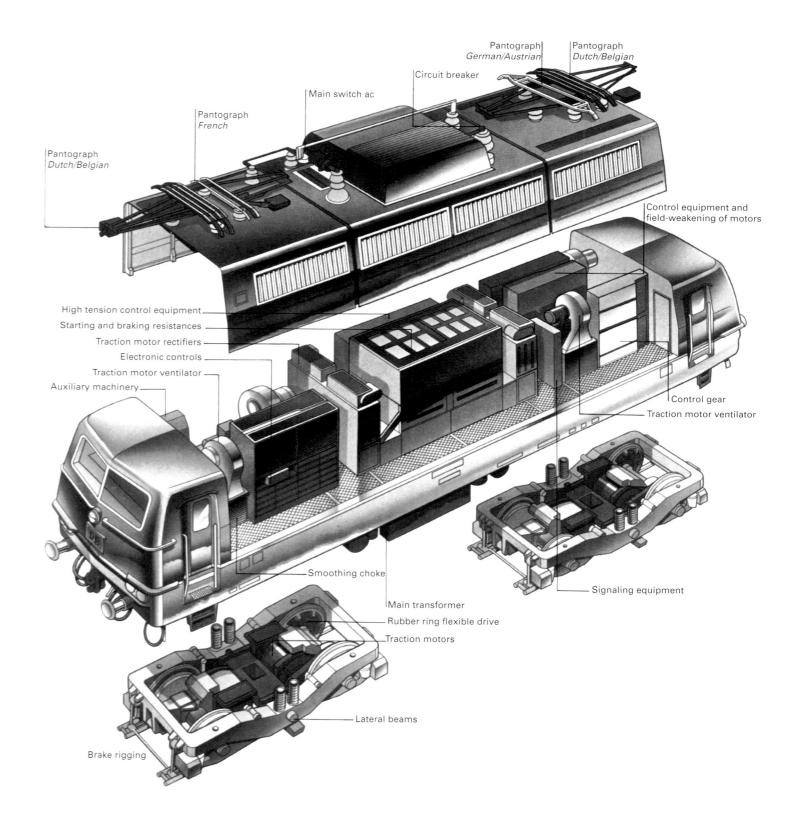

RAILROADS IN NORTH AMERICA

VAST DISTANCES, NATURAL OBSTACLES, HOSTILE INDIGENOUS POPULATIONS AND LIMITED CAPITAL MADE BUILDING RAILROADS IN NORTH AMERICA A DIFFICULT TASK.

I n the United States, public railroads appeared at about the same time as those in Britain, but, almost from the very beginning, there was a difference of approach. The USA, unlike Britain, was not a country where plenty of capital was available, to the extent that a new company such as the Great Western Railroad could take pride in building a line with a capacity that was far in excess of its actual demand. Moreover, distances were long.

In America, therefore, railroad lines were generally built as cheaply and as quickly as possible, with substructures that were only just able to carry the traffic. As traffic escalated, it was hoped that profits would increase, thereby attracting fresh investment and allowing the lines to be rebuilt to a better technical standard. The most successful lines were double tracked, but many relatively prosperous lines remained in single track formation,

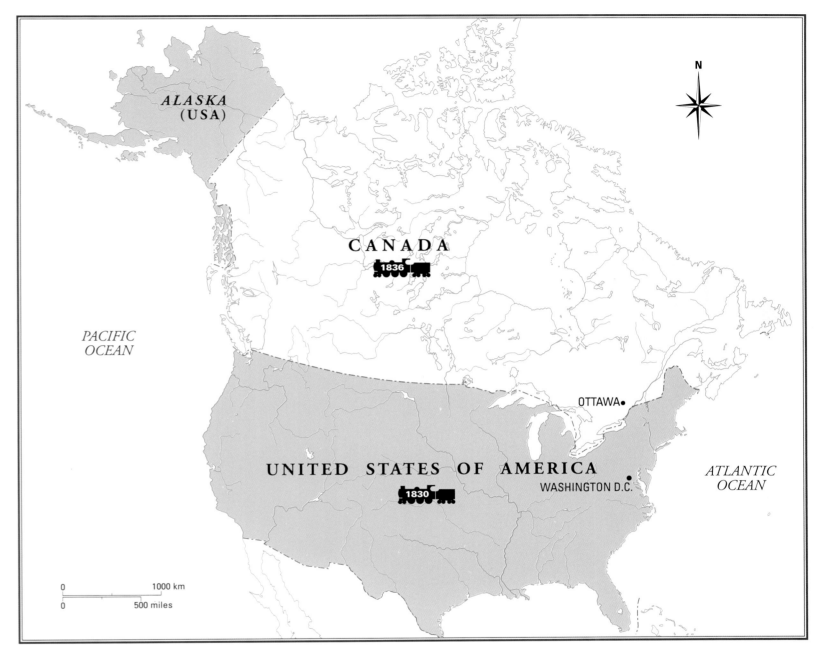

ALASKA
(USA)

N

CANADA

1836

PACIFIC
OCEAN

OTTAWA

UNITED STATES OF AMERICA
WASHINGTON D.C.

1830

ATLANTIC
OCEAN

0 1000 km

0 500 miles

and continue as such even in the twenty-first century.

Government regulation was initially weak, and this encouraged the appearance of railroad 'kings', ruthless men who pushed forward their railroad projects with a blend of flair and unscrupulousness. This approach got things done, but at the cost of many failed lines and ruined investors. Federal regulation was at its strongest with the founding of the Interstate Commerce Commission, the purpose of which was to prevent railroad owners from creating and abusing monopoly situations. The federal government effectively settled the gauge problem when it prescribed standard gauge for the first transcontinental railroad.

In Canada, there was a blend of styles. Capital investment came mainly from Britain, and the British administrative approach was the general rule in the early decades. The geographic and economic parameters were similar to those of the USA, however, so American-style technology and operation soon prevailed.

American enthusiasm for railroads led to their introduction in the USA in 1830, only five years after the first steam railroad was built in England. Surprisingly, for part of the British Empire, Canada did not see its first railroad built until 1836.

Opposite page: Two Canadian National GMD 1m diesel locomotives double-head a freight train at Edmonton, Alberta, Canada.

Railroads in the United States of America, from 1830

FROM THE EARLIEST DAYS, THERE WAS GREAT ENTHUSIASM FOR RAILROADS IN THE USA. DESPITE MANY OBSTACLES, A VAST NETWORK WAS BUILT THAT COVERED THE COUNTRY FROM NORTH TO SOUTH AND FROM COAST TO COAST.

In the USA, railroads began with projects to connect the Atlantic seaports with the rich valley of the Ohio River, between which lay the densely-wooded mountain ranges of the Alleghenies and the Appalachians. The Baltimore & Ohio, dating from 1827, and the Chesapeake & Ohio, by their names, indicate the extent of their initial activities. Another famous early line was the Pennsylvania, from Pittsburgh over the Alleghenies to Atlantic tidewater at Philadelphia. West of the mountains, a considerable network began to develop from Chicago and St. Louis down the valley of the Mississippi. This was one of the main battle areas during the Civil War, and the railroads played a major part in the conflict. It was during the war that Abraham Lincoln realized the importance of having communication with the west coast and ordered the completion of the partly finished lines of the Union Pacific and Central Pacific, which eventually met in the famous 'gold spike' ceremony at Promontory, Utah, in 1869. In the meantime, the great proliferation of lines radiating from Chicago earned that city the title of 'greatest railroad center in the world'.

In main lines alone, running south-west and west, there were no fewer than four different routes to Kansas City and beyond—those of the Illinois Central Gulf, the Santa Fe, the Rock Island and the Burlington; while to Omaha, en route to the far west, there were five routes all covering different tracts

of the intervening country. Due north, jockeying for position as it were beside the shores of Lake Michigan, were the Chicago & North Western, and the Chicago, Milwaukee, St. Paul & Pacific, once steam rivals in a high-speed passenger service. From the east, crowding around the head of the lake, were the Baltimore & Ohio, the New York Central and the Pennsylvania; the Wabash, the Monon and the Illinois Central came up from the south.

The discovery of gold in the Colorado Rockies, coupled with the extreme difficulty of the terrain, led to the building of a network of narrow-gauge lines, which weaved their ways through seemingly impossible mountain gorges. One of the most famous of these, remaining today as a major standard-gauge artery through the region, was the Denver & Rio Grande Western. Two other routes to the west coast were the Atchison, Topeka & Santa Fe, from Chicago, through Kansas City and Albuquerque to Los Angeles; and the Great Northern from St Paul, running just south of the Canadian border and rivalling the Canadian Pacific to Spokane and Seattle. However, the Great Northern did not have the

By 1860, there was an extensive rail network throughout the eastern half of the United States, but a link with the west coast would have to wait until after the Civil War.

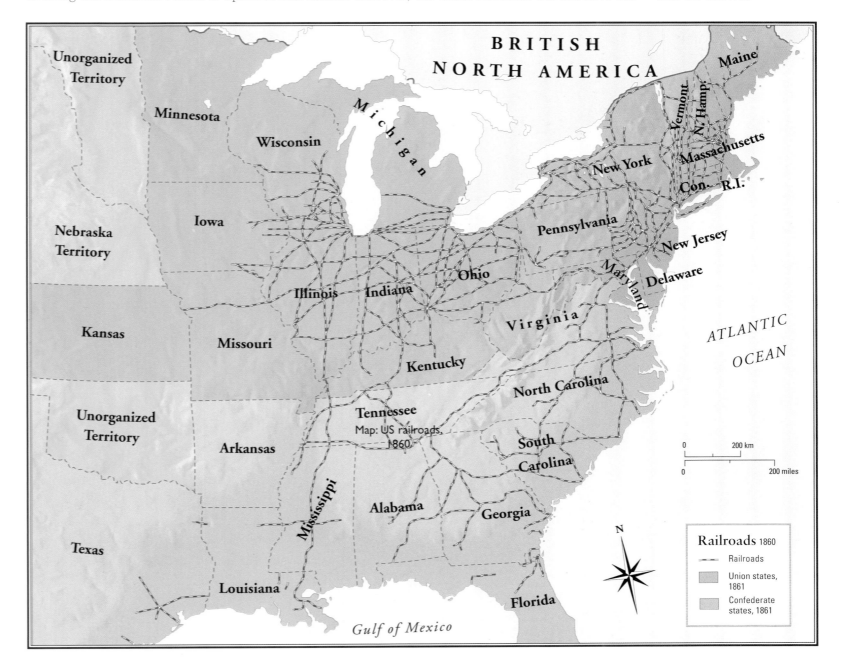

Opposite page: During the early twentieth century, many U.S. railroads merged or were taken over by more prosperous companies, shown in these major consolidations.

One of two restored 4-4-0 steam locomotives at the Golden Spike National Historic Site in Utah, USA. The site commemorates the joining of the Union Pacific and Central Pacific Railroads in 1869, establishing the first rail route across North America.

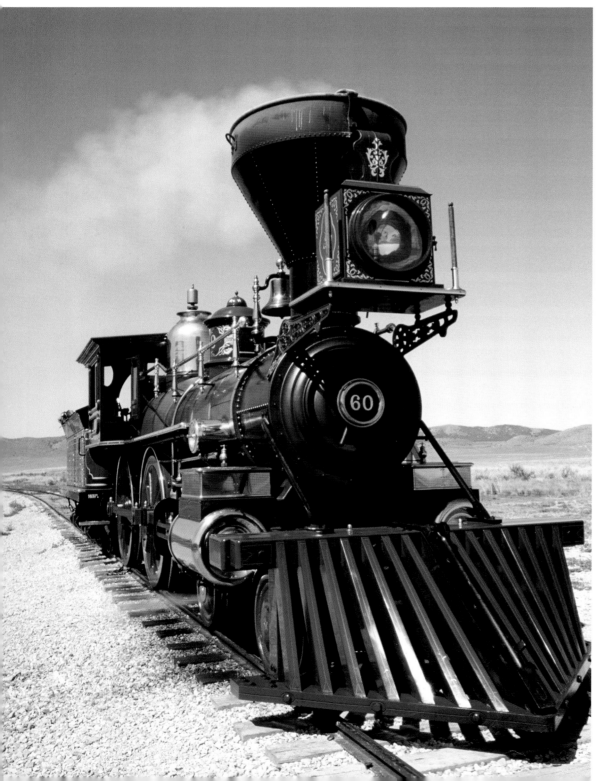

territory south of the border to itself. From Minneapolis westward, there were two other routes, those of the Northern Pacific and of the Chicago, Milwaukee, St Paul & Pacific. All three made their way to Spokane by diverse routes, then through the highly picturesque Cascade Range to the west coast. Later, the Great Northern and the Northern Pacific were included in the Burlington Northern Railroad, which competed to a degree with the Milwaukee. Connecting the cities of the west coast and continuing south along the Mexican border to New Orleans was the Southern Pacific.

By the end of the nineteenth century, railroads covered the entire United States, and the many private companies entered the new century on a great wave of confidence and prosperity. A huge manufacturing industry had grown up to supply the needs of the railroads in locomotives, passenger and freight rolling stock, signaling and track equipment. Few of the railroad companies built their own, although some, like the Pennsylvania, had extensive research facilities. Names like the New York Central, Union Pacific, Norfolk & Western, Erie, Louisville & Nashville, together with those of the great pioneers, became well known in the world of transport. Delegations from celebrated railroads in Europe traveled to the USA to study methods. Although exuberance and over-confidence sometimes led to bad accidents and serious loss of life, a tremendous bank of operating experience was amassed, the benefit of which was reaped in later years.

Compared to the railroads of Europe, those of the USA were very little affected by World War I. In 1917, however, almost nine months after the USA declared war on the Central Powers, President Woodrow Wilson put the country's entire rail system under government control, a measure that would be enforced for over two years.

American railroads entered the period between the two world wars with renewed strength and, for a short time, were moderately successful. Then the increasing use of road transport began to prove serious competition, although because of the great distances sometimes involved, initially it was not as much of a

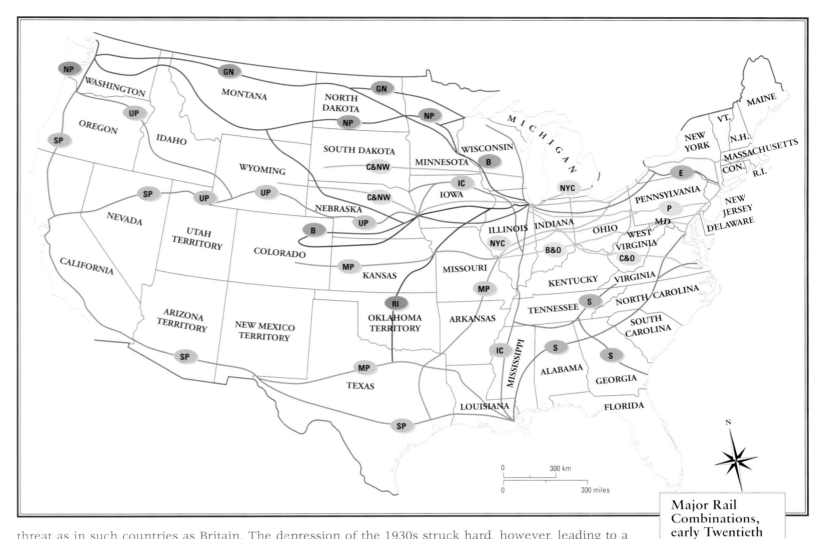

threat as in such countries as Britain. The depression of the 1930s struck hard, however, leading to a decline in equipment and manpower. Despite these setbacks, many spectacular new services, using diesel power, were introduced.

In World War II, America fought on two fronts, which made tremendous demands on the railroads, particularly on routes to the Pacific coast. Modern signaling technology was applied in an attempt to secure the maximum traffic of trains on single-line tracks. Both steam and diesel locomotives were called upon to perform outstanding feats, not only of power output, but also of aggregate distances traveled per month. In the immediate post-war era, British engineers visited the USA to learn how it had been done.

Soon, however, a great recession began. With the rapid development of internal airlines, it became unfashionable to travel by train. Patronage of the great express trains of international fame, such as *The Twentieth Century Limited*, diminished; postal traffic was transferred to the air, leaving trains like the *Fast Mail* of the Santa Fe with no business at all; and long-distance trucking on state subsidized highways began to supersede the freight train. Several famous American railroads went bankrupt; others sought to discontinue their unprofitable passenger business. The federal government would not allow this, however, and in 1971, the National Railroad Passenger Corporation (Amtrak) was set up to support the operation of inter-city passenger trains with federal funds. This provided a network of main-line passenger services.

Major Rail Combinations, early Twentieth Century

———	Vanderbilt Roads
NYC C&NW	New York Central Chicago & North Western
———	Morgan Roads
S E	Southern Erie
———	Pennsylvania Group
P B&O C&O	Pennsylvania Baltimore & Ohio Chesapeake & Ohio
———	Harriman Roads
UP SP IC	Union Pacific Southern Pacific Illinois Central
———	Hill Roads
GN NP B	Great Northern Northern Pacific Burlington
———	Gould System
MP	Missouri Pacific
———	Rock Island System
RI	Rock Island

In the meantime, by employing improved technology and immense drive, the railroads began to win back much of the freight traffic lost to road transport. There were major mergers of companies and pruning of redundant services. The largest of the mergers was that of Conrail, in 1976, a grouping of bankrupt eastern railroads, supported by a large loan from the federal government. This included such previous giants as the Pennsylvania and the New York Central, the financial plight of which was enough to show the severity of the recession suffered by the American railroads after World War II.

Today, besides the activities of Amtrak, the principal accent is upon freight, American railroads having developed the technology of handling huge loads at medium to high speed to an unparalleled extent. At the points of traffic concentration, the classification yards are fully computerized, while the operations over entire railroads are monitored from a single command center, through remotely controlled color-light signaling and radio communication with train crews.

The breakthrough for U.S. railroads came with the Staggers Act of 1980, which ended their

A pair of EMD SD70M-2 diesel-electric locomotives of the Florida East Coast Railroad head a northbound freight train across Turkey Creek, Palm Bay, Florida, January 9, 2007. These massive locomotives are rated at 4,300hp.

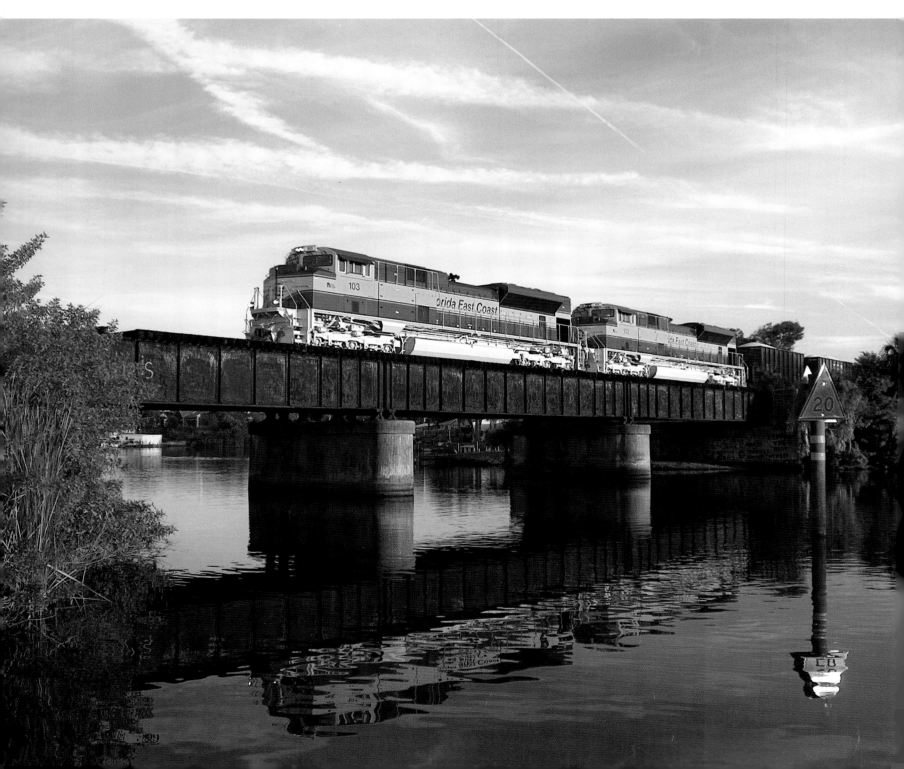

subordination to the Interstate Commerce Commission. This organization, formed at a time when it was felt necessary to curb the monopoly practices of the railroads, regulated rail tariffs. Since it could (and did) prevent railroads from introducing lower tariffs to reflect improved efficiency, managements were hampered in their hard struggle against highway freight carriers. After the Staggers Act, they were able to compete on price and, by using container trains, were able to win back much traffic. The advent of double-stack container trains and the vast increase in containers arriving at seaports have meant rapid traffic growth.

At the same time, exploitation of new mineral reserves, such as the coal resources of the Powder River Valley in Wyoming, has produced much new traffic of the heavy-haul type, for which railroads have always been well suited. By the early part of the twenty-first century, the American railroads were no longer seen as a depressed industry.

Despite many company failures and amalgamations, the USA retains an extensive rail network, the primary purpose of which is to transport freight. The system is densest in the eastern half of the country, reflecting the industrialized nature of the region.

The Alaska Railroad extends from Seward, in the south of the state, to Fairbanks, in the interior. It carries freight and passengers between the two cities and destinations between, including Denali National Park. The railroad's mainline is more than 470 miles (750km) long. It is connected to other states via three rail barges sailing between the port of Whittier and Harbor Island in Seattle, but has no land connection with any other railroads on the North American network.

RAILROADS IN CANADA, FROM 1836

RAILROADS IN CANADA BEGAN IN THE EAST AND PROVIDED LINKS TO ATLANTIC PORTS, BUT THE FORGING OF AN EAST–WEST, COAST-TO-COAST LINE PROMPTED FURTHER EXPANSION.

Railroad development in Canada began along the line of the St. Lawrence River with the Grand Trunk, authorized in 1852 and incorporating some earlier projects. This railroad knew no international frontiers; when the first line was completed, it ran from Sarnia through Toronto and Montreal to Portland, Maine, in the USA, which provided a means of communication with Europe during the winter months when the St. Lawrence estuary was frozen over. At its western end, it also penetrated south of the border. However, it was thought desirable to have a line to an Atlantic port that was independent of the USA, particularly as relations had not been entirely amicable since the War of Independence. Thus was born the concept of the Intercolonial Railroad,

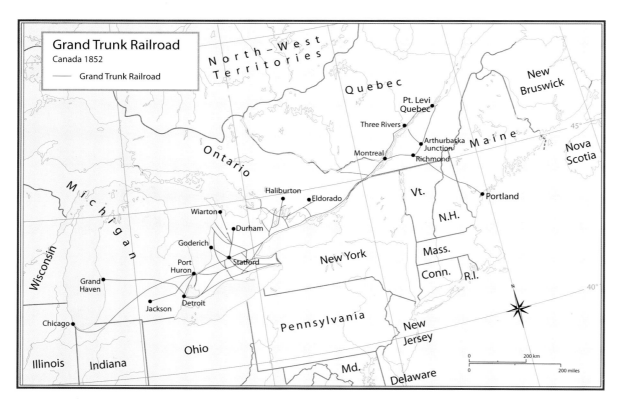

Grand Trunk Railroad
Canada 1852

—— Grand Trunk Railroad

North–West Territories

Quebec

New Bruswick

Pt. Levi
Quebec

Three Rivers

Arthurbaska
Junction

Maine

Richmond

Montreal

Nova Scotia

Ontario

Michigan

Haliburton

Eldorado

Vt.

Portland

Wiarton

N.H.

Durham

Goderich

Mass.

Port Huron

Statford

New York

Conn.

R.I.

Wisconsin

Grand Haven

Jackson

Detroit

Pennsylvania

New Jersey

Chicago

Ohio

Illinois

Indiana

Md.

Delaware

0 200 km
0 200 miles

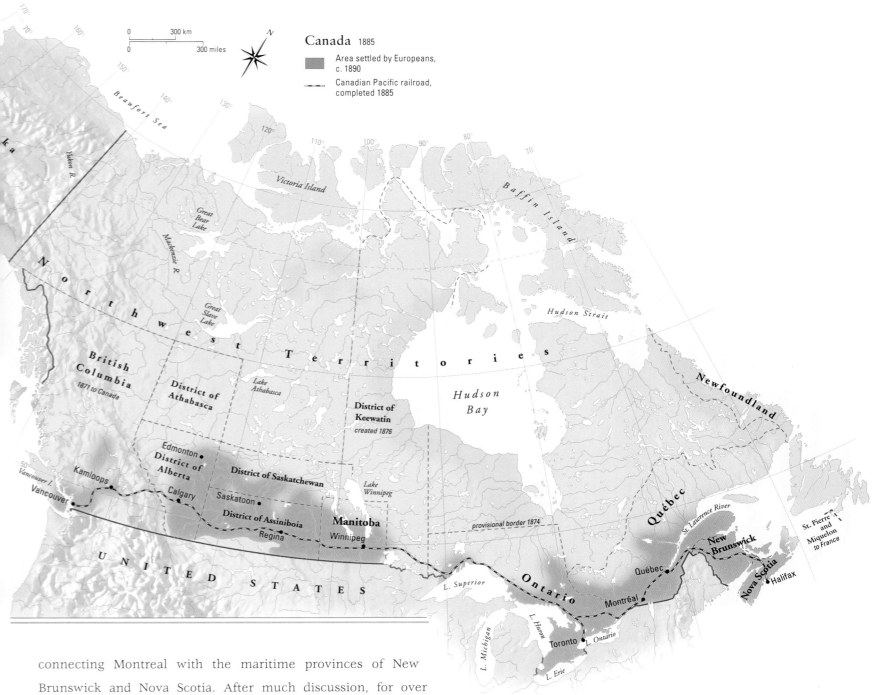

Canada 1885

Area settled by Europeans, c. 1890

Canadian Pacific railroad, completed 1885

connecting Montreal with the maritime provinces of New Brunswick and Nova Scotia. After much discussion, for over twenty years, the Intercolonial was authorized, being built by that great engineer Sandford Fleming. Later, Fleming made the first surveys for the Canadian Pacific. The undertaking to build a railroad connecting British Columbia in the west with the eastern provinces was contained in an agreement signed in Ottawa in July 1870, and Fleming's first surveys encouraged the government to decide that the line should pass through the main range of the Rocky Mountains by way of the Yellowhead Pass.

Although some contracts had been let for western portions of the line, eastward from Vancouver, the work was under government control, and progress was slow and unsatisfactory. It was not until ten years after the Ottawa agreement had been signed that the task was put on a sound business footing. An agreement was signed in England, in September 1880, between the government and a syndicate of Canadian businessmen, the construction work being handed over to a company formed by the

Above: In 1885, much of Canada's population was spread along the border with the United States; the railroads followed suit. The Canadian National railroad provided a vital link with British Columbia, helping to create a unified nation.

Opposite page: The Grand Trunk was the first railroad to be built in Canada and initially followed the route of the St. Lawrence River. It became an international railroad, with lines running south into the United States.

The Grand Trunk Pacific Railroad began construction in British Columbia in 1908. One of the most difficult sections of track ever laid in North America, it cost $112,000 per mile. The completion ceremony in 1914 began with a race between the track-layers and crews from the eastern and western ends. Each crew was timed to see who could complete their last half mile the fastest. The eastern crew won by a margin of only a few minutes and the western crew placed the last rail.

syndicate. The 'big four' of this arrangement were George Stephen, Donald A. Smith (afterwards Lord Strathcona), R.B. Angus and a fiery entrepreneur named J.J. Hill. The last mentioned made perhaps the greatest contribution of all, because he brought in, as general manager, that most outstanding of railroadmen W.C. van Horne, then an American citizen. The line across Canada was completed in November 1885, the last spike being driven in at Craigellachie, in the Rockies of British Columbia.

The success of the Canadian Pacific in developing the prairie regions—as King George V, when Prince of Wales, said in a speech in London in May 1908—

'...helped to make a nation.' It also led to the building of competitive railroad lines, the Canadian Northern and Grand Trunk Pacific.

When it came to actual construction, the Canadian Pacific did not go through the Yellowhead Pass, but took a shorter route through the far more difficult Kicking Horse Pass. However, its two rivals from Winnipeg to Pacific tidewater went through the Yellowhead, alongside each other. The Canadian Northern came abreast of the Canadian Pacific in the canyons west of Kamloops and eventually reached Vancouver, while the Grand Trunk Pacific continued north-west through virgin territory to Prince Rupert. Both of these railroads, and the lines connecting with them from the east at Winnipeg, fell into financial difficulties and were kept going during World War I by substantial government loans. In 1922, all of these lines were amalgamated with the Grand Trunk and the Intercolonial to form the huge Canadian National Railroads, a publicly owned enterprise that worked alongside the privately owned Canadian Pacific Railroad.

After World War II, the two railroads were still in competition, although occasionally they co-operated. Over the two more-or-less parallel routes from Quebec City through Montreal to Toronto, they operated non-competitive 'pool' passenger trains, sharing the rolling stock and revenues. CPR was only one of Canadian Pacific's interests; it also had hotels, steamships and an airline. Like the

Great Western in Britain, it exploited its history to create a favorable public image. CN, on the other hand, was a more modest undertaking and somewhat constrained in its initiatives by the need to obtain government approval for many of its strategies. This ended in 1995, when it was sold to private interests and rapidly developed, both by purchasing U.S. railroads like the Wisconsin Central and Illinois Central, and by introducing new operating methods. Its successful abolition of most freight offices and all railroad territorial divisions, and the centralization of operational control of its trains in all of Canada to a center in Montreal brought professional delegations from as far away as Russia.

Meanwhile, both companies were able to transfer their mainly loss making passenger services to a publicly supported corporation, Via-Rail, founded as a crown corporation in 1977 to maintain passenger services on much of the network. There remain in Canada several other railroads that are regional in scope. Among them are Ontario Northland and British Columbia Railroads, both initiated by their provincial governments.

In the main, Canada's railroads remain in the southern part of the country, echoing the distribution of the population.

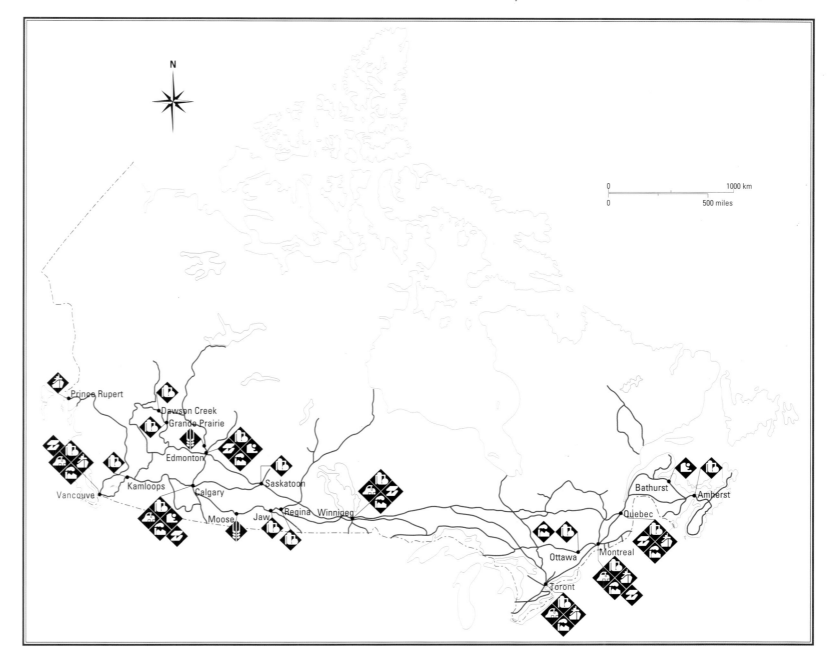

North American Transcontinental Routes

CROSSING THE CONTINENT OF NORTH AMERICA WAS A MAJOR CHALLENGE FOR THE EARLY RAILROAD BUILDERS. ONCE ACHIEVED, MANY MORE ROUTES FOLLOWED, OPENING UP AND UNIFYING TWO GREAT NATIONS.

ACROSS THE USA

At the zenith of steam operation in the USA, busiest among the great trunk routes were the rivals operating between New York and Chicago. The New York Central, with its 'water level' route, had the advantage of no grades, but the Pennyslvania had the shorter distance. The physical characteristics balanced each other and both maintained a 16-hour service between the two cities, operating two trains: *The Twentieth Century Limited* (New York Central) and *The Broadway Limited* (Pennsylvania). These posted average speeds of 60 and 56mph (96 and 90km/h) over 960 and 900 miles (1,536 and 1,440km) respectively.

The Pennsylvania Railroad had much the harder route, because it cut through the heart of the Allegheny mountains. From Harrisburg, the quadruple-tracked main line followed a picturesque course up the valley of the Juniata river to Altoona, where the company's great workshops were situated. Then, by means of the great Horseshoe Curve, it climbed to its summit in the mountains in the Gallitzin Tunnel. This was followed by an equally severe and picturesque descent to Pittsburgh. The New York Central, on the other hand, went due north at first, beside the Hudson river, turning west at Albany to run through the Mohawk river valley, then close to the south shore of Lake Erie —mostly level, but hard going with loads of more than 1,000 tons needing to be hauled continuously at around 80mph (130km/h).

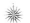

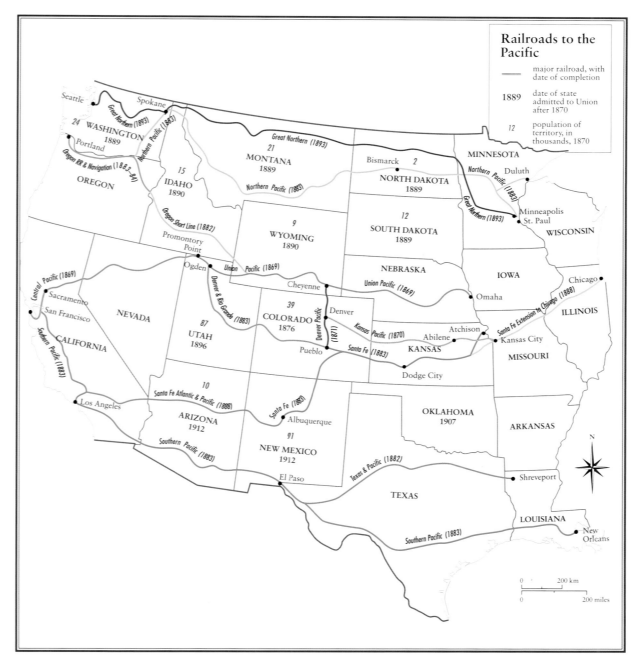

Railroads to the Pacific

— major railroad, with date of completion

1889 date of state admitted to Union after 1870

12 population of territory, in thousands, 1870

By the early twentieth century, all the North American transcontinental routes had been established.

Westward from Chicago, the Atchison Topeka & Santa Fe Railroad provided a great route to the west coast. The main line of the Santa Fe from Chicago to Los Angeles was 3,577km (2,223 miles) long. It ran through seven states and three time zones, crossed three great mountain ranges, and witnessed daily some of the fastest passenger and freight operations in the USA. At the peak of the steam era, during World War II, when an efficient service of heavy trains to the west coast was a national necessity, only two locomotives were needed for the entire journey. A 4-6-4 was used over the relatively level eastern section of 990 miles (1,595km) from Chicago to La Junta, Colorado, where it was changed for a 4-8-4, which took the trains over the remaining 1,982km (1,232 miles) to Los Angeles, through the mountain ranges of New Mexico, Arizona and California. The mountains are stark, rugged and near-desert in places, displaying magnificent coloring under the blistering heat of cloudless skies. The full journey took more than two days, and there was much night travel. The great train of steam days was the *Chief*, supplemented by the diesel hauled *Super Chief*. Later, under Amtrak, it was the *Southwest Chief*.

The New York Central and
Pennsylvania railroads operated
rival services between New York
and Chicago.

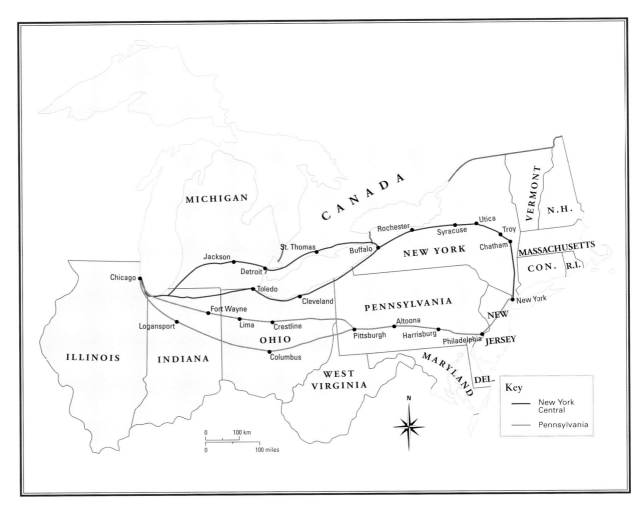

For sheer spectacular country and superb train operation, the Denver & Rio Grande Western, between Denver and Salt Lake City, could not be surpassed. The main route, used by the thrice-weekly *Rio Grande Zephyr*, and daily by a dozen or more large freight trains in each direction, was a composite one. The original main line took a circuitous route, running due south at first from Denver to Pueblo, then turning west to cut through the Colorado Rockies in the breathtaking Royal Gorge, and from there over the Tennessee Pass. The distance from Denver to Salt Lake City by this route was 745 miles (1,192km). By 1934, the magnificent line of the Denver & Salt Lake Railroad had been connected to the original Rio Grande by the "Dotsero Cutoff" line, reducing the distance to 570 miles (912km). Although without the scenery of the Royal Gorge, the shorter route via the Moffat Tunnel was (and is) magnificent. It climbs from the plains of Denver for 38 miles (61km) on a continuous grade of 2 percent, passing through 30 tunnels hewn from solid rock in a distance of 14 miles (23km), even before reaching the Moffat Tunnel under the main range of the Rockies. Beyond this summit, in canyon and near-desert country, the line crosses Colorado and Utah, cresting Soldier Summit in the Wasatch mountains of Utah before descending to Salt Lake City.

The Southern Pacific, the activities of which extended from New Orleans almost to Seattle, in the Pacific north-west, operated a train called the *Coast Starlight*, which ran between Los Angeles and Seattle, passing through Oakland (San Francisco) on the way. Like most of the American railroads, the Southern Pacific was a mighty freight operator, with originating traffic in two distinct areas, namely California, and the cities of Texas and the Gulf of Mexico. These areas were connected by the main

line running from Los Angeles and close to the Mexican border. There was one great line: by which the Southern Pacific took its traffic to hand over to the Union Pacific at Ogden, Utah, for the run to Chicago.

In the steam era, the Southern Pacific was distinguished by its gigantic cab-in-front articulated freight locomotives, and brightly painted 4-8-4s on the north–south passenger trains. Today's *Coast Starlight* is an Amtrak service, and on the northbound run in high summer, it is possible to see the scenic gem, Mount Shasta, shortly after passing Dunsmuir after daybreak. The southern part of the same journey includes much coastal scenery, both north and south of Santa Barbara, and except where the curves demand caution, the modern diesels wheel their heavy trains along at 70mph (113km/h).

The eastward line of the former Southern Pacific today is the route of the one-time Central Pacific, climbing over the Sierra Nevada range and heading for the historic end-to-end meeting point with the Union Pacific, at Promontory, Utah, where, in 1869, the last spike of America's first transcontinental railroad was driven. In those days, the line passed around the north of the Great Salt Lake on a considerable detour. Now, with the aid of a causeway, the line is carried across the lake, and the place where the "last spike" ceremony took place is no more than a tourist attraction, two restored locomotives facing each other rather forlornly in the desert.

The Union Pacific is another great railroad. It cuts through rugged country in the mountains of Utah and Colorado, then makes fast time across the plains of Nebraska to reach the west bank of the Missouri at Omaha before running on to Chicago over the tracks of the former Chicago & North Western. Until the recession after World War II, passenger trains to and from the west traveled on the direct line from North Platte to Cheyenne, but now the *California Zephyr*, the only through passenger train between Chicago and San Francisco, under the auspices of Amtrak, travels via Fort Morgan and Denver. In many ways, Ogden, Utah, was the grand junction of the Union Pacific. For while the running farther west on the transcontinental line was taken up by the Southern Pacific, the UP had main lines running south-west to Los Angeles, north to Butte, Montana, and north-west to Portland. Today, its distinctively colored diesel locomotives remain a familiar sight.

Yet another great route to the west is that later followed by Amtrak's *Empire Builder*, running between Chicago and Seattle. This was an interesting journey because it used parts of three different railroads. The eastbound run was the most scenic, leaving Seattle just before noon. The name of the train, which Amtrak inherited from the Great Northern, commemorates the nineteenth-century tycoon J.J. Hill, who was a member of the syndicate that organized the formation of the Canadian Pacific Railroad Company. He disagreed with the others so strongly over the route, which he wanted south of Lake Superior and through American territory, that he left the syndicate and initiated his own all-American line to the west coast—the Great Northern. Through his vigorous and successful prospecting of railroads in all directions, Hill eventually became widely known as "the Empire Builder."

The Amtrak train was rerouted over the former Northern Pacific line out of Seattle (later part of the Burlington Northern system), however, and from Everett, where it turns away from tidewater, the long ascent through the Cascade Range begins. There follows over an hour of traveling through densely-wooded mountain country as the train climbs to nearly 3,000ft (900m). At around midnight, it reaches Spokane, a general junction, and there passes on to the former Great Northern line. It is daylight when

the train runs beside the Glacier National Park, then comes the fast day-long run across the prairies of Montana and North Dakota. Yet another night passes on the train, with breakfast soon after leaving Minneapolis. The line is now that of the former Chicago, Milwaukee, St. Paul & Pacific—the "Milwaukee Road"—over which the steam hauled *Hiawathas* of pre-war days used to speed at 100mph (160km/h). At first, the line follows a delightful course beside the upper reaches of the Mississippi, before leaving the great river at La Crosse and passing eastward to reach the shores of Lake Michigan at Milwaukee. From there, almost within sight of the lake for the rest of the journey, it continues on to Chicago.

ACROSS CANADA

The Atchison, Topeka & Santa Fe was one of America's great railroads, with an extensive network stretching from Chicago across the country to San Francisco and down to the Gulf of Mexico.

Canada has been wittily described as a country 3,000 miles (5,000km) long and two railroads wide. There is no doubt that the construction of the Canadian Pacific Railroad helped in welding the far scattered provinces of Canada into a single, strong and united nation; the route that it followed through the mountain ranges of British Columbia befits its role in what has been called the National Dream. In the incredible adventures that the pioneers had in finding any sort of route through the of mountain

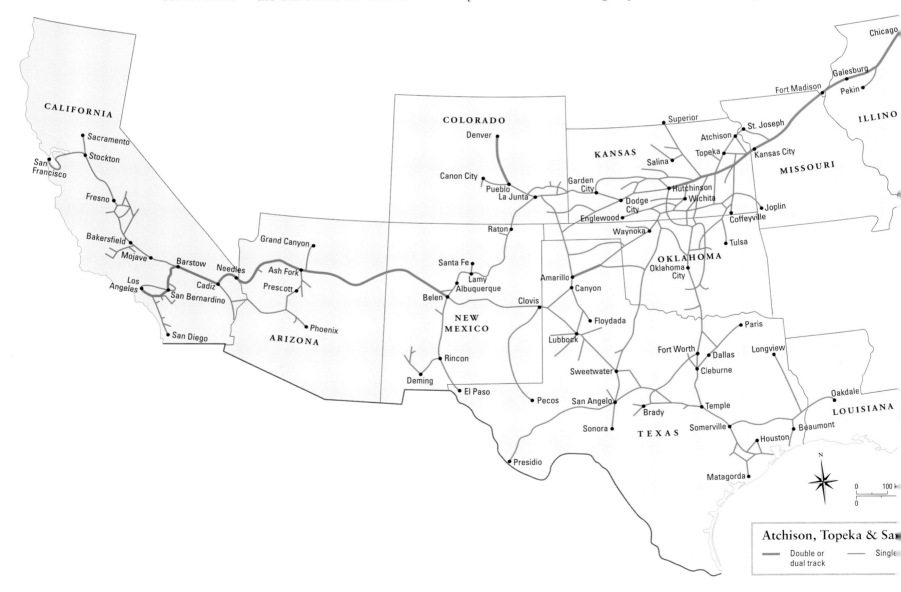

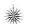

Southern Pacific lines ran all the way down the west coast from just below Seattle, along the Mexican border and on to New Orleans, while cooperation with other railroads provided access to Chicago.

peaks, densely-forested slopes and swift flowing rivers, in the magnificent engineering embodied in building the line and in the challenge its curves, grades and tunnels make to the locomotive men of today, it remains a route without parallel on the world's railroads. It is no mere mountain track built to open up a virgin land, but a major artery, nevertheless so terribly graded that on one stretch, Beaver Hill, it needed thirteen 3,000hp diesel locomotives to lift every 10,000-ton coal train—four a day —that in the 1960s began to run through the Crow's Nest Pass to Vancouver, for export to Japan. This operation takes place in the shadow of some of the grandest mountain scenery that can be enjoyed from a train anywhere in the world.

Although the Canadian Pacific was first through to the west coast, by way of Kicking Horse Pass, the Yellowhead Pass, which was farther north and had been the original choice for the line, did not have to wait long for its railroad. Two rivals to the Canadian Pacific struck out west-north-west from Winnipeg, both heading for Edmonton, Alberta. The Canadian Northern and the Grand Trunk Pacific strove to open up different parts of the intervening country, but they were never far apart; when both were merged into the Canadian National system, the line through Saskatoon was chosen for transcontinental services. That great pioneer engineer Sandford Fleming had good reason to recommend this route, because west of Edmonton, the approach to the Rockies is relatively gentle. The scenery is beautiful as the line draws near Jasper and passes through its nature park. There is some stiff climbing in the final approach to

the Yellowhead Pass, but on the westbound Canadian National's *Super Continental* train, it was night, and the passenger was conscious of difficult country only when watching the way the locomotive headlight swung from one side to another when rounding the many curves. From Edmonton to the Yellowhead Pass, the present main line is a synthesis of the best locations of the previous two rivals, sometimes Grand Trunk Pacific, sometimes Canadian Northern, making for a splendid fast running main line.

Beyond the Yellowhead, the routes diverge. The *Super Continental* turned south and downhill into the valley of the Thompson river, reaching Kamloops in the early morning. Then followed an amazing run through the canyons where the Canadian Pacific is on one side and the Canadian National on the other, never out of sight of each other until reaching tidewater, and never more dramatically than when they execute a scissors movement —each crossing from one side to the other, as the viaduct of one strides over the viaduct of the other at Cisco.

The Fraser river, which the Thompson river joins at Lytton, provided travelers on both the Canadian Pacific and the Canadian National routes to Vancouver with some grand spectacles. These were less astonishing than the first sight of the Fraser river from the Cariboo Dayliner of the British Columbia Railroad, when descending from Williams Lake to Lillooet, on the southbound run from Prince George to North Vancouver. This is a route of astonishing scenic variety, ranging from an almost pastoral Scottish quality between Prince George and Williams Lake, and finishing alongside Howe

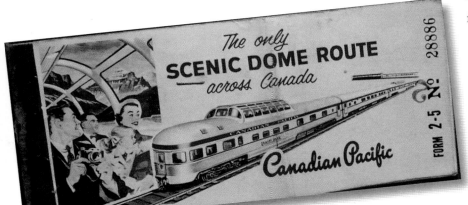

The Canadian Pacific made much of the virtues of its scenic dome coaches.

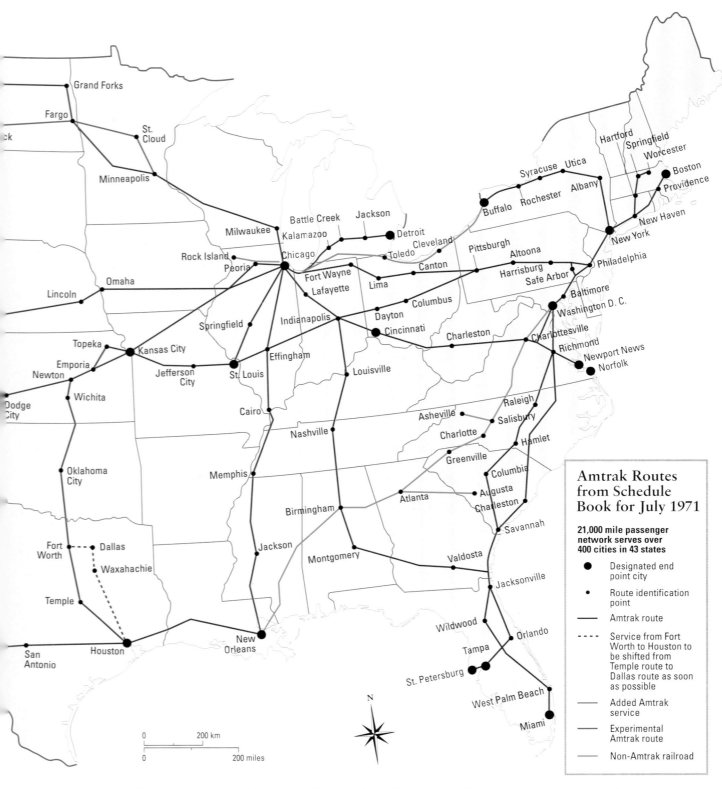

Grand Forks

Fargo

St. Cloud

Minneapolis

ck

Battle Creek Jackson

Milwaukee Kalamazoo Detroit
 Cleveland
Rock Island Chicago Toledo
Peoria Fort Wayne
 Lafayette Lima

Omaha

Lincoln

Springfield Indianapolis Dayton
 Cincinnati

Topeka Kansas City Effingham
Emporia Jefferson
Newton City St. Louis Louisville
 Wichita

Dodge
City

Cairo Nashville

Oklahoma
City Memphis

Fort Dallas
Worth
 Waxahachie Jackson

Temple Montgomery

San New
Antonio Houston Orleans

Hartford Springfield
 Worcester
Syracuse Utica Boston
Rochester Albany Providence
Buffalo New Haven
 New York
Pittsburgh Altoona
 Harrisburg Philadelphia
Canton Safe Arbor
 Baltimore
Columbus Washington D. C.
 Charlottesville
Charleston Richmond
 Newport News
 Norfolk

Raleigh
Asheville Salisbury
Charlotte
 Hamlet
Greenville
 Columbia
Atlanta Augusta
 Charleston

 Savannah

Valdosta

Jacksonville

Wildwood
 Orlando
Tampa

St. Petersburg

West Palm Beach
 Miami

Amtrak Routes from Schedule Book for July 1971

21,000 mile passenger network serves over 400 cities in 43 states

● Designated end point city

· Route identification point

— Amtrak route

---- Service from Fort Worth to Houston to be shifted from Temple route to Dallas route as soon as possible

— Added Amtrak service

— Experimental Amtrak route

— Non-Amtrak railroad

0 200 km

0 200 miles

N

Sound in fiord-like scenery, stretching from Squamish to Vancouver. This last section had, and may have again, the compelling attraction of a vintage steam run, regularly scheduled and worked by one of the magnificent Royal Hudson 4-6-4 locomotives.

Nowadays, Via-Rail operates a thrice-weekly transcontinental service, using the Canadian National route, but carrying the old Canadian Pacific title of Canadian. Tourist companies also run occasional trains through the Rockies.

Amtrak was set up by Act of Congress to take over loss making passenger services from the U.S. railroads. This map shows its major routes in the year of its inauguration.

The Chief, Across America in Style

FAVORED BY THE RICH AND FAMOUS BEFORE THE ADVENT OF DOMESTIC AIRLINES, THE CHIEF CARRIED ITS PASSENGERS IN LUXURY THROUGH SOME OF THE MOST DRAMATIC SCENERY IN THE WHOLE OF AMERICA.

The Atchison Topeka & Santa Fe, now merged with the Burlington Northern, was one of the largest railroads in the USA, with a route length of more than 13,000 miles (20,800km). Its lengthy mainline of 2,226 miles (3,562km), from Chicago to Los Angeles, carried some of the most famous trains on the North American continent, such as the *Fast Mail* and the *California Limited*. The queen of them all, however, and one of the world's greatest trains, was the *Chief*. In the days before and during World War II, it was always popular with the most elite of travelers. Consequently heavy, it frequently had to be run in two sections. At the zenith of steam on the Santa Fe, however, it ran in two sections only from Chicago to the west coast. A Hudson type 4-6-4 was employed over the more level eastern section of 991 miles (1,595 km) from Chicago to La Junta, Colorado, with one of the mighty 4-8-4s of the 3765 or 3776 classes onward to Los Angeles.

The normal load of the *Chief* was 14 coaches, comprising (from the locomotive) two mail storage cars, a railroad post office, a combination baggage and dormitory lounge car, four sleeping cars, a dining car, three sleeping cars, and an observation lounge coach bringing up the rear. The journey time from Chicago to Los Angeles was nearly two days, and the accommodation and service en route were of the finest standard. In the days before air transport became the prime mode of travel for wealthy patrons and businessmen, the standards set by the Atchison Topeka & Santa Fe were second to none on the railroads of the world.

Eight states were crossed on the journey west: Illinois, Missouri, Kansas, Colorado, New Mexico,

Opposite Page: The *Super Chief* being serviced at the Albuquerque depot, New Mexico, some time in March, 1943. The locomotive is fitted with a headlight black-out shield, a wartime requirement because the train operated in the Pacific Coast region.

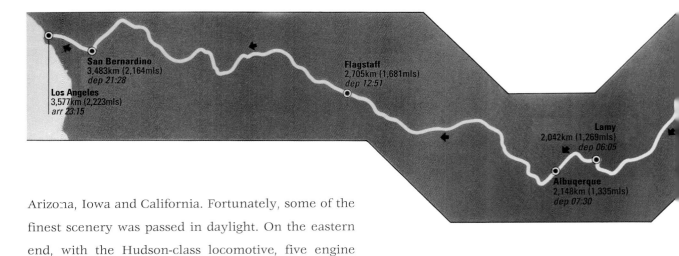

San Bernardino
3,483km (2,164mls)
dep 21:28

Los Angeles
3,577km (2,223mls)
arr 23:15

Flagstaff
2,705km (1,681mls)
dep 12:51

Lamy
2,042km (1,269mls)
dep 06:05

Albuqerque
2,148km (1,335mls)
dep 07:30

Arizona, Iowa and California. Fortunately, some of the finest scenery was passed in daylight. On the eastern end, with the Hudson-class locomotive, five engine crews were involved; from La Junta, with a 4-8-4 on the head end, nine crews worked the train in succession, making a total of fourteen different crews on the entire two-day journey. They were changed at Fort Madison, Kansas City, Newton, Dodge City, La Junta, Raton, Las Vegas, Albuquerque, Gallup, Winslow, Seligman, Needles, and Barstow. Because of its availability, the fuel used throughout from Chicago to Los Angeles was oil, and the locomotives were serviced twice on the route.

From La Junta westward, the route crosses one mountain range after another, in majestic and often breathtaking scenery. First comes the Sangre de Cristo range, and the grade up to the Raton Tunnel is so severe (3.5 percent) that even the huge 4-8-4 locomotives had to take a "helper." Next comes fast downhill running, followed by another hard climb from Las Vegas, New Mexico, to the crest of the Glorieta Range, then downhill into Apache Canyon, along the old Santa Fe trail. It was "give and take" hard slogging for the locomotive all the way from La Junta until the summit of the Cajon Pass was reached in the early morning of the third day. One enthusiastic American observer recorded, "Often it seems they are doing the impossible, as they smash at long sustained grades at high speed, tip over high mountain passes, drift down, to attack a gleaming tangent (straight track) at 100 miles an hour."

At Albuquerque, after 344 miles (553km) of hard going, the locomotive was detached from the train briefly, being taken to a bay in the neighboring roundhouse for servicing. Then it returned with the fourth crew of this section of the journey, climbing on a gradual ascending grade to the top of the Continental Divide at an altitude of 7,248ft (2,209m). The ensuing descent toward Gallup, New Mexico, is one of the finest racing stretches of the whole route, and it was common for the enormous engines to cover 133 miles (214km) here in two hours. At Winslow, Arizona, the locomotive was serviced again during a 20-minute stop. Even in summer, it would be dark by the time the train left, so it continued through the night into California. Faced with this type of work, with continuous hard steaming, nothing but the most thorough and efficient servicing by dedicated staff ensured the reliability demanded of the Santa Fe.

The diesel hauled *Super Chief* was running by 1936. Although faster, it never supplanted the *Chief* in popularity, until the great recession in American rail travel began in the 1950s, when the cream of the business passed to the airlines. Nevertheless, older travellers remembered the *Chief* of the Santa Fe with affection.

Later, under the auspices of Amtrak, the *Super Chief's* place was taken by the *Southwest Limited*. This

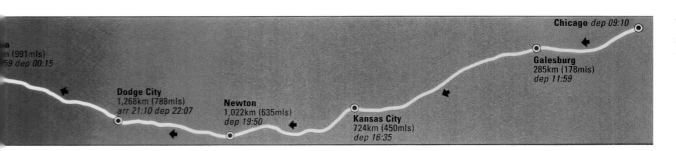

Chicago *dep 09:10*

Galesburg
285km (178mls)
dep 11:59

a
n (991mls)
59 *dep 00:15*

Dodge City
1,268km (788mls)
arr 21:10 dep 22:07

Newton
1,022km (635mls)
dep 19:50

Kansas City
724km (450mls)
dep 16:35

The *Chief* passed through seven states on its route between Chicago and Los Angeles and required 14 different crews.

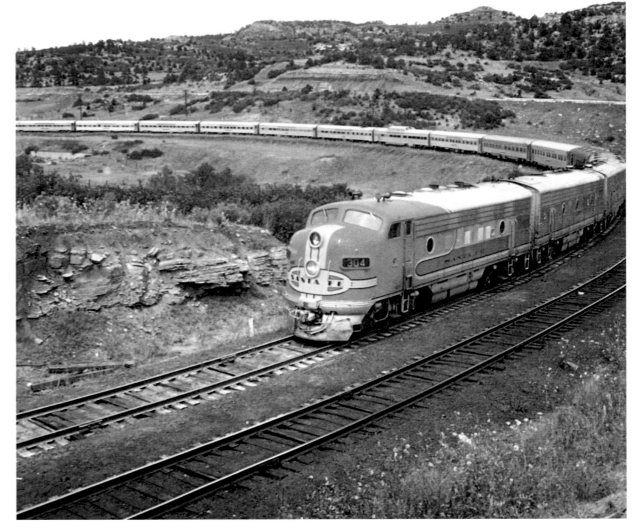

Resplendent in the ATSF company's classic "war bonnet" paint scheme, an EMD F7 cab-unit diesel locomotive and four boosters head the *Super Chief* on another run from Chicago to Los Angeles.

was hauled by two 3,000hp diesel-electric locomotives from Chicago to La Junta, where a third was added for the heavy-grade work over the western mountain ranges. The time from there to Los Angeles was 5 hours 30 minutes faster than with steam. There was much running at 85–90mph (137–145km/h) on the straight and level stretches. Nowadays, reequipped with bi-level coaches, the train bears the name *Southwest Chief*.

Diesel or steam hauled, it is a run that could scarcely be paralleled anywhere else in the world, both for its sustained interest for the railroad historian and enthusiast, and for the variety and grandeur of its ever changing scenery—some of the most dramatic on the entire continent.

CONRAIL, RESCUING THE FALLEN, 1976–99

WITH GOVERNMENT SUPPORT, SIX BANKRUPT RAILROADS IN AMERICA'S NORTH-EAST WERE COMBINED IN AN ATTEMPT TO REINVIGORATE THEIR FREIGHT BUSINESS; THE RESULTS WERE QUITE REMARKABLE.

Opposite page: A GE Dash 8-40CW six-axle diesel-electric locomotive, operated by the CSX Railroad under the Conrail umbrella, heads a southbound freight train at Folkston, Georgia, October 2006.

Map: The Conrail network stretched throughout the northeast corridor of the United States and totaled some 17,000 miles (27,200km).

The Consolidated Rail Corporation (Conrail) was a private, profit making corporation established in the USA by the Regional Rail Reorganization Act of 1973, chartered in the Commonwealth of Pennsylvania, and was composed of portions of six bankrupt railroads, namely the Penn Central, the Central of New Jersey, the Lehigh Valley, the Lehigh & Hudson River, the Erie Lackawanna and the Reading. It began operations as Conrail on April 1, 1976. Of the constituents, the Penn Central was by far the largest, having been the product of a merger in 1968 between the Pennsylvania and the New York Central railroads. Subsequently, the New York, New Haven & Hartford was included in the Penn Central. The reasons for the decline and eventual bankruptcy of all these companies was ascribed to the growth of competitive modes of transport, supported in part by large government financial resources. Continuing animosity between former New York Central and Pennsylvania railroad managers was another factor.

With access to government investment funds of up to $2,000 million to launch operations and achieve the goal of long-term viability, Conrail rebuilt on a massive scale. It operated some 17,000 miles (27,200km) of route, of which the Penn Central contributed more than 13,000 miles (20,800km). A great program of track improvement enabled the speed of trains to be restored to the high standards achieved in the heyday of all the constituent companies, which included some of the most famous names in American railroad history. The system network covered all the states in the northeast corridor, from Washington to Boston, and intensively those of Pennsylvania, Ohio, and Indiana, penetrating westward

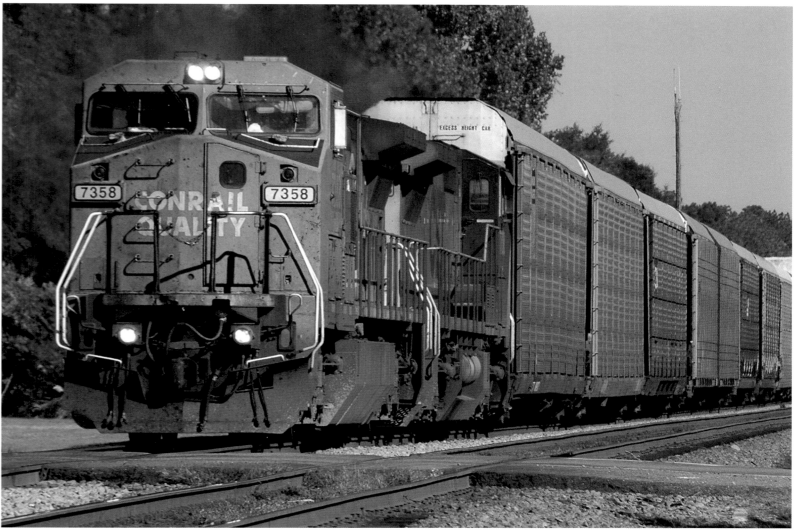

into Illinois, and northward into Michigan. It operated 4,500 diesel locomotives and 148 electrics, and ran an average of 1,500 freight trains daily, employing more than 151,000 freight cars. There were eight operating regions, with headquarters situated in New Haven, New York, Philadelphia, Pittsburgh, Newark, Detroit, Chicago and Indianapolis.

In 1999, having achieved its objectives, Conrail was divided between the Norfolk Southern and CSX railroads, although three of its switching districts continued to operate under the name of Conrail Shared Assets.

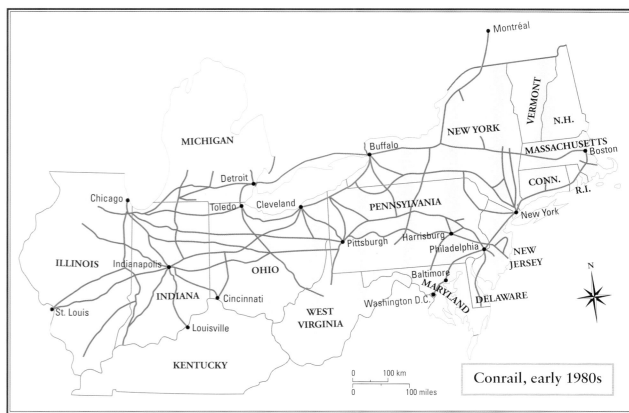

Conrail, early 1980s

The Canadian, Premier Transcontinental Express

AROUND THE GREAT LAKES, ACROSS ROLLING PRAIRIES AND THROUGH JAGGED MOUNTAIN RANGES, THE CANADIAN PASSED THROUGH ALL THE GRANDEUR THAT IS THE MAGNIFICENT LANDSCAPE OF CANADA.

The *Canadian* of Canadian Pacific Rail was indeed a train with a pedigree. Its predecessors date back to the very dawn of transcontinental travel in Canada, and that is to the inception of the Dominion itself. The integration of the far-flung centers of early colonization into a unified community that would grow into a great nation depended entirely upon the provision of a railroad line to connect British Columbia and Vancouver Island in the west with the prairies, the cities of the St. Lawrence basin and the maritime provinces in the east. When the great pioneers had found their way and built the line through the colossal barriers of the Rockies and the Selkirk range, and the last spike had been driven at Craigellachie on November 7, 1885, this extraordinary route had to be operated, all 2,908 miles (4,680km) of it between Montreal and Vancouver.

During the early 1900s, Canada's crack transcontinental express, the *Imperial Limited*, made its stately way along the Canadian Pacific Railroad. It was not a fast train, and in the mountain passes of British Columbia, where some of the grades were as steep as 4 percent, it needed one locomotive

to every two cars in the train. Before long, the burden of working this fearful incline, which at one point had a grade of 4.5 percent for 4 miles (6.5km), became excessive, and in 1909, the tremendous task of easing it was undertaken by boring two spiral tunnels in the Swiss fashion, and reducing the grade to 2.2 percent. It remained a single-track railroad, however, and even though much larger locomotives were introduced, the weight of trains continued to increase, such that by the beginning of the 1930s, the need for triple-headers was not unusual. The atmosphere in the cab of the third of three hard worked steam locomotives in those single-track tunnels must have taken some withstanding!

In Janaury 12, 1977, VIA Rail became a Crown corporation in Canada, responsible for handling the passenger train services of both the Canadian National and Canadian Pacific railroads. Here, the *Canadian*, sporting the colors of VIA Rail, is seen among the grandeur of the Canadian Rockies.

By that time, the primary transcontinental train was known as the *Dominion*. In 1931, however, the Canadian Pacific began running another, called the *Canadian*, although not on the same route, which became the fastest in the world. On the Montreal–Toronto run, it covered the 124 miles (200km) from Montreal West to Smith's Falls in 1 hour 49 minutes. There followed fierce competition for the inter-city traffic between the Canadian Pacific and the Canadian National Railroads, which ended soon afterwards with a pooling agreement.

In the meantime, the *Dominion* continued as the principal transcontinental train until 1955, when, in the floodtide of post-war development, a second train, consisting of splendid new stainless-steel rolling stock, was put on. This train was named the *Canadian*, and it supplanted the *Dominion* as the premier service. Both continued, however, for another ten years on the Montreal/Toronto–Vancouver service; after that, declining traffic led to the withdrawal of the *Dominion*.

The *Canadian*, diesel hauled, left Montreal at 11.15am; the Toronto section, which did not have so far to go, departed at 3.30pm, and the two were combined at Sudbury, Ontario, leaving there at 10.25pm. It was a most luxurious train, made up of seven types of coach. Coupled next to the locomotive was a baggage/dormitory car, which included living quarters for the dining, and buffet car crews and the stewards; although the locomotive crews were changed at each division point, the train crews were changed only once on the long journey, at Winnipeg. Next came the deluxe cars, which provided seating for sixty passengers, followed by the scenic dome car. This included a buffet and snack lounge, and the skyline coffee shop. Then came the dining cars, trailed by the sleeping cars. Finally, at the rear of the train, there was a special observation lounge, which had an elevated dome portion and a lower-level stern-walk lounge buffet—a most satisfying car in which to ride. All the cars on the *Canadian*, except the baggage and sixty-seat cars, were named, some with the prefix "Château" and others with the suffix "Manor." They commemorated famous men in Canadian history, such as *Château Montcalm*, *Château Cadillac*, *Wolfe Manor* and *Dufferin Manor*.

The route of the *Canadian* varied in its scenic and historical interest; apart from the tremendous scenery in the Rockies, one of the most beautiful stretches—especially if the weather was fine—came soon after breakfast on the second day out from Montreal, when the train made its way along the

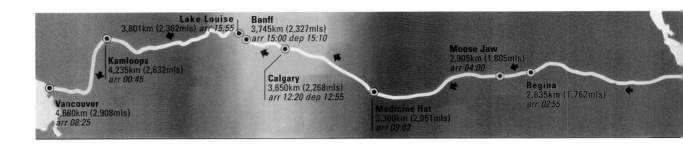

Lake Louise
3,801km (2,362mls) arr 15:55

Banff
3,745km (2,327mls)
arr 15:00 dep 15:10

Kamloops
4,235km (2,632mls)
arr 00:45

Moose Jaw
2,905km (1,805mls)
arr 04:00

Calgary
3,650km (2,268mls)
arr 12:20 dep 12:55

Regina
2,835km (1,762mls)
arr 02:55

Vancouver
4,680km (2,908mls)
arr 08:25

Medicine Hat
3,300km (2,051mls)
arr 09:02

northern shores of Lake Superior. This was a terrible section to build, requiring a ledge to be cut in the towering walls of rock that rise sheer from the lake. In this region, the best way of supplying the work gangs was by boat across the lake, or by sled during the winter months when the lake was completely frozen. Passengers could enjoy the ride as the train rounded one bay after another and passed through tunnels in the solid rock; it was not necessary to be in one of the domes to see the front and rear of the long train at the same time. At Thunder Bay, reached about lunchtime, the first time change took place, from Eastern to Central time. Winnipeg, on the threshold of the prairies, was not reached until late in the evening of the second day.

The richest of the prairie regions were passed in the night, and at Swift Current, watches were

The *Canadian*, headed by an EMD F40PH diesel-electric locomotive, noses into the station at snowy Ignace, Ontario, Canada, c. 1994.

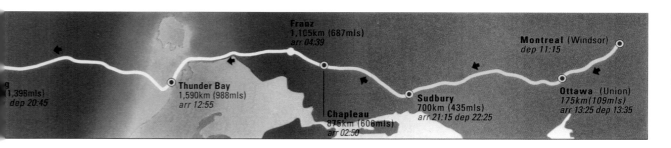

Franz
1,105km (687mls)
arr 04:39

Montreal (Windsor)
dep 11:15

Thunder Bay
1,590km (988mls)
arr 12:55

g
(1,398mls)
dep 20:45

Chapleau
875km (600mls)
arr 02:50

Sudbury
700km (435mls)
arr 21:15 dep 22:25

Ottawa (Union)
175km (109mls)
arr 13:25 dep 13:35

Passing across four time zones, the transcontinental route of the *Canadian* took it through some of the most spectacular scenery in North America.

put back again as the train entered the Mountain time zone. There was a long daylight run across the western prairies on the third day, from Swift Current to Medicine Hat, 148 miles (236km), and then on into the province of Alberta and its capital city of Calgary. By that time, the long, fascinating snow-capped range of the Rocky Mountains was already in sight. The train stopped for half an hour at Calgary, and for a dollar, passengers could break their journey with a ride to the top of the station's Husky Tower, a Calgarian equivalent of London's Post Office Tower, for a marvelous view of the city and surrounding country. Finally, with the shadows closing in, the train made a dive into the mountains in earnest for the third night of the journey; Vancouver was reached at about breakfast time on the fourth day.

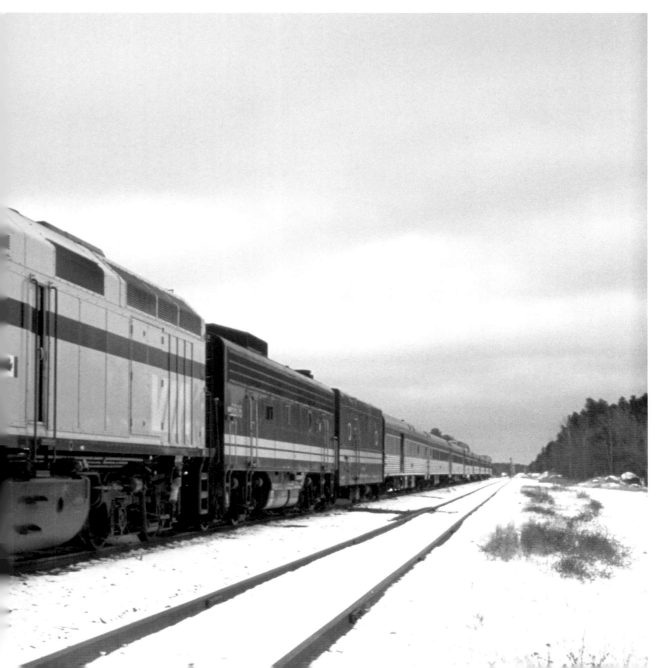

MODERN PASSENGER ROLLING STOCK

A CHANGING MARKET, SHORTER JOURNEY TIMES AND INCREASED PASSENGER NUMBERS HAVE PROMPTED MAJOR CHANGES IN THE DESIGN OF MODERN PASSENGER ROLLING STOCK.

In recent times, the bi-level passenger car has provided a solution for those railroads that need extra capacity —particularly on commuter trains—where it is impractical to increase the length of trains. These examples are seen at Harvard station, Illinois, on Chicago's Metra commuter line.

There has always been a marked contrast between the basic layout of European and North American passenger cars. In Europe, the separate compartment type was favored, each compartment being entered from a side corridor. At one time, British cars of this general type had individual doors to each compartment on the side away from the corridor, but later there was a change toward the Continental style, with entrance doors only at the ends. By contrast and almost exclusively, North American railroads employed the open car, which originated from the early so-called "colonist" coaches, used for conveying immigrants. In North America, this type has since been developed to a high standard of comfort and amenity, with adjustable seats that can be reclined for travel at night.

In the nineteenth century, wood was the universal material for coach construction, both for bodies and underframing; when the change to steel began, many of the railroads that built their own rolling stock retained wooden bodies, but adopted steel underframing. There was a period on many railroads when trains were made up of a mixture of wooden and steel cars. The former suffered severely in collisions and derailments, becoming crushed between the stronger steel cars. Wooden rolling stock was also a fire risk, particularly before the days of electric lighting.

Today, the open type of passenger coach has been widely adopted on the continent of Europe, and it is universal in new

construction in Britain. The open car offered many advantages in modern travel, particularly with reduced journey times. To the businessman, the tables were a convenience, allowing papers, books or documents to be studied en route, or impromptu discussions to be held with colleagues; on many trains, a cart service of drinks and snacks was provided for those who did not wish to walk through several cars to a buffet car.

On the fast inter-city trains of British Rail, there was often insufficient time to take a full dining-car meal. For families, the layout of a table between two pairs of facing seats was ideal for picnic meals and other incidentals of an excursion outing.

The provision of dining cars on long-distance trains became an attractive feature of travel around 1900; the serving of breakfast, lunch, or dinner became something of a ritual, the stewards being selected specially for the task and taking as much pride in their service as the head waiters in fashionable restaurants. Echoes of this age in railroad travel were to be seen on some prestige trains on the continent of Europe, but for the most part, railroad meals became simpler and taken in greater haste, often from the bar counter of a buffet car. In the new trains of open cars, certain parts of the train were set aside for the service of meals and were available only to those passengers wishing to dine. At one time, a walk from one's seat to the dining car provided a welcome diversion during a long journey, but on many prestige trains today, meals are available at all seats.

The evolution of the sleeping car has followed different paths in many parts of the world. In the early days in Europe, little was done to provide additional comfort for night travel. The longer continuous journeys made across the American continent, however, led to forms of seclusion being developed for the early colonist or open cars, including blinds that could be lowered on each side of the central gangway so that passengers could undress to some extent. When sleeping cars were introduced in Britain, for first-class passengers only, they provided completely private single-berth compartments, whereas on the continent of Europe, even the first-class sleepers on the prestige international trains had compartments with two berths, one above the other. This form of accommodation is still in use today. In Britain, third-class (now second-class) sleepers were introduced in 1928; these had two-tier bunks in a compartment. Nowadays in Britain, sleeping accommodation is available only between London and

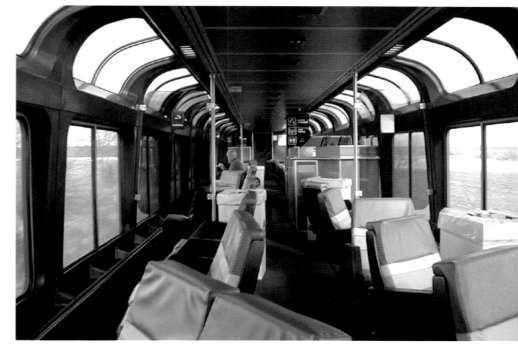

The upper level of Amtrak's Superliner I Sightseer Lounge car features comfortable, casual seating and wraparound windows for an incomparable view of the scenery by day and the stars by night, while a bar serves drinks and snacks.

In modern sleeping cars, the two-berth compartment is common. Beds are arranged one above the other.

Some modern railroad cars, such as this French example, have comfortable reclined seating and space saving folding tables for dining or working.

Scotland, and London and Cornwall.

By 2007, comfortable sleeping-car accommodation was still provided on the long-distance services of Amtrak, although that company also provided "coach" passengers with reclining seats on which sleep was practicable for most people. India and Russia were also great users of sleeping cars, and, to a limited extent, so was Australia.

Much has been done in recent years to improve the smoothness of ride. New and advanced designs of truck have been introduced that give an excellent ride over long periods, at much higher speeds than previously, with a minimum of attention. The methods of suspension have been subjected to constant research.

The great distances traversed by transcontinental trains in North America and Australia led to a demand by wealthy patrons for a level of accommodation beyond that of the ordinary first-class car, and its associated dining and sleeping cars. As a result, passenger cars with private suites were introduced, while more generally available bar-lounges, club cars and observation lounges were run on certain trains.

More recently, there has been a tendency toward airline-style passenger accommodation. The technical features that were developed to provide a comfortable ride at high speeds were epitomized, to a large extent, in the new cars built for the Paris–Lyon TGV (*Très Grande Vitesse*) line in France. On this line, it was decided to adopt powered train sets, in preference to locomotive hauled coaches, with no more than moderate axle loading, which was considered essential for stability at 185mph (300km/h). The cars were articulated, having trucks between the car bodies, which allowed a reduced height and, therefore, lower wind resistance. To provide rapid acceleration, six of the thirteen trucks in each train set were powered.

Hand in hand with the introduction of fast new trains has come a more complete understanding of the relationship between wheel and rail. For some time, an American roller test plant has been in operation at Pueblo, Colorado, on which track conditions can be simulated and the reaction of vehicles passing over the track observed under laboratory conditions. This plant, and another near Munich, Germany, act in parallel to the stationary locomotive test plants, in that the unit to be examined can be run at maximum speed without moving from the test-bed.

Some of the latest techniques in coach production for rapid-transit lines were embodied in new stock for the Paris Métro. Aluminium is an attractive material for car bodies because of its low weight, but until recently it was impracticable because of its higher cost than steel. In the light of major advances

in aluminium assembly techniques, however, French manufacturers were able to achieve lower build costs for aluminium car bodies, and large orders were placed, not only for Paris, but also for several other cities.

For commuter services on certain main lines around Paris, some very handsome double-deck passenger cars have been in use, hauled by electric locomotives. The cars and locomotive make up a two-directional train set, in the same way that steam locomotives were used on early commuter trains. The locomotive is not uncoupled, and when hauling the cars in one direction, it propels them in reverse. The car furthest from the locomotive has a driving cab, from which the locomotive is controlled remotely.

In 2007, almost all locomotive hauled passenger stock on order by the world's railroads was double-deck. (Britain was an

Airline-style seating is now common in many long-distance trains. This is the interior of a first-class compartment in a Swedish X2000 train.

exception because of its size restrictions.) This favoring of the double-decker was due partly to lower costs per passenger, but mainly to increasing congestion as passenger numbers increased. On many lines, it was impossible to run more trains, so trains of the same length, but increased capacity, seemed the only solution.

In Britain, especially, closer packed seating became the rule; that is, there was less space for the passenger, although there were few complaints about this because such seating had a modern "airliner" allure. Nevertheless, in Britain, weight of rolling stock per passenger rose; this was largely because of the provision of more facilities, a significant space consumer being the obligation to include wheelchair-accessible toilets. Some new trains offered at-seat sockets for computers and entertainment, and retention toilets (instead of the traditional track dumping kind) became the standard.

Trains became more protective in case of accident. Crumple zones were often built into the designs, and stronger couplings meant that a train was likely to hold together in a derailment. In the 2007 accident to a fast British train at Grayrigg, the strong couplings, closeness of seating and absence of interior obstructions meant that injuries were remarkably few.

The self-propelled train rather than locomotive hauled formations became increasingly favored. Many manufacturers offered such trains, Alstom, Siemens and Bombardier predominating. However, a number of new enterprises attacked the European market; Poland was expected to sell a cheap and reliable train, while the Japanese company Hitachi won a substantial British order.

RAILROADS IN CENTRAL AMERICA, MEXICO AND THE CARIBBEAN, FROM 1837

WITH THE EXCEPTION OF MEXICO AND CUBA, THE RAILROADS OF CENTRAL AMERICA AND THE CARIBBEAN HAVE COME AND GONE, USUALLY AT THE WHIM OF FOREIGN INTERESTS.

Opposite page: The Sierra Tarahumara & Chihuahua Pacific, or Copper Canyon Railroad opened in 1961 after decades of construction, designed to connect the Pacific Ocean with Mexico's central desert territory and Chihuahua. The route continues to be a major freight connection between Chihuahua and the Pacific coast.

Map: Many Central American and Caribbean railroads were built by foreign enterprises, usually to allow the exploitation of natural resources. Only in Mexico and Cuba were they put on a more permanent footing.

Bordered on the north with USA, and on the south with Central America, Mexico alone has acquired a nationwide network, originally inspired by engineers and capital from the USA. In the rest of Central America, interest has concentrated on routes across the isthmus, and none of these has been developed into an adequate national rail system. In part, this can be attributed to the difficult terrain, which makes railroad construction a real challenge; the climate compounds the difficulty, torrential rain leading to frequent washouts. Generally speaking, however, the railroads here, like those in Africa, have been built by outside interests for purposes of exploitation rather than national development.

The first Central American railroad was built to provide transport across the isthmus. The Panama Railroad, which opened in 1855, saved so much time and money, by cutting out the voyage around Cape Horn, that it was able to charge passengers $25 for the 48-mile (77km) journey. Another proposal was for a "ship railroad," with six lines of rails that would carry ships bodily across the isthmus. More recently, some banana growing states have had lines built by the United Fruit Company of Boston, and the Standard Fruit Company of New Orleans, to facilitate immediate shipment of the fruit, which is essential. There are also proposals for constructing a rail "land bridge" across the isthmus.

From time to time, railroads appeared on the Caribbean islands, typically in connection with the extraction of raw materials, but few survive, with the exception of Cuba. Thanks to its size and

potential traffic, Cuba has maintained a sizeable railroad system. After the Spanish left, the railroads came under American influence until the arrival of Castro, after which the few items of railroad equipment that could be imported came from the communist bloc, although one British maker of diesel locomotives found a way around the trade embargo. Early in the twenty-first century, the Cuban railroads, although threadbare, provided a reasonable service.

MEXICO

Mexico's first train ran in 1850, but most of the present extensive network was constructed in the 20 years after 1880. During that time, 7,687 miles (12,300km) of track were laid. Most lines are standard gauge, but the nationalized system, FC Nacionales de Mexico (N de M), operated 280 miles (450km) of 3ft (914mm) narrow gauge.

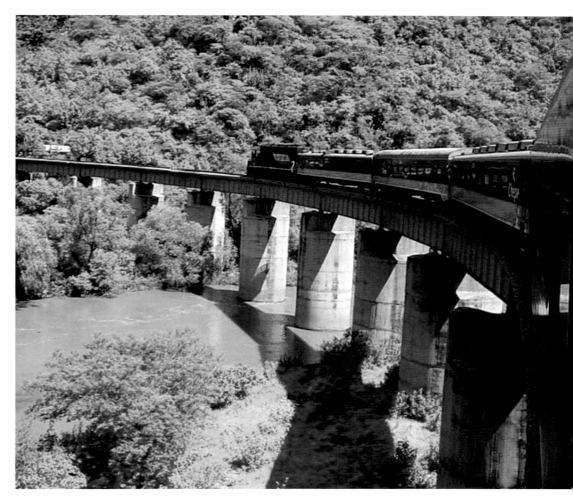

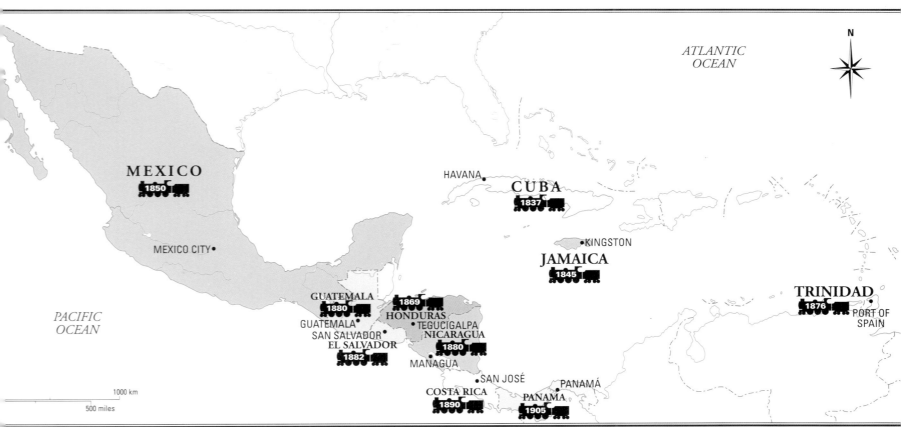

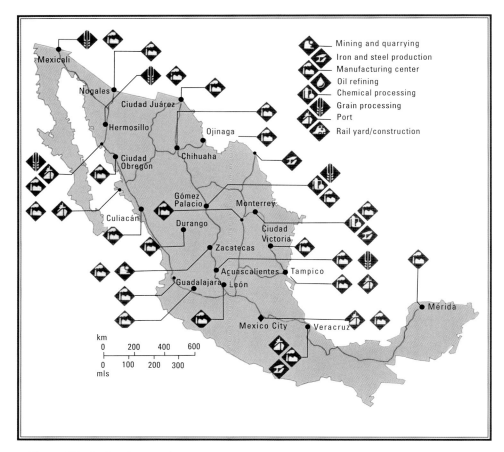

Mining and quarrying
Iron and steel production
Manufacturing center
Oil refining
Chemical processing
Grain processing
Port
Rail yard/construction

Mexicali
Nogales
Ciudad Juárez
Hermosillo
Ojinaga
Ciudad Obregón
Chihuaha
Gómez Palacio
Monterrey
Culiacán
Durango
Ciudad Victoria
Zacatecas
Acuascalientes
Tampico
Guadalajara
León
Mérida
Mexico City
Veracruz

km
0 200 400 600

0 100 200 300
mls

Most of Mexico's rail network was built after 1880. For many years, the bulk of the system was operated by a nationalized company, N de M, but privatization was embraced in 1995. There are close links with the USA, and U.S. railroad companies have financial stakes in Mexican rail firms.

The creation of N de M began in 1908, when the National Rail Road of Mexico merged with the Mexican Central Railroad. Other railroads were acquired later, but at least two large lines remained independently managed, and N de M could claim to own only 71 percent of the Mexican railroad system.

The largest of the independents was the FC del Pacifico, once a subsidiary of the USA's Southern Pacific. It stretched 1,330 miles (2,140km) from Guadalajara to the US border.

A privatization process began in 1995, and the system was divided into regional railroads. U.S. railroads, keen to exploit opportunities stemming from Mexico's increasing role in the U.S. economy, acquired key elements of the system. Passenger services almost disappeared, although some have been restored, often with the help of local authorities.

GUATEMALA

The main rail network in Guatemala belonged to the International Railroads of Central America, one of whose lines crossed into El Salvador (where it was nationalized). This company was formed in 1904, although Guatemala's first train had actually run in 1880.

The Guatemalan railroads were nationalized in 1962, and collapsed in 1996 while they were in course or re-privatization. Since then, American capital and experience have been used to help restore the situation.

HONDURAS

The first train ran in Honduras in 1869. In the late twentieth century, there was a gradual nationalization, which saw former U.S. fruit company lines of 3ft (914mm) gauge attached to the Honduras National Railroad's 3ft 6in (1,067mm) system. At the end of the century, the national railroad had more narrow-gauge track than wider gauge.

EL SALVADOR

Ferrocarriles Nacional El Salvador was established in 1975 by the merger of two nationalized lines previously. The larger section was part of International Railroads of Central America until 1974. This is a small system, with only a dozen diesel locomotives. There are plans to upgrade, with foreign aid.

NICARAGUA

The only railroad of any importance in Nicaragua was the FC del Pacifico, which was owned and operated by the government. The initial section, from Corinto to Chinandega, was opened in 1881. The line was finished in 1903, although Granada, the inland terminal, had been linked to the railhead since 1886 by a lake steamer service. The gauge was 3ft 6in (1,067mm). Nicaraguan railroads closed in 1994, but there have been attempts at rehabilitation.

COSTA RICA

The original concession for a Costa Rican railroad was granted in 1871, but it was not finished until 1890. Running from the Caribbean port of Limón to San José, it connected with the electrified Pacific Railroad to form a route from sea to sea. The Pacific opened in 1910 and was electrified in 1930. Isolated in the south was the FC del Sur. The railroads closed in 1995.

PANAMA

Panama has three independent lines. The first opened in 1855, a predecessor to the Canal as a means of crossing the isthmus. It is 5ft (1,524mm) gauge. In 1914, a line was begun from the Pacific port of Armuelles, intended to be part of an intercontinental Mexico–Argentina line. In the north-west, a line owned by an American company runs 30 miles (48km) into Costa Rica.

An engineer prepares to manually refuel a General Electric U5B diesel locomotive of City Rail in La Ceiba, Honduras. The passenger 'car' behind is a converted freight wagon with sides removed and benches added.

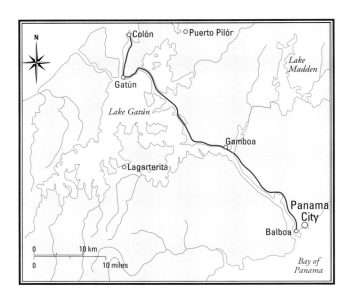

The main railroad in Panama crosses the isthmus, from coast to coast, and was built before the Canal. It was the first railroad built in Central America.

The railroads of the other countries of Central America are small-scale operations that have struggled to survive. Those still in operation face an uncertain future.

JAMAICA, DOMINICAN REPUBLIC, AND CUBA

Jamaica's first train ran in 1845 on the first ever British colonial railroad. The bauxite industry provided most traffic. The public rail service offered by the Jamaica Railroad Corporation declined and disappeared, although efforts are made periodically to restore parts of it. It has been reported that some of the bauxite lines are still in operation.

Dominica's railroads suffered from road competition: passenger services have ended and only a few sugar-cane lines may still be in use.

Cuban Railroads is the oldest system in the Caribbean, and despite economic difficulties, Cuban National Railroads has achieved some minor upgrading. Second-hand Spanish trains were imported for the electrified Havana–Matanzas line, while other equipment has been imported from Europe and elsewhere. The steam operated sugar-cane lines had almost disappeared by 2007.

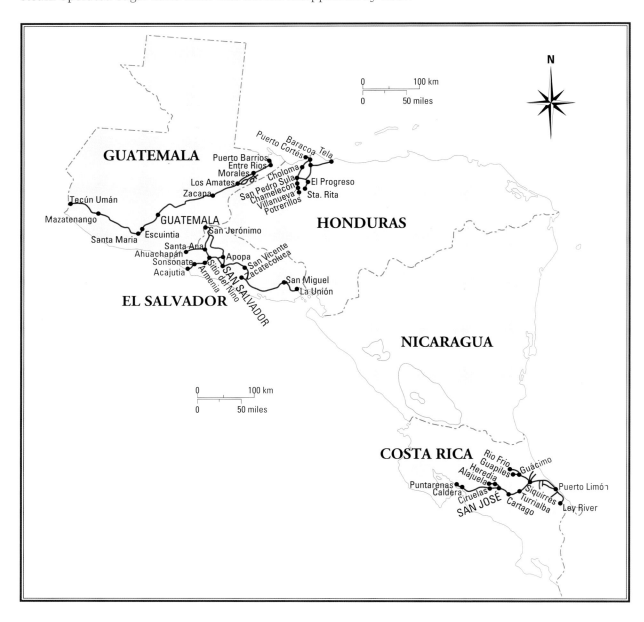

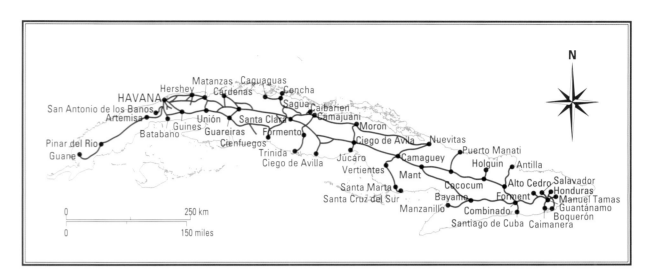

The oldest railroad network in the Caribbean, the Cuban system is extensive. In recent times, parts of the system have been upgraded, and secondhand Spanish electric trains have been imported.

A hard working steam train on one of Cuba's sugar-cane lines.

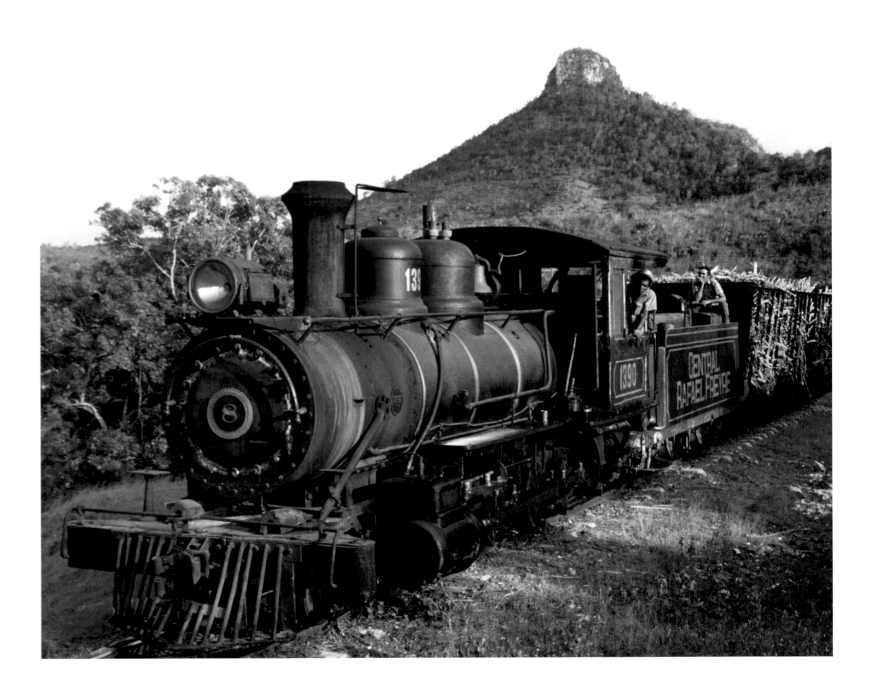

MODERN FREIGHT ROLLING STOCK

HAVING LOST MUCH BUSINESS TO ROAD TRANSPORT, RAILROADS
ARE WINNING BACK FREIGHT CUSTOMERS WITH SPECIALIZED
ROLLING STOCK THAT IS CAPABLE OF CARRYING MASSIVE LOADS
AT HIGH SPEEDS.

The modern freight car is very much a specialist vehicle, no more so than when designed to carry the product for which the earliest railroads were built—coal. The British hopper car of today, used on the unit coal trains, are in size, though not in the sophistication of their equipment, the baby brothers of some of the gigantic hopper car used in other countries. The New Zealand railroads, for example, although operating on the 3ft 6in (1,067mm) gauge, employ large, bottom-discharge cylinder-shaped hoppers that carry a payload of 42 tons, while in the USA, the Chesapeake & Ohio, one of the greatest coal carriers in the world, had thousands of large hopper cars each capable of carrying 90 tons of coal. These are still used in the export coal trade from Newport News, where stationary turn-over car dumpers are capable of handling thirty cars—2,700 tons of coal—per hour each.

The Canadian Pacific runs a remarkable coal operation from the Crow's Nest Pass, British Columbia, to Roberts Bank near Vancouver (for onward shipment to Japan). There, the 100-ton coal cars are discharged on to conveyor belts one by one without them being uncoupled from each other in the long train. The couplers, including the continuous air-brake connections, are designed so that each car can rotate about its horizontal axis without the connections being broken. The mechanized handling equipment moves the whole train forward one car's length after the coal has been discharged and the empty car has been rotated back to its normal position. Similar operations are to be found in other parts of the world.

Discharge through bottom hoppers, or by the rotation process, is not always possible, especially in the conveyance of waste products from industrial plants, such as blast furnaces and steel works. In the USA and other countries, side dumping cars are used. Each car's body resembles an extra-large version of an ordinary gondola, but it is supported on four huge compressed-air cylinders. If right-hand dumping is required, compressed air is supplied to the two cylinders on the left-hand side, extending their pistons, which tilts the body to the right. For left-hand side dumping, the right-hand cylinders are extended.

A CSX rotary gondola wagon used for carrying phosphate rock from the Bone Valley region in Florida to transloading facilities at Tampa Bay. These cars have rotary couplers, allowing them to be turned upside-down for unloading without being uncoupled from the train.

Today, enclosed or box cars are built to great size. Although many are nothing more than empty boxes, designed to carry general merchandise, others incorporate highly specialized equipment for handling such items as perishable goods or newsprint.

The transport of automobiles and road trucks has become another specialized part of rail freight business. In Britain and on the continent of Europe, cars are loaded on two levels, while the extra height of the North American loading gauge enables three levels to be employed. On the latest American automobile transporters, fifteen vehicles are carried, five on each deck. In Britain, however, the limitations in height imposed by the loading gauge are compensated for in length, four-unit articulated cars being used. Each unit of the car carries seven automobiles, and only five trucks are needed to support the four units; fully loaded with twenty-eight automobiles, the entire assembly weighs as much as 93 tons. These remarkable vehicles are capable of running at 75mph (120km/h) if required.

The introduction of special-purpose rail vehicles grew to a remarkable extent in the USA, where

The Amtrak Roadrailer is a specially designed freight vehicle for use in railroad intermodal service. It is equipped with a set of wheels and tyres for road haulage, but can be mounted on trucks to run on rails.

strenuous efforts were made to win back traffic that had been lost to road transport. In no respect was this trend more noticeable than in the cooperation between the railroads and individual manufacturers for delivery of their products. For example, the Southern Pacific Railroad and General Motors developed the ingenious vert-a-pac car carrier, specifically to convey new automobiles from manufacturing plants to distribution centers. On each side of these enormous box cars, there were fifteen doors, which were hinged at the bottom; when opened, each door formed an inclined ramp on to which an automobile was driven. It was secured to the ramp for transit, then the door was shut so that the car was in a vertical position inside the car.

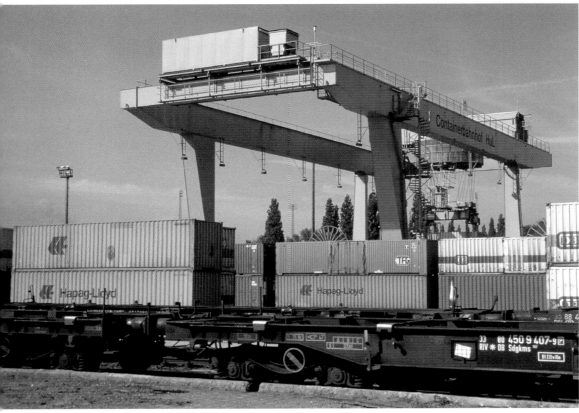

A container rail freight yard in Germany. The massive gantry crane can straddle rail and road vehicles, allowing the easy transfer of containers from one form of transport to another.

The idea of a sealed container that can be transferred from rail to ship, then back to rail, is not a new one; it was practiced for many years in the days of steam operations on the Continental boat-train services from London, across the English Channel to France. The modern rail concept is to have a train with a set number of flatbed cars for each scheduled service and not to alter that number, even if a full complement of containers is not available on some occasions. For example, until the 1970s, a nightly service from Garston Docks, Liverpool, to Glasgow would contain a set of twenty flatbed cars, each capable of carrying three containers—sixty to a train. If, by loading time, however, the traffic of the day had produced only 47 containers, the train would be dispatched with some of the cars not fully loaded. The transit of these trains was given top priority in the night. During these hours, express passenger trains were run at considerably lower speeds than in the daytime, and the container trains, or "freightliners" as they were called, running continuously at 75mph (120km/h), were equally fast. A fully loaded twenty-car container train would represent more than 1,000 tons, or roughly double the weight of a heavy night passenger train; on the heavy grades in the north of England and Scotland, two 5,000hp locomotives were needed to maintain the fast schedule speeds.

The transport of livestock requires specially equipped freight trains. In the past in Britain, sheep and cattle were carried in single-deck four-wheeled cars with open caged sides, but this traffic ceased. In some countries, however, it remained a major task for railroads. The modern general concept of the high-capacity car was applied to this traffic. Large double-decked sheep cars were run on the Iraqi

A Pacer Stacktrain at Rochelle Railroad Park, Rochelle, Illinois, USA, 2005. This specialized five-unit gondola car carries ten double-stacked containers. The ends of adjacent gondolas are supported on a single truck.

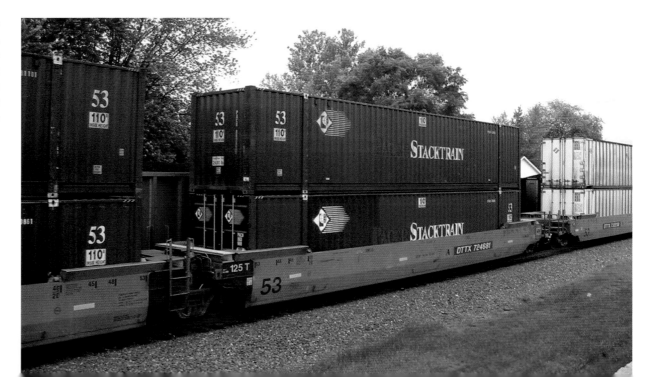

State Railroads, and even larger ones in the USA.

Specialized cars are used for the bulk transport of materials in powder and pellet form. On British Rail, while the private owners' cars of former days were no longer to be seen as individual loads in freight trains, agreements were made with large industrial concerns to run daily freight trains carrying a single product. The Rugby Portland Cement Company had a fleet of large, four-wheeled cylindrically-shaped cars, each of which had a gross laden weight of 50 tons and could run at speeds up to 60mph (96km/h). Considerably larger were the 100-ton cars operated for the Blue Circle Cement group. These carried a maximum payload of 78 tons and were also run at speeds of 60mph (96km/h).

Oil tank cars wait to receive their cargo at the Totton Terminal, Southampton, England. Owned by Shell, these freight vehicles will be formed into a single train, rather than being integrated into multi-product freight trains, as would have been the case in the past.

All these large vehicles imposed an axle load of approximately 25 tons on the track. This could be accepted only on main trunk lines because it was similar to that of locomotives.

All modern freight cars require trucks that will permit safe and steady running up to 60mph (96km/h). Every effort is made to reduce unsprung weight, while load-sensitive dampers and disc or clasp brakes are standard equipment. British fast freight trains are fitted with Westinghouse automatic air brakes, permitting the safe and smooth control of the heaviest trains in the most adverse circumstances.

In recent decades, there has been a big increase in the number of specialized freight cars, even though the all-purpose car has a better chance of securing a return load. There is a continuing effort to design cars with a higher net-tare ratio (proportion of weight of load to weight of the empty vehicle). In the USA, where many railroads raised their clearances to permit the running of double-stack container trains, an opportunity was presented to introduce so-called "hi-cube" enclosed cars, the great size of which delivered a reduction of costs. The net-tare ratio can also be enhanced if maximum axle loads are raised; usually, the extra track maintenance costs that this imposes are more than covered by the reduced transport costs, which can fall by 40 percent if the axle load is raised from 22.5 to 30.5 tons. Such high axle loads are allowed on main U.S. lines today. Designing cars in three- or five-unit sets, permanently coupled, can enable great tare weight reductions. The same effect is produced when, instead of using conventional flatbed cars, containers are carried on skeletal cars consisting of little more than trucks supporting a central beam or sill.

In Europe, the multi-purpose van has appeared. This has a sliding roof and sides, and sometimes end doors as well, enabling awkward consignments to be loaded.

Railroads in South America, from 1851

LARGELY DEVELOPED WITH FOREIGN CAPITAL AND MAINLY FOR USED FOR MINERAL EXTRACTION, THE RAILROADS OF SOUTH AMERICA WERE BUILT IN PIECEMEAL FASHION WITH LITTLE THOUGHT TO INTEGRATION.

Railroad construction in South America started very late, as it was dependent upon the availability of foreign capital and was adversely affected by the lack of political stability. However, most of the current network was completed by 1930.

Because many of the countries had closer ties with Europe and the USA than with each other, South America appears like a group of islands: the separate hinterlands of each port and their railroad lines are often isolated from each other except by sea. One result is that a profusion of gauges have been used: there are at least nine existing in substantial route lengths on the continent.

Much of South America's railroad traffic is still of the mine-to-port pattern, however, and the lack of inter-regional trade has meant that gauge differences have not been the acute problem experienced in other parts of the world, such as Australia for example. The decision of Paraguay to alter its gauge in 1911—in order to make through working with Argentina a possibility—was an isolated early example of a change that was unlikely to be imitated elsewhere, no matter how desirable.

Over the last decades, there has been considerable restructuring on most of the Latin American railroads, sometimes with the aid of overseas capital. Passenger trains virtually disappeared in some countries that previously had enjoyed them, but recently there has been support for reintroducing passenger services. Several administrations have been purchasing secondhand rolling stock from Spain for this purpose.

The railroads were late to appear in South America; when they did, it was usually to exploit a local resource on behalf of a foreign run enterprise. The piecemeal development has led to a lack of integration, and cross-border links are few.

Laurita, a narrow-gauge, German built, Orenstein & Koppel well tank steam locomotive hauls logs at Puerto Casado, Paraguay. The well tank design of engine has a relatively small water capacity, making it suitable for short runs only. Note the spark-arresting smokestack.

COLOMBIA

Although Colombia is the third most populous country in South America, its railroad system is somewhat inadequate. In part, this is due to the mountains that divide the country into several regions, between which transport of any kind has always been difficult. Political upheavals have also taken their toll, culminating in civil war in 1899; foreign capital was difficult to attract, and the few lines that were built cost the government dear. As a result, it was a long time before a national rail system was developed. Even then, Bogota, the capital, was of secondary importance to the city of Cali, which was

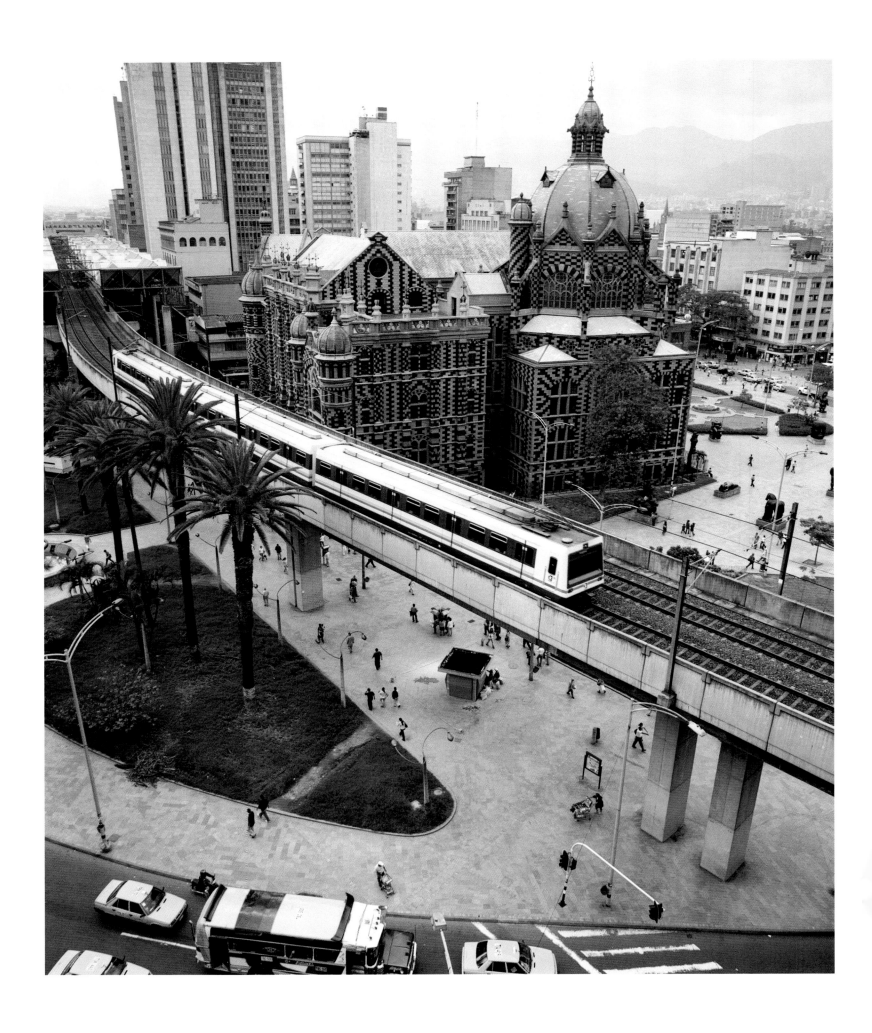

the first to acquire an outlet to the sea. To this day, the link between Bogota and the Pacific port of Buenaventura is extremely circuitous, and the missing 69 miles (110km) of the direct route, from Ibagué to Armenia, is no more than a project. There was an attempt to build it in 1913, but the work was finally abandoned in 1930. The Atlantic line was not completed until 1961.

The long-drawn-out process of nationalization (it was started in 1901, but not completed until 1962) enabled the gauge of Colombia's railroads to be made uniform at 3ft (914mm).

Social and economic problems in Columbia have beset the railroads in recent years, although there have been sporadic attempts at rehabilitation, usually with the advice or assistance of Spain. Despite this, however, the situation remains difficult. The railroads remain essential, however, not only to the coal export trade, but also to many other businesses.

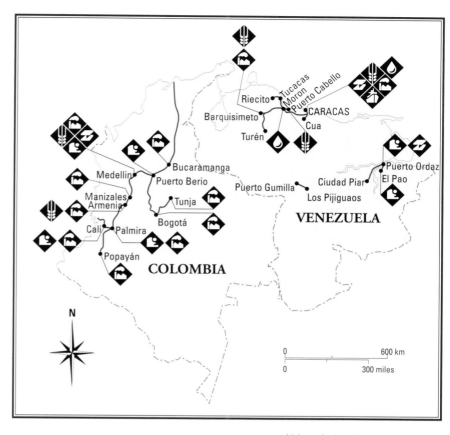

Although development of railroads in Colombia has been sporadic, they are essential for the export of coal and other industries. In Venezuela, the short length of line has been closed, although attempts are being made by the government to reinvigorate the railroad.

ECUADOR

Railroads arrived in Ecuador in 1871, when the line from Guayaquil to Quito, the capital, was begun; geographical and financial difficulties prevented its completion until 1908. Although its 11,841ft (3,609m) summit is not high by South American standards, it is one of the more dramatic Andean lines. The total curvature of the line amounts to 16,000 degrees, the equivalent of forty-five complete circles; many have a radius of only 198ft (60.35m).

Between Sibambe and Palmira, the line climbs 4,700 ft (1,433m) in only 22 miles (35km), on an actual grade of 5.5 percent; compensating for the curvature, this equals a straight 6.6 percent. It is entirely adhesion worked and accounts for 40 percent of Ecuador's route length. Joining it are two other lines of 3ft 6in (1,067mm) gauge, and there are also two isolated narrower-gauge lines on the coast, at Bahia and Puerto Bolivar.

Ecuador's railroads comprise about 620 miles (1,000km) of 3ft 6in (1,067mm) route. The main system is under three divisional managements: Guayaquil–Quito, the Cuenca branch, and the San Lorenzo line.

In 1999, proposals to privatize the system were published. Since then, traffic has fallen owing to parallel highway construction, and repeated line closures due to floods and landslides. Many parts of the main line have been relocated following flood damage. Nine French diesel locomotives, bought with French aid in 1992, represent Ecuador's modernization, but much of the system remains antiquated and sporadic in its operation. However, there are plans for upgrading the system, and new railroad construction.

Opposite page: A metro passenger train runs past El Palacio de la Cultura Rafael Uribe Uribe in Medellin, Colombia. Passenger operations were suspended in Colombia in 1992, but reintroduced in the late 1990s.

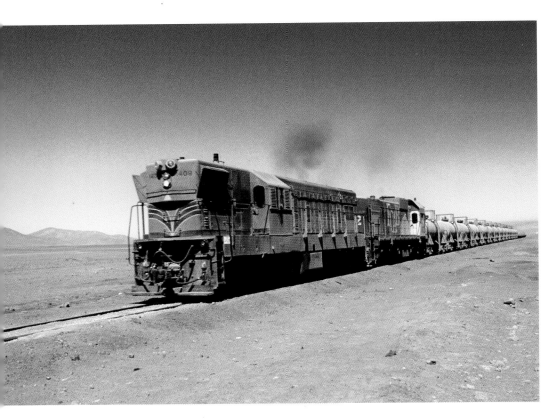

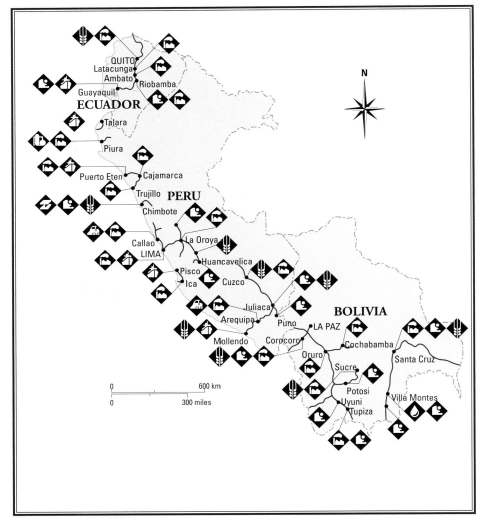

VENEZUELA

Venezuela's first rail line was begun in 1873. About 620 miles (1,000km) of narrow-gauge lines were built in 1894, but all have closed, the last in 1967. The government has been building a standard-gauge network, which now extends to a distance of about 310 miles (500km).

CHILE

Although Chile claims that the line from Caldera to Copiapó, which opened in 1852, is the oldest in South America, it was not the first; that honor goes to a now-defunct railroad in Guyana. The Caldera line was built by the American William Wheelwright to exploit the silver and copper deposits of Atacama Province. Chile's mineral wealth stimulated many of the early railroads. The government became involved from an early date, through having to step in to keep open lines whose economic justification (a mine) had closed. In 1873, the Organic Law for Railroad Operation was passed. It established the state railroad administration and a plan for a national railroad construction policy. The plan envisaged a north–south trunk line through the Central Valley, with cross-branches to the coast and to the foothills of the Andes.

Today, Chile's rail system conforms very closely to the ideas established by the law. When it was passed, there were 594 miles (950km) of government owned lines, and 784 miles (1,254km) of lines under private ownership. It was not intended to be a vehicle for the nationalization of the railroads, however, and almost 1,187 miles (1,900km) of line are still in private ownership. The largest such line is the Antofagasta (Chili) and Bolivia Railroad, which operates a meter-gauge line over the Andes with a weekly through train to the Bolivian capital, La Paz. It is one of the most financially successful of the Andean lines. Three

other lines cross the Andes, including the Arica-La Paz Railroad, which is isolated from the rest of the Chilean system.

Most of the railroad system is operated by Chilean State Railroads (EFE), although concessionaires handle some traffic. An EFE subsidiary, Fepasa, was established in 1993 to handle freight traffic. Some passenger trains still run. Of the five gauges, the commonest are 5ft 6in (1,676mm) and meter.

ARGENTINA

The construction of Argentina's first line began in 1855. It was built by the English engineer William Bragge, using 5ft 6in (1,676mm) broad-gauge equipment originally destined for the Crimean War. The first section opened in 1857. Although established by accident, the broad gauge was used for all early lines, and almost 14,375 miles (23,000km) remain. In 1872, however, meter gauge was chosen for the line from Córdoba to Tucumán; it has grown into a system of 8,413 miles (13,461km). In 1874, the East Argentina Railroad opted for the standard gauge, and the country now has 1,929 miles (3,086km) of this. Even so, there are few problems with breaks of gauge; most lines were built to facilitate the export of agricultural produce, and nearly all the original railroads, of whatever gauge, had access to the port of Buenos Aires, from which the Argentine system spreads like a gigantic fan.

The British maintained their early interest in the development of Argentina's railroads, and by the 1920s, about 70 percent were British owned. The railroads were nationalized in 1947. The state system

Opposite page, top: A pair of EMD GR12 diesel locomotives head a tank train carrying sulphuric acid on the Antofagasta (Chili) & Bolivia Railroad, c. 2006.

Map: Constructing railroads in Ecuador, Peru, and Bolivia was hampered by the mountainous terrain of the Andes. This called for much creative thinking on the part of the engineers.

A British built 4-8-0 steam locomotive working hard to haul a train of mineral cars on one of Argentina's broad-gauge railroad lines.

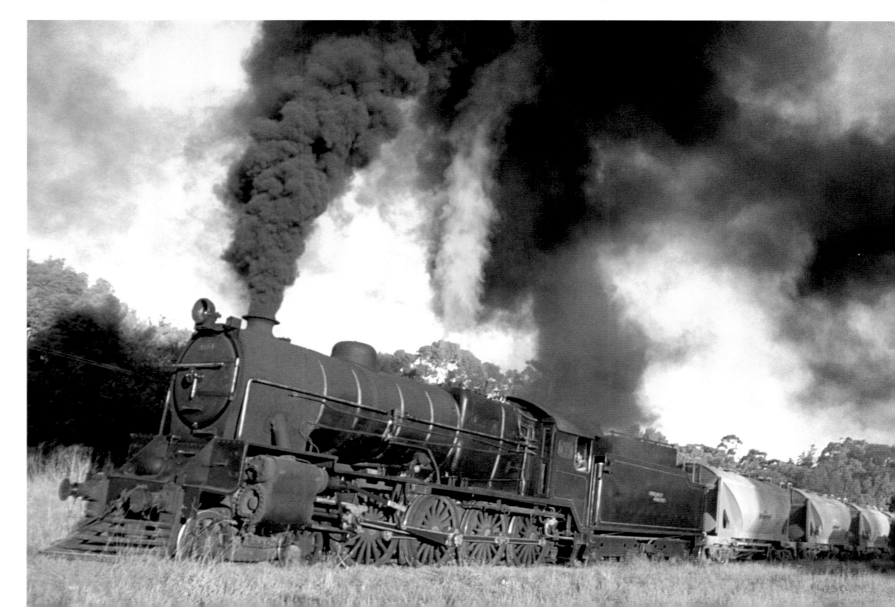

was divided into six lines, each named after an army general. Four of these lines were broad gauge, one was standard gauge and the other meter gauge.

Since the end of military rule, Argentina's railroads have been in a state of flux. Currently, they are operated by a number of concessionaires, some of which are based on former state railroads, while others specialize in freight or passenger traffic. There were severe losses of passenger service, but lately some of these have been revived.

PARAGUAY

The first section of railroad in Paraguay, from Asuncíon to Paraguarí, was built to a 5ft 6in (1,676mm) broad gauge by British engineers employed by the government, and opened in 1861. Political upheavals delayed further construction until after 1889, when the Paraguay Central Railroad Company was formed in London and continued construction under government guarantee. Rails finally reached Encarnación in 1911, across the River Parana from the Argentine North Eastern Railroad. To permit through traffic (carried on a train ferry), the Paraguayan system was converted to the Argentinian line's standard gauge in the same year. Little has changed since. The government bought out the British company in 1961 and, in 1964, it was named FC Presidente Carlos Antonio Lopez.

In the 1990s, the railroad was still struggling on, carrying a sparse traffic with elderly steam locomotives. By 2005, however, operations had more or less ended.

URUGUAY

Most of Uruguay consists of rolling plains. Even the hills in the north do not rise above 2,000ft (610m). A comprehensive network was built in this easy countryside, one of the densest national systems in South America, mostly by British interests between 1865 and 1915. The first line was opened in 1872, by a company that became the Central Uruguay Railroad four years later, and which grew into one of the three groups owning Uruguay's railroads when all were nationalized in 1952. Projects are under way to extend the present system, and three new lines are planned.

The state railroad (Administración de Ferrocarriles del Estado) became virtually an infrastructure company, although it was allowed to operate some services in competition with new operators. Passenger services were withdrawn in 1988, but over the last two decades, there has been a restoration of these. Uruguay's lines are all standard gauge, reducing the usefulness of the connections with railroads in Brazil: all of Brazil's lines at the border are meter gauge.

PERU

The railroads of Peru are lines that run inland from ports, some to serve sugar plantations, and two to assault the Andes. Despite the dramatic achievement of operating over the Andes, Peru has nothing approaching a rail network. In 1972, the railroads were nationalized, and present government plans would do much to expand the system. A coastal line from Nazca north through Lima to Chimbote, and

the joining of the trans-Andine lines by building from Cuzco to Huancayo are the major proposals. The latter is hardly new, however, as it was first surveyed in 1907.

At present, only the two Andean lines are of much importance. Both were built by the American engineer Henry Meiggs, although he died before the most spectacular, the Peru Central, was completed. It climbs 15,693ft (4,783m) with a ruling grade of 4.5 percent between stations on the upper section. It is adhesion worked throughout. A mineral siding off this line rises to the highest altitude ever achieved by a railroad.

At Oroya is the junction for the erstwhile Cerro de Pasco Railroad, the lowest point of which is 12,272ft (3,740m) above sea level and which advertised itself as "a railroad on the roof of the world." Only just eclipsed by these achievements is Meiggs' other line, the Southern. This connects the coast with Lake Titicaca, where the railroad runs a steamer service at 12,526ft (3,818m)—the highest navigation in the world. This single-line track depends on freight traffic for its survival, although the expanding tourist trade has given it a new importance.

The railroads were handed to a foreign consortium in 1999, which was granted the right to operate them for 30 years. Passenger services had been suspended over much of the system by the mid-1990s, but there has been some restoration since. The Southern Railroad has continued to operate the Lake Titicaca ferry.

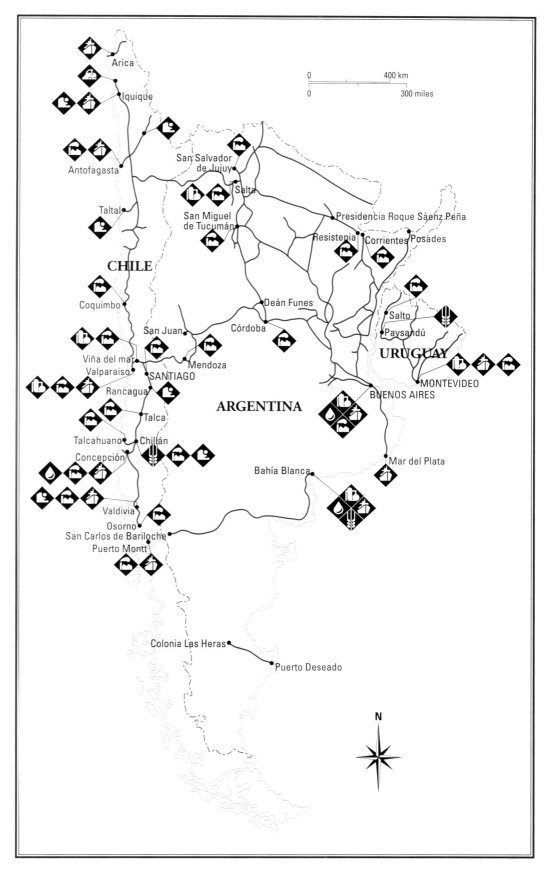

The trans-Andine lines are both standard gauge; 220 miles (354km) of 3ft (914mm) gauge have also been built. The Chimbote-Huallanca Railroad is thought to be closed after being badly damaged in an earthquake in 1970.

Chile, Argentina, and Uruguay have the most developed networks in South America.

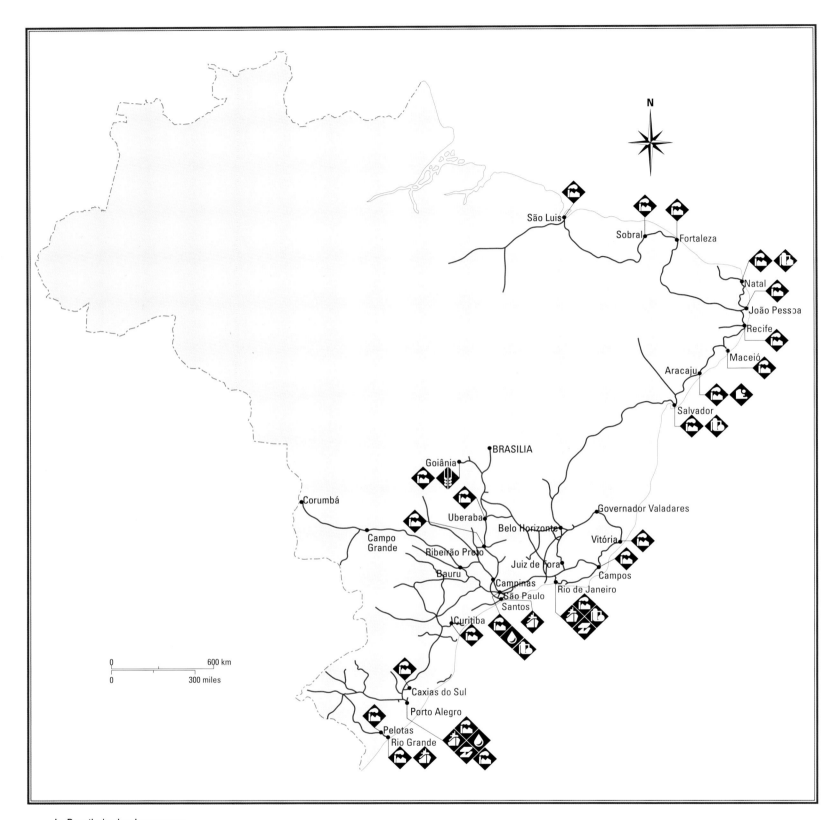

In Brazil, the landscape was a major obstacle to the development of railroads, and much of the interior has not been penetrated.

BRAZIL

The geography of Brazil has been a great obstacle to railroad development, and this vast country of over 3,000,000sq.miles 8,000,000sq.km) has only 20,625 miles (33,000km) of lines. Ninety percent of the total is to be found within 300 miles (480km) of the coast. This reluctance to penetrate the interior

stems from the difficulty of ascending the steep scarp of the interior plateau, and the neglect from which the Amazon basin has suffered until only very recently. The escarpment exercised the talents of several early engineers, including Robert Stephenson, who produced a report for a projected line from Santos to the interior as early as 1839. The English engineer James Brunlees constructed a spectacular solution in the 1850s: the São Paulo Railroad ascended on an incline 5.3 miles (8.5km) long, with cable haulage on a grade of 10 percent.

In Amazonia, the first attempt to build a line, in 1878, was defeated by fever. It was promoted for a traditional nineteenth-century reason, to get around a set of rapids blocking navigation of the River Madeira. After the discovery of quinine, it was tackled again in 1908, successfully this time. It is the only railroad in the vast Amazonia region.

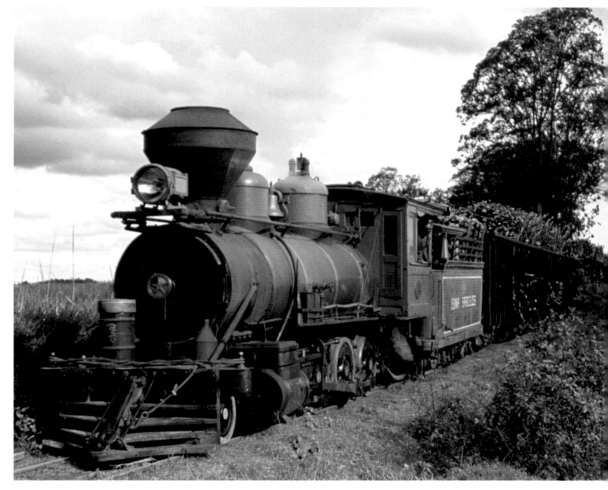

As in other South American countries, railroads in Brazil have been used to exploit natural resources. Built in the USA in the 1890s, this 2-8-0 locomotive continued to do sterling duty hauling logs in Usina Barcelos, Campos State, well into the twentieth century.

Only relatively recently has Brazil realized the economic potential of the interior. The government made a dramatic gesture to publicise the possibilities by creating a new capital, Brasilia, 600 miles (960km) inland in 1960. A new line was completed to the city in 1968. The government also developed a five-year plan, ending in 1979, to construct another 1,560 miles (2,500km) of line and, to some extent, standardize gauges.

Today, Brazil's railroads are owned and operated by a variety of organizations, some of which are consortiums; others are mining companies and state governments. The rapid growth of the economy has led to some new construction, as well as development of suburban services.

BOLIVIA

In the landlocked Andean state of Bolivia, railroads are particularly important. There are two meter-gauge systems: one links with the Pacific ports of Antofagasta and Arica; the other connects with Santos and Buenos Aires. The missing 186-mile (300km) link, from Aiquile to Florida, has been surveyed; its construction would complete a transcontinental through route of 2,351 miles (3,784km). Operating conditions are severe. The first diesels found the rarefied atmosphere indigestible, and had to be supercharged and have their brake compressors enlarged. The line down to La Paz is adhesion worked with electric power on a grade of 7 percent.

Railroads Across the Andes, 1870–1914

The steep mountain ranges and deep narrow valleys of the Andes, in South America, are home to the highest railroads in the world.

The trans-Andine railroads included seven major routes. Two connected Chile and Argentina; three gave the landlocked country of Bolivia access to the Pacific Ocean; one linked Lima with the mountain valleys and mineral region of central Peru; and the most northerly connected Guayaquil and Quito in Ecuador. In the main, these railroads were built between 1870 and 1914, to a variety of gauges: standard gauge in Peru, 2ft 6in (762mm) and meter gauge in Chile and Bolivia, and 3ft 6in (1,067mm) in Ecuador. At the time they were built, they helped to bring some political unity to the scattered and diverse populations of the countries they served, but their main function was economic and their main interest freight traffic. They were, and most remain, vitally important to the mining industries of Peru, Chile, and Bolivia. Passenger traffic was never more than a troublesome obligation.

The Andes rise steeply from the Pacific coast of South America, consisting of a number of mountain ranges and plateaus dissected by deep narrow valleys. Crossing them meant building the highest railroads in the world. The Peruvian Central Railroad reaches 15,845ft (4,829m), the defunct Collahuasi branch of the Antofagasta (Chili) and Bolivia Railroad had a summit of 15,835ft (4,825m), and the Rio Mulatos–Potosí line in Bolivia climbs to 15,705ft (4,787m). Railroad construction presented civil engineers with serious problems, for they had a confined space and short distance in which to lay tracks over passes that exceeded Mont Blanc in altitude. The solutions they adopted were tight curves, switchbacks, and, in two cases, rack sections. Operating the lines created further difficulties: steep grades, the lack of local sources of fuel, heavy wear and tear on motive power and rolling stock, and frequent landslides and washouts. The southernmost route, from Los Andes in Chile to Mendoza

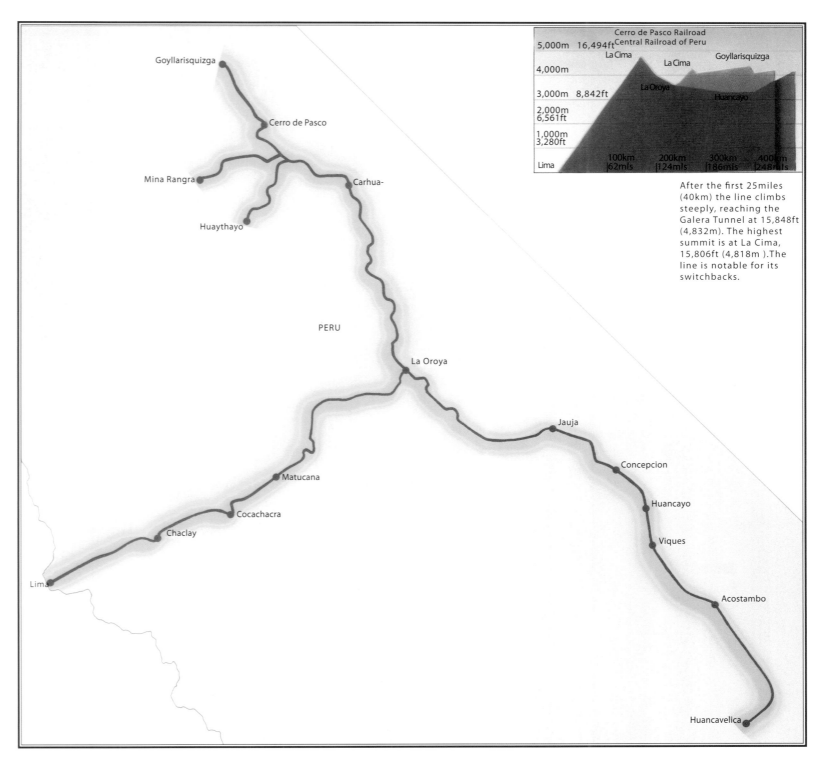

Cerro de Pasco Railroad
Central Railroad of Peru

After the first 25miles
(40km) the line climbs
steeply, reaching the
Galera Tunnel at 15,848ft
(4,832m). The highest
summit is at La Cima,
15,806ft (4,818m).The
line is notable for its
switchbacks.

in Argentina, also encountered the hazards of heavy snowfalls and avalanches. Despite road and air competition, most lines remain in operation, albeit with varying degrees of efficiency and reliability. They offer some of the most exciting railroad scenery anywhere in the world.

The Peruvian Central is perhaps the most impressive of the seven routes. Engineering the line meant overcoming immense problems. From Lima to Chosica, grades are gentle and the route is straightforward. East of Chosica, though, the deep Rimac valley, the only feasible route to central Peru, narrows to a maximum width of perhaps 656ft (200m). Within its limits, the engineers had to find a way of climbing from 2,802ft (854m) above sea level at Chosica to 15,693ft (4,783m) at Ticlio, a

The Central Railroad of Peru, the most important railroad in South America in terms of engineering scale. The line that runs between Huancayo and Huancavelica includes 103 tunnels and 76 bridges.

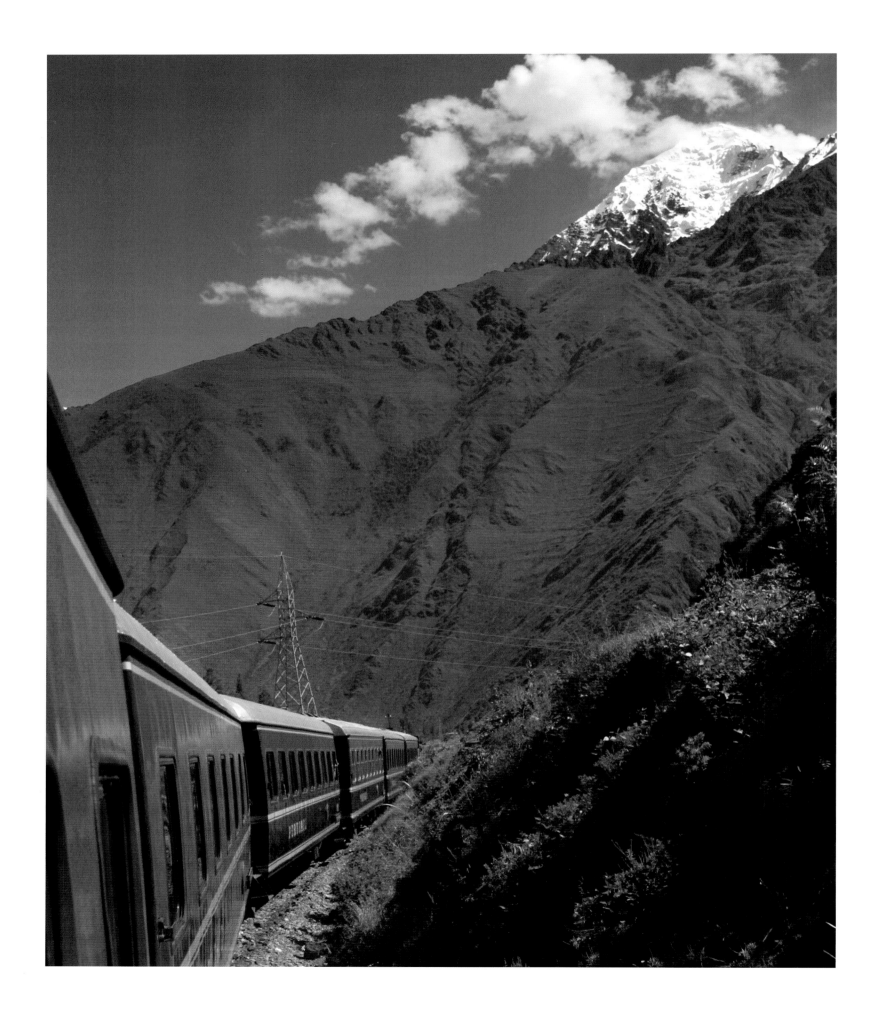

distance of no more than 47 miles (76km) by the modern direct road that runs along the bottom of the valley. The twists and turns needed by the railroad to gain height have made the rail distance far greater: 73 miles (117km). To keep the grade down to 4.3 percent, the single-track railroad has to use the whole width of the valley, crossing frequently from one side to the other; even this would be impossible without the use of the famous switchbacks to gain height. Between Chosica and Ticlio, there are six double switchbacks and one single, sixty-six tunnels, and fifty-nine bridges to cross the Rimac and the valleys that enter it.

Contrary to popular belief, it was not the famous American entrepreneur Henry Meiggs who surveyed and laid out the route, but a former Peruvian government engineer, Ernesto Malinowski. Meiggs' task was to convince the sceptics of the practicability of the route, and to contract and organize the necessary labor and materials. Construction of the line, which began in 1870, presented many problems; thousands of workers died of a mysterious disease at Verrugas. By 1877, when Meiggs died, Peru was bankrupt and the rails extended only as far as Chicla, 80 miles (129km) from Lima and 12,215ft (3,723m) above sea level. Meiggs had laid out the roadbed as far as the summit at Ticlio, 18 miles (29km) farther on, however, so when the Peruvian Corporation leased the railroads from the Peruvian government in 1890, it had a comparatively straightforward task to complete the line to the proposed terminus at La Oroya, 130 miles (209km) from Lima and 12,179ft (3,712m) above sea level. Later extensions took the tracks on to Cerro de Pasco (1904) and Huancayo (1908); a meter-gauge line was constructed from the latter to Huancavelica in 1926.

For many years, the Peruvian Central's commercial returns were disappointing. Only in 1897, when a rise in prices made it economic to mine copper in Cerro de Pasco, Morococha, and Casapalca, did the railroad begin to give an adequate return on the capital invested; the large quantities of mineral traffic provided about 30 years of commercial success, which ended with the world depression of the 1930s.

The problems faced by the Central were common to most high-altitude railroads. Operating costs forced it to charge some of the highest freight tariffs in the world, while the large number of bridges and tunnels made

Opposite page: A PeruRail train passes through a dramatic landscape on its way from Cuzco to the historic site of Machu Picchu.

Map: The Southern Railroad of Peru includes a ferry crossing of Lake Titicaca.

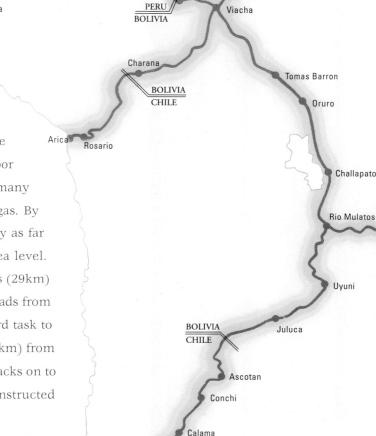

engineering maintenance expensive. Seasonal rains, between January and April, caused landslides. At best, these could close the railroad for a few days each year; at worst, they left behind huge repair bills. Floods in 1925 caused $350,000 of damage and interrupted traffic for 82 days. Steam locomotives had to be strong enough to withstand the rough conditions, and powerful enough to haul heavy freight trains up the continuous grades. Invariably, British locomotives proved too weak for these demands.

The management's record in adapting to the problems was extraordinarily good, several attempts being made to save on the heavy fuel bill. The company prospected for coal in the region, converted its locomotives to burn oil in 1909, and later considered plans to electrify part of the line. The mechanical department developed the powerful Andes class of 2-8-0 locomotives, which could negotiate the tight bends and steep grades with a payload of 180 tons of freight. It also constructed special cars that could be used to haul oil one way and minerals the other, thus cutting down on the expensive movement of empty rolling stock.

After 1930, the railroad's financial problems worsened. The Central Highway, which ran parallel to its tracks, was completed in 1935 and attracted much of the more valuable traffic. The government proved reluctant to allow the railroad to raise tariffs or to protect it from this competition. In the 1960s, however, foreign loans financed a modernization plan. By 1967, ALCO diesels had replaced steam locomotives. The expense, though, led the railroad into even more financial difficulties, and the government nationalized the line in 1972.

By 2000, the lines to Huancayo and Cerro de Pasco, plus the Huancayo to Huancavelica line, had been joined into a single unit for the purpose of offering a concession to private interests. Passenger services had dwindled to an occasional train for tourists.

The chief interest of the Central Railroad has always been freight, and it remains essential to the mining industry. Fortunately, however, the ordinary traveler can still depart from Desamparados station in Lima at 7.00am on any day of the week to enjoy the 9-hour journey to Huancayo. Except for those unfortunate passengers who suffer from altitude sickness and have to be given oxygen by the green-coated attendants, all will marvel at the ingenuity of the men who built this railroad and at the ability of those who have operated it since, amid some of the most rugged landscapes on earth.

Three railroads serve the *altiplano*, a grassy plain 12,800ft (3,900m) above sea level, which extends for 200 miles (300km) from north to south in southern Peru and Bolivia. The Southern Railroad of Peru, a standard-gauge line, was largely built by Meiggs between 1869 and 1875. It runs from Mollendo through Arequipa, the second city of Peru, to Juliaca on the *altiplano*. There, it divides. A short, level, 29-mile (46km) line runs around the shores of Lake Titicaca to the port of Puno. A 211-mile (338km) line runs north to Cuzco, the ancient Inca capital, crossing a summit of 14,154ft (4,314m) at La Raya. A steamer service across Lake Titicaca gives the Southern Railroad access to Bolivia, where, in 1906, it completed a short meter-gauge line from Guaqui, the Bolivian port, to the capital city of La Paz.

Although the Southern Railroad climbs to an altitude of 14,668ft (4,471m) at Crucero Alto, it presented no serious engineering problems. The average construction cost of the 325 miles (523km) between Mollendo and Puno was less than half that of the Central Railroad's Callao-Chicla section. The line is single track throughout.

Passenger trains succumbed to road competition on the Mollendo–Arequipa section, but east of

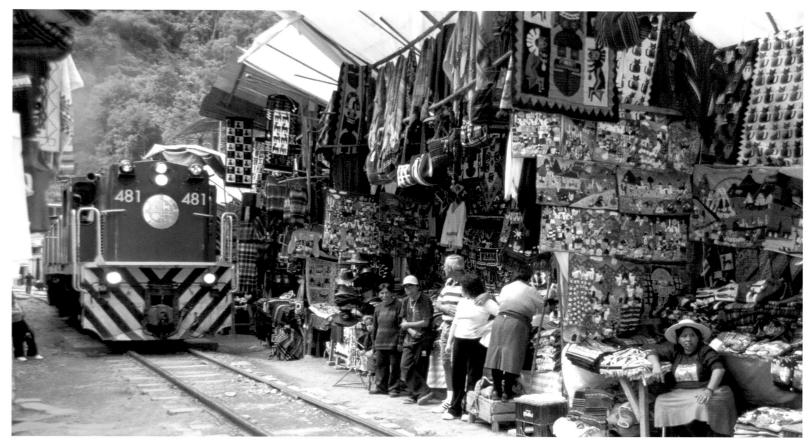

The closest village to Machu Picchu is Aguas Calientes, and the railroad that takes tourists to the Inca ruins runs right through the middle.

Arequipa, on the mountain section, passenger traffic survived and extra trains were put on to cope with the demands of a growing tourist trade. Like all the Andean railroads, passengers have never provided the Southern Railroad with more than a small fraction of its revenue. The freight traffic for Bolivia has always been important, making the navigation of Lake Titicaca an integral part of the railroad's operations. There were steamers on the lake in the 1860s, before the railroad. The *Yavari* and *Yapura*, which were carried up from the coast by mule and assembled on the lake, can still be seen at Puno. Later, the Peruvian Corporation added three more steamers on the Puno–Guaqui run and, in 1971, introduced a train ferry service across the lake to the Matilde mine in Bolivia.

The 284-mile (458km) railroad between Arica and La Paz was completed in 1913. It was built by the Chilean government to fulfil the terms of the 1904 peace treaty between Chile and Bolivia. Construction was extremely lengthy and difficult, and until the firm of Sir John Jackson took over the contract, it seemed unlikely that it would be completed. It includes a 26-mile (42km) rack section of the Abt two-bar type between Central and Puquios. There were no commercial reasons for the construction of another route between Bolivia and the Pacific, and the railroad made a loss until 1922. The problems were manifold. All ascending trains had to be broken into three parts to traverse the rack section, and government control of both the Chilean and Bolivian sections introduced inefficient management. This dated back to the opening of the line, when leading figures from both countries arrived at La Paz to find that their baggage had been left at Arica. Moreover, the port was little more than an open roadstead, which gained an unhealthy, but deserved, reputation for theft and delays. Except for the times when the Bolivian government encouraged traffic to use this route, for political reasons, the line was an economic failure, although its strategic importance to both countries is considerable.

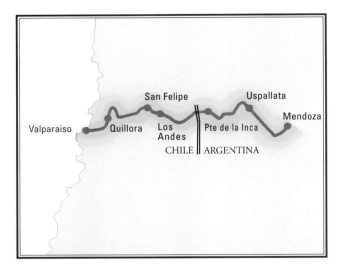

Part of the trans-Andine railroad is the line that runs between Valparaiso in Chile and Mendoza in Argentina. It reaches its summit at 10,452ft (3,187m) at the Cumbre tunnel. Rack working is necessary on both sides of the summit.

The Antofagasta (Chili) and Bolivia Railroad, usually known as the FCAB, lies farther south and is the longest of the lines serving Bolivia. It was built in the 1870s with a gauge of 2ft 6in (762mm) and ran inland from Antofagasta to the nitrate pampas. After the Pacific War (1879–83), Chilean capitalists extended it inland to the Bolivian town of Uyuni, which it reached in 1889. In the same year, British interests bought out the Chileans and continued the railroad to the mining center of Oruro, on the *altiplano*, 680 miles (930km) from Antofagasta.

The line has always been the most profitable of all the Andean railroads. There were few engineering problems to raise costs, and the management could rely on three major sources of traffic: nitrates and copper from the Chilean section, and tin from Bolivia. In 1908, the FCAB took over the recently constructed meter-gauge line between Oruro and Viacha, changed its own line to meter gauge as far south as Uyuni, and began the construction of branches to the important cities of Potosí and Cochabamba. Both railroads involved a climb to over 13,450ft (4,100m) in the eastern chain of the Andes, and their construction posed far more serious problems than anything found on the main line.

Each of the three routes serving Bolivia had disadvantages. On the Peruvian line, freight had to be transhipped twice to cross Lake Titicaca. On the Arica line, the rack section caused delays and expense. Moreover, until 1928, when the FCAB changed the gauge of its Chilean section, all freight on that route had to be transhipped at Uyuni. Until the construction of Matarani in southern Peru in 1948, none of the ports had adequate warehousing or harbor facilities. The major engineering problem, though, with the exception of the difficult section of the Arica route, was not crossing the Andes, but the descent into La Paz, which lies in a ravine 2,300ft (700m) below the *altiplano*. The Peruvian Corporation's Guaqui–La Paz line, completed in 1906, had grades of 7.1 percent and employed electric power to descend into the city. The FCAB completed its own line in 1917, but frequent landslides and washouts caused it to relocate the track in 1924 with a ruling grade of 3 percent.

Since the 1950s, these routes have been modernized with varying degrees of success. The Southern Railroad introduced ALCO diesels and new rolling stock, including lightweight passenger cars, after 1958, and the line has been operated solely by diesels since the mid-1960s. Financial problems followed nationalization in 1972, impeding the purchase of spare parts, and frequent breakdowns interrupted services. The Bolivian railroads faced similar problems after nationalization in 1964. Despite attempts to introduce diesel locomotives throughout the system in the late 1960s, frequent breakdowns and slow repairs meant that steam locomotives were still common sights in parts of Bolivia in the mid-1970s. The Chilean section of the FCAB escaped nationalization in the early 1970s, and its shares are still quoted in London.

Two routes, both of them uneconomic, connected the Chilean and Argentine railroad systems. The more recent of the two, a meter-gauge line between Antofagasta and Salta, was not completed until 1948. The notion of connecting the Atlantic and Pacific by rail, though, had been held since the mid-nineteenth century, and the first rail connection was completed in 1910, after over 20 years of construction. This meter-gauge line ran from Los Andes, between Valparaiso and Santiago, to Mendoza

in western Argentina, a distance of 159 miles (254km). It was not high in comparison with the other trans-Andine railroads, rising only to 10,453ft (3,186m) in the Cumbre tunnel, but it included six rack sections on the Chilean side and seven on the Argentine, using the Abt three-bar system. Moreover, it was far enough south to suffer quite severely from snow and avalanches, unlike the other trans-Andine routes. Landslides and washouts were common. One, in 1934, destroyed part of the Argentine section, interrupting through rail traffic for 10 years. The railroad never justified the hopes of those who promoted it a century ago. It has been closed for some years, but there are proposals to reopen it.

The Guayaquil and Quito Railroad (misleadingly nicknamed the "Good and Quick") connects the two major towns of Ecuador: Guayaquil on the coast, and Quito in the mountains. Work began in 1871, but it was not completed until 1908. Unusually, for South America, it is of 3ft 6in (1,067mm) gauge. It extends for 288 miles (463km) and climbs to 11,841ft (3,609m). Curves are tight, and the maximum grade of 5.5 percent was quite staggering for a steam operated, adhesion railroad. Like the Central Railroad of Peru, the Guayaquil and Quito employs switchbacks to gain height in confined spaces. It has never been a commercial success, and the resulting lack of money for spare parts and replacements has given it a dreadful reputation for chaotic administration, breakdowns, and derailments. The fact that it continues to operate over much of its length is perhaps more amazing than the fact that it was ever built.

A colorfully dressed local woman watches a PeruRail train arrive at the station at La Raya Pass. At just over 14,000ft (4,267m), this is the highest point on the journey between Puno and Cuzco.

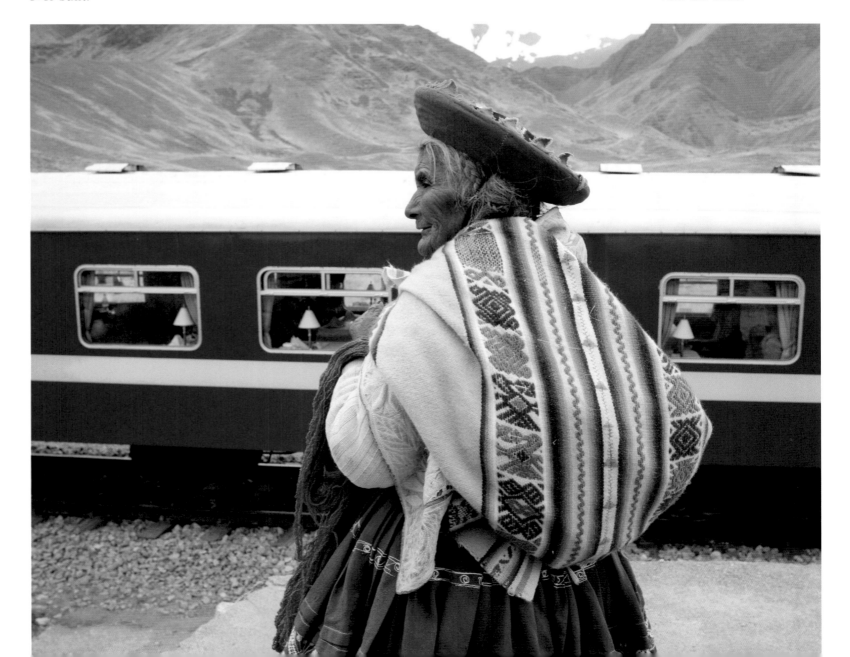

High-speed Trains

RAILROADS AROUND THE WORLD ARE INTRODUCING FASTER

SERVICES, NOT LEAST TO MEET THE COMPETITION BY AIRLINES. BUT

THERE IS MORE TO HIGH SPEED THAN BUILDING FASTER TRAINS.

High-speed trains are those that run at more than 100mph (160km/h), and there are not many places in the world where that speed can be achieved. Speeds have been increasing, however, and that trend looks set to continue. This urge to accelerate has been affecting all the advanced countries of the world.

Two quite distinct ways of introducing high-speed trains are in progress today: one is by building new special-purpose railroads, such as the Japanese Shinkansen and the French TGV; the other is by upgrading existing lines. From an engineering viewpoint, rather than financial consideration, the latter method is by far the more difficult, especially on old established railroads, such as those of Britain. The cost of realigning curves and remaking difficult junctions to permit uninterrupted high speed can be prohibitive, while in mountainous country, the physical circumstances could make the project impossible. It was to meet these conditions that the principle of the tilting train was developed.

The braking requirements on high-speed trains, and the difficulties that could arise on a "mixed" railroad, like those of Britain, can be seen by a direct comparison of the signaling arrangements on the Euston–Crewe section of Britain's West Coast main line and the Paris–Lyon TGV line in France. On the Euston–Crewe line, the four-aspect, color-light signals were spaced, on average, about 1,200yd (1,100m) apart. The lead-up to a red signal was first a double yellow, and then a single yellow, making the distance from the first warning to the red, where the train needed to stop, 2,400yd (2,200m). This provided a safe margin for trains traveling at a maximum of 100mph (160km/h) and consisting of ordinary passenger cars hauled by electric locomotives. The diesel powered HSTs were equipped with special braking equipment, which enabled them to stop from 125mph (200km/h) in the same distance taken by ordinary trains from 100mph (160km/h). On the French TGV line, by contrast, the distance between signals was exactly double that of the British line, and the normal stopping distance allowed was four sections, or 9,600yd (8,780m). Nevertheless, the trains were equipped with brakes that would

permit an emergency stop in 4,100yd (3,750m), from a speed of 170mph (274km/h). The line could be signaled in that way because it was used exclusively by the TGV trains.

An important point to be considered in the running of very-high-speed trains is that of passenger comfort. That is not comfort "in flight," as it were, but rather the sensation in the train when the brakes are applied because of an adverse signal. The effect in a diesel powered HST, when braked hard from 125mph (200km/h), was not noticeably different from that in an ordinary train in similar circumstances from 100mph (160km/h), although the initial rate of deceleration was necessarily higher. At over 155mph (250km/h), it can be noticeable.

A further consideration was the ability of the driver to see signals at such speeds. On the Euston–Crewe line, the color-light signals came up every 25 seconds at 100mph (160km/h), with an audible warning in the cab to mark each signal. Compare this to the more secluded atmosphere in the cab of a Japanese Shinkansen train, with no visible or audible signals, and only the speed direction to observe. The Shinkansen line did not have to provide for other classes of traffic in addition to the 100mph

Based on the Japanese 700 series Shinkansen train, the THSR 700T operates on Taiwan's high-speed rail network, running from Taipei in the north to Kaohsiung in the south. The 700T travels at up to 186mph (300km/h).

The fastest and most powerful trains to run on Japan's high-speed network are the 500 series Shinkansens. Capable of 200mph (320km/h), they have computer controlled suspension systems to ensure a safe ride. Each train comprises sixteen cars, all of which are powered. Only nine of these expensive trains have been built, and they are reserved for premium passenger services.

(160km/h) "flyers." On the French TGV line, at 180mph (290km/h), the signal locations were passed at intervals of about 28 seconds, which compared closely with British Rail's Euston–Crewe system.

It is interesting to compare the locomotive power on the high-speed lines. The early electric units on the Euston–Glasgow route were 5,000hp, and they hauled trains of up to twelve cars on the fastest schedules. The Western Region HST trains of seven passenger cars were powered by two 2,200hp diesel units, for running at 125mph (200km/h) on level track. On the Japanese Shinkansen trains, which consisted of sixteen cars, every axle in the train was powered, making a total of 16,000hp. The designed speed on the later sections was 160mph (257km/h), but the distribution of power throughout the train gave a very smooth ride, and almost imperceptible braking. On the French TGV trains, which had eight cars, six trucks out of thirteen were powered, the combined output of the two power units being 8,500hp. This was not considered excessive, given the speeds to be run, but the designers hoped that a

certain amount of power would be saved at very high speeds by the elaborate streamlining of the nose and tail of these trains. The weight of the passenger cars of these trains was 405 tons, compared to the maximum of 610 tons hauled by the CC6500 class, 8,000hp, electric locomotives at 125mph (200km/h) on the Paris–Bordeaux route.

The French Paris–Lyon TGV was soon extended to Marseilles, and by the end of the twentieth century, traffic had increased so much that Alstom double-deck trains were put into service. Another TGV line was built from Paris to Lille, where it split into a line serving London through the Channel Tunnel, and another that ran to Brussels. In the British part of this scheme, the new TGV line was scheduled for completion only in 2007, the trains meanwhile traveling over conventional track for much of their Folkestone–London trajectory. Elsewhere in France, the TGV line from Paris to Tours was finished, and work begun on its extension to Bordeaux and the Spanish frontier. Much of the new line from Paris to Strasbourg was to be completed in 2007. Alstom produced the new TGV POS train for this, which was multi-current, so that it could work into Germany and Switzerland, although it was expected that Siemens-built ICE trains would work into Paris from the German side. This line, Paris-Est, was intended for speeds of 199mph (320km/h). Naturally, average start-to-stop speeds were some way below those of the authorized maximum. By 2005, the world's fastest start-to-stop schedule was that of a French TGV between Lyon and Aix, where 180 miles (290km) were covered at 163mph (263km/h); that was on a line with a 199mph (320km/h) authorized maximum.

In Germany, where the ICE train operated, much of the high-speed running was on upgraded track, but new lines were built between Hannover and Würzburg, and Köln and Frankfurt, with more to come. Spain began to build TGV-type lines (known as AVE) at a fast rate, initially with lines from Madrid to Zaragoza (and eventually Barcelona and France), and from Madrid to Seville and Malaga. Lines into Portugal were also under way. A feature of the Spanish AVE trains was that, in addition to running on the standard gauge chosen for these lines, some could have their wheel sets changed so that they could continue to destinations on the Spanish broad gauge. German Velaro trains, a derivative of the ICE, were on order, and they were to have a maximum speed of 217mph (350km/h). In Italy, the first high-speed line ran up the spine of the country, from Naples to Milan; in 2007, this was open from Naples through Rome to Florence. It was a different story in Russia. There, a single high-speed train had been introduced in the 1980s, making a return trip between Moscow and Leningrad just once a week. Then a start was made on constructing a high-speed line, and a prototype train was built for it. Neither made much progress, however, and the project was postponed while the existing line was upgraded instead, for which Siemens was invited to build fast trains of the ICE type.

High-speed lines continued to be built in Japan, and were introduced in Korea and Taiwan, with China also making plans. In the USA, high-speed lines were not built, but Amtrak's Eastern Corridor route was upgraded to operate the Acela tilting trains, partly based on Alstom's TGV technology.

In Britain, the successful diesel HST remained in use, and new tilting trains were introduced on the West Coast route, again on upgraded track; laying new high-speed lines in Britain, with the exception of the London–Channel Tunnel route, was not favored. In the Low Countries, density of population did not deter the construction of a high-speed line from Amsterdam to Antwerp, although in 2007, for various avoidable reasons (like out-of-phase deliveries of equipment), it was still not open.

TILTING TRAINS

TRACK CURVES RESTRICT THE SPEED OF TRAINS BECAUSE OF CENTRIFUGAL FORCES. FOR HIGH-SPEED SERVICES, THE ANSWER LIES IN TRAINS THAT CAN TILT TO COUNTERACT THOSE FORCES.

Running high-speed trains over existing track, sharing the line with slower trains and coping with curves, meant that fast services over upgraded track could never reach the speeds attained on the purpose-built high-speed lines. On curves, the outer rail is set higher than the inner to counteract centrifugal forces, but this cant can only be a compromise between the fastest and slowest trains, and cannot work if a very-high-speed train needs to be accommodated; either there is too much or too little cant. This problem can be solved by using trains with bodies that tilt when running over curves. That way, passengers need not suffer the centrifugal effects of their trajectory, and the train does not need to reduce speed through the curves.

Tilting mechanisms can be active or passive. In a passive system, the car body is simply pivoted and tilts naturally in response to centrifugal forces; in an active system, one side of the body is raised by a jacking mechanism. Passive tilt is simpler, but the degree of lean is less than that obtainable by active tilt. The latter, however, requires a means of instructing the mechanism to begin and end its action as the train passes a curve.

Both the French SNCF (with its Pendulum) and the Chesapeake & Ohio

Hydraulic system
1 Tilt jack
2 Pressure line: left tilt
3 Pressure line: right tilt
4 Control valve
5 Accelerometer
6 Pump
7 Accumulator
8 Reservoir

Tilting trains can be run at high speed on existing tracks by allowing the body of the train to lean inward on bends, much like a cyclist leans when turning. In an active tilting system, hydraulic jacks alter the angle of the train body automatically when it encounters a curve in the track.

Railroad (Train X) experimented with passive tilt in the 1950s, but with no conclusive outcome. Much more impressive results were obtained in Spain, where the mountainous terrain imposed serious speed limitations on conventional trains. The Talgo company had built a successful line of lightweight trains consisting of short, low-slung vehicles, and the Talgo Pendular was a great success when introduced in 1980, enabling schedules to be cut by a fifth, even though the maximum tilt did not exceed four degrees. Talgo tilting trains were widely used in Spain, and in an Americanized form were chosen for the Cascade services sponsored by the state of Washington and centered on Seattle.

Active tilt, with its potential of twenty degrees of lean, was pursued by British Rail from 1967 to 1985 with its APT (Advanced Passenger Train) prototypes. Although many problems were solved by this work, there were so many others that eventually the project was abandoned. One mistake was the decision to use a degree of tilt that would completely cancel out the centrifugal forces acting on the passenger. This meant that a passenger looking out of the window while passing a curve would

Japan's Hokkaido Railroad Company introduced DC283 tilting diesel trains in 1997 to provide an intercity express service between Sapporo and Kusiro. They can run at speeds of up to 87mph (130km/h).

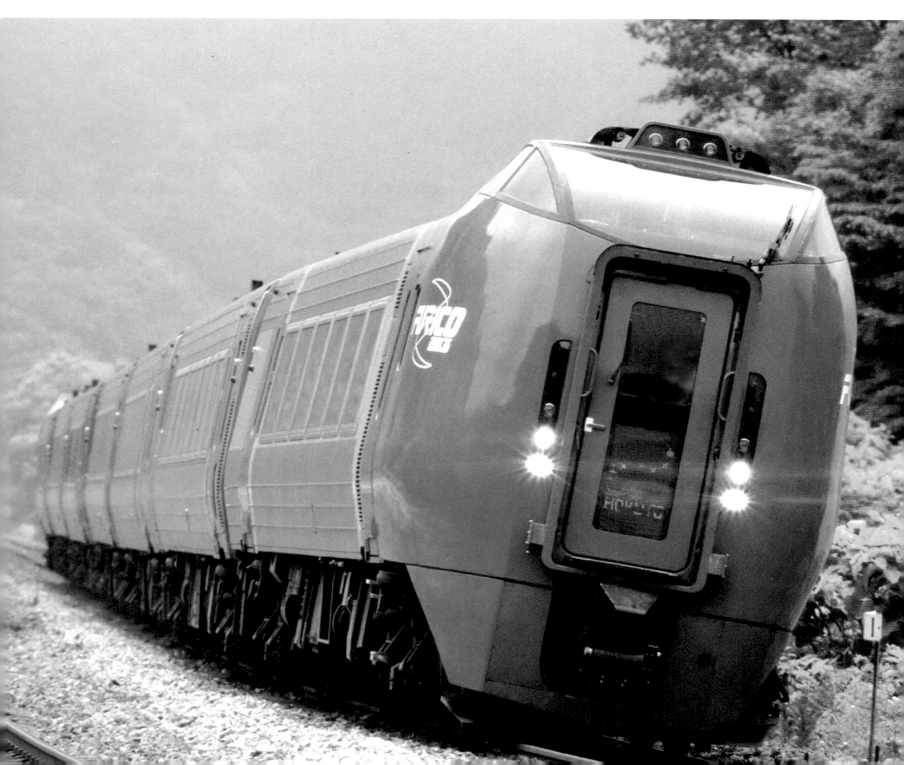

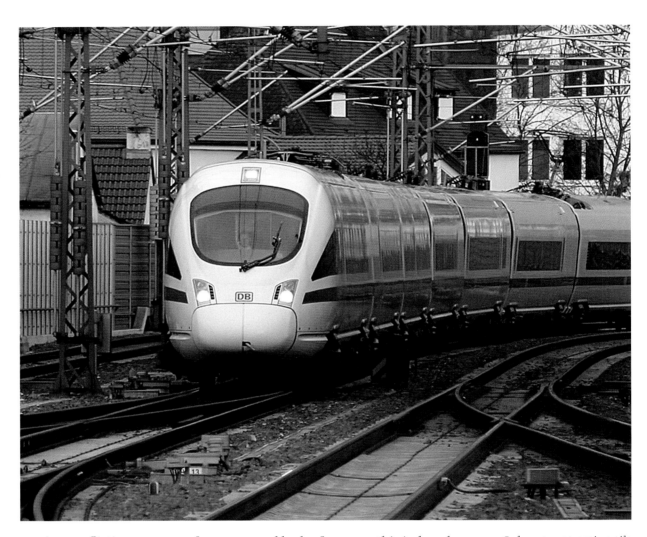

An ICE-T tilting train of the German railroad Deutsche Bahn negotiating a curve—note the different angles of the cars. Built by Siemens as a development of the non-tilting ICE intercity express, the ICE-T allowed the high-speed service to be extended to lines not previously developed for fast traffic.

receive conflicting messages from eyes and body; for some, this induced nausea. Subsequent active-tilt ventures aimed at only a partial reduction of centrifugal forces.

Meanwhile in Canada, VIA Rail introduced its LRC (Light, Rapid, Comfortable) trains between Montreal and Toronto. These, designed and built by Bombardier of Montreal, had hydraulic tilt, but suffered many breakdowns in their early years, being withdrawn from service for a time. Even when they returned to service, they never provided a really fast service, although the trains did set new standards of comfort.

In Sweden, the X-2000 train was introduced and proved successful, the tilt being provided by under-floor jacks. In the 1990s, twenty of these trains revolutionized the Stockholm–Göteborg service, cutting an hour off the conventional four-hour schedule, speeds up to 118mph (200km/h) being attainable.

The most successful of the tilting trains were those produced by Fiat of Italy. This family was marketed as Pendolino trains, the name reflecting their distinctive feature, the pivoting of the body—not at floor level, but at roof level. Although this required vertical frames above the wheelsets to support the body, which took up space that could have been used for seats, the results seemed to justify the sacrifice. The first, experimental, Pendolino went into service in 1976. Then, fifteen similar trains, in first-class-only form, began an accelerated Rome–Milan service. A succession of improved designs followed, many for export; the Pendolino concept could be incorporated in both electric and diesel trains. Some were produced under license in other countries; they were chosen for the joint Finnish-

Russian Helsinki–St. Petersburg service. In operation, the tilt mechanism needed to cut in at precisely the right time and with the right speed of tilt. On the Pendolinos, an accelerometer noted the build-up of lateral forces as the train entered a curve and actuated the mechanism accordingly. This was supplemented by a gyroscope that sensed the approach of the curve from the gradually increasing cant of the rails leading up to it; this ensured that the leading vehicle would begin its tilt in good time.

By 2007, Pendolino trains had replaced the previous main-line trains of Virgin Rail in the UK, including those on the Anglo-Scottish services. They proved very successful, although the passenger accommodation was cramped compared to normal trains. This was because tilting required greater clearances and, with British lines having quite severe width restrictions, the problem could only be resolved by narrowing the car bodies at top and bottom. Before their introduction, very expensive track upgrading was carried out, and critics pointed out that the money could have been better spent on other parts of the network that were in desperate need of renewal. After all, most passengers on the Anglo-Scottish services do not travel the whole distance; their journeys are often quite short, and the tilting trains shaved only a few insignificant minutes off the journey times.

Certainly, there was a price to pay when introducing tilting trains, and there were occasions in the early years of their development when mechanical or design defects meant that the trains had to be removed from service for alterations. They were a great public relations success, however, and attracted considerably more business.

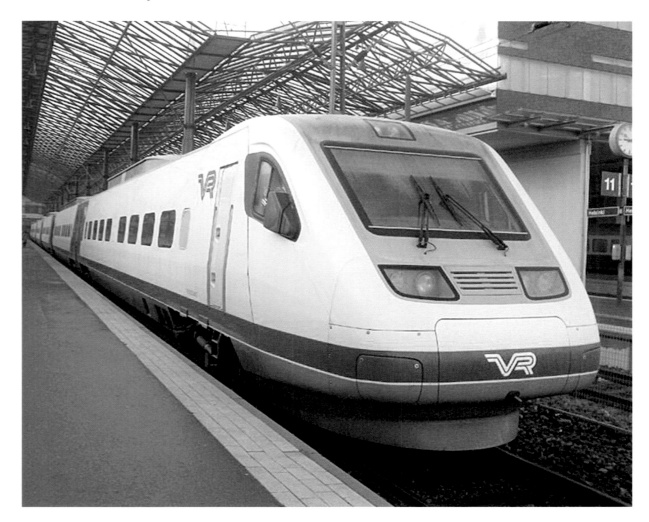

Developed in Italy by Fiat Ferroviaria, the Pendolino series of high-speed tilting trains has found many customers around the world. The Sm3 is a Finnish adaptation of the technology, built to cope with the harsh conditions encountered in the Scandinavian country. These trains were put into service during the 1990s and cope well with the twisty Finnish lines.

RAILROADS OF ASIA

THE RAILROADS OF ASIA ARE VARIED.
SOME ARE HIGHLY DEVELOPED, OTHERS
LESS SO. SOME ASIAN COUNTRIES,
HOWEVER, ARE STARTING TO BECOME
MAJOR PLAYERS IN THE RAIL WORLD.

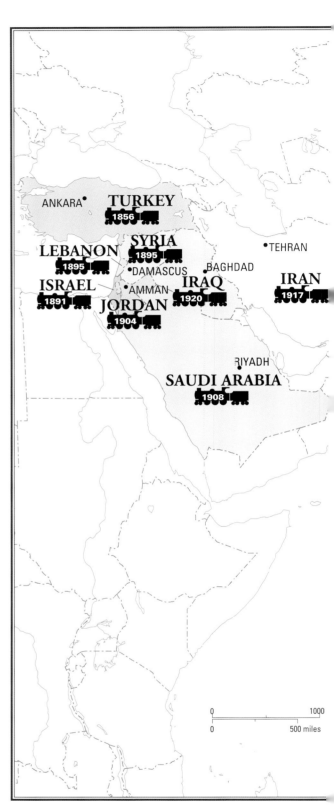

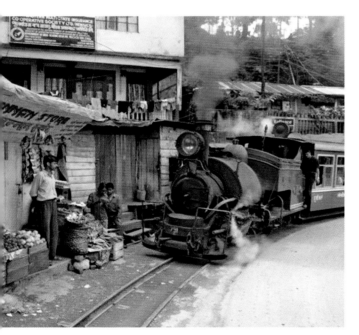

A Sharp Stewart narrow-gauge, 0-4-0, saddle tank locomotive on the Darjeeling Himalayan Railroad. Built in 1927, the engine is still in regular use.

Asia has some of the oldest and some of the most modern trains in the world. The Japanese, for example, opened their first Shinkansen high-speed line in 1964; over a major trunk route, trains were run at a frequency that was usually associated with commuter lines at speeds up to 130mph (210km/h).

Asia is a varied mixture of rich and poor, of countries that were once colonies, and those that were left to develop their own rail systems in the national interest, rather than that of the colonizing power. As a result, Asia's railroad lines consist of a multiplicity of gauges, while some countries own systems that are much more comprehensive than others.

During the twentieth century, the major advancing countries of India, Japan, and China began to establish themselves as active players in the railroad world. Japan was first to act; long before their

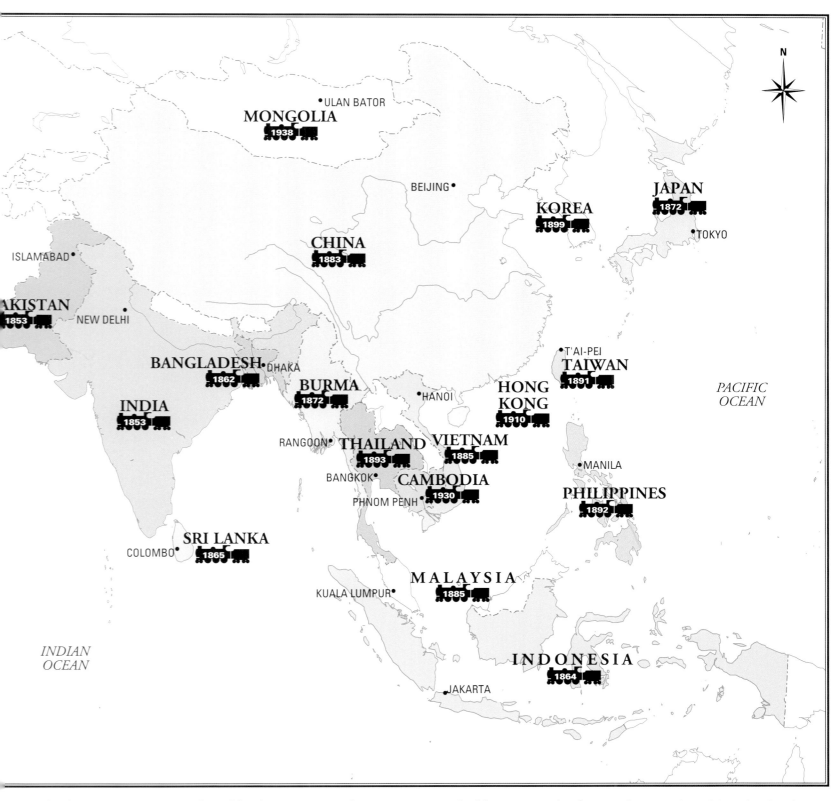

MONGOLIA
ULAN BATOR
1938

BEIJING

JAPAN
1872
TOKYO

KOREA
1899

CHINA
1883

ISLAMABAD

PAKISTAN
1853
NEW DELHI

BANGLADESH
DHAKA
1862

BURMA
1872
HANOI

T'AI-PEI
TAIWAN
1891

PACIFIC
OCEAN

INDIA
1853

HONG
KONG
1910

RANGOON
THAILAND
1893

VIETNAM
1885

MANILA

BANGKOK
CAMBODIA
1930

PHILIPPINES
1892

PHNOM PENH

SRI LANKA
COLOMBO
1865

MALAYSIA
1885

KUALA LUMPUR

INDIAN
OCEAN

INDONESIA
1864

JAKARTA

Shinkansen trains attracted worldwide attention and imitation, Japan had been exporting locomotives to other countries.

In recent years, India has supplied consultants for railroad projects overseas. China has done the same and has provided investment for new projects. The Tanzam Railroad, linking Tanganyika and Zambia, in Africa, was a notable example, which provided a lucrative market for Chinese equipment and rolling stock.

Many of the railroads in Asia were built originally by colonial powers during the nineteenth century. Today, there is wide variation in their condition.

RAILROADS IN TURKEY AND THE MIDDLE EAST, FROM 1856

DURING THE TWENTIETH CENTURY, THE RAILROADS OF TURKEY AND THE MIDDLE EAST SUFFERED FROM WAR AND POLITICAL UPHEAVAL. EVEN TODAY, THOSE CONDITIONS APPLY TO SOME.

TURKEY

The old Ottoman Empire straddled the Bosporus, and the Turkish railroad system consisted of little more than the route of the *Orient Express* in Europe, and about 2,500 miles (4,000km) of route in Asia Minor, being independent, unconnected, and serving local areas. After the Balkan War of 1913, however, Turkey was left with no more than a foothold in Europe, while its association with the Central Powers during World War I, and involvement in their collapse, left the country and its railroad network in very poor condition.

Turkey began building a high-speed rail network in 2003. To provide a service, ten electric, multiple-unit trains were imported from Spain.

While Turkey was under strong German influence, a railroad was built through Asia Minor to connect Constantinople (present-day Istanbul) with Baghdad. This was completed in 1918. The starting point of the modern railroad system in Turkey was the proclamation of the republic in October 1923 and the move of the capital city from Constantinople to Ankara—then little more than a remote settlement. A well-balanced system of railroads being essential to build up the economy of

the country, plans were prepared for a fully integrated network in Asia Minor. In 1927, the General Management of the Railroads and Harbors of the Republic of Turkey (TCDD) was set up, and since then the railroad length has virtually doubled. Ankara was placed on the principal main line from Istanbul to the Iraqi and Soviet frontiers, although the route of the Taurus Express, from Istanbul to Baghdad, is that of the German sponsored line built earlier. In mountainous country, the Turkish railroads of today follow the winding river valleys and cross high mountain passes.

In the late twentieth century, there was a long period of stagnation, although during that time steam traction was phased out. Accounting and efficiency was poor, and this, together with the curving, single-track nature of the routes, meant that the railroads could not compete with the highways. Turkish State Railroads still existed in 2006, although plans for privatization had been drawn up in the 1990s. A new investment plan was adopted in 2003, envisaging new and upgraded lines with an increase of train speeds. Among other things, this will enable the Ankara–Istanbul passenger trains to cut their schedules from 6 hours 30 minutes to 3 hours, making them competitive with the airlines.

The Turkish railroad network owes much to work carried out after 1927.

A Bombardier double-deck commuter train at Tel Aviv Merkaz station, Israel.

ISRAEL

Today, all of Israel's lines are standard gauge, although the first, completed in 1890, was meter gauge, while the second was 3ft 5½in (1,050mm). The latter ran from Haifa to Dera'a in Syria. Now closed, it included 129 miles (80km) below sea level. Middle East politics have isolated Israel: before 1948, trains ran to Egypt, Lebanon, and Jordan via Dera'a. Within Israel, however, the system has been expanding.

JORDAN

Jordan's first train ran in 1904, as part of the Turkish inspired Pilgrim's Railroad (Damascus–Medina). The line was damaged in 1918 and fell into disuse south of Ma'an. Part was refurbished in connection with the

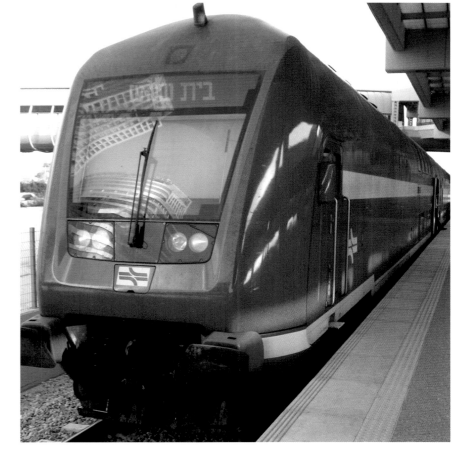

Although the rail networks in Israel, Jordan, Lebanon, and Syria are not extensive, there are connections between the various countries. The railroads owe their beginnings to the Ottoman Empire, which held sway over the region for many centuries.

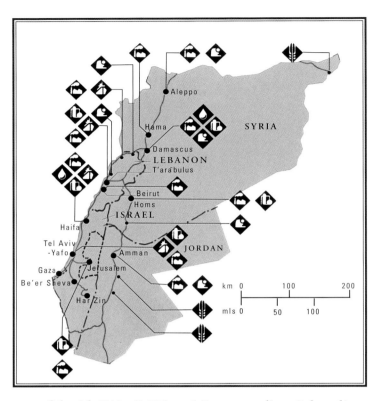

new Aqaba line (opened in 1975). The Aqaba Railroad Corporation, devoted to the transport of phosphates to the port of Aqaba, is the main carrier. The Hedjaz Jordan Railroad has been through difficult times, but may yet recover. Jordan's railroads, like those of Syria and Lebanon, have the unusual gauge of 3ft 5½in (1,050mm).

LEBANON

Lebanon was carved out of the Ottoman Empire with no regard to the existing rail system. Running inland from Beirut (with 51 miles/32km of rack rail) is part of the 3ft 5½in (1,050mm) Damascus line. Others lines are of the standard gauge, but the junction of the system is located in neighboring Syria. All lines were closed by the civil war, and recovery has been slow.

SYRIA

There are two railroad systems in Syria: 3ft 5½in (1,050mm) linking Damascus with Lebanon and Jordan; and standard-gauge in the north, connecting Homs/Aleppo with Lebanon and Turkey, soon to reach Damascus. There has been some new construction over recent decades.

IRAQ

Railroad construction began in Iraq in 1902, being part of the Berlin–Baghdad project and intended to be a standard-gauge through route. After the British invasion of 1914, the Basra–Baghdad line was built with surplus meter-gauge equipment from India. Iraq had both gauges until 1988, when meter gauge disappeared. The main line runs from Basra to Baghdad, but in the 1990s, new lines were planned. Following the invasion of Iraq in 2003, operations were very much curtailed; much rehabilitation was required in 2007.

SAUDI ARABIA

Saudi Arabia's first railroad now lies derelict, damaged by Arab forces led by T.E. Lawrence (Lawrence of Arabia) in 1918. Trains had reached Tabuk from Jordan in 1906, and Medina in 1908. The lines now working opened in 1951, having been built by ARAMCO as one of the conditions of its oil exploration

license. The lines are run by Saudi Railroads Organization (SRO), and there has been considerable recent investment. A new land-bridge from sea to sea is one project under consideration; a high-speed line is also under study.

IRAN

Iran acquired its first line in 1916, built by the Russians from their frontier to Tabriz. It was 5ft (1,524mm) gauge until 1958. The Trans-Iranian Railroad, running from the Persian Gulf to the Caspian Sea, was opened throughout only in 1938. The link to Turkey was completed in 1971. A 10–25-year development plan, drawn up so that it could be proceeded with as fast or as slowly as required, called for another 5,900 miles (9,500km) to be built—twice as much as the country owned. One line planned is a link to Pakistan Railroads, whose system extends over the border to Azhedan (where gauge changing facilities will be needed). A section of this line, from Zarand to Kerman, was opened in 1977. The plan also proposed extensive electrification. Since then, there has been considerable upgrading and new construction. A large import of French diesel locomotives was a considerable asset. Iran's railroads have also made a success of French turbotrains.

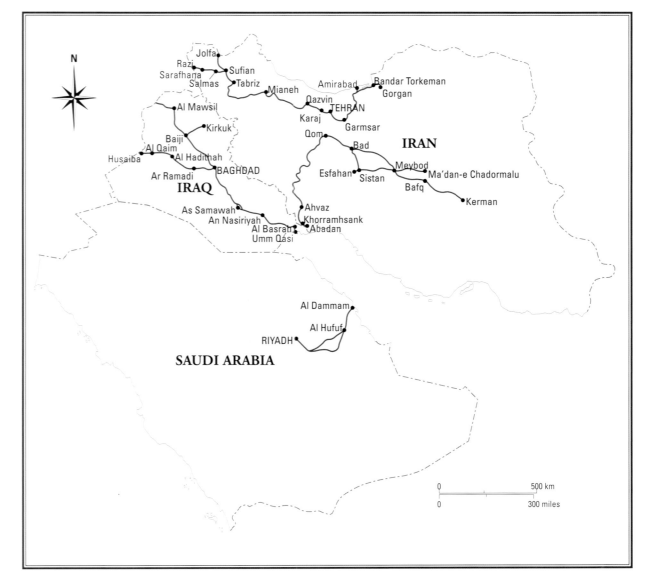

The railroad networks in Saudi Arabia, Iraq, and Iran are relatively small, and all owe their beginnings to foreign interests. Both Saudi Arabia and Iran are developing their systems, while in Iraq much work is needed as a result of the recent wars.

THE RAILROAD GAUGES

SEVERAL GAUGES ARE IN COMMON USE AMONG THE RAILROADS OF THE WORLD. THIS CAN CAUSE SERIOUS PROBLEMS WHERE TRACKS MEET AT FRONTIERS BETWEEN COUNTRIES AND REGIONS WHERE GAUGES VARY.

Railroad gauge is the distance separating the inner faces of the two rails, measured at the running edge. It relates to straight track, because on curves, there needs to be a slight widening. At a time when railroads seemed to be just an interesting local device, George Stephenson pointed out that the gauge needed to be standardized, so that one day trains would be able to run all over Britain without break of gauge. His choice of gauge was simply that used by the existing colliery lines with which he was familiar, to which he added half an inch when he found that his new rolling stock needed a little more side play. Thus was born the gauge that later became known as Standard Gauge, 4ft 8½in (1,435mm). In modern times, a few millimeters have been shaved off this gauge to improve the smoothness of motion.

Stephenson's contemporary, Brunel, thought that a wider gauge would be better, permitting more powerful locomotives and rolling stock of a vastly greater cubic capacity. Brunel was probably right, but the coexistence in England of both the standard gauge and the Great Western Railroad's 7ft (2,133mm) gauge proved very inconvenient, with passengers and freight needing transhipment at break-of-gauge stations like Gloucester. Railroad users, shareholders, parliamentarians, and writers all joined in the controversy (see, for example, Thackeray's short story, *Jeames on the Gauge Question*). Eventually, Parliament ruled that the Great Western's broad gauge would have to be changed to standard, and over the course of decades, this was done, the last broad-gauge train running in 1892, when the main line to the West was finally converted in a remarkable weekend effort. Wisely, Parliament did not insist on Irish railroads moving from their 5ft 3in (1,600mm) to match Britain's standard gauge.

British engineers were hired in all parts of the world to build the first railroads, and each decided the gauge question in his own way. This brought particularly bad consequences for Australia, where each

of the states built its own system. Victoria and South Australia built to the 5ft 3in (1,600mm) gauge, while New South Wales, after a change of engineer and consequent change of mind, opted for standard gauge. The other, poorer, states of Queensland, Western Australia, and Tasmania found themselves with the "colonial" 3ft 6in (1,067mm) gauge, largely for reasons of cheapness. This outcome became a serious handicap, weakening the economic links between the states of what soon became a politically unified new country. When the government sponsored Trans-Australia Railroad was built across Australia, 4ft 8½in (1,435mm) was chosen, and in this way standard gauge became the potential gauge for all Australia. Gauge conversion was a costly and often unwelcome enterprise, however, and proceeded slowly. In 1930, Brisbane and Sydney had a standard-gauge link, and by 1970, Sydney and Melbourne, and Sydney and Perth were similarly connected. Further conversions followed slowly.

Likewise, Latin America became a region that contained a variety of track gauges. While British engineers brought the 5ft 6in (1,676mm) gauge to Argentina and Chile, and narrower gauges elsewhere, the American engineers favored the narrower 3ft (914mm) gauge in the mountainous regions.

In the USA, the 5ft (1,524mm) gauge became popular in some of the southern states, but this was changed to 4ft 8½in (1,435mm) after standard gauge was chosen for the new transcontinental railroad. Before this happened, an engineer who had been building railroads in the south was hired by the Russian tsar to build the new St. Petersburg–Moscow railroad, and he took the 5ft (1,524mm) gauge with him. Subsequently, this became what the Russians called "Normal Gauge" in their empire.

In much of the British Empire, including South Africa and New Zealand, 3ft 6in (1,067mm) was chosen. In British India, however, the first heavy-traffic lines were built to the 5ft 6in (1,676mm) gauge. Then, to provide rail access to less important parts, meter gauge (3ft 3⅜in) was adopted by virtue of its lower cost. Finally, some 2ft 6in (762mm) lines were built. In recent decades, the Indian government,

Top left: A preserved section of 7ft (2,133mm) broad-gauge track from Brunel's Great Western Railroad. The engineer argued that the widely spaced rails provided greater stability, allowing more powerful locomotives to be used.

Above: Smoke pours from a British built locomotive designed for Argentina's 5ft 6in (1,676mm) broad-gauge railroads.

The Hakone Tozan line's dual-gauge system at Odawara Station, Kanagawa, Japan.

Standard- and narrow-gauge trains meet on the Leek & Manifold Light Railroad in England's Peak District.

often under political pressure, has financed the conversion of the more important meter-gauge lines to the standard 5ft 6in (1,676mm).

Elsewhere in the world, there have been moves to introduce standard gauge into countries where other gauges have proliferated. In Japan, for example, where 3ft 6in (1,067mm) gauge was the standard, the revolutionary Shinkansen high-speed lines were built to 4ft 8½in (1,435mm) gauge; it was thought that this helped Japanese companies seeking export markets. When Spain built its new high-speed lines, these too were laid to standard gauge rather than the country's prevailing 5ft 6in (1,676mm) gauge; this was necessary to facilitate through trains to other European countries. Portugal

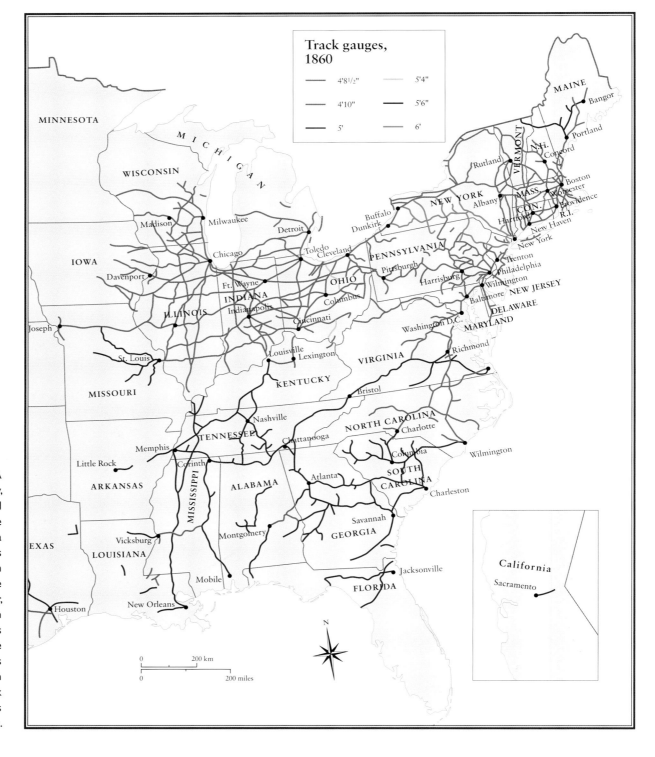

Track gauges, 1860

— 4'8½" — 5'4"
— 4'10" — 5'6"
— 5' — 6'

As railroads grew in the USA during the nineteenth century, the various companies all had their own ideas as to the ideal gauge, and there was a proliferation of different gauges throughout the country, as can be seen from this map of the situation in 1860. However, as trade increased between regions of the country, this proved a great obstacle to the efficient transport of goods. As a result, the decision was taken to convert the entire network to standard gauge, which was achieved by 1886.

decided to follow the same path. Suggestions that Russia might admit the standard gauge into its territories were soon condemned, however, although for nationalistic rather than economic reasons. Russian Railroads sponsored a regular "1,520mm Conference" in the early twenty-first century, which embraced railroads using the 5ft (1,520mm) gauge, that is most countries of the former USSR plus Finland. But, in 2006, the former Soviet railroads of Kazakhstan were contemplating a new standard-gauge link to connect standard-gauge lines in China and the Middle East, thereby attracting valuable transit traffic.

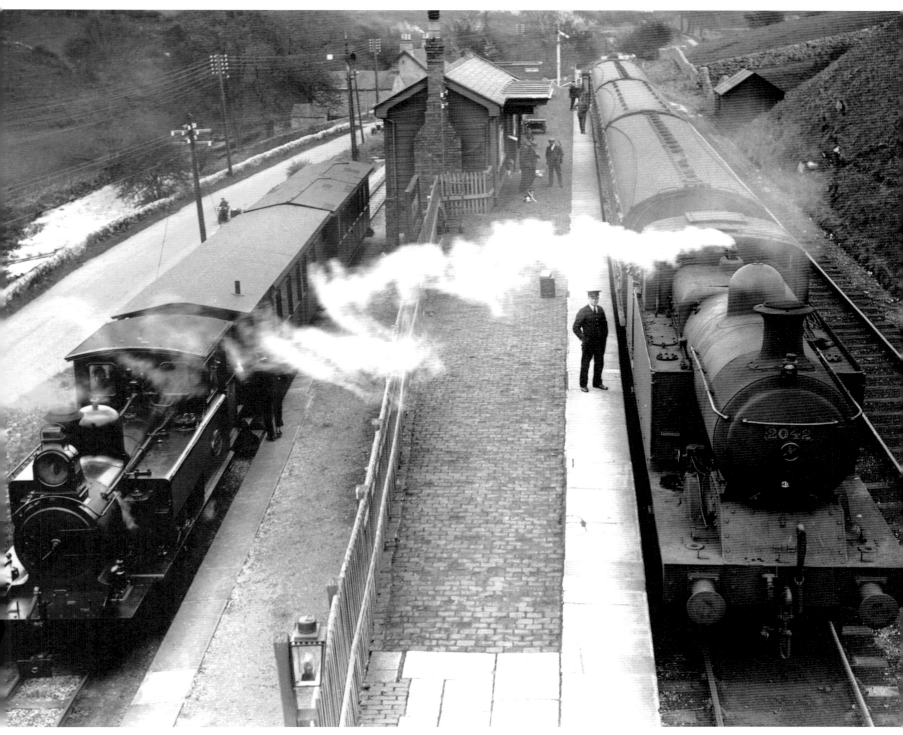

THE NARROW-GAUGE RAILROAD

CHEAPER THAN CONVENTIONALLY SIZED RAILROADS, NARROW-GAUGE RAILROADS HAD A REDUCED CARRYING CAPACITY, BUT WERE IDEAL FOR MOUNTAINOUS TERRAIN.

Narrow-gauge railroads are cheaper to build, equip, and operate than standard-gauge lines, which makes them an attractive proposition for industrial applications. This is a typical industrial setup, with a track gauge of 2ft (610mm).

In the Railroad Age, there were towns and territories that were not prosperous enough to attract the railroad promoters, but that wanted a railroad because they thought it would make them prosperous. In these situations, the narrow-gauge railroad seemed to offer an attractive solution: it was about a third cheaper to build in flat country, and two-thirds cheaper in the mountains. The advantage in hilly terrain came from its ability to snake around short-radius curves, so it could cling to hillsides and follow rivers with little need for expensive bridges and tunnels.

However, the narrow gauge did have its drawbacks. It was unsuited to heavy freight traffic, due to the small cubic capacity of its vehicles. If it joined a main-line railroad, its freight and passengers had to be moved into vehicles of the wider gauge if they were to proceed farther. But there was always the expectation, sometimes justified, that when traffic built up, it would be possible to convert the line to the standard gauge. Moreover, a change of gauge was not always required—a line built to exploit a source of raw materials and convey that commodity to the nearest port was self-contained. Many of the Welsh narrow-gauge lines originated for that purpose, shipping slate or stone down to the sea.

As things turned out, the advent of the internal-combustion engine changed the picture for narrow-gauge lines, since their small and usually scattered traffic could be handled more cheaply by road transport. Many of them soon became victims of this new competition.

The definition of narrow gauge varied from country to country. In those countries

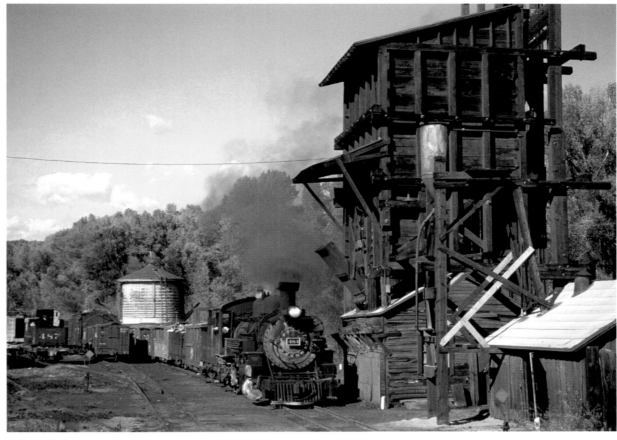

Train Arriving at the Yard
The Cumbres & Toltec Scenic
Railroad train arrives at the rail
yard in Chama, New Mexico.
ca.1992.

where the 4ft 8½in (1,435mm) gauge was regarded as the standard, anything smaller was deemed to be narrow gauge. In many other countries, however, narrower gauges were themselves the standard. In much of the British Empire, for example, 3ft 6in (1,067mm) was the standard gauge and was not referred to as narrow. The meter gauge (3ft 3³/₈in) was also popular as a standard, although in France, where local authorities sponsored their own meter-gauge lines, it was regarded as narrow. Nowadays, it is conventional to regard any gauge less than a meter as narrow.

Therefore, the 3ft (914mm) gauge favored by some American engineers is a narrow gauge. Many lines in Latin America were built to this gauge, and some still exist. It was also the gauge chosen for certain mountainous lines and networks in Colorado and New Mexico, sections of which have survived as tourist lines. At one time, the Denver & Rio Grande Railroad had a narrow-gauge main line running 770 miles (1,239km) from Denver to Ogden.

The 2ft 6in (762mm) gauge—identical for all practical purposes with the ¾-meter or 750mm gauge— was probably the most popular of the narrow gauges. Apparently, the British chose it in preference to the 2ft (610mm) gauge for India because it enabled two cavalry horses to travel side-by-side. A very notable 2ft 6in (762mm) gauge line was built in the Austro-Hungarian Empire from Belgrade, across the mountains of Serbia and Bosnia, to the Adriatic. In Russia, there was also enthusiasm for this gauge, and some of these lines remain in use today, partly because they serve settlements that have no highway access.

The 2ft (610mm) gauge (sometimes rendered as 1ft 11½in/600mm) was employed when economy was paramount and carrying capacity less important. In the USA, it was hardly used, except in Maine, where the "Maine Two-Footers" became part of local tradition. The Welsh lines also preferred this gauge.

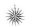

Opposite page: An 0-8-2 steam locomotive of the Sargan Eight mountain railroad, which operates on the northern slopes of Mount Zlatibor, in western Serbia. The 2ft 6in (760mm) gauge railroad was once part of the narrow-gauge line that ran from Sarajevo to Belgrade, which was closed in 1974.

The Ffestiniog Railroad is a major tourist attraction in Snowdonia National Park, Wales. Built originally to transport slate from the quarries around Blaenau Ffestiniog to the harbor at Porthmadog, the narrow-gauge—1ft 1½in (597mm)—line passes through spectacular mountain scenery.

It was used by the Deceauville lines in France; these were built initially as small-scale farm railroads, but later the technology was chosen for the so-called "trench railroads" used by the military.

In the later nineteenth century, narrow-gauge railroads seemed to be on the verge of a renaissance. Their big disadvantage, small carrying capacity, was being tackled by innovative engineers. On the 115-mile (185km) Barsi Light Railroad in British India, for example, ingeniously designed locomotives of light axle load, but exceptional power, were hauling 15-ton-capacity steel freight cars over well-engineered, lightweight track. The Ffestiniog Railroad in Wales was using the new Fairlie type of locomotive, essentially two locomotives joined into one, with a flexible wheelbase. Engineers traveled from all over the world to inspect this phenomenon, although in the end, the Fairlie locomotive was not widely adopted. Other flexible-wheelbase locomotives, such as the Mallet and the Meyer, were tried with some success in continental Europe, while in the British Empire, the Garratt flexible-wheelbase locomotive was used occasionally. These new types of locomotive allowed significant increases in train weights, but their maintenance was more demanding. Their advent did not prevent the inroads that shortly would be made by the highway truck and the bus. By the end of the twentieth century, there were few narrow-gauge railroads left, but sections of some of them survived as tourist lines.

Left: The narrow-gauge locomotive *Linda*—now retired from service on the railroad—is shown approaching Blaenau Ffestinog station in 1994, with the mountainous Welsh scenery as a backdrop.

Blaerau

Tanygrisiau

Moelwyn

Campbell's Platform · Dduall

Coed-y-Bleiddiau

Tan-y-Bwlch

Garnedd

Plas Halt

Penrhy

Minfford

Porthmado · Boston Lodge

N

0 — 1 km
0 — 1 mile

Key
—— Ffestiniog railroad
—— Main line

Railroads on the Indian Subcontinent, from 1853

LARGELY BUILT BY BRITISH ENGINEERS DURING THE DAYS OF EMPIRE, THE RAILROADS OF THE INDIAN SUBCONTINENT WERE ONCE A UNIFIED SYSTEM, BUT THEY WERE SPLIT UP BY THE PARTITION OF INDIA IN 1947.

INDIA

A suburban train from Mumbai (formerly Bombay), c.2007, manufactured for the Mumbai Rail Vikas Corporation by the Integral Coach Factory (ICF); these trains transport three million people annually.

The railroads of India, as a basic national network, were planned by the Marquis of Dalhousie when governor-general in the early 1850s. His plan was to develop trade routes connecting the sea ports of Calcutta, Bombay, and Madras, and to provide good communication from the ports to the Northwest Frontier, where the greatest military danger was thought to lie. From 1853, when the first railroad was constructed from Bombay, the main-line network was built on the 5ft 6in (1,676mm) gauge recommended by Dalhousie. Later, however, when many more lines were found to be necessary and the cost of construction was high, the government agreed to the establishment of a system of feeder lines on the meter gauge.

Railroad building in India and what is now Pakistan involved some tremendous feats of civil

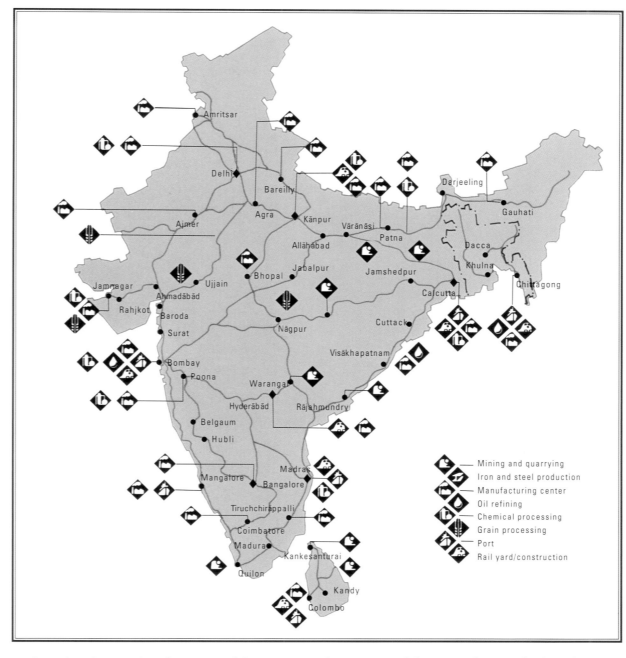

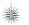

The railroad network of India owes much to the days of the British Empire. Lines were planned and built with trade in mind, connecting the major sea ports and important regions inland. Military requirements were also considered, particularly the need to defend the Northwest Frontier.

Mining and quarrying
Iron and steel production
Manufacturing center
Oil refining
Chemical processing
Grain processing
Port
Rail yard/construction

engineering, in crossing the range of the Western Ghats eastward from Bombay, in fording the great rivers Indus and Ganges, and in carrying strategic lines of communication into the mountain ranges of the Northwest Frontier.

In imperial days, the railroads of India were household names in transport and engineering circles: Great Indian Peninsula; Bombay, Baroda & Central India; Madras & Southern Mahratta; East Indian; Bengal Nagpur; Eastern Bengal; and, above all, His Exalted Highness the Nizam's Guaranteed State Railroad. Some of the railroads were state owned, others were operated by private companies holding concessions and certain financial guarantees. When the concessions ended, they were taken under government control. After the granting of independence to India and Pakistan, the railroads were nationalized. Those of India are operated in nine territorial zones: Northern, Western, Central, Southern, Eastern, Northeastern, Southeastern, Northeast Frontier, and South Central. After independence, great strides were made toward the provision of all rolling stock and technical services by indigenous

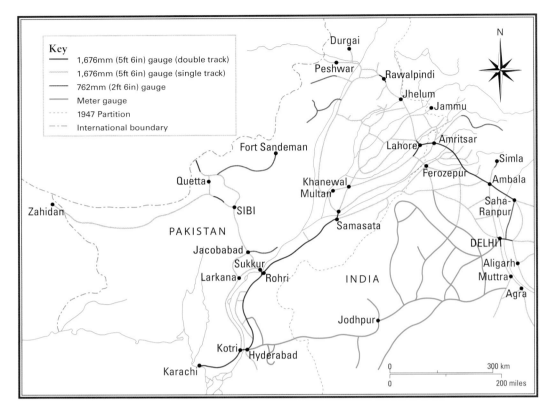

Key
- 1,676mm (5ft 6in) gauge (double track)
- 1,676mm (5ft 6in) gauge (single track)
- 762mm (2ft 6in) gauge
- Meter gauge
- 1947 Partition
- International boundary

The first line to be built in what became Pakistan was the Scinde Railroad in 1861, which ran between Karachi and Kotri. Eventually, the line was extended to Amritsar and on to Delhi. Subsequently, a number of lines of various gauge were built in the region.

manufacture and technology.

Despite considerable investment (a quarter of the route mileage is electrified), Indian Railroads remains overloaded in a rapidly developing economy. Further investment is expected to cope with future traffic increases. With its 1.6 million workers, Indian Railroads could claim to be the world's biggest employer, and its annual four billion passenger journeys have made it the world's biggest passenger railroad. In 2006, it actually made a profit.

The previous restrictions on maximum size of train were relaxed and it became possible to buy travel tickets online, a big advance over the long queues at ticket offices that had been the norm for long-distance journeys. Another notable advance was the appearance of air conditioning in some third-class vehicles. It was found possible to run double-stack container trains on trunk routes. New construction under way included a spectacular and politically important line through the Himalayas into Kashmir. In 1996, the Konkan Railroad was opened, providing a direct route between Bombay and Mangalore.

PAKISTAN

The first line in Pakistan was the 108-mile (173km) Scinde Railroad between Karachi and Kotri, which was opened in 1861. It was promoted because of the hazardous navigation along the lower Indus. By

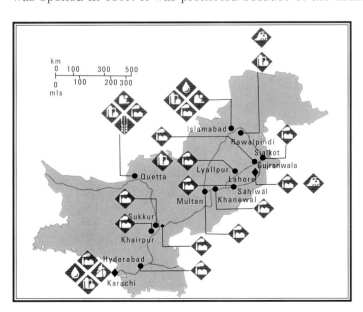

Upon the 1947 partition of India, Pakistan inherited a substantial portion of the North Western Railroad, which forms the basis of its network today.

1865, a route had been completed via Amritsar to Delhi, the capital of British India, but it still included a 570-mile (912km) river voyage. Thus began the North Western Railroad, which became the largest railroad company on the Indian subcontinent. Divided by the 1947 partition of India, the major portion became what is now Pakistan Railroads. The countryside presents extraordinary challenges. One line crosses the Sind desert, another ascends above the snow line. The Quetta route climbs 5,000ft

(1,524m) in 50 miles (80km). Above all, the railroad is plagued by the capricious flooding of the River Indus, despite much magnificent bridge building by the original engineers. Like India, Pakistan's railroads were built to four gauges, but 88 percent of the route length is 5ft 6in (1,676mm) gauge.

In 1998, Pakistan Railroads was divided into business units, one of them being for infrastructure, and it was envisaged that privatization would proceed from this change. In the early 1990s, there were traffic reductions, but the situation stabilized. New investment was an urgent need, but it was hampered by the lack of foreign exchange. However, the acquisition of thirty Blue Tiger diesel locomotives from Germany was of great benefit. More recently, new locomotives and rolling stock have been obtained from China.

BANGLADESH

The Bangladesh Railroad originated as an integral part of the Bengal-Assam Railroad, which was arbitrarily divided at the partition of India and Pakistan in 1947. Further administrative upheaval came in 1973, in the wake of the civil war that created a separate Bangladesh. The system is built to both Indian gauges: about a third is broad gauge (5ft 6in/1,676mm), the rest meter.

SRI LANKA

Sri Lanka's first railroad opened in 1865, built to the Indian 5ft 6in (1,676mm) gauge. The present route length is around 872 miles (1,400km), and a large-scale program of upgrading and refurbishment has been accomplished since the beginning of the 1990s.

MYANMAR (FORMERLY BURMA)

Myanmar Railroads owns the longest double-track, meter-gauge line in the world—the 137 miles (220km) running north from Rangoon. The country's first line opened in 1877; all were built by the government of India, from which Burma separated in 1937.

A few steam locomotives are still in use, supplementing the stock of mainly French diesels. Some new lines have also been built, using the labor of soldiers and local inhabitants.

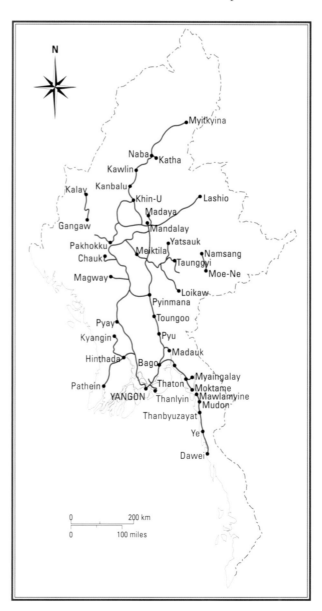

Most of the rail lines of Myanmar (Burma) were built when the country was part of India. The country possesses the longest double-track, meter-gauge line in the world.

India's Fastest – the Rajdhani Express

CONTINUING THE TRADITION OF THE GREAT INDIAN TRAINS FROM THE EARLY DAYS OF EMPIRE, THE RAJDHANI EXPRESS STILL CONVEYS TRAVELERS ACROSS THE VAST CONTINENT IN AIR CONDITIONED COMFORT.

India's crack locomotive during the 1960s and 1970s, the WP hauled prestige trains like the *Rajdhani Express*.

In Imperial days, several famous express trains crossed the Indian subcontinent, such as the *Frontier Mail* and the *Imperial Indian Mail*, from Bombay to Calcutta. Since independence, however, the railroad requirements of India have changed considerably, and one of the most important considerations has been to give improved and accelerated service without incurring heavy capital investment, or recurring capital charges. An important innovation was the "Janata" (People's) express, a series of trains for third-class passengers traveling at the same speed, more or less, as mail trains. Hitherto, most third-class passengers had to travel by the slower trains.

Later, the outcome of much research work by Indian Railroads was the introduction of two *Rajdhani Expresses*, one running between New Delhi and Calcutta, the other from New Delhi to Mumbai (Bombay). One Rajdhani operated between New Delhi and Howrah, the great terminus on the right bank of the Ganges opposite Calcutta. This fine train,

which ran twice a week in each direction, covered the 900 miles (1,450km) in just over 16 hours, an average speed of 55mph (88.5km/h). It stopped only at Kanpur and Mughalserai, and was classed as a deluxe train, conveying both first- and second-class passengers. A small supplement was charged for the speed of transit. A speed of 60mph (96km/h) was then the maximum permissible with passenger trains on the broad-gauge 5ft 6in (1,676mm) lines in India, but later the *Rajdhani Express* ran at speeds of up to 75mph (120km/h) over long stretches.

The design of the rolling stock was interesting. The train ran through the night, leaving New Delhi at 6.15pm on the eastbound run, and Calcutta (Howrah) at 5.10pm westbound. The cars were fully air conditioned throughout the sitting and sleeping accommodation. The "chair" cars each had 73 seats and, taking advantage of the wide gauge, these were arranged three on one side and two on the other side of the aisle. The price of a seat in one of the "chair" coaches included the cost of evening tea, dinner, early morning tea, and breakfast; meals were served airline style with boxes for every seat. Each sleeping car, in which the fare was three times that of a "chair" car, had three four-berth compartments, and three coupés with extra-wide windows and sunk-in upper berths. There was an air conditioned pantry car on the train, in which the excellent food prepared at base establishments was stored, hot or cold, until it was served at the appropriate meal times.

The second *Rajdhani* service, between New Delhi and Mumbai, was a journey of 860 miles (1,384km), the route passing through Kota and Vadodora Junction (Baroda). This was also a night service, but it was not possible to schedule so high a speed as on the Delhi–Calcutta run. The southbound train left at 5.00pm and reached Mumbai at 10.55am, with stops at Ratlam and Baroda. Nevertheless, the overall average was very good—48mph (77km/h)—for this long run. The corresponding northbound train left Bombay at 3.30pm. Like the *Rajdhani* trains to and from Calcutta, the Mumbai trains ran twice a week in each direction.

By 2005, there were fifteen pairs of *Rajdhani* trains, but they were beginning to suffer from airline competition. Not only were they slower than airplanes, but also they were becoming more expensive, so there was some doubt about their future.

Map: The *Rajdhani Express* route from New Delhi to Mumbai. The prestigious train covered the 860 miles (1,384km) in 18 hours.

Top left: One of the remaining *Rajdhani Express* trains leaves Kharagpur station bound for Bhubneswar, in 2007.

Below: The comfortable interior of a *Rajdhani Express* first-class sleeping compartment.

New Delhi
dep 17:00

Mathura
141km (88mls)

Sawai Mādhopur
358km (222mls)

Kota
469km (291mls)

Ratlām
732km (455mls)
dep 02:28

Vadodara Junotion
993km (617mls)
dep 06:07

Surat
1,122km(697mls)

Bombay
1,384km
(860mls)
arr 10:55

ENGINEERING THE TRACKS

COMPETENT DESIGN AND SOUND CONSTRUCTION ARE ESSENTIAL

ELEMENTS OF THE TRACK ON WHICH TRAINS RUN, CONTRIBUTING

TO THEIR SAFE OPERATION, PARTICULARLY AT HIGH SPEEDS.

New railroads for heavy modern traffic are being built in many parts of the world; in Britain, what is virtually a new railroad has been built over the tracks of one that is more than a hundred years old. The very heavy utilization of refurbished British and French routes, and their success in carrying fast and frequent traffic at unprecedented speeds, provided an invaluable fund of experience for the building of new railroads. The problems encountered in laying out and building new railroads in countries like China and in the remoter parts of Australia differ considerably, however, because even with today's modern equipment, there are difficulties of terrain, of procuring indigenous labor, and of climate that can dictate much of the form a new railroad takes. The traffic forecast can also be crucial. For example, a new line in the style of the Japanese Shinkansen would not have been engineered if the principal traffic was likely to be in heavy minerals.

A major consideration is the economic factors involved in alternate methods of construction. While it is clearly desirable to avoid heavy grades as far as possible, because this will reduce operating costs on a completed line, with modern motive power, this is not so important as in the days of steam. The spectacular civil engineering of some of the early British lines, through relatively easy country, was due to the limited tractive power of early locomotives and their inability to climb a grade at good speed with a paying load.

It is interesting to compare the approximate relative costs of laying a new railroad by hand, which might be considered in a country with an abundance of local labor, and by mechanized methods. In the simple preparation of the roadbed, removing topsoil, trimming sides, and cutting drainage slopes, the difference for a 60ft (18m) length of single track would be between 150 man hours by hand and four man/ hours by machine. It can be imagined what the difference would be if deep cuttings or high embankments had to be formed. On new lines, the ballasting is often done in two stages, a third of the total volume being put down in advance of track laying, and two-thirds afterward. In the actual laying of the track itself,

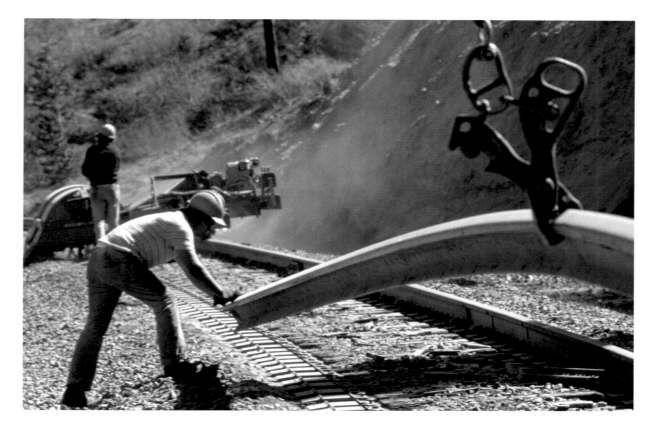

Railroad workers laying track at Spartanburg, South Carolina, in May 1976. Note the flexibility of the rail as it is lifted into place.

the difference in cost can be relatively small where labor is cheap, but mechanical laying is four to five times as fast and, therefore, would cause less interference to the laying of the bottom ballast. On double- or multiple-track routes, where a close parallel track is available for rail borne supplies, replacement of old track can be effected expeditiously by laying completely prefabricated track direct from transporter vehicles alongside.

The most remarkable examples of railroad construction in recent times are the new high-speed lines, built for continuous running at 185mph (300km/h) or more. All the preliminary work was preceded by comprehensive aerial surveys, and with particular regard to the environment, great care was taken to avoid towns and villages. Because an abundance of power was built into the new electric trainsets, grades as steep as 3.4 percent or more were permissible. Although the lines were engineered to provide notably straight courses, and consequent freedom from speed restrictions on account of curves, the inclusion of such steep grades meant that in hill country, tunnels were avoided, although lengthy viaducts were necessary. By using modern earth moving equipment, construction proceeded rapidly, and with the surveys providing for convenient "cut and fill" techniques, the spoil excavated from relatively shallow cuttings was readily moved to form the contiguous shallow embankments in undulating countryside.

The underlying reason for the construction of the original TGV line, an addition to the French national railroad network, was that, at times, the existing main line of the former Paris, Lyon & Mediterranean Railroad was approaching traffic saturation point. The new line, with its acceleration of service, attracted much extra traffic. The Japanese Shinkansen lines were built for similar reasons. In contrast, however, some of the most interesting lines built recently in Australia have been entirely private commercial enterprises, connected with long-range projects for the export of coal and iron ore. The cost of a first-class main-line railroad, through harsh and barren country, has been simply a part of the capital investment in

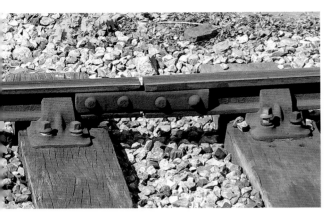

The traditional method of joining lengths of rail was to bolt the ends together with steel plates, known as joint bars. These rails are also supported by "chairs."

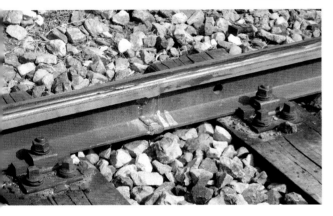

Today, most railroads use continuous welded rail, which is stronger than jointed rail and necessary for high-speed trains. These rails are secured by base plates and clips.

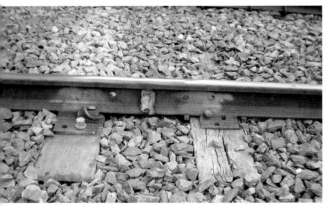

Here, one side of a welded joint is secured by a spring clip and base plate; the other by a spike and base plate.

mining plant, mechanized handling equipment at the mines and port of shipment, and provision of houses, shops, and recreational facilities to attract workers to an otherwise unattractive part of the country.

The evolution of track itself has passed through several stages to arrive at its present standard of excellence and general reliability. The one-time, highly favored British "chaired" track is now obsolete, although a few lengths of it remain in service on secondary lines. It was conceived by the great pioneer engineer Joseph Locke, who propounded the idea of a rail that was shaped like a dumbbell, having the same sized heads, which could be turned over when the upper edge was worn, thus doubling its life. It was not successful, however, because the undersurface, resting in the cast-iron supporting chair, became damaged by the constant pressure of traffic. Although the equal-headed rail was abandoned, the bullhead type survived and, until the end of World War II, remained the British standard. Nearly everywhere else in the world, the Vignoles, or flat-bottomed, rail was the norm. Subsequently, a British investigation into a future standard rail type came out in favor of the flat-bottomed rail, because it had a greater lateral stiffness for the same weight per length and thus was likely to need less work in maintaining a good line. This was an important feature at a time when labor was scarce and the cost of it steadily rising.

On most railroads around the world, up to the end of World War II, flat-bottomed rails had been spiked directly to the cross-ties, or sleepers, as they are known in Britain, but a feature of British track had always been a slight inward inclination of the rails to give a centering effect and to counteract any tendency of locomotives or rolling stock to yaw from side to side. To achieve the same effect with flat-bottomed rails required the insertion of slightly tapered tie-plates between the tie and the foot of the rail. At the same time, it was felt that there was a need for a more positive form of anchor than the simple American dog spike. Great ingenuity was shown by British manufacturers in the design of spikes or clips that had a spring feature; these have been used in great quantities on the modernized high-speed routes in Britain, and now are becoming favored on some of the most heavily used railroads elsewhere. Tie design has also been developed. A rectangular section of lumber is the simplest, and is still almost universal in North America, where ample supplies of suitable wood are available. In Europe, and particularly in Britain, reinforced concrete is generally superseding wood, usually Baltic pine. Concrete ties can be designed in a shape that provides strength to match the distribution of stress due to passing traffic; they were used with conspicuous success on the high-speed electrified line from London (Euston) to the North. The French railroads have also adopted concrete ties, but in a different form. Whereas the British design takes the form of a continuous concrete beam, the French arrangement has a concrete block beneath each rail, connected by a steel tie-bar. This design has also given excellent service on high-speed routes.

An essential of all track—particularly where continuous welded rails are used, as on most British high-speed routes—is a solid and well-maintained bed of ballast. This is usually provided by granite rock chips of regular size, which are solidly packed beneath and around the ties, and are spread to a considerable distance beyond them. With such a bed of ballast, no trouble is experienced with continuous welded rails, which have less freedom to expand along their length with

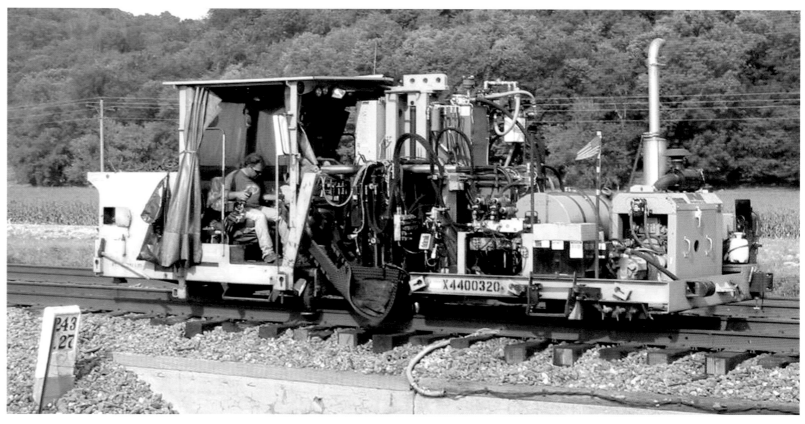

A spiker in use at Prairie du Chien, Wisconsin, on the Burlington Northern Santa Fe Railroad, in August 2004. The machine drives spikes into the ties to secure the rails.

changes in temperature—most of the stresses due to temperature change are absorbed internally.

Experiments were made in Europe with the so-called "slab-track" used on parts of the Japanese Shinkansen lines. Instead of ballast, there was a base slab of concrete that extended to the full width of the ordinary ties; on top of this was a paved slab. The latter took the place of the ties, the fastenings for the rails and their tie-plates being set in it. An advantage of this design is that it allows a reduction in total depth of the roadbed, which is beneficial in tunnels. The system was used to good effect in tunnels on the approach to Glasgow from the south, when the line was electrified and the rails had to be lowered to provide space for the overhead electric wires. Recently, some railroads have tried slab track on lengths of open line.

Another prerequisite of good track is a carefully designed system of drainage, particularly in areas where the subsoil is clay. There is a tendency for clay to migrate upward and impregnate the ballast, but this can be counteracted by the insertion of a thick layer of finely powdered granite between the clay and the ballast.

The need to reduce the cost of track maintenance and, at the same time, provide a line of consistently high quality on which high speeds can be run with complete safety has led to the design of many ingenious machines for such tasks as ballast cleaning, checking alignment, and, when repairs are needed, for changing ties without disturbing unduly the adjoining ties and ballast. In the past, the alignment was checked by the gauger getting down on his knees and simply looking along the rails. These men, with a lifetime of experience, were consummate experts at the job, and with two or three track layers on hand with their crowbars, any slight irregularities in the line were quickly corrected. Today, there is neither the time nor the labor for this skilled task.

One of the greatest boons to track maintenance is the automatic, self-leveling and tamping machine,

A Plasser & Theurer ballast tamper in action at Temple Meads station, Bristol, in England. The machine tamps down the crushed stone ballast beneath the tracks to produce a firm foundation for the line.

the word "tamping" meaning the packing of the ballast around the ties. Many variations of this machine are used throughout the world, at least one of which has a built-in alignment feature.

In keeping with the great advances in the basic design of track on what is termed "plain line"—that is where there are no crossings or other intersections—have been the developments in switches, or points, and the method of their operation. As with so many aspects of modern railroad equipment and working, it is often a question of line capacity. For example, at the junction of two first-class main lines, one route will probably be straight and the other involve a curve. Even with the most advanced type of junction switch in use until recently, a speed restriction of about 45mph (72km/h) would have been called for on the diverging route. Today, however, "high-speed turnouts" are installed, enabling the divergent line to be taken at 70mph (113km/h). These are also employed on some sections of quadruple track to enable a train to change tracks at 70mph (113km/h).

In recent times, much research has been applied to the wheel-rail interface, that very small patch of contact between the moving wheel and the weight bearing rail. This plays a crucial role in safety, wear and tear, noise levels, and traction efficiency. Rolling contact fatigue (RCF) is a key issue; it results in hairline cracks that are hard to discover and can eventually lead to rail breaks. The British Hatfield disaster of 2001, caused by a multiple rail break, gave fresh impetus to the study of this treacherous condition. Grinding of rail surfaces where such faults are thought likely, and the precautionary replacement of rails affected by them, are the normal measures taken. The cross-sectional shape of the rail, the nature of traffic passing over it, and the precise type of steel used seem to be the contributory factors in its occurrence, with curved track and switches being the most susceptible.

In heavily worked areas, particularly in and around cities where there is intense commuter traffic and

much complicated trackwork, the wear on the rails is often severe at the switch points in a switch layout. Moreover, it is a characteristic of the power units of multiple-unit suburban trains, with the electric motors carried on the trucks, to be very hard on the track. In consequence, it has become common for the most vulnerable parts of switch layouts, switch points in particular, to be made of highly wear-resistant, cast manganese steel, instead of ordinary rail steel. Over many years, it has been found that for standard rails, a medium manganese steel gives the best service for heavy, high-speed traffic.

The operation of switches and crossings is the job of the railroad signal and telecommunications engineer, in that he provides the apparatus to move the switches; where this is electric, as in all modern installations, the engineer designs the electric circuits for the control, with appropriate interlocking with the signal control circuits. The principles of interlocking are described in more detail later.

Modern electric switching apparatus has three functions. Before the switches can be thrown, the facing switch lock must be withdrawn. The provision of a facing switch lock is a legal requirement at all switches over which passenger trains run in the facing direction. When the lock has been withdrawn, the switches are moved over and the lock reinserted, securing the switches in their new position. The third function is to detect that the switch point is fully home and fitting snugly against the stock rail. Only when this has been confirmed is it possible to clear signals for a train to pass over the switches. The electric switching device completes all these functions in about three seconds.

A Russian track geometry car, used for checking various aspects of railroad track. As it passes over the track, the car employs a variety of sensors and auxiliary wheels to measure rail position, curvature, and alignment. It can also determine the smoothness of the rails and whether adjacent lengths of welded rail are level.

RAILROADS IN THE FAR EAST, FROM 1853

IN THE FAR EAST, RAILROADS VARY CONSIDERABLY IN COMPLEXITY
AND SOPHISTICATION. JAPAN AND CHINA HAVE EXTENSIVE
SYSTEMS; OTHER COUNTRIES ARE LESS WELL SERVED.

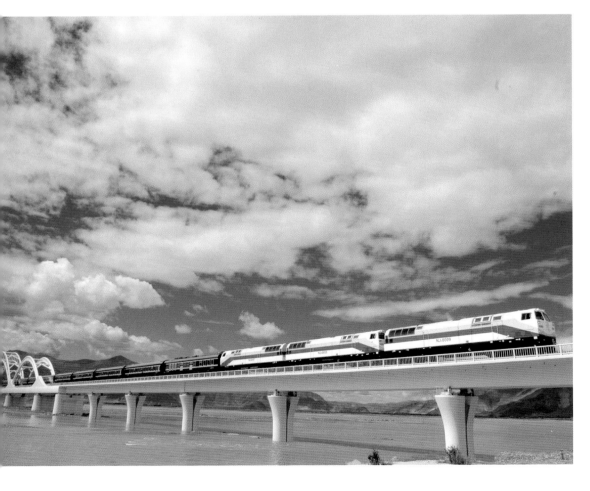

CHINA

After the first railroad line was opened in China in 1883, the possibilities of development soon began to be exploited by foreign investors, and building accelerated, particularly after the war with Japan in 1894. From 1908, all foreign contracts had to give complete administrative control to the government, and the formation of the republic led to a degree of consolidation of the railroads with the establishment of central control in 1915.

At the time of the Japanese invasion of Manchuria in 1931, the total route length was 9,022 miles (14,436km), but in the following period, over 3,728 miles (6,000km) were ceded to the Japanese. This led to a divided development of the area, the national government attempting to build new lines to compensate for losses to the Japanese in the

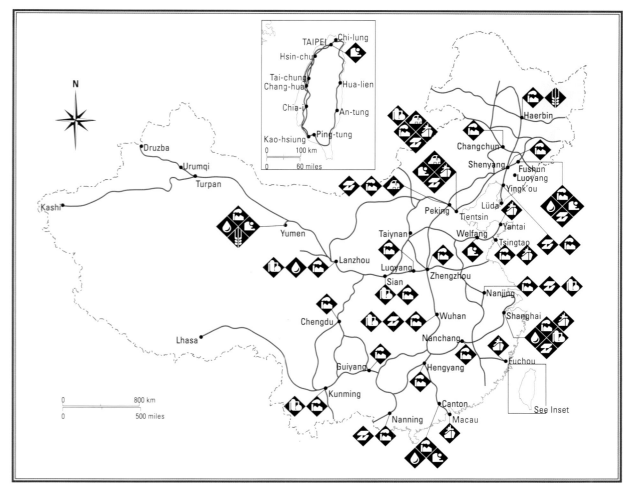

The establishment of railroads in China owes much to foreign interests. Even after World War II, substantial assistance was provided by the USSR. After 1960, however, China poured a massive effort into upgrading the system and extending it. With the country's present vibrant economy, the network will continue to grow.

Northeast. The two systems were reunited following the Japanese surrender in 1945.

Postwar development until 1960 was heavily assisted by the USSR, particularly after the establishment of the People's Republic in 1949. It was during this period that the link between Peking and Ulan-Ude in Russia, via Ulan Bator, was completed, thus cutting 1,500 miles (2,400km) off the old Trans-Siberian route to Europe via Kharbin.

Since the split with the USSR, the Chinese have forged ahead with railroad expansion, tackling difficult terrain with great determination, and a vast increase of route length is envisaged in the near future. The whole network is extremely well maintained.

During the last part of the twentieth century, mass production of the heavy QJ freight locomotive supplied most of the requirement for traction power, but steam is no longer used on the national system, being confined to industrial lines. Substantial orders for high-power electric and diesel locomotives have been placed in Japan, Europe, and North America, while other designs have been built domestically. In 2005, a plan was adopted to build 17,400 miles (28,000km) of new line by 2010, bringing total mileage to 62,100 miles (100,000km). Main lines have been steadily upgraded for higher speeds, but the faster and more numerous passenger trains have increased line congestion to such an extent that a policy of building segregated freight and passenger lines has been adopted. A high-speed line between Beijing and Tianjin was planned for completion in time for the Beijing Olympics. Moves to end Chinese Republic Railroads' monopoly position began in 1993; some lines have been taken over, or built, by local governments, and joint-stock railroad companies are also appearing.

Opposite page: The first Qinghai-Tibet train passes the La Sa Te bridge near Lhasa station in 2006. China opened the first train service to Tibet across what it called the world's highest railroad, a controversial engineering feat that was meant to bind the restive Himalayan region to China. ✳

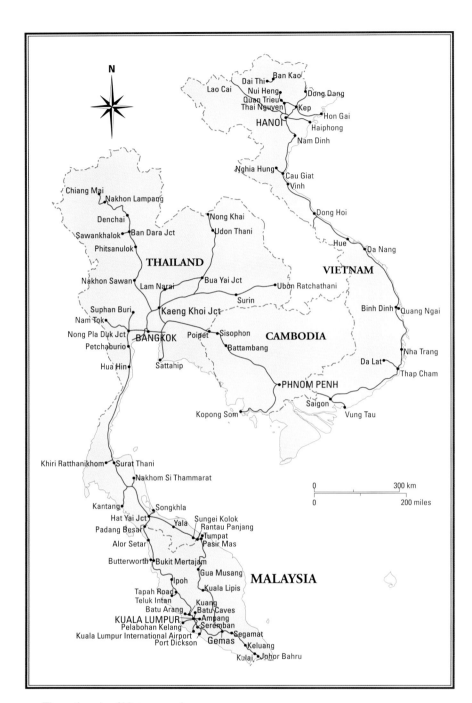

N

Ban Kaol
Dai Thi
Lao Cai
Nui Heng
Quan Trieu
Thai Nguyen
Dong Dang
Kep
HANOI
Hon Gai
Haiphong
Nam Dinh
Nghia Hung
Cau Giat
Vinh
Chiang Mai
Nakhon Lampang
Denchai
Nong Khai
Dong Hoi
Sawankhalok
Ban Dara Jct
Udon Thani
Phitsanulok
Hue
Da Nang
THAILAND
VIETNAM
Nakhon Sawan
Bua Yai Jct
Lam Narai
Ubon Ratchathani
Surin
Binh Dinh
Quang Ngai
Suphan Buri
Kaeng Khoi Jct
Nam Tok
Nong Pla Duk Jct
Poipet
Sisophon
CAMBODIA
Da Lat
Nha Trang
BANGKOK
Battambang
Petchaburio
Thap Cham
Hua Hin
Sattahip
PHNOM PENH
Saigon
Kopong Som
Vung Tau

0 300 km
0 200 miles

Khiri Ratthanikhom
Surat Thani
Nakhom Si Thammarat
Kantang
Songkhla
Hat Yai Jct
Yala
Sungei Kolok
Padang Besar
Rantau Panjang
Alor Setar
Tumpat
Pasir Mas
Butterworth
Bukit Mertajam
Gua Musang
MALAYSIA
Ipoh
Kuala Lipis
Tapah Road
Teluk Intan
Kuang
Batu Arang
Batu Caves
KUALA LUMPUR
Ampang
Pelabohan Kelang
Seremban
Kuala Lumpur International Airport
Segamat
Port Dickson
Gemas
Keluang
Kulai
Johor Bahru

The railroads of Vietnam and Cambodia suffered from a considerable amount of damage due to war in the 1960s and 1970s, but they have since been rebuilt. Thailand's system has links with the railroads in neighboring Burma and Malaysia. The latter's network is considered to be the best run in the region.

HONG KONG

Hong Kong's railroad opened in 1910, the British section of the Kowloon–Canton line. It is now part of China's system. Hong Kong has a separate mass-transit line.

TAIWAN

Taiwan's first train ran in 1891. Later, its 3ft 6in (1,067mm) gauge was adopted for all lines, the 109-mile (176km) East Line, built to 2ft 6in (762mm) gauge in 1939, being converted. Route length is 930 miles (1,500km). A high-speed line has been built from Taipei to Kao-hsiung.

VIETNAM

About 1,370 miles (2,210km) of meter-gauge lines were opened, the first in 1885. The system suffered from years of warfare and it is planned to rebuild only 1,045 miles (1,680km). Services between Hanoi and Saigon were reinstated in 1977. After peace came to Vietnam, there was considerable investment. Infrastructure and operating costs were separated in 1994, and an intermodal service was established from the port of Haiphong.

CAMBODIA

The Vietnam War put an end to rail transportation in Cambodia, but in 1993 trains did begin to run again.

NORTH AND SOUTH KOREA

Korea's first line was opened in 1899, and 3,980 miles (6,400km) were developed during the Japanese annexation of 1910–45. At partition in 1948, the network and stock were divided by 2:1, North Korea getting the greater share. In the war of 1951–3, much damage was done. North Korea's Korean State Railroad is now largely electrified; a few surviving steam locomotives were expected to disappear in 2007. Locomotives were imported from the communist world, and included Russian and Czech designs, but domestic production of locomotives has started.

The Korean National Railroad in South Korea has been a prosperous enterprise, many lines being electrified. A high-speed line has been built across the country from Seoul to the Sea of Japan.

MALAYSIA

Railroads were first introduced in Malaya in 1885. By 1918, the 490-mile (787km) West Coast line from Thailand to Singapore was complete, except for the Johore Strait causeway. The East Coast line was finished in 1931, providing another route to Thailand.

The Sabah State Railroad, which was built between 1896 and 1905 by the British North Borneo Company (Sabah was North Borneo until 1963) is part of Malaysian railroads.

The Malaysian railroads have benefited from considerable financial investment and are considered to be smartly run. In recent years, the Kuala Lumpur airport link has attracted much favorable attention because of its modernity.

INDONESIA

Indonesia's railroads are built to three gauges. The widest gauge is 3ft 6in (1,067mm); during World War II, the Japanese narrowed the standard-gauge lines. The first 16-mile (26km) line opened in 1864. Since then, Java has acquired a comprehensive network, but Sumatra has only three isolated systems.

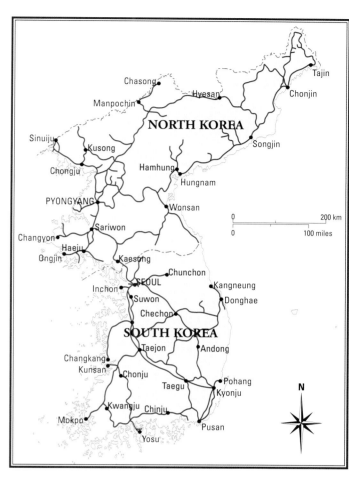

When the Korean network was split in 1948, following partition of the country, the North inherited about two-thirds of the track and equipment. Serious damage was done during the Korean War, but today both systems have a large amount of electrified track.

PHILIPPINES

Most of the Philippines lines are on Luzon, the main island, where the first railroad was opened in 1892 by the English Manila Railroad Company. Ownership of the system was acquired by the government in 1917.

THAILAND

Thailand's first line was begun in 1891, built to standard gauge. However, meter gauge was used for the south line, which was begun in 1898 to link with Malaya.

Burma also chose this gauge, and it was decided to convert the first line to this format as well, the work being completed in 1930.

Left: The majority of the rail network in the Philippines is on the main island of Luzon.

JAPAN

There could not be a greater contrast between the leisurely, almost primitive, beginnings of the Japanese railroad system in 1872 and the tremendous volume of passenger traffic carried at equally tremendous speed on the modern Shinkansen lines. With British advisers and mechanical engineers, the first lines, to 3ft 6in (1,067mm) gauge, were constructed on a meandering route along the coast from Tokyo to Yokohama. Those early railroads suited the temperament of the people of those days, being quite unable to hurry. Eventually, a narrow-gauge system was extended across the country, built by both the government and private enterprise. The mountainous nature of the country called for some heavy engineering works and confirmed the aptness of the original choice of a narrow gauge. When the government nationalized the seventeen major private railroad companies in 1906, it made itself the owner of 4,004 miles (6,407km) of route. From an early reliance upon foreigners, the Japanese railroads had quickly become self-sufficient, and a high standard of engineering was established.

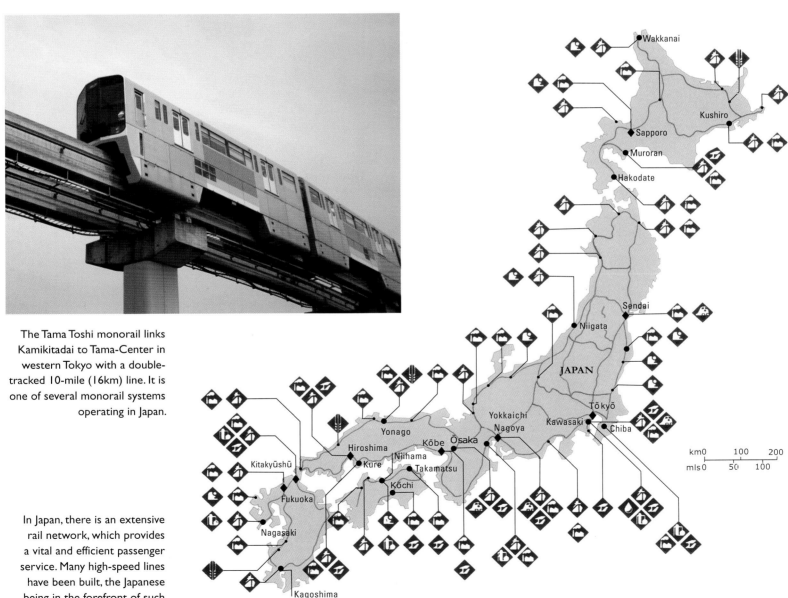

The Tama Toshi monorail links Kamikitadai to Tama-Center in western Tokyo with a double-tracked 10-mile (16km) line. It is one of several monorail systems operating in Japan.

In Japan, there is an extensive rail network, which provides a vital and efficient passenger service. Many high-speed lines have been built, the Japanese being in the forefront of such advanced technology.

A major consideration in any railroad construction work was to take every possible precaution against the effect of earthquakes; even so, much of the system, particularly the lines around Tokyo and Yokohama, suffered terribly in the catastrophic earthquake of September 1923. Accompanied by a tidal wave and fires, it destroyed much of those two great cities. Reconstruction was rapid, however, and by the early 1930s, the traffic on busier parts of the system was approaching saturation point.

Plans were then made for the building of a new high-speed line, using the European standard gauge, to provide for through traffic on the most congested line (between Tokyo,

Nagoya, Kyoto, and Osaka). It was not going to be a mere duplication of the existing line, but was entirely new and virtually straight to permit far higher speeds. The speed limit on existing lines was then 62mph (100km/h).

Development of this plan was interrupted by World War II, during the later stages of which the Japanese railroads were severely damaged by bombing. Such setbacks delayed the opening of the first of the new high-speed, or Shinkansen, lines until 1964. Its engineering was spectacular, carrying the tracks straight through or across any obstacle, and permitting continuous speeds of 130mph (210km/h). It set the pattern not only for extensions in Japan, but also for new lines in Italy, France, and West Germany. The Shinkansen was originally intended to be a general-purpose railroad, but its popularity proved so great that it was used exclusively for passenger traffic.

In 1987, Japanese National Railroads was split into five companies, each allocated a specific territory and intended for eventual privatization. A separate freight company handles bulk and intermodal traffic over the whole network. At the same time, the number of small local railroads increased as the new big companies divested themselves of minor and unprofitable operations. The Shinkansen lines have continued to extend, and some of the traditional lines have also been widened to standard gauge in order to accommodate them.

Unique styling sets the Nankai 50000 series electric, multiple-unit train apart from other high-speed trains. Introduced in 1994, the six-car trains operate an express service serving Japan's Kansai International Airport.

A Japanese commuter train ticket, bearing a photograph of the train concerned. The ticket is printed on ultra-thin plastic.

THE TRANS-ASIAN RAILROAD

ALTHOUGH NOT YET COMPLETE, THE TRANS-ASIAN RAILROAD
WOULD PROVIDE A THROUGH ROUTE FROM EUROPE TO CHINA,
BRINGING BENEFITS TO MANY COUNTRIES ALONG THE WAY.

Istanbul's magnificent terminus on the eastern bank of the Bosporus, Haydarpasa, is the planned starting point for the 8,750-mile (14,000km) Trans-Asian Railroad.

Only in recent years has the concept of a trans-Asian railroad come into prominence. The reason is that although the railroads in Turkey, Iran, Pakistan, India, Bangladesh, Burma, and Thailand were developing and extending, it was a long time before governments and railroad authorities gave any thought to the possible advantages of linking them. The United Nations Committee for Asia and the Pacific (ESCAP) became interested and began to hold biennial meetings to review progress. ESCAP's researches indicated that although long-distance through traffic was unlikely to be large, short-distance traffic on sections of the proposed Trans-Asian Railroad would often be considerable; the example of Turkey and Iran was cited, where there had been a substantial increase of international traffic since the railroads had been linked in 1971. ESCAP also estimated that overland freight shipping costs would be competitive with those of seaborne traffic.

The envisaged Trans-Asian Railroad starts at Haydarpasa, Istanbul's eastern terminus across the Bosporus. The railroad from Europe to Istanbul was completed in the 1880s, and train ferries

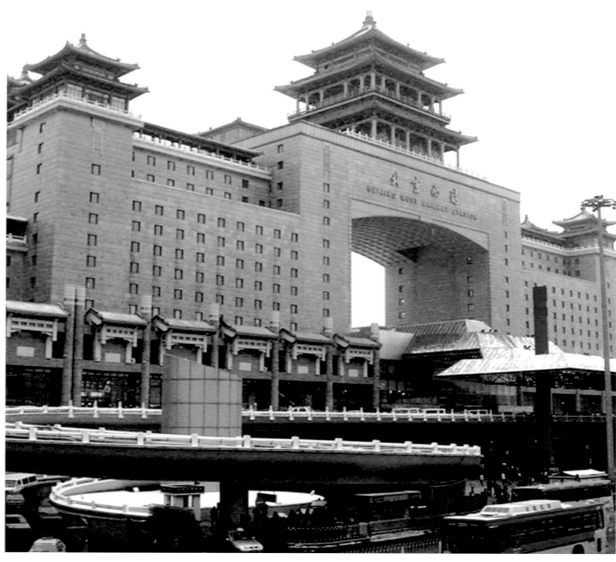

One of the goals of the Trans-Asian Railroad would be a link between Europe and China, possibly Beijing's West station, the largest in China. Trains departing this station leave for destinations in the West and South, except for coastal destinations, which are served by Beijing railroad station. The Jingjiu Railroad, or Beijing–Kowloon line, begins from this station. Since the opening of the Qingzang Railroad in 2006, it is possible to catch a direct train to Lhasa from West station.

take rolling stock across the Bosporus, although a railroad tunnel under the straits was expected to be ready in 2009. From Haydarpasa, the line climbs to Eskisehir and then runs eastward across rolling country to Ankara, the Turkish capital. From there, it passes through Kayseri and Malatya to Tatvan on the shore of Lake Van. Ferries carry trains across the lake, and so to the Iranian frontier at Qatur.

In Iran, the line skirts Lake Urmia to Tabriz and continues on to Tehran, through hilly and windswept country. From Tehran, the line runs south to Qom Junction, and from there southeastward for some 500 miles (800km) to Kerman. From Kerman, the line was planned to go to a junction with the isolated section of the Iranian State Railroad, running from Zahedan to Mirjaveh on the Pakistan border, a distance of less than 300 miles (500km).

At Murjaveh, the railroad would change from standard gauge to the 5ft 6in (1,676mm) gauge used in Pakistan and India. At first, it was expected that all passengers and freight would be transhipped; later, however, a plan was announced to reduce the amount of transhipment by changing the gauge of through rolling stock, as is done between France and Spain. The branch line of the Pakistan Railroad that runs to Mirjaveh will be rebuilt to main-line standards to take the anticipated through traffic. Trans-Asian trains will use this line, crossing the Indus at Rohr; from there, they will continue at speed on the electrified main line to Lahore. From Lahore, the line runs to the Indian border, and from there

to Delhi, then down the Ganges valley to the neighborhood of Calcutta.

With the gap between Kerman and Zahedan filled, there would be a through rail route from Europe to Calcutta, and the economic forecasts are favorable. The remainder of the trans-Asian route, however, has not been settled. It would diverge from the line to Calcutta some 186 miles (300km) north of the city. All the railroads in Myanmar (formerly Burma), Malaysia, Thailand, Cambodia, and Vietnam are built to meter gauge, so a transfer point for all traffic must be established somewhere in eastern India or in Bangladesh.

The Trans-Asian Railroad would cross into Bangladesh and run through the lush delta country to Chittagong. The government of Myanmar has approved in principle the plan for a railroad across the country, but has not indicated its preferred route. One possibility would be for the line to run south from Chittagong through Cox's Bazar and on toward Sittwe before turning east, penetrating the Arakan mountains, and crossing the Irrawaddy to Myingyan. From there, it could continue on existing lines to Thazi Junction and on to Taunggyi, before turning south on new construction to cross the Salween River to Thailand. Once across the frontier, in very mountainous country, it could join the Thailand State Railroad at Chiang Mai. There are several other potential routes, all equally difficult from the engineering viewpoint, and dependent on political decisions. The only point that seems to have been decided is that the line built in 1943–44 will not be followed.

Once on the Thailand State Railroads, the Trans-Asian Railroad will descend to the plains and pass through Bangkok. From there, it will run in an easterly direction to the frontier of Cambodia at Aran Pradet (Paoy Pet), and from there to Phnom Penh, the capital. This is the present railhead, but a line has been surveyed from Phnom Penh to Ho Chi Minh City (Saigon) in Vietnam. The Vietnam Railroads system runs from Ho Chi Minh City to Hanoi along the coast, then turns inland to Pingxiang, which is the frontier town of China. At Pingxiang, there already exists a transhipment point, where traffic transfers from meter gauge to Chinese standard gauge.

Because of various political tensions and a lack of resources, not much was done to make the project a reality in the first decades following its launch under United Nations auspices in 1960. In fact,

The majority of the route of the Trans-Asian Railroad already exists in the railroad networks of the various countries involved. There are gaps, however, and there is a significant problem in the different gauges used. At many places, there will need to be break-of-gauge facilities to allow trains to continue on their way.

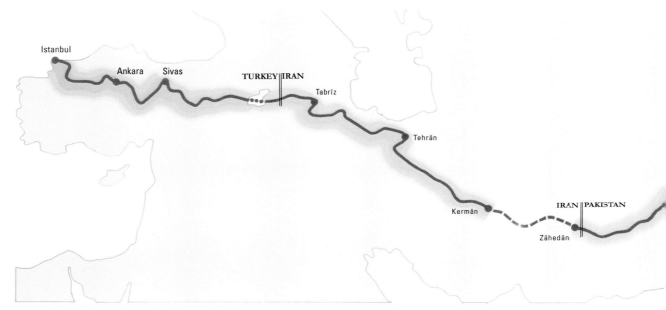

the project envisages four systems. There is the Southern Corridor connecting South China through Myanmar, Thailand, Bangladesh, India, and Pakistan, to Iran and thence Turkey. At present, there is a long gap in Iran and another in Myanmar, but a boost to the prospects of the Trans-Asian Railroad came in 2006, when India formally signed up to the project. With this encouragement, China offered help in restoring some of the intended link across Indo-China. The Northern Corridor is much farther north, through the former Soviet Central Asian republics, connecting China and Korea with Russia and thence Europe; Kazakhstan is already preparing a new standard-gauge line to provide an important link in this route. Then there is the North–South Corridor, from Northern Europe, Russia, and the Caucasus, or Central Asia, to the Persian Gulf. Meanwhile, an associated sub-regional system covers Southeast Asia, including Malaysia, Singapore, and eventually Indonesia. These projects entail enormous trouble and expense, not only involving different gauges, but also the choice of common technical standards.

A Korean Railroads employee explains the network of lines that will be incorporated in the Trans-Asian Railroad, over 40 years after the scheme was first proposed by the United Nations in 1960.

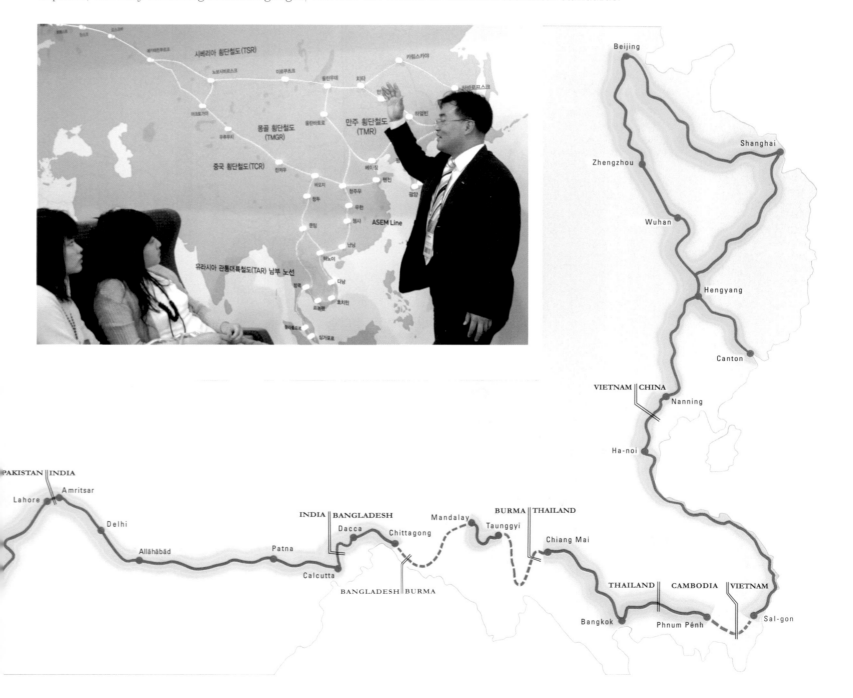

The Railroads of China

For many decades, Chinese railroads were financed by foreign interests, reflecting that in their equipment and working practices. Today, they are distinctly Chinese.

I n recent years, the Chinese railroads have become more obviously Chinese. This might seem an odd statement, but until less than 50 years ago, there were no Chinese standards or specifications; each railroad adopted the methods and designs of the country that had financed its construction. As a consequence, British, French, American, Japanese, Russian, and even Dutch and Belgian designs could be seen at work, which lent the railroads a colorful variety. While now Chinese standards and specifications are used, they are still influenced by the good railroad ideas of other nations.

There are just seven rail entrances to China. Since the country is enormous, covering an eighth of the habitable area of the world, this may seem very few, but China has, historically, never encouraged intercourse with other nations. Of those seven entrances, only two are in regular use. One of these is a line that leaves the Trans-Siberian Railroad at Ulan-Ude, crosses the Gobi Desert, and reaches Jining in China, where the passenger car trucks of Russian 5ft (1,524mm) gauge are changed for others of the Chinese standard gauge. The other is a line that drops south from the Trans-Siberian, from Chita to Kharbin. Of the remaining entrances, two connect with North Korea, two with Vietnam, and one other with the Trans-Siberian Railroad in Manchuria. The last three all require a change of gauge.

The Chinese railroads are well maintained, well run, and profitable. The standard-gauge track is solid and well ballasted. Bridges are being strengthened and loading gauges give ample room. A relic of British influence is that, on many railroads, high platforms are in use—through passenger cars always have end aisles and steps, with a deck that is used at high platforms. Passenger cars are eastern European in general appearance, while the freight cars, though based on British and Japanese designs, have an American look. In the main, motive power is diesel, although electric power is used increasingly on lines with heavy traffic and steep grades.

The principal lines run a distance of 1,400 miles (2,260km), from Canton in the south to Beijing in the north, via Wuhan, where the Yangtse is crossed on a magnificent road and rail bridge. The route

is mainly through hilly and attractive farmland, although after crossing the Yellow River on another remarkable bridge, the hills disappear, and the line crosses the great North China Plain bound for Beijing.

A second main route is that from Beijing, through Tientsin and Tsinan in Shantung, to Nanking on the Yangtse, crossing an even finer and larger bridge en route. From Nanking, the line runs southeast through rice paddies to the outlying factories of Shanghai, one of the largest cities in the world. From Shanghai, it continues south to Hangchow and onward in a southwesterly direction through lush farmland, which gradually becomes more hilly, joining the Canton–Wuhan line at Chuchou.

Perhaps the most remarkable of the Chinese railroads runs

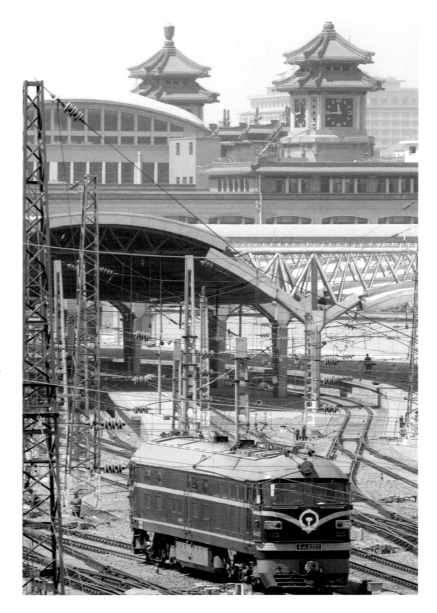

A diesel-electric train approaches Beijing railroad station in 2006. China embarked on an ambitious plan to upgrade all its rail network, the single most important sector of the booming economy's transport infrastructure. More than one trillion yuan ($140 billion) was to be invested in building 3,400 miles (5,400km) of high-speed tracks by 2010.

east and west across China, connecting with the two main routes already described. After crossing the fertile land of Honan, it enters loess country, where the scenery becomes spectacular, especially when seen from a shelf above the Yellow River. The line continues through Sian, an ancient capital of China, and Lanchow, a rapidly developing city. Then it runs over 620 miles (1,000km) westward to Tumen, with its oil wells, on to Urumchi and finally to Kelamayi, another oil city.

Two separate lines unite China proper with Manchuria, both reaching Shenyank (Mukden). This is at the center of an industrialized district, with the great Fushun opencast coal mine and the massive Anyang steelworks a short distance to the south. From Shenyang, railroads run south to Luda (Taien), southeast to Korea, northeast to Hailung, and north to Changehun and Kharbin, an industrial city on the former Chinese Eastern Railroad, which has junctions with the Trans-Siberian Railroad to east and west. There are many other lines in China, but those mentioned are the most important. The most spectacular of all, is the line running northwest from Beijing through the Nankow Pass, under the Great Wall, to Kalgan, and from there westward to Baotou and Lanchow. As can be seen, China's railroads are on a par with any others in Asia, and they are expanding faster than any in the world.

RAILS INTO TIBET

PLANNED ORIGINALLY TO HELP STRENGTHEN CHINA'S HOLD ON TIBET, THE QINGZANG RAILROAD PRESENTED ENGINEERS WITH FORMIDABLE PROBLEMS WHEN LAYING THE TRACKS.

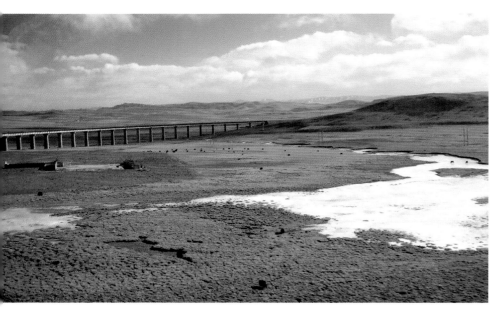

A viaduct on the Qingzang Railroad, a section of which holds the record for being the highest railroad line in the world. It runs through the Tanggula Pass at a height of 16,640ft (5,072m) above sea level. More than half the length of the railroad is laid on

In the nineteenth century, constructing railroads could be part of empire building, with colonial lines extending the territories claimed by the major powers. For example, British fear of any new Russian railroad pointing in the direction of India was a notable concern of diplomats during that period. In a sense, the new line connecting the Chinese railroads with the Tibetan capital of Lhasa echoes that history. For half a century after China's reassertion of control over Tibet in the 1950s, there was an urge to consolidate the situation by means of a railroad connection. The sheer physical difficulties of this held back the project, but finally, in 2001, work started, about 38,000 migrant workers being employed, for whom, among other things, four hospitals and more than 100 emergency medical centers were put in place. In 2006, a year ahead of schedule, the Tibetan line (known in China as the Qingzang Railroad) was opened by the Chinese president.

Passing through terrain that was long thought impossible for railroad building, the line extends from its junction with the main system at Qinghai for 710 miles (1,142km) to terminate at a grand station in Lhasa, modeled after the local architecture. In the course of their journeys, trains climb to more than 3 miles (5km) high. More exactly, the highest point is 16,640ft (5,072m) above sea level, which is far higher than the previous railroad height record in Peru's Andes. Some 87 miles (140km) of the line run at over 15,240ft (5,000m). This means that oxygen masks and trained first-aid staff have to be carried by all passenger trains, although only a minority of travelers need them. General Electric

provided high-power diesel-electric locomotives for the line, their engines being specially adapted for low atmospheric pressure. These, plus expensive engineering that kept gradients at a manageable level, mean that heights are not the main physical problem. What did cause enormous difficulties was permafrost, a condition in which the ground is permanently frozen, but can expand in the warm season, making the engineering of stable structures very arduous.

The Chinese engineers solved the permafrost problem in a variety of ways. Most substantial structures had bigger than normal foundations. In places, the roadbed was lined by parallel rows of hollow vertical rods. The alternate condensation and evaporation of moisture in these, plus convection, has a refrigerating effect on the ground into which they were driven. Elsewhere, horizontal steel pipes were laid transversely under the track, projecting on both sides. These have end doors, actuated by thermostats, that close to block the movement of warm air in summer, but open in winter to admit freezing air. In some places, sun canopies were fitted to keep the subsoil at freezing point during the summer. Despite all these precautions, however, there were instances of concrete developing cracks during the first year of operation, and in some quarters, there was doubt about the line's long-term ability to cope with global warming.

Also crossing below the track are many passages to enable the migration of wildlife. Considerable attention was paid to environmental factors, and in places native grasses damaged by the work were replaced. Inside Tibet, the construction of further lines is planned, an extension to Xigaze being the first. In fact, a Tibetan rail network is being created, and this will include a line into Nepal, which, no doubt, will cause sleepless nights in New Delhi.

Apart from the GE locomotives, a Chinese main-line design has also been introduced (known as the Snowy Land Holy Boat type), and some less important duties are entrusted to the standard Chinese built DF4 diesels. For the passenger trains, the Bombardier company built 361 cars in its Chinese plant. These had not only oxygen-supply apparatus, but also protection against ultraviolet radiation.

Passenger trains travel at 62mph (100km/h) on the new line, providing a journey time of little more than 10 hours. Considerable traffic has been reported, some describable as "pilgrim traffic." The trains also carry many foreign tourists, for this has become a contemporary "trip of a lifetime." The best time for tourists is summer, when both ends of the line can be seen in daylight. The middle sector, almost uninhabited, is less scenic. At the northern end, there is a sequence of glaciers to be enjoyed.

The Qingzang Railroad is a *tour de force* of railroad engineering, having been built through some of the most inhospitable terrain in the world. Engineers were faced with many difficulties, not the least of which was having to deal with permafrost. The line took five years to complete.

SHINKANSEN – JAPAN'S PIONEER FLYER, FROM 1966

THE INSPIRATION FOR HIGH-SPEED RAIL SERVICES AROUND THE WORLD, JAPAN'S SHINKANSEN TRAINS OPERATE ON THEIR OWN PURPOSE DESIGNED NETWORK OF TRACKS.

Opposite page: The 200 series Shinkansen trains were built for the Tohoku and Joetsu high-speed mountain lines in the 1980s. Although they resemble the original 0 series "bullet" train, they are lighter and more powerful. A small snowplow blade is built into the front to cope with winter conditions. These trains can travel at up to 150mph (240km/h).

The first railroad in Japan, built along the old Tokaido Trail in 1872, had no pretensions to being a speedway. On the recommendation of British engineers, it was built to the 3ft 6in (1,067mm) gauge, as used in South Africa, New Zealand, and much of Australia; to minimize the cost of construction, it took a meandering course near the East Coast, skirting obstacles and including steep grades. At first, this did not matter. As a nation, the Japanese of the nineteenth century had a complete inability—indeed a reluctance—to hurry, and the trains were very slow. They became little faster as the line was extended southward to the farther extent of the main island of Honshu.

How, in a mere 50 years, the Japanese changed from this pastoral, easygoing existence, first to defeat Tsarist Russia in a major war, and then to advance to become one of the leading industrial and military powers of the world is one of the phenomena of history. In the process, the Tokaido line of the Imperial Japanese Railroads, although enlarged to double track throughout and with the addition of several cutoff lines to ease grades and reduce overall distance, became completely saturated. In the late 1930s, although its 345 miles (552km) of route between Tokyo and Osaka represented only 3 percent of the total Japanese railroads, it was carrying 25 percent of the total passenger and freight traffic. This perhaps should not be surprising, since 40 percent of the total population of the Japanese islands and 70 percent of the industrial output were concentrated in the narrow belt of land between the central mountain range and the sea, being served by what can be called the old Tokaido line.

A scheme was worked out for an entirely new line that would cut the time between Tokyo and Osaka to 4½ hours. This was a startling proposal, because such a time would involve an average speed of 75mph (120km/h)—infinitely faster running than anything that had previously been made in Japan.

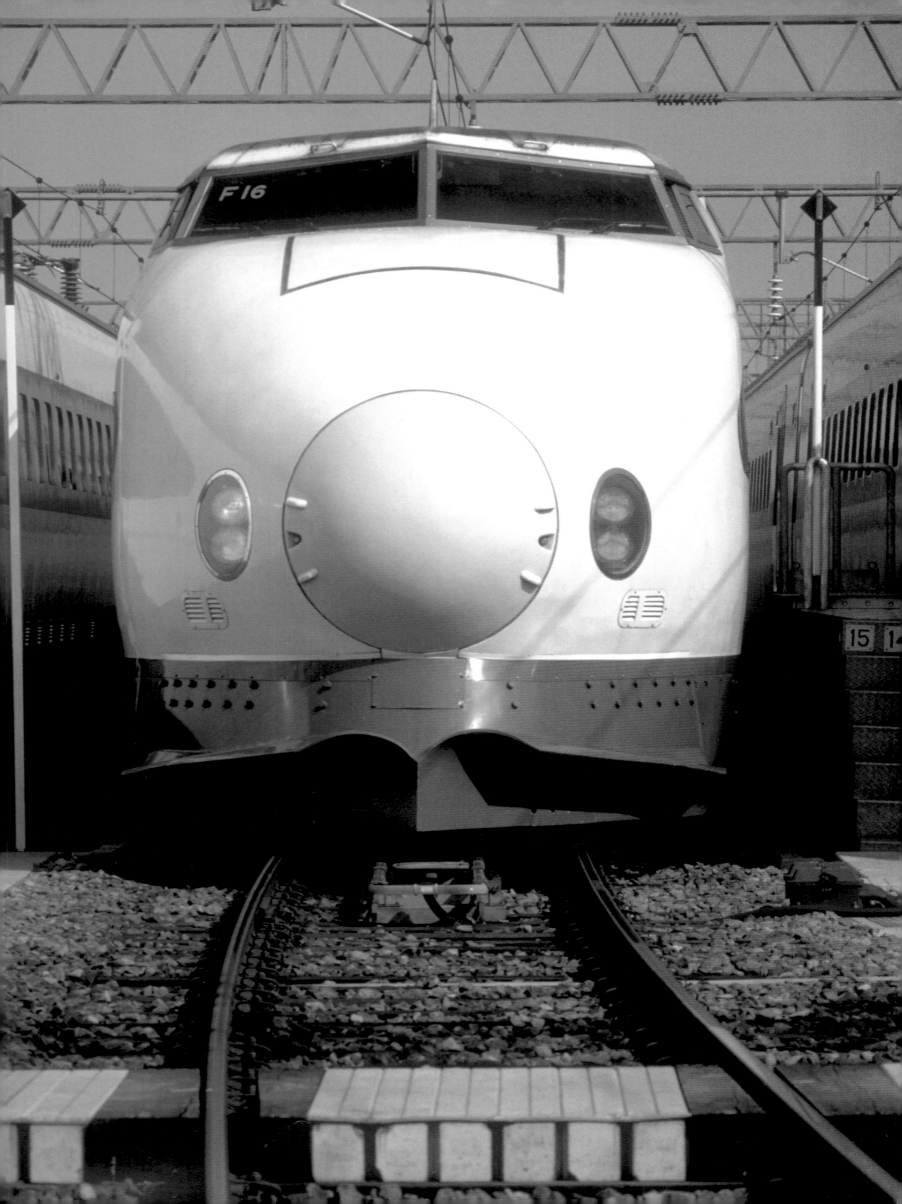

But the country's precipitate entry into World War II, and the tremendous damage to her railroads and industries that ensued before her surrender, necessarily caused suspension of the great plan. When it was revived after the war, it took an even more ambitious form. With the speeds that were proposed, it was considered that the 1,067mm (3ft 6in) gauge of the existing network would be inadequate, and this led to the conception of a new, quite separate Shinkansen line on the standard gauge. Moreover, having taken this decision, the Japanese National Railroads determined to build a line of such straightness and massive construction that the standard passenger train speed on it would be 200km/h (125mph). By comparison with what had been achieved previously in Japan, this was a staggering proposition. In August 1957, the government decided to set up an investigation committee. A year later, an aerial survey of the route was made. In March 1959, funds for construction of the line were included in the national budget, being approved within a few weeks.

The incredible speed with which the line was built was fully in keeping with the fast service that was promised. No more than a week after the project had been approved by the Japanese parliament, a groundbreaking ceremony was performed, and in the astonishing time of five years and five months, a full commercial service began between Tokyo and Osaka.

To permit uninterrupted high speed, outside the city area of Tokyo, no curve had a radius of less than 2.4km (1.5 miles). There were no road crossings, and in that densely populated strip of country, the line was carried for the most part on viaducts high above the towns, especially where there might have been intersections of any kind. Lengthy viaducts were built to take the line on the level across river valleys, and where mountains blocked the direct line of the railroad, there was no thought but to tunnel straight through. In view of the high speeds to be attained and the forecast intense utilization of the tracks, very great care was taken in forming the embankments to ensure that the piled-up earth was compacted adequately. The tremendous amount

The first stretch of the Shinkansen network, between Tokyo and Osaka, was opened in 1966. Later, it was extended to Hakata. Since then, the system has been progressively enlarged with new lines and extensions to existing ones.

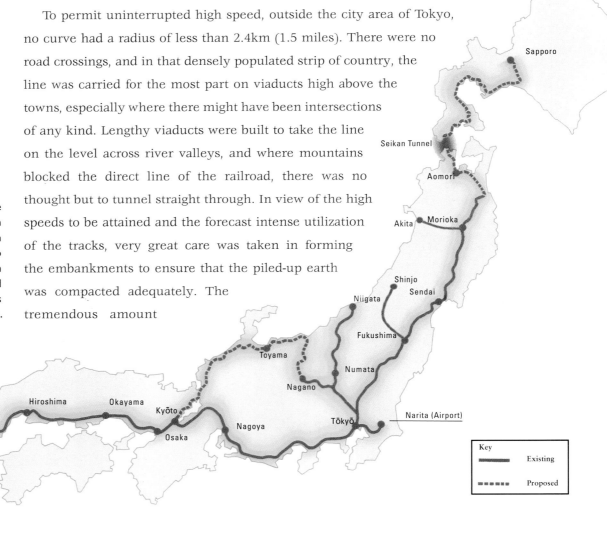

of work put into this feature of the construction was vital, since a high-speed passenger service was to be inaugurated at once. On older railroads in Great Britain and elsewhere, it was common practice to run at moderate or even slow speeds at first while all the earthworks were compacting fully, but the time schedule permitted no such settling in period on the new Tokaido line. In crossing urban areas, the tracks were carried on elevated rigid concrete frames, with rail level about 6.4m (21ft) above ground. These required a much narrower right of way at ground level than conventional embankments.

There were some very long bridges on the new line, mostly crossing the estuaries of rivers and adjoining marshland. One of these gives a magnificent view of the sacred Mount Fuji and, from the outset, has been a favorite place for publicity photographs of the new trains at speed. Great care was taken in the design of these bridges, many of which are in localities of natural beauty. The frequency of trains, both in these areas and where the line crosses urban complexes, led to the need to minimize noise. High parapet walls were built on many viaduct sections. There are no fewer than 66 tunnels between Tokyo and Osaka, and by this more direct alignment, the length of the line was reduced from the 552km (345 miles) of the old Tokaido line to 515km (322 miles). Twelve of the new tunnels are more than 2km (1.25 miles) long, and in all of them the aerodynamic effect of two trains passing at speed, which would give a combined speed of more than 400km/h (250mph), had to be taken into account. The standard distance between the nearest rails of opposing tracks in Great Britain is 1.8m (6ft), but in the tunnels of the new Tokaido line, this distance was made 2.7m (9ft). This is the standard 'distance between' on the new line as far as Osaka, but south of that city, and on subsequent extensions where speeds of 257km/h (160mph) were expected, this width was increased to 2.9m (9ft 6in).

Traffic operation on the new Tokaido matched the basic conception and the magnificent civil engineering. Between 6.00am and 9.00pm, one of the Hikari, or 'Lightning', trains left Tokyo approximately every 15 minutes for Osaka, covering the 515km (322 miles) in 3 hours 10 minutes, inclusive of brief stops at Nagoya and Kyoto. This was an average speed of 160km/h (100mph), and the volume of the traffic can be imagined—each train consisted of 16 cars and provided seating for about 1,400 passengers. The loading averaged about 1,000 passengers per train, taking an average over the entire day, and over all 365 days in the year. At midday, most of the trains were completely full. Taking the averages over the year, one could wonder why 55,000 people wanted to travel from Tokyo to Osaka every day, while another 55,000 were travelling in the opposite direction.

As a scenic ride, the Shinkansen was rather disappointing. The windows in the air conditioned coaches were placed rather high up in comparison to those of British and other European trains, and passengers had the impression of a landscape sweeping past, and built-up areas passing swiftly below. It was only when crossing the broad river valleys or where there were glimpses of distant mountain ranges that the view was appealing. Then again, much of the line is in tunnel. This is not so marked on the original section as it is on the newer stretches south of Osaka. On the Sanyo Shinkansen, south of Okayama, through Hiroshima to the very southern end of the island of Honshu, nearly 55 percent of the line is in tunnel – almost 225km (140 miles) of it. It is hardly the kind of journey one would choose

Eye-catching design on a Japan Railroad ticket.

This ticket bears the image of an 800 series Shinkansen train, which has operated on the Kyushu high-speed line since it was opened in 2004. Slightly slower than its predecessors, the 800 series can travel at up to 260km/h (160mph).

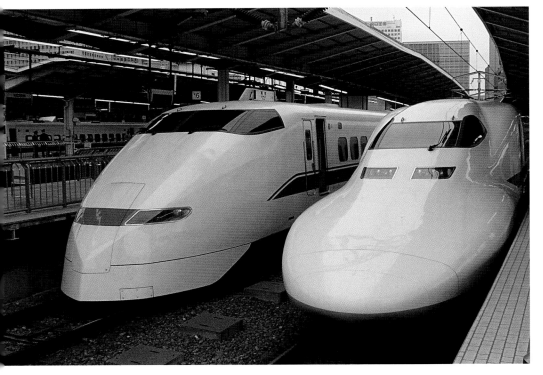

There are several different designs of Shinkansen train, being allocated to specific lines. Here, a 300 series (left) and 700 series are side by side at Tokyo Shinkansen station. Both operate on the Tokaido and Sanyo lines as 16-car units. The top speed of the former is 168mph (270km/h), while that of the latter is 177mph (285km/h).

for sightseeing, although it is certainly excellent for getting quickly to one's destination.

The section south of Osaka, to Shimonoseki, was 318 miles (509km) long, and the Hikari trains covered the distance in 3½ hours. However, the fastest trains running south of Osaka did not stop at Shimonoseki, but continued by means of the tunnel under the Kanmon Strait to the island of Kyushu. There, the Shinkansen line terminated at Hakata, which was reached in 6 hours 56 minutes from Tokyo. The Kanmon Strait is quite narrow, between relatively high ground on both sides, and the existing line ran in a tunnel beneath it, in a location that involved sharp curves at each end and steep grades. Because of the high speeds planned for the Shinkansen line, it needed a much longer and deeper tunnel, and the effect of this was seen in the schedules operated by the faster of the new trains, which did not stop at Shimonoseki and which covered the 133 miles (213km) from Hiroshima to Kokura in 1 hour 14 minutes—an average of 108mph (172km/h) start to stop.

A major project that will benefit the existing 3ft 6in (1,067mm) system in the north of Honshu, as well as the projected Shinkansen extension, is the great undersea tunnel between Honshu and the northernmost island of Hokkaido. The Seikan Tunnel is the longest undersea tunnel in the world, longer indeed than the tunnel under the English Channel. Although the Seikan has an overall length of 33.5 miles (54km), only 14.5 miles (23km) are actually under the sea. It was originally planned for completion in 1979, but unexpected and serious difficulties delayed completion, despite the most exhaustive preliminary surveys.

There was every reason for embarking on this daring project. Communication between the two islands was by train ferry, and the crossing from Aomori to Hakodate took four hours. It could be a very stormy passage, and on one occasion a ferry sank with heavy loss of life. The surveys revealed a vast fault on the sea bed, near the middle of the strait, from which unlimited volumes of water at high pressure would flow. Because of this, it was thought essential to have the roof of the tunnel 330ft (100m) below the sea bed, and at a depth of 810ft (247m) below sea level. This great depth in the center resulted in the tunnel being much longer than the actual distance across the strait, despite the use of fairly steep grades on each side. There is a level stretch for about 2.5 miles (4km) in the middle of the tunnel, reached by a 13.5-mile (22km) descent on a grade of 1.2 percent from the Honshu side. To reach the higher ground on the Hokkaido side, an ascent of no less than 17.5 miles (28km), also at 1.2 percent, is necessary. So far as power is concerned, such grades do not trouble the Shinkansen trains, with every axle powered and 1,000hp available for every car in the trains. The tunnel was designed also for trains running on the 3ft 6in (1,067mm) gauge. This was to enable the local trains from either side to benefit from the tunnel and make the use of the train ferry unnecessary.

The method of constructing the tunnel is interesting, in view of the exceptional depth below the sea. Along the line of the main tunnel, a method called "bottom drift" was used. A pilot tunnel was driven, to a distance of about 0.33 mile (0.5km) ahead of the main working to investigate rock conditions. Then the main tunnel was excavated to its full size in two stages, first the upper half and then the lower. The concrete for the arch was put in before the lower section, and finally the side walls were built. In the course of the work, additional pilot tunnels were driven to test rock conditions on each side.

The completion of this great work is awaited with the utmost interest, but in early 2008 authorization of Shinkansen extensions north of Tokyo had not been forthcoming. It is likely, however, that these lines will differ from the Tokaido and Sanyo Shinkansens in that they will carry a mixed traffic instead of being exclusively passenger. The original intention was that the Tokaido Shinkansen would be mixed, carrying freight traffic at night, but such was its success as a mass passenger carrier that a great number of additional trains had to be run beyond those originally planned, up to the present maximum of four Hikari per hour, and the night was needed for track maintenance. There was no chance to do anything in the brief intervals between trains in the daytime.

By 1980, ninety Shinkansen trains were leaving Tokyo daily for the south. The pattern had changed a little from that in operation before the extension beyond Okayama was opened. A typical set of departures was 12.00, 12.12, 12.16, 12.24, 12.36, 12.40, and 1.00pm. The 12.16 and 12.40 were "Kodama" and "all stations" to Osaka, which meant only three more stops than the Hikari at the other departure times. Already, however, the line was becoming saturated, and Japanese National Railroads was considering the construction of other lines.

New Shinkansen lines are planned. Already they extend to Hakata on the southernmost island of Kyushu, while the line destined for Hokkaido has moved steadily northward. A line across the main island of Honshu, from Tokyo to Niigata, has also been finished. The pattern was set by the Shinkansen program of 1988, which envisaged three kinds of Shinkansen. Type 1 comprised standard-gauge trains running at up to 186mph (300km/h). Type 2 was to be a conversion of 3ft 6in (1,067mm) lines to mixed gauge, on which narrow-profile ("mini-Shinkansen") trains would run at a reduced speed. Type 3 was to be lines with broad-gauge dimensions, but laid initially with the narrower-gauge track. Finance for the new lines would come partly from the railroad companies that would own them and partly from the government.

Later lines were rewarding, although not quite so profitable as the first. Local residents began to complain about the noise of these trains, and subsequent trainsets included new noise reducing streamlining and fairings alongside the pantographs. In 1996, The JR Central company ran a test train at 275mph (443km/h), and its regular Tokyo–Osaka service, with two intermediate stops, had an average speed of 128mph (206km/h). JR West company trains were reaching 186mph (300km/h) on the Osaka–Hakata line. Improved designs of train, with low-nose streamlining, appeared. Of these, the E2 series had a tilting mechanism; the prototype Fastech 360Z, which JR East was testing in 2007 for possible use on its "mini-Shinkansen" routes, also had this feature.

In 2007, work was proceeding on four new lines, extensions of existing routes. Since the Kobe earthquake, the Shinkansen trains have been fitted with earth-tremor detectors to enable them to stop in good time in the event of an earthquake.

BRIDGES AND TUNNELS

WHEN BUILDING RAILROADS, OVERCOMING NATURAL OBSTACLES OFTEN INVOLVES CONSTRUCTING BRIDGES OR BORING TUNNELS. THIS HAS LED TO SOME AMAZING FEATS OF CIVIL ENGINEERING.

The need to provide relatively straight track to meet the requirements of modern high-speed railroads has led to the construction of long bridges and tunnels over and through geographical obstructions. On these new railroads, the appearance of the bridges is notably different from the arched masonry viaducts of the pioneer lines, or the wooden trestles of North America. On the Japanese Shinkansen line between Tokyo and Osaka, for example, there are eight bridges that are more than 1,500ft (457m) long, the longest being the Fujigawa, at 0.9 mile (1.5km), within sight of Mount Fuji. In the main, the foundations of these bridges take the form of pneumatic caissons, 50–60ft (15.5–18m) in depth, on which piers of reinforced concrete are built. The superstructure varies, but where steel trusses are used, they are continuous, from one end of the bridge to the other. Construction employs the cantilever method, extending stage by stage from the completed part of the steelwork, which is anchored to the piers. On the Shinkansen lines, the standard length of span, from one pier to the next, is 195ft (59m).

In some locations, pre-stressed concrete girders are employed. These components are of quite remarkable design and provide complete support for a double-track, high-speed railroad. With its ballast and roadbed, the top platform has a total width of about 36ft (11m). The girder portion, which provides the strength to carry the weight of the trains, consists of four deep beams positioned approximately beneath the running rails. The total length of this cast, prestressed concrete unit is 75ft (23m).

Ingenious work is often involved where old bridges have to be strengthened or renewed to meet the needs of present-day traffic. If complete renewal is necessary and a new location is available, more straightforward modern techniques can be used. A remarkable example of such work is the Rajahmundry Bridge on the Howrah–Madras line of the Indian Railroads, 3,000ft (900m) downstream of the original bridge, with the piers in water about 40ft (12m) deep. In this case, the foundations are

Opposite page: A Japanese Shinkansen "bullet" train speeds across a bridge with the towering Mount Fuji providing a dramatic backdrop.

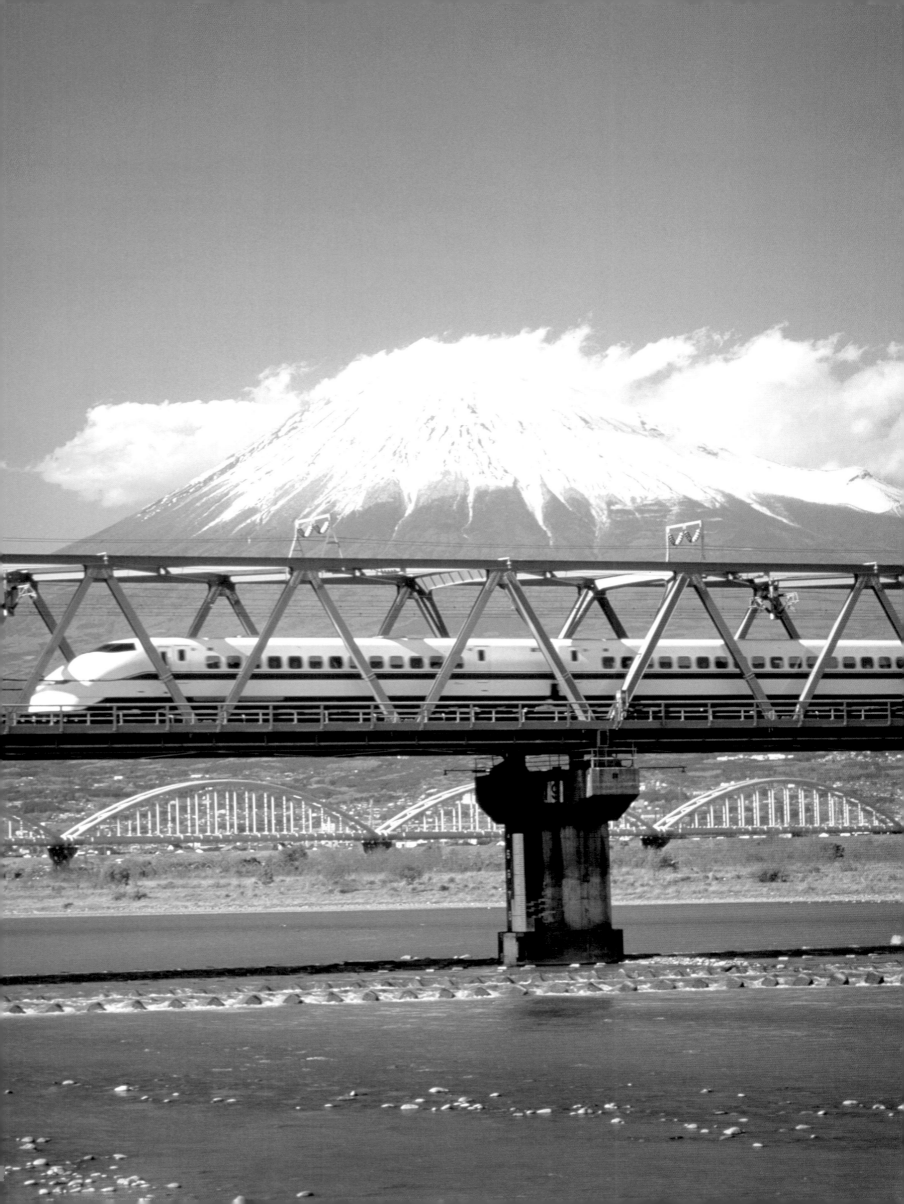

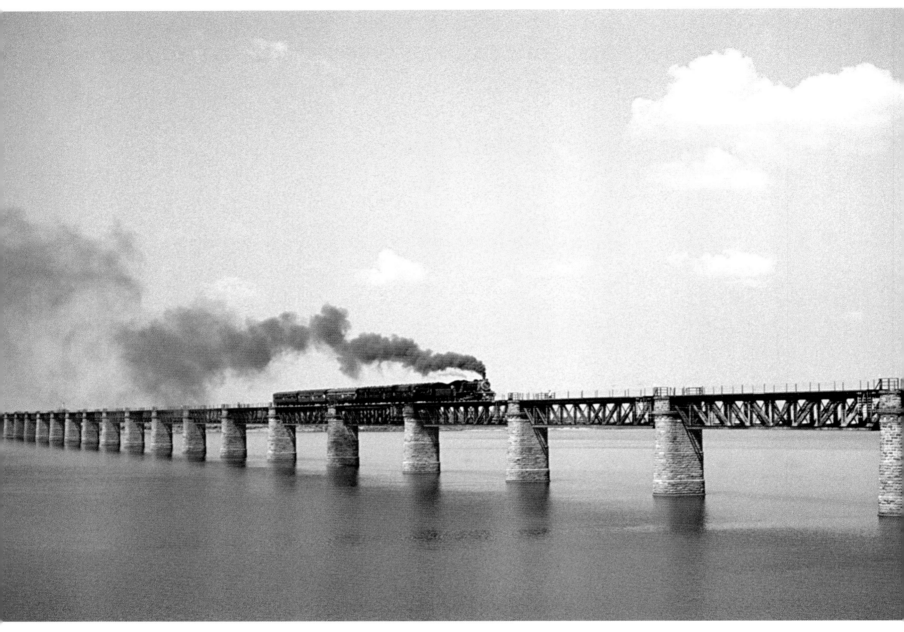

An XB Pacific steam locomotive of Indian Railroads hauls a passenger train over the old Godavari River bridge at Rajahmundry in Andhra Pradesh. Built by the British in 1900, the bridge has 56 spans and is 1.7 miles (2.754km) long. It comprises steel-girder deck trusses supported by stone columns. Today, this bridge is no longer in use, a replacement having been built alongside in the late 1990s.

on massive concrete wells sunk to a depth of 100ft (30m) below low-water mark to ensure stability in the river bed, even in conditions of maximum erosion during high floods—always a hazard on Indian railroads. This great bridge, which has a total length of 1.75 miles (2.8km), carries a roadway built to Indian national highway standards on the upper level, the double-track railroad being inside the 40ft (12m) high K-type trusses that form the superstructure of the bridge. These girders were erected by the cantilever method.

Despite many modern aids to excavation and subterranean survey, building tunnels still involves very much a plunge into the unknown; methods have to be varied according to the nature of the soil and rock encountered, sometimes after excavation has proceeded some way. In good ground, a favored technique of cutting through mountains and hillsides is known as the "bottom heading and half-section" method. A pilot heading (bore) is driven along the bottom line of what will be the finished tunnel, providing access and a means of removing the spoil. When this has covered an adequate distance, excavation to the full size begins in the upper half-section. Then shuttering is put in to support the

concrete of the top arch until it has set. With the upper half-section complete and the top arch in place, cutting on each side of the bottom heading is carried out, working outward to the full width of the tunnel until the side walls are ready to be concreted.

In bad ground, twin headings are cut at the bottom instead of a single heading on the centerline of the tunnel. In this case, a heading is driven along the line of each side wall, allowing massive walls to be put into place at an early stage. These provide protection against ingress of water or shale and support for the top arch shuttering. In some of the long tunnels of the Shinkansen lines, this side heading method had to be used for parts of the bores where the ground was considered to be too treacherous for any other method to be used.

A technique employed where there is a prospect of good ground throughout is known as the "top heading and bench cut." In this case, work begins with a heading in the upper half of the tunnel, which is enlarged to the full profile, allowing the top arch to be concreted. Then bulldozers are used to excavate the lower half to the full width, and the side walls are put in.

In recent years, when railroads have had to be run beneath waterways, excavation beneath the river or canal bed has been avoided altogether by the use of the "submerged tube" method. In Rotterdam, the Netherlands, for example, when the Metro was projected, it was known that excavation for the underground sections in the manner of London or Paris would be quite impracticable—the tunnels would fill immediately with water. Instead, a channel was dug, allowed to fill with water, and then the prefabricated tunnel sections were lowered into it. The tubes were constructed with sealed ends; after being butted together accurately, adjoining tubes were connected permanently. The same form of construction was used for San Francisco's Bay Area Rapid Transit line where it passed beneath the bay to Oakland. This tube is 4 miles (6.4km) long, and it is possible for trains to travel between the two centers in as little as eight minutes. For the underwater Channel Tunnel linking the French and British railroads, however, a huge boring machine was used.

A massive tunnel boring machine being lowered into place during the construction of the Channel Tunnel, which provides a rail link between England and France beneath the English Channel. Eleven machines of this type were used to drive the tunnel from both ends. The 31.35-mile (50.45km) tunnel took three years to build, being completed in 1994.

RAILROADS IN AUSTRALIA AND NEW ZEALAND

TWO DIFFERENT APPROACHES TO THE CONSTRUCTION OF RAILROADS WERE FOLLOWED IN AUSTRALIA AND NEW ZEALAND. IN THE FORMER, INDIVIDUAL STATE NETWORKS WERE THE RULE; WHILE IN THE LATTER, A NATIONAL NETWORK WAS CONCEIVED.

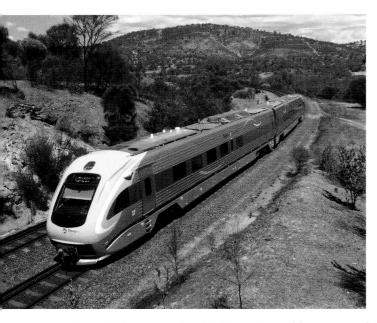

Above: A Prospector diesel train of Transwa at Toodyay, Western Australia, February 2004.

Opposite page, top: The *TranzAlpine* on the Midland Line between Christchurch and Greymouth, New Zealand.

Map: The railroads were comparatively slow in reaching the British colonies of Australia and New Zealand.

In both Australia and New Zealand, railroads appeared in colonial times, when there were varying degrees of local government, but London's approval was required for major undertakings. In New Zealand, the big developments began in the 1870s, although a handful of small lines had been built before then. At a time of economic depression, the New Zealand General Assembly accepted that the best way of ending the situation was to spend public money on useful enterprises. A Railroads Act was passed to institute a massive railroad building project, while a Gauge Act sought to standardize the gauge of the various lines.

The concept of great public works, in which huge investments were made at public expense, was also the rule in Australia. There, however, the railroads were sponsored and built by the local state governments, and the concept of a national network, with common technical standards, was not taken seriously until it was too late. Hence the problem of different gauges, which, despite considerable standardization, still exists.

In Australia, personal factors could be crucial; the chief engineers of the state government

railroads determined the gauge to suit their own personal preferences. The transformation of Australia into a federal commonwealth did not change the situation of the various state railroads, although it did lead to the construction of the Trans-Australian Railroad with its standard gauge.

In recent decades, the concept of state owned and state operated railroads has been questioned, and different states have followed various paths to introduce a degree of competition and private initiative. In Australia, new companies have appeared, while thanks to regauging, a recognizable national network has taken shape. The New Zealand experience in privatizing the state system, however, has been unhappy, and the long-term outlook is far from clear.

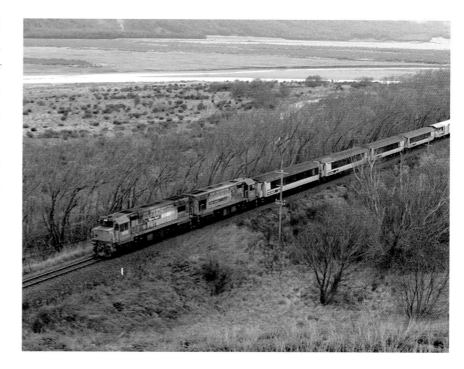

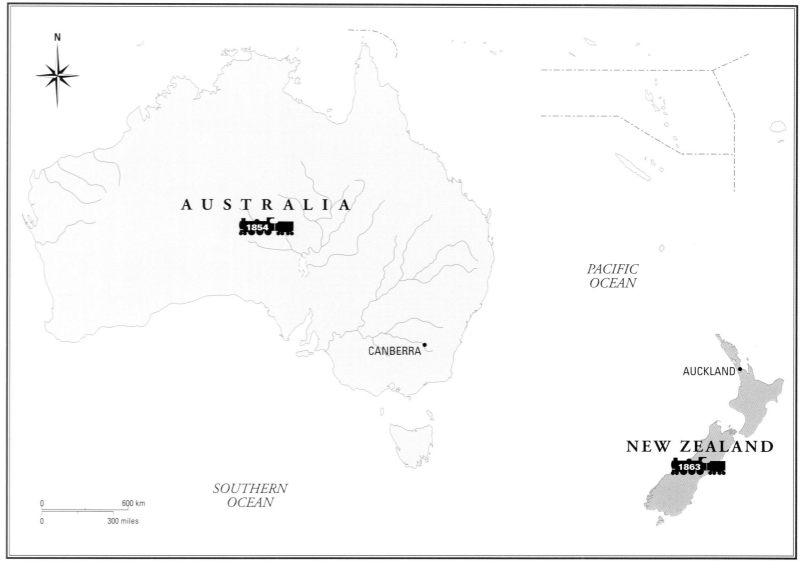

RAILROADS IN AUSTRALIA, FROM 1854

LOCAL STATE SPONSORSHIP OF INDIVIDUAL RAILROADS IN AUSTRALIA CAUSED PROBLEMS BECAUSE OF VARIATIONS IN TRACK GAUGE, AND WORKED AGAINST THE SETTING UP OF A UNIFIED NATIONAL NETWORK.

Introduced in 1937, the *Spirit of Progress* express was operated by Victorian Railroads. It was hauled by striking, streamlined, S class 4-6-2 locomotives.

Railroads began to appear in Australia at a time when the separate states were sparsely settled colonies, and matters of transport were controlled by the War Office in London. Initially, there were local enterprises in Melbourne (1854), Sydney (1855), and Adelaide (1855), but at an early stage, all were taken over by their respective state governments. In London, there was concern that the various independent projects should be built to the same gauge, but through intransigence and lack of communication, New South Wales adopted the European standard, while Victoria and South Australia opted for the Irish broad gauge standard of 5ft 3in (1,600mm). In Queensland and Western Australia, which were thought at first to be beyond any unified state system, the 3ft 6in (1,067mm) gauge was adopted to enable a greater length of line to be built for a given capital outlay.

When the Commonwealth of Australia was set up in 1901, an inducement offered to Western Australia was that a railroad would be built across the Nullarbor Plain to connect the state with those in the East. With a view to future standardization, the European standard gauge was chosen for this line. It was not until 1970, however, when the construction of further standard-gauge lines was complete, that

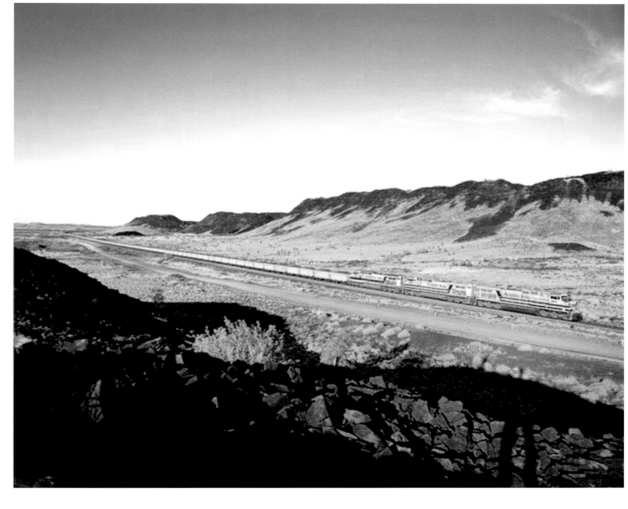

Industries such as Hamersley Iron, a subsidiary of the Rio Tinto Group, built private railroads to convey iron ore from the Pilbara region of Western Australia to the ports for shipment. Pilbara Iron operates and maintains mining, rail, port, and power facilities on behalf of Hamersley and Robe River. Here, one of the company's trains hauls iron ore across the arid landscape.

it became possible to travel without changing car from one side of the continent to the other, between Sydney and Perth in Western Australia.

The great conurbations of Sydney and Melbourne, around which nearly half the total population of Australia is concentrated, led to the electrification of the suburban lines at an early date. In Sydney, preparations had begun even before World War I, but the system was greatly developed with the completion of the Sydney Harbor Bridge in 1932 and the opening of the Circular Quay Loop on the underground line in 1956. In Melbourne, where at the great Flinders Street station all the passenger traffic is accommodated by multiple-unit electric trains, work on a quadruple-tracked underground loop, planned to spread the traffic flow more evenly around the city center, was completed in 1984. These tracks have a capacity of twenty-four trains an hour, while the station can handle up to 130,000 passengers an hour.

One of the most important recent developments in Australian railroad working has been the establishment of a number of long, single-purpose mineral lines. Some of these, such as the iron-ore run from Koolyanobbing, near Kalgoorlie, to the port of Kwinana, near Fremantle, and the coal run in Queensland, utilized existing railroad tracks. In northwestern Australia, however, great industrial organizations, such as Hamersley Iron, a subsidiary of the multinational Rio Tinto Group, have built their own railroads to act as giant conveyor belts from the mines to the ports of shipment. These special railroads have been built to carry a clearly defined tonnage of ore every day, which makes

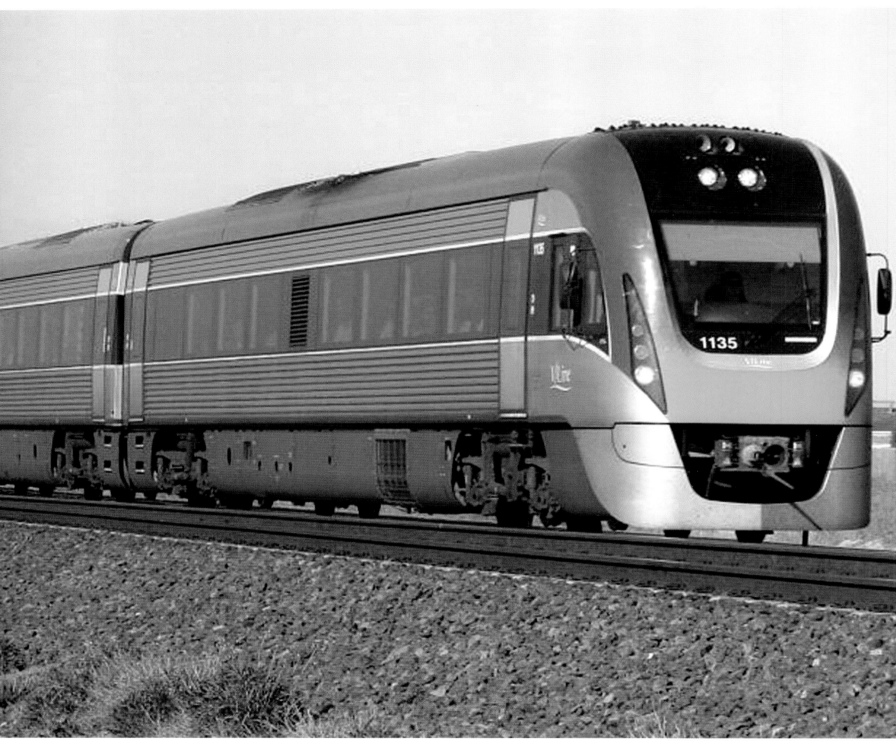

Owned by the State Government of Victoria, Australia, V/Line is a not-for-profit regional passenger train operation. Among its stock are several of these high-speed V/locity diesel, multiple-unit trains built by Bombardier. This example is shown at the town of Lara in 2006.

traffic regulation much simpler than that necessary, for example, on the Western Australia main line, where the lengthy ore trains have to be accommodated amid an otherwise mixed traffic, including some prestige passenger trains like the transcontinental *Indian Pacific*.

Large-scale restructuring of Australian railroads commenced in the 1990s and continues today, insofar as the new companies are still subject to mergers, acquisitions, and disappointments. The process differed from state to state, but invariably involved a separation of infrastructure from operations and the acceptance of open access for the new operators. Standard-gauge infrastructure of interstate significance was managed by the new Australian Rail Track Corporation. The private railroad

In Australia, the railroads were developed as separate entities, controlled by their respective state governments. As a result, there was no coordinated plan to create a national network. This has led to problems, not least the need for gauge changing facilities at some state borders. Most lines have been built in the most populated areas near the coasts, and few extend into the interior.

networks, which are owned by mining companies, have remained outside these changes.

Australian National Railroads took over the South Australian Railroads, but then was privatized, its freight operations being bought by a consortium trading as South Australian Railroads. In New South Wales, the State Rail Authority, which had earlier replaced New South Wales Government Railroads, was divided, its track being transferred to the new Rail Access Corporation, and its train operations to FreightCorp, Countrylink (for long-distance passenger services), and CityRail (Sydney commuter services). In Victoria, passenger, freight, track, and commuter services were split in a similar manner. Elsewhere, Westrail and a new track authority superseded the Western Australian Government Railroads. Tasmanian Railroads became Tasrail and was sold to an American consortium. Queensland Railroads remained a state railroad and, for the time being at least, retained its infrastructure while accepting open access in principle. Among the new operators was National Rail, formed to handle interstate freight, and the Great Southern Railroad, running the *Indian Pacific*, *Overlander*, and *Ghan* passenger trains.

During recent decades, there has been considerable reequipment. For passengers, the most impressive acquisition was a variant of the British High-Speed Train, known as the XPT, for services in New South Wales. In addition, the existing high-comfort passenger trains in Queensland were supplemented by Japanese designed, but homebuilt, tilting trains.

SPANNING THE ARID CONTINENT

THE TRANS-AUSTRALIAN RAILROAD HELPED TO FORGE THE COMMONWEALTH OF AUSTRALIA. IT CROSSES A VAST BARREN DESERT ON ITS ROUTE BETWEEN THE WEST COAST AND THE EAST.

When it was first proposed to integrate the individual Australian colonies into a unified federation, Western Australia stood apart. Separated from the rest by the virtually unknown desert lands of the Nullarbor Plain, the Western Australians saw no advantage in unification. Yet those in the East felt that without the western colony, federation could not be a success. To encourage Western Australia to join the federal government, they offered to construct a railroad eastward from Kalgoorlie to the nearest point of the South Australian system, which at that time was at Port Augusta. On the strength of this, and other inducements, Western Australia agreed to join, and the Commonwealth of Australia was inaugurated on New Year's Day 1901. Between Kalgoorlie and Port Augusta, however, lay more than 1,000 miles (1,600km) of virtually unexplored territory, occupied by only a few Aboriginal tribes. Consequently, it was some time before work began on the railroad.

Surveyors for the line went out on camels. The expeditions required considerable organization, because there was no chance of living off the land. It was so devoid of physical features and human habitation that every survey party had to be completely self-sufficient for its stay in the waterless desert. One thing the surveyors did discover was that the line could be made literally straight and practically level for hundreds of miles. Many years passed before estimates could be submitted to the federal

government to have the expenditure approved, and it was not until September 14, 1912, that the first soil was turned, with great ceremony, by the Governor-General of Australia.

The building of the line was like nothing that had gone before: there were no great mountain ranges to cross, no primeval jungles to cut through, no hostile inhabitants, no attacks by wild animals. As with the survey expeditions, the working parties had to be completely self-sufficient. In the 1,051 miles (1,682km) between Kalgoorlie and Port Augusta, there was not a single running stream, and provision of water for the construction gangs was the greatest problem of all. Water had to be divined, wells sunk, and reservoirs constructed; out in the open, with no trees for hundreds of miles, the midday heat was

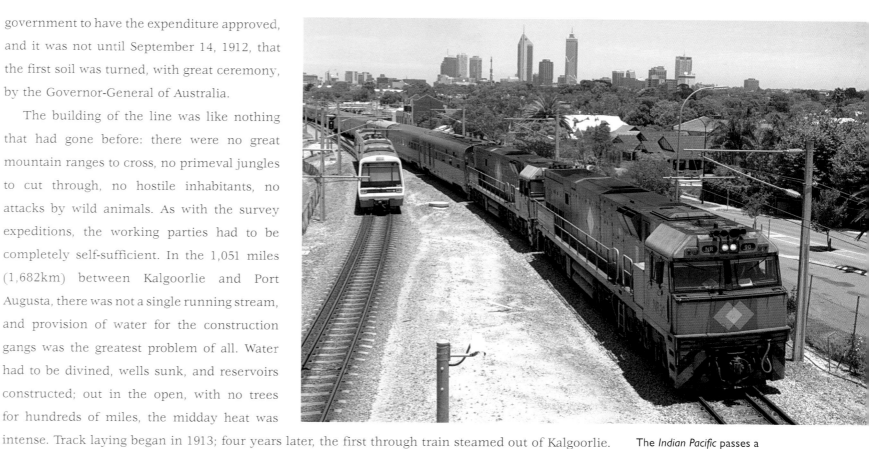

The Indian Pacific passes a Transperth commuter train on its way out of Perth, at the beginning of its journey from Australia's West Coast to Sydney on the East Coast.

intense. Track laying began in 1913; four years later, the first through train steamed out of Kalgoorlie.

It was not a through train in the ordinary sense, however, because the "Trans," as it is still called today, was laid to the 4ft 8½in (1,435mm) standard gauge, while at both ends, the gauge was 3ft 6in (1,067mm). Why the difference? At the time the Trans was authorized, the problem of different gauges in Australia was highly controversial. Only New South Wales had the standard gauge. The federal government had set its sights on ultimate standardization, however, and employing the standard gauge seemed logical, rather than the 5ft 3in (1,600mm) of South Australia and Victoria, or the restrictive 3ft 6in (1,067mm) of Western Australia and parts of South Australia. The decision was farsighted, because in later years, commercial interests justified the construction of a standard-gauge line from Kalgoorlie through Western Australia to the Indian Ocean; the final link with the standard gauge of New South Wales occurred in 1970.

When the Trans-Australian section of the Commonwealth Railroads was built, between 1913 and 1917, a vital consideration was the means of servicing steam locomotives. The line had to be entirely self-contained. At each end, it was flanked by narrow-gauge lines over which its locomotives could not run. Along its vast length of 1051 miles (1,682km), the stations were spaced not because of any need to serve local communities—these did not exist—but to meet the operating requirements of the line. They were sited to suit the coaling and watering requirements of steam locomotives, and for their replacement and remanning along the way. Three major intermediate depots were set up, splitting the line from Port Augusta to Kalgoorlie into four roughly equal sections. The depots were at Tarcoola, Cook, and Rawlinna, giving successive distances of 257, 256, 303, and 235 miles (412, 409, 485, and 376km). At each depot, locomotives were changed, but the crews were changed more often. All along the line, little townships were built to house and provide for the needs of men working the line.

Opposite page: A 1930s advertising poster, by James Northfield, extolling the virtues of the Trans-Australian Railroad. The line crosses the vast and arid Nullabor Plain, where the camel was the only other viable form of transport.

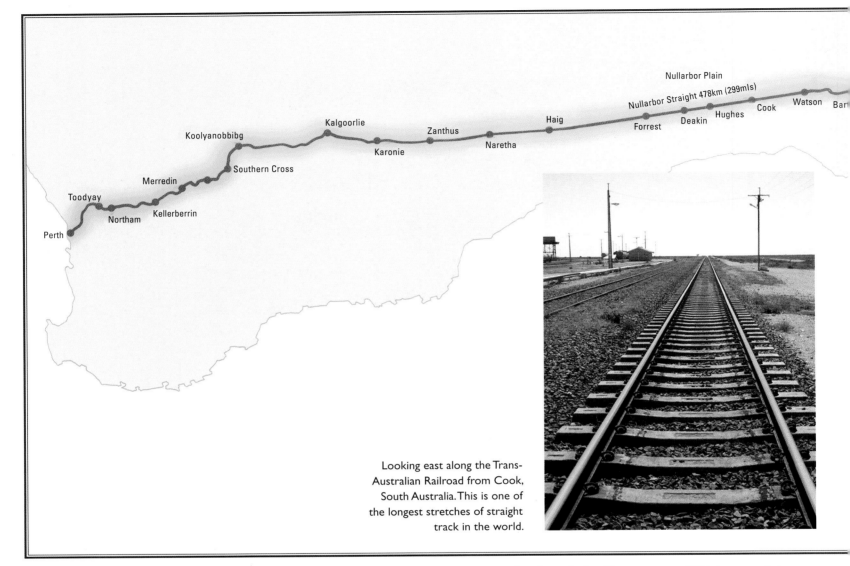

Nullarbor Plain

Nullarbor Straight 478km (299mls)

Cook Watson Bar

Forrest Deakin Hughes

Haig

Kalgoorlie Zanthus Naretha

Koolyanobbibg Karonie

Southern Cross

Merredin

Toodyay Kellerberrin

Perth Northam

Looking east along the Trans-Australian Railroad from Cook, South Australia. This is one of the longest stretches of straight track in the world.

The Trans-Australian Railroad helps link the continent by rail from east to west, a distance of 2,461 miles (3,938km). Through running trains were made possible by the construction of standard-gauge lines between Broken Hill and Port Pirie, and Kalgoorlie and Perth. Previously, these had only been served by narrow-gauge lines.

When the line first opened, the journey time for the whole distance was 37½ hours, giving an average speed of 28mph (45km/h). There were three passenger trains a week in each direction, and long before the introduction of regular airmail services, an excellent connection was provided with the fortnightly mail steamer from England. Landing at Fremantle and traveling over the 3ft 6in (1,067mm) gauge line to Kalgoorlie, passengers would change to the Trans and eventually reach the eastern cities of Australia. This service allowed travelers to cut two days from the journey between London and Melbourne, and three days if proceeding to Sydney.

With the introduction of powerful modern diesel-electric locomotives, there was no longer any need to change locomotives between Port Augusta and Kalgoorlie, but the crews changed at Tarcoola, Cook, and Rawlinna. They worked successive stages on a four-day roster from their home station. Thus a Kalgoorlie crew would work to Rawlinna the first day, lodge, and then go on to Cook the next day. On the third day, they worked back to Rawlinna, lodged again, and made the final run home on the fourth day. Similar schedules were organized from Port Augusta.

It is an extraordinary experience to ride in the locomotive cab over the 297-mile (475km) straight section of the Trans. When the line was first built, the ties were laid on the surface of the ground with very little ballast. Now, however, the line is heavily ballasted, and speeds of up to 70mph (113km/h)

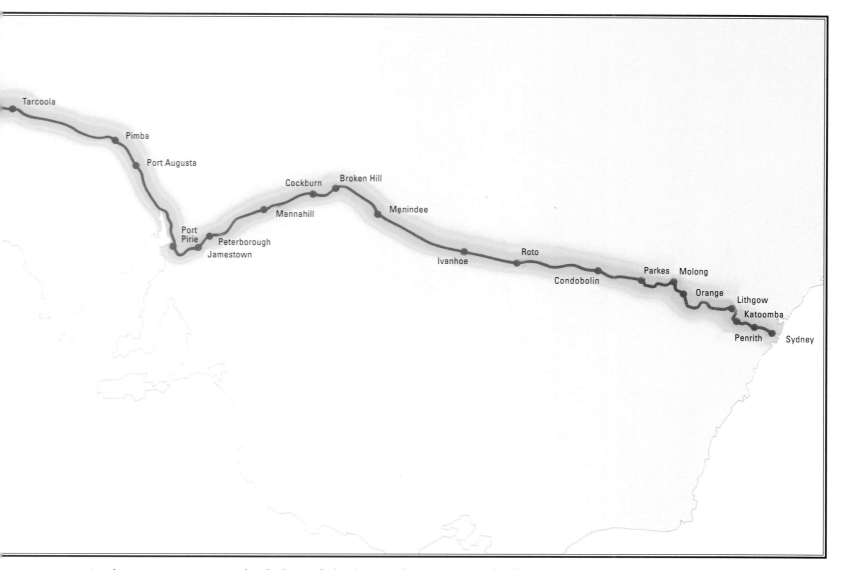

are permitted on some sections. The feeling of absolute nothingness is enthralling—there are some areas of low bluish scrub, but otherwise nothing as far as the horizon. The effect is extraordinary again when approaching one of the stations. First a few specks appear on the far horizon, which are gradually revealed as low buildings. Then comes the realization that they are being sighted over the curvature of the earth, as when gaining the first sight of islands or approaching ships at sea.

In 1970, the through train service across Australia was inaugurated—the *Indian Pacific*, named for the oceans at each end of the 2,461-mile (3,938km) journey. It travels over 729 miles (1,166km) of New South Wales tracks and 217 miles (347km) of the South Australian before reaching the Trans at Port Pirie. The section of 57 miles (91km) from this important junction to Port Augusta was changed to standard gauge years ago. The *Indian Pacific* runs twice a week, leaving Sydney on Wednesdays and Saturdays at 2.55pm. The arrival in Perth is at 9.10am on the fourth day, after two changes in time.

Passenger rolling stock on the *Indian Pacific* is of the highest standard in Australia and compares favorably with other prestige passenger stock. The stainless-steel cars are completely air conditioned, and there are many onboard amenities. Three classes of accommodation are offered: "Gold Kangaroo" (twin or single ensuite cabins), "Red Kangaroo Sleeper" (cabins with chairs convertible to berths), and "Red Kangaroo Daynighter" (reclining seats with extra legroom).

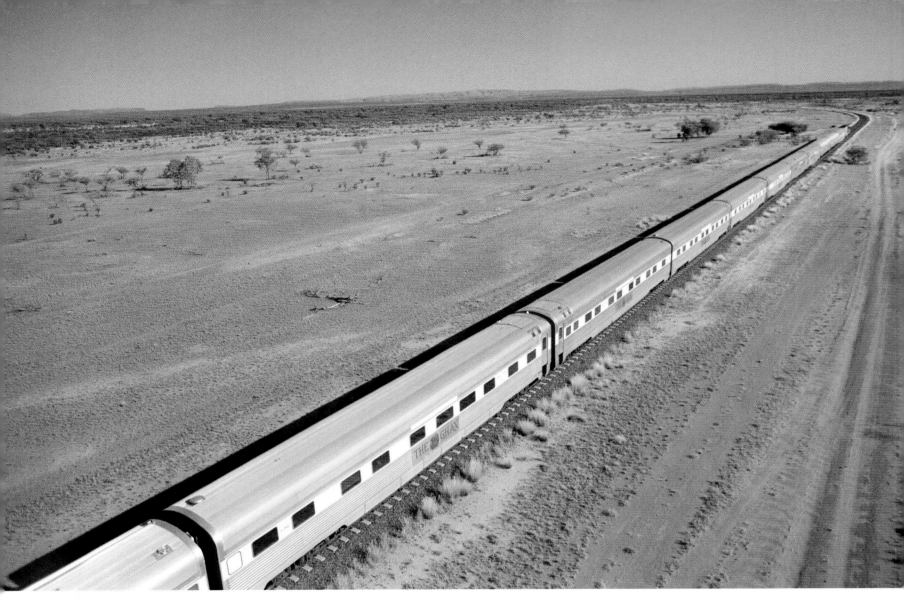

THE GHAN

TRAVERSING THE ARID HEART OF AUSTRALIA, THE GHAN PROVIDES
A VITAL LINK BETWEEN THE SOUTHERN CITY OF ADELAIDE AND
THE NORTHERN PORT OF DARWIN.

Above: The *Ghan* crosses the parched landscape of central Australia on its run between Adelaide and Alice Springs in January 1999. It would be another five years before the line would be completed through to Darwin.

The idea of a south–north railroad linking the northern port of Darwin with the rest of Australia had its proponents from almost the beginning of the railroad age, but as such a line would traverse arid, almost unpopulated country for most of its length, it did not receive great priority. There was a narrow-gauge line that ran from Adelaide to Alice Springs, however, and in the 1930s, this provided a passage for the *Afghan Express* (a name soon reduced to the *Ghan*) between those two centers, but the line did not prosper and gradually faded away. It was replaced by a standard-gauge line in 1980. Meanwhile, a line dropping south from Darwin had been started, but was far from reaching its goal of a linkup at Alice Springs.

In 2002, however, a serious endeavor began to fill the gap and reconstruct the existing lines. Track laying began in April of that year, and the 881-mile (1,420km) line was finished in 2003, the first trains running in January 2004. The speed of construction owed much to the use of massive track laying

trains. The line was not designed for high speeds, a maximum of 71mph (115km/h) being envisaged. Gradients were kept low, enabling heavy trains to be handled by a single locomotive or sometimes two. The ruling grade was 0.8 percent, apart from a few short lengths where it was 1.2 percent. Axle loads of 23 tons are permitted.

According to one source, the weight of track materials required was equivalent to 53 Sydney Harbor Bridges. Concrete ties were used; their extra weight was considered to be an advantage in coping with the frequent floodings that were anticipated, and they would not be attacked by wood boring termites, from which the original Adelaide–Alice Springs line had suffered badly.

The inaugural passenger train, named the *Ghan*, was a record-breaker in that it consisted of no fewer than 43 vehicles extending more than 1.2 miles (2km) and weighing 2,000 tons; even with that size of train, only two locomotives were needed. The original schedule provided for two return trains weekly, although one covered only the Adelaide–Alice Springs sector. The Adelaide–Darwin train completed the distance in two days.

The regular consist was 15 passenger cars plus some car-carrying vehicles, the total weighing about 700 tons and hauled by a single diesel-electric locomotive. Many of the cars provided facilities rather than seats or berths, so the total passenger capacity of the train was only about 250. For this and other reasons, fares were not cheap. There were three standards of accommodation, the cheapest being the "Red Kangaroo Daynighter," which offered a reclining seat and access to the "Red Kangaroo" lounge (for those passengers who were decently dressed). The two superior grades provided cabins with berths and access to one of the lounge/dining cars.

The train operating company is Great Southern Railroad, which took over the passenger services of Australian National Railroad in 1997 and became the operator of Australia's other transcontinental train, the *Indian Pacific*.

The *Ghan* suffered its first serious mishap in December 2004, when it was derailed after striking a highway truck at a railroad crossing. A daily freight train in each direction was operated in 2004. It was hoped that this would handle 250 double-stacked containers. In fact, traffic did not reach the anticipated level, but as freight shippers do take time to change their routines, the operating company remained optimistic. The line and the *Ghan* are now very much part of Australian life.

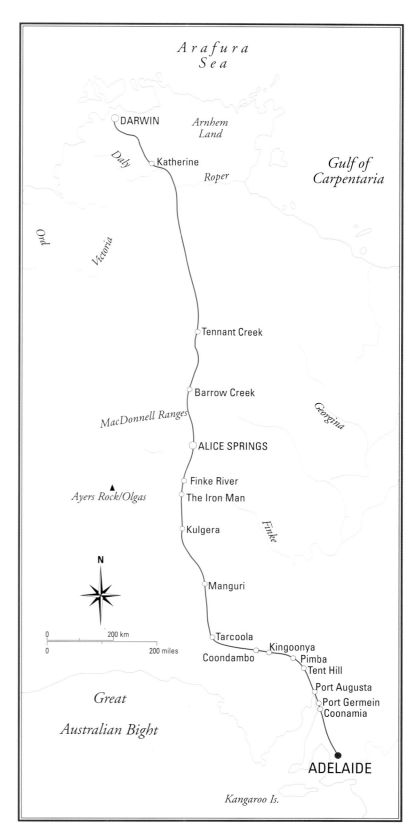

The *Ghan* ran originally on a narrow-gauge line to Alice Springs, but a standard-gauge line was opened in 1980. This reached Darwin in 2004.

RAILROADS IN NEW ZEALAND, FROM 1863

AS IN OTHER PARTS OF THE WORLD, THE RAILROADS OF NEW ZEALAND HELPED OPEN UP THE COUNTRY. ORIGINALLY STATE OWNED, THE SYSTEM HAS SINCE BEEN PRIVATIZED, ALTHOUGH WITH MIXED RESULTS.

One of two AB class 4-6-2 oil burning steam locomotives, operated by New Zealand's Kingston Flyer heritage railroad, takes on water at Kingston, 2005. New Zealand Railroads operated 141 of these locomotives, which were built between 1915 and 1925.

Early local railroad enterprises in New Zealand, all in the South Island, had resulted in no more than 46 miles (74km) of line being open to traffic by 1870. In that year, however, Julius Vogel, Colonial Treasurer, in a notable immigration and public works scheme, proposed the construction of some 1,500 miles (2,400km) of "cheap" railroad to open up the country. The idea was that as traffic grew, so the railroad would be improved. As a result, by 1880, 1,182 miles (1,891km) of track had been laid and opened to traffic, including the 369-mile (590km) South Island trunk line between Christchurch and Invercargill.

In the North Island, progress was slower, due to the mountainous country in the center. By 1886, however, there was a 250-mile (400km) line between Wellington and New Plymouth, run by the Manawatu Company. The North Island Main Trunk line, 426 miles (682km) long, between Wellington

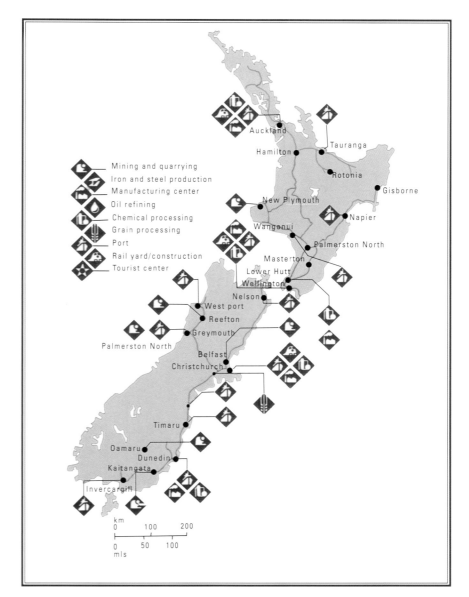

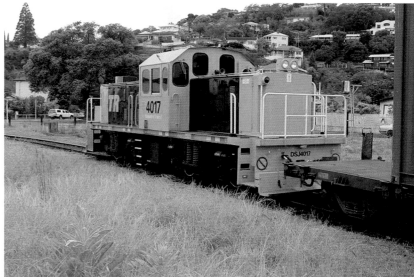

and Auckland was not completed until 1908. It included the famous Raurimu Spiral.

The Otago Central line in the South Island, providing a connection "over the garden wall," as it was jocularly described, between Dunedin, Alexandra, and Cromwell, was a somewhat protracted enterprise running through very rugged mountainous country. Begun in 1877, it was not finally opened throughout until 1921. In 1923, Westland was connected with Canterbury through the Otira Tunnel, but it was not until 1945 that the link between Christchurch and the present ferry port of Picton was completed. In the 1950s, several new lines were built to exploit large man-made forests in the North Island, and from 1968 onward, great improvements were made in many areas to shorten distances, ease grades, and reduce curvature on the "cheap" railroads built under the 1870 plan.

Subsequent restructuring appeared to go well at first, the inefficient state railroad being converted into a limited-liability company and then privatized by sale to a consortium led by the Wisconsin Central Railroad. The new company, Tranz Rail, seemed to manage well, but there was a gradual decline and services were reduced; finally, the government was forced to take back the infrastructure, leaving operations to be conducted by an Australian company, Toll Holdings, on a "use it or lose it" basis. Since then, a somewhat more optimistic picture has developed.

Top: A DSG diesel-electric switcher leaving Awatoto with freight cars bound for Hastings. This type of locomotive is in widespread use in New Zealand.

Above: The DSJ class is a versatile diesel-electric switcher used in New Zealand. It is single-engined, with a cab offset from the center, and is shorter and lighter than its twin-engined counterpart. The DSJ 4017 is shown performing switching duties at Ahuriri, South Island, in 2003.

Map: From the beginning, the railroads of New Zealand were planned as an integrated network with the intention of opening up the country.

The Southernmost Route

RUNNING FROM AUCKLAND IN THE NORTH ISLAND TO
INVERCARGILL IN THE SOUTH ISLAND, NEW ZEALAND'S NORTH–
SOUTH TRUNK LINE EXTENDS FARTHER SOUTH THAN ANY OTHER
RAILROAD IN THE WORLD.

Between 1863 and 1870, a number of short lines were built in New Zealand, mostly projected by provincial governments. These had several different gauges, but in 1870, the central government passed an Act that required all future railroads in the colony to be built to the 3ft 6in (1,067mm) gauge. Today, the principal main line in the North Island runs from Wellington to Auckland, and there are important branches terminating at New Plymouth on the West Coast, and Gisborne on the east. In the South Island, the principal main line runs south from Christchurch to Dunedin and on to Invercargill in the far south. There is an important northward connection from Christchurch to Picton, on the Cook Strait, while the east–west line, passing through the Southern Alps in the Otira Tunnel, connects to the industrial and mining centers of Greymouth and Westport. The railroads of mountainous New Zealand include many spectacular feats of engineering, dating from earlier years when the cost of deep tunneling could not be justified. The Otira Tunnel was not begun until 1908, but partly because of delays through New Zealand's participation in World War I, it was not completed until 1923. It has a total length of 53 miles (8.4km).

An early highlight of New Zealand railroad construction in the North Island was the Rimutaka Incline, where the line ascended 1,000ft (300m) in 14 miles (23km), then descended 869ft (265m) in less than 3 miles (5km). A center rack rail was employed, with special brake vehicles that gripped the center rail when descending, while tank locomotives with horizontal-grip wheels were used to haul the trains up—often four locomotives to a train. Now the mountain range is pierced by the Rimutaki Tunnel, which was opened in 1955 and is 5.47 miles (8.75km) long. Modern machinery and expertise enabled it to be built in a fraction of the time taken for the Otira. The secondary line to Napier and Gisborne, running for much of its northern part along the East Coast of the North Island, includes the

highest viaduct in New Zealand, the Mohaka. At its maximum, this is 318ft (97m) high; it consists of a series of latticed steel towers, tapering sharply in width from their bases.

When traffic increased, and with it the weight of locomotives and rolling stock, considerable improvements were made to the alignment where necessary to permit faster running. Even so, one of the most spectacular locations on the North Island main line remains. Running south from Auckland and entering the central mountain massif, the line comes to Raurimu; ahead is the task of climbing 700ft (213m) in 3.5 miles (5.6km), in a direct line. Such a grade as 4 percent would have been quite impracticable for the moderately powered steam locomotives originally employed on the line, but the track was laid out in the form of an ascending spiral. It includes a complete circle, two horseshoe curves, and two short tunnels, which artificially increase the distance between Raurimu and National Park to 7 miles (11km), with an average grade of 2 percent. At National Park, the traveler can get a close look at one of several active volcanoes.

Inevitably, the division of New Zealand into two halves by the Cook Strait has caused transport difficulties; although there are air services that provide for travelers who are in a hurry, there has always been the need to transfer railroad freight cars and highway vehicles. In 1962, a roll-on/roll-off, rail-highway ferry service was introduced between Wellington and Picton, and similar ships have revolutionized interisland transport.

With the exception of the approaches to the Otira Tunnel, the railroads in the South Island do not include such spectacular engineering as those in the North Island, but ample compensation is provided

A Tranz Scenic EF electric locomotive hauls the southbound *Overlander* long-distance passenger train near Waiouru, New Zealand, March 22, 2003. The train operates on the main north–south trunk line in the North Island, between Auckland and Wellington.

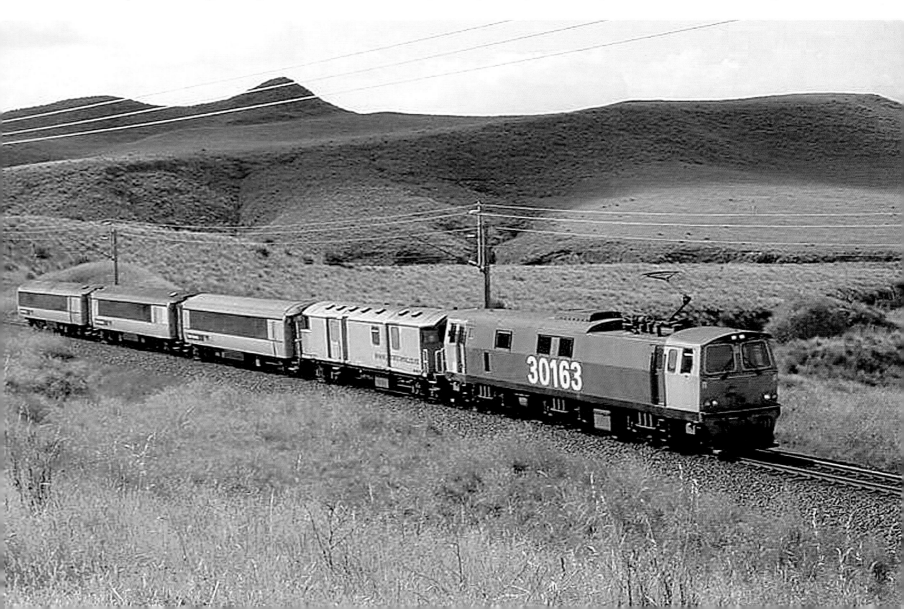

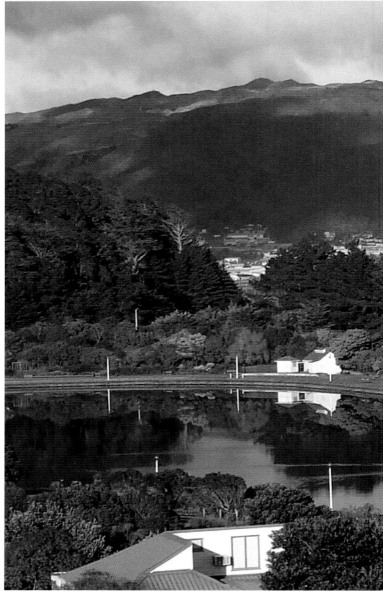

by the great historic interest of some parts of the system. The very first railroad in New Zealand was built between the port of Lyttleton and Christchurch, a distance of 4.25 miles (6.8km). Lyttleton is backed by a range of hills, and the original proposal was to go directly through them by means of a 1.25-mile (2km) tunnel, but this promised to be too expensive. Later, part of the route of this pioneer line, at Ferrymead, was taken over by a steam preservation group.

The journey south from Christchurch by a diesel hauled train called the *Southerner* had the particular fascination of reaching farther south than any other line in the world. The journey of 368 miles (589km) from Christchurch to Invercargill took just 10 hours; from the latter town, the track continued, but without a regular passenger service, to Bluff, the farthest south. After running beside or near to the East Coast for the first 280 miles (448km) to Balclutha, the main line south swung inland and westward before turning south again at Gore. This station was the junction for Lumsden, and from there, during the summer season, one of the most fascinating, and most remote, steam trains in the world operated. A branch line ran from Lumsden into the mountains to Kingston, lying beside the beautiful Lake Wakatipu, and here one could meet the *Kingston Flyer*—a train with a pedigree extending back nearly a hundred years.

In the 1880s, the branch line service between Gore, Lumsden, and Kingston was run by three small 2-4-0 tender engines built by Rogers, in the USA. They were highly decorated with a wealth of polished brass and copperwork, and their engineers used to run the branch trains in such dashing style that they were nicknamed the "Kingston Flyers." In 1971, the idea was born of running New Zealand's only vintage steam trains over the same route, and two of the celebrated AB class Pacific locomotives were saved from the scrapheap and restored to first-class working order to operate a modern *Kingston Flyer* service. This took 1½ hours to cover the 38 miles (61km) between Lumsden and Kingston.

The total length of the New Zealand Railroads is about 2,400 miles (3,900km), and most revenue comes from freight traffic. Passenger business, while efficiently operated, mostly in handsomely styled diesel railcars, was always quite small, not amounting to more than about 5 percent of the

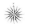

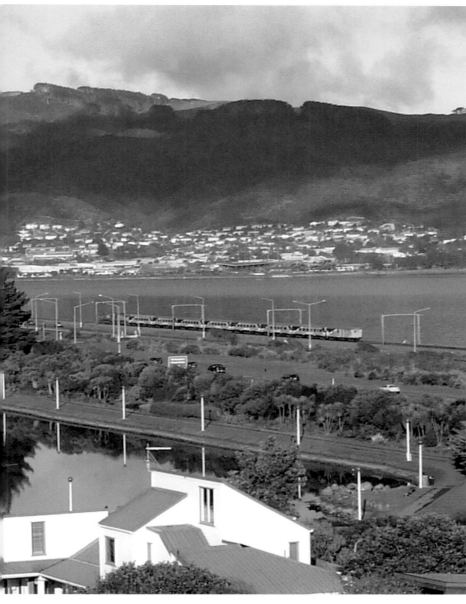

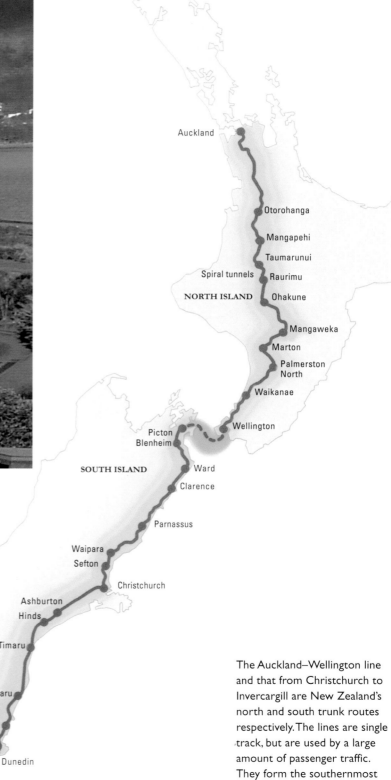

total earnings. The remaining revenue came from various ancillary services, including the Wellington–Picton train ferry. New Zealand Railroads was one of the pioneers, outside the USA, of Centralized Traffic Control (CTC), which was applied to most of the main lines.

Since the post-privatization difficulties, long-distance passenger services were reduced to four trains by 2006: the *Overlander* (Auckland–Wellington), the *Capital Connection* (Wellington–Palmerston), the *Tranz Coastal* (Picton–Christchurch), and the *Tranz Alpine* (Christchurch–Greymouth).

The Auckland–Wellington line and that from Christchurch to Invercargill are New Zealand's north and south trunk routes respectively. The lines are single track, but are used by a large amount of passenger traffic. They form the southernmost railroad route in the world.

SIGNALING SYSTEMS

EFFECTIVE SIGNALING SYSTEMS ARE ESSENTIAL TO ENSURE THE

EFFICIENT AND SAFE OPERATION OF A RAILROAD, PARTICULARLY

WITH THE ADVENT OF HIGH-SPEED PASSENGER SERVICES.

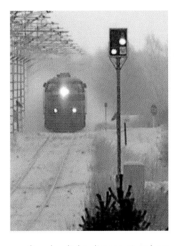

A color-light distant signal on the approach to Muhos station in Finland. The lights convey the message "Expect Stop."

The function of signaling is primarily to ensure the safe movement of trains, but equally, by giving clear and unmistakable indications, it is to give train drivers confidence to run at the maximum speeds permitted for each section of line. Modern signaling is the one feature of railroad technology without which it would be impossible to run high-speed services, or intense commuter programs. Today, signals are of the color-light type, although the code of indications varies from country to country. In Britain, it applies to "multi-aspect signalling": at junctions, it indicates the route the train is to take. In North America, the code signifies the speed at which the train should travel. Some European systems combine both "route" and "speed" aspects.

The basic safety feature underlying all modern signaling is the track circuit. Each line of railroad is divided into sections, insulated from each other, into which an electrical feed is made at one end. Connected across the rails at the other end is a relay, acting as a multipurpose switch. If there is no train in the section, the relay is energized and contacts are made. If the electrical feed along the rails to the relay is interrupted (by the presence of a train or a broken rail), the relay is de-energized. The contacts of the relay control the signal indication at the entry point of the track circuit, while other contacts enable the whereabouts of all trains to be indicated in the control center. The track relay is at the heart of the interlocking system performing a number of functions. It prevents conflicting signals from being displayed; keeps trains on the same line a safe distance apart; prevents the clearing of signals until the line ahead is correctly set through switches and crossings; and prevents the establishment of a lineup of switches that would intersect the lineup of another, creating a "collision course."

The regulation of traffic on important routes was greatly improved by the concentration of control at a few large centers, instead of in a chain of signal towers along the line. The British Rail panel signal tower controlled anything up to 100 miles (160km) of high-speed main line in addition to the local working around a large station or junction. The whereabouts of all trains were indicated by lights on

a track diagram. At junctions or among the many lines around a large station, the routes were set by the signalmen. Unlike the days of mechanical signaling, there was no need to operate each function separately. The signal immediately before a junction could lead to a number of different routes, and first the entrance button was pressed. Then the signalman selected the button at the exit of the required route. If the interlocking was free, because no conflicting movement was signaled, pressing the exit button set up the whole route. When all the switches on the route were aligned and had been detected, the signal at the entrance to the route cleared automatically and the train was able to proceed. This system, with others, remains in use.

The safeguards against a signalman's error are now so complete that modern systems are virtually accident-proof as far as track relay systems are concerned. There is no corresponding safeguard for the train driver. On British Rail, it became standard practice to sound a warning in the cab at every signal. On the approach to a green (clear) signal, a bell rang in the cab; on approach to a first-warning double yellow, or a final-warning single yellow, a horn sounded. In the case of a clear indication, no action was required from the driver, but at the warning, the horn sounded until an acknowledging lever was operated. If done promptly, control of the train remained in his hands. If he failed to acknowledge after a brief time, the brakes were applied automatically. Similar systems were developed elsewhere.

In-cab audible warning, or audible warning system (AWS), is not quite preventative. To meet that need, forms of automatic train protection (ATP) have been evolved. British Rail developed its BR-ATP, in which beacons ("balises"), set at intervals between the rails, transmitted key items of information, such as signal indications, to a computer in the passing train. This worked out how much brake should be applied and whether the train was conforming to permissible speed. If the driver did not comply with the indications, the brakes came on automatically. This system could virtually eliminate the quite common, occasionally disastrous, phenomenon of the "Spad" (signal passed at danger). Following an accident, BR installed this system over its entire network. Realizing the expense of this, the government of the day canceled further development of the system. It was replaced by the train protection and warning system (TPWS), which was much cheaper and simpler. By installing a speed trap in advance of signals, it added to the older AWS systems the ability to bring to a halt any train ignoring a stop signal. On French TGV lines, a system similar to that of the abandoned BR-ATP was installed. It employs a continuous information transmitting system based on codes conveyed through track circuits.

In 1999, a European Union directive required all new and upgraded EU lines to conform with the European Railroad Traffic Management System (ERTMS), so in Britain and elsewhere, a new signaling system (European Train Control System or ETCS) will be installed. When widespread, this will eliminate the expensive and inconvenient profusion of traffic management systems that were slowing international operations in Europe early in the twenty-first century.

ETCS comes in several levels. ETCS-1 employs balises and improves safety, but provides no economic benefits. ETCS-2 uses the Global System for Mobile Communication-Railroads (GSM-R), which provides a train with an uninterrupted stream of information, so trackside signals are no longer required. ETCS-3 does not use the fixed-block section or track-circuit train detection. Trains are monitored by a control center, and they travel inside their own moving block, the size of which depends on their braking distance at any particular point.

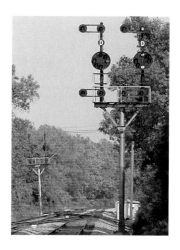

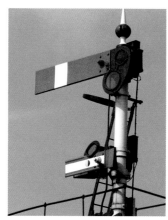

Top: A two-head, color position signal on the CSX Railroad in Maryland. Each circular head contains six lights, the color and position of which indicate line occupancy ahead and permissible speed.

Above: An old British Rail semaphore signal. If horizontal, the arm instructs the train driver to stop; if lowered, it signifies that the line ahead is clear. At night, a light is shone through either the red or green lens to indicate the status of the line ahead.

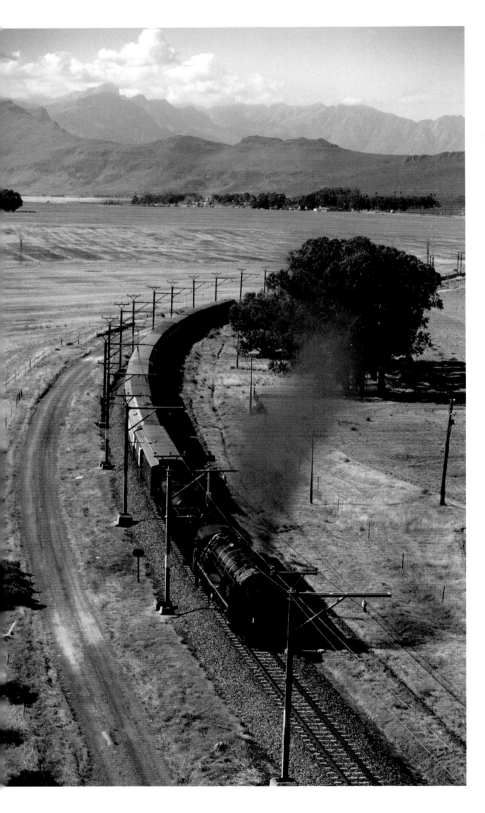

RAILROADS IN AFRICA

IN AFRICA, THE CONSTRUCTION
AND RUNNING OF RAILROADS
HAS BEEN, AND IS, BESET WITH
MANY DIFFICULTIES. EVEN
SO, THEIR VALUE IN AIDING
DEVELOPMENT IS FULLY
APPRECIATED.

The development of the African rail network up to the present time can be divided into two distinct phases. The first was as an aid to colonial exploitation and expansion by several European powers, but notably Britain and France. The colonial experience left Africa with a series of lines running inland from the coast; only in southern Africa were lines joined up into a semblance of a network.

The second phase began at the gaining of independence by the various African states. Railroads were seen as a means of binding together countries that, in some cases, were little more than loose amalgamations of tribal areas. Separate lines were linked to form national railroad systems, branch lines were

For the most part, railroads arrived in the countries that make up Africa as a result of colonial exploitation, notably by Britain and France. Subsequently, following independence, these railroads were seen as vital to the development of sound economies in Africa.

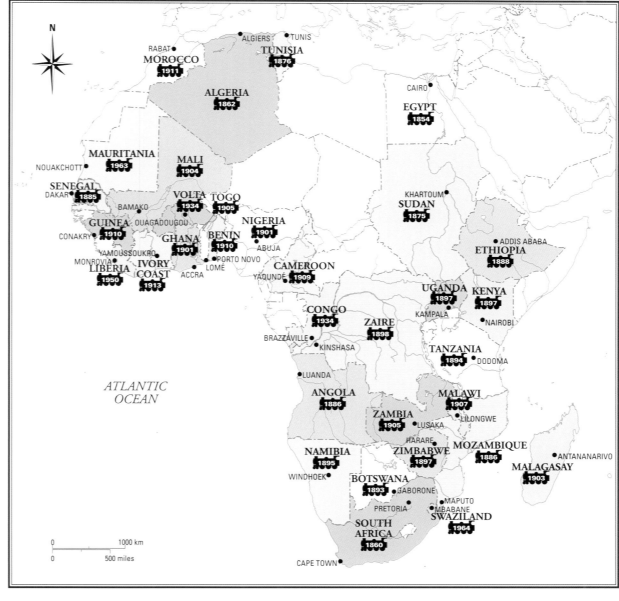

constructed, and attempts made to extend the railroads into areas that were not previously served.

A third, future, stage is the creation of a pan-African rail network. This can be said to have begun with the vision of Cecil Rhodes, who foresaw a line running the length of the continent, from the Cape to Cairo. Rhodes' legacy is the fact that most of the railroads in southern Africa were built to the same 3ft 6in (1,067mm) gauge, and several countries are now linked together. In the 1920s, a through service operated from Cape Town to Bukama, at the upper limit of navigation on the River Congo. More recently, southern African politics have precluded such services, but in theory, it would be possible for trains from Cape Town to travel to Kindu in Zaire, Lobito, Angola's main port, and to Dar-es-Salaam, the capital of Tanzania.

The 1,162-mile (1,860km) line from Zambia to Dar-es-Salaam was a major undertaking, only completed in 1975. Gabon, which emerged from the colonial era without any railroads, began work on a 434-mile (695km) line in the late 1970s, while other countries continue to extend their networks. Despite a great many difficulties, in Africa at least, the railroads are still regarded as a vital part of a nation's infrastructure.

Opposite page: A restored class 25NC 4-8-4 steam locomotive, formerly of South African Railroads, hauls a Rovos Rail luxury tourist train through the striking landscape between Cape Town and Pretoria, April 1992.

Railroads in Northeast Africa, from 1854

THE EARLY DEVELOPMENT OF RAILROADS IN NORTHEAST AFRICA OWES MUCH TO BRITAIN'S EMPIRE BUILDING ACTIVITIES ON THE CONTINENT AND FARTHER EAST.

EGYPT

Although much of Egypt appears to be far from any railroad, most of the population is confined to the Nile delta and valley. These inhabited areas are as well served by rail as many densely populated areas of Europe.

As early as 1834, a railroad was proposed from Alexandria to Suez as a means of expediting the Indian mails. Work on such a line began in 1851, with Robert Stephenson as engineer; Cairo was reached in 1856, and Suez in 1858, although the stretch across the desert was made unnecessary by the opening of the Suez Canal; it was dismantled twenty years later. No doubt, Stephenson's appointment was responsible for the standard gauge being employed on the Egyptian railroads.

The system developed in two separate forms, the comprehensive network in the delta, and the Upper Egypt (or Nile valley) railroad; the two were not linked at Cairo until 1898. South of Luxor, the Upper Egypt line was 3ft 6in (1,067mm) gauge (standardized in 1926). At Shellal, steamers waited to convey passengers to Sudan, and this line's completion in 1898 was seen as a link in Rhodes' envisaged Cape-to-Cairo route.

The two world wars internationalized the system further. By 1918, Egyptian rolling stock could be seen in Jerusalem. During World War II, the North Coast line reached Tobruk (Libya), and Egypt was linked with Europe when the Lebanese coastal railroad was completed. Political turmoil in the Middle East since the end of World War II, however, has prevented any through rail services from being developed further .

Opposite page: A freight train of Egyptian National Railroads threads its way gingerly past the teeming Friday market in Cairo, December 2000.

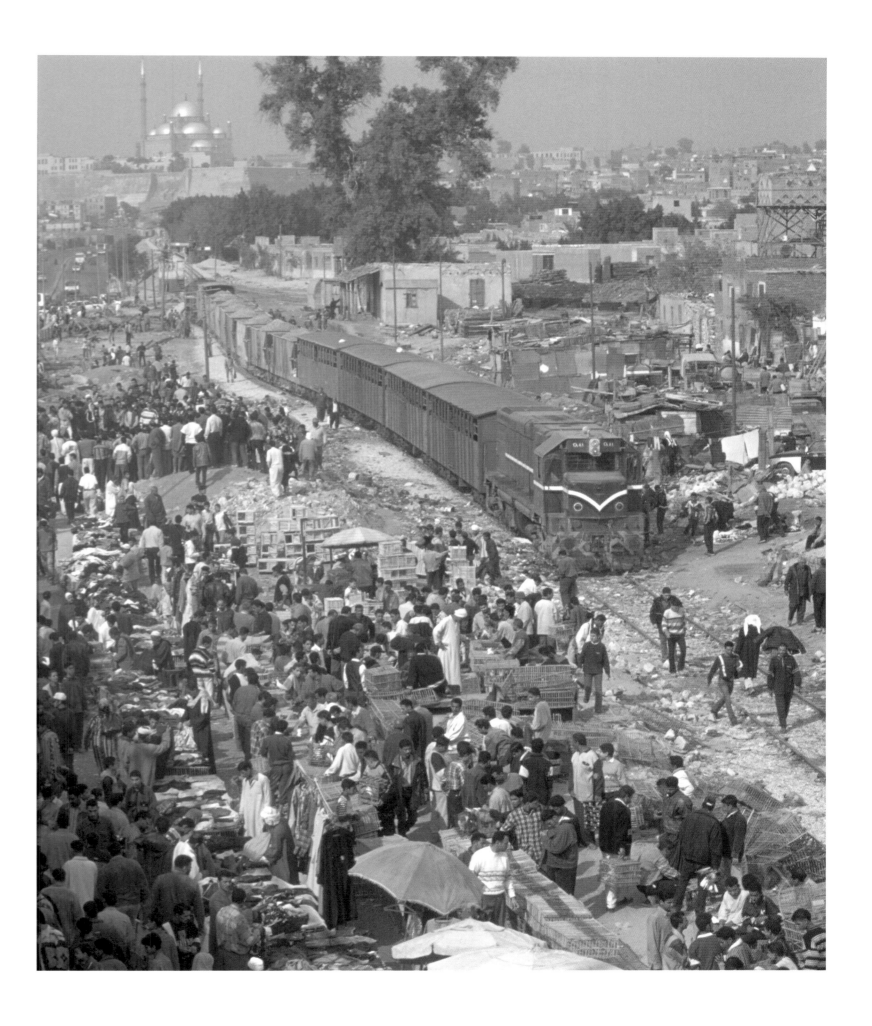

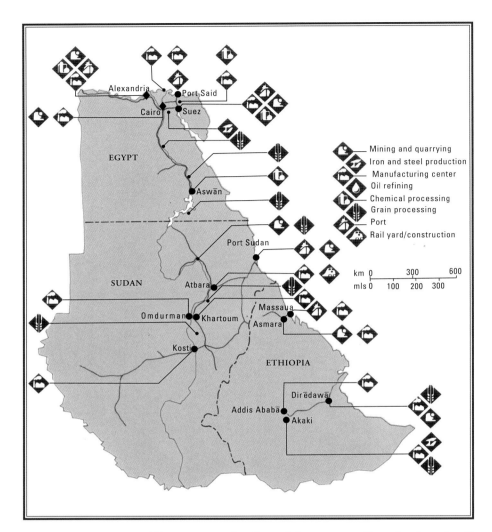

Mining and quarrying
Iron and steel production
Manufacturing center
Oil refining
Chemical processing
Grain processing
Port
Rail yard/construction

km 0 300 600
mls 0 ... 100 ... 200 ... 300

The railroad networks of Egypt and Sudan owe their beginnings to British colonialism and military adventures in the region during the nineteenth century. In Ethiopia, the French were responsible for building the line between Addis Ababa and the port of Djibouti.

Primarily a passenger carrier, the Egyptian rail service was enhanced by the building of the Cairo cross-city tunnel linking two lines. Another improvement has been the double tracking of the Cairo–Aswan main line, on which overnight luxury trains are operated.

SUDAN

The first railroad in Sudan was opened in 1875, as a means of circumnavigating a waterfall on the Nile. Running south from Wadi Halfa, eventually it was extended 168 miles (270km) to Kerma. Essentially, it was a military railroad, used by the government of Egypt (first Turkish, then British) to intervene in Sudan. Rendered unnecessary by later developments, it was closed in 1905. It was built to the same 3ft 6in (1,067mm) gauge as lines then under construction in the Cape, and these two decisions undoubtedly influenced the choice of gauge for many African railroads. Indeed, they may have sparked the idea of a Cape-to-Cairo line.

The first of the present lines is also of military origin, built by General Kitchener across the Nubian desert to Khartoum during his campaign against the Mahdist revolt (1897–9). Kitchener was certainly aware that his line might form a part of the Cape-to-Cairo route and insisted upon equipment of 3ft 6in (1,067mm) gauge.

During the following quarter-century, the north was effectively opened up. Trains reached the Red Sea in 1905, Al-Ubayid in 1912, and Kassala in 1924. The south had to be more patient: the branch south from Sennar opened in 1954, and the first trains did not reach Waw until late in 1961. Even today, the system is regarded as incomplete, as the provincial capital of Juba has only the White Nile steamer service, which is operated by the railroad.

Since cotton and cotton seed are the principal cash crops of Sudan, accounting for some 60 percent of the country's export earnings, the Gezira Light Railroad, which serves the cotton fields, has been of great importance.

ETHIOPIA

Ethiopia's civil war brought a sudden end to most of its train services, but with assistance from several European agencies, a program of rehabilitation began during the 1980s. The principal line links Adis Ababa with Djibouti

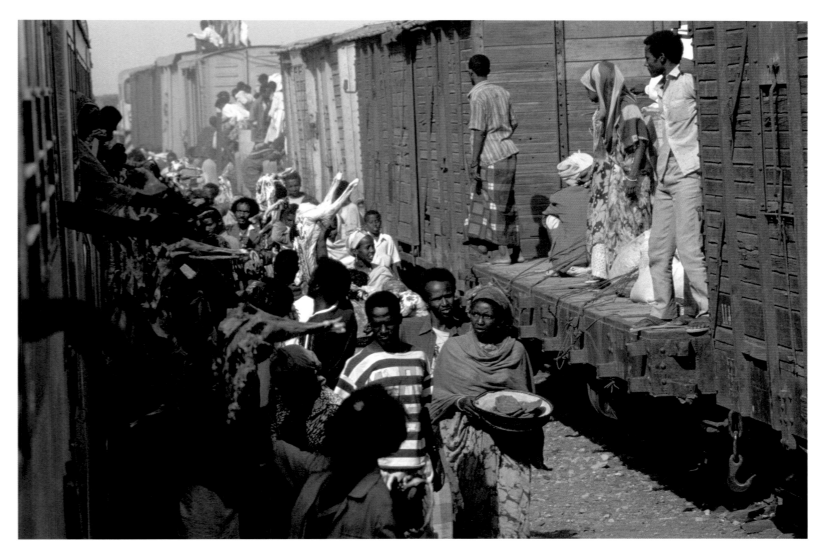

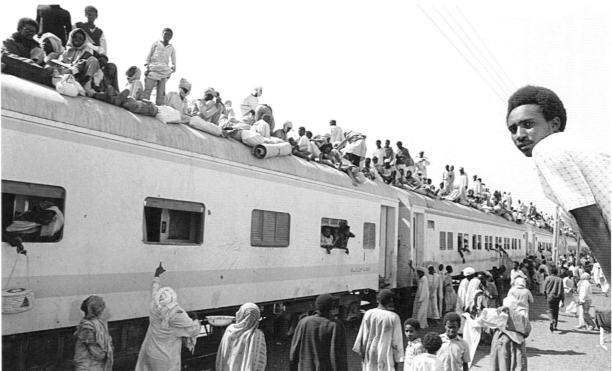

Above: Enterprising vendors sell meat to the passengers of a train on its way from Addis Ababa to Djibouti, Ethiopia, when it stops at Adagalla station, May 1990.

Left: A crowded passenger train on its way to Al Ubayyid, Sudan. For many, the opportunity of a free ride is worth the risk of traveling on the roof.

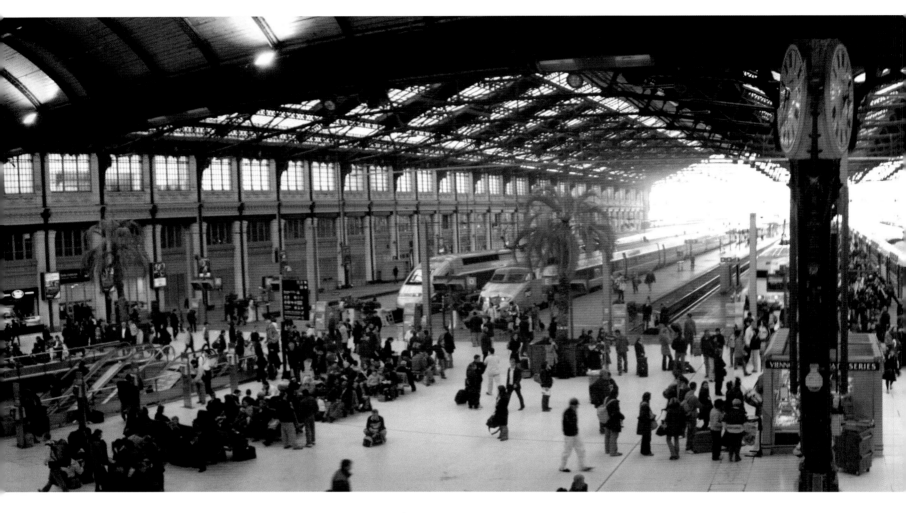

PASSENGER SERVICE OPERATIONS

OPERATING AN EFFICIENT AND ECONOMICAL PASSENGER SERVICE IS A COMPLEX TASK, REQUIRING THE CAREFUL INTEGRATION OF MAIN-LINE AND COMMUTER TRAINS.

Planning a passenger schedule on a line carrying a variety of traffic usually involves striking a balance between the immediate demands of the business offered, the economic use of rolling stock and motive power, and what is practical in the way of speed. Clearly, the rolling stock should be worked to the best advantage, securing maximum utilization, but an ideal backward and forward movement of a consist of cars might not fit in with the traffic flows, and some runs might be

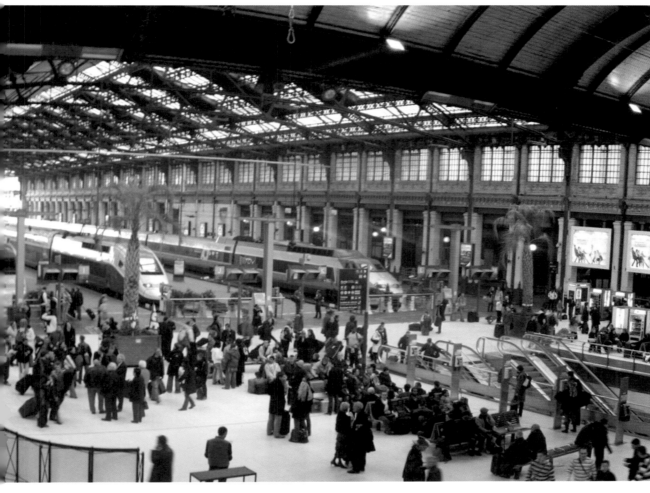

The bustling Gare de Lyon main-line terminus in Paris, France. Integrating the arrivals and departures of long-distance and local trains at such a station is a major undertaking, but is only a small part of the total effort required to run an effective passenger rail service.

no more than lightly loaded. It has been demonstrated that the introduction of regular-interval services between important centers throughout the day attracts traffic. Trains running in off-peak periods will sometimes be sparsely loaded, and in earlier times, it was the practice to work these periods with fewer cars. The fixed formation trainset presents no problems with reforming trains, and the time and labor saved compensates for the under-utilization of seating in off-peak hours. On the busiest intercity services in Britain, trainsets shuttling between major cities are never worked empty to a storage yard. These intercity trains are often at the terminal platforms for only about half an hour, before leaving again, frequently fully loaded, for the return trip.

The intensity of passenger rolling stock utilization today creates its own problems. The attraction of a fast, frequent service will be reduced if there are times when the equipment of the cars is faulty, apart from considerations such as the quality of the ride. In addition to engineering maintenance, which on trains providing an intense daytime intercity service has to be carried out at night, there are points that are small so far as overall planning is concerned, but are important for public relations. Nothing is more repellent to a passenger entering a car at the start of a journey than to find old newspapers and other debris left by travelers on the incoming service. No matter how briefly a trainset may rest at a terminal station between inward and outward trips, time must be allowed for maintenance personnel to clean the train's interior. Today, on some routes, there are onboard traveling cleaners.

Provision for track maintenance also governs the scheduling of intense high-speed passenger services. On the British Rail electrified line northward from London (Euston), the traffic was sufficient

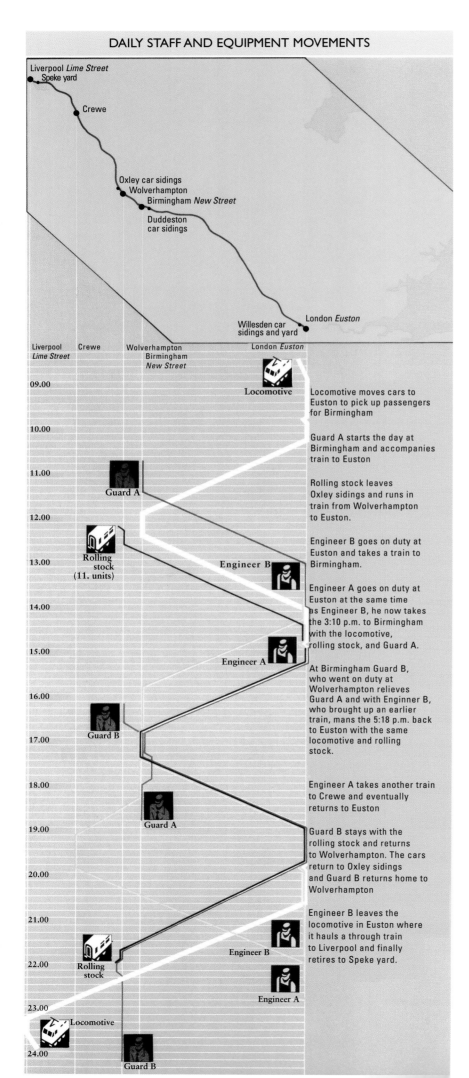

DAILY STAFF AND EQUIPMENT MOVEMENTS

Liverpool *Lime Street*
Speke yard
Crewe
Oxley car sidings
Wolverhampton
Birmingham *New Street*
Duddeston
car sidings
Willesden car
sidings and yard
London *Euston*

Liverpool *Lime Street* — Crewe — Wolverhampton Birmingham *New Street* — London *Euston*

Locomotive — Locomotive moves cars to Euston to pick up passengers for Birmingham

Guard A — Guard A starts the day at Birmingham and accompanies train to Euston

Rolling stock leaves Oxley sidings and runs in train from Wolverhampton to Euston.

Rolling stock (11. units) — Engineer B goes on duty at Euston and takes a train to Birmingham.

Engineer B — Engineer A goes on duty at Euston at the same time as Engineer B, he now takes the 3:10 p.m. to Birmingham with the locomotive, rolling stock, and Guard A.

Engineer A — At Birmingham Guard B, who went on duty at Wolverhampton relieves Guard A and with Enginner B, who brought up an earlier train, mans the 5:18 p.m. back to Euston with the same locomotive and rolling stock.

Guard B — Engineer A takes another train to Crewe and eventually returns to Euston

Guard A — Guard B stays with the rolling stock and returns to Wolverhampton. The cars return to Oxley sidings and Guard B returns home to Wolverhampton

Rolling stock / **Engineer B** — Engineer B leaves the locomotive in Euston where it hauls a through train to Liverpool and finally retires to Speke yard.

Engineer A

Locomotive

Guard B

09.00 · 10.00 · 11.00 · 12.00 · 13.00 · 14.00 · 15.00 · 16.00 · 17.00 · 18.00 · 19.00 · 20.00 · 21.00 · 22.00 · 23.00 · 24.00

to justify an hourly service throughout the day from London to Liverpool and to Manchester, and a half-hourly service to Birmingham. Every hour also, there were fast trains serving other northern destinations, in addition to which, there were trains to Scotland at slightly longer intervals. To provide an adequate time interval for small items of track maintenance and the operation of trains that intersected the high-speed main lines, the regular-interval trains were grouped in "flights," leaving London at five-minute intervals beginning at 40 minutes past each hour until 10 minutes past the next hour, thus leaving a full half-hour free for local movements and essential maintenance work to be carried out on the line.

In pre-TGV France, the fast intercity services were planned to enable a traveler from the provinces to visit Paris, have a full afternoon for business, and return by a train reaching the home destination before midnight. French passenger train travel was at its greatest intensity during holiday periods, when extra trains were run from Paris to resorts in Switzerland, on the Côte d'Azur, and in Spain. In the days before Christmas, for example, it was not unusual in the six hours before midnight for about 60 long-distance trains to be dispatched from the Gare de Lyon alone. Only six or seven would be scheduled services; the rest were extras. Such was the reserve organization available that this intense provision could be worked punctually, most trains covering between 75 and 80 miles (120 and 130km) in the first hour out of Paris, and serving such diverse destinations as Athens, Rome, Nice, Grenoble, Milan, Interlaken, and Genoa.

In France, the prestige passenger train services entering and leaving Paris had to be interwoven with commuter traffic, which is intense in peak hours, although on all the principal routes approaching the city, there are four tracks from distances of about 20 miles (32km) inward. On the main route from Paris to the southeast, particularly over the 195 miles (316km) southward to Dijon, at times, the line was worked to full capacity, even though it was quadruple tracked most of the way. The TGV relieved this congestion.

The operation of an intense commuter service presents different problems from those posed by main-line operations. A large amount of rolling stock has to be available to cater for the morning and evening peak periods, but is idle or under-utilized during the rest of the day. There is also the problem of storage, because the volume of vehicles needed for the morning peak cannot be accommodated near the city terminals; it has to be worked to suburban centers before standing by during off-peak hours. Because of the under-utilization of stock, on the basis of a 24-hour assessment, the working of commuter services tends to be uneconomic, despite progressive increases in fares. The nature of the rolling stock for such a service—whether it be the subway type or the huge double-deck cars common in North America and continental Europe—makes it unsuitable for any other duty during off-peak hours. Today, while the situation in the environs of great cities is acute, the acceleration of main-line services with the latest forms of motive power has resulted in more city workers commuting from farther afield. In earlier days in the UK, businessmen traveled to London daily over distances of 45–50 miles (70–80km); today, they commute over distances of 75–105 miles (120–170km).

A criticism directed at many commuter services is that while trains may run at frequent intervals, the overall time from outer residential stations to the city center is relatively slow, because of the frequent stops. This criticism was leveled at the extension of the London Underground to Heathrow International Airport, from which the trains entering the central area must take their turn among the swarm of other subway trains. An attempt has been made to overcome a similar problem in Paris by the construction of new, deep-level, cross-city express lines. A great deal of the congestion at main-line terminals has been relieved by diverting commuter trains to these deep lines. The new network's outstanding feature is the provision of only a few stations in the central area, in contrast to the closely spaced stations of the original Paris Metro and the London Underground. The distance between the stations Auber and Defense is 4.5 miles (7.2km), while the time allowed is only 6.5 minutes, inclusive of a 20-second intermediate stop at Étoile. The track and rolling stock match main-line standards, although provision is made for a large number of standing passengers at peak periods.

One of the most remarkable examples of complete railroad schedule integration was operated on the Netherlands State Railroads. Connecting all the major cities, such as The Hague, Rotterdam, Amsterdam, Utrecht, Zwolle, Eindhoven, and Maastricht, there was a half-hourly service of fast electric trains. A traveler could arrive at a city station and be sure that within half an hour at the most, there would be a fast train. The journey may have required a change of trains en route, but the connecting service arrived within a matter of minutes and was equally fast. To the outermost centers, such as Leeuwarden, Groningen, and Vlissingen (Flushing), there was an hourly service of fast electric trains. Everything depended upon punctuality; all trains entering the Netherlands from surrounding countries, and all freight trains, were subjugated to this basic network. So regular, standardized, and punctual was the operation that it was regulated by computer program. At the large centers, supervisors kept no more than a watching brief, and manual intervention took place only when an unusual circumstance arose, or when a train from outside the country approached one of the frontier stations outside its schedule time. The electric trains operating the half-hourly and hourly services in the Netherlands, were all of the multiple-unit type. The only passenger trains that were locomotive hauled were the international through services. By and large, despite restructuring, the system is still in place.

Opposite page: This diagram follows the movements of the staff and equipment used for a single return operation of a locomotive hauled passenger train between London (Euston) and Birmingham, in England. Although the trains are the 3.10pm Euston–Birmingham and the 5.18pm Birmingham–Euston, the diagram shows, for the rest of the day, the different paths of the men and equipment who come together briefly to work these trains.

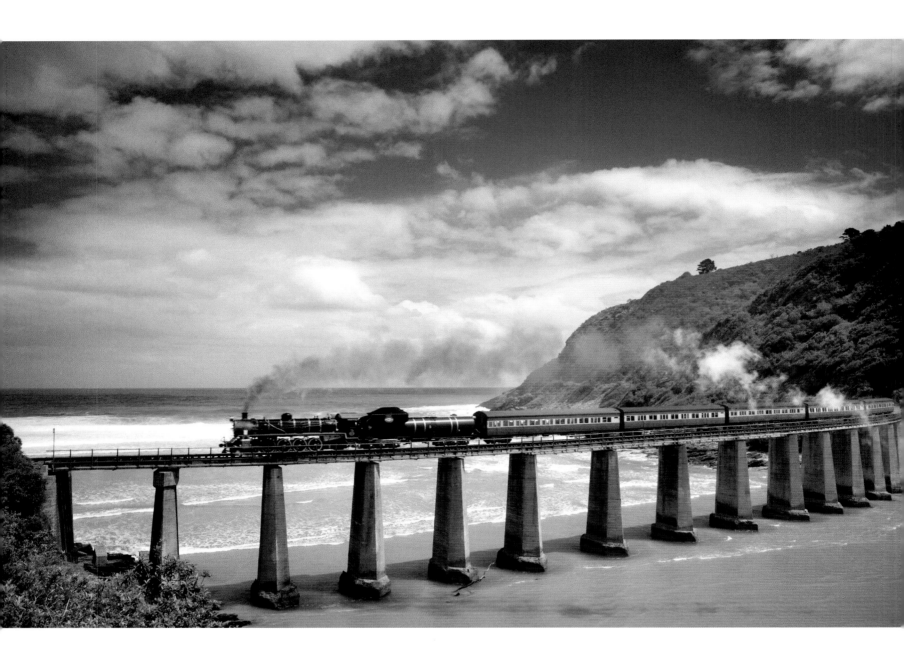

RAILROADS IN SOUTHERN AFRICA, FROM 1860

THE SPREAD OF RAILROADS IN SOUTHERN AFRICA OWES MUCH TO

THE ENTHUSIASM OF CECIL RHODES, WHILE THE DISCOVERY OF

DIAMONDS AND GOLD ADDED FURTHER STIMULATION.

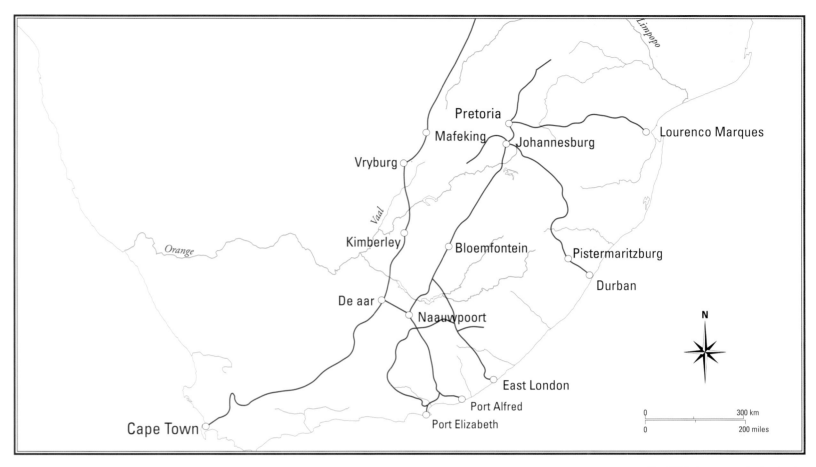

SOUTH AFRICA

By 1900, there was the beginning of a rail network in South Africa, the lines extending inland from the coast. The construction of railroads had been accelerated by the discovery of diamonds at Kimberley, and then gold in the Witwaterstrand.

The closely-knit, efficient network of the South African Railroads began as a series of individual and unconnected enterprises at a time when the whole land south of the Zambesi River was entirely pastoral and being slowly colonized by Europeans, whose aims extended no farther than farming. Short lines were pushed inland from Cape Town and Port Elizabeth, although mountain ranges and the experiences of those who had taken part in the Great Trek had suggested that there was little to be gained by extending the lines very far. Then, in 1869, there came the sensational discovery of diamonds in great quantity at Kimberley. Even then, railroad construction did not proceed rapidly. For one thing, there was the question of gauge to be settled. The Cape Town & Wellington Railroad had been built originally on the standard gauge, but when it came to carrying the line northward to the diamond mines and the severe terrain of the Hex River Pass had to be conquered, the government's consulting engineer, William G. Brounger, recommended 3ft 6in (1,067mm) as the standard for Cape Province. It was at that point that the effort to connect Kimberley with Cape Town began in earnest; a rival line driving inland from Port Elizabeth had the same objective.

An even more dramatic change came over the whole South African scene in 1886, when gold was discovered on the Witwaterstrand. By a strange twist of irony, this discovery, which transformed the entire economic and financial structure of South Africa, was made at the very place where the peace-loving pastoral farmers of the south had ended their trek in search of a place where they could settle and till the land. From that resting place rose Johannesburg. At the very start, there was a railroad race,

Opposite page: Hauled by a 1937-vintage class 19D 4-8-2 steam locomotive of the Outeniqua Transport Museum, the *Choo Tjoe* passenger train crosses a bridge at Dolphin Point, near Wilderness, South Africa, December 2005.

A Beyer-Garratt articulated steam locomotive of Rhodesia Railroads hauls a heavy freight train on the Wankie–Bulawayo line, c. 1970s.

not between trains, but between two rival nationalities seeking to be the first to connect the gold fields with the sea. One was the British, under the leadership of Cecil Rhodes, who pressed ahead with the extension of the Cape Government Railroad northward from Kimberley. The other was the Dutch, striking westward from Lourenco Marques (now Maputo) in Portuguese East Africa. Due to Rhodes' tenacity, the first train from the south steamed into Johannesburg in September 1892, nearly three years ahead of the Dutch effort.

In the British colony of Natal, railroads were being pushed inland from Durban, and these became prominent military targets during the Boer War. After the war, much was done to consolidate railroad working in the four states that eventually were combined into the Union of South Africa in 1910. In the period between the end of the war and formation of the Union, the Cape Government and the Natal Government railroads carried on as before, while the lines in the two former Boer republics operated under the name of the Central South African Railroads. The three organizations were finally merged to form the South African Railroads shortly after the establishment of the Union.

After 1910, the system developed into one of the greatest in the world, operating entirely on the 3ft 6in (1,067mm) gauge. In recent years, great progress has been made with electrification at both ends of the system. The busy suburban area of Cape Town and the main line as far north as Wellington are so equipped, while the intense network around Johannesburg is a natural place for its advantages to be exploited to the full. The South African Railroads, with the cooperation of British firms, developed the steam locomotive to its highest degree on the 3ft 6in (1,067mm) gauge, and even today steam traction is used for some regular services.

For a time, the system included the railroads in the former German colony of South West Africa, where near-desert conditions and absence of water favored the early introduction of diesel-electric locomotives on the line running north from De Aar Junction to Windhoek. Today, these lines form the railroad system of Namibia.

In 1990, South African Railroads became Spoornet, and most of the long-distance passenger services were withdrawn.

ZIMBABWE

Rhodesia's first line, from Vryburg in Cape Province to Bulawayo, opened in 1897. In 1899, the line between Umtali and Salisbury opened, and when the two were joined in 1902, 2,023 miles (3,256km) of continuous railroad existed from Cape Town to Beira. The system was continued north from Gwelo to

Lake Tanganyika, but it was diverted to the Wankie coalfield and so crossed into what is now Zambia at Victoria Falls. Until 1967, the Zambian lines were run from Bulawayo as part of Rhodesia Railroads.

Despite a deteriorating economy, Zimbabwean Railroads continued to maintain a robust service in the early twenty-first century. Separation of infrastructure from operations made some progress. Due to lack of spare parts, some diesel duties were switched back to steam traction, Zimbabwe becoming the last bastion of the Garratt-type locomotive.

MOZAMBIQUE

There are six lines in Mozambique, linking ports with the interior. Since 1970, two of the major lines have been connected via Malawi, and plans exist to join them to the southern Maputo system. The first railroad was begun in 1892 by a contractor under pressure from Cecil Rhodes to open a line from Rhodesia to the sea as quickly as possible. The Beira–Umtali line was complete by 1898, and was widened to 3ft 6in (1,067mm) in 1900. Today, only the line from Joao Belo is not to this gauge. Mozambique also runs the 139-mile (224km) Swaziland Railroad, opened in 1964. To attract foreign assistance and capital, moves have been made toward privatization in the form of operating concessions.

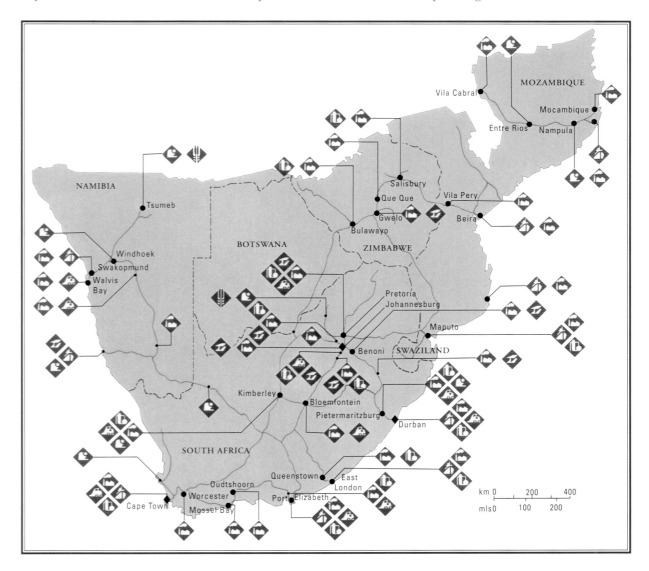

Of all the countries of southern Africa, South Africa has the most developed and efficient rail network. Much of it stems from the early days of colonial exploitation and the drive of Cecil Rhodes, whose dream was to create a rail link between the Cape and Cairo.

THE HEIGHT OF LUXURY

INTRODUCED IN THE LATE 1930s, SOUTH AFRICA'S BLUE TRAIN PROVIDED THE MOST LUXURIOUS ACCOMMODATION THAT HAS EVER BEEN OFFERED FOR RAIL TRAVELERS.

The name of South African Railroads' Blue Train would immediately remind European travelers of something much nearer home, because for some time before the SAR adopted the title, the Paris, Lyon & Mediterranean railroad of France had been running the *Train Bleu*, a nightly sleeping-car express from Paris to the much favored resorts on the Côte d'Azur. In South Africa, however, the need for a luxury train from the Cape to the cities of the Transvaal came as part of the rehabilitation programme after the Boer War. In 1903, the new service between Cape Town and Pretoria was put on, and even in those days, the rolling stock was the height of luxury. The train connected with the arrivals of the Union Castle mail steamers from England. Each train ran two days a week in each direction, leaving Cape Town at 10.45am and reaching Johannesburg at 4.30pm on the following afternoon. At the time of its introduction, it was operated by the Cape Government Railroad as far north as Kimberley; from there, the Central South African Railroad (CSAR) took over for the rest of the journey. Practically all the equipment of the CSAR was new, supplied from Great Britain.

When the Union of South Africa was formed in 1910, and the previously independently worked railroads of the Cape of Good Hope and of Natal

In keeping with the train's name the rolling stock and locomotives of the *Blue Train* are painted blue and kept in immaculate condition, in line with the luxurious nature of the service offered.

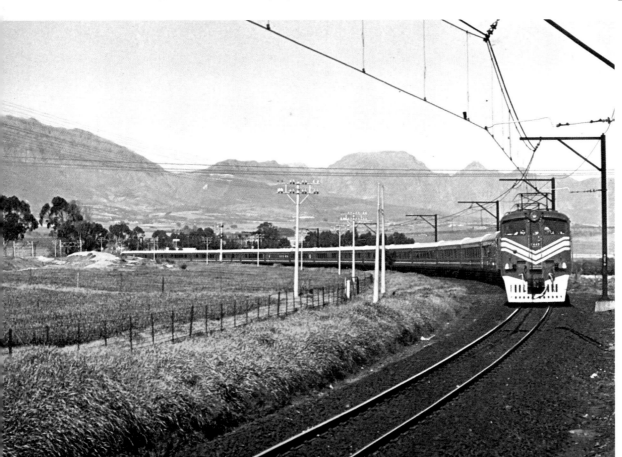

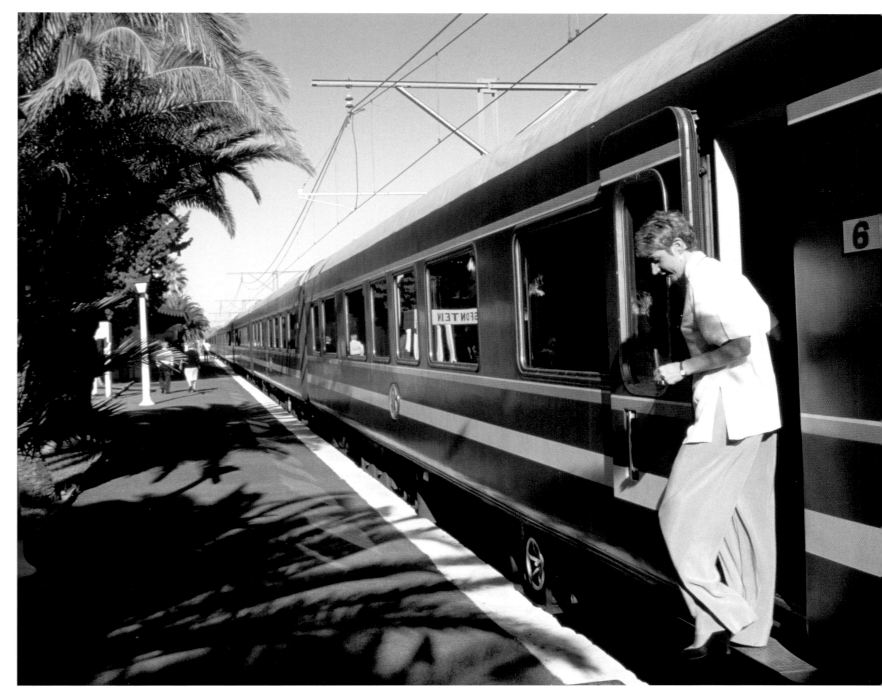

amalgamated with the CSAR to form the South African Railroads, the luxury express running between Cape Town and Pretoria was given the name *Union Limited*. Although it continued to offer first-class accommodation only, with supplements added to the fares, an "all-classes" express train ran from Cape Town to the north on the five days that the *Union Limited* did not run, taking 39 hours to reach Johannesburg, because of many more intermediate stops, compared to the 29½ hours of the deluxe train. Despite its exclusivity, the *Union Limited* became a very popular train, requiring many more coaches. The locomotives grew in size from the smart Pacifics of the CSAR to giant 4-8-2s in the 1930s. Although the track gauge was no more than 3ft 6in (1,067mm), physical conditions enabled the locomotives to be built considerably wider and taller than those on the standard-gauge railroads of Great Britain. Speeds were not high by present standards, however, and with steam traction, the maximum permitted was 55mph (88.5km/h).

A passenger takes the opportunity to stretch her legs at a stop on the *Blue Train's* 27-hour, 994-mile (1,600km) journey between Cape Town and Pretoria, in South Africa, April 1994.

In early 1939, the name was changed to the *Blue Train*, coinciding with the introduction of magnificent new rolling stock, which, unlike all other passenger stock on the South African Railroads, was painted blue. The new coaches had clerestory roofs, and the upper panels were painted cream. The compartments were more like royal lounges, or deluxe ships' cabins, than the interiors of trains available to the general public. They were upholstered in blue leather, and there were loose cushions on the seats. There were writing tables provided with attractive headed notepaper, and throughout the journey, there was an excellent valet service. The South African Railroads set store upon the public relations rendered by the traveling staff, and all those allocated to the *Blue Train* were specially selected. The dining car was sumptuously appointed, and at the rear, there was an observation car. The steam locomotives of the South African Railroads had always been black, but black or not, the engines of the *Union Limited* and *Blue Train* were always immaculate.

The train was electrically hauled between Pretoria and Kimberley, and again between Beaufort West and Cape Town, by locomotives specially painted blue, in contrast to the standard russet color of non-steam units on the SAR. It left Cape Town at 12 noon and arrived in Johannesburg after 24½ hours, an excellent overall average speed of 39mph (63km/h). Pretoria was reached at 2.00pm. On the southbound run, departure from Pretoria was at 10.00am, arriving at Cape Town at 12 noon on the second day.

In April 1969, the thirtieth anniversary of the *Blue Train* was celebrated in spectacular fashion. At the suggestion of the Historical Transport Association of Johannesburg, a special anniversary run was organized, steam hauled throughout in both directions. Great pride had always been taken in the appearance and turn-out of the mainline steam locomotives of the South African Railroads, and on this occasion, a trophy was awarded to the crew of the best prepared engine. Six locomotives were involved in each direction of operation, and the competition

Before the rise of air travel finished the ocean liner, the *Blue Train* was an important link between the administrative capital of South Africa, Pretoria, and the outside world, via the port of Cape Town. The train ran originally as a link with the ships to and from Britain, and had to match their luxury.

Kimberley 563km (350mls) arr 18:40 dep 19:11

De Aar 801km (498mls) arr 22:16 dep 22:21

Beaufort West 1,064km (661mls) arr 02:14 dep 02:39

Cape Town 1,608km (999mls) arr 12:00

Worcester 1,433km (890mls) dep 08:52

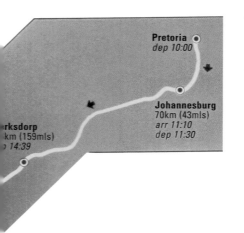

Pretoria ◉
dep 10:00

Johannesburg
70km (43mls)
arr 11:10
dep 11:30

rksdorp
km (159mls)
14:39

between crews for the trophy produced some sensational efforts. It was not merely a question of polishing up the usual externals: the wheels, motion and all the running gear, and in some cases even the interiors of the cabs, were cleaned to watchmaker's standards. At every stop on the journey where engines were changed, enthusiastic crowds were there to greet the train—even in the dead of night.

Today, the luxury train continues on its way silently and effortlessly. The only difference is that now it is operated by a private company as a tourist attraction.

Today, the emphasis is still on luxury for *Blue Train* passengers. This is the dining car, where haute cuisine is served to the accompaniment of live music.

RAILROADS IN WEST AFRICA, FROM 1862

AS IN OTHER PARTS OF THE CONTINENT, MANY RAILROADS IN WEST AFRICA HAVE THEIR ROOTS IN COLONIAL TIMES OR HAVE BEEN BUILT TO EXPLOIT NATURAL RESOURCES.

ALGERIA

The first Algerian railroad was opened in 1862, and from 1863, it was worked by the French Paris, Lyon & Mediterranean Railroad. The PLM acquired other lines in Algeria too, including some leased from the French Colonial Department. Two other major railroad companies were established: the Algerian State Railroad, which ran from Tunisia to Algiers, with a additional center at Oran, including the 3ft 5⅜in (1,055mm) gauge line south to Colomb-Béchar in the desert; and the Algerian Western Railroad, worked by the PLM from 1922. In 1933, a joint administration was set up, the CF Algériens, but with what had become the French state railroad still involved as major partner. In 1939, however, came financial autonomy and a new name for the line, Société Nationale des Chemins de Fer Algériens.

Today, the company is known as Société Nationale des Transports Ferroviaires (SNTF). The line along the coast is standard gauge. Bulk traffic transport on Algeria's railroads is assuming increasing importance due to the extensive exploitation of mineral deposits. Most lines running inland are narrow gauge. Exceptions are the Touggourt branch, standardized in 1957 when oil was discovered, and the line to Djebel Onk, built to exploit phosphate deposits (part of this is Algeria's only electric line).

MOROCCO AND TUNISIA

The first railroads in Morocco were 1ft 11⅝in (600mm) gauge military lines. Totaling 1,173 miles (1,888km), they were opened for public transport in 1915. Subsequently, all were converted to standard

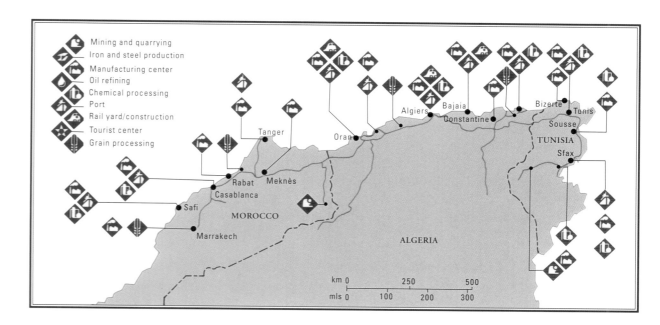

The French built railroads in Algeria during the late nineteenth century, extending the lines into Morocco and what is now Tunisia.

This fascinating hand colored photograph shows a steam hauled train arriving at the bustling railroad station in Dakar, Senegal, during the 1920s. Sacks of wheat are piled by the track awaiting shipment.

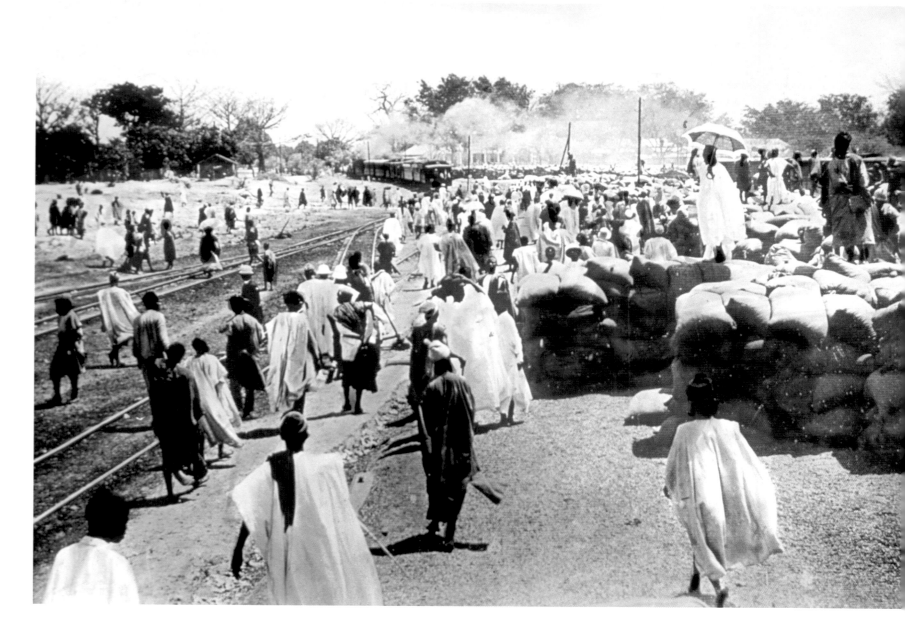

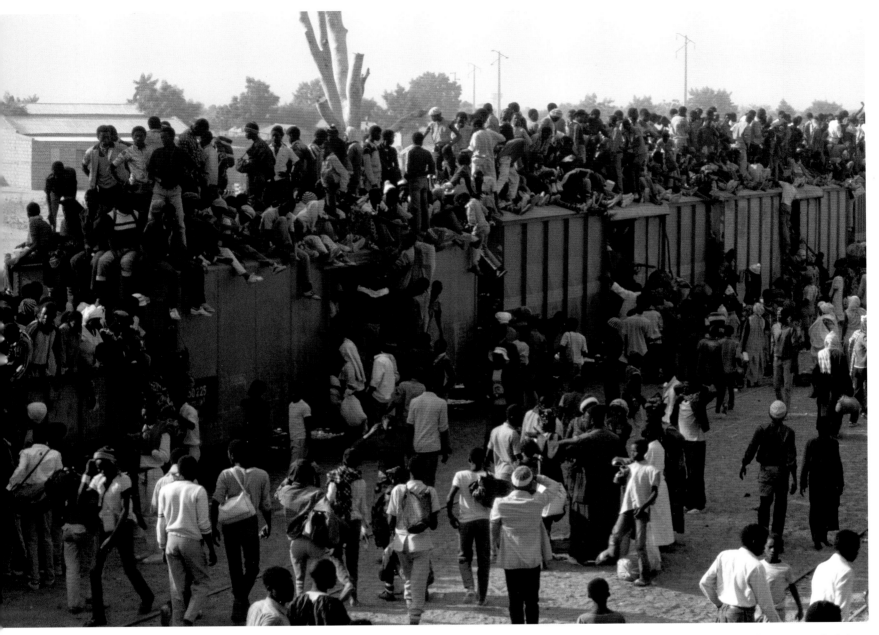

Freight cars crammed to overflowing with Mouride Islamic pilgrims at Taalides, Senegal, prior to the train's departure for Touba, 1987.

gauge, the first by 1923. The first electric line was opened in 1927. An Algerian line extended into what is now Tunisia in 1876. Because of this the lines north-west of Tunis are standard gauge. In 1897, a meter-gauge line was built to exploit the phosphates at Gafsa. Today, three-quarters of the system is meter gauge.

MAURITANIA

Mauritania's railroad was opened in 1963 to ship iron ore discovered at Fderik to the coast. However, passengers are also carried. The line is of standard gauge, with an peculiar L-shaped route caused by the need to avoid the Spanish Sahara. This detour added an extra 50 miles (80km) to the line.

At Choum, where the line turns north, there is a tunnel that is almost 1.2 miles (2km) long. To this day, shifting sand constantly threatens to bury 50 miles (80km) of the line, which is owned by the mining company.

SENEGAL AND MALI

Until the dissolution of the Federation of Mali in 1960, the lines in Senegal and Mali were part of one company, known since 1933 as the Dakar-Niger line. It was built in four stages by the French colonial administration to facilitate penetration of the Senegal River valley. The first line, opened in 1885, linked the mouth of the navigable Senegal River with Dakar's deep-water harbor. The next stage connected the upper limit of Senegal navigation (at Kayes) with the Niger at Koulikoro. Begun in 1881, but not completed until 1904, this was Mali's first line. In 1924, a link between the two lines was opened. Since then, several branches have been completed in Senegal, but there has been no new railroad building.

GUINEA

A meter-gauge line was begun in Guinea in 1900. By 1914, it had reached Kankan. In the 1970s, construction began on the 746-mile (1,200km) standard-gauge Trans-Guinea Railroad, replacing some of the meter gauge track. However, progress made so far is only partial. Some new line has been laid, using secondhand rails from Slovakia.

The railroads of western Africa were built to connect the interior with sea ports, aiding the exploitation of natural resources, such as the mining of iron ore.

LIBERIA

There are three railroads in Liberia, all engaged with the mining of iron ore. All run inland from ports, and the only two that meet (at the same port, Monrovia) are of different gauges. The first was opened in 1951, to 3ft 6in (1,067mm) gauge. The two later lines, totalling 216 miles (348km), are standard gauge, the southernmost being built for trains of 14,000 tons capacity. All three lines appeared to close during the civil war, but there have been signs of renewal.

IVORY COAST AND BURKINA FASO

The meter-gauge Ivory Coast Railroad (sometimes called the CF Abidjan-Niger) runs inland from Abidjan to the capital of Burkina Faso, Ouagadougou. Despite serving two countries, it is one administrative unit. The first stretch opened in 1904, but trains did not enter Upper Volta until 1934, and Ouagadougou until 1954. The line has been fully diesel since 1956. Some new lines have been built since then.

Handling Freight

ON MODERN RAILROADS, HANDLING FREIGHT HAS BEEN DEVELOPED INTO AN EXACT SCIENCE, ALLOWING THE MOST EFFECTIVE USE OF EQUIPMENT AND INFRASTRUCTURE.

The variety of consignments handled by the freight division of a modern railroad makes essential a study of traffic flows and the demands of commerce. In all parts of the world, the problem of using tracks to the best advantage is severe. Whether the railroad is an intensively used "mixed" line, like most of the trunk routes in Britain or the principal main routes in France and Germany, or consists of lengthy stretches of single line, as on some of the great transcontinental routes in North America, the aim is similar, albeit on a different scale: to run the longest freight trains it is practical to operate to secure minimum line occupation. This involves the making up, or classification, of formations, and the freight vehicles are coupled one behind the other as they arrive from their originating stations. Sorting, and the classification after a long run to a distribution center, is expensive, to be avoided where possible. There is a trend toward running block loads of a single commodity, like coal, or of pooled mixed freight in container trains, and these do not require much sorting.

While sorting is a relatively simple mechanical operation, consisting of adding vehicles in ones and twos to the rear end of a train, its classification at the end of a long through run can depend upon geographical circumstances, particularly when freight is arriving for shipment from a large port. Some of the largest and most elaborately equipped classification yards are located a few miles inshore from extensive dock areas. There, arriving trains from many different inland centers, bringing a great variety of freight loads, have to be sorted out and classified into trains to go to individual loading points at the docks. Notable examples of this kind of operation were established at Hull and Middlesborough, in northeastern England, and at Melbourne, Australia. There is also the matter of city distribution of incoming freight at a time when road traffic congestion is becoming critical. From the railroad point of view, there is a great attraction in concentrating the dispatch and receipt of goods at a few large stations that are well equipped with mechanized loading and unloading facilities; this is especially true with container traffic. Road transport is usually involved between the actual senders and the consignees,

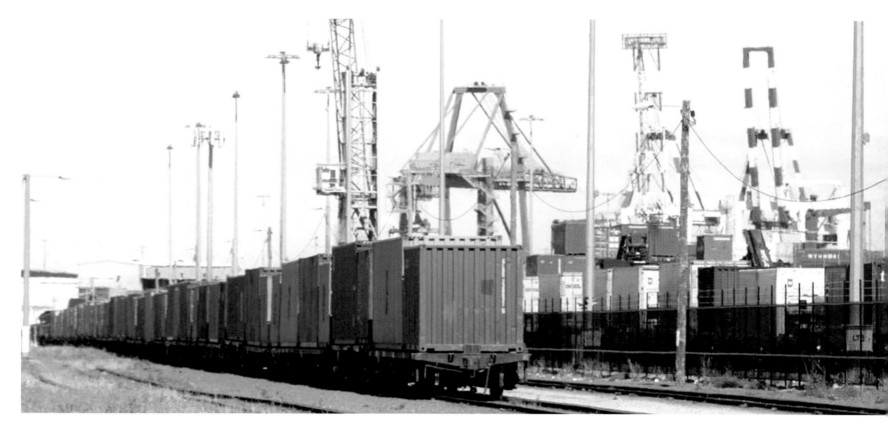

however, and inevitably this slows the overall operation. The time cycle has to be considered in relation to the length of run by rail, and in this, the shorter runs within the confines of a small country such as Britain cannot be compared even to western Europe, still less to North America.

The lengthy train required to run at speeds of 60mph (96km/h) or more presented a field for constant study and evolution in the practice of train handling. In North America, formations of 150 vehicles became common, and these were more than 1.5 miles (2.5km) long, weighing anything up to 10,000 tons. With modern diesel-electric locomotives, pulling power is likely to be the least of the problems facing operators today, because up to four locomotives can be coupled together electrically as well as mechanically so that they can be controlled by a single man, who may have 12,000–18,000hp, or more, at his disposal. The science of controlling such a train at speed, especially on long descending grades, became one of the most sophisticated in train operation.

U.S. trains are air braked throughout, but the art of braking has advanced from the basic principles patented by George Westinghouse over a hundred years ago. Numerous refinements have been added to ensure smooth application throughout a very long train. The principle of dynamic braking is used to minimize brake-shoe wear and heating during long periods of downhill running. This reverses the action of the engines on the locomotive units and causes them to be put "on compression."

Such a freight train may have its consist unchanged for a distance of 1,000 miles (1,600km) or more, except that "helper" locomotives may have to be used on certain steeply-graded sections. When this happens with long, heavy trains that require three or four diesel-electric units of 3,000hp or more continuously at the head end, the helper units are cut in intermediately, at the halfway point of the total train. The helper may consist of another three or four locomotives under radio control from the driver of the lead units. If the section of severe grade is relatively short, the helper may be manned by local engine-men. The cutting in of the helper involves stopping, dividing the train and recoupling.

The rise of intermodal services has revolutionized the shipment of freight by rail. Ready loaded containers can be transferred from ship or truck to rail vehicle, and back to ship or truck easily and quickly. Here, freight cars loaded with containers arrive at the Port of Melbourne in Australia.

FREIGHT YARD OPERATION

COMPUTERIZATION HAS PROVIDED GREAT EFFICIENCIES IN THE HANDLING OF FREIGHT TRAINS IN MAJOR CLASSIFICATION YARDS, PARTICULARLY IN NORTH AMERICA.

Although in Britain, Japan and some other countries, the predominance of container traffic and block trains has meant that many freight sorting yards have become redundant, they are still very important in countries such as the USA, Russia, India and China. The location of some of the great classification yards of North America illustrates the philosophy of freight train operation on the grand scale. The Canadian Pacific's Alyth yard, just to the east of Calgary, is a good example, lying at the intersection of two major routes with the transcontinental main line to Vancouver. The line from the south into Calgary serves a large group of prairie stations and brings in a vast amount of wheat traffic, while that to the north goes to Edmonton and the mineral bearing regions of northern Alberta. There was Conrail's great Conway Yard west of Pittsburgh, serving an enormous area of heavy industrial traffic. Out in the west, in addition to Barstow, the Southern Pacific Railroad built a well-equipped modern yard at Colton, near Los Angeles, a concentration and classification point for northbound, southbound and eastbound traffic, as well as for terminal traffic in Los Angeles itself.

The basic activity in a modern mechanized marshalling yard is simple. A train is brought into one of the receiving tracks, and then its individual vehicles have to be sorted and routed into one of about thirty classification sidings, each of which collects traffic for one destination. The sorting is often done in one continuous propelling movement over an intervening "hump." It is a continuous-flow task, and many factors have to be taken into account to maintain smooth operation.

The makeup of a train is checked electronically as it enters a big American yard, the information being transmitted automatically to a main computer, which stores all the information concerning type of vehicle, destination and ownership. This is because in North America, there is a great number of individual, privately owned railroads whose rolling stock is pooled for certain traffics, and which can claim distance rates for use by other companies. The mechanization in a modern classification yard applies to the degree of braking applied to the cars as they roll down the hump. The vehicles for

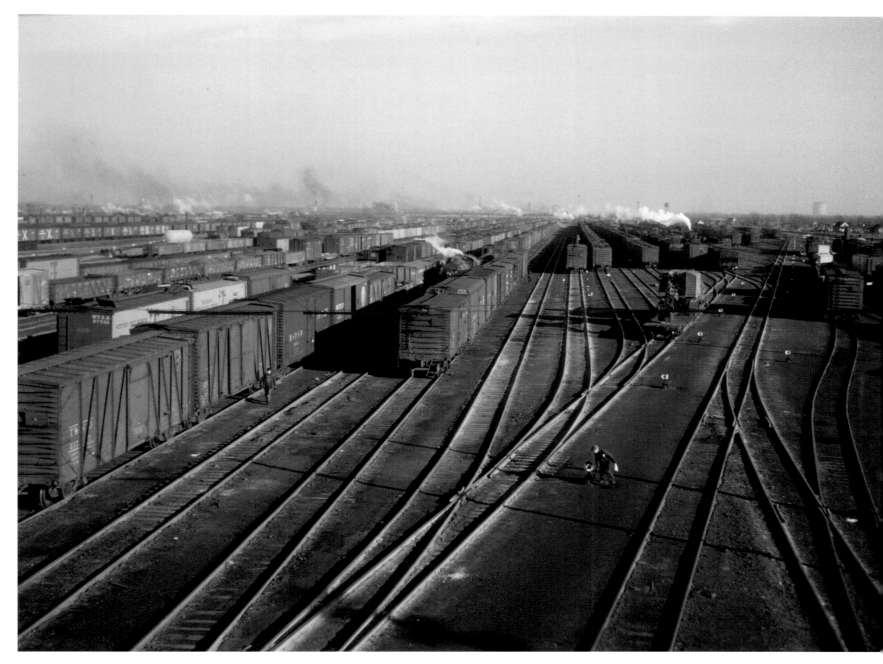

different destinations have to be uncoupled by men called "pin-pullers" as they pass toward the crest of the hump. As they roll down the steep grade beyond, they separate sufficiently for the points to be thrown between successive vehicles, or groups of vehicles coupled together, known as cuts.

Once the propelling movement starts from one of the receiving tracks, with a locomotive pushing from the rear, the computer in the main control tower takes charge. It sets the points according to the route required for each cut, and brakes the vehicles as necessary. The extent to which a cut requires braking will depend upon how much space is available in the classification siding to which it is routed; the computer "knows" this from information constantly collected from the track itself. The nature of the route leading into the siding also has to be considered: some have more curves than others. The direction and strength of the wind must also be taken into account, because a strong adverse wind can seriously retard the running of a large box car. Lastly, there is what is termed the "rollability" of the vehicle—whether it is a good or bad runner. This cannot be determined until it actually begins

The Chicago & North Western Railroad's vast Proviso classification yard, Chicago, Illinois, in 1942. The yard is packed with freight cars as far as the eye can see. Many of these vehicles would be used for transporting essential wartime supplies.

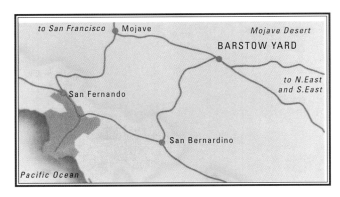

to San Francisco · Mojave
Mojave Desert
BARSTOW YARD
San Fernando
to N.East
and S.East
San Bernardino
Pacific Ocean

Above: The great classification yard at Barstow, California, is situated to receive trains from northern and southern California, as well as from the Pacific ports.
Below: The Proviso yard, showing the arrangement of the points and classification sidings.

to roll down the hump under the influence of gravity. A mechanism in the track is able to measure this characteristic, however, and the computer makes instant calculations to take account of the condition when applying brake pressure. The brakes, which may be electronically or hydraulically controlled, apply mechanical pressure by gripping the wheels of a vehicle as rolls through the freight yard.

While the great classification yards are focal points of concentrated activity in freight train handling, no less vital are the control centers, where an entire region or railroad can be controlled from one room. In these centers, illuminated track diagrams show the whereabouts and progress of every train on the network. Each controller in charge of a particular part of the network is able to tell at once the contents and ultimate destination of every freight train under his control. However, there is one important outcome of this remote supervision: there are few men along the actual lines to scrutinize the passage of trains. With North American freight trains being so long, it is impossible for either the engineer or the crew to see what is happening all along the train. Consequently, there is the possibility that an overheating journal box could go unnoticed and could deteriorate to the point of collapse, leading to a derailment. Accordingly, a comprehensive programme of installing trackside "hot-box" detectors was carried out on American railroads. These give warning to train crews and control centers of journal boxes running hotter than normal, allowing prompt action to be taken.

Receiving Yard
The capacity of the receiving yard allows trains to arrive from all directions without disrupting operations in the yard. All trains enter this yard on arrival from where incoming locomotives move to the diesel service area for necessary attention. The receiving yard contains ten tracks.

BARSTOW CLASSIFICATION YARD, BARSTOW, CALIFORNIA

Departure yard
Following the sorting of vehicles in the classification yard, cuts of cars are moved to the departure yard to be assembled into trains. The capacity here of nine tracks, which can accommodate about 1,370 cars, allows the formation of three trains, one each to northern and southern California and one eastbound. The neighboring through train inspection yard is for the examination of trains not requiring processing at Barstow.

1 Locomotive washing plant
2 Administrative office building
3 Diesel service building
4 Supervisor's tower
5 Car repair
6 Hump master's tower
7 Mechanical temperature control building
8 Hump conductors building
9 Caboose service building
10 Mini-hump control building
11 Bowl master's office

- Receiving yard
- Classification yard
- Local yard
- Departure yard
- Diesel service area
- Caboose service area
- Freight car repair
- Through train inspection yard
- Mini - hump
- Retarders

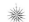

To slow free-rolling freight cars as they are sorted in the yard, the tracks are equipped with braking devices known as retarders. Operated pneumatically or hydraulically, these close to grip the wheels of cars as they pass.

Classification Yard

After trains in the receiving yard have been inspected and routes checked with the control office, they are shoved over the crest of the hump for entry to the classification yard. At the hump a total of three online computers have already stored information about all cars, and following individual uncoupling, vehicles are guided into any one of 44 tracks by a system of computer controlled switches and braking devices. Four tracks are provided for any resorting of stock. The classification yard has the capacity for over 2,000 vehicles.

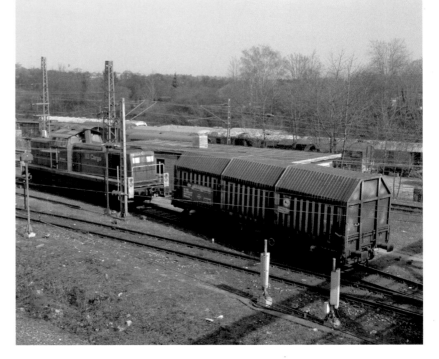

A switcher pushes a freight car over the hump in a classification yard. This allows the car to continue along the track under the influence of gravity as it rolls down the slope of the hump.

RAILROADS IN CENTRAL AFRICA, FROM 1886

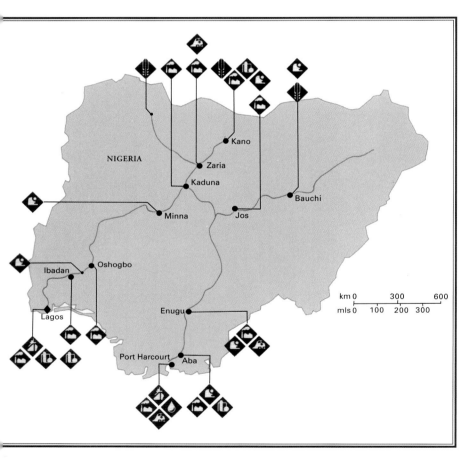

The railroads of Nigeria developed in piecemeal fashion at first, extending inland initially from Lagos. Eventually, several individual lines were connected and the gauge unified to form a national network.

THE RAILROADS OF CENTRAL AFRICA HAVE EXPERIENCED VARYING FORTUNES OVER THE DECADES. TODAY, SOME SYSTEMS HAVE STAGNATED, WHILE OTHERS THRIVE.

NIGERIA

Nigeria's earliest lines were conceived as separate entities, only being interconnected as an afterthought. Some of them were built as light railroads with a gauge of 2ft 6in (762mm), but subsequently all were superseded by railroads of 3ft 6in (1,067mm) gauge.

Railroad construction began near Lagos in 1896. By the time the line had reached Ibadan, 120 miles (192km) inland, work was almost complete on a light railroad linking the administrative center of Zungeru to the head of navigation on the Kaduna River (1901). The main line reached Jebba in 1909, but its pace had proved too slow for the new high commissioner of northern Nigeria, Sir Percy Girouard, one of Africa's foremost proponents of railroads (previously, he had been a director of Sudan Railroads, the president of the Egyptian Railroads board and Director of Railroads during the Boer War). Girouard began a line from the Niger River port of Baro north toward Kano. It opened throughout

in 1911; the original line did not meet it until 1912. Work on the Eastern Railroad began in 1913. It reached its initial objective—the coalfield near Enugu—in 1916, but did not join up with the other lines until 1926.

An important line was the Maiduguri Extension, completed in 1964. However, an ambitious scheme contained in Nigeria's Third National Development Plan (1975–80) envisaged most, if not all, of the 3ft 6in (1,067mm) gauge lines being replaced by standard-gauge tracks. The first section of an important line linking ore deposits, a steelworks and the sea was built to standard gauge in 1992. Five years later, Chinese specialists were advising on staff training, but the system continued to stagnate, despite the delivery of new Chinese diesel locomotives.

ZAIRE AND CONGO

The railroads of Zaire and Congo make better sense if considered with the rivers that still form an integral part of the area's transport system. Zaire's

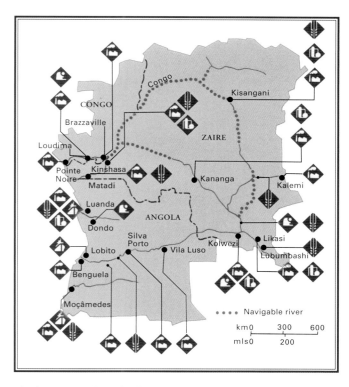

The railroad lines of Zaire and Congo rely on navigable rivers to complete the transport network, while in Angola, there is no interconnection between the individual lines.

first line opened in 1898 and ran around the rapids that keep ocean-going ships below Matadi. It linked Matadi with Kinshasa, terminus of river services up the Congo, and Kasai. Congo's main railroad is a similar line on the other side of the river, which was completed in 1934.

Transport up the Congo was improved by lines around two other obstacles: from Kisangani to Ubundu, and from Kindu to Kongolo. From there, the river is navigable to Bukama. Rails reached Bukama from southern Africa in 1919, the connections being seen as part of the Cape-to-Cairo route. The Congo River lines were built by a company formed in 1902 to construct the missing link from the Congo to the Nile. Early in the twenty-first century, such a route is partly supplied by the 1ft 11 5/8in (600mm) gauge Vicicongo line that runs west from Aketi.

Since the ousting of President Mobutu, the situation has remained fluid; Congolese National Railroads (SNCC) has been created to exploit railroad assets.

GHANA

Railroad equipment first arrived in Ghana in 1873, when the British governor, Garnet Wolseley, decided that it might help him to win an Ashanti war. He managed without a railroad, however, and it was not until gold was discovered that one was considered. Construction began from Sekondi in 1898, reaching Tarkwa in 1901 after great hardships. The line was extended to Kumasi in 1903. Another line, inland from the capital, Accra, was begun in 1909, reaching Kumasi in 1923, completing a circuitous route of 362 miles (583km). A more direct route from Sekondi to Accra, via Achiasi, was completed in 1956.

By the 1990s, assets were in poor condition and derailments were occurring every five days on

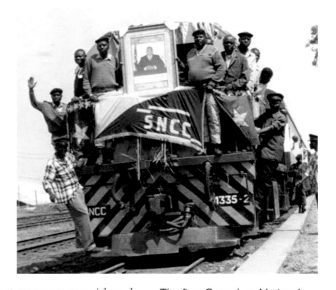

The first Congolese National Railroads train to arrive at Kindu on the newly rebuilt railroad between Lubumbashi and Kindu, Republic of Congo, March 2006.

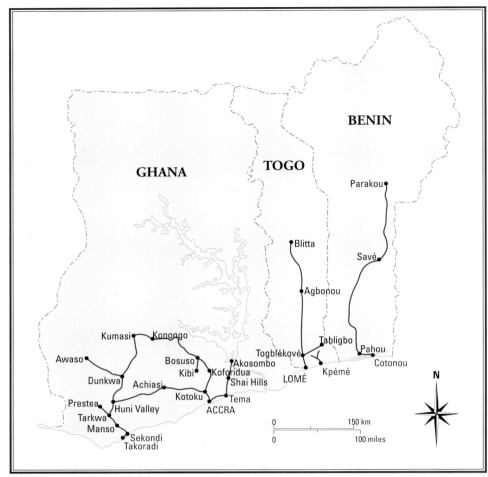

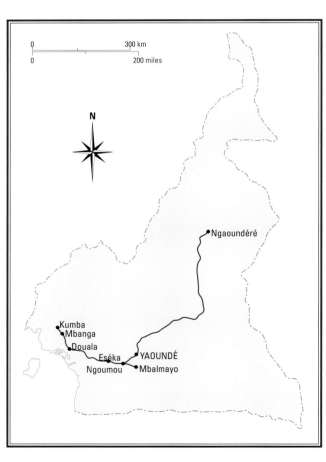

average. Since then, there have been several rehabilitation plans, and donor countries have contributed rolling stock. Competition from road traffic is strong, but a viable system has emerged.

BENIN AND TOGO

Benin and Togo have similar systems, opened at about the same time (circa 1905). Both are meter gauge and fully diesel operated, with equipment resembling that found in many other former French colonies (although Togo was German until 1914).

CAMEROON

Cameroon's meter-gauge system was begun in 1906 by the German colonial administration. After World War I, the French extended it to Yaounde. Since independence, another 393 miles (633km) has been added, the line reaching Ngaoundere in 1974. Privatization by concession began in 1999.

ANGOLA

Angola has four unconnected railroads, each running inland from a port. Only the line from Porto Amboim is not 3ft 6in (1,067mm) gauge, although the lines of the Luanda State Railroads were regauged in the 1960s. The most important line is the Benguela, begun in 1903; it meets the Zaire system at Dilolo. Through traffic was stopped during the civil war, although it has since been reinstituted.

TANZANIA, KENYA, AND UGANDA

In 1948, Tanganyika Railroads and the Kenya and Uganda Railroad amalgamated to form East African Railroads (EAR). While the union was effective under British influence, differences between the governments arising since independence caused such difficulties that EAR was split into its three constituent parts. Kenya Railroads Corporation (KR), Tanzanian

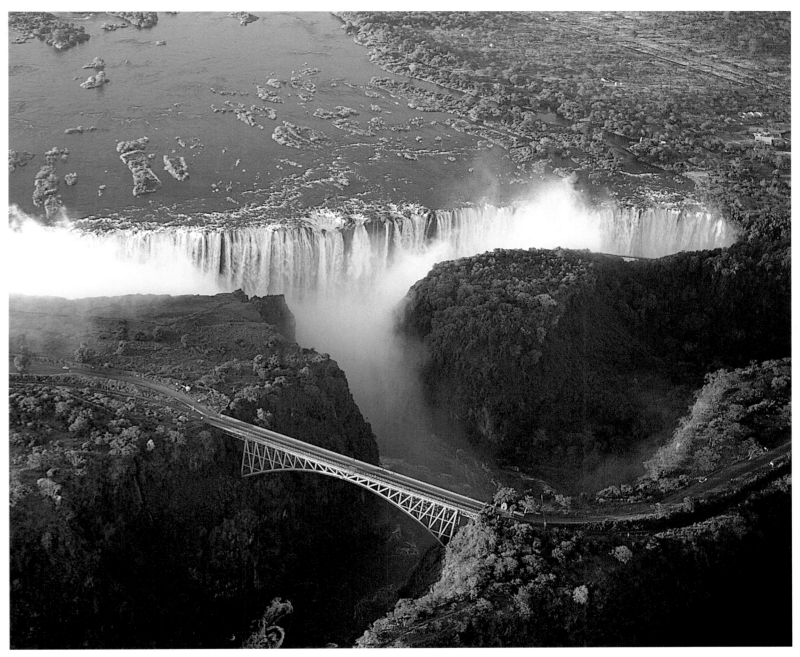

The Victoria Falls Bridge provides the only rail link between Zimbabwe and Zambia, the river being the actual border.

Railroads Corporation (TRC) and Uganda Railroads Corporation (URC) were created out of East African Railroads in 1977.

Unusually for former British possessions in Africa, the former EAR railroads operate on the meter gauge. In Tanzania's case, this is because most of the lines were built by the Germans, whose colony it was until World War I. The Kenya and Uganda Railroad was constructed to this gauge, apparently owing to a series of misunderstandings because no one in Britain wanted it built, seeing it as a mad imperialist venture on which the expenditure of public money was unjustified. Finally, grudgingly, it was built to meter gauge because cheap second-hand equipment was available from India.

The first line was the 1ft 11⅝ in (600mm) gauge, 60-mile (96km) Central African Railroad. Later, it was taken up and relaid as a tramway in Mombasa. The first of the present lines was started from Tanga in 1891, but it was only 25 miles (40km) from the coast in 1896, when building began at Mombasa. In 1901, Lake Victoria was reached; in 1914, Lake Tanganyika. Kampala's first train arrived

Opposite page, top: As in many parts of Africa, the railroads in Ghana, Togo and Benin provide important links with the coast. Bottom: Cameroon's railroad was begun by the German colonial power, and then continued by the French.

In 1948, the railroads of
Tanganyika (now Tanzania),
Uganda and Kenya, all British
possessions, were merged and
run as one network under the
name East African Railroads.
They were split, however, when
those countries were granted
independence. The railroads
in Zambia were once part of
the Rhodesian operation, the
country having been known
originally as Northern Rhodesia.
The Tazara line, which runs
from Dar-es-Salaam in Tanzania
to Kapiri Mposhi, just north of
Lusaka, in Zambia, was built in
the 1970s by the Chinese to
provide Zambia with a vital link
to the sea.

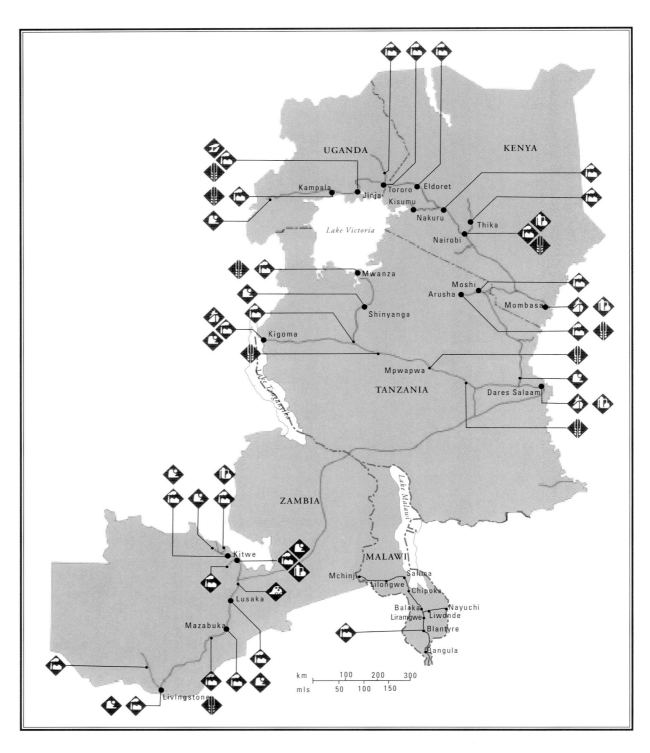

in 1931, Pakwach's in 1964. These lines were constructed with aim of aiding the area's agricultural and
industrial development.

TAZARA RAILROAD (TANZANIA ZAMBIA RAILROAD AUTHORITY)

The Tazara Railroad links Zambia Railroads with Dar-es-Salaam, 600 miles (970km) lying in Tanzania and
550 miles (890km) in Zambia. It is run as a single entity. Built with technical and financial assistance
from China, its completion earned China prestige in Africa. China provided 25,000 men, a third of
the workforce, and an interest-free loan of $420 million with generous repayment terms. It was the

largest railroad construction project completed since World War II. The line is built to Zambia's 3ft 6in (1,067mm) gauge and was completed in 1975. Over a million tons of freight was carried in its first year of operation. For Tanzania, the line will develop the neglected south-west, enabling vast coal and iron-ore deposits to be exploited. Before the Tazara line was opened, all Zambian routes led south, but events conspired to disrupt these lines: Rhodesia's unilateral declaration of independence in 1965 closed the Victoria Falls route, while the Angolan civil war caused problems to the Benguela Railroad traffic.

One 10-mile (16km) section of the railroad, between Mlimba and Makambako in Tanzania, contains 30 percent of all earthworks, bridges and tunnels on the line, including Irangi No. 3 tunnel, with a length of about 1.5 miles (2.5km).

Slum dwellings cluster around the railroad at Kibera, Nairobi, in Kenya. Although Kibera has a station, there is no commuter service, so residents are forced to use buses to reach the city.

ZAMBIA

Zambia Railroads was formed in 1967 when the Rhodesia Railroads Unitary System split. Before that, the lines were part of Rhodesia Railroads and administered from Bulawayo. The dividing point was the center of the Victoria Falls bridge.

The first line opened in Zambia in July 1905, although the bridge was not opened until September. It was built with equipment swung across the gorge on a cable. Before 1910, the rails were at Zaire's border. One of the line's main functions is to transport the copper belt's production, although when opened, it was seen as part of the Cape-to-Cairo route.

The past decades have been difficult for Zambian Railroads, a limited company. Part of this is due to unrest in surrounding countries, which interferes with traffic to and from the ports. Even copper traffic has been subject to road competition.

MALAWI

Malawi's first line opened in 1908, and the system is still expanding. Since 1970, it has linked two separate Mozambique lines, and the 70-mile (112km) Salima–Lilongwe line has opened. Malawi Railroads also operates the Lake Nyasa steamer service.

MALAGASY

Malagasy's first line was completed in 1903 by the French colonial administration. The development of the northern system of lines was completed in 1923. In 1934, an isolated line opened, running inland from the port of Manakara. Work on a 157-mile (253km) line to link this to the others has begun.

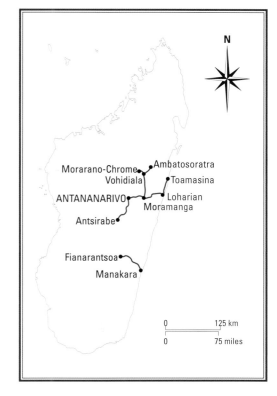

The railroads in Malagasy were built originally by the French in the early twentieth century. They provide important links with the sea.

Rail's Past and Future

ONCE CONSIDERED THE "HAS-BEENS" OF THE TRANSPORT WORLD, RAILROADS ARE ENJOYING A RESURGENCE IN THE TWENTY-FIRST CENTURY AS CONCERNS FOR THE ENVIRONMENT GROW.

For much of the twentieth century, people were encouraged to regard railroads as a technology of the past, with a historical importance, but declining future prospects. Such views were held at government level in many countries, including Britain in the 1980s. When the British government privatized the railroads in the 1990s, it did so in the expectation, indeed hope, that the railroad system would gradually wither away, making life simpler.

Yet, technically speaking, the steel wheel rolling along a steel rail is one of the most efficient means of movement. In the late twentieth century, however, wheel-on-rail was seen primarily as a possible means of handling only bulk freight and commuters.

Part of the problem has been that railroads, despite their potential, have always been difficult to manage at the political level. They were too important to be left to unrestricted private enterprise, but government supervision led to a stifling of initiative. Thus over almost two centuries, there has been a continuing argument between proponents of private railroads, and those who felt railroads should be the property and the business of the state. In Britain, opinions swung over the decades: first, the railroads were private, then government forced the private companies to merge into larger ones, then it nationalized them, and finally it re-privatized them. Britain has never had a properly integrated transport policy whereby each mode of transport does what it is best at doing.

In the USA, apart from during a few war years, the railroads remained private, but they were far from unrestricted. For decade after decade until the 1970s, The Interstate Commerce Commission crushed their initiative. Interestingly, railroads were so important in the USA that although lip service was paid to the principle of free enterprise, there was always a readiness for government intervention. It was the U.S. government that sanctioned, or did not sanction, railroad mergers, and it was the U.S. government that set up Amtrak and Conrail to solve particular problems that the free economy had failed to overcome.

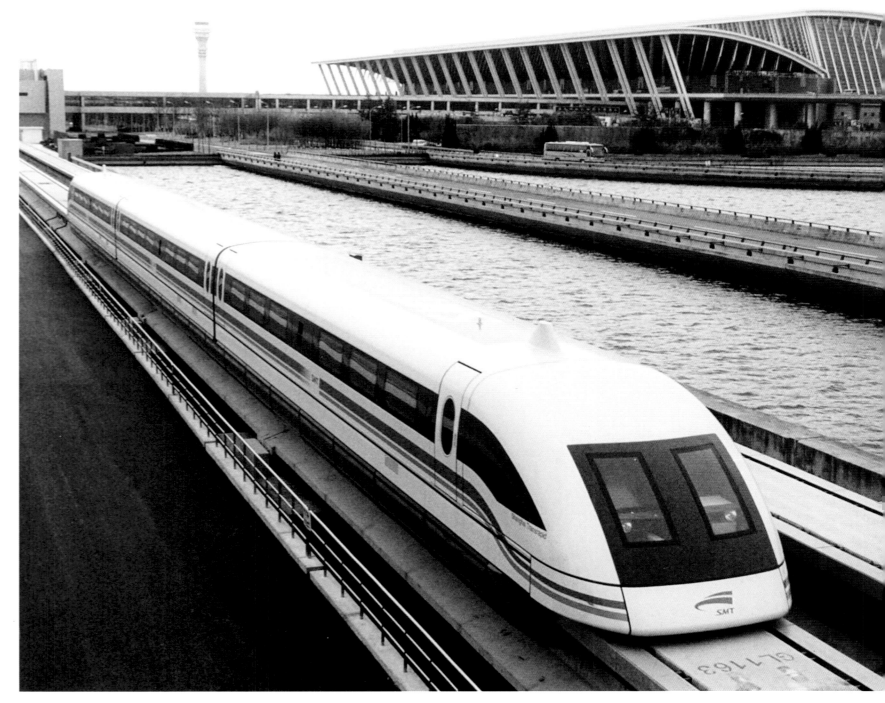

A maglev train of the Shanghai Magnetic Levitation Demonstration Operation Line, China, the first commercial highspeed maglev line in the world. The system employs electromagnetic forces to raise, guide and propel the train at speeds of up to 268mph (431km/h).

Despite being inherently the most efficient form of large-scale transport, railroads were unable to exploit that advantage when, as is universal, the facilities granted to air and road transport (both passenger and freight) always cost the taxpayer more than the taxes that air and road users paid for the use of those facilities. The railroads had paid for their infrastructure themselves and had maintained it at their own expense. Sometimes, they benefited from subsidies that helped to compensate for this, but such subsidies were highly publicized and only served to strengthen the impression that railroads were loss makers.

Indeed, many railroads are loss makers. Users expect cheap transport and, when hidden costs are taken into account, that is what they get, the gap being filled by taxpayers and, sometimes, by shareholders.

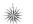

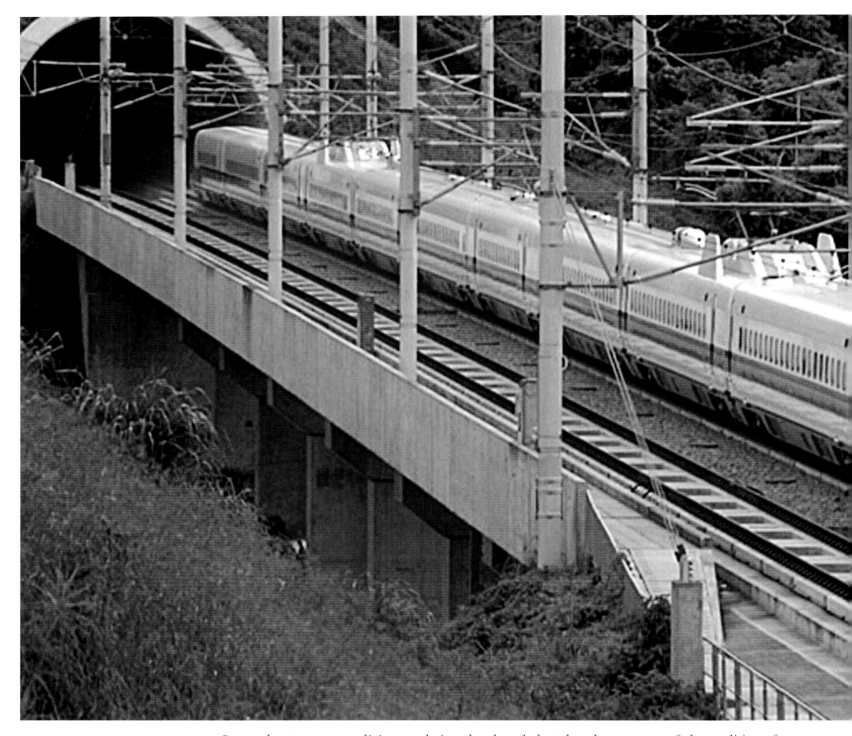

Currently, transport policies are being developed that do take account of the realities of costs and benefits, and in Europe, the clarity of accounting that is beginning to take effect will help. This is one factor in the brightening prospect for rail transport. Another factor is that many parts of the world are becoming congested; transport congestion is becoming a limiting factor, and not only in densely populated countries. The Chinese government, for one, has realized that its future transport needs cannot be supplied without a massive increase in rail transport, hence its 2004 decision to build 173,000 miles (28,000km) of new railroad by 2020. Lately, a third factor has become prominent in the public mind, the understanding that in terms of energy consumption and harmful emissions per ton/kilometer or passenger/kilometer, the train has a massive advantage over other forms of transport.

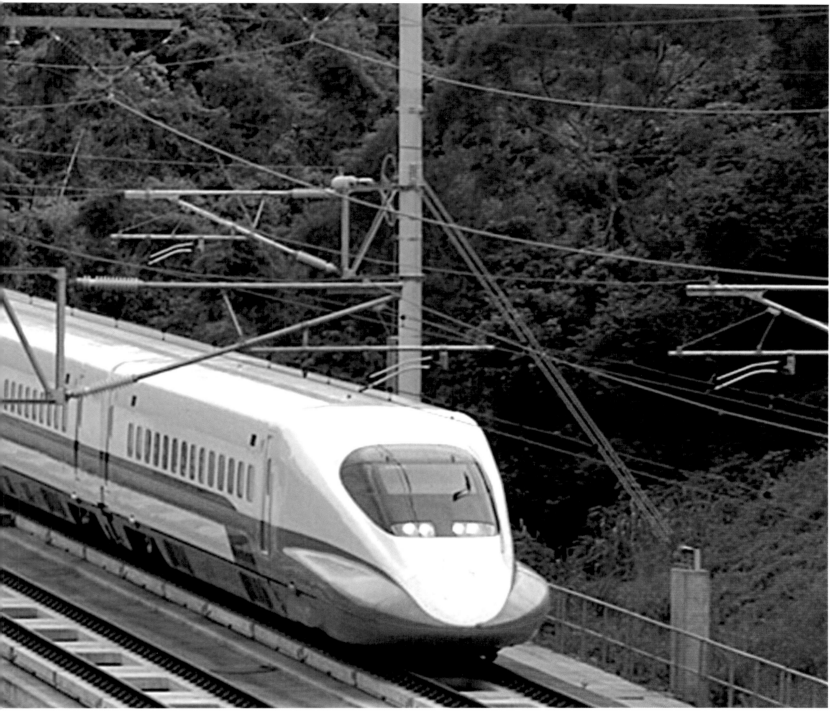

A number of governments, including the British, are urging a transfer of passengers to the railroads. In the USA, many state governments, anxious to avoid the need to build more roads, are saying the same thing and for some time have been providing funds to ease such a transfer. In Britain, as it happens, the railroads are so busy that any transfer of more than about 1 percent of passengers, including car passengers, would swamp the railroads. Thus as soon as this particular nettle is grasped, there should be a move toward longer trains. After privatization, there was a shift to shorter, more frequent trains, but there could be a reversion to the train lengths of the steam age, when 14 or 15 vehicles was common. In Britain and elsewhere, a shift to more comfortable trains, providing more facilities, can also be anticipated as efforts are made to attract more passengers; this temptation of passengers has

In 2007, Taiwan High Speed Rail opened its first line, which runs between the cities of Taipei and Kaohsiung, a distance of 208 miles (335.5km). Using 700T trains based on Japanese Shinkansen technology, the service has cut a 4½-hour journey to 1½ hours.

Fastech 360 is a prototype train for the next-generation of Japan's Shinkansen rolling stock, which can run at speeds of up to 252 mph (405 km/h). The "360" refers to the speed at which production trains were initially hoped to be operated. Production trains are due to enter service in 2011, operated by East Japan Railroad Company (JR East). Runs for production trains will be operated at 200 mph (320 km/h), surpassing the service speeds of the 500 Series and N700 Series Shinkansens to become Japan's fastest-operating bullet train in revenue service.

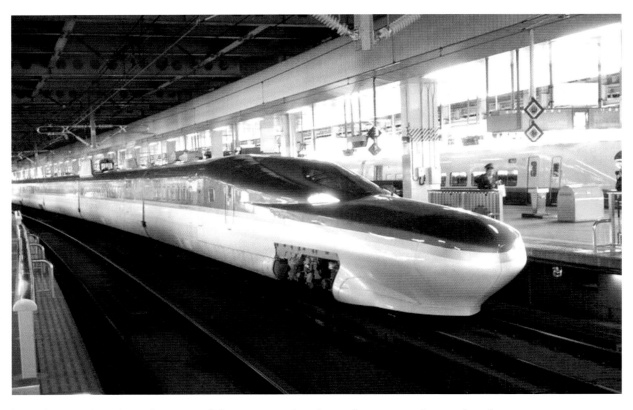

been happening since the turn of the century, but it can be expected to gather force.

Popular and political anxiety over carbon dioxide emissions must also accelerate the development of rail transport. In Britain (and developed countries where fairly high population densities would provide a similar picture), about a quarter of carbon dioxide emissions originate in transport. Passenger cars and buses produce 27 times more carbon dioxide than passenger railroads, but only 17 times more passenger/km. At the same time, road freight carries eight times more ton/km than rail freight, but produces 40 times more carbon dioxide in doing so. Domestic airlines produce four times as much carbon dioxide per passenger/km as passenger railroads.

High-speed trains have drawn significant numbers of travelers from cars and air transport. Airlines like Air France and Lufthansa have begun to actively encourage their long-distance passengers to use rail rather than air to travel to and from the hub airports. In the USA, Britain and elsewhere, road transport companies, once lethal competitors of the railroads, now use container trains for the trunk component of their hauls, shifting to the roads only for pick-up and delivery. These trends can be expected to carry on if fuel prices continue to rise and road taxes grow. Meanwhile, both national and local governments will continue to provide finance for train services that are plainly of social benefit, but unlikely to pay back their costs.

A glimpse of the near future, suggesting how railroad technology still has hidden reserves for passenger transport, can be seen in the several prototypes emerging

To reduce line-side noise, sound shielded pantographs have been introduced for Japanese high-speed trains.

in Japan. The Japanese concern for the environment became clear at the turn of the century, when Shinkansen trains had screens fitted around their pantographs to shield the public from noise. Success in designing streamlined front ends for further noise reduction is continuing, with some success. Meanwhile, radical ways are being sought to reduce the weight of trains (this will not only reduce costs, but also result in less energy expenditure per passenger/kilometer). East Japan Railroad's ACT (advanced commuter train) was on trial in 2007 and expected to go into production. The same railroad is developing the Fastech 360 Shinkansen train, which carries noise reduction so far that even the external cab door handles are recessed and covered by a sliding plate as soon as the train starts to move. This train also has aerodynamic resistance boards, flat plates that can be raised to add extra braking power at high speeds. An increasing number of trains in the world now employ regenerative braking, whereby braking force is obtained by converting momentum into electric power that is fed back into the system —one more way in which railroads can cut their carbon footprints.

As technology advances, so do the controls of modern trains, as illustrated by the computerized driver's compartment of this German DB Class 411 ICE-T. More like the flight deck of an airliner, it seems a lifetime removed from the open-air cab of a coal-guzzling steam locomotive.

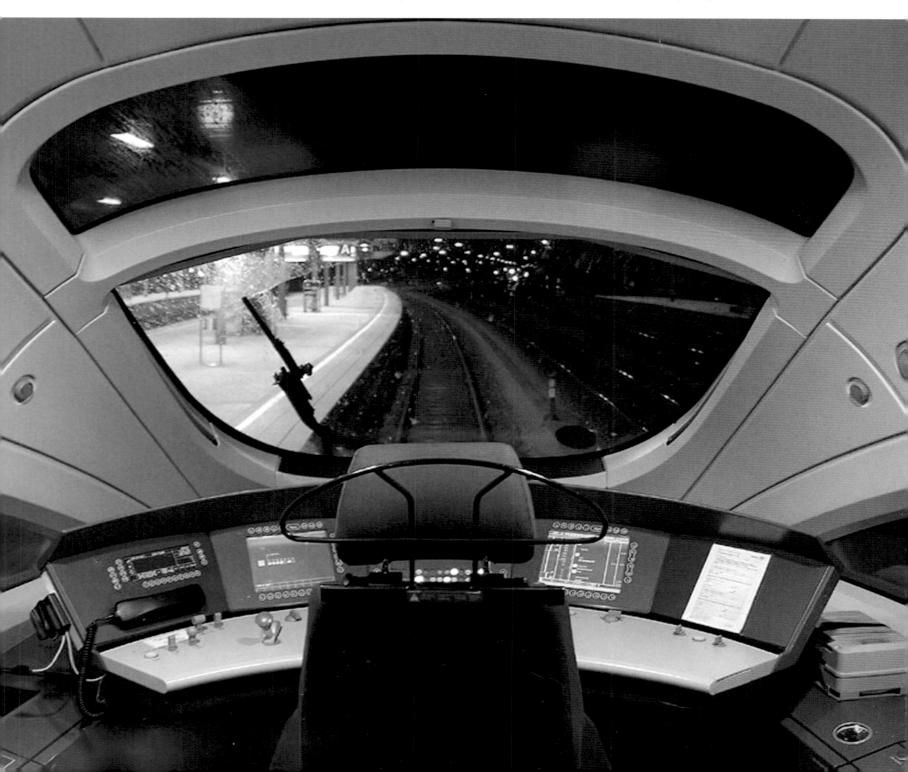

INDEX

Figures shown in **bold** type signify maps.
Figures in *italics* refer to photographs or
illustrations.

ACKNOWLEDGMENTS

Ian Christmas: 309 bottom, 321.

Corbis: 10, 12, 13, 16 bottom, 17, 24 bottom, 69, 73, 82, 83, 84, 105, 108, 109 top, bottom, 140, 148–149, 155, 165, 166, 189, 194, 195, 197, 199, 200, 212, 236–237, 247, 250, 251 top, 252, 254, 256, 257, 261, 264, 267, 269, 272, 285, 287 bottom, 289, 296, 299, 304, 309, 315, 319, 325, 326, 327, 338, 340, 348, 351, 353 top, 358, 360, 363, 367, 368.

Fotolia: 158, 240, 271.

Getty Images: 313, 353 top.

GW Travel Limited: cover, 9, 11, 123, 239 bottom, 278.

iStockphoto: 381.

Libary of Congress, Prints & Photographic Division: 20 center, 22 bottom, 30, 32, 33, 34, 36 bottom, 39, 47, 50, 78, 100, 103 top, 142, 156, 178, 190 (Jack Delano), 229, 373.

Morgue Files: 191 (Nicolas Raymond).

Robert T. Nordstrom II: cover (spine), 214, 233.

Popperfoto: 44–45, 46, 53 bottom. 353.

Railfaneurope: 204, 205.

Rail Images: 164, 184–185, 202.

Railphotolibrary: 54, 64, 66, 71, 80, 101, 151, 177.

Rio Tinto: 331.
www.trainweb.com: 201, 243, 249 bottom.

Swede Rail: 241.

John Westwood: 18, 49, 53 top, 55, 59, 89, 90, 92, 95, 97, 98, 99, 103 bottom, 104, 106, 111,

112, 113, 114, 115, 122, 125, 128, 129, 130, 131, 132, 133, 144, 145, 162, 180, 226, 285 top left, 386 bottom, 387.

Wikipedia Commons: 6, 8, 16 top left (Jan Pešula), 19 bottom right (John-Paul Stephenson), 20 top, bottom, 21 (William M. Connolley), 22 top, 23 top right (Adrian Robson), 24 top, 26, 28 top, 35, 36 top, 37 (David R. Spencer), 40, 41 (Audrius Meskauskas), 43, 51, 57 (Press Service, SJ AB), 68, 76, 77, 127–128 (Brian Harrington Spier), 134, 135, 136, 143, 146, 153, 159, 160–161, 163, 168, 171 (Jollyroger), 174, 193 (Harvey Henkelman), 208, 218, 239 top (Matthew Neleigh), 241 (Press Service, SJ AB), 245, 246, 249 top (Harvey Henkelman), 250 bottom (Sean Lamb), 275, 276 (Sebastian Terfloth), 277, 280, 281 (Ynhockey), 287, 288, 290, 291 (Herbert Ortner), 292 (Public Relations/ICF), 297 top, bottom, 300, 301 (Sean Lamb), 302 (Thryduulf), 303, 308, 310, 311, 316, 322, 328, 329, 330, 332 (Marcus Wong), 334, 335, 336, 341 top, bottom, 343, 344–345, 346, 347 top, bottom, 354–355, 365 (Andrew Balet), 371, 374, 375 top, bottom, 377, 379, 383, 384–385, 386 top, 387 (Seabastian Terfloth).